ON REPRESENTATION

T0204483

MERIDIAN

Crossing Aesthetics

Werner Hamacher

& David E. Wellbery

Editors

Translated by

Catherine Porter

Stanford
University
Press

Stanford
California
2001

ON REPRESENTATION

Louis Marin

On Representation was originally published in French in 1994 under the title *De la représentation*, © 1994, Seuil/Gallimard.

Assistance for the translation was provided by the French Ministry of Culture.

Stanford University Press
Stanford, California

© 2001 by the Board of Trustees of the Leland Stanford Junior University

Printed in the United States of America

Library of Congress Cataloging-in-Publication Data

Marin, Louis
 [De la représentation. English]
 On representation / Louis Marin.
 p. cm. — (Meridian)
 Includes bibliographical references and index.
 ISBN 0-8047-4150-6 (alk. paper)
ISBN 0-8047-4151-4 (pbk. : alk. paper)
1. Semiotics. 2. Discourse analysis, Narrative. 3. Art.
I. Title. II. Meridian (Stanford, Calif.)
P99 .M35513 2001
401'.41—dc21 2001032248

Original Printing 2001

Last figure below indicates year of this printing:
10 09 08 07 06 05 04 03 02 01

Typeset by James P. Brommer
in 10.9/13 Garamond and Lithos display

Contents

Figures

ON REPRESENTATION

Semiology and Social Science

§ 1 The Dissolution of Man in the Human Sciences: The Linguistic Model and the Signifying Subject

In a formula that achieved some notoriety in its day, an echo of Nietzsche prophesying the death of God, Michel Foucault announced the death of man.[1] Man's mortality is a venerable truth, well known to philosophers and the common herd alike; thus one of the most vigorous thinkers of our time might have lent the luster of his name to a mere banality—except that his assertion targeted a different truth, one more elusive than that of the oldest and most immediate experience of existence. This truth has to do specifically with the sciences "of man," and tends to offer them what can only be called a metaphysical foundation. Founding a science consists in stating the grounds for its legitimate claim to truth, the conditions of possibility for its exercise. If the death of man is to figure among the enabling truths of the human sciences, we have to acknowledge that there is the stuff of paradox here, calling for a look at the conditions underlying its formulation. Does the affirmation of the death of man not express, in a literary form, the truth of the scientific process itself? Just as geometric space constitutes itself by enacting the "death" of existential space, by overriding the physical object and the observer's intuition of diversity, so a certain immediate and global intuition of man, the unimpeachable testimony of consciousness with respect to man's states and his representations, experience lived as a signifying totality by a subject or a group, must give way to the results of processes that depend on breaking with that intuition, that testimony, that experience.

Thus man dies in the sciences that take him as their object, because the object of these sciences as such can only be constructed *against* global intuitions, against spontaneous representations, against immediate evidence.

The basic problem, then, is how to know what that object is, by what operations it has been constructed, what sort of relations it maintains with the observed facts, the elements of experience, the individual and collective representations of which it is the reduction and the transformation. Is "man" a governing idea in the human sciences, in the Kantian sense of the term, an idea that would constitute the horizon of the processes of objectivization, a transcendental illusion that scientific work itself ought to dissipate even while acknowledging its ineluctable force? Or is man rather a constitutive presupposition of a contextual "knowledge" within the human sciences, a presupposition characteristic of a specific historical moment? If this question brings us back to the problem of foundations, the fact remains that the problem can only be raised on the basis of the critical study of scientific research itself, and it will constitute both the guiding principle and the crowning glory of that study. In what does the process of structuring the lived experience of man consist? What is a model that serves as a representation of data? What are the rules for constructing a model? What types of relations exist among the various models constitutive of the object?

But this set of questions in turn proves to be circumstantially determined by a historical fact that may have transcendental meaning: so far as the human sciences are concerned, the processes of structuring experience through models are dominated by the model of one particular human science, linguistics, and this paradigmatic position is inscribed, as it were, in reflection on language as a science.

In other words, the models that have been constructed by linguistics over the past century or so have come to function as models in a different sense: they offer hypotheses, concepts, operative processes, to the other human sciences—ethnology, sociology, psychoanalysis, and even biology. How can one particular science work as an objectifying model for others? Is this modeling not implied by the characteristics of the construction of the concepts of sign, language, or discourse, and do they not perforce inform the theoretical production of the processes of communication and exchange? Demarcating my current investigation of the dissolution of man in the human sciences on the basis of this conceptual linkage, I propose to examine the nature and position of the signifying subject in the structural model of language as constituted by Saussurian linguistics.

In a veritable Copernican revolution, Ferdinand de Saussure made a double break with the past, involving both method and object. So far as

method is concerned, linguistics could only establish itself as a science by rigorously separating synchrony from diachrony, structure from history. As for the object, in the heterogeneous mass of linguistic phenomena—individual and collective, physical, physiological, psychological, and sociological—an observable homogeneous object had to be circumscribed, one that would constitute a systematic whole at the outset. But the move linguistics made in defining its own methodological procedures was also the move that enabled it to structure its object. The reality of the object was inseparable from the method used to define it.[2] We have only to reread the opening pages of the *Course in General Linguistics*: "The scope of linguistics should be: *a*) to describe and trace the history of all observable languages . . . ; *b*) to determine the forces that are permanently and universally at work in all languages . . . ; *c*) to delimit and define itself."[3] The first two tasks are resolutely subordinated to the third, and the latter coincides exactly with the fundamental question posed by Saussure: "What is both the integral and concrete object of linguistics?"[4] Historical research aimed at "tracing the history of families of languages and reconstructing as far as possible the mother language of each family" is integrated as part of the theory organizing the system of "general laws to which all specific historical phenomena can be reduced,"[5] and this theory is based on the articulation of procedures and criteria adequate for describing the linguistic object, procedures and criteria that are not derived from other sciences but that are properly its own. Only through these procedures and criteria does the theory of language circumscribe and define *itself*; and this operation is identical with the structural construction of its object. Whereas "other sciences work with objects that are given in advance and that can then be considered from different viewpoints,"[6] the inseparable duality of the method and the object is what makes linguistics a science and makes its object a formal or formalizable structure. "Far from it being the object that antedates the viewpoint, it would seem that it is the viewpoint that creates the object."[7]

Thus Saussure's Copernican revolution consists fundamentally in positing that language is neither a substance nor an evolving organism nor a free creation of mankind, but a constitutive *relation* between a *method* of knowing and an *object* to be known: the scientific object is a specific structuring carried out by a body of methodological procedures and criteria, and, conversely, this body is merely the complex operative projection of that object. The only models of language we know are those that we construct, and to the extent that we construct them in a rigorous process of

structuring, "language is a self-contained whole and a principle of classifi-cation."⁸ Language is defined both *a parte rei*, as a systematic totality, and *a parte intellectus*, as a principle of knowledge: it is a systematic totality only because it is a principle of knowledge and vice versa. It is a model and an operative set of models: it is a formal structure.

The opposition between signifier and signified, between language [*langue*] and speech [*parole*], stems then from this absolutely general the-oretical conception that relations antedate things themselves, that things are "effects" or products of the dual relation in which they generate them-selves in their reciprocal and differential existence.

Hence the double critique to which the Saussurian revolution is subject. The first specifically targets the process of self-foundation or self-definition of language and linguistics. The second, conversely, targets the structures of opposition. In fact if no substantial reality exists in language, if every-thing in language consists of differences, since there are no positive terms between which structures of opposition could be established, then it is ev-ident that the basic units of the system *define themselves*: the features, the characteristics, the descriptive propositions that allow us to say what a sign is, constitute, as such, the sign itself. There is nothing in a sign beyond the objectivizing operation through which it is known. And by defining the units of language, linguistics delimits and defines itself: its object consti-tutes itself to the very extent that it constructs itself. "The characteristics of the unit blend with the unit itself. In language, as in any semiological system [and we shall see the importance of this detail], whatever distin-guishes one sign from the others constitutes it. Difference makes character just as it makes value and the unit."⁹ The very process of interpretation is included, by definition, in the sign—as C. K. Ogden and I. A. Richards saw quite clearly, only to condemn that inclusion in the name of logical empiricism.¹⁰ What they take to be a vicious circle, finally amounting to no more than daydreaming and imagination, is in reality a constitutive op-eration of immense import for the human sciences, for it returns to the circular foundational movement through which Hegel totalizes the philo-sophical system. In this sense, Saussurian linguistics can claim to be the model for the human sciences because it is the science that founds them all, in the sense that it is only its object acceding to knowing awareness of itself. Thus the notion of system is central in Saussure, as any linguistic ob-ject finds its reality only through the play of relational differences within the system as a whole.

The other critique of the Saussurian revolution focuses on the opposi-
tional structures, seeing them as reified pairs characteristic of ideological
representations. According to this view, the Saussurian model of language
goes back to the ancient oppositions between mind and body, thought and
matter, and indeed a "popularized" Saussurianism does just this. The dif-
ficult concept of a difference generating the terms between which it is in-
stituted is supplanted by substantialist thought, in which each of the terms
falls into thingly independence and the relation linking them is external to
the terms themselves. To be sure, Saussure explains in the *Course* that speech
is an individual act of will and intelligence. If language is defined, in con-
trast, as a social and collective object, as a code or contractual bond, and
ultimately as a totality, speech can perfectly well appear as part of that
whole, in the same way that an individual is part of the social organism.

How can we get around these difficulties? How can the double relation
characterizing language at all levels be conceptualized, if not as a relation
that is at once systematic and dialectical, systematic because it is dialecti-
cal, dialectical because it is systematic?[11] Here lies the exceptional strength
of Saussure's thought, it seems to me: it enables the contradictory relation
that is constitutive of language to achieve self-knowledge, and it discovers
in the contradiction the self-establishment of the science of linguistics. The
fact that language is a pure system signifies that it is constituted only of dif-
ferences. The totalization of the differences is what produces the positivity
of the system of values in which the linguistic institution consists: a com-
plex and paradoxical positivity in that it is made up only of oppositions
that themselves result from differences, the positivity of a form in which
"we shall never find anything simple . . . ; everywhere and always there is
the same complex equilibrium of terms that mutually condition each
other."[12] To say that language is a totalization of differences, producing
meaning through oppositions, is to affirm its dialectical nature and by the
same token the dialectical nature of scientific knowledge of language. For-
mal and systematic Saussurian linguistics is a dialectical linguistics because
it constitutes itself as such by constituting an object that is dialectical.

We can verify this by examining specifically the relation between lan-
guage and speech in the *Course in General Linguistics*. "In order to separate
from the whole of speech the part that belongs to language [*langue*], we
must examine the individual act from which the speaking-circuit can be
reconstructed. The act requires the presence of at least *two* persons; that is
the minimum number necessary to complete the circuit."[13] Thus the ques-

tion is the following: where does language exist? What sort of objectivity does its existence have? But it is remarkable that, to answer the question, Saussure analyzes the concrete structure of speech as a relation between two speakers. For the substantialist conception of language, a reservoir of signs and collective rules in individual consciousness, and for the conception of speech as a material externalization by a single individual of certain elements from that reservoir, he substitutes a phenomenological and dialectical conception of the speaking-circuit in which speech belongs to the sender and language to the receiver of the message, as its comprehension and interpretation. Language is thus indeed part of speech, as speech is part of language: "Speech is possible only owing to the elaboration of the product that is called language and that supplies the individual with the elements with which he can compose his speech."[14] The relation between speech and language is dialectical, and that is why Saussure grasps it first of all in a dialogic relation, in the operation of exchange and communication. Language is the power to understand speech; speech is the power to produce language; both are concretely manifested at the two poles of the dialogic circuit, and yet neither one stems from one specific ontological and substantial subject, since in an exchange, the power to understand speech and the power to produce language rightfully belong by turns to the speakers who are engaged in the process. To be sure, in order to make this dialectical relation between language and speech still more explicit, that is, in order to objectify it scientifically, Saussure is obliged to go beyond the phenomenological description of the exchange operation. But the series of definitions of language that the *Course* brings into play confirms the dialectical nature of the theoretical relation, because the object of which this relation provides knowledge is itself dialectical in nature: the model constructed by the linguist is structured like a dialogue, as dialogue itself is described in terms of a model.

What Saussurian linguistics teaches us, in its Copernican reversal, is that dialectics does not necessarily and immediately signify history first and (personal) subject second, or else that it signifies them differently: dialectics signifies synchronic system and formal structure, synchronic system to the extent that the object that emerges from the dialectical process of scientific objectification is made up of relations that generate, each in its own order, the terms that they connect. By defining language [*langage*] as a value, Saussure defines it as the perception of an identity, but that perception of identity (which is a perception of meaning) is identical to the

perception of difference. When I *identify* a fragment of language in its meaning, this signifies quite precisely that I *differentiate* it from everything else in the language. Identity is difference: is that not the definition of the dialectical process? But it is also, as it happens, the definition of a system.

Furthermore, if each element of language as a constitutive unit is not distinguishable from the others through what it represents or designates, then meaning will not be constituted by the extrinsic relation of the sign with reality, by the label that a word, for example, attaches to a thing. It will be produced by the constitutive internal relation that that word maintains with all the other words of the vocabulary. In this sense, the formal structure of language is defined: it is a structure in that it is a set of determined, fundamentally binary relations; it is formal to the extent that these relations are not external to the elements that they link, but are rather constitutive of those elements.

We can then return to the initial rupture instituted by Saussurian linguistics in order to raise the question of history and the question of the subject. Saussure's Copernican revolution consisted first of all, as we have seen, in a rigorous separation between the synchronic and the diachronic, between the structural and the historical. This was the case as early as the celebrated *Mémoire sur le système primitif des voyelles dans les langues indo-européennes*, even though that text is rooted in historical linguistics. But the same dialectical process appears here; if linguistics has to be synchronic to be scientific, it can only be constituted as such by the relation with the diachronic. "The synchronic has to be treated for itself; but without the perpetual opposition with the diachronic, we achieve nothing. The ancient grammarians did their best to produce a static linguistics and did not risk confusing the two points of view, but what did they achieve?"[15] From this point on, what scientific practice will correspond to the theoretical dialectical attitude that we have seen traced out at all levels of knowledge and the linguistic object? It will consist in taking signification as its guiding principle. "*Meaning* is . . . the fundamental condition that any unit on any level must fulfill in order to obtain linguistic status . . . 'meaning' . . . is an indispensable condition of linguistic analysis. It is only necessary to see how meaning comes into our procedures and what level of analysis it belongs to."[16] Now meaning, "the basic synchronic phenomenon, is the act of communication," the speaking-circuit, "the sentence by means of which one arouses a signification in the hearer . . . in order to recognize a lin-

guistic phenomenon in a series of sounds, one needs a hearer who understands its meaning."[17]

These tenets of linguistics are fundamental for the dual problem of history and the subject. How can the problem of "the passage from one state to another in a continuous form"[18] be overcome? Does history not "reestablish our connection, outside ourselves, with the very essence of change"?[19] Better still, is that image of history not the projection of self-evidence on the part of the conscious subject in the grasp of his very essence, which is experienced at once as sameness and as otherness and thus here again as the very being of change? Now is this same problem not raised with particular clarity by the dialectics of the diachronic and the synchronic? The diachronic phenomenon cannot be called into question: sounds and meanings do change, and change continuously. "There are never permanent characteristics. There are only studies of language [*langue*] that are perpetually the transition between the former state and the following one."[20] But in the dialectics of exchange, at any given moment of the history of language [*langage*], there is only one single meaning: "words have no memory."[21]

From here on, through one of those paradoxes in which Saussure seems to have delighted and which are actually just the dialectical paradoxes of language and the science of language, the synchronic is based "ontologically" on the very experience of communication of signs, and the diachronic can be known only through the structuring and comparison of language states, that is, of moments of communication; continuous change is not and cannot become an object of knowledge except by the introduction of the synchronic discontinuity whose radical place Saussure found in the dialectical unity of communication. Hence the simultaneous conception of a synchro-diachronic history and a subject that is the space of an exchange in which there appears and is constituted for knowledge a totalization that it does not bring about; rather, it is the place where that totalization is brought about.

Thus language [*langue*] is at once in the speech of the historical subject and separated from it as a synchronic system. The instrument of a dialectical practice of language [*langage*] and the object of a theoretical dialectics of the science of language, language [*langue*] totalizes the human subject's capacity to produce meaning, but it can do so only outside the practice of a speaking subject. Language [*langue*] is not linguistic theory internalized in the human individual's memory, consciousness, and will. But only lin-

guistic theory can bring language to light, as what allows and rigorously determines the free speech of the human subject. Speech in turn manifests language in the lived situation of communication, while remaining totally unaware of it. "Language, an unreflective totalization, is human reason which has its reasons and of which man knows nothing."[22] It is that other totalization in which man finds his apodictic experience of sameness.

I suggested at the outset that the historical event of the constitution of linguistics as a science may well have had a transcendental signification, and that, for that reason, the linguistic structuring of the language object functioned and ought to function as a model for the other human sciences. This fundamental project is set forth clearly by Saussure himself, but it is marked by the same dialectical ambivalence that inspires all the concepts and operations of linguistics. Linguistics is only a part of a more general science, semiology, which "would show what constitutes signs, what laws govern them. . . . [The laws discovered by semiology] will be applicable to linguistics, and the latter will circumscribe a well-defined area within the mass of anthropological facts."[23] If the linguistic problem is a semiologic problem through and through, perhaps it is necessary not only to base the study of language on what it has in common with all other semiologic systems in order to discover its true nature, but also to consider the whole set of phenomena and human activities as systems of signs and thus to approach scientific knowledge of them semiologically. If the generation of meaning is the distinguishing characteristic of human activities and phenomena—and perhaps of living beings more generally— then semiology is the fundamental science, since it constitutes itself by modeling these phenomena and activities as sign systems. "Far from language being swallowed up in society, it is society which is beginning to recognize itself as 'a language'. . . . These innovating investigations suggest that the basic characteristic of language, that it is composed of signs, could be common to all those social phenomena which constitute *culture*."[24]

But the same movement that situates linguistics as a particular science within general semiology reverses that position dialectically. The principal object of semiology will be the set of systems based on the arbitrariness of the sign. "In fact," Saussure continues, "every means of expression used in society is based, in principle, on collective behavior or—what amounts to the same thing—on convention." Thus language, the object of linguistics, is the semiologic system par excellence, both "the most complex and uni-

versal of all systems of expression . . . [and] also the most characteristic."[25] It is the semiotic system that serves as general interpreter of all the other semiotic systems. By the same token, the linguistics that studies it is at once the model for all semiology, even though language is a particular system, and its foundation, by virtue of the irreversible semiotic relation of interpretation that connects it with all the other systems. This relation does not entail logical or ontological anteriority; it is rather a dialectical relation. Thus, to take one example, society encompasses language as a particular system in a "relation of embedding" in which the extrinsic dependencies of each are objectivized; but, conversely, language encompasses society to the extent that it is at once the necessary and general interpretant of all the other systems that constitute it and to the extent that the latter are only social or cultural systems in that they reproduce, in a more or less complete or complex fashion, the features and modes of actions of the modeling structure of the "great semiotic matrix" that is language.

We still have to ask, in conclusion, what feature is reproduced by semiotic systems other than language. This feature turns out to lie in the fundamental structure of duality in which we recognize the dialectical nature of structural linguistics and linguistic structure. What characterizes a phenomenon, an element, a thing endowed with meaning, is that its identity is intrinsically constructed from one relation to next. This fundamental articulation is reiterated at all levels, at all degrees of complexity: nothing signifies in itself and by itself. Meaning is relation: its "ontology" is a system of references in which it is produced by what it is not. Here we find the contradiction or originary lack whose embedding is constitutive of language, of symbolic systems, and of the structure of exchange in general.

Two concluding remarks:

1. The association between symbolic systems characterizing phenomena and human activities on the one hand and language on the other does not mean that the two are identical. Claude Lévi-Strauss, one of those responsible for opening and clearing that path, puts it quite clearly: "The kinship system is a language; but it is not a universal language. . . . [I]n dealing with a specific culture, we must always ask a preliminary question: is the system systematic?" This question is absurd, Lévi-Strauss adds, in substance, only insofar as language is concerned, since language is systematic or else it does not signify. But with other symbolic systems—such as social organization or art—"the question must be rigorously examined," insofar as the signifying value of these systems is "partial, fragmentary, or subjec-

tive."[26] If symbolic systems can be considered according to the model of language understood as a set of operations destined to ensure a certain type of communication among individuals and groups, whether the messages are constituted by women (kinship), words (language), or goods and services (economy), and provided that the differences are rigorously articulated, one can envisage reaching "a deep enough level . . . to make it possible to cross from one to the other; or to express the specific structure of each in terms of a sort of general language, valid for each system separately and for all of them taken together,"[27] a universal code that would come very close to realizing the Saussurian wish for a general semiology.

2. The other remark concerns the object of this study, the question of man as subject and signifying intentionality. By analyzing Saussurian linguistics as a dialectical science, by raising the question of the basis for the human sciences as the question of the circularity of an interpreting system with respect to the systems interpreted, or that of meaning as "transposition from one level of language [*langage*] to another, from one language to a different language . . . as a possibility of transcoding,"[28] it is indeed the question of the subject and of signifying intentionality that turns out to be raised. Here again, we have to conceptualize it according to the model of language [*langue*] and linguistics, as a dialectical subject (of science and of speech), as a dialogic structure of exchange, transposition, and transformation of symbolic systems among themselves, of the various levels of the symbolic order. When Saussure seeks to define the object of linguistics and to delimit and define linguistics itself in the process, he describes the speaking-circuit between two persons, that is, the operation of exchange between the sending of a message and a potentiality for comprehension. Such is the signifying subject that we discover in the linguistic model at the heart of the human sciences. In this model, human beings do not appear as subjects who give meaning, but as the place of production and manifestation of meaning, a space of rule-governed exchanges, selections, and combinations among symbolic systems, a field of operations in which these systems limit and constrain one another in a specific way: a place, a space, a field in which meaning is produced in the illusion of its self-creating substance, an illusion that we shall read as the effect of a dialectics of which it is the privileged operator.

§ 2 Theoretical Field and Symbolic Practice

Model of the Lure and Lure of the Model

In a fragment so well known that usually only the beginning is cited, Pascal denounced the art of painting: "How vain painting is, exciting admiration by its resemblance to things of which we do not admire the originals!"[1] At the heart of the century of classicism, Pascal's text challenged the pictorial mimesis that for more than two hundred years had been perhaps the most perfect expression of the system on which it was based: the system of representation. But if we reread Pascal's thought, we note that his critique of painting is accomplished by way of admiration, one of painting's most successful affective repercussions. By virtue of admiration, painting is a marvel that turns the gaze away from origins (the original), from things, from the essence of the world in its neutral and neutralized (since natural) unveiling, so as to attract and capture the world by a lure that is its substitute because it repeats and produces that world. How marvelous painting is, denouncing in the incoherence of a symbolic effect not a logical contradiction of its system, but the all-powerful nothingness of its force, its vanity. What does the painted image signify, then, by producing, through its substituted representation, a feeling that, for Pascal, designates the traces of the Other in the worldly unfolding of the same? What is the reason, of which reason knows nothing, for the sovereign insistence of the image's lure? The meaning of its grip? The truth of its sway? Natural opinion, immediate self-evidence, *commune doxa*.

Another less familiar text conceals the beginning of a response that gives a possible reason, meaning and truth, a response whose possibility is

maintained, however, by reference to another, more general question. It is again a question of the gaze turned away from the traces of the other, and its accommodation to the object that lures it in representation: a picture. "It is like looking at pictures which are too near or too far away. There is just one indivisible point which is the right place. Others are too near, too far, too high, or too low. In painting the rules of perspective decide it, but how will it be decided when it comes to truth and morality?"[2] Thus the truth of the lure of the spectator's gaze lies in the system of representation. Representative mimesis signifies itself (it takes on the appearance of a meaning) through the perspective machinery that subtends it and, with that machinery, through the projective geometry that is realized in it and that assigns the gaze its true place (that is, makes that place necessary and meaningful). This indivisible point would be discernible if true geometry did not know that, in the order of space, "we call a point indivisible when our senses can perceive nothing beyond it, although by its nature it is infinitely divisible."[3] From this point on, the true place assigned by perspective for the gaze in the art of painting is yet another lure, as we see from the question following the statement in Pascal's text: "But how will it be decided when it comes to truth and morality?" Nevertheless, with this referral, in its nature and its function, the lure of representative mimesis is displaced. It is offered as the model of the lure. The ultimate principles of the sciences of man (truth and morality) are to the great eye of reason what the indivisible point is to the gaze that contemplates a picture. The true and accurate representations that they construct are shams, like the appearances that they exhibit in their material aspect. But these perceptible appearances, when they are referred back to the perspective and projective systems that articulate them, will have had the significant advantage of signifying, as rational appearances, the "models" of man that they formulate. As a model of the lure, the image of painting denounces the lure of the model proposed by the sciences of man.

Thus common opinion, doxic self-evidence, spoke truly, in admiring the image of the being from which it was turning away, but without knowing that it was doing so, just as the analyst of perspective spoke truly in bringing to light, beneath the appearances, the truth of the hidden geometry that literally made them appear; but the analyst did not know, either, that that truth was not what he believed it to be; he did not know that that truth was the index of an aporia in these considerations about man that was worth more than all of geometry: "So opinions swing back and forth, from

pro to con, according to one's lights. . . . [T]he ordinary person's opinions are sound without being intellectually so, for he believes truth to be where it is not. There is certainly some truth in these opinions, but not as much as people imagine."[4] The author of this discourse does not know where truth is either, but he says that he does not know, or he at least articulates his learned ignorance as a question: "How will [the point] be decided when it comes to truth and morality?" And to sum up everything—the perceptible and the intelligible, space and representation, belief and truth, the art of painting and the science of man—in two fragments: "Our soul is cast into the body where it finds number, time, dimensions; it reasons about these things and calls them natural, or necessary, and can believe nothing else. . . . Who then can doubt that our soul, being accustomed to see number, space, movement, believes in this and nothing else?" Conclusion: "Custom is our nature," or, better yet, "I am very much afraid that that nature itself is only a first habit [*coutume*], just as habit is a second nature."[5] Completing the circle describes a definitive gap, the gap of origin or infinity. By putting itself in the right place, the indivisible point of perspective, the gaze admired the fine arrangement and the truth it offered—naturally, immediately, obviously, necessarily—about the picture; marveling at the lifelike appearances on the painted image, it forgot about origins, neutralizing the referent of the *analogon*, and, unwittingly, it was right.

In that point of the gaze, in that place of the eye, ordinary folk, semiskilled viewers, and learned experts are "confounded," equated, and deceived. True opinion is always also very false and very unhealthy. True opinions, vain opinions, *opinions saines, opinions vaines*: the substitution of a single letter is the measure of their confusion and their truth, of a confusion that is the truth. A speculative truth, first of all: in the closed system of representation, in the humanist thought of a universal human nature, the gaze that contemplates a painting discovers blindly the aporias of the origin (the original, the referent, nature, truth, being) and of the infinite (point, zero, instant, repose, ultimate foundations or happy medium). But the gaze continues to admire the play of appearances, it takes pleasure in them, it summons them onto the canvas, prods them into a beautiful composition: another indiscernible, unassignable truth, which is the truth of a practice without theory, of an art without rules, the art of painting, the art of persuading, the art of loving, the art of commanding: "It is not that I do not believe that there are rules as reliable for pleasing as for demonstrating, and that whoever knows perfectly how to know and use them

does not succeed as surely a[t] making himself loved by kings and all sorts of people as he does by demonstrating the elements of geometry . . . But I consider . . . that it is impossible to [discover these rules]."[6] The speculative aporias are the inverse of the marvelous security of practices whose truth lies in not having rules of their own order, practices that denounce and contest in advance any enterprise intended to formalize them, to reduce them to the state of models, to make them exemplary paradigms of aesthetics or formal constructions of science. "We do not prove that we ought to be loved by setting out in order the causes of love. . . . [W]e do not know what constitutes the attraction which is the object of poetry. We do not know what this natural model is that must be imitated."[7]

In short, this excursion through several fragments from Pascal suggests a deconstruction of the system of representation by a double operation: by producing the theoretical aporias of the system theoretically, and by filling these voids, these fundamental gaps, through the notion of practices without any theoretically formulable corresponding theory;[8] as if the theory (or at least a certain theory of the theory) made common cause with the system of representation, and as if, concomitantly, critical analysis of the system implied more or less necessarily a specific theory of practice, and not merely specific, but theoretically primary with respect to any theory of theory. This is what Hubert Damisch and Pierre Bourdieu seem to me to be proposing, in books published in the same year. The fact that Damisch alludes explicitly to Pascal in connection with the work of infinity in the system of representation and the fact that Bourdieu does the same thing in connection with the dumbing-down presupposed by any practical incorporation of culture (custom) seems to me to justify this lengthy review of the Pascalian viewpoint, which introduces the complementary problematics that articulate their arguments.

Complementary Problematics

It is significant indeed that the two books approach their specific problems through a critique of a theory that I shall term second-order, in two senses. On the one hand, the theory implies a certain conception of theoretical activity, and, on the other hand, it presents itself as the generalization of an already-constituted theory whose development includes a return to and a modification of the theory itself. The theory in question is semiology, or at least the semiology that, in conformity with Saussure's

program, constitutes both the general science of signs, including in particular those of language as one of its specific domains, and an application of the theory of linguistic signs to signifying objects other than language. This ambiguity marking the scientific foundation of semiology cannot be without importance for the theory. By granting methodological priority to research bearing on signifying practices in general, theoretical activity might be led to redefine the fundamental concepts of structural linguistics, to a redistribution of its fields of research and a restructuring of its various domains organized around the great binary oppositions of language and speech, synchrony and diachrony, paradigm and syntagma, and so on. This is one of the paths laid out by Bourdieu: the theory of material and symbolic practices that is at the root of his ethnological and sociological research leads him to expand certain suggestions, made but not fully explored in the *Cours de linguistique générale*, into a dialectical theory of language.

If, on the contrary, one emphasizes the actual history of linguistic theory, its linear extension, and the mechanical transfer of the conceptual pairs that articulate it with other signifying sets in the form of ready-made models and preconstituted explanatory tools, one's research, if it is to be rigorous, will tend to emphasize and reinforce differences, to bring to light in a critical fashion the reductive character of these methodological operations, and gradually to develop a different conceptualization. This appears to be Damisch's approach. Without calling into question the contributions of Saussurian linguistics or [Louis] Hjelmslev's glossematics, Damisch calls for a reexamination of the fundamental concepts of the science of language, and proposes a new way to formulate them, in order to explain painted images and the signifying practices that produce them.

Bourdieu and Damisch are thus drawn in different directions by their genuine methodological caution, and even more by their theoretical presuppositions. Bourdieu develops a theory of signifying practice that radically interrogates the theory and the practice of the theory, so much so that his structuralism and his semiology—whether he recognizes them as such or whether they are implied in his own scientific practice (his admirable study of Berber houses, for example, might be reread from this point of view)—may well appear as a metastructuralism and a metasemiology. His praxeology brings to light the qualitative and temporal relations at work in his object; they transform the structural oppositions of linguistics into dialectical schemas that are the only ones capable of sup-

plying a full explanation for social, material, and symbolic practices, in-
cluding the practice of language. Damisch leans toward a theory of art
history that chooses, among the products of a given symbolic practice
(painting), the articulation between theory and history as its focus; to this
end, he develops concepts capable of carrying out that articulation. A
metaphysics of writing seems to be the philosophical frame of reference
for Damisch's theory, and, here again, the effects of the theory are ac-
counted for by a dialectics that takes the place of structure and its models:
it is a reasoned, mature, self-critical semiology whose rigorous foundation
is to be guaranteed by the author's critique.

These two books are important and timely. They appeared at a moment
when the method of structural analysis had lost its momentum, if not in
the works of its founding fathers, then at least in those of their grandchil-
dren and great-grandchildren, who have turned a scientific practice into an
ideology of that practice, or even an academic orthodoxy of that ideology.
Rather than theoretical advances or the discovery of new objects of in-
quiry, this situation is an occasion for critical reflection, for testing the
concepts and methods, and thus the very basis, of structural analysis. Un-
covering the conditions of intelligibility of signifying practices is in fact the
aim of both authors: explicitly for Bourdieu, who masterfully sets forth the
reasons why a theory of practice is always what social theory leaves un-
thought and shows that by taking it as a critical theme, the human sciences
in general and sociology in particular can produce the conditions of pos-
sibility for a social theory, for its practice, and for social practices; less ob-
viously for Damisch, since his entire theoretical effort tends to lead him to
the threshold of a major undertaking, that of revealing the constitutive
processes of a signifying practice called painting, whose scientific validity
must be ensured by a critique of the history and semiology of art and of
the implicit theories of pictorial practice that are necessarily involved in
their elaboration.

Thus the conclusion of Damisch's book designates on another level what
is the very object of Bourdieu's reflection: the problem posed by a specific
practice—painting (social practices in general for Bourdieu)—understood
as a materialist process of production.[9] But this problem is perceived by
Damisch at the end of his study as that of a dialectical, qualitative history
of pictorial work in its necessary relation to a theory of art, for reasons that
have to do with the very nature of its theoretical field and its domain of ob-
jects, whereas Bourdieu's reflection in essence leaves the problem of his-

tory[10] implicit and investigates the problem of the relation, in social and cultural anthropology, of *social theory and social practices*, their objective material determinations, their modes of transmission and integration in society and in social agents and, even more, the theoretical and practical effects of social theory in the comprehension and explanation of the social practices of production and circulation of material and symbolic social goods.

Thus if I am juxtaposing these two works in a critical study, it is not that I propose to make a term-for-term comparison that would bring to light the resemblances between two investigations of different but complementary objects; rather, I am attempting to outline a second-order problematics that would indicate the points of overlapping and intersection between two complementary problematics whose levels, fields, and philosophical presuppositions are not the same, and whose effectiveness and truth value have to do with the fact that they stress two different "moments," in the dialectical sense of the term, of social theory and practice. The one focuses on history and its theory, while asking how a system or theory can subtend historicity and how a history can possess systematicity, in short how diachrony (that is, change, mutation, transformation) can be studied synchronically. The other focuses on practice and its theory, while asking under what methodological and epistemological conditions a theory of practice could be developed that would have two facets: it would be both a critique of social theory when the latter, through a speculative illusion similar to that of metaphysics for Kant, takes itself to be the truth of actual practice, and it would also expose the necessary obfuscation that real practice implies with respect to its own truth, that is, with respect to the immanent theory that real practice entails. Damisch asks: What is the synchronic structure (system, theory) of a historical diachrony? Under what conditions can the history of a specific practice—painting—be rigorous in terms of the structural theory that subtends that practice? Bourdieu asks: What is the real practical diachrony of a structural synchrony (theory)? Under what conditions can a structural anthropology be true in terms of real social practices?

By the same token, an implicit "other side" is indicated in each work. For Bourdieu, the question is how to explain and *theorize* a process of change or mutation in material or symbolic practices. For Damisch, the question is how to think *practically* the relation between a system (a theory) and the practice that expresses it. In Bourdieu's case, we may wonder whether the anthropological field and object do not imply that he is the-

oretically and practically precluded from producing the question of a real mutation, except as a process external to the field. In Damisch's case, we may wonder about the obstacles he encounters that prevent him from raising the missing question, owing to the historical and cultural field he chose to study: modern times in the West from the fifteenth to the nineteenth century and the "system" that bears its historicity—representation.

In one case, archaic, ahistorical societies with reproductive practices, inasmuch as they are objects of analysis, block the constitution of a theory of change. In the other case, the key notion of representation constitutive of an aesthetic system by its very nature (symbolic repetition and substitution) precludes grasping the practical processes of reproduction of the system in pictorial practice, because that reproduction is in some sense necessarily implied in the constitutive notion of system and precludes grasping that notion when the system is conceived and elaborated theoretically. In other words, what is missing in Bourdieu is an explicit formulation of a theory of history, while what is missing in Damisch is an explicit formulation of a theory of the functions and practical processes of art. And, to return to one of the theses that both authors articulate concerning their object of study, there is in both Damisch and Bourdieu something left unsaid in the theory of social theory or in aesthetic theory, something that resurfaces in the field each is exploring to animate that field and allow it to produce the possible that it at once excludes and implies, in the form of an "effect of the theoretical field" entirely similar to those that Damisch and Bourdieu analyze so masterfully in their respective works.

Structure of Representation and History

Hence a first problem, in which the chiasmus between the two enterprises is manifested with the utmost clarity on the level of the authors' methods of analysis, their operative concepts, and the contents and objects they study. The problem can be formulated as follows: if, as Bourdieu thinks, every theory implies a preexisting theory of practice, and if every objectivist conception of social reality[11] refers back to a reductive and destructuring attitude toward the material and symbolic practices from which it is appropriate to free oneself through a restructuring of the theory, is not the reason the fact that *historically*, the theory in general and the theory of the practice that it envelops are fundamentally linked to the system of representation that Damisch analyzes in Western painting, from the Quat-

trocento to the late nineteenth century, as the bearer of the historicity of art during that period? In other words, the problem addressed by Bourdieu in the early pages of his *Esquisse* as a problem of *epistemology* and of *methodology* of the contemporary human sciences turns out to be consubstantial with the historical perspective that Damisch adopts to explain four centuries of representative painting through the avatars of a particular iconic sign, clouds, thus with the problem of *history* that it poses in the broadest sense. This juxtaposition brings to light the "effect of the theoretical field" that causes Bourdieu to "forget" the question of history and Damisch that of the processes of production and reproduction of the system in signifying practices.

It is remarkable indeed that while critically analyzing the relations that a structural anthropology maintains with its object and while noting the effects of theoretical distortion that are produced, for the ethnologist, by his position as an observer foreign to the culture he is studying, Bourdieu articulates all the elements and all the constitutive relations of the system of representation introduced by the artists of the Quattrocento and developed in the West over four centuries: the constitution of the object as spectacle for a spectator who adopts a "point of view" toward the action, who withdraws from it to observe it, to look at it from afar and from above and who, by importing into the object the principles of his relation to that object, organizes it as a set intended for cognitive knowledge alone and reduces all the relations manifested in it to relations of communication and all the interactions to symbolic exchanges. By the same token, and because the ethnologist does not know the limits inherent in the point of view he adopts toward the object, the real practice of a specific agent or group is replaced by a model that represents it[12] and that is valid for it without remainder or residue. Thus when Bourdieu seeks to illustrate the "spectacular" structure of contemporary structural anthropology, he resorts to the example of geographical maps or the perspective of city maps, in which the landscape is presented as if seen from on horseback; such maps represent with precision the landscape or the real city "for a sort of divine spectator and not for the people destined to move about in it."[13] If we recall that the first geographical maps in the scientific sense of the term, the first chorographies of cities, appeared in the sixteenth century, and if we also recall that maps and paintings were privileged examples in the semiotic theory presented in Port-Royal's *Logic*, a text that is in many respects the "manual" of the system of representation, we may grasp, at this point in

Bourdieu's contemporary epistemological discourse, both the significance of the example and the validity of the point of interference that our own discourse suggests between *Théorie du nuage* and *Esquisse d'une théorie de la pratique.*

If we try to formalize the general structure of representation in a complex model (and we are all the more justified in doing so in that that structure appears as the original matrix of all objectivist and reductive theories of signifying practices), we obtain, as I have shown elsewhere and as we see, too, from Damisch's remarkable analyses, a simultaneous double operation of repetition and substitution between things and ideas through the mediation of the sign: an idea represents a thing (it is the thing in the mind), but that representation can only be achieved in relay fashion, by way of another thing that represents the first thing in turn for the second. Thus if ideas are things in the mind, signs are ideas for the mind, ideas as thinkable and thought, that is, communicable and communicated. Representative repetition is one side of an operation of which substitution is the other. There is repetition only in the case of substitution, and there is substitution only through repetition. In this conjunction, we clearly find the indissoluble and necessary conjunction between thought and language, ideas and words, and, through words and language, the conjunction between thought and being that is characteristic of so-called "classical" metaphysics, a conjunction that is all the more necessary and indissoluble in that it ensures, through a secondary operation of abstraction, the complete distinction between two levels and two domains. If the sign appears on the surface to be at the service of the thought that is representative of being, this service is so indispensable that neither thought as knowledge of being nor being as object offered to knowledge can do without it; and it is even more indispensable to the universal republic of minds, individual "cogitos" consisting entirely of thinking that would remain closed off in their solipsistic solitude if their ideas were not signifiable, but whose signs are nevertheless so utterly contingent that they ensure their communication in perfect transparency.

This model of the way the sign functions for the mind in its relation to the world is an ideal model. The fact that actual minds have to contend with the obstacles presented by the confusion, thickness, and opacity of language is of no *theoretical* importance; the explanatory model does not need to be revised and restructured so it can make actual signifying practice intelligible. Through a slippage[14] whose theoretical—that is, theological—justification we encounter among the "classical" ideological thinkers,

the explanatory model becomes a normative paradigm, the law of functioning, moral and religious principle, a theoretical structure, an agency of repression and censorship. It is significant that this process of displacement from model to norm is exercised essentially on the materiality of language, materiality that is nevertheless maximally evanescent, because it is the sonorous materiality of the voice.

But in this model, what are we to make of the painted image whose status, from the Renaissance to cubism, is Damisch's fundamental topic? What is its place? A painted image in the "regime" that we are describing is a representation, as a word is a representation, but in a different sense: dominated by analogic mimesis, in its very appearance an immediate visible relation of knowledge, which is recognition of a thing: it signifies a visible thing analogically, bringing it to light in its representation. It "realizes" the metaphor that is dissimulated by the spiritual *intuitus*, the mind as eye and knowledge as gaze, the metaphor that is masked by the cultural convention of the sign of language. Thus if the substitution of words for ideas and things goes unnoticed to the extent that the arbitrariness of the sign is the surest guarantee of its effacement in clear and distinct language, on the contrary the secret and the wonder of the art of painting consist in substituting the signs that are proper to it, icons, for the things that these signs represent in the immediate proximity of mimesis, in the natural doxic self-evidence of resemblance. In language, ideas substitute for signs so that minds can communicate. In painting, signs substitute for things so that imaginations can be delighted. Owing to the arbitrariness that governs the institution of signs, the cultural convention of language permits a type of substitution that safeguards the rights of ideas and minds; if the naturalness of visible resemblance that is the mainspring of mimetic substitution is to be achieved, it requires—as Descartes observed so well in *Optics*—that a geometry, a sort of "natural reason" that supplies rules and laws for visible representation, be extracted from things as objects of the gaze and from the human body as eye. These rules and laws have no purpose other than to bring figurative resemblance to its most perfect naturalness, to its immediate perceptible self-evidence, whose clearest mark will be that the painted image can be immediately *named*. "[W]ithout any introduction or ceremony, we will say about a portrait of Caesar that it is Caesar."[15] Artificial and legitimate perspective is the "realization" of that natural geometry.

However, in the complex interplay of various levels of naturalness, for which the mirror offers the essential paradigm, what disappears behind

the painted appearances is arbitrariness, the cultural convention that conditions the whole substitutive process of iconic signs and their perspective syntax, the painting [*tableau*] as *tavola* [table], a smooth support surface with regular and rule-governed boundaries, woven canvas or planed wood, a surface whose characteristic feature is its *materiality*. The painted image reproduces, according to the requirements of its order of visibility, the structure that governs the functioning of language signs within their own order of intelligibility. The first must *cause* the entity in the painted appearance *to be seen*, just as the second must *cause it to be heard* in the idea. In any event, this type of reproduction, marked by the "normative phenomenon" according to which every painting must be readable, thus expressible, thus namable, is possible only thanks to a double and inverse erasure: in language, that of the *natural* sonorous materiality of the voice transmuted to the state of sign without matter, of pure meaning, owing to the *cultural* convention of language; in the image, that of the conventional, *cultural* materiality of the undergirding medium and the colored pigments it wears, transmuted into the state of the visible, "lifelike," recognizable, namable icon thanks to the *natural* geometry of legitimate perspective and the representation of real space. Language and image then coincide, exactly as each coincides, in its own order, with the thinkable and visible entity represented—but according to inverse and symmetrical processes—and each encircles that entity in the rigorous enclosure of the system of knowledge that is the internal structure of representation.

Both in its emergence and in its historical constitution, this structure, understood as the articulation of the system, accounts for the contemporary epistemological problem posed by Bourdieu with respect to structural anthropology, the problem of reducing signifying practices to the execution of a theoretically constructed model and program that represents and substitutes for reality; and since the human sciences do not seem to have exited yet from the circle of representation, this structure also accounts for the fact that Bourdieu's critical enterprise has no need to posit *theoretically* the problem of history understood as a process of breaking open and transgressing this circle. But, on the other hand, since this structure presupposes at its origin a theory that reduces practices to a mechanical reproduction of the structure, a theory that conceals their material determinations and the processes by which these determinations are at once transformed and integrated into the object that the practices produce, we can see why Damisch is not inclined to analyze the practices as such, since

his object is to show how the system of representation in Western painting is articulated.[16]

Originary Repression and Symbolic Order

A second and equally fundamental problem is introduced by the critical analysis of structure as representation that Bourdieu and Damisch carry out on the epistemological and historical levels: that of the occulting effects of the system. Here again, the two studies overlap, and in this interference they open up the possible field of a more general problematics. The problem has two dimensions: (1) the symbolic order is the effect of an originary repression of the material determinations of any signifying practice; (2) the objectivist theory, understood as the methodological and epistemological product of the system of representation, tends to repress this repression and by the same token to deny itself access to understanding of the symbolic order.[17] Let me quote Bourdieu on the subject of the theory of the gift:

> The theoretical construction which retrospectively projects the counter-gift into the project of the gift . . . removes the conditions making possible the *institutionally organized and guaranteed misrecognition* which is the basis of gift exchange and, perhaps, of all the symbolic labour intended to transmute, by the sincere fiction of a disinterested exchange, the inevitable, and inevitably interested, relations imposed by kinship, neighborhood, or work, into elective relations of reciprocity: in the work of reproducing established relations . . . which is no less vital to the existence of the group than the reproduction of the economic bases of its existence, the labour required to conceal the function of the exchanges is as important an element as the labour needed to carry out the function.[18]

In all the examples Bourdieu analyzes, the repression that produces the symbolic order[19] bears on the objective structures "materially conditioning and objectively producing in the social agents" the dispositions or *habitus* that will reproduce, in the form of acts, behaviors, attitudes and roles, the objective structures of which they are the product. Structured and structuring, produced and producing, the "cultural" dispositions constitute, between material structures and social practices, behavioral and reactional schemas or matrices that function as authentic mediations in the materialist dialectic of society: "the habitus [is] history turned into nature, i.e., denied as such [because it is realized in a second nature]."[20]

But this dialectic would remain linear and flattened, as it were, if, in the indissolubly temporal and structural mediation carried out by the habitus, there did not appear a process of misrecognition or repression that the habitus also occasions. This process, the source of all symbolic form, affects the reproduction of the objective structures, which are ultimately determining. It is through this process that the relations Bourdieu describes to explain the functioning of social reality are truly dialectical and materialist. Between the production of habitus by material structures and the reproduction of these structures by habitus in practices, there is the "moment" of misrecognition of the first in the second that is at once the objective institution of a relation and its "subjective" forgetting. It would be pure mechanical causality if the dialectical *Aufhebung* were not operating in it as a negated negation of the material determinations in a work of another order, but it would be just as productive as the work of transformation of the raw material into the social product: a moment of *schism* whose effect is, through the negation of the determining material relation, the return of that reality, but in symbolic form.

Now, the system of representation of which objectivist theory is the reproduction in the field of science is more than any other capable of ensuring that misrecognition and of misrecognizing it. Damisch demonstrates this admirably for the theory of pictorial practice that this system presupposes. The theoretical status of the painted image in the system of representation, as Damisch develops it extensively from Giotto to Cézanne, and as I have attempted to formalize it above, is institutionally defined in such a way as systematically to produce the misrecognition of its objective material determinations, which emerge essentially, for this specific practice, from two sources: the material undergirding for the image, and the colored pigments. To the extent that, theoretically, the objective intent of pictorial practice is representation (that is, the repetition of visible things and the substitution of the product of this practice for those visible things), the set of operations that characterize it will be subordinated to the production of this analogy. That is, the painted image will be entirely dominated by an "effect of the signified" obtained, owing to the representative coincidence of the signified and the referent, by means of the reduction or the projection of the referential relation from the iconic sign onto the conceptual signified that the corresponding verbal signifier denotes. The pictorial practice, productive of painted images, is theoretically and ideally dominated by the notion of sign and, through that notion, by the function of com-

munication, of which the paradigm is verbal communication. A painting is theoretically and ideally a discourse on painting whose justification, validity, intelligibility, and beauty are measured by what it means and by the way that intention of speech is readable in the representation.

Introducing the distinction between the pictorial graph or signifier (cloud), the descriptive homonymic denotation, *cloud*, and "cloud" as signified product at the very outset of his book,[21] Damisch in turn breaks with a notional complicity that would be conceptual confusionism if it were not the clearest possible mark of the constraints inherent in the system of pictorial representation and in the discourse in which pictorial representation signifies itself, as if naturally. The fact that this coincidence or complicity is never complete at the level of the products of pictorial practice is quite obvious, and Pierre Charpentrat shows this clearly in a recent article in which he analyzes the gap, in itself highly significant, between mimetic representation and trompe-l'oeil.[22] This gap may also be manifested by the representative elements, the parts of the representation through which the representation designates itself as representation.[23] But the fact remains that the system of representation, productive of a specific practice, guarantees by its very structure the domination of a semiology over an *aisthesis*, which amounts to the subordination to the sign of what Damisch felicitously calls "painting's enduring power of sensorial appeal," subordination to measurable, analyzable, interpretable communication, a call to pleasure and enjoyment in and through the painted image. From a theoretical viewpoint, finally, the system of representation ensures, in analogic representation of the finished product, the concealment of the visible being, the productive practice, its processes and its material determinations.

As habitus, this system is productive of practices of contemplation and creation, consumption and production of symbolic products whose essential characteristic is that they repress, forget, or misrecognize, inasmuch as they are practices of production or consumption, their quality as practice, that is, their objective truth as reproduction of the objective structures that determine them. Thus, at the level of the work they produce and consume, not only is the operation of production forgotten, but also its material determinations: supporting surface and color. This misrecognition literally constitutes a painting as a symbolic object through and through: as a gratuitous, disinterested representation whose end lies in itself, as pure spectacle for a gaze that is itself gratuitous and disinterested, as the object of re-creative contemplation.

But because the system of representation is caught up, owing to its very structure, in a process of redoubling and interminable repetition, its product is not only the habitus underlying the practices of representation-reproduction but also the theory of that habitus and the theory of the practices it produces. Not only, as habitus, does it obscure, in the specific practice of painting, the material conditions of possibility of that practice, but as theory, it represents that covering-over, it formalizes it positively in a model that excludes it. It subordinates the signifier to the sign, but it also censors the repression characteristic of the symbolic practice of representation in its objective intent by a theory of the sign, which, as a secondary theoretical process, precludes theoretical access to the determinations to which the symbolic practice is blind. The semiologic theory produced by the system of representation misrecognizes theoretically: that is, it justifies, validates, and rationalizes the misrecognition necessarily implied in figurative pictorial representation, the product of the specific practice in question. Semiologic theory conveys the analogic by means of the verbal, the image by means of the sign, treating this process as a rigorous method for understanding analogy and image; it thereby conceals the real conditions of possibility of a practice productive of the painted image as figurative *analogon*, that is, the work of pictorial production and its symbolic effects.

Here we have to sketch in a possible development of Damisch's enterprise in the perspective opened up by Bourdieu at the end of his book. If painting as representation and figurative mimesis dissimulates the work productive of painting, the dissimulation is indicated and the repression appears at the precise historical moment when a schism is opening up: a split in the archaic nondifferentiation between the symbolic and the productive, between the economy of good faith and the economy of interest, between the ritual and the effective, as if artistic practice, pictorial practice in particular, signified its objective truth negatively against the grain of economic practices, when the latter attain consciousness of themselves[24] and of their objective truth (economic value of work)—a schism between the productive and the symbolic at the very moment when pictorial practice is forgetting that it is production and productive work, at the very moment when, theoretically unconscious of its material conditions of possibility, it is attaining the status of a thoroughly symbolic activity in the eyes of its agents as well as its users. But this inversion is not a pure contingency: if it is produced, at the very moment of this schism, at the point of rupture marked historically by the Renaissance and characterized by the ir-

remediable gap between the development of productive forces and the maintenance of social relations of production fixed at the previous stage, it is because the effects of that schism and that gap include the process of autonomization of art in general and painting in particular. As they become autonomous, they are separated from the whole set of practical activities of the social body and constituted as a relatively independent sector.

Thus the process through which pictorial practice is developed, structured by the habitus of representation, in a purely symbolic activity misrecognizing both its character as practice and its material conditions of possibility, is the consequence or the effect of that process of mutation through which economic structures become autonomous. Through this process, to use Bourdieu's expression, Western societies confer on economic realities their purely economic meaning and explicitly recognize in economic action the economic ends with respect to which they had always been objectively oriented, without ever recognizing them as such. By pushing the symbolic aspects of acts and relations of production back into the at once closed and ethereal world of art, where they will have no thetic relation of generation and production and reproduction with the real world and with its material determinations, in short, into a world governed through and through by the repetitive and substitutive play of representation, Western societies, caught up in a historical shift from feudal to bourgeois relations of production, could constitute the economy as such, that is, as a system governed by the laws of interested calculation, of competition, and of exploitation. Thus the system of representation as a habitus generative of artistic practices and as a theory of those practices is only the obverse of the constitution of the economic system as such, productive of habitus themselves generative of the practices that reproduce it. Hence, at the point of interference between Bourdieu's *Esquisse* and Damisch's *Théorie du nuage*, we find the possibility of constituting a semiotic praxeology or a *critical* semiology (in the sense in which Kant spoke of a critique of theoretical speculative reason) in the domain of art with three objectives:

—to bring to light the misrecognition implied by representational painting with respect to pictorial work and to the material conditions of possibility proper to it;
—to bring to light, just as necessarily, the misrecognition of that misrecognition implied by a semiologic theory of painting that misrecognizes the inherent characteristics and the specific logic of that particular practice;

—to show, finally, how that double misrecognition characteristic of the system of representation results from a general transformation of relations of production between the sixteenth and the nineteenth centuries that takes the form of an inverse effect, in the particular realm of art, of the process of schism and differentiation between productive work and symbolic work.

Polythetic Logic, Signifying Polyvalence

My reference to Kant was not gratuitous: it appears to be a crucial one for the enterprise of founding a critical semiotics as a praxeology of art. The distinguishing feature of a critique that aims to make explicit a system's conditions of possibility and also its claims to scientific validity is actually the fact that it works at the limits of the system, not in order to describe its code or codes, but in order to formulate the principles that generate them, and whose production can only be a transgression of the limits of the system. This is the effort we have observed in both Damisch and Bourdieu, at different levels, on different planes, and in different formulations: the former with a pictorial signifier, the cloud, that clearly seems to be the operator of a generalized and fundamental questioning of the system of representation; the latter with the formulation of a polythetic logic as the operative condition of a practical logic that calls back into question both the theory of theory and the theory of practice at work in contemporary structural anthropology. Here again, Bourdieu sketches in the methodological and epistemological principle of which Damisch offers a remarkable critical application.

What, then, is the polythetic logic that articulates the practical functioning? Bourdieu uses this term to describe the principles of a *practical coherence* of symbolic systems endowed with a logic that is not the logic of structure that an objectivist theory of practice abstracts from them and superimposes on them, but the logic of their genesis and their functioning. This practical logic has to account for their irregularities as well as for their inconsistencies, which are equally necessary to the extent that they have to submit to a double *practical* condition: to be consistent in themselves and with the objective conditions, and to be practical, that is, manipulable and governable. That is why, in the ritual practice taken as an example, the symbols that are at once instruments of its manipulations and objects of its activity, simultaneously indeterminate and overdetermined, are grasped

in relations of global resemblance, but at the same time used under a particular aspect of analogy, so that when they are put into practice by the ritual, that particular aspect continues to benefit, under various modalities, from all the other aspects of the resemblance—which the aspect in question seems nevertheless to exclude in its particularity.

Bourdieu has a particularly felicitous way of characterizing that process of indetermination-overdetermination, or the process of uncertain abstraction, since "the aspect of each of the terms that is implicitly selected from a unique viewpoint in a particular setting-into-relation remains attached to the other aspects through which it can be opposed to other aspects of another referent in other settings-in-relation." Thus, this uncertain abstraction, which gives to the operations of ritual practice the greatest possible consistency with a maximum of economy, is effaced by the structural reconstruction of schemas and models, to the extent that that reconstruction considers "monothetically" and *simultaneously* the modulated linkings of the symbolic practices that play *in succession* on the harmonic properties of the symbols according to the pressures or requirements of existence. Objectivist hermeneutics, because it seeks a rigorous logical reconstruction, is led by ignorance of the limits of its method to a sterile and interminable methodological overinterpretation that is quite precisely the epistemological "contrary" of the indeterminate overdetermination of the practically used symbolic instrument. The conception of a polythetic logic thus makes it possible, beyond the monothetic structures that govern structural analysis, to grasp the functioning of analogic practice "as transfer of schemas that habitus operates on the basis of acquired equivalences facilitating the substitutability of one reaction for another and making it possible to master, by a sort of practical generalization, all the problems of the same form that may arise from new situations."

Now, with his pictorial graph of the "cloud," Damisch has discovered a remarkable instrument of this polythetic logic, an instrument for the specific practice of painting analyzed in the field of the system of representation. It is reasonable to suppose that Damisch's "invention" of the cloud retrospectively obliged him, starting at the very beginning of his book, to untangle the complicity of a certain number of notions at the root of a structural semiologic theory of pictorial practice and to question it at its limits. Once posited and analyzed, is the thematic, functional, signifying polyvalence of the "cloud" not what makes it possible to disimplicate it from the mimetic relation of representation, from the bi-univocal corre-

spondence between sign and real object that it is supposed to represent? "There is no justification for thinking that the set of material features [contour, colors, and so on] is articulated systematically by an aim to produce a *meaning* . . . and still less, in Hjelmslev's terms, that these *figures* are at the service of (iconic) *signs* that would logically determine their existence." Damisch adds: "And even if one were to claim, as a hypothesis, to recognize the elements of a signifying order in cloud figures, it is not obvious that these elements are amenable a priori to a *finite* inventory, nor that it is legitimate to propose to restore their underlying system."[25] But is this not to call into question from the outset, if only on a problematic or hypothetical basis, the project of a semiology of art that, if it obeys the logical, methodological, and epistemological requirements of its enterprise, cannot limit itself to the analysis of the discourse of (on) art and of art as discourse without raising questions about the constitutive elements that this discourse would incorporate?

Even the now "classic" opposition, which was at the origin of semiology's first encounters with art, between denoted message (based on the mimetic and a-codic analogy between signifier and signified) and a signifier of a secondary meaning or connoted message (corresponding to the style of the representation), comes into "question with respect to the pictorial process."[26] And taking up again in their full amplitude the binary structural oppositions on which the objectivist theory of semiology might be thought to be based, "nothing authorizes us a priori," he writes, "to draw a distinction between style . . . and system [or between] works [and] *aisthesis* [defined as] a network of structural constraints and of formal and expressive possibilities that would give the pictorial production of a given epoch its historical coherence." Nothing, Damisch notes, in a fine dialectical "suspense," "except some signs or indices to which the context lends . . . a particular *charge* and around which it seems possible to develop an analysis that would give access, in the form of a symptomatology, to the deep structures of the images of painting grasped in the unity of the semiotic process that puts them into play."[27]

Thus the cloud is a dual operator, simultaneously problematizing certain uncriticized self-evidences of the semiology of art and placing these same self-evidences in a semiotic hypothesis that will define the limits of their validity. This critical semiotics will seek to formulate the signifying functions of pictorial production, of the practice of painting in its materiality as productive work, "without prejudging," Damisch writes, and the point

is crucial, "their relative coherence or the possibility of a more or less ex-haustive inventory of the terms and functions belonging to a single class."[28] Thus if the cloud plays its articulatory role between theoretical constitu-tion and research hypothesis, if in the very conceptualization of his analy-sis it allows Damisch to distinguish the pictorial signifier from verbal de-notation and from the production of the signified, and thus to undo the conceptual conjunction of the system of representation, it will continue to carry out—starting with the analysis of Corregio's "manner"—the decon-structive articulation of the substance and form of the expression on the one hand, [and] of the substance and form of the content on the other: not only is the cloud "one of the objects of election" of Corregio's *thematics,* one of the key terms of his figurative *vocabulary,* but it "contradicts again, by the effects of texture to which it lends itself, the very idea of contour and delineation, and through its relative inconsistency, the solidity, the per-manence, the identity that define *form* in the classic sense."[29] By the same token, as an essential and necessary part of the system of representation, since it is one of the iconic signs and one of the syntactic instruments that can assure it an all-encompassing grasp of the invisible in the image and in the imaginary, it is likewise the element that calls into question the whole of which it is a part: a limit-element, the raw material of work in the sys-tem that makes it work, the cloud introduces play into its coherence, since it shatters the system's formal and expressive enclosure by opening it up onto the infinite and the continuous, which the system of representation seemed to have the function of excluding, and by which it was no doubt negatively determined.

A pictorial graph, as a unit of denotation the *cloud* is a figure, a non-sign, a building material, but it also designates a typical space; it is the sign of a spatial relation even as it also remains an iconographic, thematic, or rhetor-ical symbol. I need only evoke the analysis of the symbol in Bourdieu's in-quiry into ritual in order to illustrate the polythetic logic of practice, in or-der to note that Damisch's project, carried out with clouds, stems, in its own order and in its own field, from a similar aim. The cloud as sign-index or symptom of the system reveals how "the same units come into play at several levels, operating in several entities at once and on the double regis-ter of the signifier and the signified."[30] Identical for the analysis of the iconic constituents of the surface of the painted image, for pictorial repre-sentation, these elements are profoundly different with respect to the func-tions they acquire and with respect to the operations that define them in the practical process of production of painting.

Thus the discovery of a representative polyvalent element in the various dimensions of the pictorial process and in the various topics of its theoretical analysis leads Damisch to the very question of the system, which he inscribes as such at the basis of an authentic semiology of art. It is a question that the "cloud" necessarily introduces in proportion to its polysemy and to the polythetic logic that presides over its use, if the system is defined as a finite and closed set, with a rule-governed combinatorial. Now art—and painting in particular—does not have, even on the theoretical level, the reality possessed by Saussurian language or Chomskyan competence: the pictorial system does not exist, even theoretically, "apart from the products where it manages to institute itself in rigorous classes."[31] But how can one make a semiology of art while paying the theoretical ransom required by a double exclusion: namely, that the system does not exist outside of its products and that the system cannot be reduced to its codes (exhaustive, finite sets of lexical elements and construction rules)?

Two comparisons guide Damisch toward what Bourdieu would call the polythetic logic of pictorial practice: the first is that of pictorial representation and writing—although this comparison does not anticipate the monothetic logical solution by promising to bring to light a finite repertory of elements and the exhaustive inventory of their possible combinatorials. If this first comparison itself is taken seriously, it allows us to connect the representative pictorial object to the material conditions that made it possible and that figurative mimesis effaces institutionally and constitutionally: succession, spacing, separation, punctuation, grouping and ordering of the "letters" on the surface, all these produce the *medium* for pictorial writing, positively or negatively, so as to affirm it as such in its materiality or to deny it through the illusionist play of the forms, colored spots, and lines that cover it. To compare painting to writing, and to compare painting, even figurative painting, to a writing that has become autonomous once again with respect to the language of the *phōnē* is paradoxically to rediscover, underneath the familiar univocal reference to the object and the recasting of the painted image as a verbal signified, the complexity, the "presence," and the power productive of symbolic effects in and through the medium and color.

The second comparison is the comparison between pictorial writing and dream writing. Like dream writing, pictorial writing does not imply, as its necessary condition and end, the production of a code. "Here," Damisch writes, "the interpreter is in a situation similar to that of the analyst whose role it is to discover the grammar of dreams . . . without being

able to hope to exhibit at any moment the system on the basis of which the dream would then allow itself to be read and translated without remainder."[32] Once again, if the comparison is pursued to the end, it indicates that pictorial writing, like dream writing, obeys a grammar, but a grammar in which the inventory of rules and the exposition of the syntactic processes have every chance of being interminable because these latter are constantly displaced, condensed, and overdetermined. But the process takes place in *history*, that is, in the temporal production of works in which semiotic and semantic elements and mechanisms are by turns invested with differing values and functions relating to the set in which they are manifested. A system, to be sure, but as Damisch declares boldly, one that is "not finite, not closed, and perhaps not systematic." Critical semiotics will have to systematically explore the diversity and heterogeneity of its processes and its entities, the effects of symbolic overdetermination that these heterotopies provoke, by bringing to light both the historical constants that are indicated in them and the invariants that are attached to a specific practice and that refer to the material entities that ultimately shape it. It is an open and constantly decentered system, postulated simultaneously by the polythetic logic of practice and the polysemy of the elements and mechanisms that it puts to work historically. It is a system that admits the presence of codes, but that cannot be reduced to them, as one might be inclined to think by a structural and objectivist semiology that, hypostasizing in the models of productive activity what seems essential to it, eliminates the residues and the "supplements" that are perhaps the essential elements. It is a system nevertheless, despite its openness, since it is not conceivable without a certain number of interdictions and limitations, but interdictions and limitations whose effects are as much positive as negative, since these constraints work on the system that they limit, not only by producing a given element, a given relation, a given mechanism associating a meaning to a complex of iconic signs, but also by the forgettings and the lacks that they provoke in the system and that also exert determining effects through the unthought that they introduce into it.[33]

At the end of this process of weaving together the points where Bourdieu's and Damisch's books interfere or overlap with each other, we might try to account for their convergence through a generalized problematics, and we could attempt to sketch out its possible development in the sense in which Damisch speaks of a *possible* field of production of the system in

its relation to history, that is, of a possibility producible by the system. Moving from the greatest generality to the specific problems of a practice, we could formulate this problematics as follows:

1. What is the relation between the theory that a *practice* conceals in its immanence and the "ultimate ground" of the objective, material determinations that every practice ultimately reproduces in the conjuncture of a particular historical situation? And by what method and what theory can this relation be brought to light without hypostasizing the theory as the reality of the object studied and reducing the practice to the theory of the practice that such a hypostasis implies?

2. What is the process of constitution of the symbolic order, and what is the nature of its effects in and through the practices that stem from it? If this constitutive process is indicated in the repression and the dissimulation of the material determinations of social practices, what is the function of that repression? How and why does the objectivist reifying theory, in its double relation to symbolic practice and to the theory that corresponds to it, both misrecognize and dissimulate, on the one hand, the relation between the theory and the symbolic practice, and, on the other hand, the obfuscating repression that that relation necessarily implies in order to constitute itself as symbolic? In other words, throughout Bourdieu's and Damisch's enterprises, what are in question are the conditions of possibility of a theory of symbolic practice that restores to symbolic practice its material, objective determinations, in the form of a qualitative and materialist dialectics that would signify how that practice is historically productive, within certain limits, of specific symbolic effects.

Such would be the task of a possible history of painting as a theory of pictorial production, or that of a praxeology in the sense of a general theory of social practices. Caught up in the system of representation, Pascal deemed the enterprise empirically impossible: even as he provided the transcendental presuppositions of its critique, he redirected it toward other ends. Perhaps it will be necessary to reflect that impossibility, with reference to contemporary art, in a different language and with different goals from Pascal's, in order to carry out the same foundational critique in a radical way.

§ 3 Establishing a Signification for Social Space: Demonstration, Cortege, Parade, Procession (*Semiotic Notes*)

It is not possible to offer at the outset, without taking certain precautions, a definition of the "complex ethnosemiotic object" (to borrow an expression A.-J. Greimas used about festivals)[1] that we know as cortege, procession, parade, or demonstration. Such an object can only appear as *constructed* and *produced* by the various methods and procedures used to analyze the social complexity of its forms and the historical diversity of its manifestations. This complexity and diversity, respectively related to synchronic and diachronic approaches to analysis, also becomes apparent, with the same dual dimensions, in the lexicon. What has our object of study been called in the past? What is it called today? What derivations, evolutions, slippages, or transfers of meaning have influenced the terms of this particular lexicon? What semantic fields are associated with these terms? What common and differential elements can studying them bring to light? On any of these points, what can we learn from dictionary definitions of the terms that we find intuitively in our own language use today, terms such as "cortege," "parade," "procession," "demonstration," "display," "ceremony," "review," and so on? On the same intuitive basis, the first four terms cited seem to articulate, in a first approximation, the various fields that I propose to consider.

According to Furetière's dictionary (1690), a *cortège* is the "escort provided a Prince or other important personage in some pomp or ceremony, with carriages, horses, and other things that do him honor." The Littré dictionary (1863–72) presents the same picture: "a series of persons who accompany another to do him honor in a ceremony," but it also notes a weakening of this first meaning through generalization: "a gathering of

persons who are walking in a ceremony," then "any considerable sequence of persons."

As for *procession*, according to Furetière, the first level of meaning of this "ecclesiastical ceremony" refers to the "prayers that the people repeat after the clergy as they pay a devotional visit to some holy place or church"; as the second or "proverbial" meaning, he gives "a long succession of people lined up one after the other." Littré picks up this second meaning, calling it "familiar language," after a first definition: "a solemn march of clergy and people performed inside or outside a church, while singing hymns, psalms, or litanies"—a definition that also applies to pagan ceremonies analogous to Christian processions.

After the domains of political sovereigns and religion, the military and martial domains are foregrounded with the term *défilé* ("parade"), since the term designates "a troop walking in columns processing past a leader," or, more precisely "the movement that consists, at the end of a review, in the procession of all the troops before the leader who is inspecting them." Or, more generally, it refers to the movement carried out by "soldiers [when,] assembled in a body, [they] are obliged to go in line and start marching one after the other, and pass through narrow places."

In constellation with these three terms, we must add the term *manifestation* ("demonstration"), which designates a "movement [of the assembled populace that is] destined to manifest some political intention" and can take the form of a parade or a cortege. Thus the populace calls attention to itself in the "field" of the cortege as such with a specific "parade," in which, to borrow Georges Dumézil's schema of the three functions, alongside the function of political and religious sovereignty and the martial function, the third function appears, but displaced from its proper domain (work) into that of politics. One could equally take into account a term like "parade," which intersects with both the military domain and the often neighboring domain of aristocratic festivals: since it signifies "the review that troops who are going to stand guard must undergo but also the march that knights used to perform in the lists before beginning a tournament"; or the term "review," which intersects with "parade" in both senses: "inspection of troops lined up to be examined and set to marching."

Among these fields, however the meanings of the various terms given here may have evolved, how do the classes or groups, the domains of functions and social roles, overlap? It seems possible, beginning with lexical definitions, to isolate some essential features of the object under considera-

tion. First of all, with the notions of troop, group, company, meeting, or gathering, the "cortege-parade" has as its distinguishing feature a collective dimension without which it does not exist. To be sure, not every gathering is a cortege, parade, or procession, but there is no such thing as a cortege-parade without a gathering, and the assembly of persons is what constitutes its origin and its existence as well as its purpose. For individuals, to parade, to form a cortege or a procession, is thus not only to gather together, but also to "form a group," to constitute a "totality," to "form a body" collectively, whatever the modalities of this constitution or the characteristics of the resulting product may be. In other words, the grouping that we know as a cortege, parade, or procession will have a complex and diversified structure, at once real and symbolic, axiological and teleological.[2]

Furthermore, with the constantly recurring notions of sequence or succession, march or movement, line or order, it appears that this grouping is a body in motion, a body moving through a specific space according to a specific orientation and in a specific order. Every parade, procession, or cortege can thus be considered as a collective process that at once manipulates space through given movements in a given time frame and also creates its own specific space according to precise rules and norms that place constraints on the movements and time frame while also valorizing them. One can say the same thing about time: the parade, cortege, or procession arranges itself in measurable time so as to structure it on the basis of its own temporality, and in so doing it produces a specific time, which at once interrupts chronological time and to a certain extent grounds or establishes it.[3]

In addition, and this is especially true of parades and corteges, not to mention reviews (of which this feature constitutes the essential element), it seems clear that groupings of this sort, as well as the processes by which they are constituted and realized, imply structures with two poles (which are not necessarily simultaneous or permanent): action and passion, activity and receptivity, movements and gazes assumed by collective or individual figures (not necessarily the same ones for the full extent of the parade, cortege, or procession), actors and spectators. In other words, a general structure of theatricality or spectacularity seems to link the participants in a parade, cortege or procession, although the specificity of the structure still has to be spelled out.[4]

Finally, corteges, parades, or processions, and more generally the complex object whose profile I have attempted to sketch by noting a few of its

features, seem to me, by virtue of those very features, to stem from the do-main of rites or ritual ceremonies, whether religious or secular, civil or mil-itary, festive, ludic, or directly functional. Cortege, parade, procession: they all in fact possess the structure of repetition characteristic of ritual systems, whether the system is of the syntagmatic or the paradigmatic type, that is, whether the rite in question responds to a series of periodic occurrences and forms a system according to a chronological axis of the calendar (for example, the Corpus Christi procession that takes place in the Catholic world on the first Sunday after Trinity, in late May or early June, or the military parade held in France on July 14), or whether it corresponds in-stead to a series of special occasions and is articulated according to a spe-cific paradigm (for example, processions held on agricultural lands to ward off drought, or the corteges accompanying the arrival of royalty in western European countries from the fourteenth to the eighteenth centuries).[5] From this perspective, corteges and processions may constitute a particular se-quence of a more extensive rite or ceremony; and, quite often, the same ap-proaches used and the same general characteristics noted in the study of rites can be applied to the cortege, parade, procession, or demonstration. If, in addition, the feature of iterability in time and in space is one of the fundamental features of signifying structures in general, then whether the object we are studying constitutes a ritual in itself or only one component of a ritual, we can recognize in it a symbolic structure organized in terms of a liturgical or formal aspect, oriented by an intentional (conscious or unconscious) schema of actions, deriving its scope and complexity from a hierarchy of actants, roles, and actors.[6] Nevertheless, the fact that military parades, princely corteges, religious processions, and even political mass demonstrations all belong to ritual in general implies by that very token that we need to look for their specificity with respect to rites, and also their frequent incorporation into festivals, which are themselves closely allied with ritual.

Thus we can propose, very schematically, some axes for interrogating the cortege (parade, procession, demonstration, and so on) as the specific symbolic structure of a ritual on the basis of its syntactic and semantic semiosis and its pragmatics.

Inquiry into the syntax of the cortege is directly related to its spatial and temporal dimensions. Corteges, parades, processions, and demonstrations all unfold (and the term itself is highly significant) in a preexisting space already articulated in characteristic sites, which are named or marked:

thus, in cities, we find streets, squares, intersections, bridges, religious or public buildings, historical monuments, neighborhoods, boundaries, and frontiers; in the country, we find paths and roads, hamlets and farms, fields and their boundary markers, woods and their paths, and so forth. The parade extracts its setting and its backdrop from this space: because certain axes of the itinerary are chosen to the detriment of others, because some places are selected and others are not, because some buildings or monuments will be visited and others will be bypassed, a parade (cortege, procession, demonstration) manipulates the preexisting space and sites. It gives this space a highly telling structure in which the places selected by the itinerary articulate the "sentences" of a spatial discourse whose linguistic equivalents (varying according to the situation—nominal sentences, narrative sequences, and so on) would be interesting to study. In this discourse, to be sure, the places rejected or avoided by the itinerary proffer a sort of counterdiscourse, a negative discourse, even a denied or repressed discourse, that constitutes the background for the chosen itinerary and on the basis of which this itinerary takes on supplementary meaning.

The manipulation of a space that exists prior to the parade is necessarily accompanied by the production of a space that is specific to it, a space that is, for example, closed to regular traffic or one in which the traffic flow is altered, a space that is punctuated by new monuments, either permanent or temporary, or in which the permanent, everyday background is hidden or modified. In this projection, and to return to the distinction between "space" and "place"[7] in which "place" is defined as the order according to which elements are distributed in relations of coexistence, and space is defined as the effect produced by operations and movements, the parade in general is a specific itinerary (process of spatialization) aiming to produce a representation of places, on the basis of a map (order of places) that conditions the itinerary and that, conversely, the itinerary presupposes or implies. To take the example of a religious procession such as the stations of the cross, we can say that its itinerary (whether the stations are marked or not) transforms an order of specific places—the side aisles of a sanctuary, the nave, the choir, and so on—into another equally specific place, through the reactualization of a narrative, the narrative of a spatializing itinerary and its places, the itinerary followed by Christ at the moment of his Passion.

The points at which a parade, cortege, or procession begin and end will thus be particularly noteworthy places among those that are linked by the

movement of its itinerary, since the former will constitute the epiphanic place of the parade as such, and the other, the place of its end in every sense of the term, whether the parade disappears there in accomplishing its "purpose," or the group is effaced there as such once its performance has been carried out, or it disperses there in failure. We may also note that the points of departure and arrival can constitute "dangerous" places for the parading group or groups, as in the case of political demonstrations, for example. Before a parade expressing protest or political opposition gets under way, at the gathering place or in its immediate vicinity, the police and other forces of law and order will try to intercept those who are only isolated individuals and not yet "participating" elements in the parading mass. At the parade's end, the place where it is to "disperse," troublemakers will slip in and disorder will be provoked by "uncontrolled elements": these gathering places and places of dispersal are limit places, boundary points that the parade crosses, either to constitute itself or to disappear, places where there is passage, in one direction or another, from the law and its rules for the existence of everyday "normal" places and spaces, to the law and its rules for parades, to the space of its itinerary and to the places that the itinerary articulates. These passages from one law to another, from one system of rules to another, are, properly speaking, "outlaw" passages, and thus they betray an element of danger.

On this basis, it may then be possible to develop an entire typology of itineraries as spatializing processes, productive or reproductive of a local order or conditioned positively or negatively by it, in particular by the notions of starting point or end point as limit places: parades that go in only one direction produce quite different signifying spaces from parades that retrace their steps or that follow a closed circuit. Indeed, a one-way trajectory implies the notion of an irreversible direction with accentuated temporality, for example, in the schematic reproduction of a narrative, or at least of its scenario. The point of arrival of the group in motion will always be in some respect the symbolic victory of the forces that that group has conveyed by gathering and parading against those whom its very march has defied or challenged in an equally symbolic antagonism.

A round trip, by placing the emphasis on a reversible bidirectional spatialization, exhibits constraint and linearity and also a nontemporal coexistence of the elements distributed along the line. In a round trip, the point at which one turns back is thus deeply invested, because it is not only a goal but also the place of origin of a "retrogression," a movement in

the "wrong" direction. This ambivalence is doubtless one of the factors that helps free the "round-trip" parade from the chronometric forms of temporality, from a succession of "events," in favor of places insistently and repetitively marked as present. In the same way, we note that the starting point is, at least locally, identical to the point of arrival, but not in terms of the process of spatialization embodied in the itinerary; these can be differentiated, in the first place, because the one was the moment of assembly and the other that of dispersal, and, in the second place—and perhaps especially—because, between the two, the march has taken place, and because it has in some sense "legitimized" the place from which it set out by reaching that place once again after carrying itself out.[8]

In the closed-circuit trajectory, other values appear in the manipulation and production of places and spaces: the trajectory makes a circle, it confines and encloses. It produces or reproduces an ideal or real limit that is the end of an unbroken surface that the trajectory instantiates while replicating the movement that grounds its existence, and that it protects ideally by putting in place an uncrossable symbolic frontier. But, conversely, the closed-circuit trajectory can "lock up" the enemy in the area it encircles, and the itinerary will be the symbolic interdiction of any possibility of escape—for example, the Hebrews' parade around the walls of Jericho. The march can then be understood as the operation aiming to substitute a "symbolic" enclosure of conquest and annihilation for the adversary's "real" walls. The closed-circuit trajectory thus turns the itinerary into a local order, and movement into repose, by eliminating the specific values of the points of departure and arrival.

It is not surprising that these few remarks, which open up the perspectives of a particular typology of parades, corteges, demonstrations, and so on, are related to the "universal" syntactic rule proposed by Edmund Leach for any festive sequence that articulates death and rebirth.[9] But we note how the "death and rebirth" schema is modulated and transformed in the various forms in which time and space, a succession of moments and a repetition of chunks of present time, on the one hand, and spatializing processes and the order of places, on the other hand, are interconnected in a diversified and ambivalent way. It is remarkable that a precise analysis of the places and spaces, "maps" and "itineraries," of a parade brings to light the complex working of the temporal mechanism whose semiotics remains to be developed: unidirectional linear time, bidirec-

tional linear time, cyclical time, but also duration-time, punctual time, static time, inchoative time, terminative time, and so on. We can recognize here both the major categories of a philosophical reflection on time and the aspectualizations of time by language. We must add that, in their various phases, corteges, processions, parades, demonstrations, and the like combine diverse "aspects" and "categories" that may be heterogeneous (for example, portions of unidirectional linear time may be integrated into closed-circuit itineraries or vice versa; thus in carnival parades, farandoles or round dances in a given city square may be introduced into the itinerary between a starting point and a terminus).[10]

We can also study a parade in terms of its own syntax rather than the syntax of its places and spaces, its times and their aspects: in so doing, we would encounter the problem of the order of the cortege, of the rows occupied by the participants, groups and individuals whom the parade melds into a totality. On the one hand, from the Panathenaea festivals or funeral ceremonies of ancient Greece[11] to the May 1968 demonstration marches in France by major union organizations, political parties, "groupuscules," and so on, from the Corpus Christi processions of the high Renaissance to the Soviet Union's Red Square parades for the anniversary of the October Revolution, this order is essential as the mechanism for apprehending the religious, civic, political, philosophical, or social "messages" that the formal or informal organizers of the parade are seeking to transmit. These often complex messages are conveyed not by the groups or individuals participating in the cortege, but by the reciprocal relations among those groups or individuals in the moving volume that constitutes the cortege.[12] Thus there are key places and rows: the beginning, the middle, the end; there are also significant positions: before . . . , after . . . , in the same row as . . . , surrounded by. . . .

Still, we must add that even before it "signifies" one or more messages, the order of the cortege signifies a message about the messages that that very order conveys through the relations among its parts, that is, the "manner" in which the messages must be heard. Let us take a noteworthy example from the French Revolution. In 1794, in an Alpine town, to celebrate the capture of Toulon, one could see "parading behind the municipal authorities" "the justice of the peace, the assembled citizenry, with 'eight chosen cantors' followed by 'all the female singers and other female citizens,' and 'all the other male singers and citizens of the commune,' while the Constitution [was] borne by the four eldest citizens on

a stretcher, under a red canopy."[13] It was quite apparent to all partici-
pants not only that the Constitution was being solemnly celebrated as
the firmest guarantee of unity among all groups (ages, sexes, professions,
and so on) and civic bodies (municipal and judicial authorities, and so
on), forming one Nation indivisible, united against all federalist sepa-
ratisms, but also that the national unity and indivisibility embodied in
the Constitution had to be received as the sacred body politic of France,
as the politico-religious body of the country, since the very order of the
cortege, its organization, and even the instruments and symbols used in
the celebration were precisely the ones used in the procession and display
of the holy sacrament. The order of the cortege then appears as the "rhe-
torical" operation that, to borrow the language Marcel Mauss and Claude
Lévi-Strauss use about *mana* or totems, transforms a metaphor into a
metonymy.[14] The Constitution metaphorically paraded and exhibited
"today" *as* the holy sacrament was "in times past" is thus presented to be
considered and perceived here and now, metonymically, as a eucharistic
political symbol of national indivisibility. In other words, the order of
the cortege functions both as a syntactic signifier of metacommunication
and as a semantic signifier.

 Let us turn now to the semantic values of parades. We should note at the
outset that quite often—and this is especially true in an urban context—a
parade's itinerary is literally a succession of place-names, a list of toponyms
linked together through its movement in a series of "noun phrases": names
of squares that it crosses, streets or boulevards that it follows, also buildings
and monuments toward which it is directed or that it passes. Let us note
that the whole set of "questions of place" (*ubi, quo, unde, qua*) turns out to
be implicated here. Now, these place-names or toponyms are not neutral.[15]
To take a contemporary Parisian example, most of the great left-wing po-
litical "manifestations" during recent years have taken place between the
Place de la Nation and the Place de la République along the Rue du
Faubourg-Saint-Antoine and the Boulevard Beaumarchais, via the Place de
la Bastille, whereas the occasional right-wing demonstrations have gone
from the Tuileries to the Place de l'Etoile via the Champs-Elysées. The
nouns name the places; an order of names is superimposed on the order of
places, and these are very rarely arbitrary. Sometimes a place transfers its
"history" to its name (for example, the Rue du Faubourg-Saint-Antoine, a
"revolutionary" or cantankerous neighborhood ever since the sixteenth

century); sometimes a place is named by its history (for example, the Place de la Bastille, the square on which the fortress-prison of the Bastille, which was to be taken by the Parisians on July 14, 1789, was located); sometimes a name transfers its own semantic charge to a place (this is the case with the Place de la Nation or the Place de la République). From that point on, the parade reactualizes a myth through the place-names along its itinerary, or perhaps more precisely, it *recites* a narrative or inscribes a text whose legend it is presenting to be read, the *legendum*, narrative, or myth already inscribed in the order of places and their names. The parade's itinerary is the inscription of a narrative in space through the inscription of a text whose names it traverses, "follows," abandons, or reaches. It is from this viewpoint (but by no means exclusively from this viewpoint) that every parade, procession, or march is an *actant of narrativity*. A contrasting case is proved by certain "wandering" demonstrations in Paris in May 1968, which could be analyzed in terms of the political tradition not only as "creating" a new historical narrative and a new political discourse, owing to the very novelty of the names encountered, but also as offering the signs of that novelty and that creativity in the names themselves, to the extent that, at least in appearance, the itinerary was improvised, one sequence at a time, and manifested the political and ideological "spontaneity" of the groups that were involved in it, in much the same way that the steadily increasing power of the obstacle encountered by "regular" demonstrations was manifested in their already traditional itineraries, which were also designated by names and places (place-names).

In a more general way, parades, corteges, processions, and so on—and here we find the function and the purpose of the repetitive structure—reinscribe through their itineraries, that is, through the narrativity of their various sequences, a hierarchized and articulated system of values of which that narrativity is the manifestation. In its turn, this narrative reinscription of values allows for a revalidation of the system, "founding" it anew, practically and concretely. In this respect, a parade is indeed an agent of social, political, or religious legitimation:[16] even the popular "demonstration" that might appear on the contrary to be a collective force of destabilization finds the legitimacy of political contestation in what is customarily called the "success" of its march or cortege, even if none of its demands is satisfied by the actual occurrence of the demonstration. The number of demonstrators, the identity of its participants (the "real presence" of certain politicians, union leaders, or well-known personalities) are among the

quantitative or qualitative "markers" of this operation of legitimation that only the parade in its realization can carry out.

To take a historical example of a cortege, royal entrances in the fourteenth to eighteenth centuries combined the dual aspect of transgression and restoration of order. As we know, the entrance of the king into one of his cities, more than his coronation ceremony or his funeral, was an extraordinary instrument for maintaining the monarchic sentiment, and for ritually opening a political and institutional dialogue between bourgeois subjects and their sovereign. While many features of the royal entrance have disappeared, changed, or given way to new ones today, the visits of heads of state to cities of the countries they govern, whatever form the political regime may take, remain in substance closely related to it. The royal entrance—and it entails an entire semiotics and semantics of space and places, of time and moments—is "first of all the meeting of two corteges at the gates of the city, the royal cortege and the civic one. The order of the individuals and groups that make them up is fixed by long-standing custom, just like the royal itinerary inside the city, and it is always at the same points that the backdrops and street theaters are set up."[17] It is worth noting that, in a certain number of cases and during a specific time period (the fifteenth century), the king, accompanied by his retinue, but also by the cortege from the city that had come to meet him at the city gate, could be led, if that was the custom, to swear an oath to the city, a solemn promise to maintain the community in its rights and freedoms, to which the community might respond by another oath. However, with increasing frequency, starting in the fifteenth century, we note the mark of obedience and subjection that consisted in presenting the keys to the king "*in signum majoris obedientiae et subjectionis.*"[18] In other words, if the cortege from the city, by meeting the king outside the walls, got him to swear to respect the city's rights, the king, surrounded by his own cortege, subjected himself symbolically to the city while passing through the gate to which he received the keys: thus a pact was woven, which later became a political contract, with the help of the encounter between the two corteges and their pauses at significant points along their way. In terms of the processes of spatialization and the order of places, it was as if the royal entrance simultaneously transgressed a limit and reinscribed it (the monarch seized the city in order both to subject it and to recognize it as a loyal and faithful subject and host), and thereby constituted the construct enclosed within that limit both as merely a part of a whole (one city among others in the

kingdom) and as the whole itself, as it is summarized and condensed in a single part (the entire kingdom as the city). In this complex movement of notions and relations, which is also a dynamic configuration of spaces and places manipulated and produced by parades, we also recognize the logical and rhetorical metaphoro-metonymic operator of Mauss and Lévi-Strauss noted above. It is this metaphoric-and-metonymic operation that the major semantic mechanisms found by anthropologists in rituals in general[19] seek, through symbolic productions, to signify and moderate, without necessarily resolving the political and social contradictions.

Another semantic dimension of parades links recollection and institution in the same structure of repetition. Parades, corteges, or processions quite often—and such a commonplace feature hardly needs to be highlighted—recount a narrative or, more precisely, repeat a story. They reproduce the story in action and by that very token they reawaken its memory: not as narrative, however, even if it is staged and dramatized, but as the symbolic and effective reproduction of a narrative, as a way not so much of "believing" the story the narrative recounts as of reliving it in the here and now, during the time of its enactment. The example of a parade organized to celebrate the memory of a lost historical hero is valuable in allowing us to grasp the nature of the compromise embodied in the semantic mechanism that a parade can establish. The corteges at the Marat festival described by Mona Ozouf are a case in point.[20] One of the organizers, who is at the same time a theoretician of corteges, says that he feels obliged to "present, for the entire length of the march, as in a moving tableau, all the major circumstances of the life of the man being celebrated, to retrace them by characteristic inscriptions and emblems in the assorted successive groups." Everything, it seems, is enacted in this way so that *viewers of the cortege* can, in the course of its unfolding, tell themselves the story of the life of Marat, all the more so in that the inscriptions come to sustain the recollection in the form of a narrative reading.

But "the contents that the cortege distributes in space," Mona Ozouf writes, "are not . . . the circumstances of Marat's life unfolded according to the order of a genesis, but a selection of legendary traits." Spectators will see passing before their eyes, not episodes from Marat's life, but floats embodying the "set of [his] public virtues," the "set of [his] private virtues," "rewards," and finally "examples": here "it is a matter of age groups, each of which can draw from Marat's life an example adapted to its own role and abilities." The fact that the examples are collected on the last float in the

form of age groups seems to me to close the cortege, not only on figures of a repetitive time, but also *on the practical injunction that to participate in the cortege*, if only through a spectator's gaze, *is in some sense to become Marat* "according to one's role and abilities." The commemorative parade, if it is successful, if it plays its role and carries out its function as fully as possible, must also be a parade of installation: to commemorate is not only to recite, but to repeat and thereby to reinstitute, that is to say, to give legitimacy to, past history as inauguration and origin. Here is probably where the performative value of the commemorative parade lies: properly speaking, it does not bring into being what has already taken place, but it inaugurates and institutes those events; it does not evoke memories, it constructs a monument of memory. In this light, the parade is thus a mechanism of the art of memory,[21] which transforms fantasy places, the signs that are arrayed in them, and the imaginary itineraries that move through them and connect them, into a real-symbolic dynamic construction, a living monument to a dead man and to the past, a monument constructed from materials constituted by the spectators and actors in the parade.

To speak of the performativity of a parade, cortege, or procession is to confront its pragmatic dimension. With the processes of recollection and inauguration, we have already touched on the problem of effects. Actually, to the extent that a parade, whether a religious procession, a royal cortege, or a popular demonstration, is always to a greater or lesser extent simultaneously a narrative scenario, a readable text, a visible spectacle, a ritual, and a ceremony, the syntactic and semantic mechanisms are in a sense already pragmatic mechanisms. Like any ritual, this one is organized around signifying nodal acts in the sequence of the parade. To pose the problem of the parade as a specific form of ritual in pragmatic terms would amount to inquiring into the efficacity of these acts and operations. Are they—as some have said—simulations of actual events,[22] simulations carried out by a conjunction of the effects produced by the ritual on the minds of the participants with the effects wrongly imputed to these acts and these operations? Must one not also try to look more deeply into the notion of symbolic efficacy? And also ask whether the specific efficacy of collective manifestations of this type does not depend on whether they simulate effective acts? In what, then, would the activity of simulation consist? Would it be indefinable only in its effects, and in particular would it be definable only in its symbolic efficacy?

As far as the parade in general is concerned, it seems indeed that its prin-

cipal effect stems from the remarkable articulation of two dimensions, spectacle and action. Unlike the classical and modern theatrical representations in which specialized actors perform a narrative in front of a public of spectators and in which, during the entire duration of the representation, each of the active and passive roles turns out to be identically filled in the same place, in the parade, even if it includes an important "spectacular" component, the spectator is always more or less implicated as an actor. In many political demonstrations, and often in military parades and in religious processions as well, the cortege properly speaking, which unfolds its trajectory from one marked place to another, by producing the space that corresponds to it, is contemplated, at certain of its key points, by spectators installed on balconies and at windows of private residences, or even on bleachers especially constructed for the purpose.[23] It is nevertheless impossible to contemplate the cortege as a whole from a single privileged point of view throughout its entire trajectory: "The cortege is an art of time as well as of area; it contradicts simultaneity. . . . It obliges the spectator to choose his observation point and thus to limit his vision."[24] Here we have a negative reason for the implication of spectators as actors in the parade. Spectators cannot "theoretically" dominate its time in its unfolding in space. They can only encounter the episodes one at a time. That is why, in a political parade, spectators are often asked by gestures and shouts to move into the street and join the parade. Some may pick up one of the slogans chanted by the paraders; others may applaud. But still more frequently, to the extent that the spectators are seen in turn by the "actors," they find themselves playing the secondary roles in the demonstration, those of actors whose role and function is precisely to watch the parade go by. Thus an essential element of the political and symbolic efficacy of royal entrances stemmed from the dialogue between two spectacles, the spectacle of itself that the monarchic power offered the city, and the one that the city offered its sovereign. And it is not surprising that, in this alternating exchange, a double coming to awareness was carried out, by a double reflection, that of the power and glory of the monarch in the splendor of his cortege, and that of the unity and harmony of the city in the diversity of its constituent groups.[25] We also note parades that are constituted by continuous assembly, by adding spectators to the march, spectators who thus pass progressively from the immobile position of "onlooker" to the movement of accompaniment, then to the march of participation; the parade thus has a training effect, or an effect of dynamic contagion through which not only

are remote, motionless spectators transformed into actors in motion, participants, but also where the "theoretical"—although partial—cognitive attitude of a "real" situation is transformed into a "practical" attitude expressive of a "symbolic" situation.

Thus we can return here to the idea put forward by Victor Witter Turner in connection with ritual festivals, namely, that parades or corteges (like festivals) transform one or more real and specific social relations into *communitas* (both temporary and symbolic). Parades, corteges, or processions represent this transformation,[26] and by representing it, I should like to add, they carry it out. From this standpoint, two major types of *communitas* could be evoked in a parade or cortege: the agonistic *communitas* that symbolically "acts out" a real antagonism internal to society in the temporary tension of a friendly competition, and the *communitas* of the warlike type in which a parade, a cortege, or even a procession, stages a symbolic "repetition" of the confrontation with the enemy external to society.[27] Examples of the former include parades of "supporters" of a given sports team as a prelude to a game, or processions of neighborhood religious brotherhoods, as in Noto (Sicily), where, on Easter morning, two processions starting from the two halves of the city, one bearing the statue of Jesus and the other that of the Virgin, meet, at the end of a race, on the parvis in front of the cathedral. As examples of the latter, it would be interesting to analyze military parades in national festivals or the opening cavalcades in Renaissance tournaments.[28]

Other Articles and Works Consulted

Bouissac, Paul. "Semiotics and Spectacles: The Circus Institution and Representations." In *A Perfusion of Signs*, ed. Thomas Sebeok, 143–52. Bloomington: Indiana University Press, 1977.

Crocker, J. Christopher. "My Brother the Parrot." In *The Social Use of Metaphor: Essays on the Anthropology of Rhetoric*, ed. J. David Sapir and J. Christopher Crocker, 164–92. Philadelphia: University of Pennsylvania Press, 1977.

Eco, Umberto. *La struttura assente.* Milan: V. Bompiani, 1968.

Fortes, Meyer. "Totem and Taboo." In *Proceedings of the Royal Anthropological Institute of Great Britain and Ireland for 1966*, pp. 5–22. London: Royal Anthropological Institute, 1967.

Gauvin, Claude "La fête-Dieu et le théâtre en Angleterre au XVe siècle." In *Les fêtes de la Renaissance*, ed. Jean Jacquot and Elie Konigson, 3: 439–49. Paris: CNRS, 1975.

Hild, Jean. "Fêtes." In *Dictionnaire de spiritualité ascétique et mystique*, ed. Marcel Villiers, S.J., Ferdinand Cavallera, et al., vol. 5, cols. 221–47. Paris: Beauchesne, 1964.

Leclercq, Henri. "Procession." In *Dictionnaire d'archéologie chrétienne et de liturgie*, ed. Fernand Cabrol and Henri Leclerq, vol. 14, pt. 2, cols. 1895–96. Paris: Le Touzey & Ané, 1948.

Lévi-Strauss, Claude. *The Naked Man*. Trans. John and Doreen Weightman. New York: Harper & Row, 1961.

Roux, Lucette Elyane. "Les fêtes du Saint-Sacrement à Séville en 1594: Essai de définition d'une lecture des formes." In *Les fêtes de la Renaissance*, ed. Jean Jacquot and Elie Konigson, 3: 461–84. Paris: CNRS, 1975.

Scheflen, Albert E., and Norman Ashcraft. *Human Territories: How We Behave in Space-Time*. Englewood Cliffs, N.J.: Prentice-Hall, 1976.

Turner, Victor Witter. *Process, Performance and Pilgrimage: A Study in Comparative Symbology*. New Delhi: Concept, 1979.

Turner, Victor Witter, and Edith Turner. *Image and Pilgrimage in Christian Culture: Anthropological Perspectives*. Oxford: B. Blackwell, 1978.

§ 4 The Concept of Figurability, or the Encounter Between Art History and Psychoanalysis

M.-J. G. (Marie-Jeanne Guedj): *Your work in art history on figurability was mentioned several times in the context of Pierre Fédida's seminar, "Theory of Places." The question is this: while psychoanalysis concerns psychoanalysts, it may not concern them alone. Someone like yourself, even if you're not directly involved—do you have the impression that psychoanalysis, Freudian theory, has changed things?*

L. M. (Louis Marin): Last May in Florence, psychoanalysts and art historians met to explore the theme of figurability, a theme that concerns us all, to the extent that figurability is a concept stemming from the interval or space between art history and psychoanalysis. Pierre Fédida participated in the colloquium; he had also come to my seminar twice to discuss the "theory of places" in psychoanalysis. For my part, I was studying the representation of the self in Montaigne, where the notion of place is essential, in the textual, rhetorical, and logical senses of the term, but also in the sense of *site*, in language, writing, and in images, in the visual realm in the sense of *subject of enunciation* as a potential figure, a figure that art history calls a portrait or self-portrait.

Hence the theme of figurability, the power and work of figurability in psychoanalytic theory and practice, on the one hand, and in art, in the history and theory of art, on the other. In preparation for the colloquium, I had studied Montaigne's narrative of the last moments of his *alter ego*, La Boétie, the friend, the other with whom the representation of the self by itself can be elaborated at will. La Boétie's dying words to his friend Montaigne were an urgent request: "Give me a place, give me a site. . . . " The encounter with psychoanalysts and with Pierre Fédida was impor-

tant to me, as was the encounter with psychoanalysis for someone of my generation.

o. a. (Odile Asselineau): *What sort of figure is Freud, for you?*

l. m.: Let me pick up right away on the term "figure." For someone like myself, positioned on the margins of art history and psychoanalytic theory, the figure of Freud is exemplary, a model. I was rereading his letter to Eduardo Weiss in which he mentions his "seances" in front of Michelangelo's *Moses*, the hours he spent sketching the statue, contemplating it: the very model of a gaze directed toward a work, at once attentive, analytical, objective, and traversed by desires and phantasms, the gaze through which everything begins, I mean all work in art history and art theory.

m.-j. g.: *What is involved here? Is it Freud looking for the relation between the work and the artist in Leonardo's painting, or Freud analyzing the* Moses *without any concern for the creator?*

l. m.: Much more the second case, the one I have just mentioned, or else Freud dealing with Signorelli in *The Psychopathology of Everyday Life*. Freud's work on Signorelli is the basis for a piece I have just published in *Opacité de la peinture*.[1] I remember making pilgrimages, staying at Freud's hotel in Orvieto. But I didn't deal with the Orvieto frescos in my article; I dealt with the ones Signorelli painted at Notre-Dame-de-Lorette.

When I went into that chapel, I thought about Freud, about the name "Signorelli," about the "work" of names, the work of proper names and of language in figures. The Notre-Dame-de-Lorette fresco struck me as being wholly devoted to a breakdown of voices and names, those of the origin, in the signs of written language. On the upper level, in the cupola, there are dancing angels and musicians; then one sees the church fathers and the evangelists, who are all in the process of writing or listening to the voice they are getting ready to transcribe on codices and scrolls. Then, on the lower level, the apostles are grouped in pairs with books, showing each other texts, all engaged in discussion, endless discourse and commentary, as if the further down one goes, the more the voice from above is lost. But there are two scenes, on this level, that break with the falling-away of signs into the semiotic and that show the immediate self-evidence of the "real" in the visual and tactile order. St. Paul's conversion, St. Paul overturned, blinded and seeing; St. Thomas the unbeliever, putting his finger into Christ's wound: a double hysterical conversion of the voice into a blinding vision and the touching of a torn body. Freud's text on Signorelli was an extraordinary stimulus for my work.

M.-J. G.: *In that frame of mind, you found yourself following in Freud's footsteps?*

L. M.: Yes, and I was similarly overwhelmed by the beginning of *Civilization and Its Discontents*, where the evocation of the three Romes gives a quasi-phantasmatic image of memory. I find that evocation again in Stendhal's *Life of Henry Brulard*, and it triggers autobiographical writing: it opens up the place, in the text, that the figure of the Self comes to occupy—the space of the subject's figurability. To finish with the "figure" of Freud, for someone like myself who deals with art history and art theory, let me add that almost twenty-five years ago I was introduced to this realm by Edgar Wind, who had been at Warburg and who was then a professor at Oxford. He had written a fascinating essay on Morelli and on the function of insignificant details that are nevertheless significant in the interpretation of a work of art: Wind wrote about "the characteristic trifles by which an artist gives himself away, as a criminal might be spotted by his fingerprints."[2] And, citing M. J. Friedländer, he added that "personality should be found where personal effort is the weakest . . . our inadvertent little gestures reveal our character far more authentically than any formal posture that we may carefully prepare."[3] Freud, for his part, referred to Morelli in "The Moses of Michelangelo": might the history and theory of art be grasped in a problematics of the trace, the index, or even the symptom?

A personal anecdote, in passing. I wrote my first art history text on Alberti's medallion: it is a magnificent object, an eye seen in profile with mysterious flames and the legend *Quid tum*, "What then." I was trying to show that that "what then" was a sort of "phatic" expression with a multiplicity of meanings. I alluded to *The Interpretation of Dreams* and to the quotation from Goethe's *Faust*:

> . . . a thousand threads one treadle throws,
> Where fly the shuttles hither and thither,
> Unseen the threads are knit together,
> And an infinite combination grows.[4]

The "What then," at every turn between the image and the eye and the text, has a new meaning; at every turn in this back-and-forth interpretive itinerary, *Quid tum* acquires a different meaning, apocalyptic, anagogic, and so on.

Edgar Wind responded that he had found my article very interesting, while adding, in substance, that he was quite familiar with psychoanalyt-

ical interpretations of works of art, but that, under the circumstances, if *Quid tum* had so many different meanings in my essay, it was because *the* text from the period that gave *the meaning* of the formula and thus of the work had not yet been found. Finding *the* text is the ideal of iconography. But perhaps there was no text at all; perhaps Alberti had manufactured his medallion with its legend to make meaning go astray, like the "thought factory" that Freud evokes in connection with the masterpiece of Goethe's weaver—that is, a dream.

M.-J. G.: *That's amusing, when one considers that psychoanalysis hinges in sum on the quest for the lost object, the famous text that is in any case inaccessible.*

L. M.: An amusing and interesting response in terms of what we are talking about. Wind used to say that my work was very good, but also that at its center there was a lack, a missing text.

M.-J. G.: *Certain psychoanalysts have tried to say this themselves; it has been very fashionable to work around the work of art by means of psychoanalytic interpretations—"he did x, which in fact means y."*

L. M.: Yes, what I would call the art critic talking like a psychoanalyst. That sort of approach doesn't interest me very much. People apply models to the object, but they don't go often enough to look at the *Moses* at S. Pietro in Vincoli, and they don't stay long enough; they don't give themselves over enough to the gaze of the work. Even with someone like Erwin Panofsky, whom I admire a great deal, one notices that there are moments when he is no longer looking; and yet discoveries come from what I've just called an attentive gaze inhabited by desire.

O. A.: *That's what used to be called astonishment in the face of the work of art.*

L. M.: Simultaneously astonishment and freedom, distance, play with the work. It's not a question of being fascinated by a work, but of having a free gaze—free, but not wandering. Perhaps that has something to do with floating attention in psychoanalysis, perhaps it is quite different when a work of art is at stake. But there is always a way of being called to attention, hooked, arrested by the work. Roger de Piles notes this: when you go through a gallery of paintings, you're strolling along, and then at some point a painting stops you. Here is an authentic psychoanalytic question that Freud articulates: What is it that does the stopping? What is the exchange in which all of a sudden the painting looks at me? It is not even a case of being spoken to, but of being looked at. That is why I am

much more impressed by the studies in which Freud plunges deeply, in some way, into an individual work.

M.-J. G.: *Much more his* Moses *than Leonardo.*

L. M.: Right; but there remains the vulture, or rather the kite, in Leonardo's painting. There, it seems to me, is a major axis for research in art history and theory that encounters psychoanalysis: these latent figures hidden by the great works as their secret truth; a latent figure, a sort of figurable latency, the figurable aspect of a painting, a tension in the figure of the work in which something decisive may eventually play itself out on the side of the creator. But what counts is first of all the individual work of art, that singular individual. As there can be a science of the individual, the task of research will be situated on the side of the trace, the symptom, the index. If you assign to art history the goal of being a theory of the aesthetic individual, then the science of art that that history and that theory would be can only be based on indices, traces, symptoms. This is the realm of a semiology of art.

M.-J. G.: *Freud's contribution has much more to do, for you, with his way of looking at Moses, the way Moses holds the Tablets of the Law—what is he going to do? where is he going to go?—than the analysis of the childhood memory.*

L. M.: That's quite right. Especially because if this science of art is based on what Ginzburg calls the indicial or indexical paradigm—the trace, the symptom, the index in Peirce's sense, the mark left by the passage of a force—if this science of art is based on the index, it leads us to grasp and analyze the processes and devices in the work, to do formal analysis, if you like, but while stressing that the forms of the work are a singular way of linking forces, and at the same time that in such an analysis of forms, one always runs the risk of being displaced by those forces. In what a science of art as a science of indices and traces would seek, there are always the inconsistencies or gaps in the work, the moment when the work shifts, when it is incomplete.

M.-J. G.: *You're alluding to what has been called the passage from inspirational force to the work of form.*

L. M.: I was thinking much more about the primary and secondary processes, bound or unbound forces from the Freudian perspective.

M.-J. G.: *There's the example of Maupassant and his famous psychotic episode, which he is said to have written down very rapidly, the loss of the image in the mirror, and then, secondarily, the short story he based on it,* Le

Horla, *about fifty pages with a whole process of rewriting around that loss of image in the mirror.*

L. M.: That's it exactly. I have an example that may parallel Leonardo's vulture. Poussin painted an extraordinary picture toward the end of the 1640s, one we know today as the *Landscape with a Man Killed by a Snake.* The question iconography raises has to do with the story the painting represents. It is not a "story painting" with a mythical narrative, a reference text. Fénelon himself, in his *Dialogues des morts*, has Poussin say to da Vinci that his painting has no "subject"; that it is a "caprice," and that it simply represents the effects of fear: he gives it a pathetic interpretation, based on the "affects." When one looks at the painting, it is quite certain that something is happening in the shadows, in the foreground at left, with the monstrous snake that is strangling a man, in the context of a harmonious, peaceful landscape. Nicholas Blunt has shown that during Poussin's trip to Naples, he had come across a city invaded by snakes and deserted by its inhabitants: an anecdotal interpretation. Snakes appear often in Poussin, and they are always very disturbing. The snake is the monster, the manifest, explicit figure of the "monstrous." I've looked in Poussin's letters, in biographical documents; I haven't found anything about snakes. Should one do a psychoanalysis of Poussin in which the snake would be his vulture? The snake is not a latent figure.

M.-J. G.: *Well, no, it's obvious!*

L. M.: But it's the product of a figural latency in the painting itself, in the lower left corner of the painting in the foreground, which in Poussin's work is often the place of shadow, the place where earth and water mix, the place of anfractuosity, of the abyss—the place of the unbearable, precisely a place of latencies, of figural powers.

M.-J. G.: *What's interesting is that your first move is to go looking in the direction of Poussin the man, in his letters, and when that fails, you move on to the work itself.*

O. A.: *To assure yourself that you are supplied with all the material available.*

L. M.: Poussin's letters seem on the surface not to be very informative, and when one pays attention to them, they have something to say, less about the man than about the painter, and that is what is important. The text tells me, and the work shows me; a work of painting shows and even if it holds back, even if it does not have everything on the surface, it shows, and it shows that it is holding back. So this is the direction in which analy-

sis is fundamental. To put it in different terms, the operations of dreams are actually visual operations; in the work of painting, not only do these visual operations exist, but the work shows them: displacement, overdetermination, the work of figurability. I'm not talking here about a model I apply. The work itself reflects these questions; it exhibits them and is affected by them. This is what I call the work's opacity or reflectivity: it can represent something, it can be transparent and at the same time show that it is representing. The object of a science and of a theory of art is this very complex articulation between transparency and opacity, between "putting (in)to (a) work" and the ways of showing this putting to work.

M.-J. G.: *It is the person who looks who is important; one no longer speaks of the one who created, the one who looks at and analyzes condensation, displacement . . . as a psychoanalyst . . . or as an analysand with respect to his own dream?*

L. M.: Less as an analyst than as an analysand. That is why, in my methodical practice, psychoanalysis always works obliquely, from the side. I never use it head on; it isn't a code.

M.-J. G.: *Right. Is there reason to fear that psychoanalysis applied to art will become a dead discourse, owing to a sort of vulgarization of the discourse that is being produced?*

L. M.: That is the point at which psychoanalysis becomes a code by virtue of its direct and massive application to the work. Let me take another example, that of the Filippo Lippi fresco at Prato. The first time I saw it, I had a shock: the corner of a wall. On the wall on one side, the executioner has just beheaded St. John the Baptist, and on the other side, the executioner's forearm is holding the head above the platter Salome is holding out to him. By this double cut, in the architectural infrastructure and in the story, the head is cut off twice, all the more so in that the executioner himself has a cut on his arm. It is not primarily a matter of speaking of incorporation, introjection, and castration: it is a technical problem in which I am comparing that fresco with the one depicting St. Stephen, where, on one of the walls, executioners are throwing stones, with St. Stephen on the other wall receiving them; the stones are crossing the spectator's space. In Lippi's fresco, that inconsistency, that cut, that syncope of the support and of the story leads me to a question that is no doubt the question of castration, of incorporation and introjection, but one that I am raising only on the basis of the "work" of the corner of the wall on the figures. The question is reinforced by the presence of a major figure in the foreground, the guardian of

the enigma of cutting, who is looking at the spectator: he is not the execu-
tioner, he is the guardian of the enigma.

Here is a moment of very strong overdetermination, of condensation
and displacement, that is exhibited to me as if the fresco were saying:
"Look hard and try to understand"; it is a syncope both in the narrative
and in the figure, one that affects the utterance as much as the content.

M.-J. G.: *This brings us back to the contemporary preoccupations of psycho-
analysis in which it isn't so much a question of narrative, of content, but rather
of suspense, void, scansion.*

L. M.: From that point of view, the visual arts constitute an important
body of methodological and theoretical material for approaching the prob-
lems indexed by terms like suspense, gap, syncope, pulse. . . .

O. A.: *Would there be a difference for you depending on whether this ap-
proach is applied to pictorial or literary material?*

L. M.: In literary texts too, except that there it will be played out differ-
ently, between the sentence level, where syntactic organization prevails,
and a lower level stemming from the gaps, silences, and suspension points,
in other words, from the prosodic dimension, from written intonation,
and there we are in the infratext.

Let me take an example. At the beginning of *The Life of Henry Brulard,*
the protagonist is contemplating Rome from the top of San Pietro in
Montorio; Stendhal writes:

> C'est donc ici que la *Transfiguration* de Raphaël a été admirée pendant deux
> siècles et demi. Quelle différence avec la triste galerie de marbre gris où elle est
> enterrée aujourd'hui au fond du Vatican! Ainsi pendant deux cent cinquante
> ans ce chef-d'oeuvre a été ici, deux cent cinquante ans! . . . Ah! dans trois mois,
> j'aurai cinquante ans, est-il bien possible! 1783, 93, 1803, je suis tout le compte
> sur mes doigts . . . et 1833 cinquante.

> [It is here then that Raphael's "Transfiguration" was admired for two and a
> half centuries. How different from the miserable grey marble gallery where it
> is interred today in the depths of the Vatican! So, for two hundred and fifty
> years that masterpiece has been here: two hundred and fifty years! In three
> months I shall be fifty; is that really possible? 1783, 93, 1803; I'm counting it
> out on my fingers. And 1833: fifty.][5]

The entire text plays on the sounds "i" and "oi," on the repetitions 250, 50,
with the gap signaled by the "Ah!" All this prosody is played out *on* the
painting by Raphael, the *Transfiguration,* which exposes a magnificent vi-

sual syncope, the one that separates the upper portion from the lower portion. This has posed problems for art historians, moreover. It separates the possessed, disfigured son below from the transfigured son above. That's why I have been very interested in Stendhal. Gérard Genette used to say that it was not necessary to psychoanalyze Stendhal, that he had done it himself by saying that he would have liked to sleep with his mother, that he hated his father . . . and yet the psychoanalysis of his text remains to be undertaken. It is on the side of the syncopes, the interruptions, the gaps, the "white spaces," and finally on the side of the figure of the subject of the enunciation, who always remains there in a state of figurability, of tension.

M.-J. G.: *Did art criticism exist before Freud? Did his work introduce a break in this area?*

L. M. Psychoanalysis introduces a break between two types of criticism. It is itself positioned in that break: the critique of the past, which is descriptive, and the "impressionist" critique that is not really a critique of affects, but that can implicitly be a critique from which one extracts impressions and affects.

Here is an example. When Diderot describes *The Village Bride*, he sprinkles his text with risqué implications, all the more so in that he is writing for people who will not see the painting and for whom he has to supply a literary equivalent. Aroused to a state of suspicion by the "bawdiness" of the text, it is not the Diderot-Greuze relation that I am going to interrogate from an analytic viewpoint, it is Diderot's text, and as a consequence, Greuze's painting. If Daniel Arasse has been able to show that the places of bawdiness are located not at all where Diderot pointed them out, but rather in one or another of the red and black folds of the betrothed's dress, it is because he has read Freud, because that reading induces a way of suspecting the text, especially texts with "erotic" jokes.[6]

So I would distinguish the discourse of art criticism, direct discourse expressing immediate reactions and moods, from the discourse of art history, which is both semiotic—because it aims at cognitive meaning, knowledge of the work—and sensitive and sensual—because it interrogates the work productive of sensations and affects, the work as a machine for producing affects. It is not a matter of setting aside the problems of cognition, but one of the major tasks of a much vaster history or science of art than any theory of reception, patronage, or cognition is this bringing to light of affects, the pathetic and aesthetic dimensions of a work.

M.-J. G.: *What do you think of [Meyer] Schapiro's critique of Freud, where*

he shows that Freud had turned his back excessively on art history, on histori-cal and social conceptions in his Leonardo da Vinci and a Memory of His Childhood, *by neglecting, for example, the fact that the arrival of St. Anne in the painting* Madonna and Child with St. Anne *corresponded to a preoccu-pation of the period, that great moment in representations of St. Anne?*[7]

L. M.: But Freud wasn't an art historian, he says so himself. Neverthe-less, Daniel Arasse's detailed studies show that Schapiro got caught in the mousetrap.[8] In the Mérode altarpiece, it isn't where he sees it. Which could be a quote from Lacan. What is on the table is a plane, and what St. Joseph is in the process of building is a warming device. Schapiro was mis-led by the title *Master with a Mousetrap*, by the latent image of the "rela-tions" between Joseph and the Virgin. That is superb. . . .

M.-J. G.: *As a displacement.*

L. M.: Exactly. There is also such a thing as a theoretical lapsus. Displace-ment: the notion seems essential to me for a history and theory of art.

A few weeks ago, we organized a colloquium at Beaubourg called "Be-tween the Images," with, as subtitle, "Passage, Dissonance, Edge," that is, all the processes that stem from displacement.

On that occasion I introduced the problematic of edges, limits, fron-tiers, borders, to be conceived and put to work as operators of latency and of the power of the figurable we've been talking about, those theoretical places of encounter between psychoanalysis and art history.

At the same colloquium, Pierre Fédida spoke of white, the white of the page between two words, but also the color of light, the brightness of the image: the French work *blanc* means both "blank" and "white" in English. Their relation is no doubt that of the textual, the vocal, and the visual. We are in the dissonances, on the passages and the edges; we are also perhaps truly in psychoanalysis. . . .

§ 5 Mimesis and Description: From Curiosity to Method, from the Age of Montaigne to the Age of Descartes

In 1643, twelve copies of a short work entitled *Considérations politiques sur les coups d'état* were published anonymously in Rome.[1] Its author, hidden behind the initials G. N. P., was Gabriel Naudé, Parisien. Naudé was born with the century, in February 1600; by 1631, he was a doctor, with diplomas from Paris and Padua, and he was serving as secretary-librarian to the former papal nuncio in Paris, Cardinal Bagni, thanks to the intervention of Nicolas Claude Fabri de Peiresc and the Dupuis brothers. In a sense, Naudé's *Political Considerations* represents the pinnacle of his production, its halfway point. He had begun to write the text early in his stint in Italy; in 1641, after a brief stay with Antonio Barberini, he was back in Paris, called or recalled by Richelieu, who, disappearing in his turn, bequeathed him to Mazarin. Over a period of nearly ten years, Naudé worked for Mazarin to set up the famous library that today bears the Cardinal Minister's name: countless precious manuscripts, 40,000 volumes destined to be dispersed by the wrath of the Fronde in 1652.[2]

Along with Naudé, I have mentioned Peiresc and the Dupuis brothers, and to these names I should add Gui Patin, J. J. Bouchard, La Mothe Le Vayer, and others in France; I should also mention, in Rome, Cassiano dal Pozzo, Nicolas Poussin, Traiano Boccalini, Agostino Mascardi, Virgilio Malvezzi, Giovanni Ciampoli, Giulio Rospigliosi, and others.[3] I should like to evoke the whole milieu of curious, learned, erudite libertines whose works, correspondence, stories and memorable sayings constitute the material of the colloquium, at least in part. Naudé strikes me as a good ambassador to introduce this milieu and to justify my subject: I propose in fact to begin with his *Political Considerations upon Refin'd Politicks*, in or-

der to pose the immense philosophical problem of mimesis and description between the end of the sixteenth and the first half of the seventeenth century, between Montaigne and Descartes. In Rome among the intellectuals of the Barberini clan between 1631 and 1641, Gabriel Naudé, Parisian—as Leonis Allatii hails him in his 1633 *Apes urbanae*[4]—serves in a way as the milestone marking the passage from curiosity to method. For it was precisely between 1633 and 1637 that Descartes abandoned his plan to publish a treatise called *The World* and instead developed his *Discourse on the Method of Rightly Conducting One's Reason and Seeking the Truth in the Sciences* (which appeared in 1637, followed by the *Méditations* in 1641 and 1642). In the 1639 *Political Considerations* of our Parisian in Rome, we may detect the tone of a French cavalier who has set off at a good clip in search of the truth, yet the text is dominated by a reference to Montaigne and his writing:

> For I have addressed myself to the Muses, without being too much enamour'd of them; I was pleas'd with my Studies, but not too much addicted to them; I pass'd through a Course of Scholastick Philosophy without medling with the contentious part of it, and thorough [*sic*] that of the Ancients and Moderns, without being partial to any Sect; I made more use of *Seneca* than *Aristotle*, of *Plutarch* than *Plato*, of *Juvenal* and *Horace*, than *Homer* and *Virgil*, and of *Montagn* [*sic*] and *Charon*, more than all the before-mention'd. I have not had so much practice of the World, as effectually to discover the Cheats and Villanies that are committed in it, but I have nevertheless seen a great part of them, in Histories, Satyrs and Tragedies. Pedantry might have gained something upon my Behaviour and Carriage, during seven or eight Years that I staid in the Colleges, but I can assure my self, that it obtained no advantage over my Spirit; Nature, God be prais'd, has been no Stepmother to me, and the reading of divers Authors has given me great Assistance.[5]

Throughout this striking autobiographical passage, we can hear Descartes's philosophical voluntarism with respect to knowledge, but Montaigne's skeptical distance with respect to culture is also pronounced. We recognize the reference to good Nature, the base and foundation of the mind, but also the reference to the good ancient and modern authors, the critique of scolasticism and of Aristotle, and the necessary knowledge of the world—not the world of Galileo and Descartes written in mathematical language, however, but the world that learned men encounter in histories, satires, and tragedies. Gabriel Naudé and his *Political Considerations upon Refin'd Politicks* are located between Montaigne and Descartes;

the man and the work exemplify the passage from curiosity to method. But this passage is situated—and here is what strikes me as fascinating for our research on documentary culture—in the field of political theory and practice; the Prince's coup d'état is the essence of the theory, while the Prince's council is at the heart of its practice.

The theory of the political, understood as a *description* of the principles and mechanisms of political action, can be approached by powerful minds like his own, Naudé thinks, through *mimeticism* and *simulation.* Cardinal Bagni's secretary will never penetrate into the cabinets of the powerful to "see" a coup d'état being prepared. But, like an actor, he can *play* at penetrating, he can *mime* the reflections of the Prince, he can feign political behaviors in order to understand them: his mimetics is a pretense of the imagination, a thought experiment, the methodical proposing of a fiction-theory in which representation would open up the space of an impossible theory.[6] We shall find this new investment of mimesis again in Descartes, not brought to bear on politics, to be sure, but introduced in order to found the sciences of the world and of man.

Moreover, Naudé the librarian, the scholar, believes that the science of coups d'état and state secrets can be achieved, and even justified and legitimized, through the collection and compilation of documents and the work of citation. In our day, he writes in substance, written or printed documents *trace* state secrets: rather than revealing secrets, they insinuate them. The function of the printed text, the political tract, is precisely to show the secret as hidden. Is not collating these texts, reading them with a critical eye, one of the tasks of a librarian who is also the Prince's counselor? The librarian confronts contemporary texts with accounts, narratives, and memoirs from the past; from this documentary jumble gradually emerge, if not the maxims and principles that are at the root of high politics, at least the mind-sets, the intellectual presuppositions, the ethical injunctions that put the theoretician-Counsellor in a position to conceptualize and formulate those underlying principles.[7]

Because the librarian-collector, in the privacy of the library, through his readings, has positioned himself in this way, he is able to turn imitation of the powerful into a methodical principle of knowledge. In the privacy of the library, through the collection and collation of documents, the work of citation and example, the erudite thinker constructs images of diverse political behaviors, models for state secrets, by playing out the various movements of political actions. Through documentary collection and the

work of citation—in the style of Montaigne—he opens up the possibility of a method for the proper guidance of one's reason in politics and for seeking the practical truth of effective action.

The collation and collection of documents and the work of citation is stressed by the editor of the second edition of the book in 1667, but in the name of an archaism in the writing style that makes the book a curiosity. Inserting the French translation of the Greek, Latin, and Italian quotations on each page is truly to "publish" the book.[8] As early as 1639, Naudé himself notes the documentary feature of citation, but as a politico-editorial strategy: "This Book was not composed to please all the World; if the Author had had that Design, he would not have wrote [*sic*] in the style of *Montagne* and *Charon*, whom he knows to be disagreeable to several Persons, by reason of their great number of Latin Quotations. . . . " And, evoking the twelve copies of the edition, he adds: "I know very well, that this Number is too small to let the Book be perused by as many Persons as *Balzac's Prince*, and *Silhon's Minister*. But as the Things it treats of are so much more important, so it is likewise necessary they should be the less common."[9] The quotation as document and the document as quotation work together to dissimulate politics as much as to reveal it, and the documentary collation aims to turn the method of political science into a mystery of politics and of the science of coups d'état, a very special curiosity.

All this was developing at the very moment when, between Leyden and Paris, René Descartes was explaining his intentions to the readers of his *Discourse on the Method*:

> My present aim, then, is not to teach the method which everyone must follow in order to direct his reason correctly, but only to reveal how I have tried to direct my own. . . . But I am presenting this work only as a history or, if you prefer, a fable in which, among certain examples worthy of imitation, you will perhaps also find many others that it would be right not to follow; and so I hope it will be useful for some without being harmful to any. . . . I shall be glad . . . to reveal in this discourse what paths I have followed, and to represent my life as if in a picture, so that everyone may judge it for himself; and thus, learning from public response the opinions held of it, I shall add a new means of self-instruction to those I am accustomed to using.[10]

Naudé's text and Descartes's, which are contemporaneous, are at once alike and unlike. In both, one sees the same determination to particularize statements, to rescue publication from publicity, to reject any proselytism in the

order of knowledge as well as in the order of method. But Naudé's colla-
tion of quotations after the manner of Montaigne, a practice that conceals
and reveals the secrets of an admirable science, has become in Descartes's
text a description of a life in the form of a painting, a faithful representa-
tion of a story in the form of a fable, a collection of examples whose imita-
tion is left to the readers' pleasure.

How then do mimesis and description—the two key notions of culture
in general, of the science of art and literature—work, between 1580–1595,
when Montaigne's *Essays* were drafted, and 1664–1667, when Descartes's
treatises on *L'homme* and *Le monde* were published (posthumously), so as
to manifest the historical passage toward new ideas and new procedures
for thinking about and acquiring knowledge of the past, the world, and
humankind, a passage for which Gabriel Naudé, the man and the work, a
Parisian in the Barberini milieu in Rome, has struck us as exemplary? The
subject is immense, and it cannot be treated with rigor and precision in its
full amplitude, all the less so because, in terms of its references, it is some-
what external to the geographical field of the colloquium centered on Flo-
rence and Rome. Thus the philosophic background that I seek to sketch
in will only be a theoretical decor for the work of our meeting. In order to
avoid vague surveys and hasty generalizations, I propose to examine some
specific objects of analysis chosen on the basis of Naudé and his work con-
sidered *in limine* as the historical and theoretical paradigm of our project.

~

The first of these objects, constructed with Naudé as our starting point,
is the practice of citation in Montaigne, its singular functions in the *Essays*
in the 1580s, and its role in the emergence of the modern subject. Why ci-
tation? Because citation is in a way the pinnacle of textual mimeticism, in
which representation is reduced to the simple presentation of an excerpt,
a fragment or part of an original text, in a receptor text that exposes it and
provides a framework for representing it to the reader's gaze. Excerpted,
extracted from one textual body, the quoted passage is transported into
another.[11] Whatever values may be borne by this cutting, transfer, and dis-
play, from one textual place to another, from one space of culture and lan-
guage to another, it seems to me that citation repeats in the order of the
text the function of the documentary object in its own domain. The doc-
umentary object, too, is extracted—owing to the necessities, destinies, or
contingencies of history, culture, knowledge, and the arts, or even of com-

mercial exchanges—from the whole of which it had been an integral part; it is imported into a collection that may be viewed as "spatialized" discourse, localized or visualized in a trajectory that offers it to the curious gaze.[12] The syntaxes of this "discourse" of collection still need to be reconstructed today: do they merely obey the rules of simple juxtaposition, of which a list of items, a numerically ordered catalogue, would be the most immediate transcription? And contemporary theoreticians consider, no doubt rightly, that a list of names accompanied by qualifying terms is the theoretical paradigm of description.[13] Or, much more profoundly, do these syntaxes of collection observe the logical and topical constraints of classificatory grids that use the arrangements and mechanisms of overarching inclusions and embeddings for which we could find models in Agricola or Ramus, with the tabulation of commonplaces?[14] Quotations and documentary objects, collections of quotations and collections of documents appear to function according to the same processes and to play on the same arrangements on the side of words and on the side of things, no matter what values, once again, are historically and ideologically invested in the various operations that characterize each type of collection during that restless, unstable, and complex period of the late sixteenth century and the first half of the seventeenth in Europe. Quoted texts and documentary objects: the pinnacle of mimesis, of the logic that subtends it, and of the topical economy that articulates it, I have claimed. But what does this mean?

In literature, direct citation in the most immediate sense of the term is the goal of every representative function of language: it is at once its result as representation and its accomplishment as presentation. In this case it is just as if a speaker in a court of law were to interrupt his discourse and produce before the court a piece of evidence, a document, an instrument of proof or evidence, a *production* or *presentation* that legal language moreover will call a "re-presentation," not in the sense in which the instrument of proof or evidence would be presented anew or instead of and in the place of an object or an absent text, but in the sense in which its presentation is justified, legitimized, founded in law and intended to lend authority and legal status to the discourse in which it appears.[15] The citational object is an *end* in the two senses of the term, abolition and accomplishment, of textual-scriptural mimesis; the documentary object is an end of iconic visual mimesis. In this end or culmination, the two dimensions of representation are marked with full clarity: the text cited, like the documentary ob-

ject, is indeed a product, a place-holder, the delegate for something else, which it represents and signifies. It renders present once again a past whole, a transcendence, a hidden world, just as the documentary object presents itself "in flesh and blood," if we may say so, in its own reality, and thereby brings proof, imports authority, constitutes evidence of reality, of truth, of law. Moreover, both quotations and documentary objects work this way only when they are used in representation, when they are exposed to reading in another textual whole along with other quotations, or exhibited to the gaze along with other objects in the particular space of the collection, and in that presentation, exhibition, ostentation—whether this is of the verbal, "literary" order or of the visual "iconic" order—an ownership is constituted, an identification is carried out, a juridical identity is constructed, for the text cited or for the documentary object, for the citing subject or for the curious, antiquarian, or collecting subject.

Montaigne's *Essays* are not, of course, a mere collation of quotations from Greek, Latin, or Italian sources, but they do make extensive use of quotations, although without labeling them as such.[16] This practice of introducing into the text, into its writing, a foreign object, different in space and time, and put in perspective, Montaigne calls *emprunt* (borrowing), which he holds at equal distance from *allégation* and *citation*, which both stem from the language of jurisprudence. What is alleged is a proof, an argument, a document, an object that a subject produces and displays. Allegation refers to *auctoritas*, which provides a theoretical foundation for that exteriority in relation to the subject making the allegation. A quotation from Aristotle or a Church Father is valid as proof only inasmuch as it was written by Aristotle or Gregory, an authority. Juridical citation is, as we know, the act of law through which a subject receives a summons to the court and is called to appear, a relation between two subjects, the one who cites, the other who is cited. When allegation sets texts to work among themselves, it is a gloss, a scholia or an apostil: in the margin or between the lines, it traces a movement of the text outside itself. To what is outside the text, when the text alleges it, the text delegates its powers. Citation, once juridical and now textual, moves in the opposite direction. It calls up, convokes, summons what is outside the text into the text in order to incorporate it, to absorb it. One alleges reasons; an allegation cites a law as an authority; with citation, it seems as though the writer, the citing subject, is calling into himself the writer cited or the passage that he is excerpting from the writer's work.[17]

It is easy to see what this movement owes to the new form of printing.[18] As a repeated utterance, a quotation is like an available character that has only to be summoned up. To write is to select the quotation from the appropriate box and include it in one's own text. Allegation and citation are thus the two competing poles of the strategy of re-production in the sixteenth century. The first stems from the medieval ethic of discourse and commentary, the second from the Renaissance and the new modes of re-production of writing.[19] A citation is a repetition in which a subject of enunciation is involved and in which he identifies himself in that involvement. An allegation is the argument of a different repetition that is not the operation of a subject that may be posited in the operation itself, but rather the immobile movement of tradition in which the law of *auctoritas* is embodied.

> And when I undertake to speak indiscriminately of everything that comes to my fancy without using any but my own natural resources, if I happen, as I often do, to come across in the good authors those same subjects I have attempted to treat—as in Plutarch I have just [done] this very moment . . . seeing myself so weak and puny, so heavy and sluggish, in comparison with those men, I hold myself in pity and disdain.
>
> Still I am pleased at this, that my opinions have the honor of often coinciding with theirs. . . . Also that I have this, which not everyone has, that I know the vast difference between them and me. And nonetheless I let my thoughts run on, weak and lowly as they are, as I have produced them, without plastering and sewing up the flaws that this comparison has revealed to me.[20]

Montaigne's text, with its borrowings, plays between allegation and citation. His writing is often both. By borrowing, he challenges authority and tradition in the repetition of the already said.

> I go about cadging from books here and there the sayings that please me, not to keep them, for I have no storehouses, but to transport them into this one, in which, to tell the truth, they are no more mine than in their original place. We are, I believe, learned only with present knowledge, not with past, any more than with future.
>
> But what is worse, their students and their little ones are not nourished and fed with their learning either; it passes from hand to hand for the sole purpose of making a show of it, talking to others and telling stories about it; like chits that have no other value and use than to be counted and thrown away. . . .
>
> We labor only to fill our memory, and leave the understanding and the con-

science empty. Just as birds sometimes go in quest of grain . . . to give a beakful to their little ones, so our pedants go pillaging knowledge in books and lodge it only on the end of their lips, in order merely to disgorge it and scatter it to the winds.[21]

But Montaigne does not hesitate to conclude this denunciation of citation as allegation with two Latin quotations, from Cicero and Seneca: "Apud alios loqui didicerunt, non ipsi secum"; "Non est loquendum, sed gubernandum" (*They have learned to speak among others, not with themselves* [Cicero]; *Not talking, but steering, is needed* [Seneca]).[22]

In fact, in the *Essays*, citation functions in all senses; at this moment of transition between two systems of regulation, medieval and classical, no meaning is ruled out. Borrowings are most often Latin sentences inserted without transition and without identification of the author: a reading note, an encounter with a text, but one that is the trace left by Montaigne's reading of his own text. Like the example of grammar or dialectics in Ramus, the borrowing brings back the usage, puts the experience of the Ancients alongside the text, neither to confirm it nor to persuade the reader, but through pure empiricism. The name of the author cited is not specified. The name brings to the citation neither prestige nor power. There is a simple coincidence between the two texts. The reason for the citation is neither necessary nor intrinsic. Its *ratio* belongs to an individual; it is the engagement of a subject, Montaigne, who identifies himself as "I" in this encounter. "I much more readily twist [distort, modify] a good saying to sew it on me than I twist the thread of my thought to go and fetch it," a fine remark that concludes two Latin citations of Quintilian and Seneca: "There are some men . . . *who do not fit words to things, but seek irrelevant things which their words may fit* [Quintilian]. *There are some who are led by the charm of some attractive word to write something they had not intended* [Seneca]."[23]

It is a matter of "sewing onto myself" the citation—myself, the subject of enunciation; but this self, through such stitching, will take on a density or reality that is less that of a being than that of a body of writing. A subject thus presents itself through such foreign representations, even while taking on with respect to them an uneasy distance through which the identification between self and book is endlessly called back into question:

> . . . live like Socrates. There lies the extreme degree of perfection and difficulty; art cannot reach it.

Now our faculties are not so trained. We neither essay them nor know them. We invest ourselves with those of others, and let our own lie idle.

Even so someone might say of me that I have here [in my book] only made a bunch of other people's flowers, having furnished nothing of my own but the thread to tie them. Indeed I have yielded to public opinion in carrying these borrowed ornaments about on me. But I do not intend that they should cover and hide me; that is the opposite of my design. I who wish to make a show only of what is my own, and of what is naturally my own. . . . [24]

The citation works the identification between self and book, and in this work the subject of the modern age emerges.

I have not had regular dealings with any solid book, except Plutarch and Seneca, from whom I draw like the Danaïds, incessantly filling up and pouring out. Some of this sticks to this paper; to myself, little or nothing.[25]

Montaigne wants his readers to identify him with his book, but at the same time he denies that the citations in the *Essays* implicate him, that they manifest an intrinsic relation between himself as subject of the enunciation and the foreign "system" that he presents in incorporating it into his text. Montaigne's "borrowings" do not represent the subject emblematically, or even iconically, but only in the ornaments of his book; *and yet* the subject is conquered only in this gesture of incorporation into the book in which it is constituted.[26] Here we note the tension internal to citational mimetics, the polemical polarization between presentation and representation in the text of self, between judgment or consciousness and writing or enunciation, between faculty and expression, the tension that is the space of the modern subject.

We find in Ramus the same distortion with regard to natural dialectics: dialectics, or the power of discourse, has its source and its origin in nature, which means that there is in every man an innate dialectics, which Ramus, like Plato, calls aptitude, reason, mind, image of God. The art of dialectics has to be developed by *imitation* and study of natural dialectics. But that *imitation* is nothing other than *the reproduction of the classical models*, and yet the art of discourse is for Ramus the simple reproduction of the "natural" habits of discourse.[27] Nevertheless, in Montaigne, judgment no longer designates, as it does for the logician, the second part of dialectics through disposition after invention. Judgment is the work of appropriation of the readings by and for the *ratio* in view of the elaboration of individual knowledge. The Cartesian subject in its *cogito* is virtually

sketched out here. Through judgment, every idea becomes a persona; repetition is pure chance, mere contingency, an encounter between two subjects, and citation by the same token ceases to have, as it does for Ramus, the specific value of an apprenticeship in natural dialectics.

But at this point, why cite, if it has no meaning? Why these "overweights, which do not condemn the original form?"[28] Citation compulsion, repetition compulsion. It is as though these apostils were the vestiges of a history, a biography, and a bibliography, something like the elements of a figurability of the subject in its proper place, Montaigne, in the logical, dialectical, geographical, and toponymic senses of the term.

Let us recall the Latin inscription Montaigne had painted outside the entrance to his library on his thirty-eighth birthday, the evening before March 1, 1571, when he retired from public life:

> In the year of Christ 1571, at the age of thirty-eight, on the last day of February, his birthday, Michel de Montaigne, long weary of the servitude of the court and of public employments, while still entire, retired to the bosom of the learned virgins, where in calm and freedom from all cares he will spend what little remains of his life. . . . If the fates permit, he will complete this abode, this sweet ancestral retreat; and he has consecrated it to his freedom, tranquillity, and leisure. Deprived of the sweetest, dearest, most intimate friend, than whom no one better, more learned, more agreeable and more perfect has been seen in this century, Michel de Montaigne wishing to consecrate the memory of this mutual love by a unique testimony of his gratitude and being unable to do so in a way that would express it better, has devoted to that memory this studious contrivance in which he delights.[29]

Of this text, I shall focus only on the second part, the one that concerns the death of the very dear friend Etienne de La Boétie, the *alter ego*. That death is a circumscription of the other self, or rather a cutout—after the fashion of an augural *templum*—of the place of the self and of the singular identification of self in this place, since the sweet paternal retreats consecrated to the self—and, in their center, the privileged place of documentary culture, the library, the studious apparatus—are devoted to the memory of the friend who died in August 1563, Etienne de La Boétie. The privacy of the *recessio*, which is also a desire for a self-portrait, is at once the personal sphere of *otium* (as opposed to the *negotium* of Bordeaux) and the privation of the other, dead self. A topic here is indicated not only in space and in time: the place is also made up of the limit constituted by the death of the other, La Boétie, and with that limit appears a line traced in the

time of the self, before La Boétie's death and after. The place of "self," "my" proper place, is the inoccupable, the inappropriable place of the other, the place of alterity and death that the inscription painted on the threshold of the library in 1571 on the anniversary date of "my" birth had solemnly announced, by consecrating books, reading, and writing to the death of the friend who has henceforth become the *votum* of the books of the *Essays* (that is, of the representation of the self), to the death or in the death of the *alter ego*, La Boétie.

Now, at the geometric center of the first book of the *Essays*, in the twenty-ninth essay (there are fifty-seven essays in book 1), a strange place, neither full nor empty, is indicated in the text, an essay caught up in a process of erasure, an essay that would be only the trace left by a citation, a citation that would be constituted by an entire book, the treatise written by La Boétie, the dead friend, some fifteen years earlier, and entitled *La servitude volontaire*: a trace left by that absent citation, then by twenty-nine erotic sonnets by the same friend La Boétie, a new, withdrawn citation, of which in the final edition of the *Essays* there remains only a text presenting the volume to Mme de Grammont, a text whose first sentence reads "Madame, I offer you nothing of my own. . . . "[30] And, to give more precision to this central essay which is neither lacking nor lost, but which is in the process of imminent defection, we read Essay XXVIII, "On Friendship." Here is how it begins:

> As I was considering the way a painter I employ went about his work, I had a mind to imitate him. He chooses the best spot, the middle of each wall, to put a picture labored over with all his skill, and the empty space all around it he fills with grotesques, which are fantastic paintings whose only charm lies in their variety and strangeness. And what are these things of mine [literally "what are these things here," "*Que sont-ce ici . . . ?*" Cf. "Here is a book in good faith," "*C'est ici* un livre de bonne foy"], in truth, but grotesque and monstrous bodies, pieced together of divers members, without definite shape, having no order, sequence, or proportion other than accidental?
>
> A lovely woman tapers off into a fish.
>
> HORACE
>
> I do indeed go along with my painter in this second point, but I fall short in the first and better part; for my ability does not go far enough for me to dare to undertake a rich, polished picture, formed according to art. It has occurred to me to borrow one from Etienne de La Boétie, which will do honor to all the rest of this work. It is a discourse to which he gave the name *La Servitude Voluntaire* [Voluntary Servitude]. . . . [31]

It is thus just as though, beyond the conjunctural reasons for the withdrawal of *La servitude volontaire* and then of La Boétie's twenty-nine erotic sonnets, the writing of the *Essays* consisted in a "monstrous" proliferation, a presentation apparatus, a citation, a power of figurability that, ceaselessly producing grotesque changing figures and monstrous bodies, would invade the place reserved for citation, that is, the representation of the dead *alter ego*, his book, his poems, to the point of becoming the representation as a supplement and an excess with respect to the self.[32]

It is thus just as though a migration were occurring, a displacement and a transformation from the subject of enunciation and its marginal place as frame or "presentation" to the subject, represented as "myself" to be sure, but this self substituted (and always in a state of substitution) for the "portrait" of the friend, for his citation and his representation as dead by his book, his poems, and by the withdrawal of his book, then of his poems. This substituted self is nothing other than a portrait frame turned into a self-portrait, or rather a self-portrait that, mediated by the play of citational mimetics, is never anything but its own "framing," the framing of its own place, albeit a place that would always be defined by its border. This self-portrait can only be the framing of the place of the self, quotation marks proliferating to the point of occupying the place of the withdrawn citation of the text of the other self. For that place was, at the moment of the death of the friend, marked by the friend himself with the impossible demand to rejoin "myself," Montaigne, to him there in and by his death, as we know from the long quotation reported by Montaigne on the occasion of La Boétie's death:

> He began to entreat me again and again with extreme affection to give him a place; so that I was afraid that his judgment was shaken. . . . "My brother, my brother, do *you* refuse me a place?" This until he forced me to convince him by reason and tell him that since he was breathing and speaking and had a body, consequently he had his place. "True, true," he answered me then, "I have one, but it is not the one I need. . . . "[33]

The citation of the book and the poems of the *alter ego* will mark that very singular place in Montaigne's *Essays*, and this place-marking mimetics— perfected and denied—will allow for the advent of the modern subject, in the incomparable singularity of a writing of self. This subject will have to ply the reconquering of that singular place to support for the unshakable universality of a certainty of self that does not limit its purview to covering the horizon of documentary culture in order to accumulate knowledge

in it or to extract knowledge from it, but that bases on that certainty the methodical order of modern science.

~

I should now like to evoke, at the other end of my itinerary, its *terminus ad quem*, the immense problem of description and definition, with Descartes's *Traité du monde* (*The World*) and a short fragment from Pascal's *Pensées*. Mimesis and description: just as the citation, taken from a text outside of its system and imported into another text stemming from another system, constituted the ultimate accomplishment of the mimetic or representational process, so, too, in the order of things, did the documentary object, through its introduction into a collection. Nevertheless, we can imagine the possibility of substituting a representation of the object for the object itself in flesh and blood, as faithful, exact, and detailed a representation as possible, a verbal or iconic description that would be simultaneously the object's reproduction, image, and delegate, the placeholder for its own presence.[34] Better yet, we can suppose that with the help of that artifact of language or image, the thing itself, in and through its representation, can reveal its intelligible truth, its essential cognitive structure, to the eye of understanding and thus tend toward its own essential definition, or, conversely, that it can deploy its prestige and the powers of its seductiveness, its perceptible charm and the power of its imaginary, giving rise to pleasures of meaning and affects of sensibility, and thereby becoming the lure of a desire. But description can activate the forces of rational knowledge, through the precision, clarity, distinction, and penetration of the gaze. Does not Peiresc, after all, confide to Gassendi in 1632 that he has not obtained the figure of an antiquity "with the precision that would be required through the lack of a description proportionate to the proper dimensions according to the rules of geometry,"[35] and entreat Father Ménestrier in 1635 to get him carefully taken prints of ancient feet or at least "have them drawn by some precise painter who would take the trouble to portray them quite exactly and to show in them everything that appears in them and nothing more"?[36] But description can also provoke emotions and passions of the heart through the play of its amplifications or ellipses, through the movements of its hyperbatons or prosopopoeias. In both cases, the fact remains that description in language, by aiming at objects and beings in their simultaneity, and at processes and events as spectacles or pictures, seems to suspend time and spread the narrative out in space.

But descriptive language which, as *language*, is subject to sequential time,

has to try to modulate in the dimension of sequentiality the representation of objects that occur simultaneously and juxtaposed in space. Hence the affinity between description and the setting-into-space of language by writing, and still more by the printed text, which invites the reader to consider it as text in its spatial simultaneity and makes it possible to visualize the description, or even to diagram the descriptive processes that the mechanisms in embedded dichotomies (general and particular statements about the topic) deploy in simultaneity on the printed page, as with Agricola or Ramus. In this way verbal description, by virtue of its logical structure, its tropic economy, its generative procedures, finds itself tempted to compete with the image and its immediate descriptive power over things.

Description is thus the crucial figure of the relations between words and things. To cite Erasmus, who will label it with the Greek word *enargeia*, of which the Latin equivalents are *evidentia* and *illustratio*, *enargeia*-description is the evocation of a visual scene with all its details and all its colors, "so that our hearer or reader is carried away and seems to be in the audience at a theatre."[37] One of the functions of language in truly eloquent discourse is to set before the gaze "a verbal landscape of object-things," to use Terence Cave's felicitous expression.[38] Later, Erasmus puts it more clearly: the term *enargeia*, translated as *evidentia*, is used

> whenever, for the sake of amplifying or decorating our passage, or giving pleasure to our readers, instead of setting out the subject in bare simplicity, we fill in the colours and set it up like a picture to look at, so that we seem to have painted the scene rather than described it, and the reader seems to have seen rather than read. We shall be able to do this satisfactorily if we first mentally review [*lustrare*, turn around, traverse with the eyes, make a complete circle around] the whole nature of the subject and everything connected with it, its very appearance [*facies*] in fact. Then we should give it substance with appropriate words and figures of speech, to make it as vivid and clear to the reader as possible.[39]

Mimesis, hypotyposis, *ekphrasis, enargeia, evidentia, illustratio, demonstratio, descriptio*, all these notions in the end modulate in various ways the sense in which things must come to inhabit words, must become present and self-evident in the verbal surface.[40]

Such is no doubt one of the fundamental problems for the rhetoric and dialectics of the late Renaissance and for documentary culture: the problem posed by a theory of representation of reality in language. Is a verbal

vision possible? Do not words, written or oral, interpose their opacity between readers and their visual experience of the world? Can language be effaced as such to the point where it becomes transparent to things, and can it from that point on display the thing itself in its truth even as it offers to the dazzled eye its simulacrum and its pretence? Here we are entering into the uncertainties and the vertigo of what is popularly called the baroque world.[41]

With Descartes, mimesis and description function differently. He triumphs over the seductions and fascinations of the world by using against them the very arms that had made their production possible. The ambition of modern science is, indeed, as commentators on the *Discourse on the Method* have repeatedly noted, to subject and manipulate the phenomena of the world through the use of technology. Now, that manipulation requires a preliminary derealization: the world can be subjected to technology only if its ontological foundations are removed through its assimilation to technology itself. So it is that, with Descartes, we are going to witness the mutation of modern science, carried out by a veritable transformation of the functioning of mimesis and description.[42]

The new science of nature is first of all a science of machines and mechanisms. In all realms of culture, the emphasis is on fabrication, the operative process, know-how. "We only understand what we know how to do," Marin Mersenne writes at the beginning of *L'harmonie universelle* (1636). His formula has to be rewritten, given the inescapable connection with the crisis of ontological underpinnings: "We only understand what we can feign." Lacking a metaphysical foundation, the scholar-technician replies with the fiction of a world. Baroque activity is a pretence, a technology of appearance, and it is through this fiction that modern science is inaugurated. The world is a fable; it is represented on the stage of mechanistic science, fabricated by an agency that, without some other mediation, can no longer be God.[43]

So we have come to Descartes. This move toward the mechanistic fable leads Descartes to break with the culture of rarity and marvels. Not that he does not evolve in an intellectual climate dominated by curiosity; after all, his assiduous correspondent Mersenne is a major figure in that climate. But in contrast with Mersenne's passionate eclecticism, Descartes always works to reduce curiosity, to include it within his own conceptual frameworks.

We can see this in a text written between 1641 and 1647 and published posthumously in 1701, *The Search for Truth by Means of the Natural Light*.

A good man is not required to have read every book or diligently mastered everything taught in the Schools. It would, indeed, be a kind of defect in his education if he had spent too much time on book-learning. Having many other things to do in the course of his life, he must judiciously measure out his time so as to reserve the better part of it for performing good actions—the actions which his own reason would have to teach him if he learned everything from it alone.[44]

I intend in this work to explain these matters. I shall bring to light the true riches of our souls, opening up to each of us the means whereby we can find within ourselves, without any help from anyone else, all the knowledge we may need for the conduct of life, and the means of using it in order to acquire all the most abstruse items of knowledge that human reason is capable of possessing.

But in case the grandeur of my plan should immediately fill your minds with so much wonder as to leave no room for belief, I must tell you that what I am undertaking is not so difficult as one might imagine. For the items of knowledge that lie within reach of the human mind are all linked together by a bond so marvellous, and can be derived from each other by means of inferences so necessary, that their discovery does not require much skill or intelligence—provided we begin with the simplest and know how to move stage by stage to the most sublime. In what follows I shall try to explain this by means of a chain of reasoning which is so clear and accessible to all that anybody who has not reached the same conclusions earlier will blame his failure to do so simply on the fact that he did not cast his eyes in the right direction and fix his thoughts on the matters that I considered.[45]

To be sure, Descartes is very interested in the marvels of nature, strange and spectacular meteors, celestial phenomena, but along the way he works to suppress the marvelous dimension by explaining it, that is, by reducing the unknown to the known. If the marvel is an artifact, it is then an effect of science, and admiration turns away from the prodigious phenomenon toward the ingenuity of the scholar-technician.[46] It is a matter of developing a coherent, strict, and lucid mechanism within the sciences of nature. Not letting oneself be fascinated by the object, whether it is marvelous like the rainbow or monstrous like the cadaver. In the last chapter that has survived of the first part of *The World*, Descartes formulates the following paradox, which in his physics is not one.[47] The sun might be false. If light, as Descartes believes, is the action of subtle matter on the eye, from the theory of whirlwinds it follows in fact that if the center of turbulence were not occupied by stars, it would still look the same. "There is just about no need for . . . [the sun] to be anything other than pure space in order to ap-

pear as we see it."[48] Even if the sun did not exist, we would still see it. It is difficult to imagine a more radical destitution of the visible world: perhaps the physical reality of light has no relation at all with the idea we form of it in visual experience. If in parhelia we see several suns where there is only one, does the light our eyes perceive have more reality than those false suns produced on the clouds? That is what will be shown by the analytic description of perception not by mimesis but by dissemblance, and then by the full development of Cartesian physics.

Challenging skepticism, Descartes demonstrated the possibility of a true science; but, challenging scholasticism, he demonstrated that this science is not the science of being: truth is no longer the adequation between an intellect and a thing. Between 1630 and 1633, Descartes wrote a treatise on physics that is a fable of the world.[49] Nevertheless, unlike baroque fables, the Cartesian fable presents the genesis of a new, entirely machine-constructed world, starting with a metaphysical agency that had not yet been elucidated in Descartes's day, a fiction of a world in which mimesis and description have a new and displaced function.[50]

The Cartesian world is indeed the world of representation. But the fact that the representer visibly *signifies* the represented in no way signifies that the representer is *a copy* of the represented. Nature addresses to human beings, to their bodies and their minds, an instituting language whose paradigms are geometric. But if such are the principles of knowledge of nature, and if the postulate of a physico-psychological semiology must be retained in order to understand, in the name of an eidetic phenomenology and with the greatest possible certainty, the contact between the mind and things, by breaking *on this level* with the mimetic relation of resemblance as constitution of the natural sign, the discourse of physics remains to be founded in full legitimacy on the critical epistemological level; the science of nature still has to be established on an irrefutable basis; in short, a system of Nature remains to be constructed.[51] What, then, is the Cartesian approach? It consists in the construction of a model representative of Nature that maintains no mimetic relation of resemblance with the real world. It suffices to reread the dazzlingly clear and authoritative pages of part 5 of the *Discourse on the Method* to witness this reversal, or method-driven conversion of mimesis.[52] In a first stage, Descartes resorts to a comparison with the most illusionist, the most mimetic painting there is to explain how the study of light is to Cartesian cosmology what the use of light and shadow is to painting in the aerial perspective, namely, a way of

creating an illusion of totality and completeness in the representation of a single part.[53] A cosmology in chiaroscuro, light makes it possible to suggest in shadow an accomplished physics. But here is the reversal:

> . . . I did not want to bring these matters too much into the open, for I wished to be free to say what I thought about them without having either to follow or to refute the accepted opinions of the learned. So I decided to leave our world wholly for them to argue about, and to speak solely of what would happen in a new world. I therefore supposed that God now created, somewhere in imaginary spaces, enough matter to compose such a world; that he variously and randomly agitated the different parts of this matter so as to form a chaos as confused as any the poets could invent; and that he then did nothing but lend his regular concurrence to nature, leaving it to act according to the laws he established. First of all, then, I *described* that matter, trying to *represent* it. . . . Further, I *showed* what the laws of nature were. . . . After this I *showed*. . . . [54]

In fact, at the conclusion of the generative functioning of this model, of this pretence or fable described, shown, demonstrated, or made visible by the physicist, he notes that this feigned, "machined" world, a construction outside of mimesis, is absolutely like our own, the world in which man lives. "I thought I had thereby said enough to show that for anything observed in the heavens and stars of our world [i.e., "the substance, position, motions and all the various qualities of these heavens and stars"], something wholly similar had to appear, or at least could appear, in those of the world I was describing."[55]

The representative model of the world (the fable or the pretence) realizes the "marvel" that Descartes evokes in "Optics" of an image so similar to the thing that "there would be no distinction between the object and its image."[56] The mechanistic system of Nature, a regular and homogeneous crossing of long linear chains of causes and effects, perfectly realizes the accomplished form of mimesis: a "specular" image in which the object reproduces itself while canceling itself out in its difference. But the epistemological signification of this reproduction is that it has allowed the articulation of a well-founded rational discourse. This discourse is well-founded because it is the systematic mechanical representation of the world, entirely intelligible because entirely deduced from a small number of causes and principles. On the epistemological level, the "fabulous" constitution of physical science substitutes the mechanical model for the mimesis of natural signs. Nevertheless, if the relationship representative of resemblance has disappeared at the level of the perceptible quality and im-

mediate language of Nature, in contrast the model justifies the reconstruction of that relationship, but as a relationship purified in the system of rational, intelligible relations that govern its functioning. The representation of the world in its perfect mimesis is thus engendered, deductively generated by the functioning of the abstract model constructed apart from any mimeticism by the mathematician-physicist.

This is shown with full iconic clarity and distinction by the drawings illustrating *Treatise on Man* and *The World* in 1664 and 1667.[57] Far from reproducing a thing, a phenomenon, or a process in their immediate visual appearances, the drawings aim to show the intelligible structure, the mechanical apparatus, the causal linkages that are the essential reality and the true cause of the thing. The imagination that presides over the fiction of the new world and over its mechanistic propedeutics is indeed the imagination that is closely associated with the practice and the language of geometry, an imagination generative of figures and not of images. As Descartes's rule XII expresses it under a drawing of parallel lines, squares, and rhombuses, aiming to represent the difference that separates white, blue, and red, "the infinite diversity of the figures suffices to express all the differences among perceptible things," figures that express most easily all the differences among relationships and propositions, *"figurae nudae,"* schematic figures devoid of any irregularity, confusion, or obscurity, simple, clear, and distinct figures, schema-figures or signs and not images; geometric projections of arithmetic relations, they have no mimetic relationship with the things that we perceive through the senses.[58]

But beyond these "bare figures," the illustrations for *The World* and *Treatise on Man* by La Forge and Schuyl are not only, or not entirely, schematic; they present indices that are signs of resemblance, making it possible to recognize the object: the tail of a comet, the form of an eye, rivers and boats standing for the diversity of the parts of matter (figures 1–3).[59] Other figures are not at all geometric, yet by representing parts or fractions of the human body, they render visible its mechanical model, the tubes and strings mentioned in the text. Still others, finally, and these are no doubt the most interesting ones for our purpose, are metaphorical images possessing at first glance no geometrical character at all, but making visible the textual comparison that Descartes selects and develops in order to explain, to make comprehensible, the working of the mechanical apparatus:[60] for example, the image of perforated canvas (fig. 4) that is a figure for memory in *Treatise on Man*: ". . . thus if one were to pass several needles or awls through a

canvas, as you see. . . . "[61] From this point on, such drawings, far from being mimetic visual descriptions of things, phenomena, or processes, but also far from consisting merely in a geometrical projection of the scientific model, are so many mediations that make the geometric schema the explanatory structure of the world of phenomena, of the world as we see it and as the cultural imagination of the era presents it: mediations that may often consist in making visual images of poetic metaphors, literary comparisons, or verbal images with propedeutic or pedagogical functions. Thus was achieved, in the age of Descartes, the "methodical" conversion of the documentary image and the descriptive mimetics that governs it into an instrument of scientific knowledge by means of imaginary experimentation on abstract models of representation of the world and of humankind.

Montaigne, Naudé, Descartes: these are the three figures I wanted to invite to the introduction of this colloquium on documentary culture between 1587 and 1666 in Florence and Rome. In closing, I note that only our Parisian doctor from Padua, secretary to Cardinal Bagni, was not, in this context, properly speaking, *displaced.* But *in fine,* too late, I should like to repair that blunder by noting that Montaigne came to Florence twice, in 1580 and in 1581, and that, between his two visits, he learned to transform the chimera of Arezzo from a *marvelous* monster into a *curious* document.[62] I should also like to note that Descartes, "a French pilgrim . . . [a] thirty-year-old gentleman—cultivated, curious about everything, an adept mathematician and a devotee of natural philosophy"[63] was in Rome on February 6, 1625, mingling with the Jubilee crowd. A great admirer of Galileo from his time at the Collegio Romano, he may have attended, that evening, the meeting of the *Desiosi* (the Desirous Ones) at the Montegiordano Palace where Giuliano Fabrici gave a talk in which he declared: "Philosophy should study the great text written by God, where the book is the world and experience the characters, and should not be subjected to the law of a litigious piece of writing which after two thousand years of interpretation is still not understood even by those philosophers who have sworn to believe what it dictates."[64] Perhaps Montaigne's double visit to *Florence* and to *Rome* in 1580 and 1581 and Descartes's visit in 1625 make it acceptable to evoke, via the two of them, the functions of mimesis and description in European documentary culture at one of the turning points of the modern age.

Narratives

§ 6 Utopian Discourse and Narrative of Origins from More's Utopia to Cassiodorus-Jordanes's Scandza

The reading of the *Gothic History* that I am about to propose is not a neutral one. It has been influenced by Gilbert Dagron's commentary, which lays out the essential themes of the research we have both been pursuing, if not in common, then at least by way of echoes, reminders, and reciprocal exchanges. Thus rather than concealing the stages in our dialogue within a definitive text, I have chosen instead to stress them, in order to show clearly that my own work, carried out "after the fact," focuses on textual effects that have already been explored, in a document that already encompasses its own commentary. But is this not always the case, even though the first readings—of which the others can only be re-readings—are often forgotten and thus neglected?

Readings

Among the problems posed by Jordanes's *Gothic History* is one of classification: to what genre does it belong? Gilbert Dagron proposes two possible registers of reading: it is either a historical discourse, a compilation of Greek works describing the valorous deeds of the Gothic nation, or else a fabulous tale, an evocation of the marvelous events from which the Goths benefited. But there may be other possibilities. The text may be the myth of the origin of a community, the utopia of a Romanized Goth that would locate the source of the present virtues of a family and a race in a misty past and on another planet, or it may depict the historical spread of an ideology of social organization, and so on. The problem of classification is of some importance, for a classificatory decision is made, consciously or un-

consciously, in every act of reading, and, perhaps without our knowledge, it defines the level of that act—that is, it establishes an order of interpretation and comprehension with reference to a particular genre and style. From this point of view, it may be useful to compare the various possible readings of Jordanes's text. It can be viewed as a pure mosaic of second- or third-hand quotations, of interest to the extent that the texts cited have disappeared—and in particular the monumental twelve-volume *Gothic History* by Cassiodorus Senator, of which Jordanes's text is an abridgment. It can also be seen as characterized by a "personal tone, proper to the author, which colors the entire work," a tone that is revealed by—among other features—the unmistakable quality of the way the borrowed texts are woven together.

It is also possible to take the work as a whole, as Gilbert Dagron proposes—to see it as an authentic text, by refusing to separate out the contributions of the various authors it draws upon, Cassiodorus in particular. This is an important methodological decision, for it gives Dagron an operational tool: it allows him to impose a dual decoding grid on the text. A historical grid—a borrowed one, moreover—gives him an initial code that permits him to reidentify events reported in the text and restore them to the continuum of historical time; at the same time, a reading grid, a so-called "utopian structure," retains its coherence throughout the entire text and allows Dagron to produce a complete decoding, different from the first but articulated with it. "[A good reading] must be attentive to the connection between the two languages that the author felt a need to use concurrently" (p. 290). But does the "utopian structure" of the tale, which is also *The Gothic History*, constitute one of the author's languages, and is Dagron's commentary really limited to the relation between two languages? In fact, what Dagron actually does in his reading, as I see it, is bring to light a language or code that the author has "unconsciously" used to encrypt his narrative. Unconsciously, for it is quite clear that Jordanes, in his own historical and existential situation, had multiple motivations for writing *The Gothic History* in a certain way. Had his motivations been conscious, they would constitute one of the "inaccurate conscious models" of which Lévi-Strauss speaks,[1] models that are designed to introduce coherence into a set of facts or events that clearly have none, but that, on the contrary, pose problems that the individual experiencing them has difficulty surmounting. We should not forget that Jordanes, a Goth and a Christian, to some

extent lived out the end of a story, the story of his own race. But there is more: these models, as we know, introduce us to deeper, unconscious organizing schemas. The models are the empirical "tip of the iceberg," structures perceptible only to the attentive reading of a researcher. And it is indeed a structure of this sort that Gilbert Dagron brings to light in Jordanes's narrative.

Jordanes recounts the history of the Goths. But this *history* is at the same time, even for Jordanes himself, and for the clear and obscure reasons we have seen, a Gothic epic, a *geste* aiming to situate the Goths within the Empire at the very moment he is writing—that is, the text is intended to give the Goths a complex status of integration. These, then, are the first two possible levels of reading: a *historical narrative* that both requires and allows an identification of its segments with respect to all the historical knowledge already accumulated about that period; and a *geste fabuleuse*, a heroic fable that unveils reasons and motivations for writing, a model designed to solve a problem with the "means at hand." But this heroic fable that explains a situation (or seeks to explain it) is itself coded in numerical figures that Jordanes uses but does not himself "possess," figures that only a researcher can bring to light and that constitute the deep structure of the text. Whether the structure in question is *utopian* is a different problem; let us simply note that here there is a third level that is not simply a supplementary level of reading but is hierarchically subordinated to the other two. This may be the level at which the link between the language of the historical narrative and that of the heroic fable is realized, the level of a more essential language whose fundamental relations have been staked out by the foregoing analysis: at the point of articulation between geography and history, through Jordanes's narrative-tale, a "metaphysics of invasion" is developed (p. 298) in which the land is represented as giving birth to a people, in an unthought dimension that belongs specifically to the text. We can see what leads Dagron to speak of a metaphysics of invasion, or of a treatise of insularity: the feeling that through the text and its concrete descriptions or anecdotes, through the event as retranscribed or translated by Jordanes, relations of a different order are indicated. These are essential relations, and they establish the empirical value of the narrative-tale in a transcendental unconscious of which Jordanes is only the voice: it is no longer a matter of islands and peninsulas, but of insularity; it is no longer a question of landings, raids, conquests, but of "invasionarity."

Ideological Schemas

Before examining this deep structure, we should perhaps look a little more closely at the intermediate model, the one Jordanes proposed. This model consists in "transcribing a complex political situation in terms of history, in order to resolve, in history, the complexity of the present" (p. 293). As I see it, we need to pay attention equally to the surface models and to the deep structures, to the extent that, the latter being *a parte rei* only the "transformations" of the former, the explanations proposed at the surface level lead us to discover the text's immanent articulations in its own empty spaces. Without examining the contents for the moment, what are we to make of a model of understanding that finds in past history the meaning of—that is, the explanation for—an inextricable present? To what extent, and for what reasons, is history perceived as a source of meaning? On the one hand, we may believe that past events succeed one another irreversibly in the intermediate times that precede our own, that these events constitute a certain order of appearance of elements that are found, here and now, in our own lived experience, in contradictory positions. History is the source of meaning to the extent that it is the place where contradictory elements appear in confrontation: the diachronic *order* of their emergence thus somehow constitutes the *reason (ratio)* for their coexistence in a difficult or unresolvable synchrony. To put it succinctly, the diachronic spread—and especially in a narrative—of a contradiction encountered in synchrony—and especially in a political status and position—is a sort of *deferred resolution of the contradiction*: thus it may be that the apprehension of a specific historical causality in specific circumstances takes the place of an understanding of those circumstances, and from that point on *explanation is understanding*—to resort to categories that have often been challenged, by Dilthey and others.

But recourse to history may also cloak another meaning, a meaning articulated with the first at points that would have to be determined with precision. Here the diachronic order of appearance ceases to be a pure sequence of events, a succession of incidents and accidents ordered in terms of "before" and "after" and connected causally: this order is in diachrony what a schema of origin is in synchrony. It is no longer the extension in the intermediate times that is *ratio* because it is *order*, it is the presence, the originary coexistence of the contradictory elements that is present in the lived situation: the present contradiction is referred back to the origin

and resolved there because it is a question of a different time and a different place, a time and a place that historical time will extend and that the present situation will repeat while establishing their articulations. Recourse to history no longer takes the shape of the time of a *narrative*, but that of the *recital* of an origin; it is simultaneously explanatory and interpretive. It is explanatory, since historical time is conceived as development starting from an origin; it is interpretive, since the origin supplies the categories and the relations that the present conceals or blurs. The deferred resolution of the contradiction in which the historical explanation would consist is thus conjugated with an originary resolution of the contradiction which is contradiction itself, but taken to its highest degree, qualitatively different, reharmonized, because it lies as much at the origin of time as outside of time.

Gilbert Dagron rightly foregrounds the judgment pronounced on the enterprise of Cassiodorus and Jordanes by one of Theodoric's descendants: "He turned the *origin* of the Goths into *Roman history*" (p. 294). How can one make a history of the origin, especially given that origin and history are, in the case in point, situated in "metaphysically" different places, the realm of the Barbarians and the realm of the Romans? In other words, how can one pass from myth to history, except by way of ideology, by making the myth of origin simultaneously an interpretive grid for the present, which it allows us to understand, and an effective force in this present, which it explains? In bringing about the overlapping of origin and history, myth and narrative, interpretation and explanation, the conscious model of our authors, which seeks to explain and to justify a politics "objectively," is nothing but an ideological model,[2] but one whose ideological character will appear with precision and rigor only once the deep structure that brings together the history and the *geste* of the Gothic race has been brought to light. This model is both explicit and conscious, but it has a systematic unconscious character—an ideological aspect—that can be grasped only through the articulations of myth and history, on the basis of the model itself.

A Textual Experiment: Thomas More's Utopia

Dagron carries out this disarticulation; but, by calling it utopian, he assigns More's text to a category that is difficult to define. It can nevertheless be said about texts of this sort that they have something to do with an origin

as exhibited by a myth, and something to do with political discourse—the discourse that justifies a politics by appealing to history—as recounted in a narrative. Thus I shall propose a textual "experiment" that consists in superimposing on Jordanes's narrative-tale a discourse that does have to be viewed as utopian, since it is the first to bear that name: Thomas More's *Utopia*. To be sure, I shall have to try to justify this experiment methodologically, for it may appear scandalous in certain respects, especially to historians. However, the reasons for the historical scandal are the very ones that produce the conditions allowing our experiment the possibility of success. In fact, it is highly unlikely that Thomas More was acquainted with Jordanes's text. He may well have been able to read certain of the texts on which Cassiodorus-Jordanes relied in writing *The Gothic History* (Ptolemy, Josephus, Strabo, and so on), and we can say that *Utopia* and *The Gothic History* drew on common sources. This remark is commonsensical, but its truth lies in its displacement toward more fundamental regions, which our experiment in fact proposes to bring to light. The point here is that texts of the period that are clearly different in nature and authorship nevertheless reveal a common organization, a homologous structure, when they are analyzed, as if similar obsessions, the same compulsive repetitions, defined a second level of articulation (to borrow the vocabulary of linguistics) from which the meaning of these texts stems.

The probable absence of influence (in the sense in which this term is used in literary history), our unfamiliarity with the direct sources of the texts being compared, the strangeness of these texts and the historical and cultural gap between them—all these scandalous conditions of the juxtaposition that I am attempting to carry out thus determine the conditions of its validity. Because we are sure that the texts are not comparable in terms of the logic of literary history, their reciprocal independence and isolation will confer upon the results of the comparison—even if we achieve these results under the aegis of a hypothesis to be pursued—a guarantee of a profound communicability, the communicability that does not refer to facts but to the consequences of a theory in its application to facts. For we also know that facts never exist in isolation, but become facts only when they are constructed by a preexisting theory, a theory that brings them to light and a theory of which they are then in turn the proof. It is thus only at the end of the operation that I propose to perform on these texts, only in the light of the results recorded, that we shall be able to register its success, or at least to envisage attempting other experiments of the same type

in related perspectives or domains. Nevertheless, as is the case with any comparison,[3] the differences are what will interest us the most, because only the small variations, the transformations or substitutions that we shall be able to record in the identity of a given structure, constitute the opening up of a meaning within this identity. It is to the extent that sameness vibrates with difference, within itself, that being is opened up to a discourse that is no longer incantation or poem but a discourse of knowledge: interpretation.

Just as Dagron offers us a double reading of the Cassiodorus-Jordanes text, we can without too much arbitrariness envisage a double reading of the text of More's *Utopia*. But whereas Jordanes articulates a single object (the Goths) according to a double register of discourse, historical and fabulous, in More's case we find instead a single register of discourse (at least in appearance) articulating a double object: contemporary England on the one hand, America freshly discovered and as if "outside of time" on the other. Even if we reach the point of recognizing other levels of discourse in More, in particular in book 1 of *Utopia* or in the conclusion of book 2,[4] the fact remains that so far as *Utopia* itself is concerned, the discourse is developed as a homogeneous descriptive narrative of a traveler returning from a long voyage. In fact, the England of Henry VIII and the America of Amerigo Vespucci both constitute referents for utopian discourse. But these two referents appear as such only in the part of book 1 that was written *after* book 2, as if More had discovered *after the fact*, in Raphael Hythloday's narrative, the referential play that allowed him to integrate contemporary England with the New World. Nevertheless, the utopia in question is neither the one nor the other: as its name indicates, it is *nowhere*. More precisely, in its "textual" reality, the utopia marks the internal gap, the active difference within the historical reality: between England, a *terra cognita* (indeed!) for More, and America, *terra incognita* still, between the historical miseries and misfortunes of the Old Continent as analyzed by the historian-politician and the peaceful happiness of the "natural" creatures of the New World as glimpsed by the traveling ethnographer-geographer, we are "nowhere," in a nonplace marking the interval, as it were, the space between, in geographic space and the historical moment: *U-topia*.

Referring to the one (England) negatively, to the other (the New World) positively, and yet equated with neither, utopia is the neutral term of difference, a difference that can neither be inscribed on a map nor consigned to a history: its reality is of the textual order, and the text imagined by

More—the fiction of Raphael's narrative, presented as the account of
someone serving as More's spokesperson, a character in a text to which
More himself belongs as one of the interlocutors in the dialogue—is where
the utopia is the point of contact between negative and positive, between
the two poles of the historical reality. In comparison to terms referring to,
and thereby presenting, reality, the utopia is neutral in relation to history
and geography; it is their double internal difference. But as a text, and as
a fictional text that speaks of history and geography, the utopia establishes
contact between them, unites them in the fiction of its complexity: the
"objective" difference exhibited by the historical reality is canceled out in
and by the text.

 Now, one of the ways of assuming difference and transcribing it, of *re-
alizing* the impossible maintenance of distance in contact, is the voyage,
the earliest form of ethnology. A utopia is first of all a travel narrative. But
there are travel narratives that are by no means utopias, it will be argued,
and this is true. Still, utopias that are travel narratives are distinguished
from travel narratives that are not utopias by a tiny, often unnoticed mark,
a signal within the text that indicates that we are changing worlds, that we
are leaving a discourse that speaks of the world and entering the world of
discourse itself. This mark is a sign of a disconnection or break: a traveler
swoons, and wakes up on some marvelous shore; a blank spot in the text
or on the map separates referential discourse from discourse that is its own
object; some noise, in the sense this term has in information theory, blurs
the transmission of the message that would localize the place in question
in some particular spot in the world, a place whose sole referential value
will lie henceforth in this spoken word. This disconnecting mark is then a
sort of caesura that breaks the *continuity* characteristic of the voyage—
continuity in space and in time—and develops a different place, a differ-
ent time; it is an *alibi* for introducing what does not *take place*, a *nonlieu*.
And it is not a matter of a simple verbal game or, rather, the verbal game
in question points profoundly to meaning. For this disconnection in the
spatial and temporal continuity of the voyage, this rupture, speaks for an
innocence whose purpose is happiness: *Utopia-Eutopia*, as More put it.[5] It
is a matter of freeing from guilt, or at least from responsibility, in a play of
words that is a play of text.

 Thus we note how a utopia may have a dual object in its discourse; we
see by what moment of absence, by what spacing, it puts itself at a defin-
itive distance from what it is speaking about so as to speak only of itself.

The utopia as the place of a voyage lies between England and America, between the Old World and the New; it is a mode of discourse through which the contact between these two shores of difference is assured, as between the two coasts of the Atlantic, even though the difference is shifted back within the very voyage that ought to cancel it out. In More's *Utopia,* we have twofold testimony to this break, in the utterance itself and in the act of its enunciation: in the utterance, since, starting in the opening pages of book 2, we witness the artificial "birth" of the island from the "caesura'd," cut-off continent; in the enunciation, since one of the interlocutors who inquires about the geographic location of the island is answered with all the precision one could wish, but the message is never received; it is drowned out by a servant's noisy cough, a fact More registers not in the text but on its periphery.[6]

Origin and History

In a sense, Jordanes's *Gothic History* is the story of a long mysterious wandering that is oriented by the poles of Romanity embodied in Rome and Ravenna, and that is finalized when contact with the Empire is established: a double discourse, the history and the *geste* of a single object, as we have seen. But this formulation is not sufficiently precise. For there is indeed a double reference that animates the voyage and gives it its orientation, its direction or meaning (*sens*). On one side, there is Scandza, the island of origin; on the other, there are the Empire and Ravenna, the port of call, the definitive mooring in history. And in this voyage, too, there are breaks, ruptures, similar to those we have encountered in More, in particular, the crossing of the Dnieper, during which a bridge collapsed and part of the Gothic race was relegated to remain outside of history. But within all these still imprecise resemblances, one structural difference stands out. More's traveler *arrives* in Utopia; the admirable island is inscribed in him as nostalgia; it is the place of arrival and return. In contrast, the Gothic "Utopia" is a point of departure, a place travelers leave behind, an archaic memory that the chronicler alone rediscovers and posits as an origin. Indeed, only the Empire orients the wanderings of the northern tribes, it is *in it* that both national integration and national exaltation must be sought. From this standpoint, More's discourse and that of Cassiodorus-Jordanes are exact contraries; while their structure is similar, they proceed in opposite directions. Cassiodorus-Jordanes's point of departure is More's destination.

By virtue of that difference, we might view the Gothic "Utopia" as a negative utopia in which only places of arrival—that is, Romanity, and, with it, history—acquire positive value; the "utopian" point of departure would thus be its negative. But at a deeper level, might we not find in this play of positive and negative, of departure and arrival, a possible definition of history—history as negative utopia? It is not at all a matter of defining history as catastrophe. But from this perspective historical discourse in its specificity is attained only by a negation of utopia; it is signified as the other, the inverse of utopia. And it is such a negation that all utopias take upon themselves, in their very name, since they find themselves denied even before they have come to be: they are the pure negativity of which historical discourse is secretly the carrier.

Here we seem to find the lesson of the contradictory directions inscribed in the text's identical structures: of meaning in the structural identity of the texts. A voyage's destination is the other of its point of departure: the former ostentatiously exhibits the negative of the latter. In the final analysis, a voyage is perhaps only the staging of this play of sameness and otherness, positivity and negativity: it operates a disconnection, by putting at the two ends of an irreversible temporal sequence what a single category connects in its synchronic relation, time being a sort of illusion of the categorial itinerary. But in the end, we shall be told, the Ostrogoth Empire of Italy is a historical fact, something More's *Utopia* is not. Still, Scandza is not a historical fact either, nor is King Berig, who crosses the channel with his three boats; they are fictional negatives of the real, positive Empire of Ravenna. A single semantic axis links them; the temporal axis of successive events is one of its possible translations. History, here, is the achievement of an origin and its negation. It is the origin that carries history along, and history can deploy its positivity progressively. As an achievement realizing an originary force, history can be interpreted only in reference—and this is what historical discourse is—as a diachronically extended repetition of an original schema. In other words, utopian *negativity* is what allows historical discourse to be positive, that is, to speak of the *real*.

But there is another fundamental difference between More's *Utopia* and Jordanes's *Gothic History*, and it entails a new approach to the opposition between utopian discourse and historical discourse. Both texts involve voyages. Raphael's voyage to Utopia, which he recounts to More and his friends, refers to a primordial voyage—that of Utopus and his army—which is only one moment in the narrative. The Goths travel from Scan-

dza across Scythia to the frontiers of the Empire, but their wanderings are not recounted by anyone in the text; their voyage recounts itself. An anonymous voice produces discourse; events arise one after another, on the horizon of the Empire, and are reported as they happen. This feature allows us to recognize historical discourse.[7] In contrast, in More's utopia, a character named Raphael tells More the story of his voyage to Utopia, More being simultaneously the author of the book *Utopia* and a character in this dialogue.

This opposition, which focuses on one of the essential points of discourse theory, the discursive position of the speaker, no doubt needs to be refined. What is the speaker's status, his place with respect to the discourse that he articulates? From what position does he speak about what he has to say? Thus, in *Utopia*, we see a partial overlapping between the subject of the utterance and the subject of the enunciation; the two subjects switch position within the text itself, in exchanges that evoke the play of syntactic substitutions in fantasy. There is nothing of the sort in *The Gothic History*. Nevertheless, we know that the text does not consist exclusively of pure historical discourse, and indeed Jordanes refers to himself at several points, not only in the preface but in the body of the narrative. For example, we find the following passages in the very first chapter: "*Our* ancestors, as Orosius relates, were of the opinion that. . . . For the race *whose origin you ask to know* burst forth. . . . from the midst of this island. . . . But how and in what wise *we shall explain hereafter . . . ,*" and so on, up to the following decisive intervention in chapter 50: "Paria, the father of my father Alanoviiamuth (that is to say, my grandfather) was secretary to this Candac as long as he lived. To his sister's son Gunthigis, also called Baza, master of the Soldiery, who was the son of Andag the son of Andela, who was descended from the stock of the Amali, I also, Jordanes, although an unlearned man before my conversion, was secretary."[8]

Like More, or like Raphael as More's spokesperson, Jordanes appears in person in his own discourse. But he appears in a very different—and to a certain extent opposite—way. Whereas Raphael (or More, through him) establishes contact, in utopian difference, between the Old and New Worlds, reconnecting the two edges of difference while maintaining it, via the utopian fiction, here, in Jordanes's text, it is not a Roman at all—not even a Romanized individual—who discovers the Goths' place of origin; instead, it is a Goth who is remembering his own history, the history of his race, and relating that history in his own voice. His interventions in the story are not

interventions properly speaking: they are modest moments—but moments nevertheless—within the story he is telling, the story that is his own, and also that of the Goths, to the extent that writing it, telling it, is a way of justifying the politics of the Ostrogoth kingdom of which Cassiodorus-Jordanes are subjects and faithful servants. This difference is not trivial; it has repercussions for the discourse as a whole. If utopia is defined as simultaneous contact with the other and maintenance of difference from the other, the genre requires a narrator who occupies a dual position in "reality" and in the fiction, who stands both outside the text, as its author, and inside it, if he is to attempt to accomplish the impossible mediation between the one and the other and in their opposition: hence the utopian "scene" where the narrators are represented. In contrast, in Jordanes's narrative, the author indeed appears as a modest protagonist-witness, but this is because he belongs to the people whose history he is relating, a history that is itself only a form of justification of the politics he is defending. Jordanes's is a case of ideological intervention: history is reconstructed in favor of a politics that finds itself not only *justified*, but *explained*. More's is a case of utopian intervention: the contradiction is not resolved, but rather maintained in its fictional obverse, which overcomes it by that very token. Here we encounter an attitude close to the position of the "subject" in fantasy, a sort of hallucinatory accomplishment of desire in discourse.

Leaving the level of discursive positions now to enter into the utterances themselves, we might summarize the play of structural differences between the *utterances* as follows:

Utopia Voyage of a fictional man from the real to the fictional
Getica Voyage of a real people from the fictional to the real

This play is organized around the categories of real versus fictional and man versus society, categories that sum up the two moments we have analyzed so far. The play of structure thus uncovered is going to move around privileged points, the ones at which the two voyages constituted by *Utopia* and the *Gothic History* cross paths, so to speak. My analysis will bear most directly on one of these points in particular: if an exhaustive inventory of its features were to be undertaken, its organization would constitute the structure of a lexicon common to the two texts, the system of related differences between the elements of the narrative, over and beyond its syntactic organization. .

Islands

The first point of intersection between the two texts is the *island*. In Jordanes, an island is presented at the beginning of the voyage that will end up making the Goths part of Romanity—and history; in More, it is presented at the beginning of the text (or at least at the beginning of book 2), but it is encountered as the destination of a "voyage" of conquest about which we are told nothing except that the invading army was commanded by the founding hero, Utopus. But whether it is a point of departure or a destination, the island is the basis around which external space is organized—the place, in both cases, of conquest, expansion, or colonization; the primordial relations that will have repercussions for the entire "history" to come, narrative or description, appear within the insular structure. Hence two questions: why do islands have a privileged role in both these texts, and how do they play that role in each case?

On the basis of maps that Cassiodorus-Jordanes probably consulted directly and more or less transposed into language, according to Mommsen, Dagron offers the essential elements of an answer. Between the Ocean, which is the limit of the unknown and the impassable, and the continent, which is equated with the known world and with civilization, there are mediating lands known as islands, which belong to both, geographically, psychologically, and perhaps metaphysically. In a way, they are at the limit of the world, neither beyond it nor within it, on the indiscernible fringe between inside and outside, on the hem of the world, as it were, on the dimensionless line where the world ceases to be world, where it begins to be world: an island is a mark of boundary and difference. In this sense, outside of time, in the space of a map, that is to say in the space not of the text but of its visibility, an island is the sign of an origin: a place where the world begins, with the surroundings of the map, a place where both a reading and a vision are initiated. But at the same time this place is in itself a small world, since the island in the ocean, at its outer edge, is what the inhabited world is to the impassable unknown that surrounds it. The boundary, the origin of the world, is in itself a world. An island is the original repetition of the difference of the world from its unthinkable exterior, a difference that can henceforth be conceptualized.

Such is the function of the island for Jordanes; it serves as the very archaic memory that legitimizes an impure origin only to be forgotten as soon as it has fulfilled its function; such is the anchorage, for More, of a

reflection on the perfect society, between the island of England and the American continent. But if, in Jordanes's case, the island of Scandza is viewed by the Goths as the simple origin of their existence and the place of their creation, in More's case, the island Utopia is neither the origin of the text (it appears only in book 2) nor the origin of the history, since it is one of the history's effects and results, since it is properly speaking an artifice: let us recall that Utopus conquers the peninsula called Abraxa and, once his victory is complete, has the isthmus cut off, setting both the victors and the vanquished to work at the task. And from that point on, Abraxa is called Utopia.[9] In Jordanes, we actually encounter false islands, islands that have not yet cut their moorings from the continent; these are a kind of imperfect prototype of Scandza. For example, "the twin promontories of Galicia and Lusitania . . . since they are joined to the extremity of the Galician country, they belong rather to the continent of Europe than to the islands of Ocean."[10] But in More, the thought of the origin is rejected as such, or, more precisely, an origin is a *fiction*, a fabricated entity that results from a shaping of the earth: in the case in point, from a schism that separates the earth from itself. The island of utopia is no longer a point of origin, but a fiction of origin. It is outside the world, at the limits of the world, in this sense; not like Scandza for Jordanes, in a protogeographic space, but in the space of the fictional double: it discerns and indicates, in the text, the indiscernible difference in the origin.

But for the island to function as either a fictional or "historical" source, it has to be offered as a *womb*. Jordanes indicates this explicitly; More only suggests it obliquely, through the ambiguity of certain terms (for example, *alvus*).[11] But, more essential than the indications in language, the map that one can draw of Utopia and Scandza reveals their womblike design. In each case, the island is hollowed out in the center by an internal cavity. In Utopia, this cavity is shaped like a vagina, in the form of a gulf whose very narrow entrance, lined with rocks and shoals, cannot be crossed without a pilot. In Scandza, the cavity has the form of a central lake that reiterates, but within the terrestrial enclosure, the oceanic enclosure that defines its insularity. And we recognize the canonical form of insularity going back to Plato's Atlantis,[12] which encircles the terrestrial fullness with the aquatic void only to open up that fullness with emptiness. For here we encounter the insurmountable problem of the origin, the initial contradiction that the utopia repeats in order to resolve it in its topological space: how to connect inside and outside? The island repeats the world

outside the world, at its limit, and it is itself a limit. In its elementary spatial structure, it comes to repeat the same problem in the form of a void that is plenitude, a fullness that is hollow. The central lake of the island of Scandza is productive of peoples on the island, peoples who will go forth from the island like swarms of bees, human swarms that the island engenders, while it kills off the real swarms of bees: a metaphoric hive, without a natural *analogon*. The central gulf of the island of Utopia, with its dangerous passes, which render it inaccessible, takes in a multitude of vessels and vast wealth. The center is empty, but productive; the void welcomes, but it also engenders—it is full of a plenitude to come, or one to be expelled toward the outside in the form of conquering tribes.

Thus, in each case, we witness the appearance of a very archaic image that is carefully outlined by the protogeographic or fictional space: the image of the belly, inseminated and generative, vagina and womb. But there is a difference between Jordanes and More that reiterates the differences I have been stressing from the start. Whereas Scandza directly fulfills its role of nation-producing womb by expelling its infants onto the continent like swarms of bees, Utopia fulfills it *in reverse*: the birth takes place within the belly, and the umbilical cord that Utopus cuts is the cord that attaches the belly to the outside, to the world, to the continent. The outside is introjected within, and another world (or the world's twin) is born, through introversion, in a birth that is a return, and in no sense an exit: not at all a flight into the maternal breast as into a refuge for an idealist wounded by the world,[13] but a shaping of an anti-world—οὐτοπία—within the world, as a fiction—Utopia or the world foreclosed. Thus the small tribes that inhabit Scandza, tribes that "fight with the ferocity of wild beasts," inaugurate their march toward culture, enter into the contradictions of history, by leaving home. Utopus's army, in contrast, brings into being a perfect civilization by entering into Abraxa (which is inhabited by an ignorant and stupid mob that passes its time in fruitless struggles), by joining forces with its enemies.

These reversed movements of outside and inside that reiterate the aporias of limit and origin are fraught with consequences. For, with Scandza as the point of departure, a politics finds its ideological schema in the effaced myth of origin, and a history is produced. When Utopia is the destination, a history—and a politics—provides its own double and its other, annuls or neutralizes itself by exiting from its own interior, in a contradictory expression of the fantastic birth of Utopus's island. Places and spaces and the movements that traverse and animate them bear the mark

and supply the meaning of this radical opposition. And if we were look-
ing for ultimate confirmation of this structural play of differences, we
would find it in the historic island where the Gothic ship moors at the
end of its voyage. This is the Scandza of the origin, rediscovered as an end,
in its contrary, the island-city of Ravenna, the Venice of the Empire:

> This city lies amid the streams of the Po between swamps and the sea, and is
> accessible only on one side. Its ancient inhabitants, as our ancestors relate,
> were called αἰνετοί, that is, "Laudable." Situated in a corner of the Roman
> Empire above the Ionian Sea, it is hemmed in like an island by a flood of rush-
> ing waters. On the east it has the sea, . . . on the west it has swamps through
> which a sort of door has been left by a very narrow entrance. To the north is
> an arm of the Po, called the Fossa Asconis. On the south likewise is the Po it-
> self, which they call the King of the rivers of Italy; and it has also the name
> Eridanus. This river was turned aside by the Emperor Augustus into a very
> broad canal which flows through the midst of the city with a seventh part of
> its stream, affording a pleasant harbor at its mouth. Men believed in ancient
> times, as Dio relates, that it would hold a fleet of two hundred and fifty ves-
> sels in its safe anchorage. Fabius says that this, which was once a harbor, now
> displays itself like a spacious garden full of trees; but from them hang not sails
> but apples. The city itself boasts of three names and is happily placed in its
> threefold location. I mean to say the first is called Ravenna and the most dis-
> tant part Classis; while midway between the city and the sea is Caesarea, full
> of luxury. The sand of the beach is fine and suited for riding.[14]

It is important to cite the description of the historical Ravenna, the
mythical anti-Scandza, in full, for in many respects—in its authentic to-
pographical precision—it recalls Utopia and its capital Amaurote. Like
Scandza, like Utopia, the island-city is surrounded by roaring waters; like its
sisters, it is inaccessible; and yet, like Utopia, it is hospitable to ships. It is
wholly penetrated by the water that opens it up to the wealth of the world,
which it takes in: the island of civilization is opposed to the island of bar-
barism; the island-city swarming with citizens, full of treasure, constructed
and as if penetrated with the wisdom and power of Augustus, is opposed to
the island swarming with small tribes in the state of nature. Ravenna might
be called Scandza's utopia, with one essential difference: it fixes the Gothic
nation in history and raises it up to an impossible Romanity, whereas the
inverse Utopia, a poetic double, sets it at a distance between England and
the New World: Theodoric's Ravenna is then Scandza's "ideological uto-
pia," while Utopia is the poetic Ravenna of Henry VIII's England.

Names

Another point of intersection between the structures of our two texts is constituted by their names, or, more precisely, by the act of nomination owing to which they accede to being by their inscription as textual elements. But here again the process is accomplished in *The Gothic History* and in *Utopia* in opposite directions, in a way that needs to be spelled out. Let us recall that the Gothic king Berig, approaching the continent somewhere in the mouth of the Vistula, names the land he is approaching as he exits from the Ocean "Gothiscandza," a name that is simultaneously a means of taking possession and a way of acceding to existence through inscription on a map, as Dagron points out. Similarly, when the founding hero Utopus conquered the Abraxan peninsula and when he had his army and the Abraxans together cut off the isthmus that had connected it to the continent, he gave the island his own name, "Utopia." Here again, we note the simultaneity of access to being and to the text in the act of possession-taking constituted by naming. But the differences come into play immediately, reversing these similar features in their homology. First of all, and this is the most important of the differences, it is, in one case, a continent and, in the other, an island that are named—that is, the elements named are opposing elements in the structural relation; furthermore, reinforcing the opposition, in More's book, the continent is debaptized in the island that the hero strips away from it by separating off the isthmus; and it is the man, the founder, who names himself in naming his work, the island. Thus the direction of the acts of nomination is reversed. But by giving the island his name, by denaming the continent that he is dismembering, Utopus actually confers a name that cancels out the island, even while endowing it with existence, since to name the island "Utopia" is to eradicate it in its existence: οὐτοπία, nonplace. Thus the continent accedes simultaneously to insularity and to civilization, by receiving the name of the man who is responsible for its existence as an island and who neutralizes it as a fiction of an island, who designates it in its absence; the name of the "neutralizing" hero that the island receives, after the peninsula is cut off, causes it to become other, the other of the continent, the other of existence: it receives the name of the other.

In contrast, the island as origin is maintained as the name in the first stage of the Goths' voyage toward civilization. By contributing to naming the continent, the original island survives in it as a name: it becomes a

continent owing to the persistence of its name, owing to the insistence of the same name on the map where it is inscribed for the first time. It receives only as a supplement, and as a reward for this persistence, the affix "Goth." Thus the continent on which Berig sets foot is the Scandza of the Goths, whereas the Scandza that he leaves or that engenders them was a Scandza belonging to no one, or rather belonging to a multitude of small tribes. By appropriating the continent for themselves through nomination, Berig's Goths bring Scandza into being, for the first time, as their land of origin. That land gave birth to them, and they, in turn, by naming it as their land, come to possess it. Here we see a persistence of sameness in contrast with a neutralization of otherness, through the act of naming.

But the opposing play of names transparently indicates a different play: that of the peoples, from history to fiction, from fiction to history. In fact, Utopia is the result of the combined action of the invaders and the invaded, and that conjunction is marked by the absolute disjunction of names, since Abraxa becomes Utopia. Nevertheless, the name given to the island thus created by the joint action of autochthones and immigrants is a pure disjunction, since it signifies a nonplace. And this is how the historical conjunction of the Old and New Worlds is denied in its other, which is Utopia, a wholly positive fiction, overinvested with favorable value judgments. Negative in its name, positive in its fictional content, Utopia disconnects in the space of the imaginary what history is in the process of joining together. In contrast, the exit of Berig and his people from the island of Scandza separates the Goths from the multitude, from the aggregate of fierce, small tribes of which it is the womb.

This separation is probably the fundamental creative act, and we shall see it reiterated throughout the whole long march toward Romanity. But through the name given to the continent, the origin persists in its consequences: Goths and Scandza are conjugated under the name of Gothiscandza, which defines them as the only proprietors, not of a given land but of the entire land, of the whole earth; it defines them as already—from the beginning and in principle—equal to, integrated with, those others who possess the whole earth, the Romans; it defines them as identified with the totality of the earth known as the Empire. In leaving Scandza, the Goths lose their origin (they create themselves in separating themselves from that origin), but they acquire through Scandza (through its name) a place that becomes mythically, mystically, their own. Henceforth,

while keeping Scandza definitively at a distance, Berig's Goths, through their naming of the continent on which they land, deny a split, reduce a difference, cross a boundary. But it is noteworthy that they do not stop—and therein lies their history: "an impossible catching-up," Dagron calls it (p. 299); they keep on reducing that difference, crossing that boundary, until the day a Goth is made emperor, until the day a Goth is installed in Ravenna as a delegate of the emperor of Constantinople.[15] And yet, if the continent, *terra firma*, is Romanity, through the name "Gothiscandza" the island of origin has become a continent, and its legitimation is announced. This contradiction, which Jordanes has to overcome, nevertheless allows him to open up a diachronic dimension: the *progressive reduction of a difference* denied at the outset by the act of nomination that defines its end and that, by the same token, orients progress as an aim toward a *telos,* as an oriented wandering or the filling of what the naming had posited as empty. From this point on, we see how history is produced as the deferred reduction of a difference, a reduction that a name brings about in a single stroke.

A utopia, on the contrary, is from the outset and in the first place—archaically—the affirmation of a distance. What was continuous and unmarked owing to indifference—and to the silence of the text—will be articulated in a dismembering, a cutting. The continent is set at a distance in the affirmation of the pure difference constituted by Utopia in relation to that continent, radically other both in its name and in its being. Thus a utopia cannot generate history, for it is generated by history, but it is also inside history, as its mirror image, situated at an irreducible distance from history, which is transcendent. If the march of the Goths into the land they appropriate for themselves opens up a diachronic structure, the utopian caesura brings to light a synopsis, a panorama that can only be traversed by a gaze, in an instant that is eternity—that is, the neutral, neutralized time that does not emerge because everything is given at once. So Raphael's discourse in book 2 of *Utopia* will be first of all a description, whereas that of Jordanes-Cassiodorus will be first of all a narrative.

Cuts

And yet the continuous progress of the Goths, their great oblique march along the *limes,* the space of historical and narrative ascesis, before they are allowed to enter into Romanity, will be articulated by other cuts or breaks.

And yet the landscape of the utopia, devoid of shadows and secrets, since the sun's gaze remains immobile at the zenith,[16] will admit stories, fragments of history that will provoke temporal shocks in its serenity. And the breaks involved in the Goths' progress and the shocks encountered in the utopian panorama will manifest a strange correspondence, for the two texts face similar and complementary problems. For Jordanes, the problem is how to mark time—diachrony—in what is the open and simultaneous space of a map. How can one make a history out of this geographical simultaneity? How can history be produced on the basis of space that still lies outside history, since it lies outside Romanity? For More, on the contrary, the histories or fragments of history will serve to mark off utopian space; they will be carefully bordered illustrations—as if framed or mapped in a synchronic system that offers everything at a single glance to the gaze, but that Raphael's discourse traverses in sequence owing to the constraints of language. How can one make an immobile image of that linguistic sequentiality, if not through temporal fragments that have no function except to *illustrate* what the discourse presents as sequential and that must be perceived and experienced as immobile?

The continuity of the Goths' progress toward Romanity is articulated by a break quite comparable to the one that inaugurates the Utopian cosmos, a break that marks the end of its history. I am referring to the episode of the crossing of the Dnieper, during which the bridge that served as a means of passage collapses at a point when part of Filimer's army (Filimer is Berig's fifth successor) has not yet gone across, so that it is no longer possible for the first group to turn back or for the rest to move ahead. Now, this crossing takes on great geographical and historical meaning: it marks the Goths' entry into Scythia and serves as the initiation to their prehistory. In a sense, the episode of the broken bridge repeats Scandza's fate, and in this repetition we shall find the characteristic feature of the "myth" of origin that returns relentlessly to the contradiction that its narrative must overcome, owing to that very reiteration. The question in fact is the following: how can one exit from the space of limits in order to enter into the staked-out and legitimizing time of history? How can one insert oneself into a historical line?

The bridge episode repeats the exit from the island in the sense that the Goths, who in a first stage had distinguished (separated) themselves from the other small tribes, now separate themselves from themselves: Dagron has skillfully analyzed this mark of the irreversibility of the for-

ward movement, which is none other than the irreversibility of historical time. We ought perhaps to add that it is precisely a matter of a "mark of origin" on the basis of which time has historical value. It acquires this value only through an internal separation that involves not space, this time, but community or people. From this point on, historical time has a vector: the Goths are split in two, the good divided from the bad, by a sort of abstract predestination taking the form of a pure event with the value of a sign.

This caesura is thus not only a break in space and time and the sign of the passage from one mode of being to another, but it also marks the passage from a people without history to a prehistoric or quasi-historic people. And as if there were a need to repeat this schism yet again and to overdetermine it more decisively, it is hard not to superimpose a second break on the first; here, Jordanes recounts the origin of the Huns. Let us recall the episode that takes place during the time of King Filimer himself: the discovery of witches, their expulsion into a swampy zone where unspeakable spirits lurk and unite with the exiles to give rise to an ignoble, disgusting, scarcely human race shut off in a sort of continental island whose surroundings are impassable: the Huns.[17] But unlike the bad Goths, who are left behind in space after the bridge breaks, and thus will never accede to time, the Huns will exit from their continental island, marvelously; they will accede to history, as its negative, "as the Goths' evil twin," until they are crushed in the [so-called] Catalaunian Fields [the *locus Mauriacus,* near Troyes, in northeastern France, in the summer of 451]. By producing itself on the basis of a "myth" of origin, history also produces its own negative twin. It is not possible to leave evil behind at the point of origin so as to discover and deploy an entirely positive history; therefore the evil elements have to be negated historically. Thus a kind of dialectics is sketched out, a sort of philosophy of history, in which it is easy to discern the launching of an ideological schema. History goes from difference to difference without ever abolishing difference, always deferring its resolution, between the island of origin and the island-city destination.

In our text, *swamps* provide a specific mark of this feature. An island is the very mark of difference, the difference between continent and ocean, earth and water, the world and its outside; the mark of a limit, it is the world itself in its outside, and it is on the basis of this meaning that the exit from Scandza is understood mythically as the crossing of the limit, as the original negation of difference. Now it is noteworthy that the internal

schisms, those that make the Goths first a quasi-historical vector and then
a nation historically integrated within the historicity of the Empire itself,
are placed under the sign of the swamp, or situated in that place of con-
fusion. Swamps mark the mingling of earth and water, a blurring of lim-
its, a weakening of difference; they signify the complexity in which mate-
rial extremes blend indiscernibly, the wrong negation of difference, the
one from which one must free oneself before acceding to an authentic his-
toricity. And this is how, in Scythia, on that immense glacis of the Empire,
which is at once its limbo and its negative fringe, we witness the appear-
ance of continental islands known as swamps: "potholes of unstable
ground surrounded by an abyss," in which earth and water mingle to be-
come isolated in a dubious insularity in the middle of the land. The fact
that the Huns exit from the swamps where they were confined just as the
Goths come out of the island underlines their opposition as surely as the
monstrous miracle of their origin.

In More's *Utopia*, in contrast, there is only one caesura and there can
only be one, for its value is precisely the opposite of that of the breaks in
Jordanes's *Gothic History*; it marks, indeed, the end of history. From this
point on in More's text, it will no longer be possible to go back to what
had been, to go back in time; in contrast, Jordanes's breaks are events that
articulate history by separating the decisive moments in a continuum.
Once the isthmus has been broken, as the bridge over the Dnieper was
broken, the Utopians live a zero moment of time, as the Goths live the
first moment of a series of moments in history. Utopus's subjects enter
into an insular cosmos where time is rhythm, ritual, and ceremonial re-
turn of the same instant, just as Filimer's subjects enter into the overlap-
ping linear series of time, carrying them forward and extending them,
through their actions, to the encounter with events, unforeseeable breaks
on the basis of which the new appears. And yet there will be fragments of
history in the utopia, fragments that all stem from the intrusion of the
subject of the enunciation into the utopian cosmos, the intervention of a
subject, Raphael Hythloday, who describes the utopia. Immobile in his re-
petitive rhythms, Hythloday introduces the virus of time and narrative to
the island; without him, however, the utopia could not tell its tale. To take
on its fictional being as text, the utopia can only give the lie to itself as
utopia: it has to recount itself as history, through the voice of the one who
uses it as a figure of the sickness of time—the writer More.

Cultures

This will be the final point of intersection we shall examine between the utopian structure and the historico-ideological structure: an episode, a utopian "anecdote" that strangely resembles an event and perhaps a turning point in the history of the Goths, the one that Dagron characterized in the following formula: "The conquest by civilization has replaced the conquest by civilized peoples. . . . Culture has seized power" (p. 302).

The Goths in fact had their Raphael: between their fifth king, Filimer, and the tenth, Zalmoxes,[18] someone—Dicineus, master of culture, science, and religion, a quasi-king—came in from the "outside," just as Raphael and his four companions appeared one day in Utopia with their humanist library. The parallelism between these two instances of cultural contact is remarkable. It allows for just one difference: in *Utopia*, the taleteller is none other than Raphael himself, and in a utopia, it cannot be otherwise, whereas in *The Gothic History*, Dicineus's action is described from the outside, as an event—but then its explicit meaning disappears. Who is Dicineus? Where does he come from? What does he teach? We do not know, and instead and in place of this "historical" information there appears, in the form of a trace, the indication of a twin royalty, political and religious, that comes into being upon Dicineus's death with the advent of King Comosicus, who "was accounted their priest and king" by the Goths "by reason of his wisdom."[19]

As the other of history, utopia realizes the end of time in the form of a secular eschatology that is already present in history: its fictional obverse. But by cutting the isthmus, Utopus did not protect the holy island definitively from time; time will manifest itself as the cultural contribution of the West, of the Old World, not in the New World but in the Other World. And it is because this contact between cultures takes place that there is a teller to tell us the story of utopia. The tale-teller thus has to enter into the text itself, has to be part of the utopia he is recounting: the only possibility left open is that of contacts that unfold in the literary mode, in the form of books within the book that is first of all and essentially the utopia. The intrusion of external time into the cosmic immobility of the utopia takes the form of a humanist library, the most contemporary library possible (since it even includes works printed after Raphael's fictional voyage to Utopia).[20] The Utopians will assimilate this library into

their harmonious totality: thus they will master transcendent time, absorbing the serene rhythms of Utopian space.

More notes the two reasons for this integration. The first is that in reality the new contribution, the acculturation of which Raphael and his companions were the vectors, is not a radical novelty; it does not spring up *ex nihilo*, without precedent. In fact, "[a]ccording to my conjecture," Raphael says, "they got hold of Greek literature more easily because it was somewhat related to their own. I suspect that their race was derived from the Greek because their language, which in almost all other respects resembles the Persian, retains some traces of Greek in the names of their cities and officials."[21] Thus the contact between cultures, the irruption of the new, of an unforeseeable time in Utopia, is only a motive for recollection, a pretext for an anamnesis of the depths of the origin. In the contribution of the Old World, new to them, the Utopians rediscover an even more archaic past than that of the travelers who visit them: they discover their own past, which their own annals have not preserved. However, their language includes traces of that past, and these inscriptions establish an affinity with other inscriptions, the ones in Raphael's books: learning, for the Utopians, is only an opportunity to remember, and Raphael is the midwife of the past that they already bear in themselves.

The other reason for the cultural assimilation of the Utopians lies in technology, and specifically in the technological exploitation of the discoveries brought in from the outside: printing and papermaking. How did they proceed? "[W]e talked about the material of which paper is made and the art of printing without giving a detailed explanation, for none of us was expert in either art. With the greatest acuteness they promptly guessed how it was done."[22] The Utopians master a foreign discovery, thus what is most radically new in a cultural borrowing, through the technology that not only gives reality to new ideas but also repeats them in thousands of copies. The technological repetition of ideas in objects that embody them is what puts an end to their novelty.

The irreplaceable, the exceptional, the singular, all these characteristics through which time is marked as irreversible linearity are thus doubly called into question: (1) the exceptional is only what has been forgotten, the new has always already taken place, it merely returns; (2) the singular, the irreplaceable, loses its meaning when it is produced in series, whereas the same in its uniqueness is repeated interminably. Thus, in Utopia, in the search for what is most ancient, in the quest for what is original, between the lines

we discover the other of the present that the Old World is in the process of living through in its contact with the New, the society to come of the industrial revolution and capitalism; this latter society can be read in Utopia only in the form of those products that do not belong first and foremost to industry, namely, books. Thus the books within More's book, inscriptions at once ancient and new, in the text, utopian objects by definition, are what constitute the blind center of the society to come, its nonplace.

What happens on the Scythian steppes? "[W]hen Buruista [Burebista] was king of the Goths, Dicineus came to Gothia at the time when Sulla ruled the Romans. Buruista received Dicineus and gave him almost royal power."[23] It is from the "outside" that culture comes in its universality, and to a people that has everything to learn: from the outside, that is, from the continent, from the Empire, from Romanity. Hence the double reference to Sulla and to Buruista-Burebista, inside the Empire and in the barbarian world outside: this double reference determines the arrival of Dicineus as a dated event in the history of the Empire and in the time of barbarity: Dicineus is the miraculous envoy of Romanity, the cultural redeemer of the Goths. His arrival pinpoints a new stage in their progress toward the inside, the center, in their meaning and in their legitimacy: his action marks a decisive mutation in the accomplishment of the Gothic destinies. Natural and moral philosophy, law, astronomy and mechanics, theology and political science: there is not a single domain of knowledge that escapes Dicineus and his pedagogical enterprise. Thanks to him, the Goths have become spiritually worthy of entering into Romanity.

Here we can see the ideological schema at work. It is indeed noteworthy that the marvelous story of Dicineus frames the allusion to Caesar the Conqueror, "the first of all the Romans to assume imperial power and to subdue almost the whole world, who conquered all kingdoms and *even seized islands lying beyond our world, reposing in the bosom of Ocean*,"[24] who gained possession of the known world right up to its ultimate limits, except for the Goths, whatever he might have thought. Gothia is eternal and the *forces* of Romanity will not prevail against her. But if this is so, how can the Goths be integrated with Romanity? Dicineus then appears and turns the Goths into the people most worthy, owing to their learning, laws, and religion, to join the Empire. Dicineus, as Caesar's cultural *double*, makes it possible to achieve the Goths' integration into the Empire *without conquest*; from afar, he gives authentic legitimacy to the kingdom of Ravenna, the kingdom of the mind. Having come from the outside

(from the Empire), he authorizes the Goths to enter the inside of the Empire; he is the ideological figure of the political and historical process of deculturation.

Raphael, too, comes from the outside (the Old World). Like Dicineus with the Goths, in a sense, he makes the Utopians humanists and eventually Christians. And we can imagine a converted American Indian, some Sioux or Algonquin Jordanes recounting the arrival, during Henry VIII's reign in England, of Raphael Hythloday, who became almost a king among his people because he brought the ancient literature, physics and astronomy. But the utopian object has different laws, different internal necessities: once constituted in its fiction, it cannot admit external time in the form of a new event. And Raphael's intervention is only the opportunity for recalling a past more ancient than Raphael himself and his young science: for the Utopians are archaic Greeks, and they learned all of Roman and Egyptian science in Constantine's time. Raphael, the *contingent cause of a recollection*, allows Utopia, outside of acculturation, to rediscover its origins; he gives the island-dwellers, after the fact, the archeo-logical foundation they had always had but had forgotten: he retrospectively allows that island of artifice, that pure fiction, to have what it lacks, an origin, a mooring in a very ancient but shared history. What the Goths, with Dicineus, seek to recapture in the "future," the Utopians, with Raphael, seek to find in a "past" that they have in common with their author.

∼

After studying the gaps in the resemblances between Jordanes's text and More's, one must also stress the absolute gaps constituted by what is absent in one or the other of these documents. Here I shall only recall the complex overlapping genealogies that are literally woven through Jordanes's text, whereas they do not exist in More's. The reason for this is immediately apparent: the accession to history, the legitimation of a political status, of a national position in the present, requires these difficult excursions back into the generations. A cosmos that is subject only to ceremonial returns, to ritual rhythms, has no need to be based on an earlier time that it is, in fact, abolishing. Utopia does have a founder, Utopus; but we do not know who he is or where he comes from: he occupies at its origin (the origin that has been abolished, erased by the caesura) the same place that Dicineus occupies in a historical and ideological moment; he is the key to the Goths' progress toward Romanity.

At the beginning of this study, I justified my undertaking somewhat presumptuously by its results. Differences on each of the points examined have indeed continued to accumulate, but they have also regularly inscribed themselves within the framework of signifying correlations that I had too hastily posited as my hypothesis. They have animated the play of categorial oppositions defined operatively as the general problematics of these texts, and by that very token they have inaugurated the meaning of the texts studied, or at least one of their levels of meaning. The hypotheses I began with have certainly not been proved, but the solid analysis of the historian I have been reading received felicitous confirmation after the fact from a text that was nevertheless independent on some particular points. Further research would be warranted in order to pin down, by ever more significant gaps, the strange status of utopian discourse in the overall set of discourses that the West maintains about its own origins.

Appendix

My commentary had been completely drafted when Mircea Eliade's *De Zalmoxis à Gengis-Khan* appeared (Paris: Payot, 1970; in English as *Zalmoxis: The Vanishing God: Comparative Studies in the Religions and Folklore of Dacia and Eastern Europe*, trans. Willard R. Trask [Chicago: University of Chicago Press, 1972]). Eliade's second chapter, focusing on Zalmoxis, brings new elements to bear in the reading of Jordanes's text. Eliade's approach, his methodological orientations, do not seem to me to compromise the analyses presented in my own study and Dagron's. Rather, his immense erudition calls our attention to additional details that could lead to a more thorough structural analysis of our text. Here are a few examples:

1. As a key element in the analysis, I have noted the mysterious appearance of Dicineus at the court of King Buruista (Burebista). Similarly, we can observe the functional character of the appearances and disappearances of Zalmoxis as Mircea Eliade interprets them according to Herodotus's well-known text.

2. I had noted, without attaching any particular importance to it, the surprising disappearance of Zalmoxis from the royal genealogies established by Jordanes: after only one mention, this king does not appear again. This observation can be compared with the one Eliade makes: "We

do not know what happened to Zalmoxis and his cult after Dacia became a Roman province (A.D. 106). . . . It is difficult to imagine that the principal god of the Geto-Dacians, the only one who interested the Greeks and, later, the elites of the Hellenistic and Roman worlds, and whom writers continued to mention down to the end of antiquity, should have been the only one to disappear without a trace and to be completely forgotten after Dacia was made into a Roman province" (pp. 67–68).

3. It would be equally interesting to read Eliade's analysis of the "ambiguity" of the Geto-Dacians in the final centuries of antiquity and of their presumed assimilation to the Goths and the Scythians. The author writes: "In contrast to other 'barbarians,' [the Geto-Dacians] were praised for their moral qualities and their heroism, for their nobility and their simple way of life. But on the other hand, especially because they were confused with the Scythians, the Geto-Dacians are presented as nothing short of savages" (p. 70). These indications could then be compared with the analysis of the structural function of the Huns in relation to the Goths that Gilbert Dagron and I have undertaken.

4. But the essential element in the suggestions offered by Mircea Eliade's fine book concerns the duality of the king and the magician-priest, about which Jordanes's text contributes important details, following Herodotus and Strabo, whose texts Georges Dumézil studied in great depth. I shall not return to this point.

§ 7 From Body to Text: Metaphysical Propositions on the Origin of Narrative

> But in the Grave is found the real point of retroversion; it is in the grave that all the vanity of the Sensuous perishes. . . . You must not look for the principle of your religion in the Sensuous, in the grave, among the dead, but in the living Spirit in yourselves.
>
> —Hegel, *Lectures on the Philosophy of History*

> Need I recall that all mythical thought and ritual consist in a reorganization of sensory experience within the context of a semantic system?
>
> —Lévi-Strauss, *Structural Anthropology*

> Always and everywhere, . . . notions . . . occur to represent an indeterminate value of signification, in itself devoid of meaning . . . ; their sole function is . . . to signal the fact that in such a circumstance, on such an occasion, or in such a one of their manifestations, a relation of non-equivalence becomes established between signifier and signified, to the detriment of the prior complementary relationship.
>
> —Lévi-Strauss, *Introduction to the Work of Marcel Mauss*

Seizing the opportunity provided by Xavier Léon-Dufour's fine book *Résurrection de Jésus et message pascal* [*Resurrection and the Message of Easter*],[1] I should simply like to offer here some *metaphysical propositions* for approaching the text of the Bible through the methods and procedures of structural analysis. This approach is a way of responding to the challenge posed by Paul Ricoeur to Claude Lévi-Strauss in a well-known debate.[2] If the results of structural analysis were not debatable when they were applied to the myths of archaic societies (American or African), Ricoeur argued, the narratives of Semitic or Indo-European societies in contrast manifest both such complexity and such "proximity in difference" that other methods would have to take over if these narratives were to be understood; a science or an art of interpretation, a hermeneutics, would have to encompass structural analysis as one of its means, among others, and surpass it by an operation of much broader scope, since it would aim to explain both the relationship that today's readers—always in some way Jewish or Indo-

European—maintain with the fundamental texts of their own culture, and also the universalizing compass that that relationship entails.

But in fact, as guarantees of this structuralist enterprise, we have had Vladimir Propp's *Morphology of the Folktale*,[3] in which the sample was constituted by a hundred Russian tales, as well as Georges Dumézil's vast and important work on Indo-European narratives, myths, and epics; and, concerning the biblical text itself, we have had the exegetic method of literary genres. We have no doubt tended to see this method as connected to the search for the primitive layer of the text, and it has introduced into its textual analyses a chronological and historical design that structural analysis did not seek *at first* to identify. But by rigorously constructing the text in its content as a system of intersecting, overlapping, embedded *forms*, structural analysis played the role of a *stylistics* of the biblical text; it could only be reproached for stopping short, for confining its textual analysis to the notion of genre, the most general and least precise of the a priori codes of discourse.[4] Might it be possible, if one could reveal the essential structural presuppositions of the earlier analyses at the level of the major narrative units, to go further, to move toward a structural analysis of the text that would take its semantic and discursive syntax into account?

Referent and Communication

In other words, could one consider the biblical narratives in general and the evangelical narratives in particular as messages with multiple codes, differing in level and scope, each endowed with a partially independent grammar and lexicon, whose rules of combination and articulation would constitute a "general" grammar and a "reasoned" dictionary of narrative in general? The fact that the first texts approached from this angle were stories of "the women arriving at the tomb"[5] is a choice that, after the publication of Léon-Dufour's book, turned out to have the value of a sign, for I had stumbled at the outset, without realizing its full importance, on a narrative that on the one hand posed in a radical way, both in the meaning it contained and in its narrative form, the question of its referential object, and that on the other hand aimed to communicate in narrative form the pure form of communication in general. This story thus introduced the very question of "speaking-about-something-to-someone."

"The women arriving at the tomb" *recounts* the fundamental dual operation that any language carries out: first the transposition into words, sen-

tences, discourse, of an object, a situation, an experience situated *hic et nunc* in the world; then the transmission of the result of that operation to an "other" who understands, that is, someone who interprets the elements of the discourse received through the production of a discourse that simultaneously maintains and displaces the words addressed to him, thereby provoking another discourse, and so on. The first phase of the operation is, so to speak, the passage from perception to language, with the knowledge that, from this point on, perception is organized like a language, and that the world of perceptible experience already signifies—which does not mean that it makes sense. In the second phase, the dialogic structure of language is deployed; we observe that this structure overlaps dialectically and phenomenologically with the structural opposition between language and speech, between code and message, between the relation of signifying and the relation of interpretation. From this standpoint, language is the power, held by the receiver, to understand the speech uttered by the sender, and speech is the result of the transposition of experience into language so that it may be understood (or interpreted).

Fundamental Narratives

To come back to Xavier Léon-Dufour's book, it has struck me, after the fact, that by giving it the dual title *Résurrection de Jésus et message pascal,* and by justifying this duality in part 4 by a hermeneutic return to the narratives of discovery of the empty tomb and to those of Jesus' appearances to the disciples, the author was indeed setting forth (p. 246) the double "problem" of the referential operation (the Resurrection) and of the dialogic structure of the discourse (the Easter message). But the problem was actually posed by the texts of the New Testament themselves, rather than by later reflection carried out by philosophical, religious, or scientific discourse. Once again, the narratives in question are those of the fundamental operation of any language, any narrative. They constitute a model for that operation in a double sense: not only do they offer a remarkable example (among others) of the operation, but they also recount the operation: they have the privileged status of being at once interpretable linguistic objects and the possible interpretation itself, narrative utterances but also the metanarration of such utterances. With them, narrative is constituted as its own knowledge, but in narrative form.

Thus I would willingly accept—and with presuppositions that are not

necessarily those arising from religious belief—Léon-Dufour's essential re-
mark in this regard: "Unlike the historian, we dare not state that the past
has a meaning; the exegete knows that he knows, through the resurrection
of Jesus, the totality of the meaning of what is past" (p. 199). I accept this
willingly in that the narratives of the Resurrection in the New Testament
are *fundamental narratives*: narratives of the past in the sense of an origi-
nary historiality, they define the very conditions of possibility of all dis-
course. Nevertheless, because they formulate those conditions narratively,
they constitute their interpretation itself as a narrative that is none other
than that of history. In and through that narrative, there comes into be-
ing, through continuous recitation-interpretation of the Resurrection nar-
ratives, the effective realization of their possible meaning, through their
dual discursive and metadiscursive character, through the essential inclu-
sion of the metadiscourse in the narrative discourse as the very "history"
of what that discourse relates. The foundations of all possible discourse are
thus not posited speculatively as in Greek philosophy (Heraclitus, Parme-
nides, Plato, Aristotle) and thus not open to philosophic or scientific in-
terrogation in terms of truth or falsehood. These foundations are narra-
tives whose recitation reiterates and makes explicit the very foundation of
language as the setting into signification of experience in its communica-
tion, in the time during which it takes place, in which a given possibility
of meaning is realized.

Here, the fundamental narratives embody the potential for meaning be-
cause they are narratives and because they are narratives of the discursive
operation itself. It is in this perspective that I propose to bring up the prob-
lem of history and the relation between the past event, the present of the
hermeneutic discourse, and the future of speech that Léon-Dufour sche-
matizes in diagramming the closed circle of history and the open circle of
exegesis (p. 200). For the Resurrection narratives *recount* how the event of
experience comes to language and to discourse and how this advent con-
stitutes itself as communication, because this discourse itself is a narrative
and, in its communication, its possible meaning is indefinitely exploited.
In that respect, it is history, a discourse in which the possibility of meaning
as reality is interminably manifested. Communication through the dialogic
structure of discourse brings about the always reiterated and always dis-
placed deployment, in short the interpretation, of the incessant transfer of
the unity of virtually meaningful perceptible experience into the coherence
of a system of discursive significations: truth.

Figure and History

When I assert that these narratives are fundamental narratives, do I mean that they are the narrative figure of the foundations of all possible discourse, or that they constitute these foundations themselves? I can only answer that question by recognizing, as I suggested earlier, that they belong—whether we like it or not—to the culture to which we ourselves belong. They are, along with others, the originary narratives of our culture, and the whole enterprise of knowledge has to consist in disentangling that origin from the narratives themselves, in formulating the origin theoretically.

Thus I can maintain that the Resurrection narratives are actually figurative discourses that represent the foundations of language; as narratives, they cannot contain the speculative discourse that a theory of language and of discourse requires in order to be conceptualized. As figures, these narratives offer only a "thinkable," an "interpretable," a "possible" of interpretation. But I can maintain at the same time that in their structural arrangement, in the relations and correlations that articulate them and through which they tell their story, they may be constitutive of the symbolic order of our own language: they supply us with one of the "thinkables" through which we integrate our experience of the world, of things and of others—that is, a signifying organization in which and through which we think and relate our experience. We do not do this in an allegorical or imaginary fashion, by making some sort of abstract or conceptual signification correspond to a given narrative element or sequence. But we find, constituted in the narrative itself, the structural relations that have been and will be multiply fulfilled by the significations of which they constitute only the conditions of possibility or, to remain closer to the text's literal dimension, the places of investment. Thus, through our reading of the evangelical texts and the Resurrection narratives, we are caught up in a set of relations of which our discourse today and the Occidental discourses of yesterday and tomorrow have been, are, or will be—radically, fundamentally—the combinatory trajectory.

Metaphor in the World of Discourse

The first fundamental operation of narrative discourse is the transformation or transfer of the experience of the already signifying world into dis-

cursive significations, in speech. Such is the referential dimension of the semiotic triangle proposed by C. S. Peirce or by C. K. Ogden and I. A. Richards (whatever important differences there may be between these two ways of structuring the functioning of linguistic signs); such is the "objective motivation of designation" for Benveniste, when he analyzes the notion of the arbitrariness of the linguistic sign in Saussure. It may well be that linguistic science has relegated outside the understanding of the linguistic sign the fact that "one certain sign and no other is applied to a certain element of reality, and not to any other."[6] However, this has no bearing on the problem of transferring the experience of the world into significations: the problem remains on the horizon of scientific research, even if the linguist "will do better to put [it] aside for the moment."[7]

What does the expression "to talk about something" mean? How can a narrative—conceived as a narrative utterance, discourse, or text—tell a story, take into account in language the relation of an event or a series of events? This questioning is misunderstood by both naive thinking and scientific inquiry. The latter errs, as we have seen, in the name of the constitutive formalization of its object, the structural unit of the sign, grasped in the consubstantiality of the signifier and the signified. To put it concisely, scientific thinking recognizes only discourse, text, narrative utterance; this is the "only level that is offered directly to analysis . . . the only instrument available to us in the field of the literary narrative."[8] But naive thinking also takes a mistaken view of the problem, deeming that "there is a complete equivalence between language and reality. The sign overlies and commands reality; even better, it *is* that reality."[9] Only insofar as a narrative gives a representation of that reality that strays too far from the norms and laws understood naively by the speaking subject in the reality he is experiencing will the narrative be questioned and the basis for its credibility be examined. But this naive questioning will always take place with reference to reality itself, inasmuch as reality is already informed by a potential narrative—one according to which the dead, for example, do not pass through walls and share meals with the living. This naive perspective has made it possible to develop a rhetoric of fiction, the study of the means through which authors, in their communication with readers, consciously or unconsciously impose "their world."[10] Bringing this referential relation within the narrative utterance to light is one of the essential objectives of the scientific study of narrative.

Missing Presence and Meaning

Now, with the story of the women's arrival at the tomb, we read the narrative of the production of this relation in a double sense: it is brought to light there (pro-duced, brought forward), but it is represented in its very operation of transposition. For the women—as we know—come to the tomb to anoint a dead body, a corpse, or to weep over it; yet they find the tomb empty, and in the place of the body, a message: "Do not be afraid. I know that you are looking for Jesus who was crucified. He is not here; for he has been raised, as he said. Come, see the place where he lay" (Matt. 28: 5–6). Xavier Léon-Dufour was right to center his interrogation on the naive question that is at the same time the most profound question: "What exactly happened?" (p. 200). Such is indeed the question of the "focal point": one focuses on the fact, the event, but in order to observe that the fact is constituted in its positivity—that is, as a historical event—only in a discourse that is formulated in a radical difference, only in "the operation that creates a space of signs in proportion to an absence; that organizes the recognition of a past . . . in the form *of a discourse organized by a missing presence.*"[11]

Now what exactly did happen at the "focal point"? With the women, we encounter an absolute lack precisely where a presence of being was expected, if only the presence of death in the dead body. The evangelical narrative relates this lack of presence, a sort of "hole" in lived experience, in a moment experienced as a whole by a subject or group of subjects. The narrative was already taking shape for us as a legal institution, a ritual, a political and historical event, a cultural pattern, and so forth. Women come to the tomb to anoint the body or to weep; they ask each other how they are going to roll away the stone blocking the tomb, and so on; such a series of events would constitute in language a simple narrative utterance in which it would be necessary simultaneously to construct the internal correlations of the sequences, the syntax and its rules (by comparison with other narratives), and also the actual influence on its construction of historical, juridical, geographical, and cultural constraints, and so on.

But now we find this utterance folding back on itself in one point of its development and encountering an element of the story that it cannot relate. This is an operation that utterances have been carrying out "naturally" from the beginning, but one that can become self-conscious only because

the tissue of events, the continuous text of perception in the relatively closed and determined unity of experience, is torn at one point—the point where a presence is manifested by its lack and by the substitution of spoken words for that lack. From this point on, the narrative discourse of the real event (the event or reality that is the story the narrative tells, the story to which it refers) recounts that substitution of words for the missing body and thereby brings into play an event of another order, which is a speech event (in place of a real event). This latter event will function henceforth in the narrative the way the reality to which it referred functioned—as a speech act, active speech (I recommend Léon-Dufour's admirable analyses of this initiative, pp. 58–59, pp. 148–49, and elsewhere); it brings into being its own reality by proffering itself. In short, it supplies an other, the irreducible other that is always constituted by the test of experience, but an other that is only language: a message.

Have people sufficiently *meditated* up to now on the fact that what is called "Resurrection" is first of all this: that *the women came to the tomb of Jesus and did not find his body there*" (p. 211) and that in its place they met a Messenger, they encountered the proffering of a message. In other words, as Léon-Dufour also says, they encountered the "meaning [of] the fact" (ibid.), or (to paraphrase Léon-Dufour), *meaning as fact*, which the juxtaposition of these two enunciations brings to light: "He is not here = he has been raised." The fact of the missing presence is stated, in and through the message, as meaning; or, put another way, the missing presence of the fact is replaced by the utterance of the message, by its meaning. *The meaning is the present fact encountered as lack*: such is the fundamental speech act that comes into being in the "hole" of the narrative tissue, as the central element—the "focal point"—of this surprising narrative.

The Originary Contradiction of the Symbolic

Several questions still remain. Does every speech act, every narrative as an act of narration or production of the operation that transforms experience into discourse, result from such a lack, from a gap or breakdown in experience? Does discourse as a whole aim to fill the originary lack that produces discourse, and in which discourse is produced in order to reduce that lack? Certain metaphysical thrusts of ethnology or linguistics would seem to point in that direction. Lévi-Strauss's thesis on the origin of language is a familiar one: "As in the case of women, the original impulse which com-

pelled men to exchange words must be sought for in that split representation that pertains to the symbolic function."[12] Symbolic thought, from which language stems, is animated by a "contradiction" that its very exercise must allow it to overcome. With symbolic thought we have a properly dialectical situation that is only the projection of its originary dialectics through which things are perceived in a simultaneous relation with the self and with others, with sameness and alterity; "the only way to resolve this contradiction is in the exchange of complementary values, to which all social existence is reduced."[13]

Thus the symbolic order, which is the very order of discourse in its origin, is constituted by the schism constituted by the other within the same, by the fact that a thing in its presence is in some sense hollowed out by its difference; by the fact that being, constituted by this difference—which is the relation to the other—always "supposes a somber half of shadow" that exchange, communication, speech addressed and received seek to cancel out by the always-intended coalescence between a signifier and a signified in a single plenitude. The relation to the other, constitutive of the presence of the symbolic thing, is that breakdown, that lack; it signifies that the thing itself in its presence is not what it is in the immediate relationship of its being to the self, but that it is other than the self in the relation that it maintains with the other, and that discourse is used to fill the lack through dialogic exchange. Discourse institutes this cancellation by transmitting to the other the thing as other and by receiving from the other the thing as self.[14]

But, in this exchange, there is an initial moment that is pure relation, the contradiction between identity and difference—difference as constitutive of identity. It is this initial moment that the Resurrection narrative *relates* in its initial sequence about the empty tomb: the thing itself (the dead body, already caught up in the various networks of legal, ritual, and cultural institutions, positioned by the series of events in a coherent experiential situation) suddenly, here and now, turns up missing. The absence through which it manifests itself is the other, the very difference of its presence, the zero through which and in the emergence of which the symbolic order of discourse can be inaugurated and manifested. For the absence of the dead body is instantly referred back, like speech addressed and received, to those who register it: "He is not here; for he has been raised, as he said. Come, see the place where he lay." Through this speech, the very absence of the body, which is the contradiction of its presence, is exchanged. Through *the speech*

of its presence, through *its presence as speech,* through the message "he has been raised," being emerges once again, but now in the symbolic order. From this point on, it is no longer linked to the empirical particularity of the experiential situation being lived in the here and now; instead, it is raised to the universality of speech in a discursive exchange. The perceptible phenomenality within which human discourse is confined, by falling back on itself in order to discover itself as constituted in its very identity by its alterity, is transcended within itself. The absent "this" is the condition of the possibility of the message, a message that is, itself, the mark of that absence: a *nothing* that is not a "beyond" of phenomenality, but a gap within it. And in the empty space opened up in the tissue of phenomenal experience, the new reality is constituted as communication, as the very essence of communication: it is the community speaking and understanding the messages that the community itself is uttering on the basis of language constructed by regrouping and reorganizing the languages that preceded it, languages that were used to express earlier experience.

The Place of the Narrative

It would doubtless be fruitful to analyze, with more precision than I have brought to bear elsewhere, the structure of gapping or deficiency through which the phenomenal experience passes to the exchange of words while constituting itself as the reference and origin of that exchange. I shall not pursue this analysis in detail here. However, there are many valuable suggestions on this subject in Léon-Dufour's book, in particular on a critical point that I shall formulate here as a question. What "consubstantial" relation links language to space and to the body? This question both particularizes and extends the one I introduced earlier in speculating about the passage from phenomenal experience to message, from signifying form to signification. It does, in fact, seem that the key notion allowing us to conceptualize the problem—and this is undoubtedly one of the profound semes of the narratives under study—is that of *place.*

> Finally we must not forget the concluding words: "See the place where he was." For this is not simply an announcement of the Easter event. What we have here is a community imagining itself in immediate proximity to the tomb, and the narrative must be read in this sense. This is the meaning of the surprising interest in the location. It is not a question of demonstrating the reality of the Resurrection by the fact that the body is not there. . . . We have

only to think of Sunday worship, with the purpose of calling to mind how God, in Jesus Christ, conquered Sheol and death. . . . The narrative reaches its climax with the message of the angel. . . . This narrative does not relate "the discovery of the empty tomb"; it proclaims God's victory over death. (p. 113)

That *the ultimate "place" of the message* brought by the angel should be a *designation of the place* in which the absence of the *dead body* is marked constitutes an essential moment in the transformation of the signifying experience into discursive communication.

What is a place? A fragment of space endowed with its own unity, a space inhabited or visited, a dwelling. Houses, temples, and tombs are places; so are dining rooms, bedrooms, gardens, and palaces. A place signifies the *relation* of a given space to a function or characteristic of the being that is indicated and exhibited there in its absolute individuality; in other words, a place is the relation of a space to the only possible epiphany of being within it: the body. A place is a body-space, the return of space to the pre-objective state it has when its signifying form emerges in perceptual experience, the perceptible experience of the emerging of its signifiance, thus the return of space to a state of origination. From this point on, then, places belong to narrative, that is, to the discourse (of which they are the primitive and fundamental moments) in which speech can refer to experience; they form networks of proper or common nouns that are guideposts mapping the act of narration in a narrative utterance.[15] If, as others have shown, the noun of designation (one that identifies an individual person, animal, or place as an individual) constitutes less a linguistic deictic (that is, a demonstrative) than the lower limit of a cultural classification beyond which one no longer speaks, but rather shows,[16] we understand that a place signifies the precise point at which signifying experience accedes to discursive-cultural signification.

Place, Death, Meaning

Now, the angel's message *states* the place, and in stating it, the message indicates the place in its relation to the absent body: "Come, see [an imperative, a deictic *indication*] the place *where he lay*." The place indicated was "the place where he lay" only through the presence, at that point, of the dead body. It is a tomb, a sepulchre, but in which the body is no longer present; it would thus cease to be a place if it did not recover its function in the story that is told about it: "*This is* the place where *he lay*." There is

place only in the narrative already being inaugurated: place of the narra-
tive, place of the discourse, *topos*. This *indication* is what is *signified* by the
angel in the message in which a speaking community is instituted—that
is, a community sharing a common history in which that operation is sig-
nified. The fact that the place in question is a *tomb* and the fact that the
phenomenon of absence is that of a vanished *body* introduce the transfor-
mation of the topography into a topos, the transformation of a place in
space into a place of speech, into the semantic dimension of history. The
narrative emergence of and in the symbolic order can then be interpreted:
it is carried out in a figure that has to be decoded.

Hence the temptation of allegorical interpretation. It is certain that this
temptation is one of the possible paths of interpretation, but one that takes
on its full value only if we emphasize the *ultimate* character or the *limit* po-
sition of the story through which this operation of including the referent
in discourse is carried out. The structure of deficiency that we are analyz-
ing—the contradiction of the missing presence overcome by the narrative
enunciation—acquires its universality only at this singular limit: *it is be-
cause it is a question of death* that the production of the message substitut-
ing for the missing body in the tomb takes on its greatest, most radical
power. Only in this mortal arena, only in the hollow place of the tomb, can
the illusion of *narrative*—a simple mirror of *reality*, of language, a copy of
the world, words, labels for things—vanish, and only here can the essential
link between universality and death be revealed.

For how might one try to name the presence of a lack? How might one
try to signify, in language confined within the phenomenality of space and
time, the substitutive and supplementary relay of narrative discourse, if
the presence to be named, the story to be told were not already signifying
themselves as absent, that is, as death? We may take this as a figure of
speech, but we still remain aware that what is in question, at this point
and for what is to be said, can be only a figure. This figure is absolutely
necessary because it is posited at the very place of origin of discourse, be-
cause nothing in language precedes it for which it might serve as figure: it
is both model and paradigm.

Patterns at Work

This originary figure is characterized by extreme complexity in the utter-
ances in which it is formulated and that it puts to *work*; that is, it makes

those utterances operate the fundamental transformations I have indicated. Thus, for example, according to Léon-Dufour, in the utterances of the Easter message, two patterns of the Resurrection and the Exaltation are present. We see them developing narratively as the "Jerusalem" type and the "Galilee" type, the first stemming from the prophetico-biographic type and the second from the apocalyptic and Christophanic type (pp. 6–12, 33, 82–94, 94–100). For the problem—or the mystery—is indeed one of naming or rather of *telling* the missing presence—death and the dead body—and its replacement in life and speech by the living word as an *other* body; in short, it is a problem of sustaining the narrative of the untellable and the unbelievable, in a language and a discourse that never cease to be confined within spatio-temporal experience.

The narrative as such, as we have seen, cannot accede to the illusions of speculative discourse. This accounts for the simultaneous and reciprocal work of the two patterns in the constitution of the narrative: the first, that of the Resurrection, is the pattern of time as the *order* of the sequential occurrence of the real events in the form of historicity. "He was crucified, died, and was buried; on the third day he rose again. . . . " Here we have a pattern, in short, of "before" and "after" in which the resurrection is the ultimate event, the terminal point of a series of events (the life of Jesus) and the starting point for another series (the preaching of the message and the constitution of the universal community). The other pattern is the one articulated by the semic category of "high" and "low," a spatial pattern of perpendicularity defining a *point* on the horizontal plane and invested with the significations of meeting, emergence, irruption, and instantaneous manifestation. The two patterns belong to the forms of time and space. Neither one frees the significations of the discourse from spatio-temporal confinement. But even if, as Léon-Dufour shows, one becomes predominant over the other (pp. 102–3), even if the prevalence of the temporal form appears as a frame for the recitation of the narrative that "founds" the Church, it is the work of one pattern on the other, their reciprocal exchange, that, by deconstructing one of the forms of the perceptible by the other, prepares *the empty place*, the neutralized space that is the possibility of meaning, the possibility of interpretation, the obverse of the utterance that the utterance cannot formulate and that the narration alone can sketch out in the narrative through the two contradictory patterns on the basis of which the discourse is generated.

In fact, with the pattern of "before" and "after," a space is articulated as

the trajectory of successive places according to the oriented and irreversible line of historicity. With the pattern of "high" and "low," what is canceled out is time, in the temporal zero point that is the unique instant. In other words, the representation or the productive image that makes the imaginary possible (and here indeed we have the precise meaning of the word "pattern") is, in the case of the temporal pattern, the spatial line with the oriented and irreversible trace, and in the case of the spatial pattern, it is the point—a unique temporal instant, a zero origin and end in which time is both produced and abolished. The two patterns constructed in the imagination are not *congruent*, but a single narrative makes them *cohere* (and we note how careful Léon-Dufour is to reject hasty concordances). This noncongruence is *essential*, fundamental: it is the only possibility that human language possesses to *express what exceeds it*, what we call transcendence, eternity, or mystery. I should like to be clear on this point: we are dealing with a narrative whose productive patterns liberate through their reciprocal work (and this is the meaning of their operation) a potentiality of significations none of which is capable of producing its representation.

The Book, the Other-Body of the Community

One final word about these texts upon which we have been meditating with Xavier Léon-Dufour's book as our starting point. I have said that the Resurrection narratives are narratives of the fundamental operation that transforms the topography of phenomenal experience into a narrative topos of communication. Instead of a perceptible particularity, in which the presence of the being itself is lacking because it is the place of death, a universal message is substituted; the universality of this message is none other than the occupation, by interpretive speech, of the empty place that the Resurrection narrative liberated. This means that the very construction of the narrative, with its active patterns, its linkages, overlappings, and interferences among literary genres, narrative sequences and paradigms—in short that the *text*, in its constitutive reality—preserves the space of the interpreting discourse by linking it via the constraints of its various levels. This space is commmunication itself, plural and yet regulated by the semiotic constraints of the text and by the external constraints that limit the possible operations of its syntax and its lexicon. (Thus why is there wine at the eucharistic meal, and not beer? Thus why is there a tomb, why is there a dead body to be anointed and not a bonfire and ashes?) These may

be places where the text is lacking: points where the text plays. More fundamentally, the space of interpretation is the place in which the text produces itself as such. This relation of communication is possible only on the basis of that lack, the lack manifested by the empty tomb. The message of the message is constituted there, the discourse of reality and the reality of discourse—because its meaning is the very potential for meaning. This speech is the other of being, the *other-body* in the place of the dead body; it is not "here and now" in the empty place. It is the other-body of exchanged speech, the historical universal.

§ 8 Critical Remarks on Enunciation: The Question of the Present in Discourse

In homage to Emile Benveniste

In this study I propose to offer some general reflections on "the formal apparatus of enunciation," to echo the title of an important article that Emile Benveniste devoted to the topic.[1] My project is a limited one, in two respects: first of all in its content, since it deals with only one particular aspect of the theory of language; second, in its development, for I shall simply allude to a certain number of texts without being able to analyze them adequately.

Before entering into the heart of my subject, however, I should like to specify its horizon. Hjelmslev once wrote that there is no philosophy without linguistics: in other words, every philosophical construction implies or implicates a linguistics. I shall argue here that, conversely, every linguistics implies or implicates a philosophy, that scientific theory in general—in the human sciences in particular, and in linguistics most of all—finds at once its ground, its center, and its greatest capacity for interrogation in philosophy. My intention is thus, first, to extract the philosophy that is implicit in some of the texts in which Benveniste elaborated the program of a semiotics of enunciation and to make that philosophy explicit; second, to make it clear that the philosophical presuppositions that at once establish and fashion the scientific theory of language in its spoken or written practice have been recognized as such, in diverse forms, in what constitutes the problematics of metaphysics—what we call, in contemporary discourse, the problematics *of presence*. I am indeed speaking of problematics, and not of fundamental and originary self-evidence. By this I mean that the metaphysics in question finds the basis for its certainties, the origin of what it takes to be self-evident, only in a blind quest that at

once legitimizes and compromises the various philosophical discourses that stem from it; I mean that philosophical discourse itself is nothing other than the attempt, continually renewed in various periods in history, to occupy the place of its foundation and its origin, an attempt that is undone at the very moment of its accomplishment.

I shall thus begin by interrogating the semantics of enunciation as to its two fundamental categories, person and tense, in order to show how, in their discursive production, they refer to the supplementary gesture of *ostension* or indication, the now silent "here" of the *meinen*, of the "self-address" in which discourse itself is at once produced and nullified.

The fact that Benveniste's various texts necessarily conjoin the categories of person and time surely signifies that there is in discourse something *like* a synthesis or a constitution of the subject that is temporal, and, reciprocally, something *like* a synthesis or a constitution of time that is subjective—a double reference in which one readily recognizes the Kantian critique of the *cogito*. In the consciousness that I have of myself with pure thought, I am being itself. It is true that thereby nothing is yet given me to think: how is the indeterminate, being, determinable by the determination "I think"? Internal difference, the form in which the indeterminate is determinable by the "I think," is the form of time. Benveniste teaches us that the position of the subject as self is the "reflection" of a universal structure of oppositions inherent in discourse, oppositions that acts of language set to work in particular locutionary situations; the subject as self, reflection, image, or product of universal forms of discourse— that means, of course, that the person who is speaking always refers by the same *indicator* "I" to himself who is speaking.

But perhaps there has not been enough reflection on the reason for the fascination exercised on the semanticist by this most ordinary, most naive, most immediate of acts. In other words, perhaps we have not asked—as semanticists—the properly philosophical question that the familiar strangeness of the speech act entails. In fact, it is quite obvious—and it is in this sense that the very proximity and familiarity of the speech act are blinding—that in the proffered "I" are conjoined the most massive, the most redundant of identities, identity *itself*—the same indicator "I"—and the most extreme, the most singular of differences, difference *itself*. For the act of saying "I," for the one who says it, is new every time, since it realizes every time—blow by blow, singularly—the insertion of the speaker in a new moment of time and in a different texture of circumstances and

discourse. A systematic identity, the language form "I" is similar to the
other forms, jointly possible parts of the system, grammatical paradigms
coexisting together in a rigorously coherent way. And yet, in the phenom-
enology of speaking experience, "I" is a singular, unique semantic unit,
different at each instant—in short, the *very* act of difference *itself.*

But—shall we ever finish recognizing the strangeness of that familiar-
ity?—this is not all. This conjunction of the same and the other between
the system of language and the speech act—a conjunction that is achieved
at the level of discourse and that defines discourse—is carried out *dialog-
ically.* It does not involve a linguistic *phenomenon* recognizable as a simple,
monologic identification of the same and the other. It is a matter of a re-
lation that is constituted at the price of a separation between the speaking
"subjects" "I-thou," in the correlation of subjectivity. For "that act of dis-
course that utters *I* will appear, each time it is reproduced [in its very re-
production], as *the same act for the one who hears it,* but for the one who
utters it is a new act every time."[2] It is thus the other as "thou" who fills
the empty identity of the form "I," who carries it out as the same act of
full identification, who construes the phenomenological difference be-
tween "I"s as an identity. In other words, it is the other as "thou" who
constitutes, in the mediated immediacy of the linguistic exchange, the "I"
as Myself. From this point on, and to sum up the uncanny structure of
the act of speaking in a non-Hegelian formula, I shall say that the ontic
identity of *Myself* is the difference—and here is the dialogic structure of
its constitution—between possible systematic identity and real phenome-
nological difference. The being of Myself is the being of difference, not at
all identity between the nonidentity and identity of the same, but non-
identity between the identity and the nonidentity of the other.

The linguistic-semantic deduction of temporality is directly articulated
with that of the subject, *ego,* in the sense that it simultaneously repeats
and displaces it on another level. In fact, it is a *permanent present* that is
the present of discourse itself in its enactment as speech. I quote: "This
present is displaced with the progress of discourse, *even while remaining
present.*"[3] A permanent present that is none other than the present or the
permanence of the dialogic structure of enunciation, a permanent present
that is discourse itself. But at the same time, it is a *present now* that, for its
part, is reinvented every time a person speaks, because it is a new mo-
ment, not yet lived, an *originary instant* in which "the coincidence be-
tween the event and the speech act is signaled,"[4] in which, I would say, the

event of the act of discourse emerges. Such is the strange temporal structure of enunciation.

Now, Benveniste tells us that this fundamental relation between the permanent and the now, which is properly constitutive of the present presence of the *ego*, is implicit, or, if it is made formally explicit, "it is through one of those redundancies that are frequent in everyday usage"[5] and, I would add, by a metadiscursive position-taking on the part of the *ego* with respect to its own discourse, which in no way allows it to escape from the implicitation of the present that is characteristic of its discourse. What does this mean, if not that the presence of the present of the *ego* is not at all signified in its discourse, that no signifier expresses it directly. Only the "progress" of discourse, to use Benveniste's vocabulary, *indicates* it immediately, because a discourse is being proffered in the place of silence. I stress (and I shall return to this point) this gap in the discursive chain, in the concatenation of words, between signification or expression and signaling or indication. Past and future are, on the contrary, expressed, signified, in and through discourse, but "language," Benveniste writes, "does not situate them in time according to their proper position, nor by virtue of a relationship that ought to be then other than that of coincidence between the event and the discourse, but only as points seen behind or ahead *on the basis of the present*."[6] Thus in discourse the signifiers of past and future bound and delimit the *missing signifier* of the present, of the permanent and the now.

In this way, the theoretician of the semantics of enunciation posits, in the fundamental position in the theory, a paradox, namely, that all discourse and its speech acts are expressed by signifiers that signify what discourse is not (they signify the noncoincidence between event and discourse, between past and future), but also that these signifiers of past and future can only actualize their signifying capacity on the basis of what discourse does not signify, from the standpoint of this position in which discourse does not signify *itself* but from which it *indicates*: here discourse *indicates itself* through absence (the present). In other words, the present of enunciation is a *lack* of language, coextensive with the totality of discourse and with each of its utterances, a lack on its surface and in each of the points of this surface, a lack through which, however, it is constituted as signifying discourse. By the same token, Benveniste remarks that the two temporal references of past and future, because they are necessarily explicit in signifiers, indicate the present as a pure limit between what is no longer present and what is not yet present.

From this point on, if the ontic identity of the *ego* is the very difference, in discourse, between the identification by the other of a possible form and the instantaneous difference of a speech act, this difference itself turns out to be replicated by the difference between the permanent of discourse and the now of speech and by the difference between the mute self-indication of discourse and its capacity to signify the nonpresent. Now, is this whole play of differences and gaps not constitutive of what Husserl called "the Living Present of the phenomenological monad"? The Living Present, the immanence of life itself, which is always already what Aristotle called the apostasy of the now, the distancing of the present from itself, what Plato discovered for his part as the break in the continuity of time occasioned by the suddenness of the present falling straight down upon it, or again, the Living Present in Hegel, at the end of the first chapter of the *Phenomenology of Mind*, where meaning is constituted only by the evanescence of the here-now of indication; or in Freud, with the nontemporal present and the nonspatial here of the unconscious primary process, unknowable or, to put it more accurately, nonexistent (since there is existence only in time and space); or in Augustine, in his *Confessions*, with the present of the soul, its present presence conceived as its essential "*dis*-tension." Hence a Living Present whose plenitude is always already "breached"—as the term signifies ambiguously—at once by the opening of a gap and through that gap. We rediscover this whole play of difference at the place of origin, at the "source-point," constitutive of metaphysical thought, which means that it is elaborated on the basis of difference and that this difference calls into question its very elaboration.

Let me quickly mention three markers that help conceptualize these implicit philosophical presuppositions of the semantics of enunciation. First, Plato, who raises the question of the present in connection with change and the passage from one contrary to another, which alone shares with eternity the privilege of the "there is." But by holding the present within eternity, through opposition to the past and to the future, which are applied to time properly speaking, Plato would be led to a radical separation between time and eternity—time being then only a shapeless mass of past and future, since these are detached from the present, which alone gives them meaning—if he did not conceive of the present instant as a double threshold, horizontal between past and future and vertical between time and eternity. Always already given in eternity, the present is, in time, the irreducible point where past and future come to die and to be born.

Now Plato calls this present instant "the sudden," the "all at once." It is a break, a discontinuity, a fissure of time out of which the present emerges, the place of a leap, the place of difference. If time implies first "this," then "that," the present is the difference between "neither this nor that," on the one hand, and "both this and that," on the other hand. Between "it was hot" and "it is cold," the present itself "it is cold" opens onto the difference between "it is neither hot nor cold" (which is the sudden, the all at once of the discontinuous) and "it is hot and cold" which is the present of the coexistence of contrary possibles, of their permanence in the system, the world of eternal intelligible forms. To put it differently, there are two presents, the first being the now, at once this *and* that, the second being *neither* this *nor* that. Eternity is the absolute now where "this" and "that" coexist; it is the foundation or the condition of possibility of the instantaneous present that is neither this nor that, on the basis of which time is deployed as first this, then that; it is change, passage from one contrary to the other. A metaphysics of the present of presence: we see in what sense Platonic philosophy is constituted as such since eternity as absolute "now" allows time to unfold, but in the very moment in which that presence, the originary present, is posited as a foundation, it also dissolves, since, on the level of temporality itself, it is "neither this nor that," it is the neutral of the "sudden," the pure difference that is the condition of possibility of the "sometimes this, sometimes that" which characterizes time. The present operates this double articulation: the present—and the subject that is linked to it—is, in one and the same philosophical movement, constructed as the "now" structuring change within the identity of an achronic model, and deconstructed as the neutral function of the difference that nevertheless allows it.

We find the same movement of construction and deconstruction in Aristotle. He too poses the problem of time and the present in relation to the problematics of movement and change—the very problem of being in motion. Now motion is, for Aristotle, the essential attribute that radically prevents being from coinciding with itself. As Pierre Aubenque writes, "it is not one accident among others. It is what is responsible for the fact that being in general entails accidents."[7] Consequently, the presence of the present can be neither the immutable presence of the eternal nor the indivisible punctuality of the instant. Modification, alterity, and diversification are inscribed in this presence, opening it up to the novelty of the contingency of the event. In his analysis of the "now," Aristotle writes enigmati-

cally: "It potentially divides time. And in this potentiality one 'now' differs from another."[8] A little further on, he notes in an admirable formula: "For, whatever it be that the 'now' pertains to, to that must the interval determined by it pertain."[9] The "now" bears this interval in itself, constitutes it as deconstituting. The gap is located at the site of the "now." Far from being an indivisible kernel of being and presence, the "now" bears in itself that which causes it to burst outside of itself. A unifying force, the "now" links the past to the future, but by a movement of separation and division that is its index.

Finally, there is Augustine: striving to develop the conditions of possibility for writing an autobiographical narrative in part 2 of the *Confessions*, he rediscovers and articulates the characteristic gap of the Aristotelian "now" and of the Platonic "suddenly," in the problems raised by the constitution—in the elaboration of the autobiographical text as a discourse of memory—of the subject *ego*, a temporal being. In fact, even as Augustine is wondering: "Who am I, myself, now?" he continues to split his query into two parts: "Who am I, myself, up to now?" where the present "now" appears as the result of a past history whose disappearance memory strives to master in the utterances of its discourse; and "Who am I, myself, at the present moment?" which *is* the very question in which the present of enunciation attempts to express itself through the interpretation of the text written by the Other himself, God: namely, the Bible, and specifically the beginning of that text, where the narrative of the "creation" of time is recounted. Augustine will attempt to conceptualize the gap of the "now" and the discontinuity of the "suddenly" through the notion of *distensio animi*, the dis-tension of the present on which Husserl, at the beginning of *The Phenomenology of Internal Time-Consciousness*, asks his reader to meditate at length because it sums up the question of philosophy par excellence.

The present, my present, is indeed what is closest to me, what is immediately myself, here-and-now, in my most intimate familiarity and which nevertheless remains no less immediately inaccessible to the very question that I am asking about it *and* about myself. As Augustine put it in a well-known formula in which the enigma, which is that of philosophy itself, has not been sufficiently noted: "What then *is* time? If no one asks me, I know; if I want to explain it to a questioner, I do not know."[10] Ernst Bloch, in *Spuren*, points up the same uncanny familiarity of the present through the disturbing image of a permanent fall into the trap, the hole, of the present. It is time for us to take up the question of the present here,

while attempting to develop it differently; we must try to make the trap of the present do its work, and to this end we must deal with what, at the beginning of this essay, I called the referral of the subject and time back to the movement of indication.

The use of the term "this" appears to coincide with this gesture of pointing. I quote Benveniste: "Of the same nature and referring to the same structure of enunciation are the numerous indices of *ostension . . .* terms that imply a gesture designating the object" occurring as the term is pronounced.[11] My commentary, as has become clear, "philosophically" reverses the order of the semantic analysis of enunciation: its structure is philosophically related to the gesture designating the object. Hence the question stemming from this reversal: when the gesture of indication is recalled by the term "implication," in a recasting that evinces the supplementarity of the word, what does the implication to which the semanticist alludes "mean"? What does it mean philosophically, if not that at that very point, in the originary place where speech is formed and uttered, in the very same moment, it falls silent in the gesture of the body toward the body: very precisely, supplementary. In sum, on the one hand, we have the elementary singularity of the thing here-and-now, and, on the other, the no less singular event of the linguistic act, a seminal (*semel-natif*) event, says Benveniste, an event engendered once again every time there is an enunciation, each time pointing anew, reaching across the threshold: the finger pointed toward . . . is what "this" says supplementarily. Why not then carry out yet another new movement on the borderline between language and the body? Why not say, with the archaic philosophy that is always censored by philosophy itself, that nouns in speech acts are like instantaneous representatives, in the here-and-now in which they are used, of these supplementary "thises"? That they embody movements of pointing in the very acts of knowing that they perform?

To summarize: the entire semiotic system of language flounders in the semantics of enunciation. In turn, the semantics of enunciation, analyzing the present of the speaking *ego*'s presence to itself, flounders in the hole or trap of the present by discovering, in speech itself, the gesture of indication and of self-indication: a silent "now" that does not signify but that serves as a sign. Naming itself—the general, functional concept of the noun—then also appears as the very gesture in which all discourse is neutralized, in the sense that the only philosophical discourse is the discourse that, for every act of reasoning, for every attributive judgment, carries out

the triple movement that brings its elements back to the elementary movement of indication in which all metalanguage is instantly undone.

We need to go a bit further still in these reflections on the here-and-now and indication; we need to notice, as Hegel saw at the beginning of *Phenomenology of Mind*, in the immediate gesture of indication in which every utterance is formed and annulled, the virtuality of immediate desire, the potential for consumption. Freud notes this in an extremely dense text that bears directly on the question of enunciation with which we are concerned. Freud is analyzing the process of denegation that affects the very structure of enunciation, since the person or subject, in the very present where he is positing a past utterance, refuses to claim it as his own, explicitly denies his own status as enunciator of his utterance; thus he makes manifest the double articulation of the enunciative present or of the subject of enunciation that we have already encountered in Plato, Aristotle, and Augustine. But the great interest of Freud's analysis, its radical deconstructive import, even in the most explicit references he makes to classical philosophical theory, lies in the fact that he formulates it in terms of force and power. I quote what seems to me to be the key passage, for my purposes, of the article "Negation."[12] What is in question is judgment: the proposition, the sentence, that is, the minimal semantic unit (in Benveniste's sense): "The function of judgment is concerned in the main with two sorts of *decisions*."[13] I emphasize the term "decision": judgment—and is this not what Descartes was already saying?—is decision, act, modality of desire. But in Descartes, this act is *one*, and the entire chiasmus, the entire exchange, the sleight-of-hand between language and things in the philosophical discourse on representation, is carried out in favor of that unity. In Freud, judgment has two decisions to make: "It affirms or disaffirms the possession by a thing of a particular attribute; and it asserts or disputes that a presentation has an existence in reality."[14] A double decision in which we shall recognize the dual function of the "is," logical copulation in discourse, enunciative act and ontological position in reality, utterances that belong to the language of things. Freud continues: "The attribute to be decided about may originally have been good or bad, useful or harmful."[15] I stress this recourse to origins even as I wonder whether the deconstructive philosophical discourse does not have to be itself this movement of regression, not at all as a genetic *explanation* on the basis of origins, but as a practice to be pursued with any discourse that purports to be true discourse. Freud himself writes:

Expressed in the language of the oldest—the oral—instinctual impulses, the judgement is: "I should like to eat this," or "I should like to spit it out" and, in a later transposition I want to introduce that into myself and exclude that from myself. Thus: that must be in me or outside of me. The original Myself-Pleasure . . . wants to introject into itself all that is good, reject outside itself all that is bad. . . . The other decision that the judgment function makes, the one that bears on the real existence of a represented thing, interests the definitive Self-Reality, which is developed on the basis of the initial Self-Pleasure (reality test).[16]

The ontological function of judgment is not primordial. It is a result, an effect. In other words—and the rest of Freud's text makes this clear—the truth as *adequatio rei et intellectus*, the constitutive decision on the truth of representation, namely, that what exists in the Self as representation may also be rediscovered in perception, is the development of the most original decision formulable in the terms of the *pleasure* principle: "I should like to eat this"; "I should like to spit it out." The gesture of pointing is the trace of this decision, or, more precisely, since the gesture of pointing is here now (in its internal difference with expression, as a constitutive gap of enunciation and discourse) what persists in all discourse and what all discourse represses, pointing is the present of the gesture as the possibility of "consuming," an atemporal present, as Freud also says, of desire *in* discourse, an unassignable present censored according to the forms and categories of time and space thanks to which discourse articulates its *dictio*.

It is doubtless time here and now to put the hole or trap of the present to work, the hole or trap of desire—a gesture of pointing in the semantics of enunciation. I shall raise the question of critical discourse in general—the discourse of literary criticism or art criticism being only one type of critical discourse—in the following form: What happens for philosophical discourse *itself*, when *a* philosophical discourse "regresses" to the point of eating or spitting out words? When this regression is a philosophical "decision"? The enunciation of philosophical speech is then speech in desire, speech of desire, a pure supplement to the gesture, singular, instantaneous, atemporal, always present: an affirmation. It then becomes narrative, anecdote, fiction, when it is written. It abandons the claim to occupy the assured positions of the metalanguage of true knowledge, the position of theory, in order to practice its unassignable present.

But since we are obliged by virtue of the place and the moment at which we are speaking to make general remarks, I would say, in a programmatic fashion, that one task of the criticism known as literary seems to me to be to show how, according to what processes, discourse in the written organization of its *dictio,* that is, in the forms and categories of the space and time of writing and reading, *negates* the enunciative position, the now and the here on the basis of which it is uttered, *eludes* the present by tirelessly occupying, through representation, the gap, the difference in which it is manifested. It is a denegation of the enunciation constitutive of any representation, which carries out the exchange between language and things *instead of* producing an indication of desire; at the end of this exchange, discourse offers itself as the equivalent of being, true discourse, discourse that imposes itself as true. The metasemantic analysis of discursive representation, by showing how present or atemporal unconscious desire is simultaneously posited and repressed in discourse according to the categories of time-space, ought to make it possible to pinpoint the way desire, in the historically diverse forms of representation, is inscribed or persists in the theoretical subject and—something that is perhaps more essential still—it also ought to be possible to put to work, in the analysis itself, the inscription or the inflection of desire as "critical." My own work on the writing of history as narrative representation with an excluded narrator illustrates the analysis of theoretical disinvestment *and* of critical reinvestment.

Another essential task of "literary criticism," conversely, would be to show how certain texts, certain forms of writing, attempt and reveal—through the very impossibility of succeeding at them—the *expression* (and I do mean expression) of the here-and-now of desire that I have tried to circumscribe by these philosophical reflections on enunciation: an example might be what I have elsewhere called the utopian structure of figurative or literary texts that seem indeed to develop their representation only as a space or a scene of play where the present, atemporal instant of desire blazes forth, where time and space come together and cancel each other out outside of discourse in the immediate and singular intensity of reading or viewing.

I am gesturing toward a critical erotics or an erotic criticism, if that expression has any meaning: the body-text of pleasure in which, literally, reading *is* writing, that is, consumption of the text, a way of eating it, where every metadiscourse, every metalanguage is neutralized as power and the in-

stitution of power, of truth in power, is absorbed by the writing-reading, becomes fiction.

Perhaps one of the most subversive forms of this reading-writing, or this critical erotics, would be the construction of little traps, the laying of the brief and intense textual ambushes that were for a long time characteristic of the "philosophical discourse" of the weak and the marginal, in which the power of institutional truth—that of knowledge—is turned against itself and caught in its own grasp, in its own empire, and falls into what Ernst Bloch called the hole or trap of the present. Traps and ambushes: I learned how they work from Pascal and from the Greek sophists, in texts where philosophic speech becomes a humoristic parody of representation, the narrative of a gesture, an anecdote of consumption.

To conclude, here is an anecdote of this sort, related by Diogenes Laertius. Stilpo of Megara used to say "that he who asserted the existence of Man meant no individual; he did not mean this man or that. For why should he mean the one more than the other? Therefore neither does he mean this individual man. Again, 'vegetable' is not what is shown to me, for vegetable existed ten thousand years ago. Therefore this is not vegetable." In the same passage, Diogenes tells the following story: "Once when Crates held out a fig to [Stilpo] when putting a question, he took the fig and ate it. Upon which the other exclaimed, 'O Heracles, I have lost the fig,' and Stilpo remarked, 'Not only that but your question as well, for which the fig was payment in advance.'" Crates sets up a dialectical trap for Stilpo by offering him the fig: "How can you claim, Stilpo, that the word 'fig' signifies nothing since at the very moment when I say 'fig,' I offer you that fig, of the best sort, a fig of Attica. How can you say that 'fig' is not this one that I am offering you on the pretext that it existed before I said 'fig' while showing it to you."[17] Stilpo eats the fig: the fig no longer exists—despair on the part of Crates who, in asking his question, in offering his trap and his fig, "brings about the nothingness of [the perceptible thing]" and "sees [it] bring about [its] own annihilation."[18] Stilpo's response is the foolish reply of an animal: silent gesture, discourse outside of discourse. Would it be then that "fig" subsists universally in the atemporality of the nominal concept, as Hegel thinks in the fragment cited, and that Crates' trap closes, all at once, on Stilpo's own trap? No, for Crates *wanted* to eat his fig, once the verbal joust with Stilpo had ended to his advantage. Hence his anger: "I've lost my fig!" Stilpo, a goodhearted fellow, then does have to speak: but he speaks only to say what Crates ought to

have known already had he not wanted so badly to eat his fig, were he not so angry at going hungry. "At the same time you also lost your question, the trap you were setting for me: the answer I would have given to your advantage is now already made. I have already paid myself." The anticipation (future) is already past (it no longer exists). The future result (answering to Crates' advantage) is included in the current decision (eating the fig) which is now, from now on, the future response (but to Stilpo's advantage) since it causes Crates' question to disappear, since it annihilates it. "I have already paid myself in getting the better of you."

The present is a hole, the open mouth or trap that swallows up the fig and the whole question of language, of its representative truth and of time as diachrony. The teeth that crush and grind Crates' fig also chew up metalanguage in the silence of pleasure: an instantaneous enunciation of the body.

§ 9 On the Religious

I have no basis for presenting Bernard Sarrazin's fine book *La Bible en éclats: L'imagination scripturaire de Léon Bloy* [1977] except that of friendship: an encounter in connection with readings of some biblical texts. Still, such encounters are too rare not to be marked in one way or another. Hence this text today, although I am aware that it will not really be an introduction to Sarrazin's book or even to a reading of it; it will simply evoke an event.

I do not know the work of Léon Bloy, in any case not in the at once erudite, passionate, and distanced way in which Sarrazin knows it. But it so happened that while reading a Pascalian text (I say Pascalian, since it was quite probably rewritten by [the Jansenist theologian Pierre] Nicole), the *Discourses on the Condition of the Great*, I was struck by the "image" with which it opened, a parable:

> A man was cast by a tempest upon an unknown island, the inhabitants of which were in trouble to find their king, who was lost; and having a strong resemblance both in form and face to this king, he was taken for him, and acknowledged in this capacity by all the people. At first he knew not what course to take; but finally he resolved to give himself up to his good fortune. . . . But as he could not forget his real condition, he was conscious, at the same time that he was receiving this homage, that he was not the king whom this people had sought, and that this kingdom did not belong to him. Thus he had a double thought. . . . Do not imagine that it is less an accident by which you find yourself master of the wealth which you possess, than that by which this man found himself king.[1]

This Pascalian parable had led me to reread the Gospel parables and in particular that of the sower, and this is how Sarrazin, reading Bloy, and I myself, reading Pascal, met in the reading of the Gospels.

Now, the evangelist, or Jesus, the narrator of the parable of the sower, like Pascal in the *First Discourse*, proposes an interpretation of the narrative: "Let anyone with ears listen!" Let anyone with eyes see. Unfortunately, every moderately attentive hearer or reader will observe that the interpretation offered in either case is not yet a discourse of knowledge, of truth; it remains a narrative that leads its reader or hearer once again to interpret. Every moderately perceptive eye or ear will notice that this interpretation-narrative does not decode everything, that it leaves holes, losses, blanks in the original narrative, as if the parable were always in excess over its interpretation. Every moderately subtle mind or imagination will discern, finally, through a strange reversal, that what the parable is talking about, what it recounts, is precisely a story of loss and/or of excess, of lack and/or of surplus, of deficiency and/or of overabundance. In other words, what the parable recounts, its original narrative and its interpreting narrative, is the *enunciation* of the parable and its reception; for between sender and addressee, narrator and reader, there will always be an event of excess and lack at one pole of the enunciatory circuit or the other, and because *one* never tells stories or listens to them except in order to try to master that excess and/or to fill that lack, to appropriate the gap, to identify the strange irruption, to make the narratives and discourses cohere and finally reach transparency. And at every turn and return of the enunciatory circuit, the same event of difference is produced, sending the reader or hearer off again on a new, interminable trajectory.

The king, at the center of the Pascalian parable, never finishes getting lost; hence the castaway's position in excess. *By chance*, the castaway resembles the king in face and body; he is and is not the king, he represents him in a quasi-identity, but this "almost" cuts him in two: thus at every moment, he thinks doubly, the same and the other and the difference between the same and the other. Thus Pascal, a castaway in his own tale, who, telling the generic story of a great man *in the guise* of decoding the "image" that he has the eldest son of the duc de Luynes read, forgets the lost king, the king whose loss has made possible this excess of glory, honor, and wealth; the forgetting of a loss in the second reversal that provokes the interpretive supplement, his own (Pascal's), mine, and what new forgetting, in my own narrative, will provoke a new overabundance of reading?

Given this series of events of telling and reading, my telling here of this Pascalian-evangelical story as a preface to Sarrazin's book on Léon Bloy will serve to mark another event, that of our encounter. For inasmuch as I do not "know" Léon Bloy, I shall have to explain, after all, why—on what basis, between excess and lack—I am writing this introduction. "To those who have, more will be given . . . but from those who have nothing, even what they have will be taken away." Let anyone with ears listen. . . . "Many prophets and righteous people longed to see what you see, but did not see it, and to hear what you hear, but did not hear it." "The reason I speak to them in parables is that 'seeing they do not perceive, and hearing they do not listen, nor do they understand.'" And one more passage: "Therefore every scribe who has been trained for the kingdom of heaven is like the master of a household who brings out of his treasure what is new and what is old" (Matt. 13: 12, 17, 13, 52).

Sarrazin writes his book as the narrative of a loss and of an excess, quite precisely in the place of interpretations and readings where books, the *Book*, are torn, distanced, cut, that is, cited and glossed so that another book, the writing of a reading, can be written in its turn, and then another in this new place, another that tears and cuts the previous one. . . . At each stage, there is loss and excess, profanation and consecration, without it being possible to say whether this blasphemous and euphemistic discourse is a discourse of lack or of supplement: Sarrazin offers a reading of the reading that Bloy produced of the Bible but also his reading of the Bible through or in that of Bloy. It would be to misunderstand Sarrazin, I believe, to suppose that the three levels of which he speaks in his introduction constitute a hierarchy in which his own book would occupy the supreme position and that in the last analysis his would be the ultimate discourse, the last word in the analytic regression of readings and interpretations. What Sarrazin discusses in his work on Bloy—in Bloy's work and specifically in the work that grew out of Bloy's reading of the Bible—is his own reading of the Bible and more generally the unstable, torn, splintered status of the religious, of religious discourse today. On this horizon, Sarrazin—himself an intrepid and well-armed reader—propounds his own account of the symbolic order, that of culture, language, and society, a viewpoint grasped and worked through in its *radical*: religion.

Religiere: re-collect, conceal, traverse anew, extract and choose, re-link and re-read, repeat "the old story of the relations between writing and reading" (p. 16) and, in the process, regress and announce. Such is the work of

the scribe who, as the owner of his ancient treasure, discovers also in that reserve the new, the difference that exceeds his property and disappropriates him. Let those who have eyes to re-collect what is said read, but the desire to hear may go unfulfilled in the opacity of the Book—unless that falling short, that frustration is the only fulfillment possible: the Other *may always* (I am not saying "will necessarily always") come to me while withdrawing like a wave on a beach wiping out the traces of footsteps. Pascal again:

> This strange secrecy, in which God is impenetrably withdrawn from the sight of men . . . and when it was necessary that he should appear, he concealed himself still the more. . . . He was much more recognizable when he was invisible than when he rendered himself visible. And in fine, when he wished to fulfil the promise that he made to his apostles to remain with men until his final coming, he chose to remain in the strangest and most obscure secret of all, . . . the Eucharist.[2]

The Eucharist or the Book in the book, the parable-narrative as essence-or-manner of dwelling and coming, of coming and withdrawing, of inviting reading and interpretation and of fading away into the opacity and silence of writing. "Let anyone with ears listen." It is this double and contradictory movement that Sarrazin (if I have understood him—or, rather, this is how I have read him, this is how our encounter has taken shape) calls the metamorphosis of the Book-Institution into Text: a meeting of writing and reading in its radical, the religious.

This proposition can also be written in a more neutral way: it is a matter of taking the paths of the imagination into the Book to see, taking shape at its limits, at its edges, on its margins (filled with black, red, green, or blue—your writing, mine, his) but also at its crossroads, branchings, and forks, at all its joints, adventures that are marked and traced there, Jewish, Christian, Bloyian, without counting our own critical adventures as twentieth-century readers, and to think the symbolic as this topological network in the topography of the space of the book. Imaginary-symbolic, "but the imaginary is not illusory . . . it beckons" (p. 16), and if it beckons, it is because in it the symbolic is at work, for whoever tries to read the traces in it, to grasp its figures and graphs: hiero-glyphs. To grasp in *representation* the work of *fiction*: force or desire held in check, immobilized by all the images and all the institutions, all the monopolies, as Sarrazin says, but of which perhaps a reading, a writing can venture to reactualize

the effects, to repeat them, or rather to constitute itself or situate itself in that repetition.

This is what I should like to try to do, in my turn, by rereading Sarrazin as he tried to do in reading Léon Bloy, reader of the Bible: imaginary, symbolic; representation, fiction; utopia. Let us read, reread the pages that Sarrazin devotes to Bloy's fantastic Parable, a disquieting distortion of the parable of the prodigal Son in a bourgeois nineteenth-century salon: "The conversation had reached that point when Someone who smelled bad came into the apartment" (p. 123). The narrative breaks off, the story comes undone. . . . Unless we judge that it concludes outside the narrative with the entrance of the prodigal in the person of Someone, a signifying void-figure, the "place of a wavering of meaning through a sort of 'fading' that is produced at the moment when fiction interferes with reality. At the very point where fiction and reality cancel each other out, the possibility appears of two contradictory readings, a play between meaning and non-meaning, nonsense and supersense" (p. 132).

At this point, all the motifs and all the motives of the interpretation-reading are separated out and broken down: representation and fiction, fiction and reality, the power of truth and the truth of power, the neutral and play, historical time and the enduring instant. Everything comes together and comes undone around or with the entrance of that Someone between discourse and silence, on the threshold of the interrupted text in which the interruption points to an outside-the-text, the real, but also a wordplay, a play of sentences in which the text operates its strongest effects, a place of limits and edges, a place of contradiction: the neutral.

The notion of the neutral, so difficult to think that it does not seem possible to construct its concept for fear of seeing its cognitive and pragmatic effects dissipated or rather blocked, aims at any fracture of the totality through the contradiction that places the parts of the totality at a distance from themselves: at the contradiction or the differentiation productive of differences. Utopia: in the nominal signifier, the noun establishes, neither exceeding nor falling short of negation and affirmation, the place of the limit where the instituting disjunction of knowledge—the disjunction that is at the basis of the institution of the true—is suspended: either true or false, either real or illusory. The negation coupled with the space that the noun designates opens up the field, suddenly inexhaustible, of the possibles that are not the possibles of truth: neither yes nor no; nei-

ther true nor false; neither the one nor the other. "Someone" unidentifiable, on this threshold, a diacritical figure since it is not expressible except on the basis of what it disjoins, is then unoccupiable, unthinkable, since discourse only traverses my reading, my interpretation, to go from the one to the other, from the true to the false, from the false to the true. The neutral here is not the neutrality of the institutional power of the dominant truth, nor is it that unlinking of the imaginary, that gap in representation where beautiful forms can unfold and where the desire to be freed from the determining constraints of reality can be fulfilled. The neutral is the name given to the signal for an exit and an entrance, at the threshold where outside and inside are bounded, where going in and going out are inverted and annulled (for example, the exit from the text, from the story, and the entrance into reality, or the entrance of the real into the text and the exit from the text into the fantastic); it is the name given to all limits by thought about the limit: contradiction itself. Now it seems as though the destiny of the cognitive thinking is to resolve contradiction in a change that annuls it while surpassing it, in which the totality is reconstituted, other, to be sure, but identical to itself, in each moment of synthesis. The stripes of contradiction are eradicated each time, the traces of its passage are no longer anything but the features determining the whole, which capitalizes them as its *own* treasure, its *proper* treasure: *properties* of the whole, thus posited as linked and combined differences in the growing complexification that totalizes them. The discourse of thought or that of being, while collecting differences, by this collection itself, annuls differentiation—productive contradiction—through integration.

Is it possible to express and to think contradiction as neutral? To maintain it in activity? Fiction and not concept or image, play, joking, "someone who smelled bad . . . ," a factor that turns us over to the undecidable, an undecidable reading, an undecidable interpretation (nowhere, fiction, utopia) that the imagination organizes in representations, that critical discourse institutionalizes in theory. The power of interpretation, the authority of reading occupy the place of the uninterpretable and in the name of truth knowledge takes over what is not its outside, but its play. About the limit, the neutral, or fiction, it is not possible either to write or to speak, for speech or writing are obliged to offer or trace themselves in the blank and empty space-time termed neutral, tirelessly throwing down their signs among the *relata* of differences, interminably conjugating them to make them heard, to make them read, to make them seen. The double

negation, the unheard-of logic of neither the one nor the other becomes in representations of discourse the double reconciliatory conjunction, the totalizing logic of "both the one and the other."

The question asked by Bloy as read by Sarrazin at the level of the radical of any representation, reading, interpretation, is then the following: of what fiction, of what differentiation, of what contradiction is interpretation—reading, theoretical-critical discourse—the product and the representation? To what reality, to what absent term does this discourse ultimately refer? What are the *figures* that traverse it, inaudible, and through which it is articulated nevertheless? What "other" does it indicate without signifying it? Onto what end of discourse does it open up once the reassuring thesis of a truth on the basis of which it speaks turns out to be missing? What happens if the authority, the power of this thesis gives way or simply comes into question? Sarrazin plays this movement or game of interrogation and suspense, but far from conceiving of it as a systematic strategy that would totalize all its possible moves, he thinks it and writes it as a match in which the rules of the game merely describe the system, whereas the players in conflict re-invent and exceed the system with every move: at the instant of play, the totality is actualized and yet every play is a supplement, in excess over the system and its strategy:

> These empty signs, the indefinite pronoun (someone) and the three suspension points operate a closing-opening of the text toward two readings, that of fantastic nonsense, a literary game through and through, and that of religious supersense, referral to a prophetic discourse that traverses the narrative discourse whose laws it transgresses. The "fantastic parable" plays on these two registers. In our turn, let us play with an ambiguous vocabulary: is this empty sign the other of the text transcending its structure, or the apocalypse of the Transcendent Other, *Deus Ignotus*? (132)

"Someone," the neutral operator of a structural transformation, a neutral figure in which contraries are posited and annulled, a neutral place (on the threshold of the apartment), a neutral time (apostasy, interval between two disconnected narrative times): what are we to make of this local and temporal neutral term? And how is the move of interpretation-reading played in this place and time? Taking the neutral as the phantasm of the limit and taking the narratives as stagings of the neutral, of the limit whose representation conjoins in the imaginary the contradictory terms it produces, the interpretation-reading, by describing "neutral" spatiality in

critical-theoretical fashion, is formulated thereby in the terms of a *topon-omy*, made up of hierarchically organized impulses, a system of levels ar-ticulated by matrix figures, and figures that it constitutes as such only to bring into coherence the distortions, the warpings and inconsistencies of the places that the representation organizes. A toponomy of the phantasm of limits, of frames, scenes, and settings, but a phantasmatic topic of critical-theoretical discourse that is constituted—as in dreams, or screen memories—only to fill the gaps, to articulate the voids, to produce and structure in the blanks in the space of the text the elements of the system that is indispensable to its intelligibility, to its transparency; production, articulation, structuring that can be expressed only on the basis of a place that is supposed to be true knowledge.

Now it is this topical interpretation-reading through hierarchically or-ganized impulses and through systematic totalization that Sarrazin sus-pends in what I shall call the apocalyptic moment of the question that he raises, or rather that his entire text raises. "Uncertainty," he writes quite rightly, "signifies [for my part I would say indicates, or signals] that we are 'on the threshold of the apocalypse,' at the crossroads of historical time and eternity" (p. 132). This crossroads which Plato called *exaiphnēs*, the all-at-once, the "now-suddenly" that allows us to perceive fleetingly accord-ing to the two dimensions of nontime, that of the instant and that of per-manence, is the singular event in which, each time, *all* of time is opened up. And can we not think that what we call time, in the a priori form of internal intuition, is only a punctuation of occasions, of presents, only a flashing of instants in which everything is given and taken back in the same instant, without our being able to hold onto the instants or to hold ourselves inside them: "The present usually hurts. [I]t is never our end [and yet it is] the only [time] that belong[s] to us. . . . Thus we never ac-tually live."[3] The present, time that belongs to me because it is always there, but in which I never live because it is already no longer, since it wounds me and makes me die—the moment of the Other who suddenly says *I*. Next to Pascal, whom I have just quoted, a citation from Bloy by Sarrazin: "I am the Absent from everywhere, the Stranger in all inhabit-able places, the Dissipator of Substance . . . and my tabernacles are set on such dismal hillsides that even the reptiles from the graves have made laws so that the paths of my desert would be wiped out" (p. 136). Must one de-cide, Sarrazin writes, whether this is the play of the imaginary or pro-phetic speech? Yes, really, must one decide? Since what is in question here,

the question itself, is the duty of decision-making, the obligation of identity, of sameness, of the univocal that a certain connection between structure and absence renders uncertain.

In this interrogative suspense as to meaning, and thanks to Sarrazin, I discover, for our critical-theoretical modernity, the exceptional place occupied by Bloy. I say "exceptional" in part in the sense in which, as Sarrazin indicates in his introduction by citing Daniel Sibony, and as he develops it throughout his reading (in particular of [Bloy's] *Salut par les Juifs*),[4] the question raised for the West, for its origins, is that of the existence of "a People that sets itself apart as a whole and posits itself as a nonwhole in the eyes of others," a question that "has an 'exceptional' logical and historical import" (p. 17). This question signifies the religious not only as a screen or an ideological representation but as the radical of our readings, of our interpretations, of our modern discourses. We read the analyses devoted to "Léon Bloy, Christian, at once Semitic and scatologically anti-Semitic" (p. 18), discovering in the *figure* of Israel the other of theological representation, the Other as figure, the figure as the other in the relation of the God who is one and three: a theological phantasmatics reversed in the fantasies of Bloy, reader of the Bible. But thanks to—or through the Grace of—this return and this reversal, Bloy writes himself and is himself written by the Other at the moment when he is tracing the figure of the Other. "An imaginary production: Bloy seems to live . . . on the imaginary level, in the symbolic register" (p. 18).

More generally, I discover the exceptional place Bloy occupies in terms of the "religious" today, caught between the imaginary, phantasms, representations, and eschatological symbolics. It is an exceptional place less in terms of the question of the religious than in terms of the religious as a question or as a "utopia." Does religion not aim at the future of human society, the advent of perfect reconciliation? Does it not recall in its representations an origin that is a happy end? Does it not cobble together an unprecedented future, a future of desire, with the fragments of a nostalgic past? An imaginary futurology, an imaginary archaeology? In this perspective, Sarrazin has traversed—without opening himself up, as was too quickly said of his enterprise, to the reproach of methodological syncretism—the Bloyian imagery and mythology following the paths of literary and cultural history, of the history of religions and myths or the paths of Jungian stereotypes. He pursued this course quite simply because Bloy had taken all those paths, deploying the salient discoveries he had made in

his own phantasmatics, and because there was no surer way for Sarrazin to set forth in this connection what I have called the critical-theoretical phantasmatics of today. But the exception of Bloy as read by Sarrazin is, in the return-regression and the reversal of that imaginary, the explosion of pure contradiction conveyed by visions, images, stereotypes, theological motifs. Mad "games of ambivalence," but games that are themselves ambivalent. This book derives its strength and its "object" from allowing itself to be torn between phantasmatic suspense and an eschatology held in suspense: the strength of a violence done to the limit that is internal to all criticism and to all discourse, manifested in a polemical oscillation, a rhythm of excess and lack that opens up the unidentifiable, always possible place of faith.

§ 10 The Pleasures of Narration

For Fabienne and David

Even as I make this moral plain and clear,
If *Ass's Skin* now came to my ear,
My joy would be extreme, nothing less.
The world is old, they say; I believe it. Just the same,
It must like any child be diverted by a game.
 —La Fontaine, "The Power of Fables"[1]

Just as the fabulist is about to write the moral of his fable about the power of fables, as he is about ready to formulate the lesson he wishes to impart to the person to whom his narrative is dedicated, the Sun King's ambassador to London during the period when the details of the peace of Nijmegen were being worked out with difficulty,[2] another fable, a different story, an echo of a tale-telling voice, suddenly diverts him from his purpose.[3] It distracts him by evoking the pleasure—the extreme pleasure—of a virtual narration. Thinking about the pleasure of narration cuts short the discourse of morality: whatever its content may be, the latter is always produced in the authorized, authoritarian mode, the mode of a didactics and a pedagogy, even if the lesson to be learned, in this particular case, is that a story told out loud has the irresistible power to distract and divert its listeners, and in so doing to persuade them of a truth.[4] The echo of an inaudible voice thus intervenes to distract the writer from the moral discourse that is supposed to be the "point," and, as it were, the pedagogical imprint of his narrative, its sense of ethical truth; this echo intervenes to be inscribed, like a title in a name, "Peau d'âne," interrupting the lesson that has almost already been written, but in such a way as to prove the lesson's validity through its effects. The echo of that second fable—in its name— suddenly manifests the irresistible power of narrative: the power to distract the attention of knowledge in the extreme pleasure of listening, to replace the desire for truth and knowledge with the fulfillment of a different desire, the desire for the voice of fiction.

One tale, unheard, branches off from a different, written tale that has just been read. The branching point is the name of this tale that gives it a

title *at its beginning*, but that announces and utters it in its entirety, since
the name *evokes it* in everyone's memory, the name "Peau d'âne," which
crosses paths with the writing of a different tale, a fable *nearing its end*, at
the moment when the writer, according to the law of the genre, is sup-
posed to write what his fable means, spell out its moral, impart its lesson.
The branching connection *realizes* practically, *pragmatically*, and through
this voice of fiction, what the writer was about to utter *theoretically* through
the writing of the truth.[5]

At this point of bifurcation, the narrator who holds the tale-telling
power is suddenly transformed into the hearer of a story that a voice could
begin (again) to tell him. All at once, he is subject to the power that he
himself held a moment earlier, or rather he is announcing (writing), when
the name "Peau d'âne" is mentioned, that he would be subject to that
power *if* he were to hear "Peau d'âne." It is as if he were thinking about
giving up the place (the position of power [of fables]) from which he is
writing, at the very moment when he is preparing to capitalize on this
power in the lesson of knowledge, in order to occupy another place, the lis-
tener's, in which he would hear a tale as irresistibly powerful as the one he
has just written: Peau d'âne. It is as if the echo of that voice announced the
dilapidation of a treasure trove of meaning and the expenditure of the trea-
sure in a paroxysm of pleasure. This raises a question—a *virtual* question:
would holding the power of the narrative (as narrator) in the end, in the
last analysis (but what end? what analysis?), be less agreeable than being
captivated by it (as hearer)?

Still, the tale-teller continues to write, and no one tells him "Peau d'âne."
His pleasure, extreme though it may be, remains virtual: only the promise
(although guaranteed) of pleasure (although in excess). The height of plea-
sure, happiness? Beauty, a promise of happiness, the virtuality of every nar-
ration.[6] According to this reading, the promise has the value of a proof: an
ostensive proof limited to demonstrating the power of fables in their ef-
fects. But this tale alludes to all tales in order to keep the appointment with
politics and diplomacy in London with the ambassador of Louis le Grand,
and a voice is already saying its name, a voice that had already told it be-
fore—the pleasure of a narrative evoked in its title, which pops up at the
tip of the pen—at its point, like the didactic point of a moral that will not
be written. Through this voice a memory speaks that is even more ancient
than that of the listening of days gone by: "The world is old, they say." But
the adult tale-teller, taken back for a moment to his childhood, also de-

clares that pleasure would surely be his if, at that moment, the tale were repeated to him: "I believe it; however, the world must still be amused like a child." This virtual present pleasure is perhaps also the pleasure of the memorative sign ("Peau d'âne") of a past pleasure:[7] a memory beckons in the echo of a voice. This repetition of the lost event through the written signs of loss—a repetition that, even while designating the loss, assuages its bitterness: such would be the pleasure of narration, an extreme pleasure, the happiness of orality, the "interval" of which Stendhal speaks, between writing and voice: an echo.

At this point in the text, which is a branching point, a fork, one discursive position is instantaneously transformed into another: from the position of "making known" through writing into the position of "giving oneself pleasure" through listening, from a position of power over others into a position of power over oneself. In this metamorphosis, this "on the spot" transformation, the very nature of power changes: the pleasure that, given as a supplement, was the mainspring of the narrator-writer's mastery over his reader (consider the story of the Athenian orator that the fabulist had just written for the ambassador) becomes the end, both goal and object, supplementary to a self-directed storytelling that remains virtual and that no one else hears:[8] to give "me" pleasure ("Si *Peau d'âne* m'était conté . . . ," if someone were to tell me the story of *Ass's Skin* . . .). The passive voice in the French text has an intense value; the story is already known; the pleasure is *extreme*. Here we have the erotics of the narrative drive: I give *myself* the pleasure of telling a tale, and the effect of the telling is power over whoever listens to me. Why does telling a story give "me" such pleasure in giving pleasure, in giving myself power over the person who listens to "me"? This "I" who is telling a story while effacing *himself,* while suppressing *himself* (as they said in the seventeenth century) in his narrative statement, opens up within the narrative itself the space in which the listener is captured: the "I" turns its narrative into that very space. Its hearer forgets "himself" or "herself" in the tale. There is a double reciprocal (de-)negation, a double pleasure in this dual fade-out of two subjects: does this annihilation bring extreme pleasure, *jouissance*? The pleasures (metamorphotic insistence on the plural) of narration (of the event of narrative enunciation) partake of power and seduction.[9]

Charles Perrault (who wrote "Peau d'âne") justified his narratorial position in a prologue.[10] How could he make the seizing of narrative speech that he carries out in writing, his appropriation of the tale-telling power, ac-

ceptable, or, better yet, desirable? Occupying the place of the master of nar-
rative does not go without saying, it seems, simply because that place has
become that of the master; it has been displaced, for it is a matter of writing
once and for all something that had always been spoken, of picking up in
a monument of permanent signs the multiple and ancient voices of
grannies and nannies who transmitted the story by word of mouth. Thus
strength becomes power (and seduction), desire, pleasure (and *jouissance*).

Hence a double strategy, and with it, a double pretence in which the
narrator's "coup d'état" is concealed.[11] He tells a tale only to satisfy the de-
sire for narrative of one particular reader, a woman of the world, the mar-
quise de Lambert; such is the fiction of a writer who at little cost gives
himself the simulacrum of the desire of a (female) *other* in order to give
himself the pleasure of tale-telling. In a movement that is the opposite of
the one in which La Fontaine, at the end of his fable, transformed himself
for a moment into the hearer of a tale whose narration hung on its title
alone, Perrault's prologue allows him *fictively* to change the listening posi-
tion, that of a desire for a tale, into the storytelling position:

> Thus without fear of being condemned
> For using my leisure badly,
> I shall, in order to satisfy your just desire,
> Tell you the whole story of *Ass's Skin*.[12]

"*Thus* without fear . . . " this operation comes as the conclusion of an-
other, which is the essential one: not only "I am telling a tale because I
want to please you in satisfying your desire," but also "By what right shall
I tell a tale? From what juridical predicament can I authorize myself as a
writer?" Now the answer is itself the power play:

> As for me, I dare to suggest *in fact*
> That at certain moments the most perfect mind
> Can love even the Marionettes without blushing. . . . [13]

The mastery of tales is a given; it is the province of the writer-prince.
The tale-teller takes possession of the narrative voice simply by beginning
to write; he is a pure *factum* of a power that institutes its own right to
rewrite, to re-cite, that founds itself as an authorized power. The narrator-
subject constitutes itself here, all at once, as a legitimate subject. This fact
of mastery, a self-legitimizing force, writes only the fact, its own fact, by

registering the pleasure of the tale and the pleasure of listening to it, the pleasure of meaning dislocated, of truth as suspended in the fable's telling:

> . . . And there are times and places
> When grave and serious things
> Are not worth as much as pleasant tall tales.[14]

The right to write, the right to listen to tales: these are synonymous with the right to pleasure. The "pleasure principle" here is the foundation of right, the source of law, but the law in question is neither general nor— still less—universal; it is valid only for certain moments, times, and places whose contingencies are not spelled out by any rule. The narrative is written only on an occasion, and the rule of the occasion is the pleasure that is without rule, except that it can only be grasped in the interval, the momentary, contingent interruption of meaning and truth, a place and a moment occupied by the writing of the tale.

However, the interruption that triggers the pleasure (of the tale) is not foreign to the reason and vigilance that characterize it. Pleasure here is by no means a principle opposed to the principle of reason. The pleasure of the tale is still a pleasure of reason, the pleasure reason takes when it goes on vacation, when it takes a holiday in the land of fictions while giving time off to meaning and truth. Such is the pleasure of regression, and in this non-Cartesian regression[15] the pleasure of one's own diversion (or transversion) in which reason recreates itself in its childhood, in its archaic beginnings:

> Why must we be astonished
> That the most sensible Reason,
> Often tired because it has been too watchful,
> Through tales of Ogres and Fairies
> Ingeniously lulled,
> Takes pleasure in nodding off?[16]

From here on, the power of tale-telling on whose authority the narrator acts through the pleasure that he gives (himself) is indeed established by the power play that seizes possession of the place, the moment, and the position of narration, but this legitimation found in the fact-of-the-right to pleasure is instituted as such only insofar as it is the diversion-regression of the power of Reason, guardian of meaning and truth. The power of the

tale-teller is the power of Reason that reason turns against itself by re-
turning to the cradling of a primitive *jouissance*, that of a voice indiscern-
ibly one's own and another's, the pleasure of an originary voice that, by
telling, protects against what the voice itself has brought into being by its
narrative—is the ogre not "that wild man who used to eat little children,"
as Perrault remarks in a note to his prologue?

Just as the narration of a tale diverts the power of the discourse of rea-
son, the discourse of law and order—of the symbolic, of society—via the
power of the "pleasure-desire" to tell a tale, so what *this* tale, "Peau d'âne,"
tells, the story that it re-cites, turns the discourse of absolute power against
itself through the pleasure-desire of love.

∼

The problems I have just raised emblematically—by rewriting, between
La Fontaine and Perrault, the rewriting of the voice of a tale, the plays and
stakes of the pleasures of its narration—unquestionably belong to the
"classical" rhetoric of discourse. They refer more precisely to the relations
among the three "moments" of discourse, between its means and its ends:
delectare, to please; *movere*, to move; *docere*, to instruct. The art of pleas-
ing, the art of *delectatio*, the art of pleasure and *jouissance*, does not have
its end in itself, but in instruction: did Perrault not say this in his preface
to the 1694 collection: "These are Tales written for pleasure . . . [but] these
bagatelles [are] not pure *bagatelles*."[17] Pleasure is an envelope for the seri-
ousness of instruction and morality, it is a disguise that enables truth to
have an impact; this practical truth is the pleasure effect of narrative. "Is it
not praiseworthy for Fathers and Mothers, when their Children are not
yet capable of appreciating solid truths which are stripped of all orna-
mentation, to make the Children like them, and if one might say, to make
them swallow them, by wrapping them in tales which are enjoyable and
proportioned to the weakness of their young age?"[18] One of these means
of delight, perhaps its privileged means, is the pathetic, the awakening of
the reader-listener's passions in view of instructing or persuading him, in
view of leading him to accept the truth of what the discourse has to offer.

To charm, to give pleasure in order to induce belief: this is the enter-
prise whose mechanisms Perrault allowed us to glimpse by putting them
to work in the art of telling tales about ogres and fairies. Pascal wrote
about the same thing around 1657, in a powerfully concise little treatise,
The Art of Persuasion.[19] This text provides the theoretical model for the en-

terprise, which is based on a theology of grace and greed; however, the way the writing breaks off in mid-sentence recalls the interval between voice and writing where, from La Fontaine to Perrault, the most powerful pleasure effects of narration were located.

> No one is unaware that there are two ways by which opinions are received into the soul, which are its two principal powers: understanding and will. The most natural is by the understanding, for we ought never to consent to any but demonstrated truths; but the most usual, although against nature, is by the will. For every man is almost always led to believe not through proof, but through that which is attractive. . . . [W]e believe almost only in the things we like.[20]

Beneath the traditional philosophical terminology and beneath the no less traditional natural psychology of human faculties, Pascal in fact constructs a schema of the human psyche. It involves two agencies called understanding (reason, mind) and will (heart, feeling); their entire function is to structure the effects of discursive forces and thereby to constitute the pragmatic economy of discourses. The Pascalian schema thus opens up the space of the soul to discursive effects according to a double grid that connects and articulates their forces—two places in which that space finds itself irremediably riven in an antagonism in which the Port-Royal thinker locates the traces left by the age-old story of fall and redemption. Understanding and will, the two agencies that organize the field of receptivity of discursive effects, each according to its own logic, are not inert; the economy of effects is not passivity. The human mind and heart are powers that

> each have their principles and the prime movers of their actions. Those of the mind [*understanding, reason*] are natural truths, known to everyone. . . . Those of the will arise from certain natural desires, common to everyone, such as the desire for happiness which no one is without, apart from several particular things which everyone follows in order to achieve it, and which, since they have the capacity to please, are powerful enough, though harmful in fact, to activate the will, as if they were achieving its true happiness.[21]

It is thus around this conflict between reason (or mind) and will (or feeling) that "true" rhetoric is constructed. The supreme goal of "true" rhetoric is to induce belief, to bring people to accept the true and the good through discourse, particularly in encounters

> where things we want to be believed are well founded on accepted truths [and thus should win our belief in the name of natural reason], but which at the

same time are opposed to the pleasures we enjoy most. . . . It is then that there is an uncertain balance between truth and pleasure, and that the knowledge of the one and the feeling of the other creates a contest whose outcome is very uncertain, since, in order to judge it, we would need to know everything that happens in the deepest interior of a human being, who nearly never knows.[22]

It is precisely in this balancing between truth and pleasure that we find manifestations of displacement, in the field of the Cartesian *epistēmē*, of Augustinian thinking about sign and discourse, a semiology that Pascal (more than Arnauld, Nicole, Lamy, or Malebranche) will redeploy in "classical" representation. In the logics and economies that control its "transitivity" and its referential dimension, in its essentially cognitive effects, the Augustinian Pascal brings to light what escapes him irremediably even while rendering "classical" representation possible and especially effective: in the very transparency of "classical" representation, in its effects of communication and transmission of knowledge, he points up the opacities that shape it, expressions and contagions of affects, feelings and sensations of body and soul.

In order to determine the effects of representation with the rigor of rational knowledge and measure its aesthetic and pathetic effects on belief (the acceptance of truths and values), the human art of persuasion would have to be able to achieve perfect knowledge of the addressee; even when the speaker is exercising careful control over the resources of his own discourse and the forces that deploy ideas and judgments in words, sentences, and argument, he would have to possess total mastery of the subject he is addressing, would have to be able to sound his addressee's inner depths, see into his heart. In short, the speaker would have to be God, or at least occupy the place of God. The reflective dimension of all representation thus remains irreducibly opaque to any human art of persuasion, in particular in its pleasure effects.

From this it appears that, whatever it is one wants to persuade people of, we must take into consideration the person with whom we are concerned [the addressee], of whom we know the mind and heart, the principles admitted [the realm of reason, understanding, "geometric" knowledge], and the things loved [the realm of will, desire, affect and feeling, "erotic" knowledge]; and then we must take note, in the matter concerned, of the relationship it has with admitted truths or of the objects of delight through the charms we attribute to them [those of affect and the feelings of the heart]. So the art of persuasion [the art

of "making believe"] consists as much in pleasing [the art of pleasure(s)] as it does in convincing [the art of rational proof and geometric demonstration].[23]

However—and here we recognize one of the most remarkable features of the Augustinian (Pascalian) version of "classical" rhetoric—the formulation of an art of pleasing, the theoretical construction of a rhetoric of pleasure and ornamentation proves impossible. The subject of representation remains opaque to any discourse of knowledge; the subject effect that representation implies in its presentation is without an ultimate controllable and masterable cause, so that in the final analysis the agency of enunciation ought to be defined and, paradoxically, determined at its two poles, that of speaker as divine subject, and addressee as subject of the unconscious. On the one hand, in order to know "everything that goes on within man," the speaker ought to occupy the transcendent position of divine alterity. On the other hand, if he is to be exposed to the discourse, the addressee should be posited as the place of the depths of lust in the strangeness of self-love and its infinite folds, "which man himself almost never knows." Similarly, any theory exposing the rules of an art (*technē*) of pleasing is discounted as theory.

> But the way of pleasing is incomparably more difficult, more subtle, more useful, and more admirable. And so, if I do not discuss it, it is because I am incapable of doing so; and I feel myself so unequal to the task that for me it would be absolutely impossible. It is not that I do not believe that there are rules as reliable for pleasing as for demonstrating, and that whoever knows perfectly how to know and use them does not succeed as surely a[t] making himself loved by kings and all sorts of people as he does by demonstrating the elements of geometry to those with sufficient imagination to understand the hypotheses. But I consider, and perhaps it is my weakness which makes me believe it, that it is impossible to achieve. . . . The reason for this extreme difficulty comes from the fact that the principles of pleasure are not firm and steadfast. They are different for everyone, and vary in each particular, with such diversity that there is no one more unlike another than themselves at different periods. A man's pleasures are not the same as a woman's: those of rich and poor differ; prince, soldier, merchant, bourgeois, peasant, the old, the young, the healthy, and the sick; all vary. The slightest mishap changes them.[24]

The reason it is "impossible" to formulate the rules of the art of pleasing, those of the pleasure effects of discursive representation, involves not simply the (near) impossibility of knowing everything about human-

kind—for "man" is not an intelligible totality, exhaustible in his rational structure, but an inexhaustible, unsummarizable infinity ("man infinitely surpasses man"), or a singularity whose ultimate difference in the lived temporality of experience is unattainable (each man is different from himself at each moment, each one is infinite difference). But this reason has even more to do with the impossibility of mastering the diversity of the situations and contexts of enunciation: sexual and biological difference; social difference, and so on—situations and contexts that are as irremediably singular as the enunciating subjects that find themselves situated there.

But if a theory of the pleasure effects of representation turns out to be beyond the scope of a rhetorical science of humanity, of a discursive semiotics or even a discursive pragmatics, a certain practice of discourse, on the contrary, a certain practice of enunciation that would have an acute consciousness of the radical "human" impossibility of a theorization of the art of pleasing, a rhetorical practice that would find its aim in the thought of the singularity of the one to whom it is addressed, of human beings as infinite difference, such a practice of discursive enunciation might—perhaps—put such effects to work, put them into action. It might even put into place what could be called an erotics of discourse, an erotics of language: language is no longer (or at the very least, it is no longer only) an instrument for the communication and transmission of meanings; representation no longer stems (or, at the very least, no longer stems only) from a semiotics. Discourse is first of all a dialogical power of persuasion, not only seeking to "induce belief," "gain acceptance" of truth, but seeking as well to "make oneself loved"—or at least "not to make oneself hated" in order to escape the hatred of others, the war of all against all that is the iron law of the state of nature. To make my addressee love what I am proposing in my discourse—truth or values—through the pleasure effects of my representation of that truth and those values: such is the great Augustinian thought of an erotics of discourse and its aesthetic and pathetic means for satisfying the irrepressible desire for happiness, a natural desire common to everyone, which the original sin of humanity "suppressed" but did not completely destroy.[25]

Thus signs and the organization of signs of language are subject in Augustine—and Port-Royal adopts the same approach—to the rule of usage. Human beings must use the signs that mark their path toward the delectation of God, which is humanity's sole need; these signs indicate that goal by tracing the return voyage toward the fatherland. But we sinners have inverted the rule for the use of signs and turned it into the rule for seek-

ing pleasure. Instead of using the signs of happiness as instruments for the attainment of happiness and as means for realizing our desire, we have turned those signs into objects of fruition, goals of our desire, in short, into objects of pleasure that divert us in diversity and in the nonsatisfaction of the only thing we need.[26] Instead of being means and instruments toward the goal of happiness, signs of happiness have become autonomous partial ends in which the desire for happiness is fulfilled; pleasure is *jouissance*, appropriation and consumption of signs, perverted substitutes for humanity's unique goal.

> All men seek happiness. There are no exceptions. However different the means they may employ, they all strive towards this goal. The reason why some go to war and some do not is the same desire in both, but interpreted in two different ways. The will never takes the least step except to that end. This is the motive of every act of every man, including those who go and hang themselves. Yet for very many years no one without faith has ever reached the goal at which everyone is continually aiming.[27]

In this fragment, Pascal returns to the central motif of *The Art of Persuasion*, that of the infinite diversity of situations and positions of enunciation, that of enunciation itself as infinity, but while positing that diversity as an essential nonsatisfaction of desire, as a radical lack of object. "All men complain: princes, subjects, nobles, commoners, old, young, strong, weak, learned, ignorant, healthy, sick, in every country, at every time, of all ages, and all conditions."[28] The agency of discursive enunciation is, in its own order (the order of signs and language), a positioning agency of the desire for being, the desire for happiness, the desire for fruition, a desire whose pleasures are never anything but a temporary, ephemeral, and unsatisfying fulfillment:

> What else does this craving, and this helplessness, proclaim but that there was once in man a true happiness, of which all that now remains is the empty print and trace? This he tries in vain to fill with everything round him, seeking in things that are not there the help he cannot find in those that are, though none can help, since this infinite abyss can be filled only with an infinite and immutable object; in other words by God himself.[29]

Thus we can understand the interruption that suddenly intervenes in the writing of *The Art of Persuasion*. Its incompletion opens up the blank space—an inaudible, uninscribable space—of persuasion, of an accep-

tance of the true that would be the pleasure effect of grace in ordinary dis-
course. "One of the main reasons which so put people off who are start-
ing to penetrate the understanding of the right way they have to follow is
the concept they first encounter that good things are inaccessible by being
labelled great, mighty, elevated, sublime. That ruins everything. I would
like to call them lowly, commonplace, familiar. These names befit them
better. I hate these pompous words. . . . "[30]

Within our Pascalian interruption, why not introduce the resonance of
an echo from the dedication of "Peau d'âne":

> There are those whose limited minds,
> Under perpetually wrinkled brows,
> Tolerate, approve, and value
> Only what is pompous and sublime.
>
> . . .
>
> Why must we be astonished
> That the most sensible Reason,
> Often tired because it has been too watchful,
> Through tales of Ogres and Fairies
> Ingeniously lulled,
> Takes pleasure in nodding off?[31]

∼

This brings us back to narrative, to narrative representation and to the
mimetics that controls the economy and the logic of its pleasure effects.
Narrative can in fact be characterized by a double operation: first, that of a
cut or caesura marked in a privileged way by the aorist tense, which is used
for events separated from the person of a narrator. These events are "dis-
connected" from the agency of enunciation, which nevertheless takes them
into consideration in the narrative that it produces; without any interven-
tion on the part of the speaker, the narrative presents phenomena that
came about at a certain moment in time: "The events are set forth chrono-
logically, as they occurred. No one speaks here; the events seem to narrate
themselves," with all the effects of distancing, objectifying, and autono-
mizing implicit in the caesura thus formally marked in the very function-
ing of language.[32] But this first operation is only the obverse of a second
one, which seems to overturn it. Objectification, distantiation in the past,
a caesura breaking with the agency of enunciation and its specific position
in language, a clean cut in the continuous temporal flows of a living tradi-

tion—it is at this price that the past, the absent one, the dead person can make a return to the present world of the living, on the stage of the text or the image, on the stage of representation, as re-presentation.[33] The autonomy, the independence and self-sufficiency that are implied by the gesture of cutting and distancing imply in their turn the possibility of a presence of what had first been excluded from the sphere of enunciation: the presence of the thing or person that had been "suppressed" from it (events "are characterized as past from the time they have been recorded and uttered in a historical temporal expression")[34] is declined here, in the text or the image, in the mode of a return. The past, the absent one, the dead person, these are all present once again, but in the imaginary space of a fiction. We can understand then how "cutting" into the quick of a temporal or existential continuity is the major "objective" condition for the return as narrative re-presence of what has been cut.[35] One of the most profound pleasures of narrative is situated at the point of articulation between the caesura and the return. It is this conjunction between distancing and re-presentation that arouses the most vivid pleasure effect of narration. How? Why?

If we refer to Aristotle's *Rhetoric* 1.11, in which the Stagirite proceeds to draw up an inventory of the various sorts of pleasure, we note that a number of these are not necessarily linked with presence; thus there is a certain pleasure (*tis hēdonē*) that accompanies most desires: "Most of our desires are accompanied by a feeling of pleasure, for the recollection of a past or the hope of a future pleasure creates a certain pleasurable enjoyment."[36] Hence the discovery of the differential and ambivalent character of the pleasure effect of (mimetic) representation: "The lovesick always take pleasure in talking, writing, or composing verses about the beloved; for it seems to them that in all this recollection makes the object of their affection perceptible. Love always begins in this manner, when men are happy not only in the presence of the beloved, but also in his absence when they recall him to mind."[37] In *Nicomachean Ethics*, Aristotle describes the birth of love as a genesis of representation and as its specific pleasure effect: "Goodwill seems therefore to be the beginning of friendship, just as the pleasure of the eye is the beginning of love. No one falls in love without first being charmed by beauty."[38] The charm in the pleasure of contemplation is a necessary but not a sufficient condition of love: "One may delight in another's beauty without necessarily being in love: one is in love only if one longs for the beloved when absent, and eagerly desires his presence."[39]

The pain of absence is thus, less strangely than one might think, the in-

tegral component—at once necessary and sufficient—of the pleasure of desire, to the extent that it is conjugated with the pleasure that grows out of the representation of the loved object, its imaginary presence. That is why Aristotle notes that "even when [the beloved's] absence is painful, there is a certain amount of pleasure even in mourning and lamentation; for the pain is due to his absence, but there is pleasure in remembering and, as it were, seeing him and recalling his actions and personality."[40] Such is the key element of one of the pleasure effects of narration: in the same movement, the narrator recounts the object, the loved being, as past, absent, lost, or dead, and he recalls the loved one to life, but in the element of language or image. To illustrate this point, Aristotle cites the *Odyssey*: "So he spoke, and in them all aroused the desire of lament."[41] It is noteworthy that the poet marks with the formulaic clause "he spoke" (*os phato*) the almost phantasmatic force of King Menelaus's narration, when the latter literally evokes the absent Ulysses, who has not yet returned from Troy. If Ulysses had come back from Ilion, "I would have given him a city to dwell in, and would have built him a house, when I had brought him from Ithaca with his goods and his son and all his people. . . . Then, living here, should we often have met together, nor would anything have parted us, loving and joying in one another, until the black cloud of death enfolded us."[42] Having said these words, having uttered the pure fiction of an impossible union, having recounted that unreality, with his narration Menelaus inspires in every listening heart the desire to lament and the specific pleasure effect of that desire.[43]

From this point on, we may wonder whether one of the profoundest and most archaic but also most enigmatic pleasures of narration, between the pain of loss of the object in the past and the pleasure of its return in language, does not stem from the power of narration to institute an origin and to originate a beginning, to "repeat" an event from the past while giving it, through its enunciation, the "force" of an *initium temporis* in the story told, that is, in its representation. Between the production of the narrative by the spoken word (the minstrel's song) and its reception by the listening receiver, in a situation in which the agency of enunciation is instituted from an exchange and from a practical and symbolic community (for example, in the *Odyssey*, book 4, that of the meal and the hospitality offered), the narrative interlocution, from sender to receiver, can be seen as an occasion for sharing the pleasure of mastering time by making it commence, or rather re-commence, with its representation.

"Learning and admiring," Aristotle writes, "are as a rule pleasant,"[44] for admiration is a desire to learn, so that what is admirable is desirable; through what is desirable, the order of knowledge is advanced and with it all the pleasure effects arising from the cognitive dimension of representation, the pleasures of mimesis and in particular those of narrative mimetics.[45]

> Since learning and admiring are pleasant, all things connected with them must also be pleasant; for instance, a work of imitation, such as painting, sculpture, poetry, and all that is well imitated, even if the object of imitation is not pleasant; for it is not this that causes pleasure or the reverse, but the inference [*sullogismos*] that the imitation and the object imitated are identical, so that the result is that we learn something.[46]

Upon listening to an artfully-told narrative, as upon contemplating a precisely executed image, the hearer or viewer recognizes what each thing represents, that "that one is he," that "that figure is so-and-so": the pleasure of representation is allied with the pleasure of recognition.

Between admiring in order to learn and contemplating in order to recognize, between the pleasure effect of the admirable, the desire for knowledge that it arouses, the pleasure of knowing that fulfills it, on the one hand, and the pleasure effect of representation, the desire for presence that it provokes and the pleasure of recognition that accomplishes it, on the other hand, the full distance occupied by the arts of representation in the world of nature and in the processes of the soul is opened up: the pleasure of representation is the "cognitive" effect of a recognition through which hearers, readers, or viewers rediscover in the work what they already knew in reality: pleasure is a bonus brought by the denotative function of the work, its referential dimension, its mimetic transparency. Here again, but in the order of knowledge, the pleasure effect of narrative representation is the effect provoked by the return of a being, object, or person in an image, narrative, or character—in short, the return of the real in fiction, provided that the "real" is imitated with precision, that the object represented is shaped according to certain norms that are rules of fiction (verisimilitude or necessity of the actions, consistency of the characters).[47] Still, Aristotle does not fail to signal the displacement of the pleasure effect, the referential function, and mimetic transparency to all the varieties of enunciatory opacity: "For, if one happens not to have seen the subject before, the image will not give pleasure *qua* mimesis but because of its execution or

colour [*khroia*] or for some other such reason."[48] From this point on it is no longer the pleasure of re-cognition that the hearer or viewer experiences, but the pleasure that comes from presentation or re-presentation, the pleasure that grows out of encountering the agency of enunciation itself inscribed in discourse or image.[49]

Thus, on the basis of these notes on *Poetics*, a double pleasure effect of narration could be outlined. The first of its modes would have more to do with *narrative* and all its semantic and pragmatic characteristics; to go straight to the heart of the matter, it would stem from the success of the work of mourning for the "real" through representation; it would manifest mastery of time and death through the transparency of the artifact of language or image. The other would stem rather from *narration*, from the agency of enunciation, from all the features of presentation of representation, at the three poles where that presentation is manifested: the places of the sender-subject and the receiver-subject, and the complex contextual site of the acts of enunciation; a pleasure effect that would stem from the opaque characteristics of narrative representation, in particular when sender and addressee are specifically figured in the articulations of the narrative (its frameworks, its edges) or when the enunciatory situation itself is represented in the narrative.

The first pleasure effect is of the cognitive and pathetic order; it belongs more precisely to the pathos of knowledge and of re-cognition. The second pleasure effect, that of narration, is of the aesthetic and theoretical order: in a sense, it exceeds the mimetics of representation since it belongs to the conditions of possibility and effectiveness of that mimetics. Thus when these enunciatory features are represented, the pleasure that stems from this "representation of presentation" is no longer that of a domination of time and death, that of a mastery of the violence of change and the corruption of being and the subject. The pleasure is that of mastery itself, that of the power and strength of mastery implied by the very act of creation in language and in images.

In a difficult passage of *Poetics*, Aristotle notes Homer's excellence.

Homer deserves praise for many other qualities, but especially for realising, alone among epic poets, the place of the poet's own voice. For the poet should say as little as possible in his own voice, as it is not this that makes him a mimetic artist. The others participate in their own voice throughout, and engage in mimesis only briefly and occasionally, whereas Homer, after a brief in-

troduction, at once "brings onto stage" a man, woman, or other figure (all of them rich in character [*ēthos*]).[50]

Homer does not go on speaking from one end of the poem to another; he does not endlessly say "I." He intervenes in his text, puts himself on stage, only briefly; a true practitioner of mimesis, he then goes on to create characters, consistent and plausible individuals, credible fictions. He does appear in the proem, however (as he does in the juridical discourse of the exordium). "Tell me, Muse, of the man of many devices. . . . Of these things, goddess, daughter of Zeus, beginning where you will, tell us in our turn."[51] He appears in order to give a sample of the work, to "show" a sketch of it. The poet announces that he is singing and tells what he is about to sing. As an "I," he stands before his work as before an object (of language): his words have a nonmimetic but metapoetic function. Thus "the hearers may know beforehand what [the story] is about, and . . . the mind may not be kept in suspense, for that which is undefined leads astray; so then he who puts the beginning, so to say, into the hearer's hand [like Ariadne's thread] enables him, if he holds fast to it, to follow the story."[52] Here the text has a phatic function, once again nonreferential; the pleasure of mastery is manifested in the very act of creation, and the power of narration is thus represented at the extreme boundaries of narrative in language or image. As for the addressees, the pleasure they take in hearing or reading is inconceivable, for Aristotle, in the transparent Greek light, without some knowledge of the ending.[53] Only those who know can forget the pain of being in history to take pleasure in the sufferings of the hero.[54]

More profoundly still, the pleasure of creative mastery manifested by the gesture of narration when it is shown and expressed around the edges of the tale, is, for the one listening to the narrative, the one for whom the gesture of narrative is deployed and accomplished, the pleasure—for a moment, the time it takes to tell the tale—of being master of the unknowable and unpredictable destiny of existence, able to contemplate its twists and ruses, in short, the pleasure of being god through the grace of the narrator. . . .

Fontvieille, November 1990–July 1991

Visibility

§ 11 The Ends of Interpretation, or the Itineraries of a Gaze in the Sublimity of a Storm

"My gallant Perseus, tell me by what craft,
What courage, you secured the snake-tressed head."
And Perseus told him of the place that lies,
A stronghold safe below the mountain mass
Of icy Atlas; how at its approach
Twin sisters, Phorcys' daughters, lived who shared
A single eye, and how that eye by stealth
And cunning, as it passed from twin to twin,
His sly hand caught, and then through solitudes,
Remote and trackless, over rough hillsides
Of ruined woods he reached the Gorgons' land,
And everywhere in fields and by the road
He saw the shapes of men and beasts, all changed
To stone by glancing at Medusa's face.
But he, he said, looked at her ghastly head
Reflected in the bright bronze of the shield
In his left hand, and while deep sleep held fast
Medusa and her snakes, he severed it
Clean from her neck. . . . [1]

There was a pool, limpid and silvery,
Whither no shepherd came nor any herd,
Nor mountain goat; and never bird nor beast
Nor falling branch disturbed its shining peace;
Grass grew around it, by the water fed,
And trees to shield it from the warming sun.
Here—for the chase and head had wearied him—
The boy lay down, charmed by the quiet pool,
And, while he slaked his thirst, another thirst
Grew; as he drank he saw before his eyes
A form, a face, and loved with leaping heart
A hope unreal and thought the shape was real.
Spellbound he saw himself, and motionless
Lay like a marble statue staring down. [2]

—Ovid, *Metamorphoses*

This is not an hors-d'oeuvre . . .

Why speak of a painting, again? And why write about it? To say what in the end can never have been completely, exhaustively, said; to say just part of it, to retraverse a slice of time in which *that* painting came back like a haunting enigma, a problem, a question; to keep the "minutes" of that traversal, to stockpile the readings done, questioned, revisited, inexhaustible; to produce dazzling, sometimes patient, often inadequate traces of these readings.

. . . or rather, this is an epigraph

"A small space outside the design, which is used in a medallion for the placement of the inscription, the date": . . . then, by internal extension of this place that is both outside and inside what is found there, "the word, legend, date found in that space," a margin of this text on a painting, a text of that painting, a border on which what will be written finds its place, its word, its date.

Why write to express the pleasure taken in this painting, its particular quality, which varies, however, from one reading to the next? But perhaps it is necessary to write in order to *know* something about the painting, even though no knowledge is purely knowledge, no factual knowledge is without its own specific affect. Which can also be expressed by saying that it is necessary to write this text on that other margin between factual knowledge, familiar knowledge, theory and sensibility, passion, affect. If theory designates contemplation of an object and delight taken in that object, perhaps it is necessary to write this painting so that the theory (of art, of painting, of the work of painting, of a particular painting, of this painting) can be pursued in its delight, so that passion, the affect of the eye, of the gaze, the pleasure of sensibility, can be held up to contemplation as well, can be heightened in theory: a double edge—surely utopian—on which the pure pleasure of reconciling sensibility and understanding in a symbol might be born; a *symbolon*, with two separated parts searching for their desirable junction, this caesura traverses the work of painting. Does an attentive eye, a gaze of contemplation ever succeed in closing this wound? This text on (of) this painting would like to write itself, this gaze in this eye would like to be the scar, a present sign of the cut that has always streaked paintings from one edge to the other, through and through.

An impossible ambition: not so much to turn this painting into a theoretical object as to recognize it as such, a theoretical object affecting the eye, the gaze, with pure pleasure, and to do so by means of a written text that traverses the object. Thus the art of painting—in this painted picture—always has the same theoretical issue. One must not only acknowledge this issue—one is forced, compelled, to do so—but also signify it, to avoid allowing the shadows of its somber half to pass over the discourse of knowledge and science, over its transparency, to avoid allowing its forever nocturnal face to point itself out, by default, although that self-designation cannot ever be realized in a theorem, the theorem of total pacification (passivication) of the idea and the affect in a light so even that any objects bathed in it would cast no shadows on the ground from their positions. For if that were possible, that light would frankly always be a little gray. What is at issue can be compared to Yves Bonnefoy's idea of the other country:

> For the more convinced I am that it is a sentence, or rather a music, at once sign and substance, the more cruelly I feel that a key is lacking, among those that would allow us to hear it. We are disunited, in this unity, and what intuition anticipates, action cannot achieve or face up to. . . . Yet certain works give us an idea of an impossible virtuality. The blue in Poussin's *Bacchanale à la joueuse de luth* [*The Andrians*] has the stormy immediacy, the nonconceptual clairvoyance that our conscience ought to have as a whole. . . . *Here*, then, we are struck by a mysterious ailment of the soul, or else it is some fold in appearance, some defect in the manifestation of the earth that deprives us of the good that it can give. *There*, thanks to the more obvious form of a valley, thanks to the lightning immobilized one day in the sky, as it may be, or by the workings of a more nuanced language, . . . a people exists that, in a place in its own likeness, rules secretly over the world.[3]

Stormy immediacy, nonconceptual clairvoyance, lightning immobilized one day in the sky, in a place, there, almost similar to our own world: this painting.

There is indeed a storm, a tempest, and a secret kingdom, a woman and a mother, and a child: the *Tempête*, the *Tempesta*, a canvas signed by Zorzo (da Castelfranco), a Venetian painter we know as Giorgione (c. 1477–1510), today in Venice, at the Academy (82 x 73 cm.).

Why write—*écrire*—about *a* painting? How to describe—*décrire*—*this* painting? A slippage from one to the other, *écrire-décrire*, thanks to an added letter, the displacement of a reason that explains and justifies by its

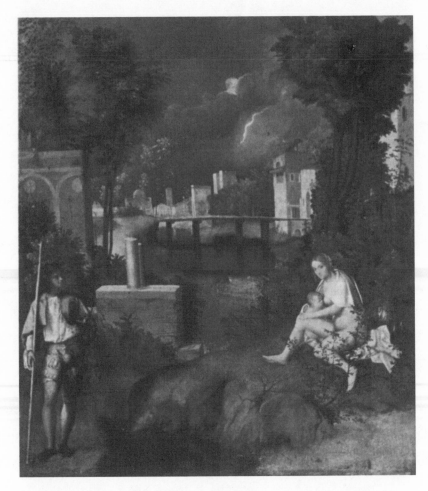

FIGURE 11.1 Giorgione, *The Tempest.* Accademia, Venice, Italy. Photograph courtesy of Alinari/Art Resource, New York.

ends—the purpose of a gaze, of a discourse, of a text, to rediscover the purpose of a painting contemplated, from one theory to another, in which the first is summed up and consumed—into an art of means that interminably makes *epochē* of its end, a technique of language within the image, and on its edge: art for art's sake, yet with something theoretical at stake, with no end except to desire that the one should measure up to the other.

Where to begin? The exact art of the means—no longer to write *on* or

about a painting but to write, to (de)scribe *the* painting—begins only with the choice of that first manner in which the beginning (of the discourse, of the text) is indicated by a crossing: where? *qua?* the fourth question of place that tells itself *no* about a stasis *here*, not movements toward a goal or starting from a point but a moving entity in pure trajectory, without origin or end, which does not remain, which does not define its site except in relation to the trajectory that visits it without settling there, mere transit, intrusion without introduction, departure with no goodbyes: "In the cities through which one passes, one is not concerned with being respected. But when one is to spend a bit of time there, one is concerned. How much time is required?"[4] How to describe? Where to begin?

A certain lightness of approach would be required, in all senses of the term, agility, rapidity without concern for recognition or authority or authorization, an art of means without depth or *constancy*, a bit imprudent and casual, and yet undertaking the task of scribing—of describing—the painting.

The Colossus and the Column: On Interpretation

Opening Edgar Wind's fine book, *Giorgione's "Tempesta,"* one observes that between a quotation from Kenneth Clark and another from Vasari—an initial display of interpretation—irresistibly (inexplicably?) it is the middle ground that draws and fixes his gaze and his discourse: "a pair of neatly broken columns standing upright on a ruined stylobate, with no trace left of architectural motivation, and yet treated with such emphasis by the painter that the eye is drawn to them as it is to the figures. . . . A broken column (to start with this) was a regular emblem of *Fortezza*."[5] Thus Wind begins to traverse the picture, his eye drawn to the double hieroglyphic column, numerical figure and emblem twice displaced in the painting: from the iconographic vulgate into the painted work; one has become two at the moment of transfer and through the fracturing of time, but the cut is so clean and the architectural construction so gratuitous that one can believe it is intentional, an "emphasis" in the treatment of the motif, the index of an intent to mean, of a meaning, on the painter's part: "That pair of truncated columns, standing bravely upright while the tempest approaches, seems to set the stage for the human actors."[6] If Edgar Wind begins *here*, *by* this, among Kenneth Clark's "*impressions*," which are involuntarily as suspect in his eyes as Vasari's somewhat spiteful commen-

tary on the frescoes of the Fondaco dei Tedeschi, it is because the two
columns that have been so properly cut into point up the allegorical mean-
ing just as irresistibly as they are courageously resisting the approaching
tempest: *here*, between Kenneth Clark and Vasari, between the stormy
sky darkening and flashing above the city and the human actors, on this
edge of both stages, on this intermediate semi-decor, meaning intrudes
and draws the gaze to its end: *unde?* of knowledge of the motifs, themes,
and *legenda* of the Renaissance: *quo?* toward the learned (de)*monstration*
of an allegorical abstraction bathed in the poetic atmosphere and wholly
permeated by the painter's highly personal lyricism; *ubi?* in the painting
known as *Tempesta*, an excellent opportunity for the traversal of interpre-
tation (*qua?*).

The question of description is an exasperating one: not only where to
begin to describe, but, at each beginning, why precisely there? In this par-
ticular case, why begin with the middle ground, with an architectural con-
struction that is twice ruined, since it bears marks of the ravages of time
and since it "manifestly" eludes any architectural function; and why begin
in particular with a pair of columns close together that could never have
supported stone or marble, and that are so cleanly cut, so clearly without
purpose and without end that their cutting can only designate an end and
a goal, an intention of meaning properly calculated by the painter and
that, through this intention, movement in the direction of the interpreter
is begun, toward its end: two columns so properly cut that they do not
support and have never been able to support and sustain anything *but*
Giorgione's "intent-to-make-meaning" and the "desire-to-appropriate-the-
meaning-for-oneself" manifested by Edgar Wind (and others); columns
without end or goal or termination, columns that have no end or goal but
to stand there bravely, courageously, nobly in the face of the approaching
tempest, in an erection interrupted, but cut off or cut down by the artist
to erect meaning, an erection that will be achieved in its end by the dis-
course of interpretation, the final, virile meaning in an allegorical abstrac-
tion, the *Fortezza* of which the vigilant soldier, the noble and courageous
sentinel assigned to guard the gypsy suckling her child, is the other figure.

> Undaunted by the threats of the rising tempest, emblematic of capricious For-
> tune, they display the martial confidence and the maternal affection that be-
> fit "a soldier and a gypsy"—characters whose unsettled mode of life has made
> them familiars of *Fortuna*. Uncertainty is their natural element, the congenial

setting for their virtues. Hence the mysterious unison between landscape and figures, which has always been felt to be the essence of the painting. The wayward elegance of the heedless pair, firm and alone in elemental adventure, is comparable to the grace of the fractured columns, rising from a weather-worn base in which the rough brick-work can be seen below the marble.[7]

This is the way interpretation takes hold, as it grasps the economy of the painting traversed in broad strides. "The wider lesson implied in that astute confrontation of valour and feminine abandon is one that the Renaissance never tired of imparting: that Virtus and Amor belong together—*Fortezza* must be joined to *Carità*."[8]

But everything—description, interpretation—has begun with the cutting of two columns in the middle ground. [In Jacques Derrida's words:]

> . . . a certain *column.*
>
> A colossus, rather, a certain *kolossos* which erects itself as measure [*en mesure*]. What is it to erect *en mesure*?
>
> The column is not the same thing as the colossus. . . . *colossus* and *column* are two indissociable words and two indissociable things which have nothing to do [*rien à voir*] together and which together have nothing to see: they see nothing and let nothing be seen, show nothing and cause nothing to be seen, display none of what one thinks.
>
> And yet, between the Greek *kolossos* and the *columna* or *columen* of the Romans, a sort of semantic and formal affinity exerts an irresistible attraction. The trait of this double attraction is all the more interesting because it has to do with, precisely, the double, and the one, the colossus, as double. . . .
>
> Through the *effigy* . . . and in the fictional space of representation, the erection of the *kol-* perhaps ensures . . . the movement from cise, which is always small or measured, to the disproportion [*la démesure*] of the without-cise, the immense. The dimension of the effigy, the effigy itself would have the fictional effect of demeasuring. It would de-cise, would liberate the excess of cise. And the erection would indeed be, in its effigy, difference of cise. The *kol-* would also ensure, more or less in the effigy of a phantasy, the passage between the colossus and the column, between the *kolossos*, the *columen* and the *columna.*
>
> . . . You come across columns in it [Kant's *Third Critique*], and the colossal is not only encountered, it is a theme. But the column and the colossal do not occupy the same place here. . . . [W]hen it supports an edifice, the column was, for example if not by chance, a *parergon*: a supplement to the operation, neither work nor outside the work. One can find in the *Analytic of the Sublime* a distinction and even an opposition between the column and the colossal.

The column is of average, moderate, measurable, measured size. The measure of its erection can be taken. In this sense it would not be colossal, the column. . . . But the sublime, if there is any sublime, exists only by overspilling: it exceeds cise and good measure, it is no longer proportioned according to man and his determinations. There is thus no good example, no "suitable" example of the sublime in the products of human art. . . . In what examples must one *not* seek the sublime, even if and especially if one is tempted to do so? Well, precisely . . . in edifices and columns.[9]

A marginal note: if the parergonal (or exergonal) column is measured, for Kant, in terms of its usefulness for supporting the building, if such is its size, its proper size, and if the colossal sublime is what exceeds proper size and proportion, what are we to make of a cut-off column (and its twin), truncated, falling short of its size, lacking its proper proportion, never made *in order to* support a building, and yet standing upright, unceasingly standing upright in that lack, a *colossus* falling short of the colossal, not measuring up to a proper column, frozen in its immobility, undisplaceable; erected and cut back, a column whose meaning is read by the desire for interpretation, a desire captivated by its singular phantasm; the apotropaic finality of stopping the approaching storm in the emblematic figure of a couple, a man and a woman, a soldier standing watch and a gypsy mother suckling a child, virile strength and maternal charity.

A tempest:

> . . . in what we usually call sublime in nature there is such an utter lack of anything leading to particular objective principles and to forms of nature conforming to them, that it is rather in its chaos that nature most arouses our ideas of the sublime, or in its wildest and most ruleless disarray and devastation, provided it displays magnitude and might.[10]

When in an aesthetic judgment we consider nature and a might that has no dominance over us, then it is *dynamically sublime* . . . [if it is presented] as arousing fear. . . . [C]onsider bold, overhanging and, as it were, threatening rocks, thunderclouds piling up in the sky and moving about accompanied by lightning and thunderclaps, volcanoes with all their destructive power, hurricanes with all the devastation they leave behind, the boundless ocean heaved up, the high waterfall of a mighty river, and so on. Compared to the might of any of these, our ability to resist becomes an insignificant trifle. Yet the sight of them becomes all the more attractive the more fearful it is, *provided we are in a safe place.* And we like to call these objects sublime because they raise the soul's fortitude above its usual middle range and allow us to discover in ourselves an

ability to resist which is of a quite different kind, and which gives us the courage [to believe] that we could be a match for nature's seeming omnipotence.[11]

The Gaze and Its Figures

How to describe? Where to begin, where to put to work the art of means we call (de)scribing? How to begin so that this beginning may be, in its very initiality, a pure traversal? This beginning, that of a gaze of the painting that comes across the invisible transparency of its surface to gather at the place of my eye. A figure, a woman on the right is looking at me, at me who am looking at her, a figure that I name using the most general possible term "a woman," a figure that is a figure only in order to bear this gaze on the part of the painting toward what is outside itself. Through the figure, the surface (and its underpinnings) called a painting, which is only constituted as such in its destination by virtue of being contemplated, makes a fold in one of its parts, in one of its elements, in order to send back this general and anonymous gaze that is its end while determining its singular place. The figure of the woman is also a figure in another sense, a trope, a conversion in the form of a reversal wherein the painting, the gaze's object and its passion, gazes in its turn, in return, and actively fixes the site from which it is that object while enjoining that it be such. And for this trope to operate, for this figure to be instituted and along with it, the painting, the painting has to figure itself, take shape in a figure, the figure of this woman who is turning her head and looking at me: a figure of reflection which is the painting itself (the painting presents itself for what it is, an object that exhausts itself in the gaze, in this gaze that returns my own), but a figure too, in space, of what the painting represents, on the right, in the foreground, the figure of a woman who is turning her head.

Here one notices that it is both necessary and useless at this point and in the painting to distinguish a "figurative" reading from a "plastic" reading, the first endowing the "surface" objects with a "natural" interpretation according to a reading grid whose key notions would be those of imitation and recognition, the second to point to what the painter sought to "do" and not what he wanted to "say," attempting to articulate the painted surface in terms of plastic categories, lines, contours that establish the discreteness of the various units of the signifier, colors that individuate the terms in their integrality. This distinction is necessary to the extent that the painted object, a framed "picture" delimited as a surface and specific

underpinnings, is not first of all nor essentially an object of discourse in the double meaning of this expression (an entity consisting in words and phrases, and a motif or theme in language) but a visual object for the gaze and for contemplation in the singular assemblage of the lines and colors it offers to view. But such a distinction is useless *at this point*, for the question will always remain: how can a gaze be made visible except through its actor, the eye that directs it and the head that carries it in a body—in short, how can a gaze be made visible without investing the term "plastic," whose relational grasp is constitutive of the work of painting in its specificity as an object, in a "figure" that is recognizable and nameable, in other words, a figure that constitutes itself in linguistic signs: "eyes," "head," "face". . . . Write, (de)scribe this in a single very simple sentence, "that woman on the right, in the foreground, is looking at me"; hear, or read, "that woman, a figure in the painting, is sending *me* back *my* gaze, is returning *my gaze* on the painted picture to *me*."

Where to begin to write? Where to begin to (de)scribe *this* painting? With this pure traversal of a gaze that denounces even as it enunciates for itself the representationalist model and the illusion of pure description, since through this gaze—the figure and the trope of the gaze of a represented woman—the representation (a "cognitive" utterance that represents states of things, that describes—after its fashion—states of things) presents itself, "refers to a reality that it constitutes itself." In "the sense of the represented" is reflected the fact of its representation. In *this* thing that is represented (in what the painting represents, figures . . .), a figure—an actor, a face, a woman's eyes—figures the reflection, and does so by reflection, owing to the fact of its representation: to offer to sight and be seen, the offering of a contemplation. Is it a paradox, this figure of reflection that is part of the represented whole and at the same time its self-representation?

About tropes, figures of expression by way of reflection, Pierre Fontanier writes:

> We cannot always use veils and images in discourse, and moreover there are many in which they are not appropriate. To what means shall we turn, then? In order to continue to charm the spirit of others by exercising it, we shall present our thought only with a certain indirectness, with an air of mystery; we shall not so much express it as imply or hint at it, through the relation between the ideas uttered and those that are not expressed, and on which the first will in some sense be *reflected*, on which they at least call for *reflection*, at the same time that they arouse them in memory.[12]

From the rhetorician's definitions and classifications, I shall retain for the time being only this presentation of thought by way of a detour, in an air of mystery, a detour and a mystery whose effect is both produced by the play of ideas among themselves, among those that are uttered and those that are not, and productive of a recollection, a re-cognition in the intimacy of the addressee.

Let me retain for the moment only the traversal of the invisible transparency of the picture-plane, of the plastic screen, by the gaze of a figure that re-turns my own to me, carrying out the same crossing toward the whole of what is offered to view in the enclosure of the *quadro*.

Let me (de)scribe gazes, or at least another gaze that doubles (copies) that one. Here on the far left, in the foreground, upright in the lower corner of the frame, there is a figure: a man is looking at the female figure who is looking at me as I am looking at the painting: a new traversal through which, from left to right, from the man to the woman, in the description itself, something like a narrative begins, a narrative of which, for the time being, I can only stammer out if not the first sequence, at least the contract, or rather the initial pact, the traversal of a gaze from one place to another, from one bank to another, from a pedestal at the water's edge to a promontory that overlooks it and is sunk into it. Thus the man on the left is looking at the woman on the right, who is not looking at him but is looking at me, and at the whole painting that gives them to me to look at. The woman is not looking at the man as the man is not looking at me but is looking at her. Strangeness, mystery . . . for I, who am not represented by and in the painting, here I am, seen by one of its figures, whereas the man at the far left, in the interminable presence of the painting, is invisible to the woman on the right and yet he is represented, since I am looking at him figured on the canvas.

In this three-way play of gazes, there is thus always a third party invisible to the other two. Thus it is that the painting perhaps secretes its secret.

Let me reread these first statements differently, emphasizing the play and the effects of traversing the "painting": the first exchange of two gazes with which the description began, my gaze on the painting sent back to my eye through the gaze of the figure on the right—to be grasped, affected by it from the beginning in the very activity of my contemplation, of my theory—this exchange of two entirely heterogeneous spaces in two of their places, in two of their figures (the space of what the painting represents and the space in which the painting is presented, the space that the

frame encloses and the space "outside the frame"), the one where the painter once positioned himself, at the beginning of the sixteenth century, the one in which I position myself now in the Academy, that exchange— or that traversal of the invisible surface of the painting, invisible because it is transparent, from one eye to another—is displaced here, turned around by a new trope, lateralized *in* the "internal" space of the painted work, from the figure on the left, the man, to the figure on the right, the woman, in a plane parallel to (although slightly divergent from) the plane of the picture (the plastic screen, the space of representation, its surface). The first is doubled and copied in the second, similar and different: *a relation of depth* between two heterogeneous places, between a figure of the painting (which fictionalizes its representation by reflection) and the real or potential viewer, I who am looking, is transformed or transferred into a relation "of breadth" between two figures of the painting, a man and a woman, its two poles, which belong to the same world.

A second "picture," which is invisible to me (since I shall never see anything but its evanescent profile perpendicular to the canvas I am contemplating), a fictional "painting" (a fiction that is my own but that is also the one that the figures of the "real" painting are maintaining) is thus deployed under the gaze of the man on the left: from his edge, from his site near the water, he contemplates on the promontory, from the other side, a woman who does not see him, the fine profile of a face, a gaze that is fleeing toward the right (what or who is she looking at?), a lovely nude body seen from the front, in a recess of trees and leaves. He *surprises* her in the act of seeing something or someone, myself, whom he does not see, I, who surprise him in turn in his surprise. He surprises her in her privacy (she does not see that she is seen) as I surprise him in his (he does not see that I see him), as I myself might well have been surprised, a moment ago, by that figure of a woman who saw me seeing the painting in which she figures when I approached to see it. An instant of shock, immobilization, an instant of suspense that lasts forever: a story of voyeurs surprised in the enjoyment of their secret perversity in which the chain of surprises is hooked onto that first gaze of the woman who captured my own, already almost a Medusa story, a narrative of a lovely Gorgon, but with *shared* magic, since three "characters" are caught up in the round of stupefactions, although the round is always already immobilized in the present presence of the painting.

Perhaps this is the way the viewer (myself) entered into the space of the

painting. This is the way my theoretical gaze (of contemplation) on Giorgione's painting, *Tempesta*, in search of its truth (let us leave the possessive undecidable for a moment: the truth of the painting, the truth of my theory) is turned into fiction by the male figure on the left in the foreground. The man is seen by me and does not know that he is seen, as I am seen by the woman who does not know that she is seen by him. (I imagine the title of a libertine narrative: "Stolen Glances.")

This transformation, which affects half the field of the painting, the first level up to its limit, which has already been re-marked by the double truncated column, could be rewritten as follows: the male figure on the left is the delegate or representative of my gaze in the represented space of the painting. The man is the representative of my representation and, thanks to him, my gaze is figured (a fiction of theory, of contemplation) in the painting. Thanks to him, in a word, I see my gaze in his figure: such would be the provisional outcome of this story of gazes on the proscenium of the painting, a way of answering the question: "What eye can see itself?" Stendhal asked this question in *Henry Brulard* by way of a fictional dialogue of the dead: "If there is another world, I shan't fail to go and call on Montesquieu, and if he says to me: 'My poor friend, you have no talent whatsoever', I shall be angry but in no way surprised. I often feel this, what eye can see itself? It's not three years since I discovered the *reason why*."[13] An answer, then: produce an eye or find one, invent the figure of one, simulate (fictionalize) the truth of theory and the theory of truth, mine, in both cases, at the heart of the chiasmus.

"Ideational representative. . . . Idea or group of ideas to which the instinct becomes fixated in the course of the subject's history; it is through the mediation of the ideational representation that the instinct leaves its mark in the psyche,"[14] that which represents (the instinct) in the domain of representation, that which is its delegate, the proxy of power (and one knows that such a delegate enters into a new system of relations that can modify its perspective and inflect the directions it has been given).

Perhaps every painting—at the very least this painting (hence the power it has long held as an enigma for its interpreters)—is such a mechanism for inscribing the drive to see—to gaze, to contemplate: theory—through one of its figures, here, the man on the left, the ideational representative that operates the fixation of the drive to see by reflection and which, by making it possible fictively to see *my* gaze in my eye *would inscribe* seeing in the invisible itself. "In fact Freud makes a clear distinction between two compo-

nents of the instinct's psychical representative [i.e., that of the instinct to see]—namely, the idea and the affect—and he points out that each of them meets a different fate: only the first—the ideational representative—passes unchanged into the unconscious system."[15] Representation repressed in the ideational representative. Painting, at the very least this painting, as a machine for (de)negating: ". . . only one consequence of the process of negation is undone—the fact, namely, of the ideational content of what is repressed not reaching consciousness. The outcome of this is a kind of intellectual acceptance of the repressed, while at the same time what is essential to the repression persists."[16] This figure of my gaze offers it to view, but it is only its figure. The drive to see shows itself in the figure, while remaining blind to itself. I see *my* figure inscribed on the painting but it does not see itself seen by me, and in the same way, in the whirl of stolen looks, the female figure on the right does not see itself seen by its other; each is blinded in its own gaze. Only mine sees both, and sees itself seen by the one. But is mine not already fictionalized, figured, frozen, inscribed on the left in its figure, which does not see itself seen?—and, having stopped for a moment, the round of gazes starts up again, reinvigorated.

For the moment, let us leave the question of affect in suspense (or displace it into a pure traversal of description of the gazes); let us leave questions like the following unanswered for now: "How does the gaze of the female figure affect me in response to the affect of my own on her (the picture)? Am I invited by her? Seduced? Is this surprise felt as a threat? What is the affective, emotional tonality of the gaze (mine) of my delegate in the painting? How then am I to see the painting in my figure?"

To speak, to write, to (de)scribe gazes is to describe, to trace, an oriented line; it is to describe, to follow a meaning, a direction; it is to let oneself be directed. The gaze of the woman on the right comes to gather me in, to gather itself up, in the dimension of depth, in my eye, its destination; the gaze of the man on the left, in the dimension of width, surprises the woman on the right and fixes itself there. Returned by the female figure, my in-depth gaze on the painting, which she has seized in her own, has become lateral by means of the gaze of my delegate in the represented space.

The Painting's Two Eyes

Thus the place of the viewing point is figured laterally by the male figure on the left, in proportion to the fictionalizing of the vanishing point by

the gaze of the woman on the right. Where is this place of vanishing of my gaze on the painting, the place the woman figures and sends me back from the painting itself by determining the place from which I look at her? A new traversal of the painting is in order, but now across the space allotted to the "tempest."

The question, then, is how to find the vanishing point. Is it possible to pinpoint a place that would be the "true place of the gaze" of the painting, a place formally, structurally, equivalent to the place from which I look at it? How can this be done? How can that art of means (of intermediaries, also of mediations) known as description be implemented? How can one do this with a "Venetian landscape" in which space is constructed, represented, only by the play of light, shadow, and colors? How can one trace the

revealing lines with ruler and compass starting with these surfaces and these regular and regularly arranged volumes, hardwood floors, ceilings with parallel beams, cubes and parallelopipeds that index, within the representation of a "state of things in the world," the constructive activity of the geometer-painter? Giorgione is more discreet, more secretive, and yet it is possible to find a means, a means that is exposed in the middle ground of the painting and in its left half, the boundary level of the scene, the intermediary décor, which—to speak in Edgar Wind's terms—sets the stage for the human actors. And it is here that we rediscover in this architectural construction lacking in architectural purpose, doubly without goal or end, which had irresistibly attracted and fixed the discourse of interpretation in order to lead it to its goal and to its end, meaning: the strange intermediary edifices of the left half, invaded by wild grasses and bushes, the middle half-plane set up as background for the viewer's delegate in the painting, the male figure. These doubly endless structures, a ruined wall (of brick?) decorated with a covering (of marble or stucco), which is interrupted vertically and encloses nothing (and has perhaps never enclosed anything); a bit more toward the foreground, a parapet of disconnected bricks the upper part of which has become a stone stylobate of two truncated columns, a base that has never supported anything, columns that have never held anything up, and, finally a cubic paving stone where the whole ensemble falls to the ground. Parallel to the plane of the picture, might not these *constructions* without end have the end or goal not of pointing to the ultimate meaning of the allegory but of making it possible to *construct* the invisible geometric network of the represented space that gives it its intelligible unity, an *internal* finality of the spatial artifact that is also the painting whose artistic destination is to open up, onto a support structure and in a surface, the whole simulated depth of the world of the figures, the depth that a figure at right figures by the trope of my gaze sent back to its viewing point?

By means of the ruler, let us try to remark, if not that point, at least the invisible place that is sealed, in its surface and its thickness of painting, of figures, by the texture of the painting.

Now it appears that there are *two places*, secret places, from which the painting invisibly fixes the viewer in his own place outside the canvas, two closed eyes in the painted text, two hidden focal points of the topological grid of the space represented on a support structure and in the surface, one situated a bit above, almost on the edge of a roof, almost at the peak of the first building, a square tower, past the wooded thickets on the other

side of the river; the other a bit below, a bit to the right of the last two pilings of the wooden bridge that crosses it, almost on the bank, at the foot of the square tower. I am indeed saying two focal points and not two points of intersection; the ruler of the geometer of perspective hesitates at the edge from which the line has to trace its imperious straightness; its reasoned necessity trembles at these edges, light and shadow, the touch of the brush, the paste and the grain of the pigment blur the straight lines that lack thickness, thicken the points that lack surface. Hence the slowness of a scribing, the heaviness of a (de)scribing that drowns and loses itself in the blur of circumscriptions: "a bit," "almost," "perhaps," as the eyes drown in tears and the gaze is veiled at the edge of the eyelids.

The fact remains that there are two secret places, two hidden eyes, two (elliptical) focal points, two sites of a double gaze missing from what the painting shows, the double blinded condition of the picture's representation, the space of a landscape where the tempest threatens, above the city, at the edge of its river traversed by a bridge, two places secretly pointed up by the structures without end or reason found on the other side, situated on a quasi-vertical line almost at the top of a tower, almost at the foot of a double bridge piling: two places, as there are two truncated columns at their end without end or goal, as there are two figures, a man and a woman, the one who bears my gaze on her, the other who sends me back my own gaze (hers) on myself who am looking at the painting.

To (de)scribe a painting, this painting, is to seek gazes, to trace their meaning, to inscribe their traversal: to sharpen the gaze, to refine its *acumen* in these two places of gazing. At the peak of the roof, at the top of the tower, in the uncertain place, a sign perhaps signals this secret, a white bird, poised, perched on the extreme point of the building, a unique and miraculous living creature of the city, an old crane, across from the fiery serpent of the lightning flash that falls from the cloud, the storm. At the foot of the bridge pier, (almost) directly below the tower where the white bird stands watch, in the other hidden place of the gaze, there is *nothing* except the dense night of the shadow carried from the apron of wood onto the immobile night water, which reflects it like a mirror, nothing but this place pointed up contradictorily by the geometry of the structures with the double cut-off column without purpose or end, at the black base of the last bridge piling, the one *that has become two columns planted* in the water of the river and supporting at their end the apron of the bridge that crosses it, *two columns without a base* except the night and the water, but not with-

out a purpose, since, by means of these two, the bridge is achieved and accomplished.

The two eyes, the two hidden, secret places of the painting secrete a double and discrete figure: the vigilant crane facing the fiery lightning, the two columns of the bridge that hold it up in the night from an abysmal, bottomless bottom. A double and secret figure that operates in the background of the painting, the right half, that works a chiasmus with the two other "inverted" figures of the ruined structure, without purpose or use, on the left half of the middle ground: two columns without base but not without purpose, two columns without purpose but not without base, the bird of vigilance standing watch at the frontiers of the city facing the lightning, the strange covering of the structure on the far left, which, frontally, from the height of its ruin, simulates with its two arches, its pilaster and its two blind *oculi*, the face of a watcher who has been turned to stone, stupefied in stone and brick.

G(i)org(i)one: Zorzo(n): Gorgone.

Let us allow this short phantasmatic figure (a second-degree figure, a trope of a figure of the painting) to act a moment more, this simulation of a guardian-face: let us imagine—and every reading, every contemplation of a painting is made up, *nolens volens*, of nothing but such imaginings—the *oculi* open as eyes bearing gazes, let us imagine the stone and brick animated as if it were a "real" face: then in the middle ground of the painting, in its left half, a head would be raised behind the bushes and leaves, a head would rise up, enormous, disproportionate in relation to the figures of people and things, the colossal head of a colossus, the head of a Medusa or an Argus whose eyes would be staring into mine, into my viewing place, just as, on the right, in the foreground, a woman is looking at me while sending back, returning, my gaze, which up to now has been a general and anonymous gaze on the painting.

To write the painting, to (de)scribe this painting, is first of all to look for a gaze, for multiple, plural, secret gazes sealed into the texture and figures of the painted work, because gazes are pure traversals, generating plural and singular spaces.

This picture returns, a second time, this trope poised on this half middle ground: Medusa-Argus does not grip me, does not capture me, does not surprise me: it is not he (or she) who stupefies me behind the leafy bushes, in his (or her) leafy crown: it is he (or she) who is surprised in the ruin of a stone or brick wall and its pathetic decor.

An old story of mirrors and reflections, which is also the painting, any painting, Medusa caught in her own gaze, stupefied, Argus the attentive watchman hypnotized, fascinated by his own attention and falling asleep, his eyes open, in the beam of my passing, traversing voyeur-gaze, my Hermes gaze.

Yet in the background, at the top of the square tower, facing the approaching storm, the tiny white bird keeps watch; yet in the foreground, on the right, the woman gazes at me, as I face the painting that gazes. Thus is drawn or sketched, at the crossing point of the "perspective-geometric" network that discreetly articulates the surface, a strange figurative network of gazes. This latter network depends on the former and displaces it, transforms it, subjects it to metamorphosis, gives it a motivated resonance: the vigilant crane and the dazzling lightning-serpent, the petrified architecture of a blinded gaze and the turned head of a woman suckling a child and gazing at me. Thus I have—but I knew this perfectly well, from the beginning, in the immediate presence of *this* painting that I am contemplating—or rather my eye, my gaze, has some relationship (figurative? functional?) with the lightning of the storm, through the referential play of these multiple figures.

Let us go on a moment longer: for we shall have plenty of time to return to the tempest, which had immediately announced itself through the lightning and the title given to the painting. Let us resist this too-obvious self-evidence. Would this not be the painting's trap, the trap that protects its secret? Let us defer this fall of contemplation into the fall of the lightning that falls, dazzling; let us allow ourselves some play, the play of free attention (which is not free association) in order not to let ourselves be mesmerized, stupefied by the self-evidence of what the painting presents and what the discourse represents precipitously, falling head over heels, in what it names. Let us not look behind what is shown here, though, for a meaning hidden in the crypt of a mystery: the allegorical numerical figure of univocal signification. On the contrary, let us seek—let us state—only what the painting shows. In a word, let us follow the precept of the old magus (wise man) of Ephesus: the painting, like the god's oracle, neither states nor hides; it indicates, it designates. Let us allow its sign-making (its monstration) to show itself.

For there are indeed two places, two elliptical eyes of the painting reduced to its ambiguous geometrical-optical network. We have seen them. The one toward the top of the square tower in the background between

the bird and the lightning, the other at the foot of the last two pilings of
the bridge, in the obscurity of the motionless water, the bottomless depth.
And to put it very quickly here, there are thus two sites providing viewing
points at the height of a double horizontal line, the one plunging down-
ward, dominating the space represented from a "celestial" place; the other
rising upward, raising, lifting the gaze toward the world of the city on the
other side of the river starting from an "aquatic" point: not the one or the
other but the one and the other, at the height of the stormy sky, which is
consumed in an instant in the flash of the lightning, in the depth of the
night water, the motionless duration of a bottom with no reflection but
the dense shadow of a bridge. The one and the other, neither the one nor
the other, the neutral complexity of oscillation or the simultaneous rhythm
of the gaze produced in the half-opening of two places, two sites, in the
opening of an elementary opposition—one that is figured in the "ele-
mental" polarity of the air, which in an instant has become fire, and of the
water, which has always been dense and heavy in this place. Two places,
thus two eyes, an ambiguous horizon—and this pattern of duality is re-
peated *across* the whole space of the painting and its figures, with the bridge
pilings divided into two on the other side of the river that the bridge
crosses, the double truncated column and the double gaze on me of Argus
stupefied in the ruin and of the woman on the other side of the painting
and the water.

But my gaze—surprised by that of the female figure—has henceforth
delegated its figure within the painting: the man, standing on his grassy
pedestal, beyond the nocturnal pool that separates the two figures and that
his gaze crosses toward the woman who does not see him; the man stand-
ing, leaning on his stick, just as the two truncated columns are standing in
the middle ground on their stylobate of dislodged stones and bricks: the
man standing directly under the stucco (marble) pilaster that decorates the
interrupted wall behind brush and bushes that mingle with its remains.
Vertically aligned with the "nose" of the "watchman" stands the colossal
face—fascinated, petrified in the ruin—which *sees me without seeing me*
with its blinded *oculi*, just as from beneath it "my" profile figure, looking
sideways, sees without being seen by her, the woman who is turning her
head, facing forward in order (?) to see me without already knowing that
she is seen by someone who represents me.

A double column erected without purpose or end stands as does the
double bridge piling, arising from a bottomless bottom. The man with the

lateral gaze that traverses the space (as the bridge traverses the river supported by its pilings) also stands upright (with his stick), looking toward the woman who is looking at me. He contemplates her as I would have been contemplated by the face of the tilting colossus whose gaze is reproduced by the woman suckling the child. She looks at me without knowing that she is seen—already—always already—by my figure, the man who is "for" the woman what she is "for me."

A new network of figures, single or double, is immediately readable in the self-evidence of the visible (nameable) or secretly encrypted by metamorphoses of things (represented) as singular phantasms: double piling, double column, the face of a stupefied colossus, the man and his stick, all repeating variously the same erection, without end or goal or terminus, without bottom or base, all repeating variously the same thrust, the same traversal of a gaze that they return, send back to one another, lose and rediscover: my gaze and the painting's, face to face.

Let us take one more step in our imaginary traversal to read in it—in its figure—the affect of my desire to see, bodily passion in my act of contemplation, the effect of my theory of the painting, Giorgione's *Tempesta*, searching for its truth—its truth, my truth. It will again be a question of a strange gaze, of another gaze on the part of the representative of my own: the grotesque mask of two empty eyes and a nose. Directly under the stupefied colossal watchman (behind the bushy vegetation that encloses his interrupted enclosure), directly under his "pilaster-nose" and doubly crowned by the stucco (or stone?) "arch-eyebrows" and the blinded, damaged *oculi*, the man leaning on his stick, the man and the stick standing upright, looks at this nearly nude woman, who has, for a moment, turned her head to look (at me). A head in profile (for me) is looking at a body straight on and at a head in profile (for him). But he wears a mask—between legs—that signs his agitation at this spectacle: his member stands erect in the sheath of his fly like a colossal nose pointed in *my* direction, a nose surrounded, surmounted by two hollowed-out eyes, two black commas, the folds of his breeches. The pilaster, a pillar caught in the surface of the wall in ruins, the muffled nose of the colossus transfixed on his watch, and the two blinded *oculi* are transformed here into an erect male member and its two orifices in the form of little rods, a sign-mask or rather an affect-effect of a lateral gaze on the spectacle of a nearly nude woman in her niche of greenery, but an affect-effect of the body that takes

the form—still—of a profound frontal gaze, toward the outside, beyond the frame, under the figure of a mask, not a disguise but an *incognito*, "the incognito of [the eye's] passion and under which this passion runs its course without being recognized,"[17] the incognito of my apathetic passion, the contemplation, the theory of this painting in and through my desire to see, while the representative of my desire among the figures of the painting, the man at the far left, manifests the incognito in his distanced and serene, vaguely benevolent gaze. But the tempest threatens, lower down, in a mask, a figure within a figure, a figure turned two or three times, turned away, turned around, a trope to the second or third power of a gaze, a nose-fly and two hollowed-out eyes-breeches signal passion. The tempest threatens below, between legs, as it bursts forth, dazzling, above, a tempest-lightning that also has—as we have seen—something to do with my eye.

Or with my gaze. From the fiery serpent falling at an oblique angle streaking the heavenly cloud and consuming it in a split second under the vigilant eye of the watchful white bird at the top of the tower, to my gaze outside the frame contemplating the painting, two trajectories are thus launched and traced in the network of figures opened up in the surface by the whole depth of the landscape of the scene, the one, upright and on the right, through the female figure turning her head *in order* to look (at me) outside the frame, or perhaps *because* I am looking at her and because she has just surprised my voyeur's gaze; bent down, enveloping in her arms the child at her breast, she would be inscribed in an almond-shaped space except for the movement of her legs, which outline the gesture of getting up and beginning the process of flight; the other trajectory on the left, from the lightning to the double truncated column and the upright man and his upright stick (my delegate in the painting), the representative-representation of my desire to see, a desire twice figured numerically, twice denied, twice transformed into the colossal face inscribed, to be blinded and bedazzled, in the architecture of a wall in ruins, in the grotesque mask observed between legs, at the fly of the breeches where this desire, without seeing, points toward my eye. It is thus as if, from one trajectory to the other, the deep axis of the gaze—its traversal of the plastic screen engendering the represented space of the painting—found itself transformed a first time in the lateral gaze from left to right, from one figure to the other, in which the implicit contract of a narrative is articulated in the homogeneous space of a scene, to rediscover, through a second transformation that

is the inverse of the first, the deep axis of the gaze, but this time distorted in cryptic, fantastic figures that inscribe it only to deny it. But they are the ones that, by "working" the male figure—the delegate of my gaze—by copying it twice, in the colossus and the mask—*show* more of it, say *more* about it, go on at greater *length* (too long, an excess of length), about the innocence of my theory of the painting, about the purity of a serene contemplation of beauty. They are the figures that point (twice) to the effect of the painting, to the affect of the gaze, to the passion of the eye. A right-hand trajectory and a left-hand trajectory, signifying variations on a lateral crossing. There remains the direct path: how does the lightning fall into my eye in the vertical line of its instantaneous undulation in the "deep-surface" of the work of painting? How will that fall from its place end up rejoining my own place outside the painting? How will it traverse all that space and escape from it? That is another story to be written elsewhere.

The Secret, the Fetish

But, to conclude, why not tell this story according to the agreement reached between the upright man leaning on his stick and the woman, the mother who is suckling her child and looking at me? This story: a story of suspense, of suspension. A suspended gaze, a fixed gaze, attached to and interrupted by what attaches it. "I am hanging on, suspended by, your words, I am tied to those that you will utter but that you have not yet spoken." A moment of suspense, of waiting for what is coming, for what is imminent but is not quite here yet even though it is already here. Thus this painting in its landscape: I see the lightning and I wait for it, in its already vanishing brilliance, the grumbling voice of the thunderbolt already on its way to my ear. The object that suspends, to which I am suspended, that suspends me to it and that interrupts me in its very suspension, the object is here and is not here, shown and hidden, hidden-shown: quite precisely the *secret* object that exhausts its hidden substance only to secrete the signs of its hiding place. Perhaps it does not exist? Perhaps it exists only in the signs that indicate it as hidden from view, and perhaps the gaze is thereby hanging on its absence, perhaps the gaze is thereby suspended in that absence presented as hidden? Were the gaze to see it, would it be petrified by it, ceasing forever to see the eyes open or hollowed-out? Would the eye be a nose pointing to a fly or an open mouth already penetrated by the nipple of a breast? Were the gaze to see what a woman's inviting

gaze offers to view, what the mother's legs, half-open, leave and must leave forever concealed, would it be transfixed, bedazzled? Would it see only a blinding flash, the sign of a secret presented, hidden from view in the very moment of its presentation? Were the gaze to see itself in its eye, as the half-open mouth of the child feels itself in the nipple of a single maternal breast that penetrates it, at that very instant, in that blink of an eye, its eye would be closed onto its death.

Is *Tempesta* a secret painting that defies and provokes interpretation, the divination of the secret of what it wants to say, of what the painter wants to show?

Tempesta: a painting *of* the secret, of the painting's secret.

Is *Tempesta* a staging of the sublimity of a storm in a lightning flash that falls on a city, a representation of the unrepresentable in the time of a bedazzlement, in the time of a gaze?

Between a colossus petrified by its gaze and two cut-off columns, falling short of their proper height, without purpose or end, between the double gaze of a vigilant watching bird and of a man who is the benevolent sentinel of his own desire, between a woman who seduces by defiance and provocation and a mother who gives her milk to the child at her breast with half-closed eyes, between a half-open mouth and a breast, there is this painting (known as *Tempesta*), a tableau of the fetish through which the gaze escapes from absorption in its own eye, from its theoretical blindness, from its mortal reflection even while losing itself forever in the fiction of the play of its figures.

Discussion

Participants: Marie-Claire Boons, Didier Cahen, Jacques Derrida, Eliane Escoubas, Maurice de Gandillac, Gilbert Kahn, Sarah Kofman, Jacqueline Lichtenstein, Richard Rand, François Raux-Filio, Adelaide Russo, Tsunekatsu Shoda.

The discussion began with a question from Richard Rand about the doubling of certain figures in *Tempesta*. The question gave Louis Marin the opportunity to stress the importance of a pattern of duality that governs a large number of elements in the painting. In addition, emphasizing the problem of directions, trajectories, and itineraries, by pursuing the implications of one of Rand's remarks and using the example of the bridge, in the middle ground of the painting, that connects the riverbank to the

castle, Marin showed the plastic and figurative motivations that orient it from left to right without being absolutely determining.

Didier Cahen then introduced two problems, the first concerning the importance of color in Giorgione's painting, the second having to do with the possible generalization of a reading of the work of painting by following the pathways of the gaze in the picture. On the first issue, Marin began by raising the issue of the strange economy of light in Giorgione's painting. In the background, lightning flashes, but it does not illuminate: it is a "reflective" luminous source, a sign of pure manifestation, because the lightning is produced and consumed in an instant. The painting and its figures are indeed lit, but by a light whose origin is lacking: the sun is not visible even though the distribution of light and shadow makes it possible to locate its position outside the frame; thus on one side there is light but with a missing origin, and on the other there is an "origin," but one that produces nothing, one that is exhausted in its own production. Finally, there is a third difference in the way the painting makes things visible: the viewer's eye. It, too, is absent from the painting, but its gaze traverses the canvas, even as it finds itself situated, in its viewing place, through the gaze of the female figure. Thus there are interesting correlations to establish between the missing eye and gaze on the one hand, the missing sun and light on the other, and finally the lightning without light in the background. Furthermore, if the male figure on the left is the delegate of the viewing eye in the painting, then one can likewise consider that there is, on the left, a solar eye in the wings of the stage that leaves the traces of its gaze throughout the entire painting: the light in the distribution of light and shadow. More precisely, on the question of color and its economy in this painting, Marin went on to give several examples, in particular, in the "architecture of the storm clouds" recalling that of the buildings of the city in the background. Concerning the second problem raised, Marin, limiting his response to painting with figures, made some suggestions about the way the trajectories of the gaze are marked out in painting.

Sarah Kofman then returned to the pattern of duality. "In this general duality there is one thing in any event that ought to appear double and that appears singly, namely, the breasts of the female figure: she has only one breast. Then, because one always speaks of the maternal breast, and also because the child's head is positioned in such a way that by concealing the second breast, it plays that role itself, I wondered whether, if the child were not placed in such a way that, for him alone, there would be

only one breast: because, for him, and here I am reconnecting with the general theme of the colloquium and with Derrida's *Glas* in particular, breasts could never be a single one, as if that duality were something unsurpassable. The child suckling at a single breast provokes a sort of return of the repressed; this would be responsible for the fact that everywhere else duality haunts the entire painting."

Marin emphasized, along the same lines, the other duality of the woman who is a mother and also a whole series of dual elements in the forms represented, in particular the relation between the dome of the church in the background and the breast of the woman-mother in the foreground.

Adelaide Russo noted that to the question: "Where to begin?" the painting itself offers answers; thus, for example, the celestial lightning in the background and the terrestrial fissure in the foreground construct an axis that draws the eye. Marin responded by wondering whether placing the lightning "at the beginning" of the entire description is not to fall into the trap that the painting holds out to discourse. There is an art of delay when one is looking at a painting. It is indeed an art to delay the obvious fact that there is first of all immediately a flash of lightning. "I know perfectly well that something is passing between my eye and the lightning or that something will happen, but I also know that one must delay that event, for this delay gives pleasure."

Derrida then spoke up. "Two questions about reading. While asking the question 'Where to begin?' you began nevertheless with the two columns. . . . "

Marin: "If I began with the columns, it was a tactical choice and because of Wind, who began with them; that allowed me to raise the problem of interpretation in relation to description."

Derrida: "Those two columns can be read in many ways, but let us take this one: all the elements of the painting are either elements that we shall call natural, or *artefacta* that in general have a purpose. Now the two columns, *artefacta*, seem to have no use, no purpose; they are not even representative works of art, they are truncated, and so on. Here is my first question: what does it mean that you started with them, even as a tactical choice, given that, apparently, they are considered as included in a series in which all the elements are double? Do they occupy only some random place in the seriality you have analyzed or do they occupy a privileged place, constituting something like the 'transcendental' of the reading of this painting? Are they a 'reader' of the painting, at least tactically, and

why? That was my first question. Here is the other. As you alluded several times to the fact that your eye was in some sense engaged in the story and as you often designated yourself essentially as a male reader, I wonder what you might say about a female reading of this painting, of a female place? Is that thinkable for you? Can you yourself hold that discourse? Do you think that the discourse of a woman would be different, a woman who would be assuming her position as female reader?"

Marin: "I come back to the problem of tactics, which is important: the entire beginning of the presentation consisted in questioning the starting point of one or two of the major interpretations of *Tempesta*: precisely those two columns. Wind emphasizes that he is extracting them from the whole in order to point out that they have no architectural purpose. It struck me as interesting, then, to start from there to show how the discourse of interpretation was instituted in relation to what I have called descriptive traversals; and that is why, once that was attempted, I immediately disconnected that description in order to begin again with the woman's gaze, in short, positioning my own viewing site in relation to the painting; and in fact I found in that movement, but much later, the columns among the other elements of the reading of the left-hand middle ground where I found a quite different purpose: that of making the painting's eyes appear, eyes that are not shown, that are not visible."

Derrida: "I have a hunch that my second question is related to the first."

Marin: "Yes, they are related for me to the extent that what is behind this work is an attempt to show how to exit from narcissism, that is, from the impossible dream of seeing one's own gaze: an attempt to show that the representation, the painting was going both to allow and to foil the realization of that dream. So, initially, something like an exit from narcissism, and against that background my insistence on this drive to see with its affect and its detour and its turning away, and at the same time its figurative resolution, enacted fictionally by the figures of the painting, figures among which the character I call my delegate plays a very important role because he plays a somewhat phantasmatic role, both in relation to the architectural constructions in which he is inscribed and through the mask figure inscribed in his body. All that, for me, is what lies behind the two columns erected without an end. . . . "

Derrida: "My question was also a request for information. Given the structure of the painting, supposing there is one that can be abstracted from the position of the voyeur, can the story of the painting allow a

woman to say: 'I who am looking at this painting, it is at me that the woman is looking, at me, a woman,' or must a woman, taking into account what is implicit, the whole history of painting, not tell herself rather, 'I, it is I, a man. The painting has been done so that the one who looks at it is a man.' Does this question have any meaning, historically? I was not asking the question simply from the viewpoint of your situation, your self-designation as male, but to induce a limit of reading. What is the historical signification of the fact that a woman today does not say perhaps as spontaneously as you: 'I am a sexualized being,' while looking at this painting, and if she does so, is it not by transforming a relation with the whole history of painting?"

After a general discussion involving, in turn, Maurice de Gandillac, Adelaide Russo, Jacqueline Lichtenstein, and François Raux-Filio, Marin commented on two points: first, to indicate the interest of a history of the eye to be developed in the perspective opened up by Derrida's question; second, to stress the ambiguity of the female figure in the painting, at once mother and woman, mother for the voyeur-viewer in that she is starting to make the gesture of protecting the child, but woman for the male figure on the left, delegate of the viewer in the painting who, for his part, sees what the viewer cannot see, the female body straight on, legs half-open.

Marie-Claire Boons wondered about the enigmatic central figure in the middle, that of the river, a central form that would lead to a wholly different reading from the one that had been offered, and in which, in particular, the female figure would solicit the woman as woman by saying in its gaze: "Look at the way he is looking at *you.*"

Tsunekatsu Shoda then asked Derrida a question about the distinction in the painting between artificial and natural elements. In his answer, Derrida went back to the two truncated columns. "It is quite an unusual element in painting, unique in its genre, and I think it can serve as double reading head. That was the sense of my first question: I was asking whether that element was simply an element in a serial chain because, despite the singularity that I have just recalled, it also has features that make it belong to a series, erectness, doubleness, and so on, or whether, as a privileged reading head, it leapt out of the series to read the series and at that moment, then, the whole discourse was focused on what a truncated column is, a double truncated column, on what a colossus is, and so on."

Kahn: "I did not understand the answer to the question about the fe-

male gaze, since it seemed to me that this question called into question the notion that the painting can only be viewed by a male gaze."

Marin: "My answer was an ambiguous one in proportion to the ambiguity of the female figure. The mother's frightened gaze in the face of a gaze threatening the intimacy of mother and child soon slips into a gaze of provocation, challenge, seduction, and my own positioning as viewer is also going to shift."

Derrida: "Could one not say that instead of having to choose between a painting that dictates the masculinity of the gaze and a painting that dictates the opposite, there may be a conflict of forces within the painting and between the painting and all its possible viewers? From that point on, according to a historical interpretation of the painting's structure, the dominant dictate of the painting would be to constitute men as privileged viewers; but, to do this, it would lateralize, marginalize, repress another element. Then, in this conflict, which is the whole history of the reading of the painting, of its tradition, there would be a relationship of forces that could be modified and could give rise, today, for example, to this intervention: the woman is looking at me and it is starting from her question or from that woman's gaze that I reinterpret this painting and that I displace historically, politically, the 'self-interpretation' of the painting or of its dominant dictate."

Eliane Escoubas, returning to the question of the history of the gaze in painting, noted with reference to the example of a painting by one of the Le Nains that a century and a half later, the gaze constituted a certain transcendence of the subject, whereas in *Tempesta* the subject is introduced into the painting. This transcendence of the subject is, in a way, the logical aftermath of the conflict of forces that Derrida was talking about, a conflict that existed as early as this painting itself, where the gaze is male and where there can be no female gaze on it. Might there not be a link between this male gaze and the transcendence of the subject that appears later on?

§ 12 The City in Its Map and Portrait

Research Proposals

In Thomas More's *Utopia*, a book that was a best-seller at the beginning of the sixteenth century and is recognized today as having a paradigmatic character for the philosophy, theory, and practice of architecture and urbanism, the "reality" of cities was simultaneously affirmed and denied. This "reality" was posited by the proliferating presence of cities and the attention devoted to them, but it was also eradicated, ideally and theoretically, as it were, by the way cities were integrated into the various spaces in which they nevertheless acquired their essential dimensions and functions.

Thus it is not surprising to note that More's text gave a prominent place, a hierarchically primary place in relation to the continuities and evolutions of history, to geography, in the etymological sense of a writing of the earth: geographical spaces and places thus articulated were simultaneously artifacts of both the founding lawgiver and the writer. "Utopia" was at once the artificial island constructed by Utopus and the project for an island described/written by Thomas More. And yet in its very contours that island was also, in some sense, a schematic rendering of England.

But that utopian geography was realized more fundamentally still in cartography: the geography of the island was constructed in the writing of a map of which the essential feature was an arrangement of fifty-four cities spread throughout the countryside, equidistant from one another and all alike, thus constituting, by a simple schematization, an orderly seedbed of urban places. But at the same time, as part of this arrangement, a central city, a capital, was identified. Hence the key problem: how, on a map, could

one articulate redundant and repeated geometrical regularities with a centrality that necessarily implied a hierarchy and a norm?

Finally, More's text signaled the importance of *urban architecture*, of "architectography": the city and its neighborhoods, its houses, streets, and gardens. This urban architecture gave an overall shape and a hierarchical structure at once to a *topography* (an articulation of places and spaces), a *political space*, and an *economic dynamics*. The cartography of the city, in its places and spaces, was identified with a politico-economic project: it was nothing but the writing (the design/drawing) of that project. The totalization of the one inscribed the perfection of the other in space—and what is a perfect project if not, as the word "perfect" signifies, a fully realized project? The (utopian) cartographic totalization signified the complete realization (the perfection) of the utopian project. In other words, it signified the project's disappearance.

On the other hand, More's detailed analysis of the (fictional) topography of the city in its places and its surrounding space, in its relation to political space and to the economic dynamic, brought to light lacks, blank spaces, absences or excesses, overdeterminations and condensations. Now these lacks and these excesses (which could appear only in the analytic discourse of the book, a descriptive metatext) constituted a system. The local inconsistencies (specific places in the text) constituted an overall coherence. A project reappeared in the cartography, but one that was not desired either by the utopian hero or by the utopist writer; devoid of intention, this project was the very intentionality of the cartographic mechanism: the inconsistencies of maps (constituting a system) traced and projected onto maps themselves, at the dawn of the sixteenth century, what might be called the maturity of a capitalist organization of the world. One could attempt to demonstrate this claim on the basis of three propositions:

1. A map of a city represents the production of a discourse on the city.

2. The deconstructive analysis of this representation (an ironic paradox of a proposition put forward to people whose function it is to build) brings to light the ideology—the implicit presuppositions—on which this discourse is based.

3. A map of a city is a "utopics": it allows mutually inconsistent places and spaces to appear; this set of inconsistencies figures the project conveyed by a map (I use the verb "figure" to preserve the values of fiction and pretence in which the project is manifested).

Some comments on these three propositions will give us a few instruments to work with.

First remark. A city map is the representation of a production of a discourse on the city, of a speech act or a complex series of speech acts—in other words, it is precisely the representation of an act of enunciation. Like any representative device, a map possesses two dimensions. The first is transitive: a map represents something—its object. The second is intransitive or reflexive: a map (re)presents itself representing something—its subject. As representation, a map at once signifies (asserts its utterance, the theme) and shows that it signifies. This "monstration" or presentation constitutes the cartographic enunciation whose specific modalities we are seeking to identify. These latter, in language, may stem either from the major syntactic functions (interrogation, intimation, assertion), or from the formal verbal modes (optative, subjunctive) that express the speaker's attitudes toward what he or she is uttering (prayer, wish, apprehension, expectation . . .), or from operators of uncertainty, possibility, necessity ("perhaps," "apparently," "always"), and so on. Let us also note that, from this viewpoint, monstration or enunciation cannot be tested for truth value. Thus we shall have to be particularly attentive to the deontic modalities (the obligatory, the optional, the permitted, the forbidden) and to certain forms of intimation such as "instruction," of which users' manuals are characteristic examples: in French, "instructions for use" are written in the infinitive mode, as are descriptions of manufacturing processes, recipes, tourist itineraries, and directions for taking medication.

One of the questions that can be asked of a map, a cartographic map of a city, is thus the question of its enunciation, its self-presentation as a representative of a city. City maps were once called city portraits. A portrait of an individual and that of a city in fact raise related problems, having to do with the issue of cities as individuals. How do we recognize that a portrait or a city map is indeed a portrait or a map? What does the criterion of resemblance signify? In the precision and faithfulness of a map, what is the place of fiction and figuration? Might this faithfulness be a rational requirement that functions like an enticement to read? At what level might these effects operate?

The very term "portrait" is interesting and revealing: the "pro-trait" is what is put forward, pro-duced, extracted or abstracted from the individual portrayed. It is a model in the epistemological sense, but it is also what is put in the place of . . . , instead of . . . , what is substituted for. . . . In

"portrait" the trait, the line drawn, refers us back to the trace, vestige, remainder, or "ruin," but also to the drawing that is a design, and, in the final analysis, to the pro-ject. From this perspective, this design-drawing is the very structure of the pro-ject as an intended, targeted, meaningful action, as intentionality; in short, it is the structure of the enunciation. A portrait, a city map, is thus at once the trace of a residual past and the structure of a future to be produced. The question then becomes the following: how does a city draw its own portrait in its map? According to what modalities—assertive, prescriptive, instructive, epistemic, alethic, deontic, and so on?

Second remark. If we deconstruct this representation, we bring to light the implicit presuppositions on which a discourse on cities is based and around which it is articulated. The deconstruction of the representation that is constituted by a city map is already begun by the double "play" of portraits as trace and vestige, as trace, design, and project, by the discourse that interrogates enunciative monstration as to its various modalities.

To deconstruct the representation of a city in its cartography is thus to take a map as a text, a text or a tissue, that is, a framework and a chain, a specific combination of expressive materials—two essential ones, under the circumstances:

—the (visual) image, the icon, in the expressive form of graphic lines, a drawing that may sometimes be colored in, but in which the drawing, the lines, predominate over the coloring; hence the problem raised by the functions of color in maps;

—the language, or rather the symbol or sign as writing, as inscription, that is, in the expressive form of symbolic graphic lines. To make the map into a text is to show how the topical signifiers, the expressive materials in their reciprocal forms, are woven together, to show how the various forms of the content are braided. On this basis, we may well wonder where the symbolic enters into the iconic; we may wonder which are its places and/or spaces; and we may wonder, too, whether the inverse question of the place of the iconic has a meaning, whether it can even be raised.

But is not asking place questions of icons and symbols also a way of questioning hierarchies and dominances, or even dominations? We may thus wonder what meaning effects result from this complex interweaving of heterogeneous forms of expression and content. Is a city map read or seen? Presumably both. But the problem is then not only to understand how the two are articulated (can one see without reading, read without

seeing? is seeing a necessary condition for reading, or the inverse?) but also to know what meaning effects may be produced by the reciprocal blurring of these two semiotics.

And in this connection, the question evoked earlier about portraits comes up again: what does a city map represent? A city, to be sure, but that is too perfunctory an answer in its brevity, and its apparent self-evidence manifests the weight of the referential illusion that comes to light as soon as its variable forms are considered in history and in cultural fields.

A third remark, finally, concerns the way the "utopics" of cities is brought to light in their maps, and for that we must go back to the question raised at the outset: how is a city map a (re)presentation of enunciation? How does it show the enunciation of its cartographic utterances? More precisely still, how does a city map constitute itself to utter the enunciation of a discourse on the city, the city's enunciation, in the double sense, objective and subjective, of the genitive?

Three suggestions may help us answer these questions. First, we can look for markers of the cartographic enunciation. In language, as we know, quite specific indices denote the agency that is proffering the discourse in question—for example, indices of person such as "I" and "you"; indices of ostention such as "here" or "there"; demonstratives; temporal forms determined in relation to "I," the center of the enunciation whose time is the present. Do we find their equivalents in a map or portrait of a city?

Next, we can show how these markers of enunciation have been specified historically, sociologically, culturally, just as forms of language can be determined by the context in which they appear, and by the way they are produced. Thus, for example, a speaker's intonation may allow the addressee to understand an utterance in the constative form as a question or a command.

Finally, we can look for the frequencies with which certain of these markers recur; their recurrence indicates a discursive position on the city, and it articulates, in a map, a project on the part of a city in the sense of a signifying intentionality, which is that of the enunciation of the text constituted by the map. I have to stress that we are not dealing here with a deliberate "urban policy" that has been thought out and decided upon by a subject of power (legitimate or not) and that is inscribed between the lines of the city maps. We are dealing rather with the inverse: the way the cartographic mechanism functions as a signifying intentionality produces the subject of power whose "urbanization policy" will be, to a certain extent,

the specification of that signifying intentionality. The project will thus have a double meaning, an intentionality and a trace, a transformative aim for a city and a vestige inscribed in the representation of its map, a design structuring its possible future and a drawing signifying its staging.

The power of cities lies in the dynamics of urban flows presented as signs, as representation, and here again we find the inscription of a city's project in the cartographic space and its places.

Narrative and description are two major modalities of enunciation. More precisely, they are two very different ways of "disengaging" enunciation, of "throwing it out of gear." Enunciatory "disengagement" is the term used to characterize what happens during a speech act when the agency of enunciation disconnects certain of the terms and forms that are linked with its fundamental structure—for instance, "I," "here," "now," the present tense—and projects them outside the enunciation, thereby constituting the foundational elements of the discourse-utterance. Thus a narrative is created through disconnection from the time of the enunciation (the narrating speech in the present) and from the time of the utterance (a bygone past) and, in addition, through the erasure of all personal pronominal marks, for which the mark of the third person is substituted. In narrative, events seem to recount themselves as they appear on the horizon of the past, seemingly without being related by any person.

In description, this "disengagement" is ambiguous: it is a matter of making the addressee see (and thereby of seeing) the object described from everywhere and from nowhere. The descriptive agency is in the present because it affirms itself as present in all points and all times of the object it describes: as in narrative, there are no indices of person, but there are indices of ostention ("here," "now," the present tense). The object seems to offer itself to the gaze in the simple present coexistence of its parts without any need for a descriptive agency to be marked in order to describe it.

On the one hand, then, with description, we have a gaze situated outside all viewing points, a synoptic gaze that encompasses and includes a stable order of places. The corresponding text will be made up of classifications of states, an order of distribution of the elements in relationships of coexistence, of structural arrangements of positions, in short, the text will consist of a paradigmatic projection of which the prototype is the *map*.

On the other hand, with narrative, we have the gaze of a traveler in mo-

tion, working through spaces and itineraries, successively occupying viewing points that are connected with one another by oriented trajectories. The text will be made up of processual strategies and tactics, and the space will be the effect produced by the operations that orient it and temporalize it in a polyvalent unity of conflictual programs or contractual proximities. In short, narrative is a vast syntagmatics with plural syntaxes, a whole consisting of traversals, itineraries, trajectories.

But description and narration are closely linked: by inscribing a trajectory, narrative makes the voyage "happen"; it dissipates the mobility of its performance in the stability of the traces constructing the order of the places traversed. Every narrative is thus the construction of a configuration of places as the inscription of a trajectory. The portrait of a city, as its profile or one of its possible profiles, a topographical view, is a reification of the "narrative" through its beginning or its end, in its spatio-temporal indices: the city as it is seen (or could be or could have been seen) at the moment of the traveler's arrival or departure. Thus we understand that the topographical view can be oriented by an epistemic and alethic modalization depending on whether the displacement is possible or plausible.

What is described, on the contrary, is a configuration of sites in the proper order of a coexistence. But in its very inscription, it implies the intrusion of narrative syntagmas in the discrete form of possible trajectories. What is described deploys a matrix or scenario of virtual spatializations as an arrangement of spatializing strategies. The map of the city is thus its total synoptic and geometrical overview: what is described constructs its dynamic according to propositions—projects—of possible trajectories endowed with stable articulations, with spatial reference points and markers. The map manifests the city as it could be traversed, and perhaps as it is necessarily traversed, by the city-dweller, without any possibility of error, according to obligatory itineraries. For every narrative, the point of departure and the point of arrival are places that condition the production of the spaces deployed by the actors and actants of the narrative utterances as they move about. As Michel de Certeau demonstrated convincingly, places and the order of places are defined as a law in the immobility of a tradition and a memory in which the authority that produces it is founded. From this standpoint, a map can be viewed as the set of structural arrangements of strategies of displacement in which privileged names and signs cause the authority and the law of the local order to be recognized. In contrast, every narrative can be seen as a way of setting itself (i.e., of situating its readers)

outside the law of place, or, conversely, of extending the law of a specific place to other spaces.

We can thus identify the indicators of location and the operators of spatialization in the text of the plan or project; they are linked to one another by implication, presupposition, or condition. A map can then be taken as the postulate of a possible itinerary (narrative), of a project that will then be the dynamic trace of this postulate in which the project-trajectory will appear as the necessary condition of a local configuration, as the "projection" of a map to come.

The enunciatory "re-engagement" in maps and portraits (profiles) can now be accomplished not only through the intertwining of two or three typical signifiers as images (multiple or unique, fixed, simultaneous) or graphic traces of languages (names written in the image or outside it, in "offstage" writing and in writing within the frame), but also through the combination, if not the integration, of a map and a profile or portrait, either in the different locations of the complex artifact-object called a "map" or in a compromise formation such as a bird's-eye view. If we follow this approach, in short, the issue of markers of enunciation arises here at the place where a map and a portrait are articulated. The markers in question are those that indicate the articulation or connection between narrative and description, that is, two disengaged signifying sets.

We can thus wonder, for example, about the status of the "written verbal" material in the map, the verbal graphic traces with which the map is dotted. How are written syntagma that are read from left to right combined with lines of a map, which cut up its surface in neither a linear nor an oriented manner? The line of a street can be traversed by the eye in two directions, but the name of that same street is inscribed and read there from left to right. The superimposition of graphemes over the lines of a map give it orientations of reading and trajectory that the map would not have in its own expressive substance.

At the level of the form of the content, the written syntagmas are for the most part proper nouns, autonyms. They designate a place whose name they announce. Toponyms, as quasi-indices, point to individuals, to singularities. By that very token they mark off an infinite multiplicity of possible individual trajectories. They are the fundamental elements of the enunciatory disengagement of the graphic verbal dimension of the map. The autonomy of proper noun signifiers is a very powerful factor in the referential illusion. The toponymic proper names put in place not so much lex-

emes of the map as such—that is, reading units, position-finders—as "quotations" or fragments of code. More precisely, they initiate the construction of codes: touristic, historical, geographical, and so on.

In a portrait or profile of a city, proper nouns have a different function. The toponymic proper noun may be in the position of a legend in a nomenclature: the most interesting examples are those in which the same whole presents both a map and a portrait of a city. The reference letters in the profile refer to a nomenclature of names. This double "reading" places the viewer of such a city portrait in an ambiguous position: he knows the name of what he sees from a certain viewpoint. But it is more a process of recognizing the name on the basis of the sight or the icon of the "thing" represented. This is not the name of the monument or the place. Moreover, the term "recognition" must also be understood in the sense it has for soldiers or explorers: it refers to a space seen from a viewing point at the top of a hill. Here a metatextual mechanism stemming from the processes of spatialization I have described is put into place. It produces utterances of the following type: "When you enter Strasbourg and you see a church of a certain sort, then you are in front of the cathedral." It marks out a trajectory through names by constituting the toponymic paradigm of nominal competence at the moment of narrative performance: in fact, from the portrait's narrativity only one sequence of the possible narrative, the first or the last, is present. The names in the legend are the markers of possible trajectories that name narrative sequences, sequences that are not shown but named.

Moreover, by inscribing no name on or beside things, but only letters referring to the paradigm-legend situated outside the "image," any possibility of linearizing or spatializing the streets and squares by virtue of their names is eliminated. An insistent disjunction is installed between the iconic regime with uttered enunciation (point of view) and the discursive (disengaged) regime, between knowledge, or competence, and seeing, or performance. On the contrary, all the possible manifestations of spatialization and narrative orientation are opened up, although we shall never know anything about them except by imagining fictional itineraries within the city. Here, this disjunction is the place where the imaginary is precipitated, through anticipation or memory. More simply, viewers may limit themselves to contemplating the city from a distance without ever penetrating into it. A city's theory is installed curiously at a distance, its ideal, theoretical portrait, to which is added knowledge of its names, without any direct experience of the city.

The Iconic in the Portrait of a City

The city here constitutes a picture in the typographic view. Not only does the portrait-picture—the representation of a city—represent the city for us, it also presents itself representing it, and it does so by means of a very interesting modality, assertion: "Here is Strasbourg with its most beautiful buildings." This assertion, nevertheless, is combined with what I shall call a theoretical prescription: "Here is the point from which you *must* see (contemplate) Strasbourg and the names that you *must* know if you are to recognize what you are contemplating. Here, then, is the point from which you *must* see the city to know its truth." The urban portrait or profile is in this respect an essential profile (in the phenomenological sense), the eidetic profile of the city: its truth.

The eidetic profile consequently unveils the deontic power of representation, the representation of power. Thus it is not surprising to find in it the figure of the delegate of enunciation representing theoretical power, a power that is also sometimes political power. This delegate, this representative of the representation, is most often a person who figures on the represented stage, in the portrait of a city; it is the city's viewer from outside the scene, outside the representation. Thus, in Figure 12.1, the delegate of the enunciation is none other than the small figure in the middle ground at right, the surveyor-geometrician who is in the process of lifting up the map of the city, the map that is situated below him on the border of the image. But at the same time, he is contemplating the city from the place where we ourselves, as "enunciator-viewers," see it. The delegate of the enunciation is a product of the mechanism of representation-enunciation. The "I" of the reader-viewer of the city's eidetic profile is indeed produced by the "he" of the geometrician, but the latter is in turn a product of the enunciatory mechanism.

Moreover, throughout all the profile-portraits of Strasbourg, we note the redundant recurrence of an identical view, a sort of stereotype. It is perhaps this return, this very repetition that constitutes the portrait of the city as a "true" essence, an eidetics: indeed, I think it may be possible to discern a represented element that, in all profiles from the beginning of the sixteenth century to the twentieth, in some way comes to play the role of operator of the "eidetic" profile, an iconic element that becomes a symbol, to use Peirce's language, a quasi-arbitrary sign whose presence "signifies" Strasbourg. I am referring to the cathedral, presented in the center of the rep-

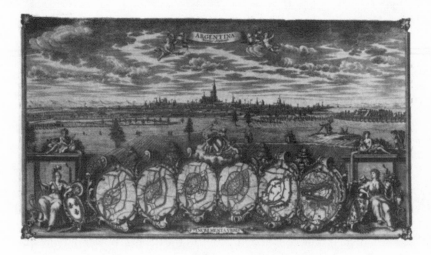

FIGURE 12.1 Barbier and Striedbeck, Profile-portrait of Strasbourg (1761–63).

resentation and very often pointing to the name "Strasbourg" with its spire, generally located on the right (whereas it is on the left on the maps).

The cathedral with its spire is an (intertextual) anaphoric iconic index of the toponymic name: "This is Strasbourg." But its function is complex, for the finger pointed toward the symbol constituted by the spire of the cathedral is also an "iconic" name: "Strasbourg." The spire can also be viewed as a sort of sign *between* iconic and symbolic, or better still, as the operator that transforms the iconic into the symbolic: "This icon is 'Strasbourg.'" But at the same time, the sign is an "eidetic" operator, as we have seen: "This icon is *truly, necessarily, unequivocally* 'Strasbourg.'"

What about the iconic dimension in maps? What is its status? With an iconic regime that is disengaged, situated outside of any viewing point, a map offers itself to view from the outset as total, exhaustive, synoptic: it shows itself while showing everything. There is nothing "hidden." The gaze is dominant, from above, but it is not in one place or one point: it is everywhere and nowhere. The map is not only power, it is *absolute* power: this is the deep meaning of iconic disengagement. But in order to be enacted as "panoptic," the map must necessarily efface itself. The syntactic figure of ellipsis animates it through and through: the ellipsis of volumes, but also of lines. The map thus *decides* what is representable and what cannot be represented. There is thus a criterion for the representable and the nonrepresentable. In fact, this decision is pragmatic: what is representable

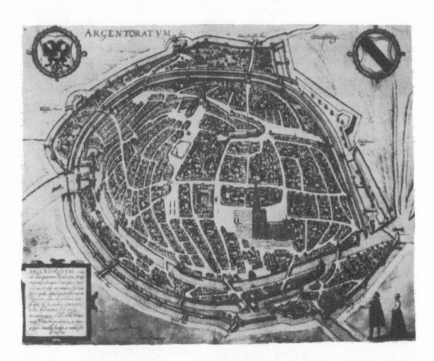

FIGURE 12.2 G. Braun and A. Hogenberg, Bird's-eye View of Strasbourg (1572). Musée de la Ville de Strasbourg.

is what is judged worthy of representation, what is noteworthy. Representation thus comes full circle and rejoins the norm.

The view from on horseback, or the bird's-eye view, is a combination of a map and a profile or portrait, in a unique text in which the point of view is both absolutely dominant, as in the map, and openly fictional, as is sometimes the case in topographic views. Figure 12.2, a map of Strasbourg in the sixteenth century, is entirely symptomatic of the compromise formation that is the bird's-eye view; on the right, we find the representation of two individuals, a man and a woman, *bourgeois* residents of Strasbourg, who play the role of delegate of enunciation we have already discussed: they see the map the way we do, in a "panoptic" gaze that the pointing gesture of the masculine figure signifies visually, but they are nevertheless not outside the place and the space. They are both included in the space of the map (within its frame) and situated in its lower right-hand corner, which then becomes the fiction of a viewing place—a steep hill—from

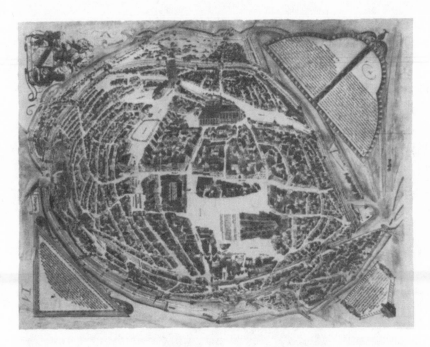

FIGURE 12.3 Map of Strasbourg (1548), colored by C. Morant.

which the city could be contemplated as a "profile-map" or a "portrait-map." On this basis, the two figures in the right-hand corner iconize the legend written in the leather of the left-hand corner, as that legend—that *legendum*—makes them shift not so much into the state of text as into the state of readers of text.

A quite remarkable example of this play of the dominant and fictitious viewing point in maps and profiles is offered by a sixteenth-century map of Strasbourg (Fig. 12.3). The buildings of the city, its houses and churches, are well represented from a bird's-eye view but, in contrast to the preceding map, it appears from the concentric arrangement of the buildings that the site from which the map is seen is located directly above the white space in its center: it is as if the viewer of the map were contemplating the whole of the city from "there," that is, from a celestial place whose projection onto the surface of the ground represented could be inscribed only by default, in the form of an absence, a central blind spot. This mechanism is confirmed by the texts written in three corners of the rectangle constituting the map, texts that are readable only if one rotates the map

around that same white space. Nevertheless, this rotation stops and/or be-
gins with Strasbourg's "coat of arms," represented in the fourth corner;
this is not to be seen and read diagonally or obliquely like the three texts,
but straight on and perpendicularly to one of the short sides of the rec-
tangle. The fact that the reading and viewing of the portrait-map have
their origin and end in the sign, at once iconic and scriptural, constituted
by the name and the title of the city is not surprising: this point of depar-
ture/arrival is marked by a sort of compensated disequilibrium of both
reading and viewing in which the law of proper form that governs each is
momentarily compromised. In the same gaze, a written text is read in the
central blank space where the viewing point external to the map is pro-
jected: the text explains this point by inscribing itself in the empty place
that is its singular mark and its strange figure on the ground, but that, by
the same token, changes this "represented" ground into a neutral back-
ground for signs of writing; it fictionalizes the ground as pure abstraction.

What we readers of the map and viewers of the city's portrait learn by
reading this text in this place and discover by looking down on the city
from straight above this space is that we occupy quite precisely the place of
the spire of the Strasbourg cathedral, which is the only building (or part of
a building) that is not represented in the portrait-map, and the only one
that cannot be represented, since it is *from that spire* that the city is seen in
its portrait and read in its map, since it is *starting from that spire* that the
portrait and the map are constituted, that it is the productive source of
both. Whereas in Figure 12.2, the two Strasbourg residents are, in the space
of the profile-map, the delegates of the enunciation, the central (or quasi-
central) blank space occupied by an explanatory text, the *empty place on
the ground changed into a support for writing is the fiction productive of the
figures of the representation.* The fact that the cathedral's spire, the iconic in-
dex of a name, the "eidetic" operator of the city, is quite precisely the place
of this fiction should not be astonishing. What may be surprising is that
the only way to inscribe and to show, to signify, the only way to make that
operator—at once symbol, index, and icon—visible, the only way to des-
ignate to the gaze of thought and eye the monument that designates this
double gaze, is to make it disappear, to eradicate it, that is, to show and in-
scribe it by its very absence: in other words, to inscribe and show, in the
representative mechanism of the city, the place of the subject that the
mechanism generates while appearing to be produced by it as a "blank,"
the blind spot of the profile-map that we are calling, here, a fiction.

I must add that, recurring just as persistently as the sign "cathedral" in profiles of Strasbourg, a single form, *the figure of insularity*, is maintained in cartographic maps. In maps, Strasbourg is and remains an island. I am using the term "figure" intentionally. Maps of Strasbourg put into figurability—to use Freudian language—one distinctive geographic feature, among others, which cartography includes in order to make it a dominant feature, that is, an organizing principle, a primary "modeling" of the representation whose meaning effect is remarkable (in the sense indicated above): Strasbourg, the city, is an island. The map of Strasbourg fictionalizes the city as an urban island. The final schema of cartography and of the urban project in Strasbourg might be illustrated as follows:

Here is an image of the law governing the set of urban transformations. But the island is, at the same time, the figure of the closure of the *panopticon* constituted by the map.

In the various images I have presented, the map as such is defective, especially in the seventeenth- and eighteenth-century examples, where a map, in the geometric sense of the term, is always accompanied by a profile-portrait of the city, while the inverse is not true. Profile-portraits have some autonomy (cf. eidetic profiles); maps are subordinated to profiles. Maps are heteronomous with respect to pictures. To inquire into the iconicity of a map, we would have to start from this point, and we would note that it tends toward the symbolic.

From this viewpoint, Figure 12.1 is remarkable, since, in the general composition of the whole, the six maps that inscribe sequences of Strasbourg's history occupy the front of the stage, between Wisdom and Abundance. They are in the foreground, in the theatrical and pictorial sense, but they are in an inferior position with respect to the profile-portrait that occupies most of the upper half of the whole.

The cartographic map refers to the urban project (profile-portrait). But here, too, a surprising circularity is manifested between the truth of the concept and the truth of the image, that of the schema as it tends toward the symbolic (the map) and that of the phenomenological *eidos* (the profile-

portrait). The constructed "conceptualized" aspect is paired with the "manifested" visible aspect.

We note the presence of six maps: three on the left, three on the right. The middle of the series is occupied by the city's coat of arms held up by two *putti*; a third is blowing the trumpet of renown. High above, in the portrait of the city, the cathedral points with its spire to the name of the city that is floating on a banner. The "topographic view" of Strasbourg in the present is not only the *eidos* of the city, but also the truth of the whole set of its maps. In relation to the six maps, this profile-portrait of the city has an interesting temporal "status." It is actually the portrait of the city "now," in which one notices the function of enunciative engager played by the "viewpoint" (at once spatial and temporal) of the representation. Yet the six maps—according to the order of reading of a written line emphasized again by the legend *"incrementa urbis"* and by their visual articulation (of increasing complexity)—are "read" from left to right as the story of Strasbourg's growth from its origins (map 1) to "today" (map 6); we may suppose that the topographical view is the profile of the latter. But the portrait of Strasbourg dominates the six maps: it is the phenomenal essence of the history of Strasbourg in its atemporal present. We are thus witnessing the staging of a remarkable thesis according to which the urban (profile-portrait) project (at once the trace of a past and the drawing of a future) is a present outside of time, an achronic truth, the structural law of a system of transformations manifested historically by the cartography of the city.

The displacement of map 6 at the sign of the cathedral and at the name "Argentina," through the mediation of the enunciatory delegate who is seeing the city in its profile here and now, but for the purpose of drawing up its final map, manifests the discourse about the city of which the cartographic map is the representation that constitutes one and the same text as the city's profile-portrait. This displacement is an operation that transforms the cartography of history (and its transformations of the past into the future) into an achronic urban project (portrait-profile) that is to be read as cartographic truth.

The "proof," if I may use this term, can be found in the side aisles of the foreground where the six maps are arranged: two pedestals carry the river gods of the Rhine and the Ill, which define Strasbourg's insularity in allegorical terms. Below them are seated two goddess figures, also allegorical: Athena-Minerva, Wisdom, but armed, with the blazon of France on her

shield, leaning against the olive tree of peace (*pax armata*); on the right, Ceres-Demeter, Abundance, with her cornucopia and all the fruits of the earth, in particular wheat and grapevines, leaning on the emblazoned shield of Alsace. From the armed and powerful wisdom of France to the abundance of Alsace: these are the *terminus a quo* and the *terminus ad quem* of the cartographic transformations, as if, from the beginning, a map had been drawn or projected by the wisdom and political calculations of which history was going to be the progressive realization in the happy agricultural abundance of a province whose urban *project*, the portrait-profile of a city, with its iconic sign and its symbolic name, constituted the atemporal truth.

§ 13 History Made Visible and Readable: On Drawings of Trajan's Column

Trajan's column is there *to be seen.* It has been offering itself to view since the time it was built,[1] at the center of the Imperial Forum; the column is the only monument in the Forum that has reached us virtually intact.[2] And we continue to be gripped by its presence. But do we really see it? Or, to put the question more carefully, is its ostentatious, triumphal, monumental visibility actually coupled with a precise, rigorous readability of the bas-reliefs with which it is covered? The drawing presented today—along with all the others with which we are already familiar—may be a response to this question about the adequacy of the coincidence between a work's visibility and its readability. Perhaps that is one of the functions of the drawing we are considering: to make readable to a knowing and knowledgeable gaze what had long been simply the object only of a respectful and admiring gaze. The question I am raising may appear trivially obvious. But quite often, with so-called works of representation, their precise readability is induced from their immediacy, their sovereign visibility. Yet the two gazes have different and perhaps even contrary conditions and intentions. The viewer is not from the outset a reader, even if being a reader presupposes being a viewer, even if reading can only be accomplished by and in vision.[3] Provided we have somewhat active imaginations, it is just as if, with the drawing that the Institut Français de Florence is offering us *to see and to read* today, the *volumen of images* that the emperor and his architect Apollodorus of Damas had drawn *vertically* from its funerary base up to the statue of the prince, in order to offer it to the city's contemplation, had been carefully reconstituted by the creator(s) of the drawing as a *scroll* that the modern reader-viewer could eas-

ily unroll and roll back up following the rhythm of the movements of his reading.[4]

In the process, however, everything changes, and despite (or perhaps because of) the precision with which the sculptured bas-reliefs in the drawing have been transposed, the modalities of the gaze are transformed: a story of the gaze is inscribed and drawn in parallel to the stories of the valorous deeds of the emperor and his armies. The triumphal ascending *spiral* that rises up around a vertical axis *from the bottom upward*, from the die and the pedestal toward its capital, from the inscriptions toward the upright statue,[5] becomes a *horizontal band* unfolding its some fifteen meters of images *from left to right*.[6] "The immense effort of ascension of the Roman world, which, rooted in the earth of Rome, rises up to the stars through the intervention of the hero and his troops"[7] is transformed into a historical narrative to be read by a comparable unfolding from beginning to end, wherein the reader becomes acquainted with the past. Apart from material explanations, which are primarily valid for the initial levels of the bas reliefs, we can now understand, perhaps, why the drawing's creator(s) did not transcribe the beginning and ending sequences of the sculptures, or the Roman fortifications along the Danube where the Roman soldiers stood guard in the light of flaming torches at the top of the towers,[8] or the scenes in which old men, women, and children were exiled, along with herds of cows, goats, and sheep:[9] these sequences indeed can only occupy the angular planes of the beginning and the end of the spiral and not the rectangular ones of the horizontal band of transcription; they could not have constituted the content of a drawn representation, or even of a painting, not without deviating from exact reference to the object to be re-presented, the bas-relief of the column. This modality of exact reference seems indeed to be the general rule behind the drawing and the continuous succession of its images.

As proof, one observation will suffice: the artist(s) did not hesitate to reproduce, all along the band, some of the forty-five small window openings that punctuate the spiral of the column to light the interior of the staircase. In the monument erected to the glory of Trajan, these rectangular windows have a specific utilitarian *function* that takes precedence over the verisimilitude of the representation on the bas-relief, on the outside, to the point of interrupting it briefly. In the drawing, on the contrary, the inscription of the skylight loses its technical function and thereby acquires *a value* that takes precedence over the "content" of the represented scene:

this is the value I have identified as exactness of reference in the design on the column, thus revealing the "scientific" rigor that presided over the highlighting of the bas reliefs. This transfer or transformation of the object's function (technical usefulness) into a value (precision, rigor of the representation) seems to me to constitute an interesting indication pointing to the destinations and even the respective purposes of the two works. The Roman sculptor does not "cheat" in his undertaking; nor does the artist of the Cinquecento. But the authenticity of each has a modality specific to its particular contexts. We might have expected that the Roman sculptor, in depicting a given scene, would make the requirement to represent coincide with the architectural requirement of the object that bears the representation—for example, by using a door or a window in one of the structures represented as a "functional" opening.[10] Similarly, in the overall set of images of the bas-relief, we might have expected the artist to eliminate from his drawing the representations of openings that interrupt the line of a hill,[11] a soldier's leg,[12] the foot of a tree,[13] and so on.

The window's structural function of usefulness in the column induces an effect in the very visibility of the object, then: namely, the fact that the column is hollow and that an invisible staircase runs from bottom to top inside its shaft. Hence the paradoxical inflection of the problem of visibility and readability of the monument that arose earlier: the existence of an architectural mechanism, the staircase, that would have made it possible to *read* the bas-reliefs, had it been placed on the *outside* (although by destroying or at the very least compromising their *visibility*)[14] but that, *inside* the column, illuminated by the window slits incorporated into the side wall, authorizes *neither vision nor reading* but only a *traversal* of the column from its base to its peak, that is, from the tomb of the prince, containing the urn where his ashes lie, to his apotheosis in the form of his statue, the "portrait" that stands over his tomb. This is indeed the fundamental and basic signification of the work, which has often been observed in recent studies.[15] But the theoretical consequence—simultaneously aesthetic and historical—of that observation has not been developed, it seems to me: the bas reliefs that surround the column with their spiral constitute *the "potential,"* although invisible, *decor* of the upward trajectory *within the shaft*; at the same time, *from the outside*, this decor becomes *truly visible*, but only *"potentially" readable* in its totality. This "double play" of the principles of visibility and readability (and their opposites) in the work, on the one hand, and of the modalities of the possible and the

real in their application, on the other hand, introduces us, it seems to me, to a subtle apprehension of the cultural, ideological, and political values of the representation of history in the imperial monument.

From the outside of the work, this representation has no reason to be read; it needs only to be seen to declare these values. But *on the inside*, in the ascending trajectory of the monument, this representation has no need to be seen to exercise its effects "objectively," through a sort of sacramental power of the image—which, in order to exercise this power, *ex opere operato*, as it were, requires extreme precision, total "definition"—in a word, perfect readability.[16]

It is precisely where the representation of history is concerned that the drawing presented here, like the other drawings of the column that were produced in the sixteenth and seventeenth centuries, comes into play in its turn. I am intentionally saying "the *representation* of history" and not "the history *represented*." Concerning the latter, we may be assured of the accuracy of its transcription, which is not compromised in the slightest by a certain number of reading errors, interruptions, or interpretive excesses. The drawing performs its reading by way of images, not only by "transposing" the sculptured frieze into a new medium (paper) and by new means (pen and wash), not only by "transforming" the cochleate frieze with an ascending orientation (the beginning at the bottom, the end at the top) into a scroll or band with a level horizontal development (the beginning on the left, the end on the right), but also by "reducing" the dimension of the whole both in format and in length (about 15 meters instead of 200) and in completeness (a third of the column is reproduced).[17] In fact, all these parameters of the transcription (I refer only to the ones already mentioned, ignoring stylistic characteristics) are organized in a coherent whole, that of optimal material and formal conditions of readability, and, in particular, the proximity of the gaze, the compelling nature of individual elements and details, and the sequential linearity of development.

Thus it is no accident that the spiral frieze of the column here becomes a *volumen*, a *book* (of images) to be read. But at the same time, the values of historical representation are altered, in two ways. The first (which the "accident" of the drawn reproduction of the window slits allowed us to notice) is that of the mediation between Rome's past history and the representation in the sixteenth and seventeenth centuries of a monument in which that history had already been inscribed in an unimpeachable way. The reproduction of that inscription, owing to the very fact of its inscrip-

tion in marble, bears witness to its authenticity and truth: replacing the glorification of the prince-hero, his *epideixis*, with direct political, religious, and ideological effects, and replacing the injunctions and prescriptions that these effects imply, *authenticity* and *truth* then come to govern the representation of a history that is still of course the history of Rome, but Rome as experienced in the late sixteenth and the early seventeenth centuries both in the irremediable distance of the past and in the continuity of a tradition. The values of knowledge—knowledge that is as detailed and accurate as possible—that will be marked in the perfect readability of the drawing will thus be affirmed simultaneously in order to signify that distance and that continuity.

All knowledge, because it is a movement of objectification and an effort at abstraction, puts its object at a distance. This is all the more the case when the knowledge in question, with the same requirements, is historical knowledge: it has the obligation to constitute the "past," what has taken place, as *absent* and *dead* here and now. The objective truth that is its ideal implies a definitive and irremediable break. All tradition, on the other hand, experiences the past as present and active in the present. One might even argue that the very consciousness of a tradition, that is, of seamless continuity between past and present, already introduces the break that inaugurates historical knowledge.[18] Viewers of the monument thereby become readers of the book, and their admiration for the work can only be realized when they become specifically conscious of what it represents.

The drawing, through the readability it offers, makes the *monument* a *document* and a *narrative*, a sacramental decor of imperial apotheosis, an *archaeology*: "Sixteenth-century scholars did not have a taste for monuments; for them, the bas-reliefs of the column were only a vast repertory of military archaeology; they were interested in the details rather than the connections, the sequencing, or the whole, and thus they gave precedence to what was merely secondary. But the details themselves, for want of practical information, are not always well interpreted."[19] These lines, written in 1633 by Raffaele Fabretti in his *De columna Traiani syntagma* point to this transformation and perhaps especially to an explicit awareness of it. In this sense, the drawings from Trajan's column become privileged models for historical narrative in general, specifically for the great historical painting of the classical period. During the time Fabretti was writing his book, Poussin sent Paul Fréart de Chantelou his painting *The Israelites Gathering the Manna*, along with the following prescription: "Study [read]

the story and the picture in order to see whether each thing is appropriate to the subject";[20] in so doing, he repeated the operation achieved by the artists who drew the bas-reliefs of the column—Muziano, and the anonymous artist(s) who created the work exhibited here today—namely, the exact and complete correspondence between the monument's grandiose visibility and the rigorous readability of its sculpted decor.

The other change in the representation of history brought about by the drawing may in a sense look like the opposite of the first. To know in order to admire, thus to read in order to see, to subordinate viewing to reading, to subordinate the eye that sees to the gaze that knows and recognizes: such was the archaeological operation achieved by the drawing. But this disinterestedness, the "theoretical" gratuitousness that will henceforth preside over the representation of history in images, has other, more immediately practical values, or other effects. Muziano, the first known artist to draw the bas-reliefs of the column, in 1576,[21] dedicated his work to King Philip II, "Trajan's compatriot." Muziano's work was reviewed and "corrected" by Bellori with drawings and engravings by P. S. Bartoli in the 1672 edition published in Rome by G. de Rossi: it was dedicated to Louis XIV, "the Trajan of France," who at the time embodied the virtues of the emperor, "powerful, merciful, a builder, a promoter of navigation." In *La colonne Trajane*, Wilhelm Froehner notes that "three sovereigns have manifested their desire to own a reproduction of Trajan's column": in 1541, François I, through the intermediary of il Primaticcio, his painter, and Vignola, the primary contractor for the enterprise; then Louis XIV, with the help of Charles Errard, the first director of the Académie de France in Rome and overseer of the project, which lasted until 1670; and, finally, Napoleon III, in 1861–62.[22] Reproductions by drawing, reproductions by casting—in all cases, undertakings ordered by princes or dedicated to them. For what king or prince did our artists work?

This information is of more than historical interest. It reveals an operation that seems to me essential for the understanding of the relation between the representation of history—of imperial Roman history in particular—and the legitimizing of the political power of the modern monarch, the legitimizing of the way that representation of the past is constituted— according to norms and criteria that I have subsumed under the term "readability"—as a cultural-universal model of representation. The game that is being played here involves achieving, without remainder or lack, a "chiasmus" between an aesthetic power proper to a certain representation of the

past and a representation adequate to the current importance of a certain political power. The representation of the Roman historical past, its explicit reproduction, constitutes it as a founding and legitimizing model, and this is the way the modern prince, in the reading of that past prepared for him, contemplates himself as an absolute monarch.[23] And this is how the gaze of reading, the gaze of universal and true knowledge of the Roman imperial past, can become contemplation of the prince reflected in his portrait as monarch. In a clear expression of this process, in 1587, Sixtus V substituted a statue of St. Peter done by G. Della Porta for the statue of Trajan with breastplate, *paludamentum*, spear, and globe. By placing the founder of the Roman Church at the pinnacle of the imperial monument, while retaining the reliefs narrating Trajan's valorous deeds, the sovereign pontiff, bishop of Rome and prince of Catholicism, recuperated the past history of ancient Rome as history, but, by subordinating this history to the image of Peter (the cornerstone), he instituted and authorized it as the symbol of an immutable permanence outside of time, the eternal and absolute sovereignty of the pope.

The drawings of the Trajan column that reproduce the whole set of bas-reliefs—even if, like those that are exhibited here, they do not represent the totality—emphasize the "continuity" of the frieze and make it possible, as I have suggested, to read it accurately. The problem I should like to raise now, in direct relation to the preceding ones, is precisely that of narrative continuity and its readability as a model of the representation of history in painting. Faced with a frieze—the point has been made frequently—through lateral displacement, the viewer sees the sequences of a total narrative appear in succession; thus the same figures can return here and there as the story unfolds, yet their return does not compromise the temporal and spatial unity of the scenes in which these figures are actors. The realistic "truth" of the narration of history is thus closely linked with the viewer's displacement along the length of the frieze.[24] Such displacement, as I and others have noted, is impossible with the spiral of the reliefs of the Trajan column. However, the *volumen* of the drawing that reproduces them allows it. The "material" unrolling of the scroll by means of a two-drum mechanism, the one unwinding the image-bearing band as the other rewinds it, is equivalent to a continuous lateral movement of the gaze along a very large sculptured frieze.[25] This displacement is also the basic condition for the readability of the narrative in images. It implies quite precisely that the reader-spectator is positioned very close to the

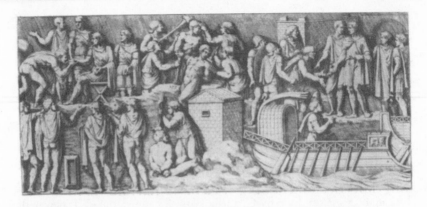

FIGURE 13.1 P. S. Bartoli, Trajan's column (1672): soldiers paying homage to the emperor; barbarian women torturing captured Roman soldiers; barbarian leaders surrendering to Trajan; end of the second campaign (sequence 33).

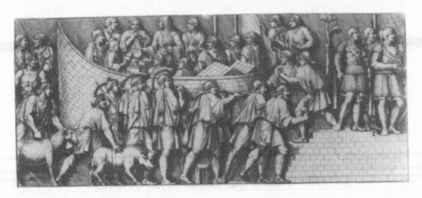

FIGURE 13.2 P. S. Bartoli, Trajan's column (1672): the emperor carrying out a purification sacrifice and addressing his troops (sequence 78).

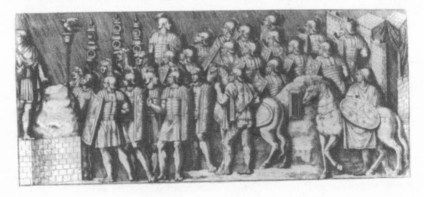

FIGURE 13.3 P. S. Bartoli, Trajan's column (1672): the emperor addressing the army (sequence 79).

band, so that he can discern and recognize the elements and the parts represented in the image, but it also presupposes a trajectory of the gaze in a plane parallel to the plane of representation, a lateral trajectory that conditions the successive grasp of the scenes that constitute the narrative. The spatial site of the gaze allows distinct knowledge of the *narrative utterances*, and its "temporal" movement allows distinct knowledge of the consecutive nature of the *narrative enunciation*.

We can thus better appreciate the meaning of my claims concerning the exact correspondence between visibility and readability brought about by the drawing of the bas-reliefs: in order to be a reader, the viewer is wholly "positioned" by the image he is looking at; his displacement in space is conditioned by the iconic "definition" of the figures and their arrangement in the space of the frieze transposed into drawings; the duration of his time is measured by the rhythm of narrational sequences that he is compelled to "traverse" if he wants to understand the story he is being told.[26]

But it may well be possible to go even further in this direction. It has been noted [by Peter H. von Blanckenhagen] that the scenes portrayed on Trajan's column lack all consistency in proportions as well as in scenic decor:

> We see, for instance, in close combination, the emperor with soldiers and captives and a scene where captured Roman soldiers are tortured by barbarian women. Hence, two scenes which happened in very different settings are closely linked [vignette 33]. Other examples show the emperor twice, once sacrificing and once addressing the army [vignettes 7, 8; vignettes 78, 79]. The available space is always completely filled with persons, buildings, trees, animals, etc. and the scale of these elements varies. . . . The buildings are seen in bird's eye perspective, the persons are in normal linear perspective.

And Blanckenhagen concludes, pointing up the contrast with the Hellenistic frieze in continuous narrative: "Here, then [on Trajan's column], we have a curious combination of rich and exact realism in detail and complete lack of realism in composition."[27] The distortions in the same represented space between two forms of perspective (even when the distinction between the one, called normal and realistic, and the other, said to be deviant and abstract, ought to be subjected to rigorous critical examination),[28] the filling of the space by the "details" of the background for the action, and so on, reveal a concern for offering very dense and rich information and, at the same time, the intention of making known as pre-

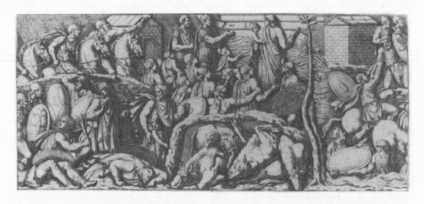

FIGURE 13.4 P. S. Bartoli, Trajan's column (1672): the emperor with female
Dacian prisoners (sequence 21).

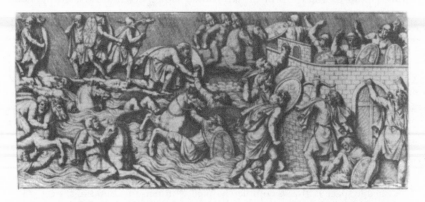

FIGURE 13.5 P. S. Bartoli, Trajan's column (1672): Dacian horsemen drowning
while crossing a river; Dacians attacking a Roman camp (sequence 22).

cisely and as completely as possible all the elements that particularize the
story told by inscribing it in perfectly determined and, in the final analy-
sis, namable moments and places. The fact that the reliefs are visible on
the column then leads to the supposition—a hypothesis suggested by
Blanckenhagen—that they constitute the reprise in marble (with all that is
implied by the inscription in stone) of paintings that had been shown, *vis-
ible* and *readable, seen* and *read,* in the emperor's triumphal procession and
that recounted, in images, the history of the Dacian wars.[29] The proces-
sional *displacement* of paintings tracing the progress of victory before view-

ers who read the pictures as they moved along, in order to familiarize themselves with the details of a contemporaneous history, is thus found anew in the rolls of drawings that reproduce, by unwinding, the immobilized reproduction of that history in the spiral of the stone column. The modern spectator thus gains *knowledge* by reading the drawings of a particular *past* history in all the details of its events, the details of their geographical, topographical, historical, and cultural background; the precision, rigor, and objectivity of this knowledge are actually authenticated and guaranteed by the "distortions" and "inconsistencies" of the represented space and its composition, which contradict, in particular, contemporaneous rules for constructing modern space in painting or sculpture.

Hence we can see how the drawings of Trajan's column can become "models" for the modern representation of history, owing to three distinct characteristics. The first involves the passage from continuous narrative to pictures. In fact, the presentation of a narrative in the successive *continuity* of its sequences, from beginning to end, does not rule out its *articulation*. We can easily spot the operators of articulation in the bas-reliefs on the column, as well as in the drawings that reproduce them. We can even distinguish two types. The first is constituted by what I shall call *operators of articulation of narrative utterances*. For instance, in vignette 21, a tree separates the scene in which Trajan—a fine example of generosity and magnanimity—receives a group of female Dacian prisoners, from the scene, pursued in vignette 22, in which Dacian horsemen are drowning while crossing a river. In vignette 28, the same tree articulates a battle scene with the episode in which old men, women, and children surrender. These trees, which have a form and a design similar to those that we encounter in vignette 16, for example (the army marching through woods), or in vignette 12 (soldiers chopping down trees in order to set up camp) thus have an entirely different function: they stop being parts of a narrative utterance (trees of a wood traversed, trees used as wood for construction) to become an instrument for separating or linking two narrative utterances. They might be said to signal the moment when the viewer who has stopped for a moment before one scene begins to move on to the next one, or the moment when the reader turns the page of the book. These articulations of utterances will readily constitute the "frames" of the historical picture in which one moment, one well-chosen sequence, is represented, abstracted by the painter or sculptor from the overall history. The operator of the divisions of the continuous narrative thus has yet another

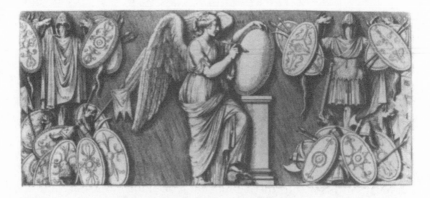

FIGURE 13.6 P. S. Bartoli, Trajan's column (1672): Winged Victory writing on a shield, between two trophies marking the end of the first Dacian war (sequence 58).

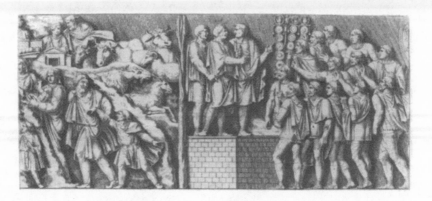

FIGURE 13.7 P. S. Bartoli, Trajan's column (1672): old men, women, and children fleeing with their herd; Trajan giving a victory speech to his troops (sequence 57).

change of function: rather than articulating two sequences, it frames and surrounds the picture; it closes off the representation at its edges.

The second type of operator of articulation can be called *articulatory operators of narrative enunciation*. We find a remarkable example in vignette 58, where the winged victory who is writing on a shield between two trophies marks the end of the first Dacian war. Placed in the exact middle of the frieze between two narratives of the campaigns, it is not only the symbolic figure of Roman victory (the shield of honor, *clipeus*

virtutis, positioned on a pilaster) and of the emperor's political and military virtue, but also the "semantic" figure of the enunciation that articulates the narrations of the two narratives.[30] It is noteworthy, indeed, that the winged figure, who is turned toward the right (the direction in which the narrative continues), has not yet written anything on the shield, but she is a continuation of the scene (vignette 57, right side) in which Trajan addresses the victory speech to his troops, just as the narrative of the second Dacian war will be crowned, at the pinnacle of the column, by the statue of the emperor. In other words, the figure of the victorious *Virtus* at the center of the frieze, in its relation to the figure of Trajan that precedes it—Trajan, who is telling his troops the story of the first war in the triumphal mode—and to his statue, which concludes the ensemble constituted by the narratives and the monument, brings to light the identification—which the great modern European monarchs will seek—between the great actor of history who is in the process of fulfilling his destiny and the history that inscribes the memory of this event for all time.[31] In fact, in the frieze on the column, the symbolic figure is also a semantic figure and the victorious *Virtus* is an operator of the narrational articulation. But through her reproductions in drawings, the winged goddess will become history itself, who *writes* in brass or marble the history that the monarch hero *creates* in the universe: we shall continue to find the symbolic figure in the skies of the great paintings of monarchic history. We shall continue to find the trophies that surround her on the frames of those paintings, unless the figure of the prince represented there *embodies* the allegory in his historical person.

The second characteristic involves the impressive mass of details, the "archaeological" *realia* that are reproduced in the drawings and that modern historical paintings will exploit in their representations to create verisimilitude: the propriety, the "costume" and the "decorum" at the time of the ancient narrative that they are presenting in images. Through "modal" transformation, in the (painted or sculpted) historical representation, the archaeological *truth* of the clothing, weaponry, fortifications, harnesses, the historical *truth* of the (ritual, cultural) gestures and attitudes, the *truth* of the localizations will become *verisimilitude*: all these details carefully transcribed, transposed, and integrated on the isolated panel or canvas will not only allow the reader-viewer to *know* the ancient "history" in its narrative, but will also make him *believe* in its truth. To varying degrees, they will all be factors in the narrative's "objectivity." From this viewpoint, the drawings of Trajan's column constitute catalogues of

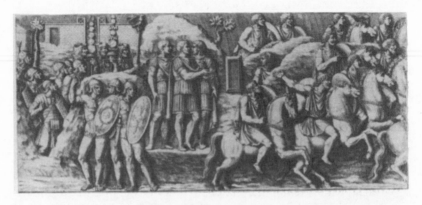

FIGURE 13.8 P. S. Bartoli, Trajan's column (1672): Trajan watches an attack by Numidian cavalry (sequence 43).

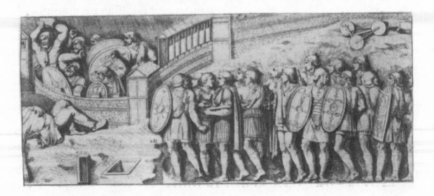

FIGURE 13.9 P. S. Bartoli, Trajan's column (1672): attack on the Dacian capital, Sarmizegethusa; Trajan and his council of war (sequence 87).

objects, lexicons of motifs upon which artists will draw. Let me take just one example, but a famous one, that of Poussin, who, in the late 1630s and early 1640s, excerpted from Alfonso Chacón's work [see n. 21] with engravings by Villamena, details, *realia*, which he [Poussin] then introduced into his major compositions:[32] studies of armor, helmets, breastplates, trumpets, ships' prows, shields and tents, military insignia and standards that we find for example in the superb "trophy" of *Venus Bringing Arms to Aeneas* (Rouen), in *The Capture of Jerusalem by Titus* (Vienna), and in *Camillus and the Schoolmaster of Falerii* (Louvre), and so on.

But a third characteristic of the drawings strikes me as much more decisive for the modern representation of history and its "modeling." It seems to me that this feature has not been sufficiently examined, perhaps because it is too obvious. It has to do precisely with the presentation in a frieze on the column—and the drawings repeat this carefully—of the figures from the narrative. Actually, the term "frieze" designates two very different things, which need to be distinguished: an *arrangement of the bas-reliefs*, in a spiral around the monument, horizontal in the drawings, and an *arrangement of the figures in the bas-reliefs themselves*, following the principle of their linearization in a plane parallel to the plane of representation. Now it is this principle of composition that obliged the ancient sculptor to superimpose several friezes of figures vertically to show their staggered succession in depth in space, thus introducing the inconsistencies in their respective scale emphasized, for example, by Blanckenhagen. The historical painter cannot allow such distortions in the spacing of the actors of the narrative that he is offering in images. The whole modern mechanism for representing space would be compromised. And yet from ancient bas-reliefs—those of Trajan's column in particular, and from the drawings that allow him to read them—the painter retains in a frieze the arrangement of the narrative figures, the actors in the narrative utterances, but *in the mechanism for representing space that constitutes for him the fundamental iconic code for the narration of history*.

To go back to the example of Poussin, not only did he excerpt *realia*, factors of objectivity in historical painting, from the engraved drawings of Trajan's column, not only did he isolate scenes or parts of episodes,[33] but he also discovered in the column and in sixteenth-century drawings of it both the principle of the linearization of the figures and some of the solutions for integrating their presentation in frieze form into the modern representation of space. I shall offer two particularly striking examples. First, certain of the drawings and engravings by P. S. Bartoli reproduced in Filippo Coarelli's architectural guide to Rome, vignettes 6, 12, 29, 45, 57, 78–79, 80, and so on—all the episodes that focus on the emperor—are constructed according to the same principle: Trajan and his counselors are placed (in a frieze) on an architectural structure that puts them in the dominant position in relation to another group of figures—soldiers, prisoners, enemies, ambassadors, and so forth, figures that are also presented in a frieze, but lower down. The "lack of realism" or "inconsistency" of the superposition designed to "signify" the ranking in depth here finds a "nor-

mal," "realistic" solution, that is, a spatial solution. This is the solution Poussin found again in his *Triumph of David* (Dulwich, London) for the background of the painting and in the *Plague at Ashdod* (Louvre), the two versions of the *Rape of the Sabines* (Louvre, Metropolitan Museum of New York), *The Continence of Scipio* (Moscow), or even *Camillus and the Schoolmaster of Falerii* (Louvre), where the left side is concerned.

The other solution, also present in Trajan's column and in the drawings based on it, consists in using some kind of device—a wall, a wall hanging, a feature of the terrain, colonnades—to neutralize the deep space behind a group of figures placed in the foreground; in other words, it consists in making the background of the bas-relief coincide with the space represented (cf. Coarelli-Bartoli 7, 9, 43, 51, 87, 93, 103, 113, and so on). This is the solution we find in Poussin as early as *The Death of Germanicus* (Minneapolis), with the drawn curtain against which the protagonists of the narrative are detached, with the left-hand part of *Mars and Venus* (Boston) and the right-hand part of *Diana and Endymion* (Detroit), the back wall of *Extreme Unction* (Pozzo/Belvoir Castle, Leicestershire), of *Marriage* (Pozzo/ ibid.), the curtain of *Extreme Unction* again (Chantelou/Edinburgh) or *Penance* (Chantelou/Edinburgh), not to mention the two versions of *Moses Trampling on Pharaoh's Crown* (Bedford, Louvre).

Unlike the "archaeological" reprise of *realia* by great historical painting as instruments of the objectivity of the *narrative*, the adoption of the principle of the linearization of the figures, their arrangement in a frieze in a plane parallel to the plane of representation, would constitute an essential factor in *the objectification of the narration* of the history. This arrangement in fact could be considered as the "figure" (in the rhetorical sense of the term) of a narrative escaping the agency of its production, eluding a subject who would narrate the story. The narrative figures of historical painting, individualized, enter successively, so to speak, into the representative scene, scarcely beyond the ideal level of representation, just as the sculptured figures of the bas-reliefs appear to be formed out of the cut background, without any gesture or gaze in the represented space marking the posture of a character, the relation to the narrative agency that has nevertheless constructed this space on the basis of its own position, that has developed the historical narrative on the basis of its own knowledge.[34] To cite Emile Benveniste with reference to what he calls "history": "The events are set forth chronologically, as they occurred. No one speaks here; the events seem to narrate themselves."[35] No one is doing the telling. The neu-

tralized narration, the historical narrative, becomes history itself. And, let me add, not only is history telling itself, but it is reading itself in the greatest possible readability. The reader-viewer does not decipher a narrative, he does not interpret forms and signs in order to construct a history. The reading is given from the outset, already read. Let me venture a paradox: the reader is read by the history that he is looking at.

Thus we understand the crucial importance of the bas-reliefs on Trajan's column once they are transposed into the drawings that reproduce them in the sixteenth and seventeenth centuries, the one exhibited here being a fine example. As artistic and aesthetic models, they do not merely constitute catalogues of forms and motifs for "classical" historical painting. Through the imperial and Roman reference that they convey, through the propositions of representation that they bring to light, they "model" a conception of history and of humanity at a key moment in the evolution of Europe.

§ 14 In Praise of Appearance

Svetlana Alpers has written a noteworthy—and noted—book on seventeenth-century Dutch art. Still, this topic is mentioned only in her subtitle. By calling her book *The Art of Describing*,[1] the art historian reveals broader and higher ambitions. She is for all intents and purposes offering contemporary art history a new theoretical and methodological model for the study of its objects in the visual arts. This model is opportune, given the current state of research in the field and in the social and historical sciences more generally: the international success of Alpers's work bears witness to its timeliness. Thus its validity goes well beyond seventeenth-century Dutch art. And yet *The Art of Describing*, as we have seen, has *Dutch Art in the Seventeenth Century* as its subtitle: a considerable number of the questions and problems the book raises have to do with the relations between title and subtitle. A new theoretical and methodological model, yes; but also presumably a model of which a historically and socially specific art is something like the artistic prototype, a model whose essential cognitive elements are supplied by the theories, knowledge, and scientific practices that were contemporaneous with that art; finally, a model that the study of seventeenth-century Dutch art needs quite specifically—after two or three centuries, after Michelangelo, Reynolds, Fromentin, and Claudel, to mention just four names—if it is to render simultaneously the historical truth, the expressive authenticity, and the aesthetic quality of that art. Thus the aims and objectives of Alpers's enterprise are situated at the point of articulation between the epistemological generality of theoretical principles, methodological postulates, and analytical procedures, on the one hand, and the historical and cultural particularity of a specific object, on

the other. But this is the point, too, where problems arise, given the stimulating, even provocative, power of Alpers's work, problems for art history and the social sciences: another aspect of the work's heuristic fecundity.

Starting in her introduction, with exemplary clarity in her writing and thought, direct and unwavering reasoning, clean and angular phrasing, Svetlana Alpers sketches in the principal features of her model, which possesses one noteworthy, properly structural characteristic: its features are defined by opposition, or differentially. Yet these differential features are not deduced abstractly, as in certain structuralist enterprises, from some elementary structure of signification; they are discovered in history. A rapid perusal of the work might lead one to believe that Alpers simply uses the old opposition between North and South, Holland and Italy, for new purposes. But this is not at all the case. By pursuing her structural work simultaneously on the twin fronts of modern European art and the history of that history, the theory of that history and the history of its theory, the art historian aims to show that if seventeenth-century Dutch art can supply a new working model, it is because it can be related oppositionally to Italian Renaissance art, to the extent that, since the Renaissance, Italian art of that period has provided artists, art theorists, and art historians with a general and enduring model of the painted image and its interpretation.

> To a remarkable extent the study of art and its history has been determined by the art of Italy and its study. . . . Italian art and the rhetorical evocation of it has not only defined the practice of the central tradition of Western artists, it has also determined the study of their works. . . . Since the institutionalization of art history as an academic discipline, the major analytic strategies by which we have been taught to look at and to interpret images . . . were developed in reference to the Italian tradition.[2]

But it is precisely on this point and in the differential work of contrasts and oppositions that Alpers encounters a formidable difficulty, which she moreover makes no attempt to evade. To define Dutch art as non-Italian, to characterize the images in Dutch painting as nonclassical or non-Renaissance, to label Dutch landscapes, still life, or portraits as non-Albertian [that is, not in conformity with the principles set out by Leon Battista Alberti in his theoretical treatise *De pictura* (1435)], is to continue to refer to the Italian model, to the categorizations to which it has given rise, and to the very language of analysis and interpretation of works that has been developed in reference to that model. Thus if the difference be-

tween Dutch art and Italian art constitutes one of the key strands of
Alpers's book, the author is nevertheless not giving us a comparative study.
This difference, or this set of differences, is not the *object* of her work, but
only its theoretical and methodological *condition*, a condition that, by the
same token, goes beyond seventeenth-century Dutch art and presumably
reveals its epistemological validity for analysis, and perhaps something
else, in the very way of looking at all the "non-Albertian" images, whether
we are considering Manet, Caravaggio, Velasquez, or Vermeer. From this
perspective, then, we have a variant of the methodological circle evoked
earlier by Edgar Wind. Indeed, it is obvious that the tools and method-
ological means of analysis were constructed for seventeenth-century Dutch
art *in its difference* from classical Renaissance Italian art, but it is no less
certain that, developed in that difference and under that condition, they
proved effective and operational in the entire field opened up and circum-
scribed by that difference.

But here is where we encounter the theoretical difficulty mentioned
above, that of giving contents to the field and to the objects of the field
provisionally defined as non-Italian, nonclassical, non-Renaissance, non-
Albertian, through negative reference to the classical, Renaissance, Albert-
ian, Italian model: contents, *that is to say*, notions and concepts, analytical
categories and schemas that are free of negative reference and that, by that
very token, could prove operational beyond the realm of Dutch art and
beyond the period under consideration, the seventeenth century. Alpers is
careful to explain what she means by "the notion of art in the Italian Re-
naissance." First of all, Alberti's definition of a "picture": "a framed surface
or pane situated at a certain distance from a viewer who looks through it
at a second or substitute world."[3] Next, the definition of that world con-
templated through the painting of a picture as a theatrical place where hu-
man figures perform meaningful acts, "significant actions based on the
texts of the poets."[4] Classical Renaissance Italian art is an art of narrative
in images. History constitutes the highest purpose of painting to the ex-
tent that its pictorial narration depends simultaneously on knowledge of
the texts in which it is recounted and on that of the perceptible, corporeal,
external signs through which its human actors show the passions that ani-
mate them inwardly in their actions. It is clear that these two defining fea-
tures do not concern a particular type of fifteenth-century Italian painting:
they construct a model in which seventeenth-century Dutch art has no
place. Hence the countermodel developed on the basis of that art by Svet-

lana Alpers, a countermodel whose first distinctive feature is that it is *non-narrative*, that is, *descriptive*, and the second is that its paintings are *non-windows* (in Alberti's sense), that is, *surfaces*. Here again, description and surface do not refer to a particular type of seventeenth-century Dutch painting. Here again, what is involved is a model, the model that *articulates* what appears to Alpers to be one of the two fundamental modes of pictorial representation. It is appropriate, then, to focus on these two characteristics in examining her work.

In fact, surface and description do not, properly speaking, constitute independent dimensions within the model thus constructed. Theoretically, they overlap: our author often refers to a surface of description (or inscription) to characterize the Dutch image of painting, just as she might have evoked, had such been her object, the phenomenal (or surface) descriptions that would, after all, fairly well characterize a given text by Kepler or Huygens or even Bacon, who is cited in Alpers's book. But the one, surface, concerns the image more directly; it covers the iconic side of the model; the other, description, stems more specifically from language and its discursive aspect. One could obviously ask how such a model for viewing seventeenth-century Dutch art was developed in order to account for this specific model of representation. It would seem that the author arrived at the concept of painting as surface and at the descriptive discourse it demands on the basis of a double operation: on the one hand, she discerns a theoretical, critical, and historical discourse that has been more or less repressed in academic institutions of art history since its constitution as an academic discipline; on the other hand, she defines the specific "historical" position of seventeenth-century Dutch art in the precise sense in which that art is situated in a well-determined epistemic, scientific, cultural, social, and political environment, which Alpers's book will study with enormous erudition, but with the aim of extracting from that inquiry the formative features of her own model.

With regard to the author's decisive determination to "break" with a certain institutional mode of discourse about art history, a discourse whose poles of reference, categorizations and concepts, and even procedures, are the Italian Renaissance and the discourse of which it has been the object, it is essential to read the pages she devotes to Alois Riegl in the essay "Style Is What You Make It," a war machine launched simultaneously against the Wölfflinian theory of style and against Panofskyan iconography: "Like

structuralists today [the essay was written in 1977] . . . , Riegl turned to
phenomena to which he stood by *their* nature, but also by *his* distance, in
a nonparticipatory relationship. He chose in other words a position from
which to see all the better the essential structure without an interpretative
bias." And it is on that basis—by studying ancient Middle Eastern fabric,
the art of late antiquity, the portraits of the Dutch group, or post-
Renaissance Italian art—that Riegl "specifically avoided . . . the often un-
acknowledged normative center of art historical studies—the art of the
Italian Renaissance."[5] Riegl's structural analysis, according to Alpers, thus
depends on the nature of the object studied, but this is above all because
that object puts its observer at a distance and, by that very token, reveals
the complicities and the connivances (all the more compelling in that they
are less often perceived) that institutional art history maintains with its
privileged domain of study and the objects it interprets on that basis: the
"normative" and—I would add—prescriptive "center" constituted by the
art of the Italian Renaissance, its history and its theory.

The distancing of the observer by the very object of his observation is
accompanied, in Riegl, by another feature, whose importance we shall see
immediately in Alpers's model, the fact that Riegl "sees the production of
art as dependent on a particular maker or community of makers. The
drive or the necessity of making is a matter of the psychological relation-
ship established between man and his world. Art is in short—though the
term is mine," Alpers writes, "and not Riegl's—a mediation between the
maker and the world."[6] And this is where we touch on one of the strate-
gies developed in *The Art of Describing.* "How then are we to look at Dutch
art?" the author wonders. "My answer has been to view it circumstan-
tially. . . . By appealing to circumstances, I mean not only to see art as a so-
cial manifestation but also to gain access to images through a considera-
tion of their place, role, and presence in the broader culture."[7] Here, too,
Alpers follows the dictates of what seems to me the essence of a structural
approach in history: the work of art is not analyzed first of all as a mirror
of the historical and social reality of which it would be the exact and me-
ticulous transcription, nor as the expression of the ideals—or even the ide-
ologies—of which that society would be the bearer at the time, nor even
as the symptom of movements or more or less hidden tendencies that the
work would bring to light. The painting, the image, are grasped in their
function, in their historical and social functioning: why and how do these
images come into being at precisely this moment? To what needs, to what

intellectual, philosophical, religious desires do they respond? To what political and economic necessities? What is their place in the sphere of scientific and technical knowledge? With Alpers, we read with new eyes, or we reread with different eyes, Constantijn Huygens's autobiography, Kepler's *Ad Vitellionem paralipomena* or *Dioptrics*, or even Bacon's *Essays*.

The art of describing—the art of description as such—is then posited as the principal characteristic of seventeenth-century Dutch art, of the Nordic tradition to which that art belongs, and, more generally, of a pictorial model that is often and too hastily labeled as realist: a model that is not confined to Dutch art but that seems, better than any other category or notion, to account for Dutch art with the greatest precision in its opposition to or its difference from Italian art, of which the "typifying ideal" is essentially narrative:

> The stilled or arrested quality of these works [Caravaggio's *Crucifixion of St. Peter*, Velásquez's *Water-Seller of Seville*, Vermeer's *Interior with a Woman with Scales*, Manet's *Lunch on the Grass* (*Déjeuner sur l'herbe*)] is a symptom of a certain tension between the narrative assumptions of the art and an attentiveness to descriptive presence. There seems to be an inverse proportion between attentive description and action: attention to the surface of the world described is achieved at the expense of the representation of narrative action.[8]

To say that a painting is a nonwindow signifies that it is a surface, but that surface must be understood as a screen of inscription-description on which is projected, or which registers, the "surface" of the world in which that surface is represented, inscribed, or, better still, replicated.

It is precisely on this point that Alpers finds in the scientific and technical culture of seventeenth-century Holland the mechanism that will "model" her own model: the camera obscura that fascinates Huygens and whose marvelous properties elicit repeated admiring descriptions. It is "a device that allows light to pass through a hole (often fitted with a glass lens) into a box or darkened room to cast an image on a surface of the world beyond."[9] To this definition Alpers adds a quite remarkable text originally written by Huygens in French:

> I have in my home Drebbel's other instrument, which certainly produces admirable effects in reflection painting in a dark room. It is not possible to describe for you the beauty of it in words: all painting is dead in comparison, for here is life itself, or something more noble, if only it did not lack words. Fig-

ure, contour, and movement come together naturally therein, in a way that is altogether pleasing.[10]

The camera obscura, a model of truly natural painting for Huygens or for Hoogstraten, is likewise the very model of the eye for Kepler, who defines vision as "a picture [*pictura*] of the thing seen being formed on the concave surface of the retina."[11] All these differences clearly imply a theory of vision as replication or duplication of the thing seen. And when Kepler declares that the psychological processes of vision do not interest him, Alpers draws a precise conclusion: that the strength of "Kepler's strategy" is that it "deanthropomorphizes vision." The world comes first, picturing itself in light and color on a "dead eye."[12] The model for vision, namely, painting, is a passive model from which any constructing subject is eliminated—for such a subject, to use Kantian language, is the tireless worker of the syntheses of the vagaries of perceptible intuition under the concepts of understanding and through the mediation of the imagination. As Kepler puts it, with superb irony:

> I leave it to natural philosophers to discuss the way in which this image or picture [*pictura*] is put together by the spiritual principles of vision residing in the retina and in the nerves, and whether it is made to appear before the soul or tribunal of the faculty of vision by a spirit within the cerebral cavities, or the faculty of vision, like a magistrate sent by the soul, goes out from the council chamber of the brain to meet this image in the optic nerves and retina, as it were descending to a lower court.[13]

No one of these metaphysical hypotheses is worth more than any other: none can broach the positive, or positivist, definition of vision as a mechanistic fabrication of the image, a simple passive result of the instantaneous registering of light rays by the retinal surface. Whereas Huygens, in the description of the camera obscura he offers his wife, marvels at the mechanism and at the image it produces, Kepler's eye, as Alpers aptly puts it, is a dead eye, and the shimmering world of appearances is reproduced in it in representations "in the dual sense that it is an artifact—in the very making—and that it resolves the rays of light into a picture."[14] Which means, in plain language, that the surface of the world is identified in and by the image on the surface of the retina. "Ut pictura, ita visio," as Kepler declares.[15]

Behind Huygen's model of the camera obscura, behind Kepler's machine-eye, there is the schema of the photographic camera. The painting is a

nonwindow, that is, a surface on which the visible world is reproduced as if on a screen (the back of the camera obscura, the retina of the eye, the photographic plate), by projecting itself there "just as light focussed through a lens forms a picture on the retina of the eye," as Alpers writes in "The Viewing of *Las Meninas*": "In place of an artist who frames the world to picture it"—hence the importance of the frame and framing as means used by a subject to construct the painted image according to the Italian model—"the world produces its own image without a necessary frame."[16] Once again, the artist does not construct, does not compose, does not create a world of painting on the canvas. It is the world that offers itself to view there, as in a dead eye, that is, an eye without a gaze.

If the surface is one of the features of the model developed by Alpers, based on the Keplerian theory of vision, on the technology of the camera obscura, that is, on the basis of the historical epistemological circumstances of seventeenth-century Dutch painting, the model for this differential distinctive feature is none other than the image produced by the apparatus, which shares some of its fundamental characteristics with the "Nordic" mode of representation, as the author emphasizes—precisely those features that give them the full power of their reality effect: "fragmentariness; arbitrary frames; the immediacy that the first practitioners expressed by claiming that the photograph gave Nature the power to reproduce herself directly unaided by man. . . . The photographic image can, like Dutch painting, mimic the Albertian mode. But the conditions of its making place it in what I call the Keplerian mode."[17] By the "conditions of its making," of course, we are to understand less the historical, social, and cultural determinations of production than the theoretical, epistemological presuppositions of which the fundamental category is not at all the icon or the symbol in Peirce's sense, but the index, that is, the trace, the imprint, the mark of the thing itself. It would thus be just as if, on the surface of the canvas, the world in its appearances, in its own surface, were affecting itself, were copying itself to produce an exact replica under the fascinated and attentive eye of the witness-viewer, the artist who has had no function, no task, except to be—the way Stendhal would want to be two centuries later in his novels—a mirror held up along his paths.

Dutch painting of the Golden Century, or the reign of the surface, unquestionably liberated: but this surface is paradoxically that of the world and that of a painting, identified in an almost magical conjunction of which Huygens's amazement before the image of the camera obscura is the

sign. Henceforth, the camera obscura, the sightless eye, the photographic apparatus—in Alpers's work, all these are at once models and metaphors, models that she extracts from the spatio-temporal, historical, and cultural circumstances of her object and from the presuppositions of both a theory of visual perception and, more generally, of an empiricist, phenomenist theory of knowledge. They are metaphors that evoke specific expressive and emotional qualities: the painted image is in a sense more "real" than the thing of which it is the image, the simulacrum, in the Platonic sense of the term; it possesses a higher degree of being than the paradigm it never-theless reproduces; in its painted projection the visible world acquires a charm, a power of captivation that it had lacked. Let us listen again to Constantijn Huygens describing the "admirable effects in reflection paint-ing in a dark room . . . all painting is dead in comparison, for here is life it-self, or something more noble, if only there were words for it."[18] Such an image lacks speech, just as does the mute poetry of painting, just as Huy-gens himself lacks the words to express its beauty: "It is not possible to de-scribe for you the beauty of it in words."[19] The camera obscura is no longer, here, the constructed mechanism of Kepler's dead eye. It is produc-tive of an enchantment, of a natural magic—it is an image and yet it is life. At the very same moment, on the "Italian" side, even the Albertian side, Marin Mersenne, Jean-François Nicéron, and Emanuel Maignan were no longer exploring the effects of metamorphosis but those of anamorphosis, in connection with that same natural magic, in the name of legitimate per-spective in portrait representations or in religious or historical narratives.

A return to the surface, then: this may well be the watchword of the "new history of art" that finds, with Alpers's book and in the seventeenth-century Dutch painting she studies, the historically, culturally, aestheti-cally, theoretically privileged object, in order to construct its operational models: the surface as the ambivalent place that is at once a work of paint-ing and an appearance of the world, image and thing—in short, the space of indices, traces, marks. We need to understand that watchword in its full amplitude by asking ourselves whether, in any painted image, we may not need to take into consideration this non-Albertian, nonnarrative, nonclas-sical, non-Italian level. Poussin appears in Alpers's book in order to privi-lege "prospect"—theatrical, narrative, Italian prospective, in a word—over Dutch "aspect," the mere appearance of things; we must not forget that at the end of his life, the same Poussin, a contemporary of Alpers's Dutch-men, defined painting as "an imitation with lines and colors, on some sur-

face, of everything seen under the sun" and of which delectation consti-
tutes the supreme end. From that spatial plane, that surface formed by the
inscription of lines and colors, which is the surface on which the entire
work of painting unfolds, we must come back—back to the level that is
not the level of iconography and that may even antedate what Erwin Pa-
nofsky termed pre-iconographic, a level that is not at all deeper or more
hidden, one that lies on the contrary on the surface, but forgotten. There,
the specific "conditions" of representation in painting are revealed: "In
what manner, under what conditions is the man represented in paint on
the surface of a canvas?" Alpers asks.[20] For the question of the secondary,
conventional, iconographic meaning is replaced not by the question of
meaning, but by the question of the *conditions of possibility* of the work in
its singularity, the transcendental question in the Kantian sense.

To raise that question and to begin to answer it require the analyst—I
do not say the interpreter—to approach the painting, to come very close
to it, "almost too close," then to distance himself from it, to move away,
almost too far; analytic discourse can be maintained only at the price of
this oscillation. Then, along with Svetlana Alpers, the analyst will redis-
cover the Nordic, Flemish, or Dutch masters who have in a sense done
that work for him: "attention to the surface of the world described is
achieved at the expense of the representation of narrative action."[21] Our
author illustrates this formula with a text by Panofsky on Jan van Eyck:

> Jan van Eyck's eye operates as a microscope and as a telescope at the same
> time . . . so that the beholder is compelled to oscillate between a position rea-
> sonably far from the picture and many positions very close to it. . . . However,
> such perfection had to be bought at a price. Neither a microscope nor a tele-
> scope is a good instrument with which to observe human emotion.[22]

And because the signs of human emotions allow iconic construction
and storytelling, here Alpers is right to criticize Panofsky's normative ref-
erence to Italian art. We could easily illustrate the oscillation Panofsky de-
scribes not only with van Eyck but also, on the Italian side, with da Vinci
drawings that reveal the structural equivalence between a flower and a
flood, between braided hair and a river's current, between capillaries and
a downpour. Under the viewer's gaze, their isomorphism inscribes the ef-
fects—at once cognitive, theoretical, scientific, and visionary, fictitious,
imaginative—of the oscillation between too close and too far.

A fragment from Pascal, written at around the same time, will intro-

duce us to the question of description and the descriptive mode, which, as opposed to the narrative mode, is the other dimension of Alpers's model. "A town or a landscape from afar off is a town and a landscape, but as one approaches it becomes houses, trees, tiles, leaves, grass, ants, ants' legs, and so on *ad infinitum*. All that is comprehended in the word 'landscape.'"[23]

Under the very conditions of the experiment Pascal proposes, the movement of approach (the approach of both the "strolling" body and the microscope) has the effect of eliminating all the givens that construct the "Albertian" representation: the fixed viewing point, the framing of the spectacle with a rigorous, stationary boundary, the exact determination of the eye on the transparent level of representation. By means of the gaze, the world is fashioned into a "nature artifact" even before being painted on the canvas in lines and colors. In the gesture of immobilizing oneself in order to contemplate from a viewing point, in the gesture of enclosing the distractions of the gaze within the frame of the viewing window, in the secret calculus of an optimum vision, the program of a desire to represent is articulated, that is, a desire to master and appropriate nature. Setting the viewing point into motion displaces not only the site of vision, but also the framing and the distance and, from then on, the very object of the gaze, the "hidden" spectacle, distanced from the world accessible to the eye, is dispersed. It is dissolved in the proliferation of singularities, in the evident fecundity of things. "Nature diversifies and imitates,"[24] Pascal wrote in an enigmatic *pensée*. Repetition not of the same but of difference.

What Nature imitates is the diversity, or rather the differentiation, that animates it. Nature endlessly repeats its own prodigious difference, its power to produce singularities; but in so doing, in that very imitation, Nature becomes accessible to reflection in and through the figure of the eye, which, as it approaches, makes out houses, trees, tiles, and so on, without pause, in order finally to bring the enumeration of Nature's presentations to an end by giving it the name that characterizes it: *infinity*. Another name is opposed to, or rather superimposed upon, the name "infinity": "All of it [that is, houses, trees, tiles, leaves . . .] is included in the term 'landscape.'" A name, a term, brings the movement of infinite difference to its terminus, to a linguistically conventional conclusion, a name that "covers" the infinite and infinitesimal singularity of every thing, the abyss of difference without ever being able to remove it. Here, then, as the inverse or underside of the peaceful Dutch bourgeois certainties of the classical century, we have the problem, or rather the aporia and the para-

dox, of the surface of description in its relation to language, in its relation to the discourse that "tells" a painting. As Alpers notes with a great deal of subtlety, one observation recurs frequently in the discourse of art history and criticism on Dutch paintings, namely, that there is nothing to say about these paintings. A seventeenth-century Dutch painting shows precisely everything that could be named; it bears all those names on its surface and it seems as though all its "substance" consists in this exhibited and always nameable articulation of its surface or more precisely of the plane of representation.

The painting is a surface of description exactly coextensive with, and perfectly transparent to, the descriptive discourse that utters it and in which it is exhausted in a "flat" tautology between image and language. "A town or a landscape from afar is a town and a landscape; but as one approaches. . . . " Now we might say—with Panofsky, looking at a painting from van Eyck's mature period—that "Nordic" or "Dutch" painting obliges us to draw near in order to see better. "The beholder," Panofsky writes, "is compelled to oscillate between a *position* reasonably far from the painting"—a distanced position of the subject that is not only gaze but point of view, not only strength of fiction but power of totalization; not only does it constitute wholes by assembling things in the opening of its angle of vision, but it reduces them to the ordered unity of a synthesis whose geometric, linear, legitimate perspective defines the operative conditions—and "*many positions* very close to it."[25] Pascal, a writer, a man of language, condemned to the linearity of linguistic significations, to their monotonous successiveness, sees with perfect clarity that those numerous positions considered by Panofsky as *simultaneously very close* to the painting are in fact, and for the discourse that utters them, *successively closer and closer*: the eye stops seeing a city and a landscape to see houses and trees, tiles and leaves, and then grasses, and then ants on the grass. . . . The description of the surface of description of the painting is a thread of language, an interminable thread unless one breaks it peremptorily by naming that "interminability" the infinite. Every description is aporetic, and it is then that the Panofskyan viewer distances himself again, moves away, and announces the title of the painting, which is its exact description: "It is a town and a landscape." It will be Pascal's strength (and perhaps his excess) or, according to another "affective" tonality, Leibniz's, to interrogate the iconic and discursive concept of description and by that very token the metaphysical concept of reality. Every description is

aporetic because it encompasses the infiniteness of singular difference, the infiniteness of reality—unless it *stops* that flow of reality so powerfully evoked by Pascal in the fragment on the two infinities and of which da Vinci's studies of flowing water could be taken as emblems, a reality that will always be lacking, but through excess with respect to discourse and image, unless its "differential elements" are fixed, in linguistic conventions and iconic codes:

> There is grass on earth; we can see it.—From the moon it could not be seen.—And on this grass there are hairs, and in these hairs little creatures, but beyond that there is nothing—Presumptuous man!
>
> Compounds are made up of elements, but elements are not.—Presumptuous man, here is a subtle point!
>
> We must not say that things exist which we cannot see.—Then we must talk like other people but not think like them.[26]

Like the others, we have to say "it is a city, a landscape . . . "; but, unlike them, we may conceptualize the infinite difference of reality without ever being able to express or represent it.

Thus if the methodical way to rediscover nature in its purity and its transparency is to observe—to deploy the gaze without prejudice and without preconceptions in favor of empirical induction, which limits itself to collecting the givens constitutive of its knowledge—we must note—and once again, the experimenter, the physicist, the mathematician Pascal has the power to see this—that the iconic and discursive description that is its recording can find its theoretical conditions of possibility, its epistemological legitimacy, its foundation, and, in its development, its cognitive stability, provided that it resorts to the philosophical paradigm of conventionalism: every thing has its name, every thing has its figure, every thing is *in its name and its figure*, immediately appropriate to itself. Exact knowledge consists in rediscovering the originary iconic and linguistic lexicon of the world on the near side of overburdened tradition, of the sedimentations, beliefs, and unconscious rigidities of the mental habits that have fixed and incorporated them.

But "as we draw near . . . ," does this figurative and nominal lexicon not come undone? Just as Pascal's eye, "living" because in motion, approaches the surface of the world infinitely to lose itself in what he called precisely by its figure and its name, "a town, a landscape," in the same way the viewer's gaze, answering the call of Vermeer's painting, approaches the

canvas to the point of absolute myopia, whether it is contemplating the *View of Delft* or *The Art of Painting*, it discovers on that surface, with Lawrence Gowing or Svetlana Alpers, the same strange, paradoxical breakdown of description through excess:

> Vermeer seems almost not to care, or not even to know, what it is that he is painting. What do men call this wedge of light? A nose? A finger? What do we know of its shape? To Vermeer none of this matters, the conceptual world of names and knowledge is forgotten, nothing concerns him but what is visible, the tone, the wedge of light.[27]

Alpers uses this passage from Gowing to illustrate a movement that for her is specifically Kepler's; through it Kepler "not only defines the picture on the retina as a representation but turns away from the actual world to the world 'painted' there." Without sufficiently stressing the paradox, it seems to me, Alpers goes on to comment that "this involves an extraordinary objectivity and an unwillingness to prejudge or to classify the world so imaged."[28] A picture's description (in the double sense, objective and subjective, of the genitive), its "quasi-retinal" surface of inscription, which is the surface of the world itself, engages the gaze in a fascinating adventure: "If we concentrate on a detail—the hand of the painter, for example, in the *Art of Painting* . . . —our experience is vertiginous because of the way the hand is assembled out of tone and light without declaring its identity as a hand."[29] A vertiginous experience: the eye loses itself in the surface where representations of things definitively lose the words that designate and identify them.

This loss in excess—this vertigo, as Alpers aptly calls it—interrogates, if not the concept of description, then at least the way it operates: it is a matter of passing from *naming* the figurative "contents" to *conceptualizing* ways of grasping them and fixing them on the surface, a conceptualization that—this must be vigorously stressed—has nothing to do with a metaphorical or poetic "descriptive" impressionism that doubtless has its value, but that concerns knowledge of works in art history only indirectly. In this direction, we may have to go even further than Alpers in the development of categories of description, refining them and making them more complex by a constant back-and-forth movement between the epistemic equipment that the historical, social, and cultural "circumstances" offer the painter for his "description" of the world through lines and colors on the surface of his canvas and the methodological means that the so-

cial sciences offer the viewer. These latter will prove operational only provided that the viewer pays extremely close attention to the painted surface, that is, provided that the questions his gaze raises for him are of precise theoretical relevance.

From this point of view, in order to measure the precision of that relevance in Alpers's book, and since her work is instituted, as we have seen, in a structural opposition between the narrativity of Italian Renaissance art and the descriptivity of seventeenth-century Dutch art, it may appear to the linguist and the semiotician that her references to "narrative" and "descriptive" modes are at once too narrow and too vague. This is certainly not the place to pursue such a critique, especially because—and this is at once a strength and a weakness of her book—Alpers has effectively constructed this opposition only on the basis of the realm of the visible and only, too, in order to account for the two visual modes of representation in art history and historiography as well as in art theory and methods. Thus she is content with marginal evocations of linguistic or semiotic models (see in particular note 11 in the introduction and note 56 in chapter 2). "Narrativity" is, in fact, in Alpers's book, the "ideal-type" narrativity of Renaissance Italian art: the subject of the painting is a story staged by human actors and actresses in a theatrical space constructed by legitimate perspective, a story from ancient mythology or Christian tradition referring essentially to a secular or religious literary text. The emphasis in the critical discourse and the orientation of the analysis are then displaced toward the construction of the scenic place in the painting, which implies a gaze-subject that constructs this space through a plane of representation that is precisely limited by a frame (*per-spective*) and whose distance from that plane and its position with respect to it strictly determine the placement of the figures and their scale in an illusory depth.

It could well be that the whole problem of narrative representation in painting in general, and in "classical" painting in particular, should be studied specifically in the light of this displacement. It would then be necessary to explore the various figurative modes of articulation of narrative in general and the (historically variable) constraints that they bring to bear on its "iconic" narration and on the perceptual, visual, optical, geometrical (and other) "definitions" of the space represented in the plane of representation. Elsewhere I have attempted to construct models for these articulations, in particular that of the painting of classical history in which the arrangement of the narrative figures in a frieze is the result, at the level of the utterance,

of an operation of transforming by figuring, rotating, and lateralizing the structure of the mechanism of representation, that is, of the formal apparatus of enunciation.[30] These undertakings are a calculated transference of Emile Benveniste's seminal article on the distinction between discourse and history.[31] If Alpers had taken that distinction into account, along with the numerous works to which it has given rise, perhaps that would have allowed us to refine the notion of description of which she aimed to construct the model for the visual arts on the basis of seventeenth-century Dutch art. It is true that, between discourse and history, the notion of description has an ambiguous status, since it has both narrative features and descriptive features. From this standpoint, Alpers's recurrent references to the works of Ann Banfield,[32] themselves in part influenced by Benveniste, are indispensable; they deserve to be pursued and developed in the realm of the visual arts and the image of painting in particular, following a path along which *The Art of Describing* is an essential stage.

In any event, the magnificent "praise of appearance" and of surface that this book contains, through its study of seventeenth-century Dutch art, is completed, in the direction of Ann Banfield's research on the gap between the *self* and the *speaker* in fictional narratives, by a calling into question of the "Albertian subject" (especially in chapters 4 and 5). The thrust of such questioning is to benefit a multiple, fragmentary subject, bearer of a plural gaze, or else to favor the one that I myself had identified in my research on utopia and modes of cartographic presentation in the seventeenth century, a nonsubject, at once everywhere and nowhere, but one whose disappearance has the paradoxical result of animating things themselves in their representation of a visual self-presentation, of a sort of "thing-consciousness" that may remind us somewhat today, in the chaotic decline entertained by postmodern modes, of the Leibnizian or Pascalian motifs proposed here as a background to our reading of a book that is important for art history and the social sciences.

§ 15 Mimesis and Description

As a preamble to this discussion of mimesis and description, I should like to offer you a little aesthetic fable about the origins of painting from André Félibien's *Le songe de Philomathe*. Painting is speaking, after she has painted the world created by her Father, the God of Gods:

> The Water Divinities also considered my paintings with pleasure; they wanted to make copies, and they succeeded so well that you see with what ease they can create a picture instantaneously. Even the great Rivers and Torrents, although hasty and impetuous, often try to imitate them, but they do not have enough patience to finish everything they start. Only the Nymphs of rivers, lakes, and fountains, who are of a gentler, more tranquil humor, have taken such pleasure in this occupation that they do nothing but continually represent all that they are offered; [however, they are] so capricious that one [can]not see their pictures very well because they always represent them upside down . . . beyond that, the Zephyrs amuse themselves by spoiling the features and mixing up the colors of their pictures.

To this, Cupid adds:

> I wanted . . . to get them to do my portrait: several Nymphs of the calmest fountains and lakes showed that they enjoyed doing so. But when they had finished my picture, I could not get it out of their hands; and as soon as I went away, they even wiped out what they had done, to put something else in its place.[1]

As you can see, for our Poussinian defender of drawing and of the classical art that several contributions to this colloquium have brilliantly

evoked, painting finds its allegorical paradigm in the reflection of things in the mirror of waters: Nature, Nature productive of images in its chance encounters with beings, is already herself a worker of mimesis—*Natura naturans, natura artifex*—and, from this perspective, painting has, if not its origin, at least its condition of intelligibility and beauty in a primordial reflection of the visible world on itself. The art of painting repeats Nature's production of artifice in turn, but by surmounting its defining particular deficiency, which is essentially temporal. The images that float on the calm surface of waves are perfect, but ephemeral: their representation co-incides with a moment of fleeting presence when they are observed by the animated beings at the water's edge. It will take Narcissus to remain im-mobile, fascinated by his own image to the point of death. Thanks to Cu-pid's desire, this time during which birds, nymphs, or gods appear and disappear is taken up by Painting in the fixity and permanence of a more durable presence—in an extension of mimesis that overlays the present presence of a representation with the present presence of an absence or a corpse. Because there is painting, the thing at the instant of its appearance has become a model, immobilizing the nonchalant frivolity of its appear-ance in the positioning of the object that a gaze captures and that a hard-working hand bearing all the *technē* and science of art transposes into the picture. Even Narcissus dying at the fountain's edge did not leave a por-trait of himself in memory of his self-love; he left behind only a flower of metamorphosis, which, of his presence thus reflected in an image, will preserve only his name. Word and image, *texte et image*, names for images; this is the vast theme that has brought us together for a colloquium. Mimesis and description: this is the subject of my own remarks, at least— for when I utter the name "Narcissus," am I evoking his body stretched out at the border between earth and water, or his image dying on the sur-face, or the shades of the one and the other painted on canvas by a Poussin or a Caravaggio, or the flower that perpetuates his memory in Nature: mimesis between the being itself, its metamorphosis, and a name that would be at once the written trace of a description and a story . . . ? I would thus like to situate my problem in the play of fables and allegories about the origin of painting, between name and image.

If we confine the issue of mimesis and description to the framework in-herent in myths of origin, it actually seems that the poet and the philoso-pher are indeed victims—like Narcissus—of the fascination of a double desire: initially, the desire for a language of words so transparent to the

world of things that description, which would be its most perfect realization or phantasm, would serve to effect a kind of generalized translatability of the imaged figures of a picture into names in language. But, secondarily, the condition of this desire itself is its other, which resembles it like a brother and could also be its inverse: the desire for a painted picture so transparent to the perceptible world that the picture would be its mirroring reverie, the reflecting phantasm of a mirror. Representation in painting would then be in turn the operation of a generalized transposition of the things of the world into painted images; it would only inscribe the return of things that would thus come to be caught in the trap of the canvas and the painted surface, a surface that is itself already a trap of language, a net or network of names: a dream of or desire for a double exchange, a translation, a transfer, a transposition in which the logic and the economy of artistic mimesis would follow the same rules as the logic and the economy of the description of images, and the inverse would end up, under the circumstances, being the same—a logic and economy of sameness for both language and image, thanks to the correspondence of the mimetic figure in painting and the descriptive name that functions only to designate. This equivalence in fact coincides with an *exchange* in which there is neither gain nor loss, and the exchange coincides in turn with complex logics and refined economies in the field of words and language as well as in the field of the things and figures whose congruence would result from a final transaction, from an ultimate balance sheet in which the lacks and excesses in one realm turn out to be perfectly compensated by gains and losses in the other. In other words, the desire for transparency between images and things and between names and images would deny a central, radical difficulty in the very space of sameness in which the equivalencies between images and things appear to be achieved.[2]

In fact, pictorial mimesis is at work in the very place where the products of its power are irresistibly affirmed, it seems, and with that power, the products of the logic that subtends it and the economy that articulates it.

Here is the first proposition of this *organon*: the art of painting produces a double of the thing, such a faithful copy, such a good likeness, that it is the thing itself, there, on the canvas. And from this point on, as Plato asked, and Pascal after him, why imitate? "How vain painting is, exciting admiration by its resemblance to things of which we do not admire the originals!"[3] How useless art is, being worth nothing in itself. . . . But if, as Philostratus wrote in his *Life and Times of Apollonius of Tyana*, mimesis is

not such a wise worker as *phantasia*,[4] the reason may be—here is the second proposition of the mimetic *organon*—that it does not produce doubles of things, and that its artifacts are only *more or less* likenesses: coming after the model, added to it, the artifact replaces it even as, in this variation of resemblance, it deploys the variety of its own resources and effects. The art of mimesis as art, with all the work, all the *technē*, all the science of art, then comes, through an innocent magic, as Félibien has Painting say, to deceive the eyes, which think they see in painting what is not there, things, beings, movements, wind and clouds. From this standpoint, the mysterious pleasure of pictorial mimesis is thus accomplished in representation. It plays out its effects between two contrary and simultaneous propositions of a single logic: between a mimetics that *exceeds* itself in the power of doubles and a mimetics that *works* likenesses and unlikenesses by means of its figures. Deceiving the eyes is not the same thing as *trompe-l'oeil*; if the viewer is deceived by the appearances that Painting deploys for the gaze through its magic, according to Félibien, the degree of deception corresponds to that of the viewer's admiration for the painter's art and goes no further. The appearances do not abuse the gaze, unlike those "doubles" that the eye sometimes meets wandering around the edges of representation, as we have been told, and that blind it to the point of wanting to touch them; the thing itself comes into representation, it thrusts itself into the image in order to cross the limits of the imaginary and the real: magic without innocence. A thing, in trompe-l'oeil, is a ghost that *recalls* the disturbing and familiar strangeness of being in the pictorial representation that presents its felicitous appearance in the pleasure of forms and colors. It could well be that, far from finding the fulfillment of its goals in the doubles of trompe-l'oeil, the art of painting, through the graceful play of its always somewhat dissimilar similarities, has no purpose but to use the innocent magic of representation to conjure away the disturbing return of doubles in the image, to fend off the return of the unnamable, indescribable being because it would put one's eyes out with its presence.[5]

The second proposition of the mimetic *organon* is thus properly that of the representation that comes as a replacement and a supplement for its model. The dissimilar similarities that characterize it, its greater or lesser degree of resemblance, put to work the "re-" of representation, between duplication and substitution. As Plato noted, any mimetic representation is a lesser being in relation to its model, but what it loses in being—ontologically—it regains pragmatically by the resources of its art in the order

of emotive and sensory effects. And no doubt this play of duplication and substitution dissimulates and suppresses, through forgetting, the phantasm of an image that would be a double for the thing as well as that of a name that would be the transparent description of the image.

In Furetière's dictionary, at the end of the seventeenth century, under the verb *représenter*, "to represent," we find a remarkable tension that puts its meaning to work. To represent signifies on the one hand to substitute a present entity for an absent one (which is, let me say in passing, the most general structure of any sign, whether it be in language or in images), a substitution that turns out to be regulated—owing to nature or to convention?—by a mimetic economy: it is the postulated similarity between the present entity and the absent one that authorizes the act of substitution. But there is another meaning according to which to represent signifies to exhibit, to show, to insist, to present: in a word, a presence. Thus the very act of presenting is the act that constructs the identity of what is represented, what identifies it. On the one hand, a mimetic operation ensures the functioning, the function, indeed the functionality of a present entity instead of an absent one. On the other hand, a specularity, a self-presentation constitutes an identity, a self-identification ensures a legitimate value of beauty.[6]

In other words, to represent signifies to present oneself as representing something, and every representation, every sign or representational process, includes a dual dimension—a reflexive dimension, presenting oneself; a transitive dimension, representing something—and a dual effect—the subject effect and the object effect. Not coincidentally, contemporary semanticists and pragmaticists will call these effects "opacity" and "transparency."[7] It is hardly necessary to point out that the entire phantasmatics of description and mimesis is built on the transitive dimension of representation (representing something) by forgetting its reflexive opacity and its modalities (presenting oneself): a mimetics of the painted image thus opens the way from words to images because the images of things (in painting) are already the names of things (in language), because a nominal description of things is already inscribed in the image. The two mirrors, language and images, are immediately identified in the work of painting, and the whole process of presentation does not fail to tarnish, to make opaque those twin mirrors in which, as Baudelaire said, the love of lovers wears itself out in an exhausting contemplation.

Thus the deployment of the mimetic transparency of representation by

its reflexive or presentative opacity might also have as its counterpart making the most of the representative transparency of descriptive discourse, through its opaque boundaries. After all, for a very long time, rhetoricians and theoreticians of discourse, from Gorgias to Fontanier, have been studying the figures of discourse—hypotyposis, *harmonisme, subjectio ad aspectum*, alliteration—that paint things in such a lively, energetic, animated way that we think we are seeing the things when we hear the words. But it is just as evident that if words paint by showing and if language describes by making us see, it is through the power that traverses language and that words articulate; it is through the flesh of the voice that sentences inform. Like the Italian theoreticians of sixteenth-century music, Poussin called this force the sound of words, as a way of formulating the analogy between spoken language and the properly pictorial modes of colors and the arrangement of figures.[8] Beneath and beyond words and sentences, the strength of these figures of language traces in the body of the work of painting or language the opaque syntax of desire that animates the painter or the speaker and the pathetic effects of that syntax, which are in turn enacted on the body of the viewer or listener. No description in language that would merely echo the mimetic machinery of images can succeed in accounting for these opaque forces of the presentation of representation in which the imaginary identifications of the subject take on *form* on the basis of their effects.

With these figures of discourse, whose power to describe the things of the world or the artifacts of art clearly resides on the near side of names and on the far side of phrastic utterances, it seems to me that, on the side of images, we encounter the inescapable analytic model that Erwin Panofsky proposed for "describing works belonging to the plastic arts and interpreting their content."[9] And we run into our problem starting with the first level at which the model functions, the level of description, of phenomenon-meaning, of phenomenology. From the outset, Panofsky stresses that there is no such thing as an "immaculate perception" of a work of art, as Pierre Bourdieu indicates,[10] even if perception is governed by the *organon* of mimesis, or perhaps precisely because it is. Between the painting and its viewer, its virtual describer, there is always already, as they say, language, the treasure-house of language and its almost infinite resources and the confused repetitious murmur, as Maurice Blanchot would say, of the naturalized discourses of *doxa*. The subject sees and does not yet speak, but his gaze finds itself prescribed and its potential description pre-written in the paint-

ing it contemplates. Owing to the internalization of cultural forms as well as those of the semantic and syntactic structures of the idiom, the perception of the thing represented is exchanged for the thing it represents, and the name of the real referent is substituted for the name of the painted referent, and, in this same process, there is a concealment of what Aristotle had already pointed out in *Categories*: namely, the simple homonymy between the painted horse and the real horse[11]—is hidden, or what the Port-Royal logicians called a *figurative* utterance ("without any introduction or ceremony, we will say about a portrait of Caesar that it is Caesar").[12]

Still, whatever Panofsky's methodological and theoretical precautions may be, it nevertheless follows that a description, of the type he calls purely descriptive or purely formal, is separated from the phenomenology of the painted work: "A description that is really purely formal ought to avoid using any nouns, such as 'stone,' 'man,' 'rock,' simply because the mimetic apparatus functions with a transitive transparency that is too perfect to allow words, substantive and predicative names, to be imposed immediately, naturally, on the descriptive discourse, at the risk of falling into non-sense if they were to free themselves from it."[13] It is then that the so-called work would literally not mean anything. In the Panofskyan model, it is easy to spot the process by which the opaque flesh of painting, its features and spots, figures, and colors, are hidden, when one discovers that it is at the third level, the so-called iconological level of a philosophy of symbolic forms, that the excluded element—which, once again quite significantly, Panofsky calls *purely formal factors*—turn out to be reintegrated. In a return of the repressed, factors that had been excluded from the descriptive phenomenological level because they were meaningless become "documents of a homogeneous meaning of a vision of the world" and thus are meaningful because, to borrow expressions from the early Panofsky, using the names of phenomenon-meaning and the cultural knowledge of signification-meaning, they construct the essential meaning, the meaning of the essence of a culture.[14]

But whatever the import of my own critique of Panofsky's model may be, the fact remains that the double movement I have sought to point out—the exclusion of the "infra-pre-iconographic" and its reintegration as the "supra-post-iconographic," which characterized description in the field of a transitive mimetics of the work of art—conveys a requirement of interpretation that has to be taken into account. Even if the constitutive categories of description—of that hither side of the names of things, that is,

of painting as painting—were somehow elaborated, the discourse that would result from it would still have to be taken into account by art history and art theory, by a history that would make its object not only transitive transparency but also the presentative opacity of representation and its effects. You may note that I am returning at this point to the issues raised earlier by Oskar Bätschmann,[15] but via a theory of art that attempts to conceptualize what Meyer Schapiro called the nonmimetic aspects of mimetic representation—that is, in Kantian terms, the transcendental sphere of the conditions of possibility of the mimesis of art.[16]

Let us not rush, then, to attack Panofsky's model with the war machine of nonfigurative painting, so-called abstract or informal art, even if the latter, in the history of its emergence, may reveal how the model can be, if not surpassed, at least made more complex. Let us linger another moment or two in the field of representation that is governed in a complex and evolving way by the logic and the economy of mimesis: let us try again to take painting at its word, a painting by its name. Let us take the claim to exhaustivity and objectivity that is implicit in any description of a painted picture and turn it into a question. Let us introduce the fictionality of that claim as a problem and the phantasm of its desire as an analytical tool. In short, let us ask the naive question already raised: does the entire painting, does everything in the painting, offer itself in the name?

I shall address this question by referring to a particular painting: Philippe de Champaigne's *Still Life with a Skull* (*Vanitas*, or *Memento mori*) in the museum at Le Mans. The thoroughgoing readability of this work is perfectly proportionate to the compelling nature of its visibility. On a stone table, three painted objects are placed side by side: a crystal vase with a tulip on the left, a skull in the center, an hourglass on the right. The picture is not only in itself the exact representation of three objects in painting, but it is also the representation, the presentation to view, of the list of names that name them: a visual paradigm of the list of names that Philippe Hamon rightly proposes as the "theoretical" paradigm of realistic description (and, in this connection, let us not forget that Champaigne is Flemish). The stone table that supports the three objects to bring them to view and to language at the same time might even be considered as the visualization of the linear succession of the names that describe them, a visual and nominal list that would find the structural center of its succession in one name and one object, the death's-head skull that is its center.[17]

The net of names taken as a descriptive list thrown over Champaigne's

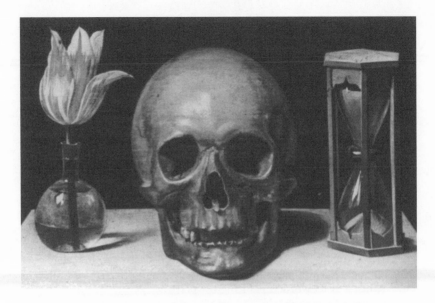

FIGURE 15.1 Philippe de Champaigne, *Still Life with a Skull* (*Vanitas*, or *Memento mori*). Musée de Tesse, Le Mans, France. Photograph courtesy of Giraudon/Art Resource, New York.

painting because it was already written there through an exact mimesis, according to the Panofskyan model, brings the entire picture back to the grasp of our gaze and our language. No doubt we could lengthen the three-name list by adding classifying and modifying predicates, predicates and predicates of predicates that would develop representative transitivity, through successive settings, from the generality of names to the particularity of their capacity for designation, in order to move toward the identification of the painted figure in its individuality and even toward the proper name of what it represents, and to end up with the name of the painting, this memento mori by Champaigne, in the museum in Le Mans. Does our nominal network, extending from a descriptive list with more and more finely woven stitches to a painting with a more and more tightly woven envelopment, restore to us the entire painting in its name? A question: what can we say about the background against which the figures stand out, on which figured names and named figures are detached in a list? What can we say about the background that *makes them* detach themselves in a figured list, a list that functions as a list figure only through that

background, which presents them as such? A black background. So be it; but what does that black background represent? Nothing. I could presumably move on to naming by nominalizing "nothing" as "the nothing": a noun that does not name, that is now only a name: the name of the unnamable, the place of effacement of the list, but a place whose cancellation is in some way the condition of its visual and verbal production; a nothing that is a remainder; a remainder in a relation of excess to the power of nomination, but in which that power finds its impulse.

But if this background represents nothing, it does, for all that, present itself as nothing: it does not present itself as representing something; it presents itself. It is in its pure self-presentation that Champaigne's painting can so forcefully represent the three objects that it represents for their immediate translation into a list of names. In other words, the descriptive gaze is present at the schism between opacity and transparency. The reflexivity of the representational sign is in some sense theoretically and practically cut off from its transitivity; thus the opening of a path toward a higher meaning, beyond iconography, may take place in this syncope, since it opens onto a hither place on this side of the pre-iconographic.

This unnamable background: of what is it the background? Of the three objects that the painted representation offers us to see and to read? Or is it the background of the painting itself, the supporting background of the represented background on which the three figures remove themselves from view by gaining access to language? Probably both. The syncope of opacity and transparency is converted *there*, in that place in that work, in the ambivalent fusion of background and surface, of painting and representation, in a hysterical conversion—so to speak—of representation in painting.

To be sure, by speaking this way, I am *describing*, but the description I am producing works in and on the mimetic economy that all the while governs transitively—and powerfully—the representation I am describing. In the very effort of descriptive discourse to "adhere" as closely as possible to the transitive mimetics of representation, the descriptive gaze has been led to develop, for this painting, the category-names that turn out to control the list of names that the perceptive gaze produced immediately by transforming the syntheses of objects from its experience into re-cognition of those that signify those syntheses: crystal vase, tulip, skull, hourglass. These category-names (or concepts)—"background-support," "plane-surface," "rim-border," "figure-non-figural," and so on—take into account in lan-

guage the parts of the representation that rose up before the perceiving gaze without being immediately namable; at the same time these concepts attempt to articulate, *in the discourse of knowledge,* not some ineffability of the painting, but only the opacity of the presentation of representation. They attempt to construct the specific modalities of the relations—that is, of the forces and their effects—that connect reflexivity and transitivity: coincidence, occultation, confusion, syncope, conversion, substitution, ambivalence, and so on. It is the space of these relations and their modalities, the field of effects of forces, that might then be formalized, in a theory and practice of description, by what I shall call the markers of virtuality—at once logical possibility and dynamic power: not the figural or figures, but figurability; not name or utterance, not nomination or enunciation, but namability, enunciability. In short, it would be a matter of drawing description back to describability, of drawing vision back from images to visibility, the reading of images back to readability. We would be talking about process and not system, about structural dynamics and not tabular statics; in short, it would be a matter of finding in a generalized Aristotelianism the conceptual means for a description that could consider the entire field of pictorial mimetics in order to rediscover, to perceive, in that field, the traces and effects of the forces at work there and of which it would very often be the powerful denegation.

Let us leave Champaigne's *Memento mori* behind for a while and turn to a text that interrogates mimetic description and transitive mimesis more forcefully than I could, although from a different angle. Let us consider the following *pensée* from Pascal: "A town or a landscape from afar off is a town or a landscape, but as one approaches it becomes houses, trees, tiles, leaves, grass, ants, ants' legs, and so on *ad infinitum*. All that is comprehended in the word 'landscape.'"[18] To play the game of mimesis in painting, let us substitute for that town, that landscape, the Dutch painting produced about the time Pascal was writing his *pensée*. If we do so, all the elements of the problem we are addressing come together: mimesis in painting and description in language. In its incisive brevity, Pascal's *pensée* reproduces the verbal gesture of pure description; the structural schema exploited by the rational processes of knowledge and the model of description as metaclassification (according to Philippe Hamon) are produced and unified in a sequence that, through the combined play of classifiers and modifiers, leads from the general to the particular. Description

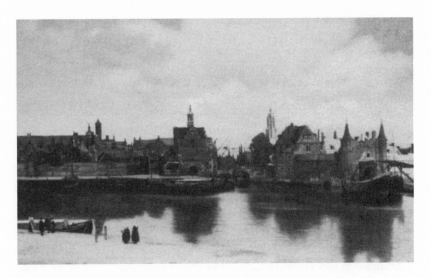

FIGURE 15.2 Jan Vermeer, *View of Delft*. Mauritshuis, The Hague, The Netherlands. Photograph courtesy of Scala/Art Resource, New York.

subordinates a more and more extensive predicative list to an encompassing unity: one noun that stands for all nouns in subsuming a determinate number of forms (houses, trees . . .). Once they have been converted (through mimesis and naming) into the corresponding things, these latter can be decomposed in turn into their constitutive parts: tiles, leaves, grass, and so on. Through this play of hierarchical embeddings, through the play of the components and connections that institute the structural hierarchy of language itself, according to Benveniste, the theory of description aims to construct the nominal enunciation of an individuality, a proper noun, which, in this picture, is Delft: the name of a particular town and the name of this particular painting or in Pascal's *pensée*, *a* town, *a* landscape. Such is the perfect reversibility of mimesis and description, of the mimetic image (of painting) and of the proper noun (the name of the town and the landscape) joined in the name of the picture that represents them perfectly.

Now this theory is what Pascal calls into question in his very construction: he calls into question a theory of description that would "realize" or reify, in things or their mimetic images, in its own process of constitution, the structural hierarchy of language, which is a constructed concept and not an operational convention. He does this by situating at the beginning

what the process of description locates at the end: "A town and a landscape . . . are a town and a landscape." He calls into question the verb *are*, which consecrates the immediate reversion of the mimetic image and of the noun that names it. He calls the verb into question by using the very process of description constructing the noun that subsumes the list, but inverting its orientation. The proper noun, an exact descriptor of an exact mimesis reproductive of things, Delft, a town, a landscape, far from being the rigid designator of a specific description, of a "mimeme," a faithful copy, is only the usual—and used-up—envelope of an infinity. It is better than nothing: it allows us to speak of things to others and to be understood by them. . . . Descriptive, designating nouns in which things *are* names, nominal images in which names *are* things—image-names, in short—are circumstantial cases of the infinite, of an infinity of lists of names embedded the ones within the others: which means that the classificatory embeddings and lists are interrupted, and that before long there are no more nouns, also that the figures and parts of figures soon blur and that soon there are no more images.

To the silence and the syncope of discourse, the formlessness of images and the syncope of figures respond like echoes, so to speak. Pascal's writing signifies this movement toward nothing sayable, precisely in the syntagma of its enunciation: "A town or a landscape from afar off is [*c'est*] . . . , but as one approaches it becomes [*ce sont*]. . . . All that is comprehended in the word 'landscape.'" The verb "to be," which marks the exchange between the name and the image in Pascal's text, is, in the enunciation, anticipatively determined by the successive allusions to movement: from far away, from close by. It is put into a state of flux. With this movement of approach in space and in language, which is also a movement of approximation in perception and knowledge, far from specifying and forming themselves, the equivalencies, the identifying recognitions, enter into a state of flux— which is, according to Benveniste, the exact translation of the Greek word *rythmos*.[19] The gaze in which the descriptive subject emerges is rhythm. The subject is in a state of flow, as Montaigne well understood: "I am myself the matter of my book. . . . I do not portray being. I portray passing."[20]

To meet the needs of our analysis, I began by substituting a Dutch landscape painting for the landscape that Pascal contemplates ideally. From afar, Delft is a city, a countryside, from afar, from the top of the hill where the painter has positioned himself—here I am thinking of certain of Svetlana Alpers's analyses in her fine book *The Art of Describing*;[21] at a certain

distance from the painting, *from afar*, where the describer-contemplator has positioned himself, it is Delft. But do you want to describe definitively, to see exactly? Then move closer, keep on moving closer: these are houses, tiles, grasses, ants. . . . Let your gaze be myopic, hypermyopic, and you no longer see tiles, grasses, ants coming to fill the lists of predicates of the noun . . . but little drops of red, green, and white, great blue and yellow splotches, unctuous flat spots, patches, a small yellow patch, short colored cross-hatches . . . shapelessness serving the purpose of figurability, all the brushwork, the work of the brush hairs, the gestures of the hand, the painter's body in painting: and it is from this pleasure of the eye that all the derivations of a *theoretical imaginary* of limits take their driving force. There are good examples of this in Pliny the Elder—yes, Pliny—when he evokes Parrhasios's lines: "For the contour ought to round itself off and so terminate as to suggest the presence of other parts behind it also, and disclose even what it hides"[22]; here I should also invoke Vasari and Dolce speaking of Titian in his old age—the pleasure of painting, which can also be a moment of linguistic jubilation, drawing upon the almost inexhaustible treasure of words and figures. And here, too, I should mention Diderot or the Goncourt brothers on Chardin. Listen to the latter in the following passage, which would warrant a long and detailed analysis:

> It shows a glass of water standing between two chestnuts and three walnuts; look at it for a long time, then move back a few paces; the contour of the glass solidifies, it is real glass, real water [and no longer a glass of water], it has a *nameless colour* produced by the double transparency of the vessel and liquid. [On the water's surface, at the bottom of the glass, daylight itself plays, trembles, and drowns.] The tenderest colour range, the subtlest variations of blue turning to green, the infinite modulation of a certain sea-green grey, crystalline, and vitreous, everywhere broken brush-strokes, gleams rising in the shadows, high-lights placed as if with the finger on the edge of the glass—that is what you see when you stand close.[23]

Language attempts in this way to express the pleasure of the eye through its own pleasure by setting up, in the face of the "wall of painting" constituted by Frenhofer's unknown masterpiece,[24] a list of words infinitely proliferating from the resources of the vocabulary. Go back to your distanced position, move far away . . . all the infinity that language cannot determine and that has to be content to mime (to reflect in its own order), all that infinity is enveloped under the name Delft, a glass of water, two

chestnuts and three walnuts, under the exact mimetic image: transitive transparency, an envelope of the presentative opacity in which is discovered a process of infinite differentiation. During this process the real comes to be missing from the mimetic mechanism that regulates its representation (to represent something, the real) and signification (I am not saying meaning), in the descriptive mechanism that articulates its enunciation (by naming the thing).

"From afar off . . . but as one approaches." The presentative opacity of mimetic representation appears in the movement of a position of the contemplating subject, the virtual describer, in the variation between the near and far of the painting: better still, the describing-contemplating subject is not identified, it presents itself as the power of the gaze and of description, only in that variation, in that oscillation between far and near; it appears as the effect of a flow, of a rhythm, a state of fluency that is the originary dimension of form, a flow that neither name nor figure could stop in order to produce its concept or provide its theme.[25] This fluctuating power underlies what people have been able to say and repeat about modern painting since Cézanne and Manet, the ordeal of the unsayable and the unnamable enacted by the discourses about modern painting as a result of its effort to explore creatively the conditions of possibility of representation, to work at the place of the syncope of opacity and transparency, and thereby to cut itself off from everything that would lead it to language, to suppress that verbalizable, describable kernel, forced by its images and figures to emerge in the materiality of painting. All this withdrawal of modern painting from languages would be situated by a more rigorous theory of description in a more exact and more precise theoretical construction and in a more attentive analytical practice of representation in painting.

From close up . . . "from afar off." To conclude, I should like to offer you two images that I have taken from da Vinci's work. From near by, close up, too close, a detail of the hair in the portrait of Ginevra de'Benci; from far away, very far, a drawing of a landscape under a deluge.[26] From very close up, there is no more exact way to describe Ginevra's painted curls than to "tell" the whirlwinds of the elementary forces unleashed on the world by God or Nature. From far away, very far, there is no more exact way to "tell" the flows and maelstroms of the heavenly waters than to describe them as curls in hair, the glory of a cosmetics. Ernst Gombrich offers a particularly admirable analysis of this phenomenon.[27] For an eye

FIGURE 15.3 *(left)*
Leonardo da Vinci,
Ginevra de'Benci (detail).
Ailsa Mellon Bruce Fund,
© 2000 Board of Trustees,
National Gallery of Art,
Washington, D.C.

FIGURE 15.4 *(below)*
Leonardo da Vinci,
Deluge. RL 12384,
Windsor Castle,
Windsor, Great Britain.
Photograph courtesy of
the Royal Collection
© 2000, Her Majesty
Queen Elizabeth II.

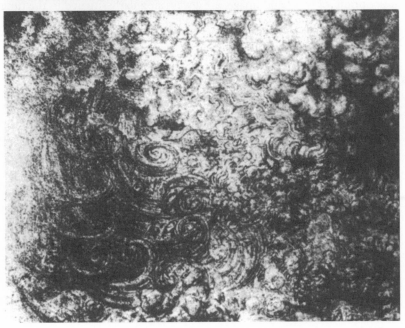

that would be God's, very high up, very far away, the representation of the cosmic catastrophe is precisely a woman's hair. For an eye that would be an insect's, Pascal's ant's eye, from very close up, the image of a curl of hair is precisely the whirlwind of the deluge. The discourse that would thus attempt to tell, to describe, the opacity of a presentation in mimetic transparency—as da Vinci's drawing and painting tell us—would conjugate the exactitude of visual recognitions and the precision of names, the homologies of sameness and resemblances, with the dazzling brightness of the metaphors of a poem, the apocalyptic images of a revelation, the heterologies of differentiating metamorphoses and figurable contraries.

Description-mimesis; word-image: our colloquium has opened up an immense program of research and study. Its scope and fecundity have to do, it seems to me, with the problematic theme that has brought us together: the theme of frontiers and edges, of limits and interfaces, which obliges us necessarily to abandon our disciplinary safeguards, the homogeneities and regularities of the field, to try to maintain the plural discourse of functional heteronomies, transgressions, and blends without ever forgetting the rigor of theory and the precision of methods. We face this obligation for the simple reason that edges and limits of mimesis and description, of word and image, are always singularly situated in the time of history and the places of culture. There is no other way to describe them exactly—to describe the effects of the forces that traverse these limits and that these limits connect and articulate—than to be the historian, the anthropologist, the sociologist of these moments and these places, one who would be all the more a historian, an anthropologist, or a sociologist in that he or she would look at works of art, each of them, their series, their sets, with the most exacting attention, would describe them with the most rigorous fascination, from very close up, the better to become familiar, from afar, with their perceptible and moving effects in their historical and cultural modulations.

§ 16 The Tomb of the Subject in Painting

By titling my talk the tomb of the subject in painting, I am seeking to situate its topic in a very precise place within the title of this colloquium, "Images of Death, Death of the Image." I want to talk about the invisible bar, or the imperceptible difference, that articulates its central chiasmus, about the place of a comma or a blank space, of a spacing or a gap, the space of a difference between death and death: between the death that images—we have all noted the title's initial plural—can be said to represent and determine by their forms, their lines, and their colors, thereby giving death over to language and to vision, death in difference from that other death that is perhaps the end of every image, which abolishes the features of the image, fades its colors, erases its forms, that other death that not only suspends all representations of itself, but also neutralizes any presentation of the imagination in the indefiniteness of the neutral, of the "neither the one . . . nor the other," at an equal and infinite distance from all positions and all negations, from all determinations. Images, the profuse plural of the representation of what is perhaps the unique object of all representation, death, which all representation may try indefinitely to qualify; images of death forever separated, by the infinitesimal space of a comma or by a brief syncope of the voice and of writing, from the death of all images, a death irremediably other, a second death in chiasmus with the first, no longer death as an object of presentation and of representation, but a subject-death henceforth exercising over every representation, over every image in general, its absolute power of effacement. Unless this second death is, in a new distance, a new gap, only a displaced usage, only a metaphor for the other, unless it is simply a more passionate, more dramatic,

more shocking way of speaking, in which the end, the disappearance, the effacement of the image makes a clean sweep, doing away with whatever refuses its prestige and its charms, with whatever turns away from the illusion and deceit of those charms to clear a space for the clarity of the idea, for the transparency of signs, and for the abstract distinction of intelligible essences. Thus it appears to me that at least three deaths meet in the title of our colloquium around the white space of the chiasmus that brings them together: death, the unique object of multiple imaginaries; death, the other subject of every image; and finally death—metaphor or catachresis—an "improper" echo of the appeal of reason to reason, of the requirement of returning to the purity of the concept.

Perhaps I should also note that during the hours we are devoting to death, to its images and its powers, we never speak about anything but the third death, the metaphoric one; perhaps we never speak about anything but the image of death, that is, obliquely and through a displacement of death itself, so as to express the death of the image. La Rochefoucauld said that "we cannot look squarely at either death or the sun,"[1] so true is it that as an object of images, like the vanishing point that perspective assigns in painting, death can never be anything but a referent pointing to infinity: not nothing, but the thing toward which everything tends, as with the hole on the horizon of the painted work where all images disappear, the point of their vanishing as images; so true is it that the subject of the image, death, is unassignable to the fixed and indivisible point of view at which a short-sighted perspective construction would seek to situate the contemplating eye of the maker of mimetic syntheses. For if death is in the vanishing point of infinity, like the infinitesimal place where images vanish on the canvas, a point that all images present, it is, by the same token, structurally and through projection, in the point of view, at the point of infinity within point of view, hollowing out the constructing-viewing eye with the same hole that leaves the vanishing point indeterminate, making the subject-eye flee in its turn into infinity, emptying it of all substance, of all ontological density, by forbidding it to fix itself in one place, in one indivisible point. "We cannot look squarely at either death or the sun." Death would thus be, here again, the metaphoric naming of the vanishing of all images into the hole of the vanishing point but also of the vanishing of this term into infinity, of its projection beyond every terminus that an image might point to as its definitive object. Death would thus be the metaphoric naming both of the emptying out of the viewing eye through

the hole of point of view and also of that place of places, that place outside of any place, where all space would disappear into another order, as Pascal would say, where the subject would be resuscitated, changed.

This metaphoric—displaced—presence of death in the perspective mechanism of representation appears to have been evoked and situated at the point where, to echo Hubert Damisch, perspective originated: in book 2 of *De pictura*, where Alberti speaks of the divine force of painting that makes absent ones present, as we say that friendship does, and almost turns the dead into living people for their greater glory and for the painter's glory. Or in a still more decisive way, it was Masaccio who, beneath the trompe-l'oeil altar of his *Trinity* in Santa Maria Novella, placed an open tomb with a skeleton lying on the slab, a skeleton that has been shown to be exactly the same height as the man standing in the nave who is positioned in the viewing point. Thus we find the empty socket of a dead man's head at one pole of the mechanism. That is what comes to fill the living eye of the viewers who come to stand, in their turn, before the masterpiece, unless, conversely, it is the living eye that plunges into the socket-hole in the skull, simultaneously finds and loses itself there, becoming the eye of the emblematic skeleton that is lying in a horizontal plane below the altar, beneath the horizon that creates the illusion of an opening up through the wall of the church into a chapel, and that is also moving—just as illusorily—outward from the plane formed by the wall and into the church, into representation by the altar and the tomb.

Thus I should like to speak of the tomb of the subject in painting—to do so by trying to pinpoint the very narrow, infinitesimal space of difference in the hollow of the chiasmus between death and image and to situate what I shall say unstably there—where, indeed, I have already installed it, unstably or metastably, by reading death, or its metaphor, in the two poles of the perspective mechanism of representation in painting, vanishing point and viewing point. In the imagination, such a mechanism or structure would authorize any representation of things so as to conceal, to cover over, to "suppress," as they said in the seventeenth century, the deadly hemorrhage of referent and subject—designating that hemorrhage in this very process. But the painting would remain, the *tavola*, the canvas, interposed between the two points and on which the whole world of colors, lines, shapes, the world of representation, is constructed and, still more, painted: to the metaphor of death at the two poles of the structure,

I have thus added, in my title, the metaphor of painting, or its image as a tomb: the tomb, or death expressed architecturally in its monument. It is clear enough that if death metaphorically names the object of the images and representations in evanescence at the vanishing point, if death metaphorically names the subject of the image in the process of fading away at the viewing point, a tomb, on the contrary, metaphorically names a painting, a painted representation, only in order to substitute for death its monumental sign and perhaps more than its sign, its strongest and most lasting representation. By that very token, through the image of the tomb, there is an attempt to achieve mastery of the double erosion of death, the erosion of images via object-death and that of the image via subject-death, via what simultaneously designates that erosion, shows it, and indicates it: a tomb, or death embodied architecturally in its monument; representation, or the triumph, of death (as object) by death itself (as subject). In understanding the genitive simultaneously in the objective sense and in the subjective sense, we have another means of repeating the chiasmus and the exchange between death as object and death as subject, between the images and the image.

Grave, tomb: in the seventeenth century, which will be the field of death treated here, a tomb is the exaltation of a grave, a "great stone that is set to cover the grave of a dead person, to mark the place where he is buried. Often," Furetière continues in his *Dictionnaire*, which I am citing here, "epitaphs are put over graves, some inscription to mark the one who is lying beneath the tomb."[2] From these admirable definitions of a grave I shall retain only two notions, which I view as essential in order to "justify"—that is, to *think*—the metaphorics of death, painting, and the subject in painting in which we are engaged. The first notion is that of a covering over of death in the dead person: the grave dissimulates, covers, *suppresses* the dead person. Yet that person will always be under the stone slab or behind the wall; the grave covers, but, as Pascal said about the Ego (the subject ego) to the libertine Miton, even if you cover it up, "that does not mean that you take it away."[3] Hence the second notion, which is in a sense an extension of the first: by dissimulating, *suppressing*, covering over death, a grave marks death, or more precisely it marks it by its place. It is not so much a mark of identity as a mark of identification or recognition of a space that belongs to death; it is thus obliquely the ultimate mark of identification of the dead person in that place. Thus Furetière is careful to distinguish between the mark of the place and the mark of the individual's

remains, by means of the epitaph: in epitaphs, supplementary and by no means necessary inscriptions characterize the dead person in the place of death. The grave is a mark, a marker that makes this place recognizable and distinguishes it from another, similar place, the place of the epitaph, the sepulchre of the dead person whom the grave covers and conceals: a name, a signature, and, we might add, perhaps even an image.

A tomb, then, can be seen as the insistence, the *epideixis*, of a grave: from the stone slab marking the place of death we move to the "magnificent or embellished place, which marks the fact that some person of importance has been buried here."[4] Here I should cite all of Furetière's examples: the splendid tomb of Mausolos, named mausoleum by Artemisia, his wife; the splendid tombs of the French kings at Saint-Denis, the epigram from Emperor Hadrian's anthology ("Pompey had many temples and had no tomb"), or Plutarch's observation that "in Sparta a dead person's name could not be inscribed on his tomb if he had not died in war."[5] The tomb is a monument, *monumentum*, which warns the living about the dead person in his place. "Siste et abi, viator," reads the epitaph on Roman tombs in the countryside, near public pathways. "Passerby, stop a while. . . . Passerby, go on your way. . . . Passerby, stop a while. Under the lines you are reading, the bones of their author lie buried. At the edge of this tomb, and just before descending into it, he himself wrote these lines so that they would cover over his ashes. . . . Passerby, go on your way and be assured today that in praying for him you pray for yourself. . . . "

Like the passerby in the Roman countryside, on the ancient Via Appia, we should stop to contemplate that literature of epitaphs, that writing, rather—those ancient and Christian funereal inscriptions. Here the grave is not only a tomb but a monument, that is, testimony to some past grandeur or power (for example, in Furetière, the Egyptian pyramids attest to a history), and we shall not be at all surprised to see the semantic and lexicographic circle turn back on itself and close around the ultimate meaning of the monument as a tomb ("The body of the Savior was placed in a brand-new monument. All the old conquerors are in the monument") and perhaps, more particularly, its meaning as those "vain tombs, or cenotaphs, monuments erected to the glory of a dead person although his body was not buried there." Since they do not cover or conceal anything, such graves stand out as signs—or rather they point up the sign function —of graves as simple marks, or of tombs as magnificent, ornate markers. They have only this value because the object is lacking, because the refer-

ent has disappeared; their function is to institute or inaugurate, to ground a representation. However magnificent it may be, a monument, a vain tomb, is a representation-sign; in other words, it is the image that restores absent objects to us as memory and idea, and that paints them for us as they are.

Let me go on reading Furetière, who will bring us back to the themes of our colloquium: "The Church has accepted images because they are representations of God and the saints. . . . When we go to see dead princes on display in their beds, we see only their representation, their effigy."[6] Thus, once again, we are not surprised to return to monuments, vain tombs and cenotaphs, through representation, for the term "cenotaph" is also used "in churches, referring to a false wooden coffin covered by a mourning stove around which candles are lighted during services for a dead person,"[7] in other words (and here I am adding my own commentary) a monument-ceremony, a tomb-ritual. But if we pursue the late seventeenth-century inventory of the meanings of representation, through a sort of development of the notion of image, we quickly come to portraits. The effigy of a dead king on his display bed had already turned the bed itself into a representation, a false coffin, a vain tomb, and it had turned the three-dimensional image of a sovereign, his stretched-out portrait, into the ultimate avatar of the stone figure lying on the slab of the tomb. But representation "is [also] used sometimes," Furetière writes, "for living persons. Of a serious and majestic face, one says, Here is a person of fine representation. . . . That son so resembles his father that he is a true representation. In optics, one also says, The image is painted on the retina; that is where the representation of objects is made." To represent will be to "make an image or a painting of an object, that lets us know it as it is"; thus the "skilled painter represents all sorts of faces" and the "mirror represents things in their natural state."[8]

There is no need to pursue this cascade of definitions here; I shall end with just one more, which points to our point of departure in death: in legal terms, "one also says that in a straight line, representation goes on to infinity; this is a way of saying that a grandson inherits from his ancestor . . . by a representation of his own deceased father, and that he shares in the inheritance as if his father were alive."[9] The juridical meaning of the term is probably the most profound, for in an enlarged metaphor (but shall we never speak of anything but metaphors of death, of images of death?), in the linear play of lineages and filiations, in these references to paternity and

origin in death, it connects both with my remarks on the perspective mechanism, its vanishing point and its viewing point which stretch out to infinity and yet which are situated at fixed points—they are in constant movement, indivisible "although by its nature [a point] is infinitely divisible" (I am quoting Pascal)[10]—and with my remarks on the subject and being, representation by filiation, and even a grandson's inheritance from an ancestor via the father's death, the father having the role and function of the screen of representation in painting, or the role and function of the tomb as mark, sign, and testimony, an image positioned as a real presence, the dead father as if he were living: the tomb of the subject in painting.

I should like to note in passing—although I shall not dwell on this point because we would be repeating the same circular trajectory—that with the term "subject," which is the second focus of my title, I shall raise three questions, as a way of marking off, with three reiterated marks, the place of my inquiry. Here again, let us follow the seventeenth-century French lexicon as we have it from dictionaries of the period: "Subject, is said of the object of an art or a science, of what they consider, or on which they work. . . . " As we can see, this definition dispenses with the so-called metaphysical and Western opposition between subject and object, and it is illustrated or elaborated by three examples:

> The human body is the subject of medicine [that is, its body of study]: and that is why anatomists call a corpse that they are dissecting and using for teaching a subject. The subject of logic is discourse and reasoning; and one says more particularly that in a syllogism, one of the terms is the subject and the other the attribute. In poetry, the subject is the matter dealt with, the event that is related, that is beautifully arranged, and that is embellished with ornamentation.

Medicine, logic, poetry, three subject-objects: the dead body that is analyzed in parts; discourse whose relations and structure are determined and whose terms are spelled out; the matter of a poem that is composed and decorated. These are three object-subjects that I would like to bring together in the same tomb and for the same painted picture, the tomb (or painting) in which a dead body is buried, or rather a tomb whose architecture, relations, and parts are the representation or effigy of that body: the tomb or monument as an empty structure that is the body-painting in its plenitude, the discourse of painting composed and arranged; the material of an event, decorated and embellished, forming a tomb-poem, a monument of painting. Thus the title of this first marking of my place,

the subject, I mean the object, of my presentation, could be rewritten: the
tomb as subject of painting or in painting, or, more briefly, the tomb of or
in painting.

But in a second stage I am told that "subject is also said of a worthy per-
son who has the appropriate qualities to carry out a charge, to do a job
well, and so forth. The king has placed good subjects in the prelacy and in
high positions. Cardinal So-and-So is a subject fit to be pope."[11]

Thus—I shall go on with Descartes—the soul that is wholly character-
ized by thinking can be posited or labeled a "thinking subject"; thus, I
shall say, along with the Port-Royal logicians, that man never posits or af-
firms himself as a thinking and speaking subject better than when he is
conceiving things, affirming them and judging them; thus the learned
painter knows how to represent all sorts of faces, all sorts of actions and
passions, all sorts of ancient and modern subjects: the subject of painting,
the painter, a subject who deals with the picture the way representation in
painting dealt with various subjects; the painter, a subject capable of
painting. So now my subject, that of my presentation, the tomb of the
subject of painting, could be rewritten quite concisely as the tomb of the
painter in his painting; and if we could remember in a flash everything I
said a moment ago about graves and tombs, monuments and representa-
tions, cenotaphs and effigies, epitaphs and portraits, then my title would
become quite simply the self-portrait, the portrait of the self in painting,
on condition however that I leave the whole problematics I have sketched
out to press itself upon us implicitly, the problematics of death, of images
of death and the death of the image, on condition that I leave understood
as a question, a concern, or a premonition something that I shall formu-
late as follows, in my role as a viewer representing the painter: What does
my portrait have to do with my death?

In a third, more scholastic and more philosophical phase, the subject is
also the matter, the substance, to which an accidental feature is attached.
We find an echo of this in Pascal, when he speaks of portraits and physiog-
nomy: "Contradiction. A good portrait can only be made by reconciling all
our contradictory features, and it is not enough to follow through a series
of mutually compatible qualities without reconciling their opposites."[12]

Subject: *sub-jectum* or *suppositum*: *suppôt*. "A man is a substance [*sup-
pôt*]; but if you dissect him, what is he? Head, heart, stomach, veins, each
bit of vein, blood, each humour of blood?" Pascal also writes.[13] Subject:
what is underneath, what lies underneath, what the qualities, the acci-

dental features cover and suppress; thus it is with the grave, the tomb, in the place of death covering over death or the Ego; thus it is with painting. Subject also signifies cause, occasion, foundation. And it may be through this meaning, it seems to me, that we can return to the first meaning we encounter in the seventeenth-century French lexicon: a subject is someone who is born naturally subjected to a sovereign prince: a subject is also someone who submits, someone who is obliged by nature or condition, or out of duty, to do and to suffer certain things, being the "object" of an action that is to be symmetrically and reciprocally the subject of a passion.

And the two examples the dictionaries offer us here again reveal, in the subject, the long-dissimulated work of death under the accidents that are only its apparent manifestation: when they are born, human beings are subject to a thousand ills; old people are subject to inflammations and infections, and finally they are subject to death. In these examples we must note the strange but essential conjunction of birth and death, in the body that is *sub-jectum* or *suppositum.*

The tomb of the subject of painting, the tomb as subject of painting, the tomb of painting. As André Félibien indicates in one of his dialogues on painting, "M. Poussin . . . could not bear Caravaggio, and said that he had come into the world to destroy painting. . . . For while Poussin sought nobility in his subjects, Caravaggio let himself be carried away by the truth of the natural as he saw it. . . . Thus they were complete opposites."[14] I should like to pursue for a moment this opposition between Poussin and Caravaggio, in the place of a tomb, a single tomb that is, as it were, the fascinating geometric place of representation in painting and its end, its achievement, its accomplishment, and perhaps its death. But there are so many ways to die. Caravaggio's way is the death of representation in painting via destruction; Poussin's, the representation in painting of death via deconstruction. Paint the truth as it is in its natural state, right there before one's eyes, bring pleasure to the point of pain, make things be seen to the point of fascination: then painting dies from the violence of the representation effect. Choose beautiful Nature, add nobility and grandeur, make the painting a theory and the image a model, represent representation as contemplation to fulfill the purpose of painting, delight: then painting dies from enjoyment of the representation effect. One should try to see rising up from the tomb of history, at the heart of Arcadia, the *Lazarus* of the museum in Messina, or see the *Christ* of the Vatican return to the tomb.

Poussin's *Arcadian Shepherds*, in the Louvre: at the center of the picture there is a picture, a seme, and at the center of the center, there is an epitaph, four signs inscribed, engraved on the wall: "Et in Arcadia ego"; and among these signs, there is the last or first sign, the origin or end, an empty signifier waiting to be filled by a living word: *ego*, myself in that place, center of the center. Myself, who has written? who is speaking here now to give life back to these signs on the wall? *Ego*, myself or the kneeling shepherd who is looking at the written words, who is pointing to them with his finger, who is proffering them, open-mouthed: but the voice is silent, buried, if I dare say so, on the surface of the painting; a message is expressed through the shepherd, through his open, mute voice, in profile. *Ego*, I? he? I in front of the painting, he inside it? Who wrote *ego*? Neither he nor I in that center on the wall of the tomb: *ego*, no one. *Ego*, except for these traces hollowed out on the opaque surface of the stone, by the chisel of some scriptor-sculptor? The tomb speaks and says nothing. On the wall of the tomb in painting, here is Poussin's answer to Narcissus, to Caravaggio's narcissism: this tomb, or the truth of Narcissus. *Ego* pointed out by the index finger of that kneeling figure, by a fleshlike finger of paint. But that finger is also the pointed tip of a shadow projected onto the wall by the light of the sun, a shadow that draws an enigmatic figure on the wall. We can never speak of death. Still less can I speak of my own death, except through image and metaphor. A metaphor of death, of my death, a displacement, a transfer that, if it is to be coherent with what it displaces or what is displaced, is and can only be an effacement, an erosion; the metaphor of death erases its own wake on the surface of language. What about the image? Poussin's *Arcadian Shepherds*: *ego*, I who contemplate, I note two absences, two lacks, two who are *dead* at the beginning and the end of my *theory*, there where there ought to have been an eye or a voice, an eye in this painting, to designate and assign the place of the contemplating-creating gaze; the painter wipes himself out. The painter effaces *I* as well as *he*, both subjects of painting; but also a voice coming out of the gravestone to call by his name the one who writes-inscribes *ego*, there, in the center of the wall. A double absence, a double death of the gaze and the name, of the subject—of enunciation—at the viewing point and its other, the signifier at the vanishing point, in its center.

In the utterance of the story that the painting declares with the harmonious frieze of its four figures on either side of the four written words, painted representation thus represents itself in presenting, at its origin, an

absence, that of the subject of representation and, at its end, the other of that absence, that of a name that puts the utterance—written in its last word, *ego*—in a state of wandering, appropriated by all because it belongs to no one and yet is forever fixed in a marble of paint, a tomb of representation. The one could well be the other: perhaps the first, the eye of the painter-subject, offers itself to view in representation only in the in-signifying form, at once devoid of meaning and insisting on provoking meaning, of a dead-sign, of a seme, a sign inscribed in an image, a *seme* written in the image of a *seme*: sign, image, tomb. This is how the kneeling Arcadian shepherd represents me and repeats me as I re-produce him by re-viewing him; he represents me in the picture as I represent him outside, included-excluded around the double death of the gaze and the voice. What the picture is for me, a viewing subject, the picture is for him, a represented subject: the tomb is his picture and his tomb is my picture. It could well be that Poussin's "theory," his delight-theory or enjoyment-theory, is all that violence buried in the tomb-picture.

The voice of the picture is rendered inaudible by the interrupted inscription overlaying the silence of the name; the eye of the subject of painting is blinded by the representation of a figure that supplants and covers it. Yet perhaps that subject of painting sees himself: not really himself, but a story at the center of which he has just traced in the wall of the tomb his substitutes, his visible and readable replacements, bodies, gestures, gazes, and fingers pointing toward the four signs of which the last is *ego*.

The metaphor of death wipes out the traces of its displacement, I was saying. The death of the eye of the painter-subject in the figures of the story that represents them has, however, left a trace spread everywhere in the picture, a trace that inscribes the absented eye in and on the figures. For that eye is the solar eye that illuminates the scene from the left illustrating La Rochefoucauld's thought anew: "we cannot look squarely at either death or the sun," only at the traces of their displacement, the traces of their effacement. . . . Now, even here, a trace of that simultaneously mortal and solar erosion is visible: the shadow of the shepherd, a reader-decoder who is my representative in the painting. The shadow of his figure appears on the wall of the tomb at the point of the central narrated event, that point remarkable above all others because it is the point of contact between the represented and visible finger, the finger of flesh and painting, and of its painted shadow traced by a movement of displacement. Forming a metaphor for the solar eye and for a written sign of the

epitaph (which marks the fact that the place of death is the place appropriated for a particular death), this point of contact is literally the point of death on the surface of the tomb. Neither the tip of a finger, nor the point of its shadow, nor the trace of the sign, and yet all that at once, it is a neutral, in-definite blind spot . . . a point where the whole dimension of depth seemingly realized on the canvas is summed up and canceled out: point of view and point and their indeterminable trajectory are condensed, *suppressed* in that point on an opaque wall . . . thanks to the absence of the solar eye and to the trace of its absence. "Poussin has painted a Shepherd who has one knee on the ground, and is pointing with his finger to these words engraved on a tomb, *Et in Arcadio ego*."[15]

As for the other shepherd (here I am adding to Félibien's description), his index finger is poised on a vertical fissure in the wall of the tomb, directly above the fracture that cuts across the ground of the scene and isolates the woman to his left. The fissure, a trace of time, runs along the wall, between IN and ARCADIA, and cuts off EGO, setting off what is centrally at stake in the painting, the schism of the writing and painting self of the painter-subject, a split through which the absence of its name is traced. Perhaps that fissure is the voice of the tomb. But the solar eye intervenes: it projects the shadow of the shepherd, of his arm, his hand, his finger, onto the wall of the tomb, his shadow, his double, his figure in death, but also the originary mythic form of fiction in paint on the smooth, opaque stone; the tomb in painting of the painter-subject is the picture in paint that presents him dead; the shadow of the arm, the hand, the finger on the wall, wipes them out in their reality of painted flesh and brings into play as substitutes the scythe of Saturn, who presides over the Arcadia of the Golden Age, but also that of Cronos, the castrating god, the time-god who makes everything die. The painted shadow of an arm of painted flesh is an iconic *hypogram* of the painter's death and of the only tomb that is the exaltation of his disappearance: the picture.

"M. Poussin . . . could not bear Caravaggio, and said that he had come into the world to destroy painting."

The defining feature of Caravaggio's school is the use of a constant light source illuminating from above without reflections, as could be the case in a room with only one window and walls painted black. . . . These devices seem ill-suited to the composition of a story and to the expression of emotions . . . because it is impossible, within a room lighted by a single window, to arrange

a large number of figures enacting a story, figures that are laughing, weeping, walking, and at the same time holding still so they can be painted.[16]

With Caravaggio, destroying painting signifies the death of story painting, in a dark room traversed by a streak of light that grips, immobilizes, stupefies the figures in an instantaneous time that neutralizes the duration of the representation in paint. Poussin, at the center of his *Arcadian Shepherds*, had represented, in the silver-gray gentleness of the Roman countryside, the massive and closed volume of a tomb. If we read Giulio Mancini, we get the impression that the sepulchre was the stage, the scenic place where Caravaggio arranged his figures, a sepulchre that a ray of light would splatter with luminous accents cast by a raised tombstone. It is not a matter of making a theory of the picture and carrying it out in the effect of delight-enjoyment. It is a matter of producing it in view of an effect, of making the tomb a force, and of making the representation a power of effect and a violence of affect. Now that power and that violence depend technically on the question of black and white.

Three theses concerning black and white: (1) pure white moves forward or backward without distinction: this signifies that space is light, that light is white, and that the indifference of the advance or the retreat manifests the opening of a space to all traversals of the gaze; (2) white approaches with black and moves away without it: this is a first principle of differentiation through the power of black that makes the gaze flow back to its source; hence (3) nothing can come closer than completely pure black. A black space is not a space, it is a nonspace, a fullness with maximum density. Black is the heaviest, most terrestrial, most perceptible color: it is a theoretical limit, a noncolor through the absolute proximity of the eye; the noncolor of the death of all gazes in the shock of contact.

The inner space of things is black: black is dense, totally enclosed space, the space of the coffin. No longer the tomb seen from the outside in Arcadia, but *arca*, chest, cupboard, casket, coffin, prison, cell, sealed tomb—impossible to know—to see—what is happening within. It contains, but what? Caravaggio's black space, arcanian space; Poussin's white space, Arcadian space. "Painting is an imitation made with lines and colors of all that is seen under the sun."[17] If, in that arcanian space, a luminous ray is introduced on the basis of a unique source, then the light will be carried to its maximum intensity and will provoke an effect of lightning: dazzling, blinding, stupefying. Caravaggio's paradox is the paradox of death as a

metaphor for effacement: that is what allows me to say that one can say nothing about it. If space means light, if light means white, black space is a contradiction in terms; the impossibility that a gaze enclosed in an absolutely sealed tomb could come to make an *image*, in order to efface that image at the very same time. Let me suggest an entirely black picture: the space that its frame would enclose could be conceived as the full surface of an infinitely dense black volume—an image of death that would be the death of all images, not the emptiness of a space deserted by its objects, but the fullness without flaw or line of a thing. The entirely black picture is a represented space that expels outside itself, outside its own surface, the objects that the painter would like to introduce into it. If then from the outside of the frame of the picture, defined as a full and dense surface, a luminous ray almost parallel to that surface is projected, this beam will almost instantaneously extract fragments of objects and figures, which, on the one hand, will remain caught in the compactness of that surface, and, on the other, will come to stand out in front of it.

Living and *petrified* fragments of a mineral disaster: an instant outside of time, a present presence that, in the time-space of the painting, of the representation in paint, can only be a hallucinated space, a phantasmatic time, the tomb of the subject of painting. For instance, [Caravaggio's] *David and Goliath* in the Borghese gallery, where the painter has staged his death on the black surface of the picture in its lower right-hand corner: the severed head of the giant vanquished by a slingshot blow to the forehead is a self-portrait. But it is this corner of the painting, this corner of the plane of representation, that carries out the decapitation; young David's sword is only its figure. The painter's severed head stands out in relation to the rest, which remains caught in the dense surface of the picture: a figure in bas-relief on the solid wall of the arcanian tomb. Severed head, self-portrait, mask. Ten years later, the Medusa head of 1595 has become Goliath's head, but the same mortal truth persists from one picture to the other, from one picture that is nothing but the mirror of Perseus's shield where the gaze of the painter as a Gorgon is reflected and left to die there of stupefaction, to the other in which the painter offers himself his own death in painting with Goliath in a tomb-picture. In the first, he represents petrification; in the second, he achieves it: the mirror-shield has become the black wall of the tomb.

Paradox of death, paradox of Caravaggio, paradox of the Medusa and of the ruse in painting that is the ruse with death: to come into contact with

Medusa and kill her (to come into contact with the gaze in her eye and appropriate it for oneself), such is the aporia (of the self-portrait, of the portrait of representation in painting), since the Medusa-gaze preserves its remove in the distancing of depth and makes its escape impossible, since the Medusa-gaze is above all movement of the body already at its end point, since it immobilizes its adversary in the place where he is, at the viewing point, by petrifying him there, right in his eye. Thus Medusa is at the end point of depth, at the vanishing point of the object, at an aporetic infinity, and in a mortal instant (that of the gaze itself, of the glance) at the adversary's viewing point, at his contact. The ruse of Perseus, which is the ruse of painting itself, of representation, consists simply in reproducing, in repeating the Medusa-gaze, copying it: it is the ruse of death itself (once again, let us take the genitive in the objective and subjective senses) discovered on the surface of the representation, on the surface of the bronze mirror of Perseus's shield. Nevertheless, when, in 1596, Caravaggio disguised himself as a Medusa, costumed himself in the woman-death on the *rotella* of the cardinal del Monte, he presented himself as a decapitated Goliath, showed himself in death—his death—on the infinitely dense wall of a tomb-painting. But the mouths are open on the same silent scream and the eyes on the same unrepresentable image, the unfigurable presence, the instantaneous metaphor of a gaze that comes to strike the eye that emitted it: a blinding flash.

Later, in 1609—a year before his life had run its course, before his death in 1610—Caravaggio managed to open up the grave of the dead in the tomb-painting; he represented the grave in the tomb as if *en abyme*, and he did so, it seems to me, in order to allow us to glimpse what our seventeenth-century lexical definitions put as subject or substance, *suppôt*, under the tomb, the marker of the place of death, the dead one: the subject or substance of painting buried under the tomb-picture. In 1609, Caravaggio opened up the tomb to extract Lazarus from it, at the sound of Christ's voice. No gaze can keep from recognizing this place of death, even if that is not the figure of death (and I emphasize *that*, the neutral demonstrative, for how could such a place be figurable?), in the lower rim of the scene, its footlights, a strip running across the whole width of the canvas, duplicating the frame, the footlights of an indistinct orchestra pit on the extreme edge of which the key actors in the resurrection are placed. It is from this frontier spot opened *en abyme*, that is neither in the picture (in what constitutes the picture) nor outside the canvas, it is from that edge

space (a nonmimetic image, an indefinite image, images without representation or imaginary presentation) that the corpse of the dead man, the subject, the substance, has been extracted: it is shown at the precise moment when, a corpse, it is struck, agitated by the flash of light and the lightning-flash of life, paralyzed as a corpse, stupefied, Medusa-struck without a gaze, a flow of life that is neither life nor death, thunderstruck by life, by Christ's gesture of pointing, from which Lazarus's right arm and his hand, his open palm facing the tip of the index finger, gather in the flash of light. At the same time, the dead man's left arm, his wide-open hand facing my gaze, it too struck by the light, lets the death's head escape onto the ground. This would be Caravaggio's image—almost naïve and popular—of the resurrection: a corpse that allows the sign, the marker of death, to escape, death with its head cut off, but at the same time the ultimate version of the *Medusa* and the Borghese *Goliath*: a death's head presented not frontally but by the base, thus showing the black hole of decapitation like a single eye playing on the edge of the painting, in a symbolics of immediate effect, which I have tried to recognize in the eye of the perspective subject at the viewing point–vanishing point of the construction. Lazarus's corpse is at this instant stupefying and stupefied, neutral, neither dead nor alive, even in the face of Christ, who is erect and tense in the all-powerful gesture of pointing. The corpse presents him with his own image as crucified: it presents to him his own death, by acting it out, in the dead body he will be. Lazarus, in an instant, in the process of resurrection outside the tomb, is already Christ in a rigid and cadaverous state and in the process of being taken down from the cross, being deposited in his tomb, and the skull that rolls on the ground, at the extreme edge of the open pit, could be that of Adam, the first man, at Golgotha. Whatever the level of the interpretive trajectory, it will meet and endlessly traverse the representation as instantaneous, a neutral instant or rather the neutral aspect of an instant, unoccupiable, unthinkable except through its edges, the a-topic place of the *cogito* of my death. The death's head is the image of my death and the death of my image: my representative canceled out in the picture, the equivalent of the anamorphotic skull in the foreground of Holbein's *Ambassadors*. "Et in Arcadia ego": even in the Arcadia of the representation in paint. I, the subject of the work, the painter subject. "Et in arca hoc": even in the tomb of the painting, from the canvas of the surface of paint there is this—nameless—substance, subject of painting.

§ 17 Depositing Time in Painted Representations

DEPOSIT n. [*dépôt*] (1) An item placed in safekeeping to be returned or used in accordance with the depositor's wishes; (2) The act of putting a thing in a place.
DEPOSIT v. [*déposer*] Allow the thick particles of a liquid to settle at the bottom.
DEPOSE v. [*déposer*] Remove a person from a high office or position.
DEPOSITION n. [*déposition*] Also refers to the taking down of Christ's body from the cross, or a work of art depicting that event.

Representation in paint, or the deposit of the time of the work, of the artifact, in space, the extended space of the canvas and the dense, thick space of the layers of paint: a painted representation is the guardian of these traces, as well as the place of the picture and the collection of these deposits. Representation in paint attempts to take away time's sovereign power of destruction by conserving time on its own surface, as its property, and in its density, *invisible*: it gathers the traces of time or the remainders of a work with which a finished whole is constructed. Time is deposited as the (invisible) ground (*suppôt*) of the visible (work). Thus representation buries time, or tries to bury it, in the tomb of the work, and thereby attempts to be the perceptible body of time, or its test, leaving us to tease out of it the paradoxes and aporias of the constitution of the self in the gaze.

Let me have time to see . . .

Standing in front of Poussin's *Self-portrait* in the Louvre, one must allow the gaze to traverse the surfaces, stop dragging it down into the depths, give it the opportunity to pass through to the far side, to the back, yet without ever leaving the near side. The figure of the painter on the canvas where the painter has recorded it immobilizes the time of existence in the "monument" in paint—the tomb—that gathers time in and transforms it into an essence that it offers to view. We can speak of this as the depositing

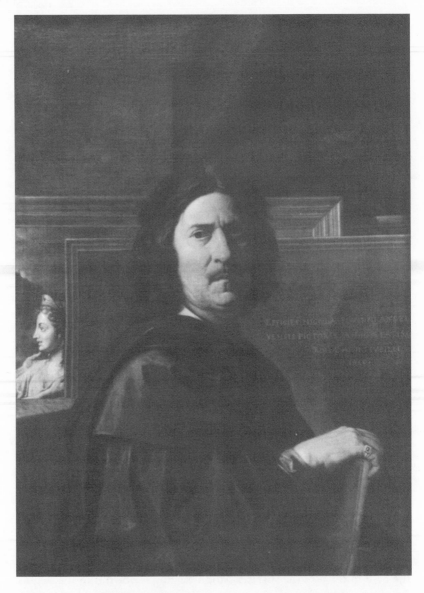

FIGURE 17.1 Nicolas Poussin, *Portrait of the Artist.* Musée du Louvre, Paris, France. Photograph courtesy of Giraudon/Art Resource, New York.

of time in the painted representation, as one speaks of the body of Christ being deposited in the tomb. A singular essence, *to ti en einai*, as Aristotle calls it, "what the meaning of being was," in Rome, in 1650, the year of the Jubilee. Time asserts itself in the name of essence and in the form of this imperfect tense that death turns into a definitive truth: the tragic history that was caught up in the contingency of its unforeseeable time finds its transfiguration into an accomplished destiny in the figure of the self-portrait, a simulation of death.

But behind the monument of the figure, we find a background made up of surfaces sliding over one another toward the edges, in a state of flight or flux, an internal tension in the field of painting. For what these surfaces represent are stretchers turned backward, a canvas prepared and not painted, and amid these others, sliding toward the left, a painting of which we see only a part. In the background, in the remotest area of the background, paintings show of themselves what is not to be shown, their other sides, their backsides. On the surface of this background, serving as background for the figure of the "painter," a canvas exhibits what is not seen of the painting, the underside of the feigned and painted appearances. The painting celebrated in the glory of the painter's self-portrait, of his monumental figure, is shown from the back and offered to view, unshowable and invisible, in the painter's workshop, as is the workshop itself, the painter's work whose layers are sedimented by time one by one, from the undersurface stretched on its frame to the noble face on display in the legend of his painted death, through the coats of paint, the pastes and pigments, the time on deposit here of the art of painting reaching for its goal, its end, which is the "subject," here the painter subject and his gaze caught in the mirror of his painting, at the point of his eye. It is a gaze stretched to the limit, as if Nicolas Poussin, in 1650, were asking the painting in which he is painting himself that it leave him the time to see, off to the left, himself, "myself," of whom he perceives only two hands gripping a woman in the painting that I glimpse at left and that succeeds in showing only that feminine figure between the edge of the self-portrait I am looking at and the prepared and unpainted canvas standing behind the figure of the painter. Let me have time to see myself, me, drawing that woman toward myself, time to make her mine, that woman wearing a diadem who is—I shall learn this later—the Theory of painting.

I have not had time to see . . .

A Roman painter—anonymous—has represented the *Martydom of Saint Blaise* in the church of Berzé-la-Ville. The saint has been *decapitated,* his head has rolled onto the ground, his kneeling body is crumpled over onto his hands and forearms. Across from him, leaning on his scabbard, the executioner raises his sword above his head *to inflict* the mortal blow with all his strength: in the place of the narrative scene, in the space represented by the fresco, the two moments of the *decapitation,* the one that precedes and the one that follows, are thus disconnected. The painter decomposes this instantaneous temporal unity, the one I am calling the "decapitation" (of Saint Blaise), to propose to my gaze only its two temporal figures, the ones that linguists aptly call "aspects," two "states of being offered to the eye, before the eyes, two views or two appearances," the beginning figure (inchoative aspect) on the right, where the executioner is raising his sword, and the end figure (terminative aspect) on the left, where the saint's head has rolled onto the ground, like a ball, surrounded by its circular halo. Between these two limiting moments of decapitation, between the before and the after of decapitation, between the beginning and the end of martyrdom, not figured except by that interval, not represented except by the cut that sharply punctures the unity of the present, there is what could not make its way into form and figure, what a repetition in the present could not render: the flash of the sword's blade, the instantaneous and decisive movement of death at the extreme point of its violence.

What thus eludes my gaze, and its attentive contemplation, on this late September afternoon, which gathers in the painted work in peaceful admiration, is precisely what, for it, will "always already" have taken place: that flash of death, that blaze of violence in the remotest reaches of the hagiographic legend,[1] neither representable in a saintly image nor figurable in a form. In that interval where my gaze falls into the vertigo of the story, a power of seeing is exhausted, that of grasping the event through representation, and in this endless loss, the subject goes through the test of time at the point of a gaze that meets nothing. For what it ought to have recognized is forever past without ever having been seen; what it ought to have encountered is forever missed. The subject will always have been late to this meeting, this encounter with a cut, the chopping off of a head that has already rolled. A measureless measure of this test of time. "I have not had time to see. I shall never have had time to see: I shall forever lack that

FIGURE 17.2 *The Martyrdom of Saint Blaise* (detail). Chapelle des Moines, Berzé-la-Ville, France. Photograph courtesy of Giraudon/Art Resource, New York.

time." As Cabanis later wrote about the machine for cutting off heads: "The guillotine slices off heads with the speed of a glance. . . . The spectators see nothing; there is no tragedy for them; they do not have time to be moved."[2] Before the torture of Saint Blaise represented by the Roman painter, by losing his gaze in the invisibility of death at the very instant of death, the subject experiences himself in his temporal destination, proves to himself, even if in anguish, the infinite virtuality of his end.

But at the same time, or in the same gesture, the Roman painter reassures the subject in *his* time by restoring to him the mastery of signs and their syntax, a mastery from which the I emerges in its permanent presence, in its capacity for self-synthesis. The image that the narrative proposes to the gaze is in fact enclosed by two inscriptions that constitute a frame, that of the place where the martyr's story unfolds, two inscriptions whose reading is unspooled, word by word, from left to right, a direction that is the inverse of the arrangement of the figures in the scene where the end figure on the left and the beginning figure on the right are repre-

sented, and where I am contemplating them. The double play of the read-able read on the border and the visible seen in its enclosure incites the gaze to make narrative time flow back into the image, to read the story in the picture by beginning at the end, retrospectively, by an after-the-fact gaze, a gaze that totalizes this place from which the decapitation has always al-ready taken place, even before I know how to read the narrative of the life and death of Saint Blaise, and to look at its pious image. He has been tor-tured, the executioner has raised his sword and the saint's head has rolled onto the ground. The first utterance, "he has been tortured," describes the totality of the scene that a "title," *The Decapitation of Saint Blaise*, in the form of a nominal phrase, would sum up, while freeing it from the secu-lar time of history. The saint intercedes for me through his sacrifice, for-ever, for me, a poor sinner, in the mystical body of the Church and par-ticularly in this "time of deviation," in the liturgy from Septuagesima to Easter, repeated each year on the day of the festival of Saint Blaise in the church of Berzé-la-Ville. But at the same time and through the same prof-fering, this first utterance describes the terminal moment of the torture and by the same token reinscribes it in the time of history: a time that nevertheless remains inverted through the effect of the written text that I read from left to right while looking at the fresco, an image wholly con-tained in the present of my contemplation, which animates it in a perusal from right to left, from its end to its beginning.

To put it another way, by inverting, through the injunction of time and of the order in which the sacred text is read, the order in the time of the represented narrative, the painter provides to my gaze the *typical figure* of representation, the martyrdom of the saint, the didactic and apologetic di-mension of the narrative, its lesson, which is the end of the story told as an image. The *after-narrative* is the *figurative finality* that has given, *from the beginning*, the "mystical" sense of the narrative through which the *I* re-covers its transcendent destiny as a member of the great changeless and glorious body of Christ's Church, while covering over the interval be-tween beginning and end, the unrepresentable, invisible flash-instant, the *punctum temporis* of the mortal cut.

I cannot stop looking . . .

Caravaggio has painted the beheading of Holofernes by Judith, who is ac-companied by her inevitable servant. He shows the viewer the instant that

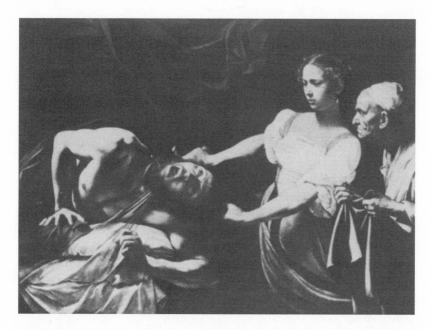

FIGURE 17.3 Caravaggio, *Judith and Holofernes.* Galleria Nazionale d'Arte
Antica (Palazzo Barberini-Corsini), Rome, Italy. Photograph courtesy of
Scala/Art Resource.

the Roman painter suppressed, the unfigurable and central instant, the
sword stroke "in the process" of being administered, the blade halfway
through its course, in the middle of the neck, the head that is beginning
to separate from the body, pulled backward by the hair gripped in Judith's
left hand, and three spurts of blood that splash onto the pillow and the
sheet. No before, no after: only this unique, decisive, mortal moment, this
infinitesimal duration, in a state of double and reciprocal shock, the rep-
resentation shocked by the event and the event shocked by the represen-
tation. Even Judith's movement of drawing back and the horrified disgust
depicted on her face are instantaneous reactions to the sword stroke that
opens up the decisive cut of decapitation between head and body. Noth-
ing in the representation remembers a past or announces a future. Sheets
and wall coverings, body postures, gestures and expressions, all these are
only immediate projections, like splashes of the mortal instant through
the space of the work.

But through a frightful and fascinating reversal, the instant of the act is

immobilized by the very representation of its instantaneousness. The blow is blocked halfway through its accomplishment. Judith will not finish what she began to do, will never be done cutting off Holofernes' head, and, with her sword at a standstill, the narrative of her exploit also halts there without past and without future—timeless. Or rather a time, a different time, is deposited in the work of painting, precisely between the place of that imperfect cut and the fascinated gaze that accompanies the cutting: the time of the interruption and the starting up again in which the "instantaneous" instant that Caravaggio has made the moment of representation is indefinitely repeated without ever being able to arrive at its end point, without ever being able to *pass.* The gaze cuts itself off, in keeping with what it is shown—the sword slicing into the middle of a neck, in the middle of a stroke (*un cou[p]*)—and then it "picks up" where it left off, goes back to the blow being struck to give it again, cuts itself off again and resumes the stroke again, as if Judith were taking herself in hand again incessantly, indefinitely, to arrive at the point of cutting off Holofernes' head. I cannot stop looking at that finally impossible cut, that death that does not stop precipitating its own decisive instant by suspending it in its accident.

This is another way of saying that the subject is forever held, placed under guard, seized by a time, the time of the death whose unfigurable instant the subject wanted to seize through representation: a single subject is present in the scene through the three figures, Holofernes, Judith, and the servant, in the process of both interruption and severance, of both cut and cutting. In its bodily aspect the cut will never be definitively cut or cutting, and as a body transfixed in the process of drawing back, but whose bag will never be definitively filled; or else, in the three gazes, Holofernes' overturned and lost, Judith's tense and fixed, the servant's fascinating and fascinated, three gazes that do not grasp one another but that play out time within the instant itself and its dazzling instantaneity: the retention of the immediate past and the protension of the imminent future (Judith) producing itself for the eye of Medusa (the servant), the figure of the unmoving, paralyzing, paralyzed "now" of the phantasm that cannot stop looking.

Or take *The Sacrifice of Isaac*: here a narrative opens, at the center, at the moment when Abraham, standing, leaning over, is about to use his knife to cut Isaac's throat, Isaac whom he holds firmly, bestially, his head crushed against the sacrificial stone. The Angel enters at this moment, on the left: with his right hand, God's envoy stops the murderous arm, and, with his left hand, pointing with his index finger for Abraham, who is

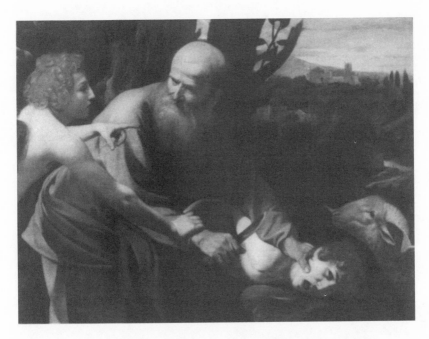

FIGURE 17.4 Caravaggio, *The Sacrifice of Isaac*. Uffizi, Florence, Italy.
Photograph courtesy of Alinari/Art Resource, New York.

turning his head toward him, to what he, the angel, sees on the right, and
what Abraham cannot yet see, the ram that *will be* sacrificed in the son's
place: a retrospection of the center toward the left (of Abraham toward the
angel), a simultaneity of presences that is an arrest, a suspension of the act,
of the cut, an inchoative and prospective immobilization through the ges-
ture and the gaze from left to right where the future is being prepared. A
narrative is instituted starting from the interval between the arrested knife
and the proffered neck: a matrix instant pregnant with the moment that
will follow. But in this gap and this interval, in this place where the pro-
hibition of a throat-cutting that *will not* take place occurs, the subject's
gaze rushes to accomplish the sacrifice in the representation and in the
time of contemplation: the *single* eye of Isaac, lying on the stone and look-
ing at *me*, constitutes me as a fascinated gaze falling into the open mouth
emitting an inaudible cry of terror. In that instant, I cannot stand to wait
any longer between the globe of that eye and the hole of that mouth, I
keep on looking and traversing the interval between the knife and the

neck to carry out the sacrificial murder. Another phantasmatic structure is played out here. Unlike *Judith and Holofernes*, where the phantasmatic scene appears to the gaze only in the inexorable gap between the—unfigurable—instant of death and the act of representing it, and where the subject is constituted only in the instantaneous syntax of three gazes grasped in the scenario of the murder, the *Sacrifice of Isaac* precipitates the subject himself and his gaze into the scene; the representation constitutes him as subject in that precipitation of his self-image that he meets in Isaac's eye and mouth; or, more precisely, he is constituted only in never ceasing to recognize the suspension of his own throat-cutting. He experiences himself in his "own" time only in the reprieve of his own death. Here the instant deposited in the representation in paint is not that of the schism of the present indefinitely, unbearably interrupted and recommenced, but rather that of the imminence of the present in the double sense that any imminence conceals, that of a future infinitely near, of something possible becoming real, that of a desire that tends toward its accomplishment and, furthermore, that of a threat that is all the more menacing, all the more "present" in that it is both indefinite and inexorable.

I have seen almost too much . . .

The Medusa time that Caravaggio's painting puts to the test of representation in paint is the time of instantaneousness, of the immediate and the imminent, of the "sudden," whose effect can be construed as an effect of stupefaction by way of shock; not the peaceful, industrious continuity of admiration, the work of a gaze that embraces all the aspects of the world, not the "theory" of a subject certain of his powers and tireless in his working of transcendental syntheses, but the brilliance—at the extreme point of intensity, almost painful, almost unbearable—of an alterity, the astonishment that immobilizes, the fracture of an ecstatic subject, lost, beside himself. Through this Medusa time, Caravaggio puts to the test the painting of a story and its shaping into image and space, if not the painting of a narrative, at least of one of its moments, so as to change it into a phantasmatic scenario—this Medusa time is, for landscape painting, the meteoric time of the tempest: a dazzling lightning flash and a deafening thunderclap; cataract, deluge, infinite fall, but also whirlwind, cyclone, tornado, stunning vertigo. The primitive material elements, water, earth, air, and fire, the species of beings, the fundamental categories of acting and suffering, of

thought and perception, are here at the pinnacle of their senseless blend through the exacerbation of their difference.

Time is no longer the a priori form of sensitivity, nor the schema of the transcendental imagination: it is meteoric. The tempest reveals nature's time, or rather one of its times, not the time of cycles and metamorphoses, alterations and generations, contained departures and returns, but the time of breaks and leaps, suddenness and rupture. With these blazes and flashes of greatness or unquantifiable power, the meteoric instant of sublimity fractures imperceptible appearances and disappearances. Such is the time of the sublime, the unrepresentable time of representation that defines in representation neither an external agency that would transcend it, as in Byzantine icons, nor a blind spot that would hollow out its center—as for example in the mortal instant in the representation of the martyrdom of Saint Blaise—but that results instead from the very functioning of its mechanism, whether its workings are impeded or enhanced: the present of representation at its peak, or, in one of the senses of the term, "that which stands above the rim of an already-full measure." Not the overflowing of this present into what exceeds all measure, the divine eternal or the immobility of the thing, but a present that still holds—not, however, within the confines of its measure, in its lived and living unity between past and future, but above them, in the imminence of this overflowing; the time of intensity in representation, a scarcely bearable brilliance, an "almost too much" (the expression is Kantian) of the representation of a natural landscape in its meteoric time; the tempest, a meteoric figure of this sublime time.

Sublime Poussin: the theoretician of representation in painting and the painter of the theory of representation is situated, to use Diderot's terms, at the crossroad between a "heightening" of landscape painting and its genre in great representational history painting, on the one hand, and in what takes representation in paint to its pinnacle, the effect of sublimity, the presentation of what is unrepresentable, on the other. The heightening of a painting of nature's time, the time of moments of daytime and light, of the periodic returns of the seasons, in the painting of human time, the time of actions and passions confronted in sound and fury, and on rare occasions, in a few moments of the painter's work, this heightening may encounter the meteoric time of the tempest; it may put it to the test; it may be put to the test, in a strange and paradoxical difficulty. The figure of the tempest in its pathetic effect presents nature's sublime, and

the painting, the representation in paint, aims to be that presentation as a *real presence*, but at the same time, the *unrepresentable* sublime, withdrawing from the figure, which can only represent it, opens up a difference or a variation that is the very condition of its presentation.

This is the case with *Pyramus and Thisbe* and its great tempest landscape in the Frankfurt Museum. This painting offers an excellent representation of the *sudden instant* of a storm through what the gaze sees in it: two flashes of lightning streaking an inky sky, a bolt striking a tree in the middle ground, a furious wind blowing from left to right stirring up trees and bushes. "I have tried to represent a tempest on earth, imitating as well as I could the effect of an impetuous wind," Poussin wrote to Jacques Stella and, continuing to describe his painting, he inscribed in the title of that "essay," in the middle ground, an attack on shepherds by a lion and the flight of their herds. He finished his letter by naming the two "story" figures in the foreground: "In the foreground of the painting, one sees Pyramus lying dead on the ground, and near him Thisbe, who has succumbed to grief."[3] The three tempests, meteoric, animal, and human, express one another mutually; they represent one another so completely in the direct or inverted correspondences of the sudden instants of their simultaneous occurrences that, through the immediacy of this interplay, a presentation of the unrepresentable comes about in the work of painting: so it is with the lightning-struck tree directly above the body of the dead Pyramus; so it is with the lightning bolt that strikes Thisbe "ideally" with its arrow and that illuminates her with its instantaneous brilliance; so it is with the blacks of the grotto and the spring, the obscurities of the stormy sky, the blinding whites of the flashes over the city or over the drama's protagonists, and the reds of the shepherds' cloaks, of the rider fleeing at a gallop on his horse, or the bloody reflections, positioned here and there, of the lightning's effects; so it is with the tragedy in the last act of its ending in the foreground, the dramatic pastoral in the middle ground, and the Lucretian cosmic poem in the sky in the background.

Global harmony, *una total simul*: three instants taken to their highest intensity, each in its order; the whole great symbolic "system" revolves around that other symbol, the unaltered sacred lake whose calm surface imperturbably reflects in an immobile duration the appearances of things and beings prey to the instant of the storm. A symbol of divine vision, a figure of theory, an image of representation, the lake sends the picture's "apathetic" gaze back to the painter's eye, and the viewer's, and constitutes

its subject in his place of contemplation. I have seen *almost* too much of it: "the prodigious effects of nature," the animal power of instincts, the emotional waywardness of men, each in the instantaneous explosion of its violence. At the center of the landscape, the symbolic eye of the subject, which reveals, by its contemplative serenity, the sovereign duration of its admiration and thus finds itself becoming for my own gaze—this Sunday morning in October at the Städtisches Kunstinstitut of Frankfurt—the mysterious source productive of the *pathos* that overwhelms the rest of the picture in the sputtering of its three simultaneous instants.

I have all the time to look . . .

"Several days had passed since our last conversation in the Tuileries, when we left Paris to go walking in Saint-Cloud." Let us accompany Pymandre and Félibien for a moment on their walk, one day when the weather is fine.

> When we arrived in the magnificent palace, where Monsieur, the King's only brother, has allied the riches of Art with the beauties of Nature, we went down into the gardens whose beds, enameled with a delightful variety of all sorts of flowers, were still embellished and perfumed with Myrtle, Jasmine, and Orange Trees, which by the beauty of their leaves, flowers, and fruits surpassed the richest compositions of emeralds, gold, and silver.[4]

The art of the landscape-garden is combined with the beauty of the Nature-landscape, but the latter surpasses the former. Once he has set up the ground of the scene and its place, whose "reality" in the descriptive text is measured precisely by this excess, the writer proceeds to the placement of the viewing point:

> We chose to sit down in a convenient place, from which we could see at the same time both the Seine, which snakes between the meadows and the hills bordering the river. There were a few light clouds in the air; their shadow, spreading unevenly over the mountains and in the plain, created a situation where our sight found darker places to rest from time to time after a period of true delight in which silence reigned with so much sweetness that it was interrupted only by the sound of the fountains, whose waters we saw sparkling through the shade of the trees.[5]

The viewer's elevated gazing point is chosen so that the natural landscape is composed as a panorama in the complex unity of its variety, river, mead-

ows, hills. A single time, that of simultaneous presence, governs the con-
templation of the things that are co-present in the space whose depth is
ensured by the "snake" of the Seine: aerial space where light and shadow
play, punctuating rhythmically with tensions and rests the trajectory of
sight in the unity of presentation of a single gaze posed in a place that is
all the more convenient for allowing an overview. And the silence, scarcely
interrupted by the sound of the fountains, is only noted by the describing
eye as the sonorous echo of the luminous brilliance of the waters in the
darkness of the woods and thickets. The viewer takes the place, occupies
the space, of the painter, and the writing he produces in that place to ex-
press it in words has no function but to construct the "subject" of the
painting that he *could* paint there; but it is a painting that would be con-
templated before it is fabricated, unless the writer, a professional viewer,
art critic, theoretician of painting, through his description, in which the
"reality" of the natural spectacle is constituted textually, identifies himself
as a writer only by identifying himself with the painter, and the descrip-
tive text, embedded in the narrative of a walk in Saint-Cloud, is read as a
"description" only if it is identified with a possible painted picture, which
it presupposes.

Now Poussin painted that picture for Monsieur Pointel, a picture "rep-
resenting calm and serene weather" as a pendant to another, representing
a storm. *Landscape—A Calm* could appear as the illustration of a mimesis
of Nature by itself through which the landscape appears to accede "natu-
rally" to the work of art. "There is nothing more agreeable than paintings
in which one sees waters that represent the objects that surround them as
if in a mirror, because they are charming images of what Nature herself
does when she paints the sky and the earth on clear, calm water."[6] By rep-
resenting things in the reflection of a lake, Nature accedes reflexively to a
sort of natural consciousness of self, a natural art to which the painter ac-
cedes in turn as "artist nature" by representing in the mirror of his paint-
ing the process of representation. In the space of that general harmony, as
in each of the places where it is realized, the time of Nature and the time
of Theory overlap, or rather are perfectly harmonized, and the natural
mirrors represented in the painted work are there to guarantee the exact
composition.

In *Landscape—A Calm*, the deep serene blue of the lake occupying all
the middle ground of the painting reflects, according to the rigorous laws
of catoptrics and according to the more subtle laws of light in painting,

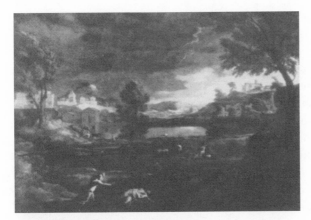

FIGURE 17.5
Nicolas Poussin,
*Landscape with
Pyramus and Thisbe.*
Staedelsches Kunst-
institut, Frankfurt
am Main, Germany.
Photograph courtesy
of Foto Marburg/
Art Resource,
New York.

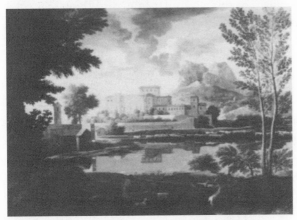

FIGURE 17.6
Nicolas Poussin,
Landscape—A Calm.
Private collection.
Photograph by
L. Marin.

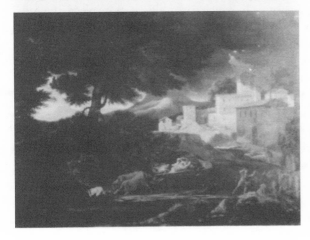

FIGURE 17.7
Nicolas Poussin,
Landscape—A Storm.
Musée des Beaux-
Arts, Rouen, France.
Photograph courtesy
of Giraudon/Art
Resource, New York.

not only the vast edifice that occupies the central place in the upper half of the canvas, but also the farm at left and the herd of cows, and also the sky whose faded blue finds in the depths of the crystal-smooth water the occasion for the intense colored density of its surface. Similarly, it seems as though the painting is demonstrating in full clarity the theorems of shadow and light and their ordered distribution, in particular with the figures that embody the rectangular geometry of the composition, and most notably in the second frame composed by the powerful tree on the left and the two graceful trunks of the trees on the right. On the horizontal lines of the lake's edges and of the wall surrounding the castle, paths and accidental features of the terrain are articulated, cutting through all the space in parallel bands, from foreground to background, and the zigzag of the path "on the forestage" of the canvas, far from disturbing that equilibrium, leads the gaze still more imperiously toward the mirror of calm water where the world is pensively reflected in harmony with a smooth and somehow unified execution, "so that if all these colors are put together in a single hue, sweetly united with one another, a harmony is formed as in music . . . [for] there is such a great resemblance between musical tones and degrees of color that a concert formed by a lovely arrangement of the latter is as sweet to sight as a harmony of voices can be agreeable to the ears."[7]

Such is the order of Nature in the landscape, the order of Art that reproduces its truth through its architectures, volumes, and surfaces; such is the peace of the horizontal lines that vertical lines punctuate with their rhythm, order, and measure, the repetition of a single measure of grandeur, the beauty of a cosmos in which each thing is in its place, the order of places rigorously governed by that of perspective: prospect, which is a function of reason, dominates aspect, which is the simple perception of the things represented. Three planes are lined up in the depth of the space to which the organization of the surface of representation corresponds exactly. The viewing point and the vanishing point occupy the geometric center of the canvas; the line of the horizon divides the painting into two equal halves. The figures come to express that rigorous geometrical architecture, less to conceal it than to emphasize its regularity. A scientific composition of cubes and parallelopipeds occupies the center of the painting, closing off all flight into the remote aerial regions of the landscape, and the unified surface of a lake exactly reflects the highest edifice on the central vertical line of the painting: these twin features appear to signify a

"page-setting" of the space according to a stable and immobile order of which natural reason speaking the language of mathematics would be the guarantee and the legitimization; they form a space of totalization whose regulated structure guarantees flawlessly the measured copresence of the places that compose it. The descriptive discourse will enunciate this by calmly repeating "there is . . . there are . . . ," while for that order of co-presences the mirroring surface of the lake assures the reflexive dimension in which the theoretical gaze finds its figure as representation. No movement comes to trouble that theoretical order. High noon: justice.

The order of space composed in the cosmos of places is that of time, the very time of contemplation that offers it to view. I have "all the time" to look because what is offered to my sight is totalized in a spatial order without remainder or lack. The marks of what the painting represents are consonant and coincident with the specific time of the "theory" of representation, the time of beauty without past or future, the present of the co-presence of the gaze with the copresences of the things painted in the order of their places. In aspectual terms—and the linguistic term "aspect" has never been so well suited to the description of a work—a single duration reigns throughout at the moment of its accomplishment. The painting's figurative marks are marks of repose and stability: the buildings, the lake and its reflections, the human and animal figures. There are no incidental events in which the contrasted times of a possible narrative might be initiated, but rather a single present totalizing and stabilizing the temporal flow: the felicity of beauty, the felicity of the contemplation of the painting. This latter felicity duplicates, and is identified with, the picture of contemplation. No matter how far the reflection is pursued, the representation of representation leads only toward the identification of a single presence. The supreme mark, on the bar of the chiasmus between the picture of contemplation and the contemplation of the picture, marks the sovereign delight of the present: the even sunlight in which beings and things bathe, each in its stable place—an atemporal moment, it seems, of equilibrium in the day. There is *no accident* in the illumination of things, but a single milieu of lighting in which painted things take their rightful places. Here the definition of painting is realized, an imitation made with lines and colors, in some surface area, of "everything that is seen under the sun." The end of painting: the delight of representation in the clarity of presence of an immobile present. Thus would be constituted the full fiction of a theoretical subject (or a subject of representation) who has *all the*

time to assume and gather up the infinite space of Nature into a single sat-
isfying whole. Thus that plenitude would be constituted if, in the general
harmony of the picture that is closed in on itself in a perfect reflection,
here and there, some elements did not create dissonance, some figures
were not strangely out of tune.

Let me withdraw my gaze . . .

So where is he heading so quickly, toward the left, the rider on his brown
horse, at a gallop, at the edge of the lake? What *impetus* is driving him so
abruptly to leave the covered water hole where his companion on a white
horse has stopped? What violence is carrying him off amid all this serenity?

From where is that dark cloud rising, toward the sky, toward the top of
the painting, to spread out right to the edge of the painted canvas? It is as
if the steep mountain that occupies the background of the right-hand side
is smoking like a volcano, smoking like the Sant'Angelo castle in the back-
ground of the landscape with Orpheus and Eurydice, so similar in its
composition and its mood to *Landscape—A Calm*. What fire is brooding
in the depths of that mountain? From where does that disturbing smoke
cloud come, signaling in the immobile time of happiness the imminence
of death? The storm is announced and initiated in the calm weather for
anyone who is capable of sensing its premonitory signs. The galloping
horse carrying its rider toward the left, incarnating desire or fear, is a fig-
ure of action and movement, a mark of passion in which future and past
are profiled on the near or the far side of the present; it is accompanied by
the accident of fire in the open air, with its ominous smoke rising up
through the sky. These two figures introduce a double variation of time—
natural, human—through a fracture of the present and its representation.

Landscape—A Storm results as much from the instantaneous metamor-
phosis of time as of space. An exploding space where the gaze never rests
in a place except to leave it at once, a space of dynamic process, whose
temporal aspect is still the present, but the punctual present of the instan-
taneous, which, far from totalizing the flow of duration, fragments it, di-
vides it so as to *reduce* the present and *dissipate* it in the infinitesimal in-
stant of the "sudden." The "now" of calm weather has become the "all at
once" of the storm, unthinkable, unrepresentable since it is a pure emer-
gence of the event—an accident without beginning or end. The instant as
instantaneous is incommensurable; *only* its effects can be grasped; there is

no way to represent their cause. "Not all rapid, fleeting actions are favorable to painters: and whenever someone succeeds in rendering them, what he produces is a miracle of his art."[8]

Two remarks on the effects of the irruption of the sublime. The first, that of light as the instantaneous dazzling of the lightning flash: the light of the flash really does bathe the luminous diaphanousness in light in order to *reveal* the forms to the eye in their proper dimensions and their exact distance; it *seizes* them both close up and far away. The processes are immobilized in "states of action" that exceed them, as it were, by default. In the second place, the instant of tempest is expressed in the figures through emotional effects that correspond to it: fright in the face of the horror that pins one to the spot, immobilized flight, insensate blindness. Still, in the picture, the lightning does not cease to be dazzling for the gaze that is contemplating its representation and its effects. Such is, in the final analysis, the unrepresentable sublime of the tempest. It will always and necessarily exceed its contemplation. The equivalence between the two times, the time of the represented and the time of the representation, in the present of contemplation through which the delight of beauty is accomplished—that correspondence is broken forever by the representation of the effects of the sublime, because the instantaneous instant of its emergence, which, through a miracle of his art, the painter succeeds in capturing in its effects, is *incommensurable* with the present of the gaze that contemplates it where it has been deposited on the canvas. And it is of that incommensurability that, paradoxically, the sublime in painting is constituted. The sublime is the impossibility of a theory of the sublime, the "monstration" of its impossibility through a sort of organic disconnection between the times of the "subject" and of the "gaze."

That is why the eye of the painter sage can never be situated anywhere but in the interval between *Landscape—A Calm* and *Landscape—A Storm*, on the double margins of the two pictures, where the happiness of beauty threatened and the terror of the emerging sublime are exposed, between the goatherd who dreams and contemplates and the cowherd who is hurled to the ground, prostrated by a holy terror. After the variations of space and time, this would be the third variation between the one and the other, that of meaning and interpretation; but for its fulfillment this one would require a third term, the painter, at the place where it is accomplished, painting the two pictures as a pair in an "antithesis." He would be situated at the place of differentiation *itself*, a place that cannot be occu-

pied by a painter's gaze. Meaning fails, then, and theory is lacking, but the antithetical pair, by filling out each of the contraries to the fullest, shows this failure and this lack as such: the end of meaning and interpretation. The gaze of the sage, of the painter, *does not settle* in the non-place of the interval: it traverses it; it passes through; it is in transit. The beauty of the calm weather is not transformed into the sublime of the tempest. Neither transformation nor metaphor, neither imperceptible metaphor nor instantaneous displacement, but a pattern of variation: *Landscape—A Storm* in its sublimity separates itself from the beauty of *Landscape—A Calm*, although the gap can never be measured: what indeed would be the measuring unit?

To put it differently, the painter's eye, the subject's eye, will never look upon the tempest except from the calm place of serene weather, and it will never seize the effects on the other canvas except to remark the trace of the instantaneous gap through which the storm landscape positions itself at an infinite distance from the landscape of calm weather, even as, in the beauty of the landscape it is contemplating, that eye picks up the premonitory signs—which are perhaps always present in happiness—of the horror of the sublime.

That is why in the *Landscape with Pyramus and Thisbe*, where the tempest breaks out in the heavens and on earth, the animals (in nature) and the sage's eye, the painter's eye (among men), will not hesitate to deposit sublime time in the space of representation, at the price of a major inconsistency, in which propriety, appropriateness, and verisimilitude collapse. The eye deposits its tyrannical violence in the figure of theory, through the theoretical apathy of its gaze, through the fictive grace of a lake whose waters, unchanged, reflect the disrupted things that surround it. In this inconsistency, representation is transgressed in its axiomatic principles, but the defect of all theory, of all contemplation, a defect that is the sublime itself, its excess in the art of painting, is *shown*.

That is also why the equivalent of the figure of theory found, in the *Landscape with Pyramus and Thisbe*, with the mirror lake of the middle ground, seems to me to be, in *Landscape—A Calm*, the absence, in the central lake, of any reflection of the smoke cloud that announces the tempest. Thus a breakdown of representation in one of its most telling figures—that of the "natural" mirror represented—would refer both to a lacuna in the reflexive dimension of the representative mechanism, therefore to a theoretical "syncope" (contemplation and speculation), and also

to an intrusion of one of the essential characteristics of the sublime—the excess of representation over itself, its "pinnacle"—in the very picture of beauty, but in the form of a negative figure, of a figure realized through absence—in the form of "figurability." Henceforth *Landscape—A Calm* would be, not only through the anticipatory figures of the storm, the smoke cloud and the rider carried off on his galloping horse, but also in its very center (the mirror lake), caught in the variation in which the unrepresentable is presented—that is, the sublime.

That is why, finally, the meteoric time of Nature that the Master's two paintings seem to present in the passage from *Landscape—A Storm* to *Landscape—A Calm* is, in fact, only the at once necessary and unforeseeable movement of the cyclical time of the cosmos, in which the plenitude of duration in which Beauty peacefully reveals herself to the contemplative eye is always already potentially fractured in its very "now," by the "sudden" instant of the nocturnal background of Nature, a senseless explosion, in which every gaze and every theory are lost.

The Limits of Painting

§ 18 Representation and Simulacrum

In 1971, Pierre Charpentrat published an important text in the *Nouvelle revue de psychanalyse*.[1] The historian of baroque art was writing here as a philosopher and metaphysician, with the discretion, modesty, and courtesy that always characterized his work. In this text, with exemplary rigor, Charpentrat introduced the opposition between mimesis and trompe-l'oeil, between representation and simulacrum:

> For some, all art in which imitation seems to be the major concern belongs to trompe-l'oeil, all art less interested in creating a world of original forms than in fabricating, in the face of "reality," an "illusory" world that is justified only by its resemblance to reality. . . . This definition is quite inadequate, since such so-called reproductions deceive no one, and since no one looking at a portrait so faithful that "it looks like the real thing" will ever mistake it for the real thing. . . . There is recognition; there is not illusion. The application of the laws of perspective allows the painter to account for the three dimensions of an object, but not ipso facto to get us to take it for a three-dimensional object. (P. 161)

And a few lines further on, after recalling the apple and the squash in Crivelli's *Annunciation*, Charpentrat expresses the distinction introduced at the outset in the following formula: "For the transparent, allusive image that the art lover expects, trompe-l'oeil tends to substitute the uncompromising opacity of a Presence" (p. 162). The term recurs throughout the article, but with a significant shift, which the obligatory recourse to the ultimate criterion of the viewer allowed readers to anticipate from the beginning: the Presence offered by trompe-l'oeil is in fact only the ef-

fect of a Presence. "The viewer grasps all the consequences of a vision that he knows to be erroneous. P. de Cortone, Gaulli, . . . , Pozzo . . . and their countless eighteenth-century Venetian and German disciples do not impose an untruthful Presence, but deliver us up all the better to the effects of Presence."

Meanwhile, from the opaque presence of Crivelli's squash to the effect of the Infinite Presence of "a space above any law" produced by the St. Ignatius ceiling, Charpentrat has identified several different types of trompe-l'oeil. The first introduces a question and "a search for another nature" (p. 162) in the world represented on canvas; the second, as in a still life by Sanchez Cotán or de Baugin, disconnects the painted object from its reference to the "real" object that it represents, to change the "lifelike" appearance into a spectral apparition; the third, as in the decor substituted by Bramante in the choir of Santa Maria presso San Satiro in Milan, compensates for a lack in the secular or religious edifice via the necessary optical effect; still another—for example, the Ambassadors' Staircase Le Brun built at Versailles starting in 1671—catches the foreign emissary off guard in the gaze of false spectators and brings about all at once the reversibility of a spectacle (is this not the essence of a trap?) that the emissary thought he dominated; yet another—the corniche of a salon in the Villa Borghese by Lanfranc—blurs the boundary not between "reality" and "appearance" but between painting and sculpture, not "on the mysterious confines of art, but in the heart of its domain" (p. 165); another, perhaps the noblest and most meaningful, is "the one that confers on palace reception rooms and the naves of wealthy churches their most unimpeachable dignity." A new relation with illusion is established; "it is no longer a matter of deceiving or even of prompting some hesitation" (pp. 166–67), and yet "the exaltation created by the whirling rise of the foreshortened painted characters" (p. 167) is not illusory. Here the viewer is won over by the effects of Presence.

Let there be no misunderstanding, however: Charpentrat's theoretical discourse is not simply a classification, an ordering, of an abundant and supple material. He covers the field opened up by the initial opposition between representation and simulacrum. By way of the simulacrum, he questions the notion of representation, so much so that at the end of his article, we may wonder whether, under cover of an analysis of trompe-l'oeil, mimesis has not wholly shifted, although in a different way, into the world of doubles, appearance into the world of apparitions, representative

and transitive images into the world of dynamic effects. If this is the case, would it not be appropriate to reverse the terms of the opposition introduced initially? Instead of a simulacrum appearing, here and there, only to pervert and violate the rules of the representative "game," would not representation and the "theory" of mimesis have the function of dissimulating and effacing the disquieting strangeness, the uncanniness, of the universe of art?

∼

"Figures bear absence and presence, pleasure and displeasure." What does it mean to represent, then, if not to convey an absent object into presence, to bear it into presence as absent, to *master* its loss, its death by and in representation, and, by the same token, *to dominate* the displeasure or the anguish of its absence in the pleasure of a presence that takes its place, and in that deferred appropriation—"reality excludes absence and displeasure"—through transitive reference and recognition, to enact the reflexive movement that is constitutive of the subject itself, of the theoretical subject? Charpentrat indicates throughout his article that perspective is the instrument and the means of that pleasure and that power. This has been said over and over, but the very existence of trompe-l'oeil, which perverts the rules governing the play of perspective, cannot help but be intriguing; it opens up the field to a different line of questioning about that pleasure and that power.

What, then, is the theoretical and practical postulate of representation? Through perspective, the three-dimensional organization of space, relief and depth are figured on a material surface and support that are by that very token negated, since it is as if the painting were a window open onto "reality": the gaze grasps that "reality" without being filtered through any interpretive grid or sieve. But to be able to represent "reality," the painting has to exist as support surface. On and through the mirror picture, reality is projected in its own image; on and through the mirror picture, the eye receives the world.

Spectacularity-specularity: the window is a mirror. The exact visibility of the referent is conjugated with its absence: the world is indeed there on the painting, but what the painting bears on its surface is only the image, the reflection of the world. The representative screen is a window through which human spectators contemplate the scene represented on the painting *as if* they were seeing the "real" scene of the world. But that screen, be-

cause it is a plane, a surface, a support, is also a reflecting-reflexive mechanism on which and owing to which "real" objects are drawn and painted. Hence the necessary position and the necessary neutralization of the material "canvas" and the "real" surface in the technical, theoretical, ideological assumption of its transparency. The invisibility of the support surface is the condition of possibility for the visibility of the world represented. Diaphanousness is the theoretical-technical definition of the plastic screen of representation.

The perspective that enacts the submission and the subjection of aspect to prospect (to use Poussin's terminology), of vision to theory, of the perceptual gaze to the rational eye, is indeed the formal structure of representation, but it is such only through a (de)negation of its reflecting-reflexive mechanism: the picture. Representation as mimesis is accomplished only through that (de)negation. It constitutes itself only by denying the theoretical subject that produces it. But, conversely, the theoretical subject is constituted only through it and at the price of its own (de)negation. If the question of representation is nothing other than the question of perspective, that is, the production of depth on the surface of a painting through a perfect overlapping of the perceptual gaze and the theoretical eye, then the question can be reformulated as follows: how can I achieve the domination and mastery of depth, how can I make depth visible, deploy it and see it from on high, how can I reflect it truthfully in theoretical truth, even as I reject it as the existential dimension of my invisible gaze? How can I preserve "reality" or keep it in reserve, how can I possess it in *my* representation even as I raise *my* gaze to the power of the theoretical eye, even as I subject my gaze to the transcendental element of all vision? How, finally, can I make representation escape its process of constitution, a process that it nevertheless requires? How can I posit it in its "objective" autonomy, which it nevertheless possesses only thanks to the theoretical desire that it enacts and in which the subject is constituted and eradicated in its very constitution? To answer these questions is to give *my* representation the juridical status of a true judgment through which, with full legitimacy, the theoretical subject appropriates being in its representative and appropriates or identifies itself. It is in this sense that all representation is narrative by nature.

Let us return to the question of the depth represented on/in the surface of the painting. The classical theories of vision, as Merleau-Ponty saw so clearly, all agree that the third dimension is invisible, for it is nothing but

our vision itself. It cannot be seen because it does not unfold under our gaze, for the simple reason that it is our gaze. How can our vision be subjected to theory if not by redeploying, as a breadth facing the viewer, the depth that the viewer cannot see, since that depth is theoretically considered to be a breadth seen in profile? If I do not see myself seeing, if I do not contemplate the third dimension, it is because I am badly placed to see it, for it is the very axis of my vision. "I should see it if I were in the position of a spectator looking on from the side, who can take in at a glance the series of objects spread out in front of me, whereas for me they conceal each other."[2] The lateral viewer would see the distance between my eye and the first object, whereas for my gaze that distance is condensed in a point. "What makes depth invisible for me is precisely what makes it visible for the spectator as breadth: the juxtaposition of simultaneous points in one direction which is that of my gaze."[3]

To deal with depth as breadth considered in profile, the subject has to leave its own place, its point of view, and think itself elsewhere, outside its own place of vision, in the wings, and precisely in that point located nearest the specular screen, the point that the viewer has to occupy in certain anamorphoses to recognize the strange figure, a simple shapeless whitish spot when he is in the viewing point. By the sequential ubiquity it requires, the facetious and troubling mechanism known as anamorphosis has the metaphysical function of unveiling the concealed operations of representation. In fact, when Poussin or Le Brun present to the gaze of the viewer facing a picture the frieze of figures that are telling the story on the stage, what are they doing if not offering to his sight, in and through that figuration and in the form of a breadth figured by the story that is telling itself on its own, the deep dimension of the gaze? Without leaving the point of view that the perspective mechanism compels him to occupy so that the three-dimensional space of "reality" can open up on the surface of the representative screen, by reading the narrative that the figures are relating for him, by recognizing the story and its characters, by giving himself over to the pleasure of fables, he sees own gaze figured, along with its existential dimension, depth; this is what he reflects in this figuration, what he dominates and appropriates for himself, constituting himself, through this fiction, as a universal subject of truth. We can understand, then, why and how the contemplation and the reading of a representation is at once pleasure and power. Pleasure, for in a representation, the theoretical desire of identification is achieved, the reflection of representation

on itself where the subject is constituted in truth; power, since by mastering the appearances painted on the canvas, the subject dominates and appropriates for itself its vision in theory, occupies fictively and legitimately the position—without position—of God. "For God, who is everywhere, breadth is immediately equivalent to depth. . . . And indeed it is the world itself which suggests to us that we substitute one dimension for another and conceive of it from no point of view."[4]

~

Charpentrat's text begins with the opposition between representation and simulacrum and it proceeds—this is the direction in which his "classification" of the various types of trompe-l'oeil is headed—by applying the notion of simulacrum to representation. The philosophical strength of Charpentrat's project stems from the fact that, throughout the field covered by his immense knowledge of works and texts, he uses only a single criterion, which is at once a touchstone for the distinctions he introduces, an instrument for analyzing objects, and a theoretical-operational notion: the effects of the painting, statue, or edifice. When he speaks as an art historian and a theoretician, he uses the discourse—to paraphrase Pascal—of the reason (the law of distribution) of effects. Thus the effect of representation—in the sense in which I have used that term—is not that it *makes us believe* in the presence of the thing itself in the picture ("no one looking at a portrait so faithful that 'it looks like the real thing' will ever mistake it for the real thing" [p. 161]) but that it *lets us know* something about the position of the subject thinking and contemplating the world, instructing us, as theoretical subjects of truth, about our rights and our powers over the "reality" of "objects." Hence that pleasure as fulfillment of the theoretical desire wherein the subject is identified, appropriated as such: inseparably, pleasure and power.

Now trompe-l'oeil exhausts itself in its effects; the simulacrum is only their sum. Still, these effects have to be recognized for what they are. Charpentier speaks of the simulacrum's opaque, uncompromising presence. Trompe-l'oeil is in no way felt—this is the trompe-l'oeil effect—as imitation or reflection. "It refers to nothing but itself": it produces effects of Presence, which Charpentrat describes at work in the effects of representation. What is in representation on the canvas is no longer the object, the object that in order to be constructed and produced there presupposes invincibly, necessarily, a subject contemplating it from a prescribed place; in

such a representation, the object's referent is delegated by resemblance in order to attract admiration, as Pascal says, admiration that the "real" would in no way provoke. What is in representation there on the intransitive canvas is the thing itself, self-sufficient, opaque, *astonishing*, stupefying the gaze. Art's lovely lie has become something like a disturbing hallucination; a beautiful appearance has become the apparition of a phantom; the representation of an object has become the magic evocation of a thing; the image has become a copy: trompe-l'oeil, or the advent, the irruption, of the simulacrum. Presumably, as Charpentier says, "we do not reach out a hand to touch the squash" in Crivelli's *Annunciation*—a simple compulsive effect of reality—and yet in trompe-l'oeil, something impels us in this direction. Or rather, it is the simulacrum that extends its phantomlike apparition toward our gaze, toward our body. "We feel ourselves . . . in the presence of a search for another nature," the writer adds (p. 162): an effect of presence through which trompe-l'oeil seeks us, reaches us in the place of contemplation and reading that we occupy, our gaze and our eye positioned and compelled by the representative structure in which the thing in trompe-l'oeil finds itself in other respects inserted, where "it remains in spite of everything . . . imprisoned in the ambient fiction" (p. 162).

Let us not confuse the effect of reality and the effect of presence. Charpentrat is not deceived; in his text, he suspends the *doxa*, the prejudice in favor of the "real"—the word is always in quotation marks—to refer to the other of the "real," Presence—a word always marked in his text by a solemn and troubling capital letter. This slippage, this displacement, which is at the same time a rupture, is what we need to understand. In a sense, trompe-l'oeil—Crivelli's squash: the simple fact that I can name it shows this—does indeed stem from the domain of mimesis, but because it manifests a servile submission to the thing itself as it appears before the eyes, the thing painted is no longer the representation of the "real" thing, but its presentation in its double: trompe-l'oeil, or mimesis in excess. To be sure, imitation is well defined by the classical century as the art of deceiving the eyes, but agreeably, with choice and discernment, under the guidance and law of a beautiful idea. Trompe-l'oeil is a supplement to imitation, at once the pinnacle of representation but also useless, as Charpentrat writes, not helping in any way to institute the order of representation: trompe-l'oeil is representation's excess or its lack, its remainder. Representative imitation in fact preserves the distance between copy and model even as it offers for the mind's inspection the law of mastery of mimesis, the law of production

and domination of appearances in the depth opened up on the surface of the canvas. Trompe-l'oeil, by suppressing the distance between model and copy, by suspending the referential relation, traps the perceiving eye in what I shall call essence-appearance, in apparition, and it delivers the body-eye over to fascination with the double, to stupefaction; by the same token, the effect is not one of contemplation and theory, a return to the serene and peaceful truth of representation, the truth of the thing absent from the real—hence the reality effect of all representation—but of surreality, an impure blend of anguish and shock: the effect of presence. To speak the language of classicism, the viewer *admires* representation, but is *astonished* by trompe-l'oeil.

One text, among others, concerning a trompe-l'oeil by Caravaggio: Francesco Scannelli, *Il microcosmo della pittura* (1657): "A unique prodigy of naturalism . . . executed with such truth, such strength, such relief that very often, even if nature is not matched and conquered here by art, the picture nevertheless confounds the viewer by deceiving his eyes, it *fascinates* and *delights* him."[5] A pleasure of a different nature from the pleasure of representation, no longer aesthetic but metaphysical: *jouissance*?

Perhaps it would be useful to reflect here on relief in the trompe-l'oeil object. For, in most cases, its relief—its third dimension, whose production in the surface of the canvas is the triumphal accomplishment of mimesis—plays its useless and excessive role in a very different way. Charpentrat notes this in passing, picking up scattered suggestions left by seventeenth-century painters. The "thing" stands out on the canvas; the apparition comes to meet the gaze; the double is strangely detached from the surface of the plastic screen. Strangely, not completely: the hallucination is in the process of being born. Let us consider for a moment a still life in which a fly has landed, or one in which a drop of water is flowing, limpid as a tear. Where has the fly landed? Where is the drop flowing? On the corolla of the flower, on the side of the flask, *represented*? A strange hesitation, for, to my naive and attentive gaze, which limits itself strictly to seeing, to seeing what it sees, to abandoning itself between vision and clairvoyance, here is the fly poised not on the petal but on the surface of the canvas, here is the drop gliding not down the crystal of the carafe but down the diaphanous plane of the *tavola*, which in other respects "perspective" opens up onto the full depth of the representation, and which the painter populates with the figures of his narrative or of his moral or religious lesson. The trompe-l'oeil thing unveils in representation the very secret of representation, the secret

of its law, by turning it against itself. For a moment it makes us see, between knowledge and vision, between prospect and aspect, in a fascinated suspension of the gaze, the transparency of the screen, the surface of the mirror, the glass of the window. As Charpentrat says, trompe-l'oeil breaks the rules of a game. A theoretical game, a game of *theoria* and mimesis in the picture. To call it transgression would be to put it too strongly, or not strongly enough. Let us call it rather a turning of the law's power back onto itself, for the duration of the instant of a viewing. Less irony than humor. Our fascination lasts only a moment; our stupefaction is ephemeral. Yes, it is true that we do not chase away the fly with our hand; we do not wipe up the drop of water on the canvas.

The theoretical scandal of trompe-l'oeil consists in *grasping* the look of painted things as they appear, emerging out of a black space: a contradiction in terms, if the open space on the canvas is light, if, to speak like Bosse or Fréart de Chambray, white, white light, is the "universal" color, the color of air. Thus if the space represented within the frame of a painting is a cube open on one of its sides, a window open onto the world and a mirror reflecting that world, pleasure and mastery, the pleasure of mastery of the world in its representation, the trompe-l'oeil thing in a place of representation, the trompe-l'oeil picture over the totality of its field, darkens the mirror, closes the window and the cube. If, as Dufresnoy has written, "there is nothing that comes closer than pure black," then trompe-l'oeil, thing or picture, presupposes or posits that the space enclosed by the frame of the painting is a simple surface full of an infinitely dense volume. Hence—as a consequence—a "black" painting is a represented space that expels from within itself, onto its own surface, the objects that the painter seeks to paint on it. These objects are apparitions, doubles. If we project onto that full and dense surface a luminous beam parallel to it, the beam will instantly extract fragments of objects and figures, which, on the one hand, will remain caught in the compactness of the surface and, on the other hand, will stand out in front of it. From this point on, that instant is a snapshot, a snapshot of vision. Hence the fascination, the stupefaction of the gaze.

Simulacrum, trompe-l'oeil, the power of representation turning back on itself: Charpentrat's article gives remarkable examples of this in the author's field of predilection, architecture. Remarkable examples in that trompe-l'oeil is revealed in them as the instrument of political or religious power— or more precisely in that the Prince or the Theologian are instituted, in the place of the simulacrum, in order to subjugate, through trompe-l'oeil, the

subject of representation and the mastery that representation confers on him and in which he is constituted. I shall look closely at just one example, the Ambassadors' Staircase where "Le Brun had two vast *loggie* painted on the wall in the background, loggias full of courtiers who are observing and commenting. In front of them, covering a balustrade, there is a hanging *carpet with dark folds*[6] that we have already noted in Crivelli and that seems to be the favorite accessory of those who produce trompe-l'oeil." Charpentrat adds: "There would be a great deal to say about those gazes, always plunging, which catch the foreigner by surprise, which pursue him and surround him" (p. 165). So here is the ambassador, the representative of the foreign king, the delegate of his power, who climbs the staircase at Versailles to reach the site of the royal audience: spectacles, artful and rigorously ordered perspectives unfold in the building before the gaze of the subject in and of representation. All at once, in an instant, and doubtless only for an instant, the spectator subject sees himself seen, observed, commented on, in his very activity as a seeing, observing, discoursing subject. He is the gazer gazed upon. The spectator has become a spectacle: or rather, he is the spectator of his own spectacle. In a few lines, Charpentrat indicates what has just happened: do these gazes

> relay, multiply, despite their conventional good-natured character, the gaze of the master? Are they reminders . . . that [even if one is an ambassador, even if one is the representative of a king] one can no longer be anything but an *object* when one enters the domain of the king [the Sun-King]? The spectacle, in any case, *abruptly*[7] appears to be entirely reversible. . . . Trompe-l'oeil rebounds, and transforms us into images. (P. 165)

All representation, all mimesis, is, in a sense, royal or theoretical: with it is instituted—as I have sought to show—a subject who dominates appearance, thereby appropriating it for himself and identifying himself as a truth-judging subject in that appropriation, veiling all absence through the captivating contemplation of the theoretical eye, conjuring away time and death for the object this subject produces and in which it produces itself: power, pleasure; the pleasure of power. But what the Ambassadors' Staircase reveals—and we could find many other examples, not only in pictures but in texts and speeches—is the process by which the royalty or the theocracy of representation is constituted: the secret of its power. Trompe-l'oeil enacts a reversal of representation and of its power by hallucinating its productive and self-productive subject. The subject of representation

and in representation represents himself represented in a multitude of gazes, which themselves represent a gaze that is not there, in the *loggie* painted on the wall in the background, but which is not hidden, either, behind the carpet with the dark folds that hangs over the balustrade, a gaze that is everywhere and nowhere, omnipresent through that powerful effect of presence, a gaze that is perhaps finally only the darkness of that carpet, its infinitely dense and blind surface.

The last part of Charpentrat's article on the zenithlike trompe-l'oeil that opens the frescoes of baroque ceilings and vaults toward the heavens deserves another reading. The text confirms my own suggestions, it seems to me, but with the means and to the ends of the religion of the Counter-Reformation. The contrast between the simulated architectures of the *quadratura* and the "supernatural unfurlings" deploys, in this case, the dynamics of a space "above all law": the effect of a Presence, of a Beyond that no one can represent in figures, trompe-l'oeil plays in the gap between representation and abstraction; it toys with each, and the irrepressible exaltation of the gaze toward the heights of which Charpentrat speaks is also the ineluctable fall toward the depths: the uncertain vertigo of the simulacrum, a sacred mastery of the simulated space of the edifice in which a hallucinated viewer is immobilized, stupefied, before plunging into the abyss.

§ 19 Figures of Reception in Modern Representation in Painting

By way of introduction, I should like to clear up a misunderstanding (in the telephonic sense of mishearing) that has slipped into the title of my talk and introduce an addition to it. The adjective "modern" in my title is intended to give my work the very flexible boundaries of a historical, ideological, and epistemological field; by "modern representation in painting," I mean the form of representation that was established in the Quattrocento and whose founding principles were problematized by impressionism and cubism in the late nineteenth century. In my contribution to this colloquium, I shall be using the term "semiotics" to refer to the theory of the signs of the reception of representation in painting. Thus, in what follows, I shall be dealing with a *pragmatics of representation in painting*, with the relation between representation as sign and the person who receives it—that is, since we are talking about painting, the person who *sees it, reads it, interprets it*: it is well understood that pragmatics, or the dimension of the use of representation as sign, cannot be separated either from syntax or semantics or from the internal organization of a representation, on the one hand, or from the relation between a representation and what it represents, on the other hand.

To speak of signs of reception (taking a sign as both a process of signification and a product of that process) will thus amount to speaking of the marks and markings of the reception of pictorial representation *in* the pictorial representation itself. I shall not place too much stress on this point: in speaking of signs of the reception of pictorial representation, I shall refer to the structure of the "viewer-reader-interpreter" that is inscribed in any pictorial representation as one of its inherent elements. If this is the

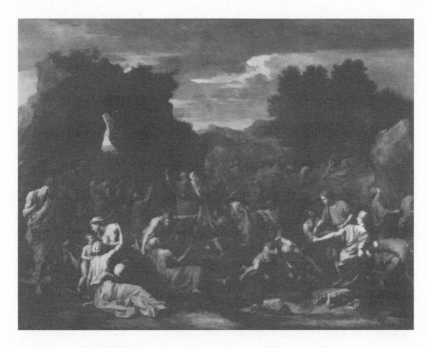

FIGURE 19.1 Nicolas Poussin, *The Israelites Gathering the Manna*. Musée du Louvre, Paris, France. Photograph courtesy of Giraudon/Art Resource, New York.

case—at least conventionally—we can say that these signs of reception are, or that the structure of reception is, one of the features of the dimension of reflexivity or opacity in representation, one of the features through which representation *presents itself* as representing something.

But if the presentation of representation, its reflexivity, is one of the two fundamental dimensions of representation, generally speaking, we shall need to define with more precision the signs or marks of that presentation and their specific operations, the markings of presentation of *modern* pictorial representation, that is to say, in the historical, ideological, and epistemological field defined in broad terms a moment ago.

An initial *figure*, or rather an essential configuration, of the marks and markings of the presentation of modern pictorial representation is its frame (*cadre, cornice*). To address this first question, I shall use as my starting point a text that is a veritable experimental mechanism for the study of the theoretical and practical problems of pictorial representation: I am referring to

a passage in a letter by Poussin that has the historical value of a manifesto, it seems to me, for representation. I have decided to choose Poussin to begin the illustration of my topic for several reasons: first, because I know something about him; next, because he represents, rightly or wrongly, one of the model paradigms of "modern" pictorial representation—its classic species; and, finally, in homage to the invitation you sent me, for Poussin is an admirable example of interpenetration between France and Italy, Rome and Paris.

Let us consider, then, a letter sent by Poussin in 1639 *from Rome*, to his client, patron, and friend Chantelou, *in Paris*, to announce that he was sending a painting—itself a manifesto of "classicism" in Rome—a painting to which we shall return, *The Israelites Gathering the Manna*. "When you receive [your painting], I beg of you, if you like it, to provide it with a small frame [*corniche*]; it needs one so that, in considering it in all its parts, the eye shall remain concentrated, and not dispersed beyond the limits of the picture by receiving impressions [?] of objects which, seen pell-mell with the painted objects, confuse the light."[1] And at the end of his letter, Poussin again tells his correspondent: "Before you exhibit your picture, it would be highly appropriate to embellish it a little."[2]

Poussin's letter is intended to announce and to guarantee the good *reception*, in the material sense of the term, of a painting that its viewer-patron, its receiver, has not yet seen, a painting that for him is absent; yet it is that absence that the letter written by the painter puts in representation, in the form of a name, *Manna*, and a *frame* (*cadre, cornice*). For it is remarkable that Poussin does not speak *first of all* of the content of the painting, of its subject, but of the painting as a simple object of the gaze: the name and the frame, in reciprocal interaction, are the minimal conditions of possibility of a reading of the painting (the name posing the more general problem of titles of works as signs of reception) and of a vision of the painting (the frame-*cornice*).

The name *Manna* is indeed the proper name of this singular picture, but at the same time, the name sets it off and announces it in relation to a series, a genre, a class: the series of *Manna*s before Poussin, the genre of religious painting, the class of history painting. Henceforth, with the reading of the picture's name, the viewing is announced and anticipated, impelled toward the reading of a narrative (the name of an episode in the history of the Jewish people), a religious narrative (the Old Testament), and the reading of a painting narrating a story from sacred history. (In this

context we might raise the question of the reception of paintings called "Untitled," or named after their author, as in "a Pollock.")

The frame is an ornament of the painting, but it is a necessary ornament: it is one of the conditions of *possibility* for contemplating the painting, for reading it, and thus for interpreting it. This is an indirect comment on a remark by Wolfgang Iser, who was himself commenting on a remark by Umberto Eco concerning the iconic sign: "What is designated [by iconic signs are] the condition[s] of *con*ception and *per*ception which enable the observer to construct the object intended by the signs."[3]

"The iconic signs of literature constitute an organization of signifiers which do not serve less to designate a signified object, but instead designate *instructions* for the *production* of the signified."[4] The letter constructs the picture as a frame for an absent picture. A necessary ornament, the frame is what embellishes and offers to view; it is through the frame that the painting fulfills its purpose of being seen, shown, published. When the viewer's gaze is substituted for the painter's eye, a frame is necessary, because the painting considered in the process of its presentation, its spectacularization, is substituted for the *artifact* considered in the process of its production.

Thus even if it does not have its own language, painting has its own specific means for *making its viewer see what it presents*, means that are neither discursive nor mimetic.

The framing of a painting is thus the semiotic condition of its visibility, but also of its readability, for, if we follow Poussin, the frame concentrates and focuses the rays of the eye on the painting while neutralizing the perception of neighboring objects in the empirical context. The frame is not a passive agency of the icon: it is, in the pragmatic interaction between viewer and representation, one of the operators of the constitution of the painting as a visible object *whose entire purpose is to be seen.*

The frame that is signaled and pinpointed in this way by Poussin's letter constructs a sort of geometrical and optical schema, a spectacular mechanism. The frame is a *model viewer* that comes to regulate visual perception. To look at a representation in painting, owing to the very conditions of its presentation, which are inscribed in it, is thus not to see an object, a thing. Poussin theorizes this observation in his distinction between *aspect* and *prospect*: "There are two ways of seeing objects: one is simply to see them [aspect], the other to consider them attentively [prospect]":[5] the frame is

one of the processes that conditions the passage from viewing to contemplation, from aspect to prospect. With the frame, the painting inscribes its own theory in itself, that is, the fact of presenting itself theoretically so as to represent something. That condition of possibility of "aesthetic" contemplation of representation is thus an element of the metalanguage of pictorial representation.

> *Simply to see* [aspect] is nothing other than to receive in the eye the form and the resemblance of the thing seen . . . beyond the simple and natural *reception* of the form in the eye, one takes special pains to find a way to know that same object well: thus we may say that simple aspect is a natural operation, and that what I call prospect is an office of reason that depends on three things, the eye, the visual ray, and the distance from the eye to the object.[6]

Here we readily recognize *prospective.* For Poussin, for modern pictorial representation in general, *prospettiva* is not merely the practical theoretical mechanism for constructing representations and for producing works. It is also the mechanism of the *theory*—*theoria*—of its contemplation and of its reception, which, as its delegate, is inherent in representation itself. The frame is one of the conditions of aesthetic reception: a sign or a mark, a process or a marking of representation in painting by the prospective mechanism. The frame, its process of framing or closing off representation, is, even more precisely, the *sign* and the *operator* of the crucial distinction between *light in the painting* as distribution of light and shadow and *light outside the painting,* "natural" light that makes it possible to *see* the painting and its light, provided that the "aspects/percepts" of neighboring objects do not succeed in introducing a confusion of light in the painting.

The frame does not prevent external lighting; rather, it separates and distinguishes it, and it preserves the representation for contemplation; this is a perceptible, empirical effect, but also and especially the effect of a theory of the reception of representation. The frame is a sign performing a theoretical act and defining the place of a symbolic operation.

The sign of that sign is the "color" of the frame that Poussin proposes to Chantelou: gold, as a "super-color," at once abstract (it is not the color of a real thing) and concrete (it is the color of light itself, *lux*). The gold of the background (an epiphany of the world of light and the sacred space of the figures) is repressed by the modern representation at its edge, as frame, that is, as a functional operational sign of distinction between the light of Nature and the light of art and thus as a specific sign of a config-

uration of presentation and representation, of its reception: as a specific sign of a configuration of the "modern viewer."

The frame is a necessary ornament of the picture; the painting needs it. It is a requirement of the painting, and not of its painter: it signals the *real* functional autonomy, and the *possible* aesthetic autonomy, of the mechanism of representation. Representation presents itself representing something; a sign of the reflexive dimension, the frame is its operator. It is an important moment *in* the construction of the "fictional" or model viewer of the representation within the pictorial representation itself: an operator of the process of transformation of aspect into prospect, transformation of the simple difference between contraries (A vs. B vs. C) into the differentiation of contradictories (A vs. non-A) that is reserved for the presentation of representation, for its specific reception. The frame as sign and process aims to transform the *infinite* difference of the perceived world (the species of neighboring things) into an *absolute* differentiation in which pictorial representation does not allow any judgment of suitability or unsuitability with respect to what is other than itself, but only a declarative judgment of its presentation as representation through exclusion of anything that is not itself. Pictorial representation is not what is seen *in preference* to something else: it is what cannot not be seen because there is nothing else to see.

Aspect and the difference of contraries are also described by the "gestaltist" distinction between figure and background that defines empirical perceptual reception. Prospect and the differentiation of contradictories define, beyond perceptive reception, a theory of reception *in* representation, by determining a position of the modern subject, thinking and contemplating the world as a theoretical subject of truth.

I should like to move on now from what I have called configurations of the structure of presentation of modern representation—one configuration being the frame—to the figures of that structure of reception, and thus to enter into the very content of painting. And to do this, I shall leave Poussin's letter and painting behind for a while to make a detour by way of Alberti, the Alberti of *De pictura*. Let me recall that, in book 2, Alberti defines the composition of bodies in representation and asserts that all parts of a painting are suited to one another; he links this definition to the *istoria* of which the bodies are parts, an *istoria* that is the painter's masterpiece.

The *istoria*, Alberti explains in effect (to summarize, I am using the lan-

guage of contemporary pragmatics or reception theory), has to be conceived and realized by the painter as a common structure of the painting's action and its viewer's reaction: "The *istoria* will move the soul of the beholder when each man painted there clearly shows the movement of his own soul. . . . We weep with the weeping, laugh with the laughing, and grieve with the grieving. These movements of the soul are made known by movements of the body."[7] Hence the importance of precise observation of these movements on the painter's part. Still, Alberti adds a crucial remark concerning these movements: "All the bodies ought to move according to what is ordered in the *istoria*"[8]—that is, they need to be suited to the subject of the painting. A double requirement is thus formulated here: each of the bodies that make up the *istoria*, each of the movements of these bodies, has to be articulated (1) in terms of the *istoria*, the narrative, and (2) in terms of the narrative's recipient, namely, the viewer. Each of these elements must be suited to the story, and each must arouse in the viewer the movement that animates him: the structure of reception of the *istoria* and its components (the painting's action / the viewer's reaction) is one of the essential dimensions of the structure of composition of the components of the *istoria*. And it is here that Alberti, in his own text, *constructs the figure of that articulation between the structure of reception and the structure of the content* (of the story). The passage is a familiar one:

> In an *istoria* I like to see someone who admonishes and points out to us what is happening there [in the story, the narrative, the painting]: or beckons with his hand to see; or menaces with an angry face and with blazing eyes, so that no one should come near; or shows some danger or marvellous thing there; or invites us to weep or to laugh together with them. Thus whatever the painted persons do among themselves or with the beholder, all is pointed toward ornamenting or teaching the *istoria*.[9]

The figure called the "commentator" is thus indeed the figure of articulation between the structure of reception and the structure of content: it is in a way a metafigure of the reception of representation in representation itself. It is *part of the content represented*; it represents *the reception of that content*; it presents *the relation between the content represented and the structure of reception of that content: it figures the interpretation of the representation*, it figures the signifying potential of the representation. I call it a metafigure in the sense that it figures the presentation of representation in painting. We could in turn make a model of its structure by saying that it articulates *the*

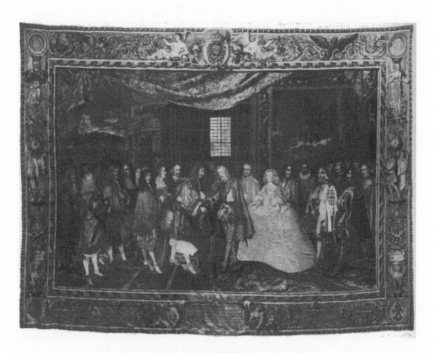

FIGURE 19.2 Charles Le Brun, *Louis XIV and Philip III*. Chateaux de
Versailles et de Trianon, Versailles, France. Photograph courtesy of Giraudon/
Art Resource, New York.

gesture of showing a part (the essential part) *of what is represented and the ges-
ture of looking at the viewer,* and it does so *by a sign of passion,* which is *ac-
tion* (movement) *in relation to what is represented, and reaction* (movement)
in relation to the viewer. Now the operation that we are going to encounter
in Poussin will consist in a transformation of that figure.

But let us put off our return to Poussin and *Manna* a little longer, in or-
der to consider two images for which Le Brun, first painter to the king,
did the drawings, two tapestries in the series called *The History of the King.*

I analyzed the first one in a text published a number of years ago.[10] This
image, to which I have returned on several occasions, seems to me to have
the same paradigmatic value, for a semiology of pictorial representation
and for the history and the epistemology of modern pictorial representa-
tion, as Velasquez's *Las Meninas:* in its stupefying complexity, it simultane-
ously exposes the syntactic and semantic functioning of the representation
of history, its pragmatic power, and also its aporias. I am referring to the ta-

FIGURE 19.3 Charles Le Brun, *The King's Entry into Dunkirk*. Musée des
Beaux-Arts, Blois, France. Photograph courtesy of Giraudon/Art Resource,
New York.

pestry telling the story of the meeting between the kings of France and
Spain in 1660 at the Pyrenees border where the agreement known by the
same name was sealed, in particular by the French king's marriage to the in-
fanta of Spain. In this tapestry, to focus on this single point, we find Le
Brun applying Alberti's recommendations concerning the composition of
the *istoria* and concerning the commentator, a metafigure of reception, but
with a certain number of historically and semiotically interesting variations.

First, we witness a schism within the metafigure of the model com-
mentator as it has just been described: one figure conveys the gesture of
gazing, while another enacts the gesture of showing, pointing out; but
(and this is the second key point) the pairing (as we speak of the pairing
of active and reactive forces in a machine) of the deictic gesture and the
gesture of the gaze is carried out by a "non-sign" of passion, that is, with-
out any need to produce a passionate expression.

Let me describe the image briefly. The two kings are in the middle of a
room hung with two display tapestries, one on either side of a large mirror

that reflects a window outside of the field (but congruent with the plane of representation) and, below the window, the silhouettes of the figures of the two kings. They are bowing toward one another, hands outstretched in a sign of peace. They are followed, respectively, by the French and Spanish delegations, of which ceremonial and diplomatic etiquette governs the composition, the number of members, just as the mechanism of representation governs their arrangement on the stage of the story that Le Brun's tapestry sets up, while at the same time unfolding its narrative. Now it is in the French delegation on the left (in which almost all the figures are portraits), it is in this French delegation—and I stress this point, which is not innocent: we are looking at a French tapestry destined for royal use at Versailles—that we discover the metafigure of reception of narrative representation, but in divided form: (1) one figure—that of Monsieur, the king's brother—whose face is seen in a frontal view and his body in profile, and who is *looking* at the viewer outside the field, but *without any expression of emotion*; (2) one figure who is seen entirely from the back—the only figure appearing on the stage of the story who is totally *anonymous*—who is seen entirely from the back, and who is *pointing* with his finger to the central episode of the meeting. One historical figure *named* the French king's brother looks at the offstage viewer, but with an a-pathetic gaze; one figure, but an *anonymous* one, shows what there is to see.

If the viewer is introduced into the representation by means of the anonymous figure who points as he ascends to the stage, it is by means of the historical figure who looks at him, and merely looks, that the viewer exits from the representation, that he is positioned as a spectator, and merely a spectator: he is not expected to participate emotionally in the king's story except through his gaze, except through his *ad-miration*, which is the passion for knowledge, the passion for the object that is great, extraordinary, marvelous, but that is devoid of corporeal signs (Descartes), and all the more so in a figure that participates in the king's story. To shift attention from the story being staged toward its frame, it suffices to note that the entire mechanism set up here has no purpose *as ornament* except *to conceal what the arrangement of the figures and the composition offer for immediate viewing* (two groups of characters equally distributed around the center of the representation in strict symmetry with respect to its median axis) *in order to offer for reading a political and historical discourse in which the superiority and precedence of the French monarchy are declared.* This is also revealed by the fact that in the specific configuration that frames the representation,

the figures of reception are on the French side in the structure of the content. We should add one more return of the viewer on the French side, not on stage but in the wings of the theatrical stage of the story, in the form of the third figure of the metafigure of reception: the profile on the far left— just as anonymous as the figure seen from the back (the deictic figure)— who merely looks, but from on stage, at the exact height of the profile of the principal Actor of the story: the king. This third figure is not merely incidental: indeed, we shall find him off and on in modern pictorial representation as the *delegate figure*, in the representation, *of the receiver-viewer* of the representation, a representative of "representation-reception."

We shall encounter this figure again right away in another tapestry, *The King's Entry into Dunkirk*, the fifth in the *History of the King* series, which recounts the king's arrival at Dunkirk on December 2, 1662. On a hill at the left, the king is surrounded by his guards and his general staff, among whom we recognize Turenne, the maréchal de Saint-Aignan, and Monsieur, his brother. The king's regiments are heading down the hill and spreading out on the plain; the king is giving them the order to enter Dunkirk, of which we see a very precise topographic view—the background on the right. Let me go straight to the key point: in these circumstances, it is the *king* who is the *actor*, or even the *arch-actor of the narrative represented*. He is the driving force behind the story being told (he gives the order with a commander's *staff*; many eyes are fixed on him); he is the dynamic center of the story under way (thus his figure stands out on the left and in a foreground that is in a dominant situation in the space represented); and at the same time he is a *"commentator" on his own story, his own* narrative. He points out the city to be entered with the deictic gesture (which is both deictic and commanding), and he looks at the offstage viewer of the tapestry—he positions the latter as a witness-viewer of the epic royal "gesture," but he expresses no emotion but the passion for order, for commandment, what I have called elsewhere the *a-pathetic passion* of the absolute monarch.

Two remarks on *the king* as a metafigure of reception:

1. The (scopic) figure of the gaze directed at the viewer is paralleled at the far left by Monsieur, the king's brother, who is also looking at the viewer. Thus there is an *emphasis*, if we may call it that, on the "gazer/gazed at" function, on the spectacular function and effect of the mechanism of representation, as if the viewer were being ordered to look: "Look: look as hard as you can, look at what you will not see again."

2. The king as a metafigure of reception is, as I have suggested, a-

pathetic. He is only *deixis* and *scopsis*, pointer and gaze. In the narrative represented, the deictic gesture is an order; in the structure of reception, it is an indication. In fact, only the figure of the king is at the pinnacle of the action in the narrative represented, in its propositional utterance—the moment at which the order that triggers the movement is given—but, by the same token, he is at rest: that posture is underlined by the way the royal horse is rearing up, quite a different stance from that of the galloping horse nearest the king. The schism here does not lie between two figures of reception who are "responsible" for the gaze and the pointing, but within a single figure.

Finally, to complete the analysis of the figures of reception in this tapestry, we discover—but this time at the far right, included on the stage of the story—the one that the king and Monsieur his brother are looking at outside the field of representation, the *viewer*, in the form of a peasant, seen in profile, clinging to a tree, lifting his hat before the king who is passing by. A physiognomic analysis of the peasant's profile (on the basis of the figures of expression of the passions by the same Le Brun) would come up with *all the "passions" of admiration*: esteem, veneration, even delight and astonishment.

The King's Entry into Dunkirk thus constructs the structure of its own reception through these three figures, in a complex figure or metafigure, at once deictics and gaze, articulating the level of the narrative utterance and that of the narrational enunciation and its diverse modalities, a gaze-figure positioning the viewer as viewer, as witness-gaze, and a figure that, even as it is a narrative figure of the story ("a peasant is watching the king go by") is also, in the story itself, *the figurative projection of the reading that the viewer (already positioned in this role) has to or is supposed to make of it*, or, more precisely still, the representative delegation of the emotional expressive modality of the reading that the viewer is to make of it (namely: admiration, esteem, veneration, delight).

Now we note that the two figures of gazing and reading occupy the edges of the narrative scene of which the complex figure (metafigure) occupies the center. Here we observe once again the effects of frame and framing of the historical representation that configure its reception, but from the standpoint of "anthropomorphic" figures that are an integral part of what the representation represents.

With this remark, we can return to Poussin's *Manna* and to his letter,

which is at once the *protocol for the reception of a painting* and the *explicitation of its structure of reception* (not to be confused with the effects of its viewing). Let us read or reread Poussin's letter:

> Furthermore, if you can remember the first letter I wrote you concerning the movements of the figures which I promised to depict, and if you consider the picture at the same time, I think you will be able to recognize with ease which figures languish, which ones are astonished, which are filled with pity, perform deeds of charity, are in great need, seek consolation, etc. The first seven figures on the left side will *tell* you everything that is *written* here, and all the rest is much to the same effect: study [read] the story and the picture in order to see whether each thing is appropriate to the subject.[11]

As we note in our reading, in a first phase, through descriptive ostentation, the text defines the whole set of emotional figures in the painting, its constitutive elements, the "letters" or "characters"—as Poussin himself says in another text—of the primary code in Iser's sense. For Poussin, this code has a universal validity, since it stems from the level of perception. Nevertheless, the text also refers to the biblical story of the starving Israelites fed by manna. The painting thus belongs to a defined genre of painting, historical painting. Indeed, a painting of history is what Chantelou ordered. With this referential relation to a text outside the picture, an entire sociocultural environment turns out to be constituted on the horizon of the work.

At this point, in Poussin's letter, a quite remarkable movement is initiated: "The first seven figures on the left side will tell you everything that is written here, and all the rest is much to the same effect." In fact, a much more specific strategy of iconic signs is evoked in a way immanent to the representation, a strategy that is set up by the "learned" painter, but that he does not make completely explicit; he simply uses it to set the "interpretive undertaking" in motion. He actually supplies the recipient with the first principles of a possible interpretation; he sets up a "representational trap," a "dummy receiver"; he models and modalizes his receiver. How does he do this?

First of all, he puts the seven figures on the left "in the foreground," in relation to the picture as a whole. This operation pulls them away from their "narrated" context, in which this group constituted the starving Israelites (before help arrived), the narrative figures of the first sequence of the story. After they were selected by the painter, these seven figures be-

come the "narrative matrix" of the entire story; thus they became figures of narration, figures of narrative enunciation. On this basis, they produce or represent the painter who is telling the story, the subject of the enunciation. By the same token, this representation constitutes—through the procedure of selection—the initiation of the strategy of the iconic sign previously mentioned, and of that sign's structure of reception.

Thus even though they are the figures of the first sequence of the story being told, the seven figures on the left inscribe the "scenario" of the story as a whole. The group represents all the figures of representation; it is a metarepresentation that opens up the symbolic level of the reading of the painting. We could try to play the game of producing all the figures of the painting, starting with the seven figures on the left. But what is certain is that at least one of the figures of the group will represent itself, will be reflected, presented, as the narrative representative of its own figure in the story.

Furthermore, the reader-viewer will continue to obey the painter's instructions, which are none other than those of the representation itself, of the narrative structure that is exposed through its figures and through the "double play" of the group on the left.

So why did the painter pick out these seven figures from their representational context? Now we notice a surprising feature that is the *index* of selection or extraction of the group and its "foregrounding": we notice in fact that one mother, instead of suckling her child, is offering her breast to an old woman, an image of a reversal of the natural relation: the mother feeds her mother and not her son.

Now this feature, which indicates and justifies the operation by which the group is displaced from the position it occupies as the first sequence of the narrative into the position of "scenario" of the story as a whole (a symbolic structure of interpretation)—this feature, through reference to the sociocultural context that Poussin and Chantelou shared, also points up the displacement of a famous grouping from ancient history, *Caritas romana*. But here the old mother replaces the old father, the Roman prison has become the Sinai desert, and the ancient pagan space is transformed into a biblical Christian space.

From this point on, and all at once, the entire interpretation "takes," and is achieved with exceptional rigor, a rigor that finds its confirmation, moreover, in Poussin's preoccupations in Rome in 1639 and in the Barberini circle to which he belonged, through his relation to Cassiano dal

Pozzo, in particular. In fact, the *Caritas romana*, through this displacement into the biblical space, becomes *a syncretic exegetic model for the traditional relation between the Old Testament type of manna to its New Testament antitype, the Christian Eucharist.*

The structure of reception is thus constructed here. In a third phase, we can now go back to the observation made earlier that at least one figure presents itself as representing the presentation of the representation, a figure that can thus be defined as the delegate for a spectator who has understood the meaning of the interpretation of the whole.

I am referring to the individual standing at the extreme left of the canvas, contemplating the living tableau of this natural miracle, the *Caritas romana* shifted to the Sinai desert. The first figure on the left in the entire painting, and the first in the group of seven figures on the left, this man, as Le Brun says in a lecture in which he gives his reading of *Manna*, indeed represents a person who is astonished and surprised in admiration: the gesture of his open palm shows this particularly clearly, as does the slight backward movement of his legs and feet. He sees, he contemplates, he admires the *marvel* of a human charity that is admirable only because it transcends the natural order of natural love (the mother for the son) in the devotion and love of the daughter toward her mother. He sees, he contemplates, he admires this act of human charity shown on the stage of the painting in the foreground at left just *as* the viewer will see, contemplate, admire the miracle of divine charity constituted by the falling of manna that is exhibited and staged by the painting as a whole. This figure represents admiration, but he also represents Chantelou, the viewer of the entire painting, even as he shows Chantelou the emotional modality that his gaze on the painting will have, or will be expected to have.

This rigorous construction, at once complex and subtle, would explain, it seems to me, a somewhat mysterious statement by Poussin in a letter to Jacques Stella, written about a year and a half (1637) before the letter we are examining.

> I have found a certain distribution for M. de Chantelou's picture and certain natural attitudes *that make visible*, in the Jewish people, the wretchedness and hunger to which they were reduced and also the joy and gladness in which they find themselves; the admiration they feel, the respect and reverence they have for their lawgiver; there is a mix of women, children, and men of varying ages and temperaments, which will not displease those who are able to *read* them *correctly*, I believe.[12]

The natural postures make the viewer see, but the complex arrangement of the emotional figures, their variety and their variation are a source of aesthetic pleasure only if one knows how to read them: there is thus identification or quasi-identification between knowledge, the condition of a correct (deep) reading, and the pleasure taken in the visual contemplation of the picture. Perhaps we have to go further: just as the entire set of figures in the painting was reflected in the group of the first seven figures on the left so as to constitute the condition of possibility of maximum readability of the picture, that is, the symbolic plane of interpretation of the narrative, in the same way the prospective mechanism (framing and the viewpoint of the eye) turns out to be reflected by the first figure in the group of the first seven figures on the left. This figure, the "delegate of the enunciator-receiver-viewer" of the painting on the narrative stage, shows the viewer, makes it possible for him to see, the emotional affective modality of his gaze on the whole painting, namely, admiration. Or else— and this would be a new relation of reflexivity and exchange instituted between reading and viewing—the figure on the left *makes* the viewer *read* what the correct viewing is (admiration).

This is to indicate the critical function in this painting of the admiring individual who is an "operator" of the reading and viewing of the painting as a whole, the producer of the semiotics of its reception—but of a "potential" reception that will be realized only by those who know how to see *well* and to read *well*, those who are not only familiar with the Exodus narrative, but also with Valerius Maximus and his collection of *exempla*.

"Study [read] the story and the picture in order to see whether each thing is appropriate to the subject." The receiver, the author, the painter, has put in place and uttered a learned and complex mechanism of reception; he has written it down for the reader of his letter and the patron of his painting, its future viewer, to read; but this mechanism has also put the viewer on stage as one of the characters in the play being performed there: it has done so by putting the reader of the letter in the position of a viewer of the painting. Poussin's letter does this three times. First, as an eye whose rays are held in by the frame and not scattered outside, the primitive condition of possibility for the reception of something visible. Next, as a gaze on the picture, a gaze that recognizes a program for painting and verifies its accurate execution. This gaze sees the painting and, in what it is contemplating, it reads what it sees; what is visible is exchanged with what is readable and vice versa. Finally, in a third staging of the reader of the letter as a viewer of the

picture, the reader-viewer becomes the receiver-hearer of a discourse on the narrative figures, a discourse that the painter writing his letter is simply repeating, none other than an epideictic discourse, an admirable demonstration, a marvelous monstration of the painting in its figures. Put on stage as a viewer of the painting, the reader of the letter is also introduced onto the stage of the story as the metafigure of reception who, through an admiring gaze and a gesture of surprise, gives the viewer, that is, himself, both the exact key to the true reading of everything the painting represents by designating the mystery that it does not represent, and the rigorous manner in which the perfect viewing of the painted work is to be carried out. And yet the painter, writing his letter, says nothing of this to his reader: he allows the reader to infer, that is, to anticipate seeing, contemplating, reading the work, and allows him to guess at its highest meaning.

Thus it is that reception, even presented and represented by its signs in the pictorial representation, is defined as a *potential* structure of relatively *indeterminate* representation, even in the case of Poussin, who said about his painting: "I have neglected nothing." Thus it is that this potential structure of indetermination of reception in representation would define, because it is potential, because it is indeterminate, the field of *aesthetic* productivity of modern pictorial representation.

§ 20 On the Margins of Painting: Seeing Voices

> Hypotyposis paints things in such a lively and energetic way that it places them before our eyes, in a sense, and turns a narrative or a description into an image, a painting, or even a living scene.
> —Pierre Fontanier, *Les figures du discours* (1830)

The text that follows will be concerned with a double hypotyposis, for in images and paintings, on the margins of representation, I shall try to capture the brief and mysterious moments in which the voice shows itself to the gaze, in which the painter offers the voice to the eye; but since my text will contain no images or paintings, in short, no illustrations, I shall try to make images and paintings visible by talking about them, so that through the reader's reverie on a written text, and also through the re-membered images that every reading mobilizes, the voice in the margins of a given image or painting can be restored, through this dual and "imaginary" mediation, to the written and read signs that articulate it, silently, in the text. On the one hand, then, an "iconic" hypotyposis will project into what semioticians and linguists call the visual substance of expression the figurative relation that Fontanier characterized in his treatise on rhetoric. Under the circumstances, language—discourse, speech—will not depict things in the "figure of style by imitation" to the extent of making a painting of them; instead, through its own "specific" figures, an image—a painting, a representation in paint—is what will make it possible to hear sounds and noises well enough to hear a voice in them. On the other hand, there is a second hypotyposis, a "critical" one, quite close to the one that our nineteenth-century rhetorician defined, but more complex in its means and more ambitious in its goals. This second one ought indeed to make visible, through its own distinctive features and through its statements in language, the paintings that have been chosen to put the first hypotyposis to work, but by means of this detour and this return, the second hypoty-posis should also make it possible, through the text and its graphemes,

along the margins of the text, to hear what the graphemes dissimulate under the artifacts of speech and discourse: a voice. A voice that I cannot help hearing as the phonic echo of *seeing*; a voice that I cannot help conceptualizing as one of the key notions of *saying*. I am suggesting, then, that to offer voices to view is the peculiar enterprise—and perhaps the crowning achievement of the enterprise—known as representation in painting. To write, to describe this "seeing" of voices: my project in this text is to allow voices to be heard (more by thought than by ear—I am producing a text of theory and criticism, not a poem) as the very substance of "saying."

Let us note that the handful of examples of hypotyposis Pierre Fontanier gives us guarantee, as it were, the convertibility of saying to seeing at the price of a description of the breakdown of speech in sleep, as in this fragment by Boileau:

> . . . La Mollesse oppressée
> Dans sa bouche, à ses mots, sent sa langue glacée,
> Et lasse de parler, succombant sous l'effort,
> Soupire, étend les bras, ferme l'oeil, et s'endort.
>
> [. . . Softness oppressed
> In her mouth, at these words, feels her tongue frozen,
> And tired of speaking, succumbing to the effort,
> Sighs, stretches out her arms, closes her eyes, and falls asleep.][1]

In this breakdown, however, through the figures of elocution by means of consonance, the voice is exposed in the "saying" that allows seeing; speech manifests an iconic performativity, which is enacted in addition by a narrative of the extinction of discourse in the cries of violence and the silence of death. An example occurs in this famous passage by Racine (which I shall cite in full as an exercise in reading as hypotyposis):

> Songe, songe, Céphise, à cette nuit cruelle
> Qui fut pour tout un peuple une nuit éternelle.
> Figure-toi Pyrrhus, les yeux étincelants,
> Entrant à la lueur de nos palais brûlants,
> Sur tous mes frères morts se faisant un passage,
> Et de sang tout couvert échauffant le carnage;
> Songe aux cris des vaincus, songe aux cris des mourants
> Dans la flamme étouffés, sous le fer expirants;
> Peins-toi dans ces horreurs Andromaque éperdue:
> Voilà comme Pyrrhus vint s'offrir à ma vue!

[Think, think, Cephisa, of that night which for
A slaughtered nation ended nevermore;
Imagine Pyrrhus, his eyes aglint with flame
As through our burning palaces he came,
Over my brothers' bodies picked his way
And, drenched with blood, still urged his men to slay;
Hear too the victors' shouts, their victims' cries
Cut short by flame or sword; and let your eyes
Find, in that hell, half-crazed Andromache:
That was how Pyrrhus first appeared to me!][2]

There is probably a great deal one could *say* about the interpellations whose rhythmic symmetries culminate in the "Voilà!" of the last line cited: "Vois là," see there, in your thought, in your imagination. . . . See, there, Pyrrhus offering himself "to my sight" . . . Pyrrhus is the offering of a vision, precisely the one created for Cephisa by Andromaque's speech, precisely the vision of a *phantasia* created by Racine for his viewer-reader through the apostrophic "Figure-toi! Peins-toi!" The dream of the cries of the vanquished and the dying gives way to the silence achieved in the final *"painting,"* that of a distraught Andromaque with Pyrrhus suddenly coming into her view. It is clear that the performativity of telling in vision seems to require complex iterations between utterances and the act of enunciation, between the substance and the form of expression on the one hand, between the substance and the form of content on the other, effects of familiarity and knowledge, finally, along with affects of pathos.

Some twenty years before Racine's *Andromaque*, Poussin had evoked the convertibility between saying and seeing in an explicitly theoretical letter (he uses the term *grande théorie*) written to his client and friend Chantelou on November 24, 1647. It seems that Chantelou had reproached the painter for neglecting him in favor of M. Pointel.

If you feel affection for the picture of *Moses Found in the Waters of the Nile*, which belongs to M. Pointel, is that a proof that I made it more lovingly than I did yours? Do you not see that, along with your own disposition, in the nature of the subject lies the cause of this effect, and that the subjects which I am treating for you [the *Seven Sacraments*] have to be done in a different manner?[3]

Poussin is playing on the visual effects of historical painting on the eye, and its affects for the gaze, between two references, one to music and the other to poetry. On the one hand, he situates the pictorial practice of the

theory of musical modes, on the other, that of the poetics of the "sound of the words," which is where I would like the voice to be recognized:

> The good poets used great care and marvellous artifice in order to fit the words to the verses and to dispose the feet in accordance with the usage of speech, as Virgil did throughout his poem, where he fits the sound of the verse itself to all his three manners of speaking with such skill that he really seems to place the things of which he speaks before your eyes by means of the sound of the words, with the result that, in the portions where he speaks of love, one finds that he has skillfully chosen such words as are sweet, pleasant and very delightful to hear; whereas, if he sings of a feat of arms or describes a naval battle or a storm, he chooses hard, rasping, harsh words, so that when one hears or pronounces them, they produce a feeling of fear. Therefore, if I had made you a picture in which such a style were adhered to, you would imagine that I did not like you.[4]

My project here consists of displacing into the field of painting itself the analogy between painting, music, and poetry that Poussin suggests to Chantelou. It is not so much a matter of interrogating the work of painting in order to identify the features in it that are the equivalent of the "Dorian mode, stable, grave, and severe," the Lydian mode, which "lends itself to tragic subjects," or the Hypolidian,[5] which "contains a certain suavity and sweetness," features that would correspond to the various accommodations of the words to the lines of verse in a pastoral, bucolic, or epic poem; it is rather a matter of inquiring how, by what means, and within what limits pictorial representation, with its specific medium, on the margins or at the peaks of its enterprise, offers to view precisely what Poussin calls, with reference to Virgil, the sound of words, that is, a certain intermediate substance connecting noise, cry, sound, and meaningful articulation or discourse. This first conversion of saying to seeing can only be thinkable, intelligible, "showable," if a second conversion also is found there, that is, if the *phantasia* of voice in painting is performed in a telling that allows it to be heard. Let there be no misunderstanding on this point: the double conversion, a new version of the double hypotyposis mentioned earlier, is, in its very marginality, in relation to representation in painting and in terms of discourse *on* painting, the central kernel of a "discourse" *of* painting and of the painted work; it would constitute a possible approach to reflection about the basis for that discourse.

The voice may be found in the margins of a painted picture; in a place,

at the edge of the painting and of the space represented in it, where repetitions proliferate in a sort of slippage of the visual and figural aspects that gives rise to rhythms and flux. "In art, in painting, and in music, it is not a question of reproducing or inventing forms, but of capturing forces. This is even the reason why no art is figurative. . . . The task of painting is defined as the attempt to make visible forces that cannot be seen. In the same way, music strives to make sound of forces that are not sonorous."[6] Let us forge ahead and make a further shift. The task of painting is an attempt to make the force of the voice visible: so be it, but only if the term "visible" is understood as what is capable of viewing (of seeing and of being seen); what is potentially vision, a *virtuality*, that is, a possibility and a *virtus*, a force.

Here is a little painting by Paul Klee that will remain, in this place of writing, invisible: a painting that will exist *here* only as a virtual *source* of descriptions. And first of all through its title, given to the work by its painter, received from the work by its painter, a title in Latin that is its first description, *Ad marginem*, at the margin, toward the margin, which I am eager to understand as "toward the margin of representation in painting, the voice."

Margo, inis, Latin for "edge, border, boundary, frontier, bank": the word is found in Livy, Ovid, Juvenal, Valerius Maximus, and especially in Vitruvius, in the last chapter of book 5 of his treatise on architecture, which deals with ports and underwater masonry.

This little painting from the museum in Basel (46 cm. x 35 cm.) will allow us, if not to answer the questions I have raised *in limine, ad marginem* of this article, then at least to circumscribe some of their edges or margins. Will Grohmann writes the following in his commentary: "*Ad Marginem* . . . looks like an old document with the dominant red planet in the center on a field of weathered green. The ghostly writing is scattered along the margins as in a child's drawing; included are plantlike hieroglyphics, a bird, fragments of figures, and letters of the alphabet—a diploma from the realm of Nature."[7]

The writing's formal elements—scattered, it is true, along the *edges* of the painting, on its margins, but precisely supported by them—are those of a refined, precious vegetation, graminaceae and umbelliferae, more abundant on one side than on the other three: a rare profusion of objects, embracing a dispersal of the gaze that corresponds to the dispersal of these botanical figures. But the gaze is continually recentered by the central red disk en-

dowed with dark rays that trace a sort of cruciform nocturnal aura on the green background. The gaze hesitates on the other edge of the painting that is its background: does that "aura" belong to the red planet—"figure"—or to the "surface-background" of the *tavola*? The gaze hesitates, too, in seeking the source of the dark rays: do they come from the red sun, through an intensification of its boundaries, or from a star that the sun is hiding in a sort of inverted eclipse?

But has there ever been, in nature, a bird capable of walking along an edge, upside down, even if only as a silhouette, a bird reduced to its simplest expression, a bird "sign," a hieroglyphic, as Grohmann says? But were even hieroglyphics or pictograms ever written like this, upside down? Yes, probably, if the gaze seeks to read correctly, appropriately, the four alphabetic letters written on its edges correctly: "v" near the upper edge, "r" on the left side, "l" on the right, "u" in the lower margin. Two of these, "u" and "l," are enclosed in a cartouche; "r" and "v" are in a free state, written on the edges of a support structure that is none other than that of the painting. Three consonants, one vowel: the central "u" in the lower margin responds with its vowel voice to the "v" in the upper margin, "v" so close graphically to "u" but condemned, as a consonant, to being sounded with its vowel "u"-"vu." The same is true for the "r" and the "l": "r-u," "u-l."

In the margin of the painting, among the aquatic plants, there is thus *a voice* underneath the graphic signs that represent it, amid the hieroglyphics and pictograms that belong to a language that is Klee's own—the voice of a vowel, or rather a vowel from a voice absent from the painting: the "u" that allows the other three letters to be spoken, pronounced, proffered: "vu, lu, ru," or "uv, ur, ul," in the margin of the underlying phonic code, "rul, vur, vul": "lur, vlu, lurv, vlur," and so on. Here, then, the gaze traverses the painting's margin in all directions, in search of a direction, a meaning, turning in a circle (or rather in a rectangle) around the central red circle: "ulvr, lvru, vrul, rulv" . . . or in the other direction.

Thanks to this trajectory, the bird walks properly on its feet, not upside down, in its margin; but then—surprise!—the "u" becomes an "n," while its three consonant companions become the signs of an indecipherable script. Here we find ourselves relegated—the better to see—to the most extreme margin of the voice. One more turn and the "u" is transformed into an inverted "z," the "r" into a plant, the "v" into an insect, and the "l" into an ornament. This quest for meaning is located in every sense in the margin of the voice, in the margin of the picture, between a vowel sign

and consonant signs that represent it to the eye and to hearing; if it is going to bear fruit, I have to be able either to make the picture pivot around its red center, or else to shift my own position around it, for example by putting it on the ground; and its margins then become the rims of a four-cornered well where, in the greenish water at the bottom, a strange red plant is reflected and captured, unless it is rising out of the depths, just exactly where my face is leaning over the edge, just exactly where my eye is looking at *itself* and discovering itself in the form of a dark-rayed star: this conversion of eye and star makes for a stupefying displacement of the primordial Narcissus that lies behind every representation.

In the museum, though, just try turning the painting on its rail or putting it on the ground and contemplating it from above! The invisible, inaudible "voice" in the painting's margin between a "u" and three consonants induces a tremor in the institutional monument. It indicates, though it in no way signifies, that for it there is neither top nor bottom, neither right nor left, or rather that every edge, every margin, is by turns top and bottom, right and left: the four possible positions of the painting correspond to four possible positions of the body; virtual paintings in the margin, one painting. . . . In the margin of the voice, there is a visual *signans* allowing the voice to be heard in a vowel and some consonants, and in search of meaning, in the margin of the panel, there are gazes that simultaneously read and see, gazes conveyed by gestures and postures, locations and positions and attitudes of the body; and all this is induced by a quest for signification, which is itself spurred by four letters scattered in the margins, by the voice in a sign read as "u" (or an inverted "n" or "z").

To show that this is indeed the case, I believe one last sign will suffice: under the "u," there is a black comma, like the sound hole of a violin, inscribed on the figure of a horn or a trunk, an incongruous sound hole here, but one that doubtless has no meaning except as it is addressed to the gaze that is reading the "u" sign: "Make the painted signs sound, make them resound, and first of all this u": and, from the trunk, three flowers emerge, geometric plants, to end up in this corner, where two eyes are looking at me: the sound hole, an opening carved into the belly of the instrument that helps augment the sound, the voice of "u" thus augmented *per-sonat*; it produces a gaze in the margin of the picture, between visual and figural, the gaze of the picture that is looking at me, as Paul Klee also wrote: a surprising, humorous return or reversal of the subject of representation in a voice, that of an absent telling.

Klee's painting *Ad Marginem* is thus a small, "theoretical" object that uses its margins to interrogate what I have called relations of convertibility between saying and seeing, relations that, in this place in the picture (the margins, the edges, the internal framing) trace in absentia, in an interval, a (common?) virtuality of speech and vision: margins of the system of graphic signs, edges of the conventionality of linguistic signs, frontiers of figurativity offered to the gaze, a framing of representation, borders of the pleasures of mimesis.

What does it mean to represent the voice silently? How can the unrepresentable breath of signs be represented pictorially, if not by means of the margins of a picture, by means of its edges, where all representation then escapes from itself, leaving in the structural *center* of the work only the trace of its withdrawal in the figure of the eclipse of a circular star with dark rays?

A first margin, a first edge: the graphic sign, the visible grapheme of the voice in the vocalic phenomenon—the vowel—where the voice is specified in opposition to the other vocalic or consonantal phonemes that belong to a particular system, a given linguistic idiom.

But there is a second margin, a second edge: the inscription of the graphic sign in representation in painting induces deviant, displaced meaning effects (or non-meaning effects): I am referring not to the effects that stem from the phonological system to which the graphic sign of the phoneme belongs, but instead to effects that shift both the voice and its signs toward figures or motifs of visual representation and that shift the picture, conversely, with its figures and its backgrounds, toward a complex pictorial-musical score for voice and images, but one in which the voice would be manifested in the syncopes of the figurative mechanism, the signs that mark space between the figures and the inscriptions.

This is the case in Poussin's *Arcadian Shepherds* (Louvre): silent dialogue, mute poetry, painting. Three figures, a "shepherdess" on the right and two "shepherds" on the left, exchange gestures and glances in relation to a fourth figure, who has one knee on the ground in front of a forsaken tomb that looks like some strange ruin in a desolate countryside. Words do not fly from mouths to ears: instead, we see one pointing gesture and three gazes, *visibilia*, the minimal alphabet of the language of painting. In that interweaving of gestures and gazes, we note that the shepherd leaning on the tomb at the viewer's left has no connection to the two people to the right of the one he is looking at. His gaze makes him visible, as his com-

rade on the right points him out and thus offers him to the gaze of the "shepherdess." By combining pointing and a gaze, the gesture toward the kneeling figure and the gaze toward the woman standing beside him, this figure conveys—between showing and looking—a question engendered by the double play of the gesture's destination and that of the gaze: "I am showing *him to you* since I am looking at *you* while pointing to *him* and since I am not looking at *him*." Hence the question: "Do *you* know what he is doing, the person I am pointing out to you?"—a silent question, a mute question, between gesture and gaze.

This is the point at which the voice can emerge for the eye's hearing. One of the "shepherds" in the center is kneeling in front of the tomb, on whose wall a few words are engraved: "Et in Arcadio ego"—attitude, posture, gesture: this is the figure who is being silently questioned by the others. He seems to be deciphering; letter by letter, with his mouth open, he is spelling out this inscription—perhaps written in a language he does not know—in order to decode it: now, through what I shall call a *visual effect of planes*, it is just as if, before my gaze, the words inscribed in the blind and deaf stone of the tomb seemed to come out one by one, letter by letter, from the shepherd's open mouth, and to engrave themselves on the stone as they are proffered, as if the *breath of the voice had the power, the virtus, of being visible to the eye and readable to the gaze*. The visual effect of planes: what does that mean? In the space constructed in the representation, the tomb is in front of the kneeling shepherd: for my gaze, which is undertaking to synthesize this space from its own point of view, the tomb is behind him, sufficiently close nevertheless for him to be able, in this space, to touch the wall with his index finger. But *in the plane of the representation*, on that abstract and transparent surface whose diaphanousness my gaze traverses to bring back together and read the appearances figured on their stage, in that plane, on that surface, *suddenly*, the profiled head of the kneeling shepherd is projected without any break in continuity onto a different surface, namely, the stone wall. And it is at this point, in this infinitely slender interval, in this infinitesimal interstice, between two figures in the plane, that the voice-of-a-telling is added to the seeing, a voice that we might take as the origin of what is said, "Et in Arcadia ego," if the saying of what is said had not always already preceded it and if the voice that conveys it were only a *visual effect of planes* in the plane of representation, an effect for the gaze and the eye. It could well be, however, that that effect carries Poussin's mysterious work to its highest meaning.

We could find this same effect in a painting by Klee in the Basel museum, a painting the painter called *Villa R* (1918), in which the grapheme R inscribes its downstroke like an anthropomorphic enjambment, visually deviant in relation to the road that is thrusting itself toward the back of the landscape, like a sign on the march, but departing from the path traced out for it in depth in the painting: the R's wandering brings the entire picture back toward the surface *plane* of representation, which *derealizes* the illusory third dimension that has been constructed according to the rules—and yet R is the initial letter of *Raum, room: space*—and makes the work as a whole a *surface* on which pictograms have been inscribed.

Hence we find a third margin of painting and of the voice, in the interval of edges of the visual and the figural where the voice is virtually present to sight, not only by virtue of its signs or its notes, but by virtue of the play of all the instruments that allow it to be manifested in cries, words, or songs: the human body, first of all, and, in the body, the gaping hole of the mouth. Poussin's *Massacre of the Innocents* (Musée Condé, in Chantilly) could without hesitation be taken, well in advance of Munch's celebrated work, as *one of the most extraordinary pictorial representations of a scream*. Nevertheless, the extreme intensity of the voice that is manifested in it has less to do with the wide-open mouth of the mother whom the soldier is pulling back by the hair than with the construction of a complex formal, plastic, and figurative mechanism: the ellipsis formed by two arms, the soldier's and the woman's, in which the two heads are the circles at the extremities and their open mouths, one in shadow, the other in the light, are the centers, an ellipsis taken up again and shifted into that of the soldier's red cloak, an exasperated double figure, caught up in the regular counterpoint scansion of the temple columns in the background being traversed by the woman in the middle ground, her head thrown back and her mouth open (a figure modeled on an ancient bacchante). But the intensity of the scream, the voice in its most extreme register, is visually "noted" by the tip of the raised sword, and even more by the obelisk in the background directly over the woman's head: the point of their intersection is empty in inverse proportion to the high-pitched note of the scream, counterbalanced by the unrealistic lengthening of the woman's arm, which gives a visual indication of an unbearable duration.

Here I ought to summon up all the mouths in painting, mouths wide open on a scream, all the mouths murmuring or whispering in inaudible voices into someone's ears, but by that very token trying to accede to the

virtuality of *visibilia*, by the play of gaps and intervals, the play of the syncopes of invisibility that sometimes traverse a painting. As an example of this play, chosen among all the paintings of St. Jerome or of St. Matthew with the angel, let us take Vouet's, in which the divine voice is represented as coming into the human writing—the writing already inscribed in the Bible or the Gospels—that it inspires. This transposition is conveyed both by the arrangement of the figures and by the shadow that buries the head of the voice-bearing messenger.

In the margin of the voice, then, we encounter all these musical, vocal, linguistic bodies, whose signs are visually representable and in which the voice has the *potential* to realize itself by specifying itself: these signs await only the gazes that will rest on them in order for the voice they manifest to awaken virtually—and perhaps to be heard.

I also need to add something that might be a fourth margin of the voice, although internal to it: the voice is not speech, and yet there is no living speech without a voice—the relation is one of substance and expression. As Furetière defined it in his late-seventeenth-century *Dictionnaire universel*, the voice is "the air struck and modified that forms various sounds"; it is "the sound produced by the human larynx"; it is song, that is, "the modification of speech insofar as it has a relation with music."[8] Thus the voice, the sound of words, is not only sound, nor must it too quickly be understood as meaning; it is to be placed in the always-open and always-closed-again gap *between* sound and meaning. As sound, the voice will never be merely an ornament of speech, since it will never be merely sound. This margin, which is a schism of the voice between sound and meaning, always a schism, almost always sutured by the use of language in speech, nevertheless makes available to all the discourses on language and speech the immense field of reflection on the powers of discourse and particularly of elocution and action, *lexis* and *hypocrisis*, in which the rules and the artifices of the first appear to be the genetic fulfillment of the "natural" expressiveness of the second. Now, it is this field of oratorical elocution and action that is meditated on, displaced, and transposed by painters, and especially by the discourse of and on painting.

The internal margin of the voice in the sound of words is in a way taken up again theoretically in the musical and rhetorico-poetic analogy used by painters and theoreticians of painting who aim not simply to describe the pathetic variations of the painted picture metaphorically or to explain them comparatively, but to produce the *science* of these variations

on a theoretical level. This is what Poussin was doing in his letter to Chantelou on musical modes and the sound of words, a letter intended to make clear to Chantelou what makes up the diversity of the expressive effects of *one* painted picture in its relation to *the* paintings constitutive of a specific group of works constructed by the painter. This science of pathetic and expressive variations ("I do not always sing on the same notes. . . . I know how to vary them when I wish") does not merely concern the representation of the figures' postures and attitudes, their gestures, which actually form, as Poussin also points out, the elements of an alphabet, whose hierarchically ordered combination ends up indeed representing the story to be painted, but also the arrangement of light and shadow and color, the construction of the represented space, and so on. Iconic hypotyposis corresponds to poetic hypotyposis. The sound of the words puts a storm or an epic battle before the eyes of the poem's hearer. The painter puts the things he represents before the viewer's eyes in such a marvelous fashion—as Poussin would say—that a voice seems to be heard in the painting: the voice *of* the painting, perhaps.

It is clear by now that the margins for the voice in representation in painting do not have to do in the first place, either directly or indirectly, with the visualization of an oral sequence articulated in words and sentences, whether we are dealing with scrolls, with *written* banners in a given location in the painted work, or with the arrangement of the figures on the representational stage in such a way that, for every informed viewer, the moment represented is the one in which a given sentence or formula was pronounced—so that an utterance in living speech should be posited as a point of reference, both invisible and auditorily unmistakable, for the representation. The margins for the voice instead involve the simultaneously deeper and more complex plane to which Klee's painting has introduced us, that of a transcendence of the voice in relation to speech (a transcendence signified by the vowel "u" in the margin of the painting), but that the painting would offer up for listening, for hearing above or below the words potentially heard, or actually read, in the painted representation.

Thus in Champaigne's *John the Baptist* in the Grenoble museum I can *read*, on the scroll that is wound around the cross carried by the saint, fragments of the words he is uttering while *looking* straight into my eyes and while designating with his outstretched arm the silhouette of Christ on the left, at the rear: "Ecce Agnus Dei qui tollit peccatum mundi." The gesture

and gaze of the John the Baptist figure, and even the expression on his face, are exact translations of the statement *written* on the scroll, and partially readable, which John the Baptist, "his mouth half-open," is *in the process* of proffering to me, to my gaze as viewer. But is this the voice of the statement that would find its translation in the picture exactly and as it were *literally*, the picture then being a historical painting, illustrating a narrative sequence from the Gospel? "Voice is used figuratively in spiritual and moral matters," Furetière writes; as, for example, in "the pastor's voice . . . God's voice."[9] In fact, God's voice, by way of his last prophet, is understood—heard—pictorially through the formula "Ecce Agnus Dei. . . . "

To grasp this, we need only compare Champaigne's painting with the work of Domenico Zampieri, which Stendhal admired. Domenico paints a narrative representation in which he has no need to write the words spoken by the Baptist on a scroll so that viewers will hear them when they look at them: he *addresses* the disciples, he speaks to them, he *says to them*: "Ecce Agnus Dei . . . ," in reply to the question that the disciples ask him and that viewers, who know the story because they have read it, see and read in the image. Even the prophet's metaphor is included in an image in the form of the lamb at his feet and in the form of the angel "of God" in the upper left-hand part of the painting, which one of the disciples is contemplating. On the contrary, in Champaigne, the saint is looking at the viewer; the picture presents him head on and cut off at the knees, moreover, by the frame. By means of his gaze and his half-open mouth, he is speaking to the viewer (and not to the disciples, as in the story) and, from this point on, the words written on the scroll, which seventeenth-century French viewers knew by heart and did not need to read in the picture in order to hear them while looking at it, have a quite different function from that of informing. They "consecrate" the picture as a pious, devotional image, between historical representation and relic (or amulet), as a "sacred object" (hence the somewhat archaic value of the phylactery). The spectator must hear the divine voice in himself and in an entirely spiritual way, the voice of grace, of which words articulated and proffered in human language at some specific moment in sacred history have never been anything but the translation in time (cf. St. Augustine in the *Confessions*). That is why Champaigne does not hesitate to veil the arm of the Baptist in shadow, the deictic arm, the one that is pointing out the very Truth that is to come. His arm and index finger designate, but in a veiled way. He shows "obscurely." Thus, reading only these words "Ecce Agnus / pec-

catum" on the phylactery, viewers looking at the painting will begin to
hear the ineffable, inaudible divine Voice murmuring within themselves,
covered over as it is by the world's noise and chatter.

To complete this exploration of the margins of representations in paint-
ing where the voice of saying comes to meet the seeing of the gaze, I
should like to use the most powerful of poetic hypotyposes to bring a very
great work into discourse, a work itself conceived in a margin or as a mar-
gin because it crowned a polyptych, Piero della Francesca's *Annunciation*,
known as the Annunciation of the altarpiece of St. Anthony of Perugia, in
which the voice conquers the virtuality of its presence, between eye and
gaze, ear and understanding.

The kneeling angel, his hands crossed on his chest, faces the Virgin who
stands with her head bowed, her eyes downcast: noble and silent adora-
tion on the one hand, humble and mute acceptance on the other. All the
words of the Annunciation have been pronounced and in particular those
of the angel: "The Holy Spirit will come upon you, and the power of the
Most High will overshadow you; therefore the child to be born (of you)
will be holy; he will be called Son of God." To which Mary replied: "Here
I am, the servant of the Lord; let it be with me according to your word"
(Luke 1:35, 38). Hence the attitudes and gestures of the protagonists of the
encounter: the angel in adoration before the Son of God *already within*
the Virgin's womb, for the power of the Most High is bursting forth in the
upper part of the panel with the divine dove and the rays of the Father's
glory; hence, too, the Virgin as handmaiden of the Lord, accepting the
word. There is thus a silence of adoration and obedience in the mysteri-
ous moment of the virginal conception. The viewer, the believer, contem-
plates the encounter.

And yet *in the painted representation* that Piero della Francesca con-
structs, and more specifically *in the construction of the space represented*, of
which he gives the generative working drawing, while investing it with a
radiant architecture, and by the *location of the figures* that he arranges in it,
the painter offers to be seen, or rather to be conceived (to be seen mentally)
the transcendence of the divine Voice (figured by the angel) and the mirac-
ulous performance of its effect (figured also by the dove in the golden rays):
he offers for viewing and conception the double invisibility of the Voice (as
transcendence and miracle) *by making the angel and the Virgin invisible to
each other.* As has already been observed, if we sketch out the scenic archi-

tecture at ground level, we find that the angel cannot see the Virgin because she is hidden by the twin columns that support the middle part of the double arch of the small open structure where Mary is standing. And Mary has only been able to hear the voice of the annunciatory angel. For Mary, the angel has never been anything but an invisible voice, and Mary, for the angel, a hidden body. On the contrary, *visually*, irresistibly, the perceptive eye of the viewer cannot keep from seeing that the angel sees the Virgin, that the latter is visible to the angel who is looking at her. Thus in this schism between what is offered to view and what is constructed for understanding, between the perceptive eye that appropriates the beautiful appearances and the intelligible gaze that is contemplating the real essences, through that in-between that hollows out the very space of presentation, that in-between position from which I myself, as viewer, look, through this schism between visual and figural, the voice accedes to seeing, and the unheard to listening, perceptible only to the eye and ear of the soul. The representation, by its very construction, constitutes this eye and this ear in the invisibility of the Voice in the margins of the picture, beyond its edge, and in its intervals and syncopes, a voice that Piero della Francesca offers sumptuously to view at the pinnacle of the polyptych of St. Anthony.

§ 21 The Frame of Representation and Some of Its Figures

In art theory as in the art of describing, it is probably useful to begin by recalling certain elements of the philosophical context in which the problematics of representation in painting has been constructed and the problems of framing have arisen: in a foreword, it seems appropriate, without getting caught in a vicious circle, to set up the philosophical framework for the framing of pictorial representation.

We find in Furetière's late-seventeenth-century *Dictionnaire universel*, under the verb *représenter*, "to represent," a fruitful tension that permeates the meaning of the term. "To represent" signifies first of all to substitute something present for something absent (which is of course the most general structure of signs). This type of substitution is, as we know, governed by a mimetic economy: it is authorized by a postulated similarity between the present thing and the absent thing.[1] But in other respects, to represent means to show, to exhibit something present. In this case, the very act of presenting constructs the identity of what is represented, identifies the thing represented as such.[2] On the one hand, then, a mimetic operation between presence and absence allows the entity that is present to function in the place of the absent one. On the other hand, a spectacular operation, a self-presentation, constitutes an identity and a property by giving the representation legitimate value.[3]

In other words, to represent means to present oneself representing something. Every representation, every representational sign, every signifying process thus includes two dimensions, which I am in the habit of calling, in the first case, reflexive—to present oneself—and, in the second case, transitive—to represent something. These two dimensions come quite

close to what contemporary semantics and pragmatics have conceptualized as the opacity and the transparency of the representational sign.[4]

While exploring the relations between these two dimensions, between reflexivity with a subject effect and transitivity with an object effect, in one of the most remarkable developments of the theory of the representation-sign, the seventeenth-century Port-Royal *Logic*,[5] and in connection with maps and portraits,[6] the two paradigmatic examples of signs for logicians of that era, I encountered frames, the operators and processes of positioning and framing, and their figures, among the mechanisms that every representation includes in order to present itself in its function, its functioning, and, indeed, its functionality as representation. The more the transitive dimension presses its claims powerfully, the more that "mimetic" transparency is manifested seductively, the more the games and pleasures of substitution occupy the attention of the gaze powerfully and captivate its desire,[7] the less the mechanisms are noticed, the less they are acknowledged by descriptive discourse on painting.

These presentation mechanisms seem to be self-evident; as Yves Michaud observed in a text written some time ago,[8] the painting of frame or decor is not seen, not discussed. So I propose to rescue three mechanisms for presenting representation in painting from their oblivion or misrecognition and bring them back into the foreground of theoretical attention and of the descriptive gaze: the background, the plane, and the frame. Properly understood, these three mechanisms constitute the general framework for representation, its boundaries, closure, as we were given to saying a decade ago.

The material underpinnings and the surface used for inscription and figuration—the background, by means of which every figure is made available to the gaze—can be looked at in terms of its relations with the other figures and in terms of its potential for reference.[9] The presence of this background is denied by the illusory depth created by the prospective apparatus that hollows it out, into the far distance,[10] all the way to infinity, an infinity represented in painting by the atmospheric work of the horizon,[11] a limit pushed toward the limitless.[12] This is the case with Claude's *Port Scene with the Embarcation of Cleopatra for Tarsus*, or Rembrandt's *Landscape with a Bridge*. Conversely, if we proceed a little further along the limit by means of which a surface "frames" a representation in its background, we shall find the background being thrust forward by a relative neutralization of depth and a negation of all figures or represented entities in the far distance; the backdrop surfaces as a wall or partition, as a black or gray surface. The back-

ground appears as surface, and it is at this point that a painting presents itself as a painting, presents itself less as representing something than as a representation. Let us take for example the black background in the *Vanitas* attributed to Champaigne; the discourse describing this background can say nothing except that it represents nothing, at the very moment when the gaze discovers that it is this nothing that gives the figures in *Vanitas* their compelling force.[13] Or there is the famous *Ex-voto* done in 1662 by the same Champaigne, in which, without any break in continuity between the corner of the cell, which hollows out the represented space in which the painter's daughter is miraculously healed, and the support of an inscription that makes of the representation an ex-voto, the background loses its feigned depth as an "image" to become the written surface of a prayer.[14]

The plane of representation, the second element in the positioning of a representation, is at work "all over," from edge to edge, from left to right, from top to bottom, encompassing the entire painting; this element is all the easier to forget in that it is entirely transparent. It is the fourth, "frontal" wall of the scenographic cube, the one that Michael Fried evokes in connection with Diderot, who asked us to imagine it closed, on the stage, so that the figures in the narrative would behave as if they were unseen, as if, in the process of representing and in the representation, they were wholly present to their own acts[15]—for example, in paintings by Greuze in which no external gaze crosses that invisible boundary and distracts the figures from their functions. Unless, conversely, this frame plane appears obliquely to the eye owing to the excess that is deposited there by a drop of water on a trompe-l'oeil or a fly in a still life,[16] an excess that is pointed up by the slightly obscene cucumber in Crivelli's *Annunciation*.[17] And we can see how, in comparison, in Champaigne's *Ex-voto*, the written surface plays, undecidably, between the surface-background and the representation-plane.

Finally, there is the frame: edge and rim, frontier and limit.[18] Among the various mechanisms that surround and present representations, I propose to focus primarily on the frame. *Cadre, cornice,* frame: the three languages seem to cooperate in exchanging the same words and significations to sketch in the problematics of the frame, of positioning and framing: the frame as *cadre* signifies the border of wood or other material within which one places a painting. To Mme de Sévigné, who writes: "I do not advise you to put a frame around that painting," Rousseau replies, through the intermediary of a dictionary, "On the . . . crudest . . . drawings I put quite brilliant, well-gilded frames."[19] Although the etymological meaning of the

FIGURE 21.1 Carlo Crivelli, *The Annunciation* (detail). National Gallery, London, Great Britain. Reproduced by courtesy of the Trustees, The National Gallery, London. Photograph courtesy of Alinari/Art Resource, New York.

word *cadre* is *carré*, "square," we also speak of round or oval *cadres*. The French term thus emphasizes the notion of edge: the *cadre* ornaments the extreme limit of the geometrically cut-out surface of the canvas.

With *cornice*, on the other hand, Italian has adopted an architectural term: the projection that extends outward around a building to protect its base from rain; a protruding molding that crowns all sorts of works, especially friezes on entablatures in the classical Greek orders; the values of ornamentation and protection, the notions of momentousness [*prégnance*] and projection are played out in this term.[20]

The English term "frame" points instead to a structural element in the construction of a painting, the latter being understood less as representation or image than as canvas. A frame is a stretcher that extends the canvas so it will be suited for receiving pigments. Rather than an edge or a border, rather than an ornament for a painting's outer limits, it is the substructure of the support mechanism and of the surface of representation.[21]

The artifact of the frame thus displays a remarkable polysemy, between supplement and complement, gratuitous ornament and necessary mechanism. As Poussin wrote to Chantelou when he sent him *The Israelites Gathering the Manna*:

> When you receive [your picture], I beg of you, if you like it, to provide it with a small frame [l'*orner* d'un peu de corniche]; it *needs one* so that, in considering it in all its parts, the [rays of the] eye shall remain concentrated, and not dispersed beyond the limits of the picture by receiving impressions [?] of objects which, seen pell-mell with the painted objects, confuse the light.[22]

In a word, the frame is a necessary *parergon*, a constitutive supplement. It autonomizes the work within the visible space;[23] it puts the representation in a state of exclusive presence; it gives the appropriate definition of the conditions for the visual reception and contemplation of the representation as such. If we analyze Poussin's advice to Chantelou carefully (although we could find identical advice in treatises on painting),[24] we find that the frame transforms the varied play of perceptible diversity, the raw material of the perceptual syntheses of recognition of the things that articulate them by way of differences, into an opposition in which representation is identified as such through the exclusion of all other objects from the field of the gaze.[25] By virtue of its frame, the painting is not simply offered, among other things, to view: it becomes an object of contemplation. In their representation on Claude's canvas, or Poussin's, the things that had simply animated the space of the world with their differences—trees and the sky, a palace and clouds, a lake and its boats—become a landscape to be contemplated,[26] an ideal, pastoral, heroic landscape, excluding the species of neighboring objects, as Poussin says, through the power of its margins and its edges, a power acquired by its frame. Here, the world is wholly contained; outside this space, there is nothing to contemplate. The representative construction has become autonomous, has taken on a different aspect, has become a simple perceptual apprehension of things in prospect, a function of reason, as Poussin also says,[27] a modi-

FIGURE 21.2 Charles Le Brun, *Louis XIV Receives Count Fuentes.* Chateaux de Versailles et de Trianon, Versailles, France. Photograph courtesy of Giraudon/Art Resource, New York.

fication, a modalization of the gaze. There, we say, we looked at the world, at nature; here, we are contemplating the work of art alone. I hardly need add that this operation of framing and positioning will itself be invested with powers, modalized by institutions, remarked by agencies of economic, social, and ideological determination.[28] Representation, in its reflexive dimension, presents itself to someone. Representational presentation is caught up in the dialogic structure of sender and receiver, whoever they may be, whom the frame will provide with one of the privileged places for "making known," "inducing belief," "making felt," as a place for the instructions and injunctions that the power of representation, and in representation, addresses to the reader-viewer.[29]

This is how we enter the world of the figures of the frame and of framing. The figures of ostentation first, the ornamental figures on the edges, flowers and fruit, weaving borders with their symmetries and their calculated repetitions.[30] In its pure operation, the frame displays; it is a deictic, an iconic "demonstrative": "this." The figures ornamenting the edges "insist" on pointing out, they amplify the gesture of pointing: *deixis* becomes

epideixis, monstration becomes de-monstration, the historical narrative represented becomes a discourse of praise[31] even while articulating this discourse more subtly than we might think possible in the space of presentation, in the viewer's space. Thus in the tapestry of the *History of the King,* the drawings for which were done by Le Brun,[32] the frame is not only a powerful ostentational mechanism allowing the historical scene represented to present itself, but it is also constructed as a mechanism for capturing natural light, the light that shines on the place where the tapestry is exhibited, since the right-hand and lower internal edges of the frame are lighted, whereas the other two sides are in shadow. Thus the "artificial" internal light that illuminates the scene becomes consistent with the "natural" external light: it is the same. By that very token, the space of the viewer is neutralized or, rather, is converted into a space of representation.[33] The tapestry was part of the furnishings at Versailles, after all. Through its figures, the ornamental decor of the frame thus becomes a "metarepresentation," a powerful instrument of appropriation and of propriety on the part of the representation itself, in its subject—what is represented on the stage of the story—and to its subject—the actor-subject in that story: in the case in point, the king.[34]

This is also how the frame (by this I mean the processes and procedures of framing, the dynamics and power of positioning) will delegate some of its functions to a particular figure, who, even as he participates in the action, in the story that is "told," "represented," will utter by his gestures, his posture, his gaze, not so much what is to be seen, what the viewer *must* see, as *the way to see it*: these are the pathetic figures of framing. Here, in fact, Le Brun and Poussin are only exploiting one of Alberti's precepts concerning the representation of the *istoria,* namely, that one of its figures should be placed in the position of a commentator, *admonitor* and *advocator* of the work:

> In an *istoria* I like to see someone who admonishes and points out to us what is happening there [in the story, the narrative, the painting]: or beckons with his hand to see; or menaces with an angry face and with blazing eyes, so that no one should come near; or shows some danger or marvellous thing there; or invites us to weep or to laugh together with them.[35]

Continuing to work with this royal and classical corpus, we can observe that the figure or figures of framing are most often figures located around the edges of the scene, the first one on the right or on the left, not a delegate

FIGURE 21.3 Jacques Gomboust, Map of Paris, 1652 (upper left corner).

FIGURE 21.4 Jacques Gomboust, Map of Paris, 1652 (upper right corner).

of the viewer (and/or of the painter), but a delegate of the frame intended
to signify to the viewer the pathic (pathetic) modality of the gaze that he
must direct onto the *istoria*.[36] Thus at the far right-hand edge of the scene,
we find a peasant contemplating the royal epiphany of *The King's Entry
into Dunkirk*; with a few variations, the head of this figure recaptures
an expressive profile of the same Le Brun, that of astonishment in the
seventeenth-century sense.[37] There is also, in an example Le Brun had al-
ready pointed out in a talk at the Royal Academy, the figure at the far left-
hand edge in *Manna*, a figure expressing reverent admiration before the
scene of Roman Charity that unfolds before his eyes.[38] We understand,
then, that under such circumstances, descriptive discourse at its most pre-
cise must turn away from the work in some sense, must turn away from
an internal reading, not so much in order to produce an external inter-
pretation as in order to formulate with adequate conceptual constructs the
signifying processes of the frontiers and limits through which representa-
tion in painting defines the specific modalities of its presentation.[39]

I noted at the outset that the Port-Royal logicians found paradigmatic
examples of representational signs in maps and portraits. Thus I would
like to turn to maps and portraits first of all as we pursue the operations
of positioning and framing, as we continue working on margins and
edges. And, to begin with, the model of the geographical map: let us take
for example a fragment of a map of Paris made by Jacques Gomboust in
1652.[40] An exemplification of the transitive dimension of the sign, at first
glance both accurate and rigorous, this representation makes present
once again a thing that is not or is no longer present. By iconic hypoty-
posis,[41] the map of Paris sets before our eyes a Paris that no one will ever
see, not even Gomboust at the very moment he was preparing this first
"scientific" map of the capital:[42] Gomboust knows the map of Paris, the
"real" configuration of the thing, so well that in the upper left-hand cor-
ner of his map he includes a picture with the written caption "Paris seen
from Mont Martre" and, in the upper right-hand section, he puts an-
other picture with the legend "Galerie du Louvre." Two images, two paint-
ings constituting part of the border, which propose to the map's user, as
a mimetic representation of Paris, a privileged trajectory from the exter-
nal northern approach to the center where the city is concentrated: the
place of its king. Through the pair of border pictures, the city in its map,
the map of the city, city and map in a precise and ideally perfect coex-
tension, are presented respectively as the represented and the representer,

the one within the other, as representation; thus they present themselves, but according to a particular trajectory and according to a singular modality in which the political power of the monarch is affirmed,[43] in a representation constructed according to the order of universal geometric reason in the truth of its rigorous ideality and the exactness of its empirical referentiation. If we look still more closely at the map, in the lower left-hand and right-hand sections, we spot a second frame configuration with small human figures on a "fictitious" hill near Charenton who are contemplating Paris, while looking in fact, as we are, at its map, its representation. Above and below, two framing devices, two modalized effects of reflexive opacity: the little figures are the representatives, on this lower edge, as the two "pictures" were on the upper edge, of the map's "self-presentation as a representation of Paris," through which the subject of representation as an effect of the mechanism of representation enters into the map, under the law of power, under the law governing the representation of the prince.[44]

A counterexample to these figures of frame, edge, and margin in geographic maps is offered by two framing images in a book that was a European best-seller in its day, at the dawn of the sixteenth century: two frontispieces, images that mark the reader's entrance into the book, engraved respectively by an anonymous artist and by the Holbein brothers, for the first and second editions of Thomas More's *Utopia* in 1516 and 1518.[45] In their resemblances and their differences, these two frontispieces reveal the subtle modal games of the frame figures of representations, all the more so in that the utopia is represented (in the book and by More's text) as a map, the product of a very learned art of describing that makes what it utters "exist" and that makes what it writes "visible":[46] thus the utopia in question is a map, a cartographic representation that constitutes what it represents as a fictional referent, a map that is not on the maps or that is there without being discoverable.[47]

In 1516, the caravel is moored before the entrance to the inner bay. The ship has reached its destination; its sails are furled, and on the bridge a small silhouette is looking at the island and/or at a map: the figure is contemplating the topographic view of the island's capital in the landscape and reads its name, *Civitas Amaurotum*, engraved on the map. In 1518, the boat is an exact reproduction of the earlier one, but inverted, a mirror image: no longer moored, it is making its way toward the coast where three men are standing on a cliff above the sea. By this re-version of the image, this re-

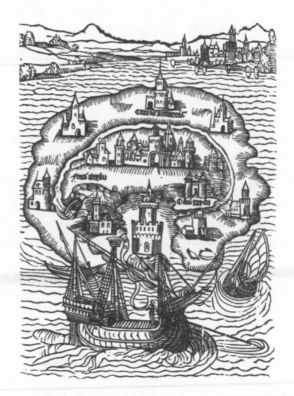

FIGURE 21.5 Frontispiece to More's *Utopia* (1516).

flection, it turns back toward us, toward our world, and the small person on the bridge, his back to the island, is looking at his approaching home-land. None of the men on the cliff is looking at the island, but one of them, perched on a cartouche in which its name is inscribed, points out the island and/or its map to his companion, Thomas More: he is *recount-ing* his voyage to More, *showing* him the marvelous island, *making* him *see* it—but by his description in language. The third figure, a soldier, seen in profile, his sword at his side, is listening to the conversation.[48]

Let me repeat that none of these figures is *looking* at the island and/or its map in the space of the world, in the space of the image. The island and/or its map has become an object of language, of listening and writing, a *text*, and we—who are about to read Thomas More's *Utopia*, who see its image and muse about what the image represents—see it only through

the mediation of the two figures, Raphael and More, only through the dialogue, the narrative and the description that these figures represent, as the *ekphrasis* that the narrative of the one and the writing of the other have constructed: fiction.[49]

The Holbein brothers engraved the interplay of travel and maps, of reality and its fiction, knowingly and ironically: in 1516, the anonymous artist had written three "toponyms," *Civitas Amaurotum, Fons Anydri, Ostium Anydri,* on or in the map of the island. In 1518, the Holbein brothers inscribed them in three cartouches that are suspended by garlands *attached to the frame of the representation.* These toponyms, which, in geographic maps, are written on the represented places that they name while making what is represented coincide with what is named[50]—these names in the Holbein engraving, through the decorative apparatus that bears them, take visual precedence over the represented objects they name; they come before the entire image; they belong to its frame, to its edge. They are positioned, as it were, on the transparent plane of the screen of representation. They show obliquely that unrepresentable part of the iconic sign, the part that, if it were represented, would, owing to its opacity, neutralize and cancel out what the representation represents.[51] They show that Utopia (the island, the map) is only a representation, a discursive *ekphrasis,* a fiction of things by means of words. But they also show, conversely, that by its edges and its limits, by the work of its frame and its powers of framing, every representation conceals a utopia, the fiction of a desire, a fiction that is realized in this very place, moreover, and of which Christo's drawings for *Surrounded Islands,* in 1983, could be said to be the "representation," echoing the Holbein brothers' engraving of 1518.[52]

The model of the portrait is the other paradigm of the representation sign. It directly exemplifies the sign's reflexive dimension. At the very moment when it is making an absent or dead being present, every sign copies, reflects, or emphasizes the operation of representation. The presentation of that operation, as the act of a subject of representation and as if it were identifying that subject in return as *its own* representation, is particularly obvious in the case of portraits. The "I" is represented as presenting itself in the sign that represents it.[53] The portrait is the very figure of the presentation of representation, a fortiori when the portrait is a self-portrait. From this standpoint, and it would not be one of the lesser para-

doxes of self-portraits in general, might we not consider it, as such, as a frame figure? This seems to be Poussin's explicit intention in his 1650 *Self-portrait* in the Louvre.[54]

It is not Poussin the individual, the unique person, the "I" who is a native of Normandy living in 1650 in Rome, that the painter represents. It is first and foremost the painter-subject, and even more the subject of the work of painting, of painting in labor and at work with its own instruments and means. Two attributes initially displace this work onto the represented image of the painter: the portfolio that contains the invisible preparatory sketches, the *disegno*, the soul of the painting, and the diamond set in a ring on the master's hand, serving as an emblem of the genesis of the whole range of colors through the sunlight refracted in the prism of its transparency.[55] But the figure of the painter refers these two attributes to the field of painting itself, to the space of the painting represented reflexively as that of the process by which the work, in its various stages, is fabricated: here is a moving confrontation between the painter and the limits and frames of representation in painting. Between two stretchers turned backward and a canvas that has been prepared but not painted, the background of the painting in fact *represents* a fragment of a picture frame and a *finished* picture slipping toward the left, but of which only a fragment of what it represents can be seen. In the remotest part of the background, the painting represents paintings that show what is not usually shown, their backsides. In the nearest part of the background, and serving as backdrop for the painter figure, a canvas shows what is not seen in a painting, the underside, what is under the painted space of the representation. What is unshowable and invisible in the painted picture is not only shown, here, but also represented as what is neither showable nor visible. The painter paints *the surface* of his painting in the canvases he represents—what is actually *underneath* and *behind* the picture he is painting, but to which his own figure has turned its back.

We need to go still further in this reflexive exploration of frames and limits undertaken by the painter himself. The canvas that shows its backside prevents the painting on the left from showing everything it represents: the frame of the simulated painting hides part of it, and that of the painting we are looking at, the painter's self-portrait, conceals another part. Between the two, on the inner frame of the work, a woman's figure is painted, a frame figure that seems to appear only to escape the canvas: an allegory of painting, Bellori tells us;[56] a figure of the theory of the art of

painting, as Donald Posner has shown.[57] Art theory, the theory of painting, is represented as the partially visible "term" for the practice of painting.

Now, in this twice-hidden picture, we notice two hands belonging to a figure outside the frame. These hands surround the allegory of art theory; they represent the practice of painting, and they belong to a figure outside the painting: the hands of the subject of the art of painting, the hands of the practice of painting, of the painter whose hands we, as viewers, shall never see, except in representation. At all events, we shall never see the *allegory* of the practice of painting joined with the theory of painting, since the self-portrait addressed to Chantelou, the picture we are looking at, realizes this junction by putting into practice, in the work, the indissoluble unity of the theory and practice of painting. That unity could not be presented except by the lack of the figured representation of one of its terms, so that the frame, in its positioning effects, inverts its function of presentation of representation in painting, or rather it puts this function to work in its interval of edges: by presenting the representation of the painter, the frame conceals the figured representation of what the representation itself accomplishes, the work that we see. But this deficiency in the framing indicates that the work of painting is what is making itself visible between edges; and representation is conceptualized in what is perceived between a canvas and a presentation.

In counterpoint to Poussin's *Self-portrait* and the work of frames on the subject of painting, it seems to me that Leonardo Cremonini's well-known canvas *Guet-apens* (1972–73) could be viewed as its modern pictorial and theoretical commentary:[58] here, as in Poussin's picture, the frames represented overlap and pile up and interrupt one another, whatever the "represented" object they frame may be—doors, mirrors, windows, or nothing, like the empty frame on the right. All these frames, like the frames, canvases, and stretchers in Poussin's painting, articulate a very narrow, "infrathin" space, which is almost reduced to the superimposition of planes. The frame that presents the picture we are looking at interrupts the frames that this same picture re-presents for us, as if the rigorous law governing the positioning of frames called precisely for making things visible by partially obscuring them from view. As for the children, dwarves, or monsters who appear among these piled-up frames, they seem to obey the same law: a head without a body on the right, a head, a body without arms or legs in the center. And, in the foreground, there is the blind child with outstretched arms, hands and arms cut off by the frames. At the same time,

on the right, an arm without a body is pushing an empty frame toward the center.

Poussin set up a monumental figure of the subject of representation against the background, the self-portrait of painting, frame, stretcher, and background; here, that figure is dismembered into four childlike (or monstrous) figures that seem to be playing blindman's buff: a game of seeing, or of being seen without seeing, played among empty frames. Or else they are frozen figures, or figures captured in motion and immobilized, as in a dream where all these frames would be trying to seize them, frame them, put them into representation: "The space of my paintings is for me a space of contradiction and conflict."[59] *Guet-apens,* "ambush," is its title, the name of a game of blinding in a maze of rectangular barriers, a *mise en abyme* of representation and its staging, in presence, by the play of its frames. Cremonini described his picture as "a very tense relation between the frame of a mirror and the stretcher of a painting," which is also the violent relation that tears the painter apart: he is torn between the desire to enclose the visible within the frame of his picture and his fascination with what eludes that space, the reality of the visible.[60] We shall find this same play with frames among the Dutch painters, in Vermeer—as Svetlana Alpers has noted[61]—or in Velasquez—where, with Foucault, we can see the birth of the age of representation.[62]

A small painting by Klee—which I came across by chance, the way one can make a joke by accident—had the good fortune to have its painter give it its name, its Latin title, which is the very title (or part of the title) that I gave to an earlier study: the work is called *Ad marginem,*[63] on the margin, toward the margin, toward the frame of representation in painting. I have said that the painter names it, but also that the painting names itself. To paraphrase briefly some remarks Klee made in a lecture in Jena,[64] the painter names it and writes its name in the margin, "Ad marginem," and the painting names itself *Ad marginem,* "in the margin."

This small painting (46 cm. x 35 cm.) in the Basel museum will allow us, if not to answer the questions I have asked, at least to circumscribe some of their edges, some margins. Will Grohmann describes the painting this way: "*Ad Marginem* . . . looks like an old document with the dominant red planet in the center on a field of weathered green. The ghostly writing is scattered along the margins as in a child's drawing; included are plantlike hieroglyphics, a bird, fragments of figures, and letters of the alphabet—a diploma from the realm of Nature."[65]

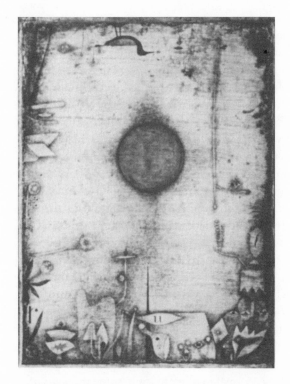

FIGURE 21.6 Paul Klee, *Ad Marginem*. Oeffentliche Kunstsammlung Basel, Kunstmuseum, Basel, Switzerland. Photograph courtesy of Scala/Art Resource, New York.

The writing's formal elements—scattered, it is true, along the *edges* of the painting, on its margins, but precisely supported by them—are those of a refined, precious vegetation, graminaceae and umbelliferae, more abundant on one side than on the other three: a rare profusion of objects, embracing a dispersal of the gaze that corresponds to the dispersal of these botanical figures of the frame. But the gaze is continually recentered by the intense central red disk endowed with dark rays that trace a sort of cruciform nocturnal aura on the green background. The gaze hesitates on the other edge of the painting that is its background: does that "aura" belong to the red planet—"figure"—or to the "surface-background" of the *tavola*? The gaze hesitates, too, in seeking the source of the dark rays: do they come from the red sun, through an intensification of its boundaries, or from a star that the sun is hiding in a sort of inverted eclipse?

But has there ever been, in nature, a bird capable of walking along an edge, upside down, even if only as a silhouette, a bird reduced to its simplest expression, a bird "sign," a hieroglyphic, as Grohmann says? Were hieroglyphics or pictograms ever actually written like this, upside down? Yes, probably, if the gaze seeks to read correctly, appropriately, the four alphabetic letters written on its edges correctly: "v" near the upper edge, "r" on the left side, "l" on the right, "u" in the lower margin. Three consonants, one vowel: the central "u" in the lower margin responds with its vowel voice to the "v" in the upper margin, "v" so close graphically to "u" but condemned, as a consonant, to being sounded with its vowel "u"-"vu." The same is true for the "r" and the "l": "r-u," "u-l."

In the margin of the painting, among the aquatic plants, there is thus a voice underneath the graphic signs that represent it, amid the hieroglyphics and pictograms that belong to a language that is Klee's own—the voice of a vowel, or rather a vowel from a voice absent from the painting: the "u" that allows the other three letters to be pronounced. Here, then, the gaze somewhat frantically traverses the painting's margin in all directions, in search of a direction, a meaning, turning in a circle (or rather in a rectangle) around the central red circle.

Still, thanks to this trajectory, the bird walks properly on its feet, not upside down, in its margin; but then—surprise!—the "u" becomes an "n," while its three consonant companions become the signs of an indecipherable script. Here we find ourselves relegated—the better to see—to the most extreme margin of the voice.[66]

If it is to meet with success, this quest for direction and meaning, in the margin of the voice and on the internal frame of the representation, between vocalic sign and consonantal signs that represent it to hearing and to sight, presupposes a displacement of the eye in the external frame of the painting, or else a rotation of the painting itself around its red center. This process of anamorphosis interrogates the modern subject by means of its frame and its representation, by means of its margins and its edge figures. In fact, if, to shift my position around Klee's painting, I put it on the ground, as Pollock, twenty years later, will do for his huge drippings, then the margins of the painting *Ad marginem* become a four-cornered well in which, in the greenish water at the bottom, a red planet is reflected and caught—unless it emerges from its depths quite precisely at the place of my eye, which is looking at itself and discovering itself in the form of a darkly radiant star: a paralyzing displacement in the reflexivity of the

mechanism, a stupefying shift in the presentation of representation by the very instrument of its closure, the margin.

To conclude this itinerary on the margins of representation and their figures, and to assess its stakes still more directly, perhaps, I should like to call to mind a moment in a painting by Frank Stella, *Gran Cairo*.[67] It belongs to a series of paintings of the same type and organization, in which it seems to me that Stella explores the various dimensions of the problematics of the frame of representation in painting with a kind of systematic attention: I have a feeling that this exploration has some relevance to my own remarks, from Poussin to Klee, from Holbein to Cremonini.[68]

At first glance, Stella's canvas is made up of frames. The plane of representation is invaded by them from its outermost edge to its center, in a triumph of the frame and of positioning—of presentation—over representation. The canvas is the field of an all-powerful force: that of its external limit, entirely directed toward its center. The traces that this force has left inscribed on the canvas are the frames. Unless we consider that the subject of the painting, what it seeks to represent, is precisely the process of framing. In that case, the movement is reversed: from the center toward the periphery, from the inside toward the outside, in particular with the four very powerful centrifugal arrows drawn in the plane by the diagonal lines.[69] Instead of being traces of the force of alterity, the frames are thus traces of an expanding internal force, a force of form regularly repeating the same forms and colors, starting from an initial matrix and with no other logic than to tend arbitrarily toward an end, toward a final encompassing form.

If the frame is one of the means through which representation presents itself representing something, this painting by Stella represents its own presentation. The painting is entirely reflexive and its transitive dimension consists in representing its reflexive dimension. As in Poussin's *Self-portrait*, Cremonini's *Guet-apens*, or Klee's *Ad marginem*, we are witnessing an iconic *mise en abyme* of the opacity of the representational sign in its transparency, or else the inverse, an iconic *regressus ad infinitum*, through the frames of presentation to its representation and from the representation to its presentation. Starting with the outermost violet frame, the describing gaze notes that it frames a blue frame, from which it is separated by a fine linear white frame: then there is a new blue frame centering a yellow frame with an optical interference between the two colors that destabilizes the blue. From the standpoint of color, it seems indeed as though these first three frames

FIGURE 21.7 Frank Stella, *Gran Cairo*. Collection of the Whitney Museum of American Art, New York. Photograph courtesy of the Whitney Museum of American Art/Geoffrey Clements. © 1995, Whitney Museum of American Art.

constitute a frame whose dominant note is a cool blue, and within this frame, there is another with warm colors, yellow, red, saturated red, red then yellow. This warmly colored frame frames yet another frame, dense and powerful: five square frames separated by four white framing lines— dark green, blue, violet, blue, dark green, in a symmetrical arrangement of cool colors exalting the central violet frame. Now we have reached the picture's center: a yellow frame framing a red frame and this last framing a dazzling small red square with the same fine white line we have seen before.[70]

This small central red square—let us recall that *cadre*, "frame" in French, signifies square—raises both an optical-visual and a theoretical-intellectual question: framed by all the positioning and positioned frames, it positions nothing itself, unless we suggest the paradox of a frame positioning itself, a paradox that is none other than the paradox of infinite reflexivity; a paradox that is, it seems to me, the one that this painting presents *visually*, like the others in the series. Is the small central square the *figure*, the unique

and extreme *figure* of a *quadro* that would be framed by fifteen colored frames? Or is it the last, the ultimate *frame* that would no longer position anything but itself, or that would frame a zero figure (infinitely), an invisible figure? We have noted that each large frame square is framed by a frame constituted by a fine white line. Is that line another sort of frame regularly distributed on the canvas? Yes and no. We can indeed view these lines as *limit* frames, frames tending to the limit, to their limit, without ever being able to reach it; but we can also view the white lines as remainders and traces of the supporting canvas, subsisting under the layers of color. Still, these lines become vestiges of the support surface only when this support is itself marked with square frames of color. The lines become traces of origin only after the colored squares have been traced: in the lines we discover, visually, a way of grasping time through spacing, or, conversely, a way of structuring space through temporal antecedence.[71]

And that is what appears, in my opinion, if, instead of applying our description to the flat surface of the colored canvas, as if, owing to the square frames, there were a remainderless coincidence between what is represented and the plane of representation, we notice that our gaze, visually, optically, descends in depth to the interior of the flat surface of the painting, as if by way of a colored staircase that hollows out the surface of the plane starting at its outermost limit. Our gaze descends this staircase to rejoin the central square, the vanishing "point" square that itself represents the "point" of the subject, that is, the place of infinite reflexivity.

But now, suddenly, everything changes. A visual event, an optical catastrophe: the staircase leading toward the depths becomes a colored pyramid, whose summit, the little red square, extends toward the viewing point, to the place of my eye, a pyramid entirely exceeding the plane of representation with all its positioning and positioned frames, entering into the viewer's space, into the space of presentation of the work.[72]

This event of optical reversal or visual conversion is, as we know from the laws of the psychology of form and the physiology of the eye, at once random in its appearance and completely determined by our optical and perceptual apparatus. Such is the time of the frame or of the positioning, of which Stella's frames would be the figure, a rhythmic time (which is basically that of the ornamental borders of classical representations, a time with a spatial beat), but without definite measure, a flow-time: the more it is determined by the processes of framing of the representation-sign, the more it appears accidental to the subject of the representation; it is a time in

which that subject is at once a completely determined product of the mechanism of representation and the chance producer of that mechanism.[73]

Are these frame squares of Stella's a well or a pyramid?[74] A well *and* a pyramid, but never at the same time. The eye cannot predict the necessary and arbitrary moment of conversion in which all the serious play of the frame and its modern and contemporary figures seem to be concentrated: the play of the rhythm of presentation and representation, the play of the subject of the art of seeing and the art of describing.

§ 22 Ruptures, Interruptions, Syncopes in Representation in Painting

I would like the three terms that give this study its title to be understood as variations on the ellipses, silences, and blanks that give our meeting its themes. The term "rupture" emphasizes the "breaking-through," the *enfonçure*, as people said in the seventeenth century, the break, cut, or caesura that tears apart some continuity in space or time, some logical and semantic coherence, or even semantic cohesion, at a specific level or in a specific realm. Rupture can even be the violent mark of a limit, a tracing to the quick, as it were, of an edge that cuts off an exposed form or an exhibited figure. Rupture can sometimes also be the visual equivalent of a silence, as in the famous painting by Edvard Munch, *The Scream*, the high-pitched silence of a sound beyond the reach of hearing, or even in Poussin's *The Massacre of the Innocents* in the Chantilly museum. The anamorphosis of the skull in Holbein's *Ambassadors* can be taken as the "classic" example of rupture in terms of the painting's semantic coherence and syntactic cohesion, but also in the mechanism that governs its impact on the gaze.

The term "interruption," for its part, emphasizes the opening up of a gap, an interval, within some continuity or continuation: distance, spacing, the *différance* of delay or postponement; it also points up the effects of such a gap for the viewer or hearer. In the treatise by Pseudo-Longinus, interruption is a characteristic figure of the sublime, and in the early nineteenth century, Fontanier noted in his own treatise that "interruption leaves suspended all at once, through the effect of an overly acute emotion, a sentence that has already been begun, in order to begin another entirely different one, or to go on with the first one only after having sprinkled it with expressions that are grammatically foreign to it."[1] Fontanier

went on to characterize suspension and parenthesis as close relatives of interruption, thus reintroducing—in rhetoric—the effects of discursive rarefaction that characterize ellipsis. A good example is found in the narrative moment represented in Poussin's Chatsworth painting, *The Arcadian Shepherds*, in which the breathless race of the figures is highlighted by their astonished suspense at meeting a death's head on the tomb while a sleeping river god, in the foreground, allegorizes the temporal continuity thus interrupted. Paul Klee's small painting *Ad marginem* offers another example: here, the spacing and *différance* of the interruption are exposed to the gaze by the way the vibrant red sun at the center relegates the figures to its edges, its margin.

As for the term "syncope," it plays on and brings into play the semantic tension underlying the notion, since it evokes an interruption of bodily functions in an odd conjugation with self-consciousness, a sudden and momentary diminution of the action of the heart combined with interruption of breathing, sensation, and voluntary movement. Montaigne and Rousseau experienced syncopes when they had accidents, mysterious occasions for each to discover happiness at the threshold of death. There is also the syncope of interrupted writing, as well (the cutting off of a letter or syllable in the middle of a word), but in which the voice takes up the interruption and effaces it—*gai(e)té*—to leave only the silent graphic scar of a circumflex—*gaîté*. Finally, there is the syncope of music interrupted and resumed (the last note of one measure is tied to the first note of the next, making a single note of the two, or else two notes are heard in succession, with the second understood as a copy of the first), hence a rhythmic effect, a repetition that produces the simultaneous intensification of a presence and an absence, as happens in Jackson Pollock's dazzling *Autumn Rhythm*, or, in an entirely different way, in the rigorous, formal, colored geometries of Frank Stella's *Gran Cairo* in the series of "Concentric Squares."

Ruptures, interruptions, syncopes, then, as variations on ellipsis, silence, blank space—but in representation in painting. So we must ask if the question I have raised—What is an ellipse, a blank, a silence, in painting?—does not necessarily provoke another: What is a rupture, an interruption, a syncope, in this realm?

As it happens, with one of the titles of this meeting, the term *blanc* ("blank" or "white"), we enter the visual realm at the outset, and the three notions of rupture, interruption, and syncope, beyond the few pictorial illustrations I have just evoked, could turn out in the long run to be theo-

retically conceivable as variations on the blanks of representation in painting, or as "opacifications"—ways of making the "white" or "blank" spaces in painting opaque.

In the seventeenth century, the golden age of representation, *blanc* was understood in the first place as the universal color, for it is the "complex" color of light, which can be divided by a prism into multiple individual colors. Pierre Nicole produced a little moral lesson about prisms, and in his *Self-portrait* in the Louvre, Poussin wears a prism on his little finger in the form of a diamond—cut in the shape of a pyramid—which he substitutes quite specifically for the book entitled *De lumine et colore* that he has in his hand in his *Self-portrait* in the Berlin Museum. We might call white a transcendental color, since it characterizes the condition of possibility of all representation, light.

Poussin, in his letter-testament to M. de Chambray dated March 1, 1665 (the painter died on November 19 of the same year), wrote that "nothing is visible without light," under the heading "Principles That Every Man Capable of Reasoning Can Learn":[2] white, the color of light, is the invisible condition of possibility of the visible, logically anterior to "everything seen under the sun," which is, according to Poussin's famous definition of painting, the object of representation in painting ("everything that one sees under the sun"); it is the color the sun would have if the sun could be painted directly as a thing or an object of the world.[3] "We cannot look squarely at either death or the sun," as La Rochefoucauld wrote at around the same time.[4]

Poussin's second principle articulates a second *blanc*—whiteness or blank space—in painted representations. "Nothing is visible without a transparent medium."[5] In counterpoint, I read Aristotle's definition of what is transparent or diaphanous. "By transparent, I mean that which is visible, only not absolutely and in itself, but owing to the colour of something else. This character is shared by air, water, and many solid objects."[6] Such would then be the blank-white, the colorless color, invisible in itself, of air or water, an invisible color that only some "other" color restores to visibility. The diaphanous is for Poussin a means of making visible.

What is this means? Poussin articulates it in the definition of painting that I referred to above: "It is an imitation [a representation] made on a surface with lines and colors of everything that one sees under the sun. Its end is to please."[7] All representation in painting is thus included—contained or enclosed—between the transparent plane of the representation it-

self, which the gaze traverses (*dia-phanēs*) in order to collect (and to recollect itself in) the painted appearances and the figures, and the surface, the instrument of visibility—as Poussin says again in his third principle[8]—the blank-white of the diaphanous, the invisible means required by everything that is visible. The blank-white inheres in the invisible surface of the painting, a surface that is not yet marked, traced, and tracked by lines and suppressed—as seventeenth-century writers put it—by colors.

Between the diaphanous plane of representation—the invisible wall of the scenographic cube that only the accident of a foreign color, the heterogeneity of a different semiotic substance, an inscription, a "real" fragment of an object, can bring back into the realm of the visible—and the invisible underside or obverse of the undergirding—a surface that is colorless, blank, devoid of any color, since it precedes all color, a canvas, a wall, *intonaco*, plaster that is neutral in coloration—between these two "blanks," a representation in painting unfolds the visual, fleshly, visible powers of its figures.

We shall see Magritte, for example, in *La condition humaine* (1934), in the *mise en abyme* of the painting, undertake an experiment with the diaphanous *blanc* of the plane of representation; we shall see Jackson Pollock, in *A Portrait and a Dream* (1953), exhibit the *blanc* of the underlying surface as a surface area of lines and colors, a screen where the figure of the self is inscribed in a diptych in the scattered form of a phantasmal nightmare.

But the background of the painting is also *blanc*, if "blank" is understood as "figure-less" or "between-figures": here the background is devoid of instrumental means for figures constituted by lines of structure or drawing, lines of articulation, but also lines of contour and circumscription that surround the figure; devoid, too, of colors in their local applications and in their aerial and atmospheric play, secondary qualities of bodies and values of shadow and light on and between those bodies. With this other *blanc*, we rediscover two more universal principles articulated by Poussin: "Nothing is visible without boundaries," that is, without lines circumscribing the figures and delineating their structure; "Nothing is visible without distance,"[9] that is, without a background, without an interval, without a gap *between* the figures. And we note that one of the most profound characteristics of "Caravaggism," and of Caravaggio himself, is the "nocturnal white" of a background in which the figure is sculpted as a bas-relief by the instantaneous violence of a light that has come from elsewhere and has gripped the figure in its dazzling force, as in the 1605 *Raising of Lazarus*.

Here, then, are four *blancs*—blanks/whites—at work in representation
in painting, but as the most general principles of its possibility and of its
effectiveness as representation, as its transcendental conditions of visibil-
ity—in other words, as what conditions the "visible" in a painting: the
blanc of the luminous (light), the *blanc* of transparency (the plane of rep-
resentation), the *blanc* of the surface (the area on which lines are to be in-
scribed and colors deposited), the *blanc* of the background (the material
underpinnings for the figures). It is on these four blanks, of and in repre-
sentation, that ruptures, interruptions, and syncopes come into play:
each, according to its own mode and in its own manner, refers to the var-
ious types of opacification of blanks in representation in painting, opaci-
fication of the blank transitivity of representation, that "imitation made
on a surface with lines and colors of everything that one sees under the
sun" and whose "end is to please."

<center>~</center>

Here I should like to attempt to define more rigorously and precisely
what I have just called the "blank transitivity of representation," so we can
better observe the play of opacification of the ruptures, interruptions, and
syncopes of its operation. We have known for a long time that two major
events marked the entrance of the visual arts into the modern era: on the
one hand, the invention, in the fifteenth century, of a new space for rep-
resentation in painting by means of geometric and linear perspective,
demonstrated in practice by Brunelleschi in front of the baptistry in Flo-
rence, manifested in painting by Masaccio with his *Trinity* in Santa Maria
Novella, and formalized more abstractly in Alberti's treatise *De pictura*;
and, furthermore, the emergence among artists and writers of a strongly
individualized awareness of their social and artistic personalities. More
profoundly, the fifteenth century witnessed the creation of a new space
whose construction was the representation of the visible world (and of the
invisible in the visible), a representation in which painting was the su-
preme means for objective knowledge. But, at the same time, along with
that space came a formalized notion of a subject. The epistemological and
philosophical founding of this subject was to be consummated in the sev-
enteenth century with the Cartesian *cogito*, the "I think" that accompanies
every representation, whose function, or rather whose functionality, was
to be something like the subjective coefficient of representation. Erwin
Panofsky could state with good reason that modern perspective is the

symbolic form of "an objectification of the subjective"[10] precisely to the extent that its construction mechanism depended quite rigorously on the position of a "subject-eye" that made it possible—at least ideally—to determine the key points of that construction (by pulling the eye down 90°, placing it structurally at the vanishing point–viewing point, on the distance points on the horizon line, in order to constitute a sort of virtual viewer starting with whom the regular [rational] recession of lines parallel to the plane of representation) could be defined.

For the theoretical discourse of modern representation, from the Renaissance to impressionism, a painting is an open window onto the world. Through the transparency of the plane of representation, thanks to that transparency, a painting represents the world truly (by means of the geometric grid that marks off metric points on the plane). But in order to do this, it must first be a surface (an area for lines and colors), a diaphanous surface, since it is hollowed out by the virtual, illusively deep space of the third dimension that perspective constructs there. It must also be a material supporting surface (wall, wood, canvas, and so on), which is nonetheless denied, annihilated, because it is assumed to be empty by an essential *aperité*, a surface-window that will soon come open, as in the great landscapes of the Dutch Golden Age, to a horizon conceived at that time, in the seventeenth century, no longer as a limit but as the index, between heaven and earth, of an infinite space. The theory of painting, from the fifteenth century to the eighteenth, asserted quite clearly—and painters' practice demonstrated—that this new pictorial space was the decisive instrument for the representation of history and its narratives. But, in order for historical painting to achieve perfect transparency, on the part of a representation, to what it represents, it was not only necessary for linear perspective to reduce the viewer's body (and the painter's) to a theoretical point, but also for that point from which painting was seen to give the viewer (and the painter) a position analogous to that of a storyteller in relation to the story he is telling: that of a gaze attesting to the objectivity of the narrative of which the painting is the representation. This is indeed the historical (or narrative) modality of enunciation as opposed to that of discourse. In the narrative representation of a story, whether in images or in language, "the events are set forth chronologically, as they occurred. No one speaks here; the events seem to narrate themselves." History, Emile Benveniste concludes in his decisive analysis, excludes "any intervention of the speaker in the narration."[11] To remain faithful to his "historian's

project," the writer of history conceals the narrator and privileges the subject of his utterance, unlike the writer of discourse, whose enunciation not only presupposes a speaker, but also inscribes that speaker in its very utterance. The representation of history in painting obeys, in its own realm and according to the specific characteristics of its idiom and its syntax, the same semantic and pragmatic prerequisites and requirements as the literary and rhetorical forms of history writing. From the Renaissance to the Enlightenment, the modern era produced all the formal varieties of visual and literary representation of history following the historical transformations of its agencies of production—painters, writers, patrons, and so on—and of reception—viewers, listeners, readers.

But the "blank" structure of objectivity, the structure of diaphanous transitivity to the event on the part of the narrative, never consisted in anything but theoretical, indeed phantasmatic, idealities of representational autonomization. Diverse modalities of opacity and various types of opacification intervened to disturb, disrupt, or interrupt the blanks of representation, or to syncopate them. Once again it will help to spell out more rigorously the notion of opacity or the process of opacification—here specified as rupture, interruption, and syncope—of the "blanks" of representation. If the term "opacity" is a terminological invention of contemporary pragmatics, its importation into the seventeenth century is not an anachronism: the notion and process are "present" under other names in theoretical texts on art, literature, and philosophy in the modern age, from Vasari to the Port-Royal logicians or Aubignac in his *Pratique du théâtre*.

An example will give us an ostensive definition of this phenomenon, the example of reading. To read, as we know, is to traverse written or printed signs—as if they were absent—in a movement toward meaning. The presence of these signs is necessary, however; otherwise, all that would be spread out before the gaze would be the white page, an empty surface, a neutral support structure. Yet these same signs must absent themselves, as it were, from the reader's gaze; they must be diaphanous. Otherwise, the gaze stops short and fixes on the signifiers alone, while their signifieds disappear. When signs are manifested as signifiers, the transparency of signification becomes opaque.

\sim

As a double paradigm of the blank transitivity of the representation-sign, classical philosophy offered the geographical map and the portrait.

As an example, let us take the map of Paris that Jacques Gomboust, the engineer responsible for the king's fortifications, drew up in the 1650s, a map considered to be the first faithful rendering of Paris. In its complex schematicism, it allies geometrical procedures for transcribing the object with the procedures of iconic description, in precise transparency to what is represented. Nevertheless, at the bottom of the map, at the top of a "fictitious" hill that appears to have sprung up near Charenton, Gomboust does not hesitate to introduce four little figures in the position of viewers. What are they actually looking at? Paris, the capital of the kingdom, the referent of the map by means of that map, or Paris represented on the map, the idea of Paris, or more simply the map itself—the representation-sign—just as we are looking at it, but from a place forever unoccupiable in the map itself or in reality? Probably all of the above. The four little characters on Gomboust's map are in some sense the delegates—in the representation—of the subject who is "looking at" the representation. In this point, which could easily go unnoticed, a discreet rupture in the "blank transitivity" of the representation is manifested through them; a reflexive opacity intervenes to trouble the transparency, to break the quasi-identification between referent and represented in the representative. More profoundly, they reveal to us that every representation presents itself representing something. They are the figures of that self-presentation.

Thus from opacity and the process of opacification will stem every feature, element, part, detail, mark, or figure that interrogates (disturbs, disrupts, interrupts, produces a syncope) the *blanc* of the luminosity, the transparency of the plane, the diaphanousness of the surface, the emptiness of the support. In the representation of some thing, reflexive opacity in its own modality brings to light the "presenting-itself" of representation, which cannot fail to produce in the representation itself a subject effect through which the "I think—I see" that accompanies every representation—to paraphrase Kant's famous formula—is inscribed in representation. A picture, a representation in painting, thinks. It conceives of itself, and the way pictures, representations in painting, have of thinking and of conceiving of themselves while representing something is to represent, to put their thinking into figures (into representation); they did this first of all in the "classical" era, through what could be called an enunciatory rupture, that is, through the (interruptive) intrusion of the sphere of enunciation into the sphere of utterance.

Since, as we have seen, the representation of history constitutes the "per-

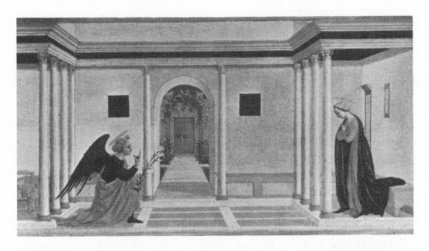

FIGURE 22.1 Domenico Veneziano, *The Annunciation.* Fitzwilliam Museum, Cambridge, Great Britain. Reproduction by permission of the Syndics of the Fitzwilliam Museum, Cambridge.

fection" of representation in painting, the opacification of the "blank" transitivity of representation will consist in the interruption of the narrative by the narration—or more precisely by the rupture of the represented narrative—of the narrative utterance, by the representation of the act of narrating it to someone through the creation of figures embodying its production-reception. Let me take an example from Siena at the end of the Quattrocento, Benedetto Bonfigli's *Annunciation,* in which the figure of the subject of the enunciation, the narrator of the story, St. Luke, writing the first sequences of his Gospel (about the childhood of Christ), enters the scene of the narrative in its very first sequence, the angel's announcement to the Virgin that she is to be the Mother of the Savior. St. Luke enters the scene both as an actor in the story, situated between the Virgin and the angel, and as its witness. Is it not to him that the angel seems to entrust the words he is addressing to the Virgin so St. Luke can inscribe them on the scroll spread out on his lap? In addition, as St. Luke is the patron saint of painters, in the St. Luke who is the scribe of the painting's narrative and its figure, we are led to see the figure of the painter who is painting him and setting into images the story told in the Gospel by the same St. Luke.

Another example, this one from Florence, is also an *Annunciation,* by Domenico Veneziano, almost contemporary with Masaccio (and Veneziano

is thought to have used a lost *Annunciation* by Masaccio—from San Nicolo sopr'Arno—in the form of a predella). Here, indeed, we can see quite clearly a powerful, systematic application of a legitimate, centered, linear perspective, whose markings are still visible in the layers of paint on the picture, giving it a sovereign autonomy in its transparency and its transitivity. A centered perspective, I have suggested: the traces of construction mark the structural equivalence between the vanishing point and the viewing point at the "center" of the predella.

Still, the vanishing point is behind the door of the Virgin's enclosed garden. The figure of the door hides it from the eye located at the viewing point, as if the hole of Brunelleschi's *tavola* were plugged, all the more so in that the structural equivalent of the eye, which is the vanishing point, is precisely the lock on the door. That lock on the closed door, which, in the literal sense, locks up the eye or the gaze, is the figured representation of the opacity or the opacification of a gaze conquering the virginal mystery (it is the door of the closed garden) of Mary, mother of God. Better yet, this locking up of the key place of the constitution of the mechanism of representation (legitimate centered perspective) is its rupture, to the extent that the lock is out of proportion with the door and the rest of the representation.

But at the same time, the gaze thus locked away from the vanishing point comes back to the viewing point—is reflected in the viewing point-eye—with the two light wells, covered by grids, on either side of the central axis: these light wells, which are not blind but are nevertheless crisscrossed by a grid, figure a gaze that comes, if not from within the Virgin's room, or from within the virginal body, then at least from her antechamber. Thus that rupture, that interruption of the mechanism of representation in its very accomplishment, is ready for its iconographic *reprise*, one that had been announced long before, according to the verses of the Song of Songs that describe the coming of the Bridegroom behind the wall, behind the grillwork, to the meeting with the Bride.

I offer a third example of "reflexive" interruption and its reprise in a visual syncope with a detail from Sodoma's *Crucifixion* (1525, Museo civio, Siena). Here we see a helmet positioned between the legs of the soldier who is standing facing the cross and Christ, while turning his back to the viewer. On this helmet, on its convex surface, the figure of the soldier looking at the cross is reflected. In this point of the representation of the crucifixion, not only does the representation present itself, but it repre-

FIGURE 22.2 Giovanni Sodoma, *The Crucifixion*. Pinacoteca Nazionale, Sienna. Photograph by L. Marin.

sents its own mimetic process—"imaging"—in the "reflection" on the helmet. The represented reflection makes visible something invisible (for the viewer), something visible that is hidden by the representation itself: the standing soldier whom "I" see only from the back. A reflexive interruption? Why? The representation escapes from itself toward its outside. It alienates itself in its very process. But at the same time, it puts its viewer in the position of Christ, the figure of representation. The "I-think," the subject, thus becomes a figure of the representation, which it appropriates for itself, and in which it is identified. Thus an extraordinary mechanism of spacing and interval is constructed within the coherent mechanism of representation, a shunting mechanism functioning reversibly: not seen / seen; not caught/caught. But in addition the reflection-bearing helmet is placed facing the viewer, on an iron gauntlet, reduced to a visor without a gaze. This is the viewing point, "displaced" in the picture onto its foreground. This virtual figure of Christ, which is also a split-up figure of the executioner-soldier, refers its gaze to me, or rather, to the subject, but in

the form of a blind gaze. The helmet, as a support surface for visibility (with the reflection it bears) and as the power of sight, is opacified at the same time as the disturbing figure of blindness, the troubling figure of the sphere of enunciation-reception in the narrative utterances.

The exploration of the figures of interruption, rupture, or syncope that we have initiated here would prove to be very fruitful, not only for the motif of the gaze interrupted by blinding, but also for the motif of the gaze subjected to syncope by dazzlement or stupefaction, of which the Medusa theme would be the strongest dramatic expression, from Annibal Caracci to Caravaggio, along with the Narcissus theme, the iconic and iconographic representation of the theory of the image grasped and paralyzed, as it were, in the myths of its origins.

~

The opacification of the whiteness or blankness of light—a transcendental *blanc*, since it conditions a priori the very possibility of the visible—can be said to be signaled on the edges and limits of representation, in the work of its frame and in the syncope of luminosity and of lighting. As we have noted, light from the sun is not an "object" of representation in "classical" representation. Light is, in some way, at the distance point of the mechanism of the construction of the represented space, like a lateral eye that illuminates the story's figures and its space from the wings of the narrative stage. But on occasion, as in Le Brun's *History of the King* tapestries, the internal border of the tapestry, the internal limit of its frame, benefits from a lighting that cannot be the one that offers the represented scene to view, but that is rather the effect of light external to the "painting," transcendent to its representation: two sides of this frame are lit, while the two others are "shadowed." The representation of the king, the central actor in the story of the world that is being told in this series of tapestries, through its border, thereby captures the "sunlight," the transcendental condition of all visibility, to the benefit of the Sun King, the condition of the possibility and the legitimacy of all history. The syncope of luminosity and the lighting receives, and, what is more, brings about, the politico-theological investment of representation at a time when the absolute monarch of France was rising to the zenith of the European sky.

Let me take as a second example a detail once again from the *Annunciation* Piero della Francesca painted in the Bacci chapel of the church of San Francesco in Arezzo (mid-Quattrocento). I am referring to the wooden bar

under the window of the light well on the second story of the Virgin's house. This painted bar of wood projects its shadow, also painted, on the wall of the house. However, the shadow does not result from the internal lighting of the representation, but from the light coming out of the central window that illuminates the back of the chapel of the choir in the church. This shadow can be taken as the one projected by a real bar of wood that was presumably added as a supplement to the representation, which was constructed on and above the plane of representation. In other words, the wooden bar represented—painted—captures in the representation, by its represented shadow, the sunlight illuminating the church through the diaphanous window of the choir. But by that capturing, internal to the representation, natural light turns out to be elevated—through a sort of mystical *Aufhebung* that denies it while achieving it—to the status of supernatural light by the Annunciation represented, which welcomes it, and in the church where it makes its image visible.

The wooden bar of Piero's *Annunciation* in Arezzo functions through the shadow it bears as a quasi-trompe-l'oeil. It is such a trompe-l'oeil that my description suggested, by imagining a real wooden bar added as a supplement to the representation. Trompe-l'oeil, as it was practiced throughout the age of representation, is a good example of opacification of the diaphanousness of the plane of representation. Thus, in yet another *Annunciation*, Crivelli's, in the National Gallery in London, there is the famous cucumber, which protrudes irresistibly into the viewer's space, in its aspect and for mere perception. This singular excess—and with it all the flies, all the drops of water that make it visible by appearing to be poised on the transparent plane of representation—thus enacts an opacification of the diaphanous by transgression, caesura, cut, or break, as a crack in a perfectly transparent pane of glass would do.

We could find in yet another context this transgressive excess that suspends one of the conditions of possibility of representation when the painters of the Cinquecento or the Seicento propose the image of the Holy Face to the adoration of the faithful. The veil on which, according to legend, the image of Christ had come to be imprinted, without the mediation of a human hand, thus had to be represented as the image of an archaic support of a no less originary presentation, a veil painted on a canvas prepared for painting on which is reproduced, but floating in its frame, the "blank" background that bears all simulated appearances. As for Christ's face, in order for its miraculous impression to be expressed in

the cloth of the veil, it had to float, escaping all the effects of folding of the painted veil that could have defigured it; it appears to be a pure image without background or support, in a transcendent aura in front of the very painting that represented it, a holy trompe-l'oeil of a holy relic, that of Veronica, of the *Vera Icona*, of the True Image, whose iconic excesses (trompe-l'oeil) and reflexive opacifications have no purpose but to signify the primordial transparency of a veil and the all-powerful luminous white-ness emanating from the divine face.

We can use similar terms to characterize the effects of the intrusion in the represented space of a written inscription that is not engraved in a rep-resented object like a pedestal, a marble block, or even the parapet of a window or the wall of a tomb, but that, floating on the plane, a transpar-ent limit between the space represented and the space from which the painting is seen by the viewer, makes the represented space suddenly visi-ble. An example is found in Philippe de Champaigne's 1662 *Ex-voto*, in which the text telling the story of the miracle of which the painter's daugh-ter was the beneficiary—a story syntactically framed within the formula of the reiteration of the daughter's perpetual vows as a nun given to Christ—is written on the plane of representation: the text makes the diaphanous-ness of the plane of representation visible by transforming it into the neu-tralized support surface of writing. In this case, it is the interference of the written signs in the visual representation, that is, the product of a hetero-geneous semiotic substance in the spaces defined by the constraints of the representation, that brings these constraints to light as such, so as to infuse the representation, of which they constitute the conditions of effective-ness, with disquiet, interruption, a fissuring of its "semantic" coherence and its "syntactic" cohesiveness.

~

We could find many other examples with which to pursue this inquiry into the various modes of opacification of the blank and diaphanous as-pects of representation in painting in the modern age, the modes I have called ruptures, interruptions, and syncopes. The very scope of the in-quiry, the richness of the corpus that it offers for analysis, the variety of the works in which ruptures, interruptions, and syncopes are manifested on the various levels subject to analysis, shows quite clearly that ruptures, interruptions, and syncopes are by no means individual accidents that would strike a given representation in a random or contingent way so as

to compromise, at some particular moment, on one particular point, its substantive continuity, its syntactic coherence, the regularity of its system, the logic of its organization, even the "rhetorical" articulation of its discourse. Ruptures, interruptions, and syncopes have to do, on the contrary, with the very conditions of possibility, of effectiveness, of legitimacy, of representation: they play on their own aporetic features, which are the very features of the general regime of mimesis to which representation belongs—in order to endow the products, the works, with maximum effectiveness, their ultimate power in the order of knowledge, as well as in the orders of affect and sensibility: semiotic, pathetic, and aesthetic effects that will turn out to be historically and socially invested by all present and future intellectual, religious, political, and social powers.

Reference Matter

Notes

The notes in the original French edition have been supplemented by the translator.

Chapter 1

Originally published in *Concilium* 86 (June 1973): 27–37.

1. Michel Foucault, *The Order of Things: An Archaeology of the Human Sciences* (New York: Pantheon Books, 1971).

2. Emile Benveniste, "A Look at the Development of Linguistics," in id., *Problems in General Linguistics*, trans. Mary Elizabeth Meek (Coral Gables, Fla.: University of Miami Press, 1971), pp. 18–19.

3. Ferdinand de Saussure, *Course in General Linguistics*, ed. Charles Bally and Albert Sechehaye, with Albert Reidlinger, trans. Wade Baskin (New York: Philosophical Library, 1959), p. 6.

4. Ibid., p. 7.　　　　　5. Ibid., p. 6.

6. Ibid., p. 8.　　　　　7. Ibid.

8. Ibid., p. 9.　　　　　9. Ibid., p. 121.

10. Charles Kay Ogden and Ivor Armstrong Richards, *The Meaning of Meaning: A Study of the Influence of Language upon Thought and of the Science of Symbolism* (London: Routledge & Kegan Paul, 1960), p. 5, n. 2.

11. In this connection, see Francis Mikus, "Edward Sapir et la syntagmatique," *Cahiers Ferdinand de Saussure* 11 (1953): 11–30; N. Slusareva, "Quelques considérations des linguistes soviétiques à propos des idées de F. de Saussure," *Cahiers Ferdinand de Saussure* 20 (1963): 23–46; Frederic Jameson, *The Prison-House of Language: A Critical Account of Structuralism and Russian Formalism* (Princeton, N.J.: Princeton University Press, 1972), pp. 3–39.

12. Saussure, *Course in General Linguistics*, p. 122.

13. Ibid., p. 11; emphasis added.

14. Robert Godel, *Sources manuscrites du "Cours de linguistique générale"* (Geneva: Droz, 1957), p. 155.

15. Ibid., p. 186.

16. Benveniste, "The Levels of Linguistic Analysis," in id., *Problems in General Linguistics*, pp. 103–4.

17. Eric Buyssens, "Origine de la linguistique synchronique de Saussure," *Cahiers Ferdinand de Saussure* 18 (1961): 29–30.

18. Claude Lévi-Strauss, *The Savage Mind* (Chicago: University of Chicago Press; London: Weidenfeld & Nicolson, 1962), p. 256.

19. Ibid.

20. Godel, *Sources manuscrites*, p. 39.

21. Jameson, *Prison-House of Language*, p. 6.

22. Lévi-Strauss, *Savage Mind*, p. 252.

23. Saussure, *Course in General Linguistics*, p. 16.

24. Benveniste, "Saussure after Half a Century," in id., *Problems in General Linguistics*, p. 38.

25. Saussure, *Course in General Linguistics*, p. 68.

26. Claude Lévi-Strauss, *Structural Anthropology*, vol. 1, trans. Claire Jacobson and Brooke Grundfest Schoepf (New York: Basic Books, 1963), pp. 47–48.

27. Ibid., p. 62.

28. Algirdas Julien Greimas, *Du sens* (Paris: Seuil, 1970), p. 13.

Chapter 2

A review by Louis Marin of *Théorie du nuage: Pour une histoire de la peinture*, by Hubert Damisch (Paris: Seuil, 1972), and *Esquisse d'une théorie de la pratique. Précédé de trois études d'ethnologie kabyle*, by Pierre Bourdieu (Geneva: Droz, 1972), *Critique* 321 (1974): 121–45. Bourdieu's *Esquisse* has been translated by Richard Nice, with substantial revisions, under the title *Outline of a Theory of Practice* (New York: Cambridge University Press, 1977).

1. Blaise Pascal, *Pensées*, trans. A. J. Krailsheimer (Harmondsworth, Eng.: Penguin Books, 1966), 40 (134), p. 38. Here and below, in citation of the *Pensées*, the first number is from the Lafuma edition; the second, in parentheses, is from the earlier Brunschwig edition.

2. Ibid., 21 (381), p. 35.

3. Ibid., 199 (72), p. 91.

4. Ibid., 90 (337), p. 53; 92 (335), pp. 53–54.

5. Ibid., 418 (233), p. 149; 419 (419), p. 153; 126 (93), p. 61.

6. Blaise Pascal, *The Art of Persuasion*, in *Pensées and Other Writings*, trans. Honor Levi (New York: Oxford University Press, 1995), p. 196.

7. *Pensées*, 298 (283), p. 122; 586 (33), pp. 226–27.

8. A double operation of which the Pascalian practice of discourse is both the expression and the practical verification.

9. Cf. in Bourdieu the requirements of a total and self-conscious materialism.

10. That is to say, in Damisch's terminology, the problem of theoretical breaks and their practical productivity, of resistances, censorships, repressions, and effects of contradiction—or work—of theory in practice, in a time period and a place in the world, four centuries of pictorial art in the West.

11. In the case in point, structuralism and semiology.

12. Translation of a repertory of rules or of a predetermined program of discourses and actions appropriate for a specific use.

13. Bourdieu, *Esquisse*, p. 2; cf. *Outline*, p. 160.

14. Which Bourdieu analyzes admirably for contemporary structural anthropology apropos of a passage from Claude Lévi-Strauss's *Les structures élémentaires de la parenté* (Paris: Presses universitaires de France, 1949), trans. James Harle Bell, John Richard von Sturmer, and Rodney Needham under the title *The Elementary Structures of Kinship* (Boston: Beacon Press, 1969).

15. Antoine Arnauld (1612–94), and Pierre Nicole, *Logic, or, The Art of Thinking: Containing, besides common rules, several new observations appropriate for forming judgment*, ed. and trans. Jill Vance Buroker (New York: Cambridge University Press, 1996), p. 120.

16. In fact, these latter remarks probably overschematize both authors' statements. In order to bring correctives and nuances to bear, we need only note Bourdieu's significant reference to Marx's "Theses on Feuerbach" (published in an appendix to Frederick Engels, *Ludwig Feuerbach*, ed. C. P. Dutt [New York: International Publishers, 1935], pp. 73–75), to observe that the notion of historical break is on the horizon of his praxeology or to note Damisch's insistence on the deconstructing moments or elements of the system that open the theoretical space of a history of the signifying practice of painting as such, that is, in its dialectically mediated relation to its material and social determinations.

17. Through what Bourdieu calls a reification effect of the theory.

18. Bourdieu, *Outline*, p. 171. In relation to the socialization of the body and the inculcation of the cultural arbitrary, Bourdieu calls this same principle an originary metonymy transforming the physiological event into a symbolic event, and—let me add—aiming through the constitution of the symbolic effect at the misrecognition of the act or the physiological reaction.

19. Which he rightly calls work.

20. Bourdieu, *Outline*, p. 78; the part of the quotation in square brackets does not appear in Nice's translation: cf. *Esquisse*, p. 179.

21. After an analysis of the decisive break in the system of representation of space constituted by Corregio's cupolas.

22. Pierre Charpentrat, "Le trompe-l'oeil," *Nouvelle revue de psychanalyse* 4 (1971): 161–68. See Chapter 18, "Representation and Simulacrum," below.

23. Cf. Damisch: pictorial series, theatrical series, or the example I have analyzed elsewhere in connection with Poussin of the principle *pars totalis–pars pro toto*, or the metaphoro-metonymic law of figurative representation.

24. The self-directed economy of the bourgeoisie and of capitalism, in Bourdieu's terms.

25. Damisch, *Théorie du nuage*, p. 25.

26. Ibid., p. 26. 27. Ibid.

28. Ibid., p. 27. 29. Ibid., p. 28.

30. Ibid., p. 30. 31. Ibid., p. 121.

32. Ibid., p. 142.

33. Bourdieu analyzes an effect of that unthought with the process of double negation consisting in refusing what is refused and in valorizing the necessary as well as the elective.

Chapter 3

Originally published in *Sociologie du Sud-Est*, special issue, *Sémiotique et mass media*, 37–38 (1983): 13–28.

1. Algirdas Julien Greimas, *The Social Sciences: A Semiotic View*, trans. Paul Perron and Frank H. Collins (Minneapolis: University of Minnesota Press, 1990).

2. Victor Witter Turner, *The Drums of Affliction: A Study of Religious Processes among the Ndembu of Zambia* (Oxford: Clarendon Press; London: International African Institute, 1968).

3. Jean Baudrillard, Michel de Certeau, et al., eds., *Traverses* 21–22 (1981), special issue, *La cérémonie*; Louis Marin, *Utopics: Spatial Play*, trans. Robert A. Vollrath (Atlantic Highlands, N.J.: Humanities Press; London: Macmillan, 1984).

4. George Riley Kernodle, *From Art to Theater* (Chicago: University of Chicago Press, 1949); id., "Déroulement de la procession dans le temps ou espace théâtral dans les fêtes de la Renaissance," in *Les fêtes de la Renaissance*, ed. Jean Jacquot (Paris: CNRS, 1956), 1: 443–49.

5. Jean Jacquot, "Joyeuse et triomphante entrée," in *Les fêtes de la Renaissance*, ed. id., 1: 9–19.

6. Turner, *Drums of Affliction*.

7. Michel de Certeau, *The Practice of Everyday Life*, trans. Steven F. Rendall (Berkeley and Los Angeles: University of California Press, 1984); Marin, *Utopics*; Charlotte Linde and William Labov, "Spatial Networks as a Site for the Study of Language and Thought," *Language* 51 (1975): 924–29.

8. Louis Marin, *Portrait of the King*, trans. Martha M. Houle (Minneapolis: University of Minnesota Press, 1988).

9. Edmund Ronald Leach, *Rethinking Anthropology* (London: Athlone, 1961).

10. Marianne Mesnil, "A propos du bestiaire archaïque d'Europe et de sa folk-lorisation dans la fête masquée," *Prépublications de l'Université d'Urbino*, special issue, *La fête: Approches sémiotiques*, ed. Pierre Smith et al., 92–93 (1980): 26–30.

11. Nicole Loraux, *The Invention of Athens: The Funeral Oration in the Classical City*, trans. Alan Sheridan (Cambridge, Mass.: Harvard University Press, 1986).

12. Michel Vovelle, *Les métamorphoses de la fête en Provence de 1750 à 1820* (Paris: Aubier-Flammarion, 1976), p. 227.

13. Ibid.

14. Marcel Mauss, *Sociologie et anthropologie* (Paris: Presses universitaires de France, 1966), pts. 3–6 published in English as *Sociology and Psychology: Essays*, trans. Ben Brewster (London: Routledge & Kegan Paul, 1979); Mauss, *Oeuvres* (Paris: Minuit, 1968); Claude Lévi-Strauss, *Totemism*, trans. Rodney Needham (Boston: Beacon Press, 1963); Lévi-Strauss, *Introduction to the Work of Marcel Mauss*, trans. Felicity Baker (London: Routledge & Kegan Paul, 1987).

15. Louis Marin, *Sémiotique de la passion* (Paris: Aubier-Montaigne, 1971).

16. Marin, *Portrait of the King*.

17. Jacquot, "Joyeuse et triomphante entrée," p. 11.

18. Bernard Guenée and Françoise Lehoux, *Les entrées royales françaises de 1328 à 1515* (Paris: CNRS, 1968), pp. 22–23.

19. Gregory Bateson, *Naven: A Survey of the Problems Suggested by a Composite Picture of the Culture of a New Guinea Tribe Drawn from Three Points of View* (Stanford: Stanford University Press, 1958); Alfred Gell, *Metamorphosis of the Cassowaries: Umeda Society, Language and Ritual* (London: Athlone, 1975); Raymond William Firth, *The Work of the Gods in Tikopia* (London: Athlone, 1975); Erik G. Schwimmer, *Exchange in the Social Structure of the Orokaiva: Traditional and Emergent Ideologies in the Northern District of Papua* (London: C. Hurst, 1973); Schwimmer, "Feasting and Tourism," in *La fête*, ed. Smith et al.

20. Mona Ozouf, *La fête révolutionnaire, 1789–1799* (Paris: Gallimard, 1976), pp. 182–83.

21. Frances Yates, *The Art of Memory* (London: Routledge & Kegan Paul, 1966).

22. *La fête*, ed. Smith et al.

23. *L'effimero barocco: Strutture della feste nella Roma del'600*, ed. Maurizio Fagiolo dell'Arco and S. Carandini (Rome: Bulzoni, 1978).

24. Ozouf, *La fête révolutionnaire*, p. 182 and n. 2.

25. Jacquot, "Joyeuse et triomphante entrée"; Kernodle, *From Art to Theater*.

26. Victor Witter Turner, *The Ritual Process: Structure and Anti-Structure* (Chicago: Aldine, 1969; reprint, Ithaca, N.Y.: Cornell University Press, 1977).

27. Schwimmer, "Feasting and Tourism."

28. André Chastel, "Le lieu de la fête," in *Les fêtes de la Renaissance*, ed. Jacquot, 1: 419–23.

Chapter 4

Interview with Odile Asselineau and Marie-Jeanne Guedj, published in *Nervure* 3, 1 (Feb. 1990): 52–58. This interview took place in the wake of a colloquium entitled *La figurabilité, entre psychanalyse et histoire de l'art*, held in Florence at the Institut français de Florence in May 1986.

1. Louis Marin, *Opacité de la peinture: Essais sur la représentation au Quattrocento* (Paris: Usher, 1989).
2. Edgar Wind, *Art and Anarchy* (London: Faber & Faber, 1963), p. 41.
3. Ibid., p. 40.
4. Goethe, *Faust* 1.4, cited in Bayard Taylor's translation in Sigmund Freud, *The Interpretation of Dreams*, in *The Standard Edition of the Complete Psychological Works of Sigmund Freud*, ed. James Strachey (London: Hogarth Press, 1953–74), 4: 283.
5. Stendhal, *The Life of Henry Brulard*, trans. John Sturrock (Harmondsworth, Eng.: Penguin Books, 1995), p. 2.
6. Daniel Arasse, *Le détail: Pour une histoire rapprochée de la peinture* (Paris: Flammarion, 1992).
7. Meyer Schapiro, "Muscipula diaboli: The Symbolism of the Mérode Altarpiece," *Art Bulletin* 27, 3 (Sept. 1945): 182–87, repr. in id., *Late Antique, Early Christian and Medieval Art: Selected Papers* (New York: George Braziller, 1979), pp. 1–19.
8. Arasse, *Le détail*, pp. 268–70.

Chapter 5

Lecture given at a colloquium organized in the Spelman villa by Johns Hopkins University, published in *Documentary Culture: Florence and Rome from Grand Duke Ferdinand I to Pope Alexander, VII*, ed. Elizabeth Cropper, Giovanna Perini, and Francesco Solinas, pp. 23–47 (Florence: Nuova Alfa; Baltimore: Johns Hopkins University Press, 1992).

1. Gabriel Naudé, *Considérations politiques sur les coups d'état* (Rome, 1639), repr. preceded by Louis Marin, "Pour une théorie baroque de l'action politique" (Paris: Éditions de Paris, 1988). In English, *Political Considerations upon Refin'd Politicks, and the Master-Strokes of State, as Practis'd by the Ancients and Moderns*, trans. William King (London: H. Clements, 1711).
2. See Charles Augustin Sainte-Beuve, *Portraits littéraires* (Paris: Garnier frères, 1862), 2: 467–512; Joseph William Courtney, *Gabriel Naudé, M.D., Preeminent*

Savant, Bibliophile, Philanthropist (New York: P. B. Hoeber, 1924); James Van Nostran Rice, *Gabriel Naudé, 1600–1653* (Baltimore: Johns Hopkins University Press; Paris: Les Belles Lettres, 1939); Jack Alden Clarke, *Gabriel Naudé, 1600–1653* (Hamden, Conn.: Archon Books, 1970).

3. René Pintard, *Le libertinage érudit pendant la première moitié du XVIIe siècle* (Paris: Boivin, 1943). See also Tullio Gregory's introduction to his edition of *Theophrastus redivivus* (Naples: Morano, 1979); Vittor Ivo Comparato, "Il pensiero politico dei libertini," in *Storia delle idee politiche, economiche et sociali,* ed. Luigi Firpo, pp. 95–164 (Turin: UTET, 1980), esp. pt. 4, pp. 118–31, "La politica come tecne nei 'libertini eruditi,'"; A. M. Battista, "Come giudicano la 'politica' libertini e moralisti nella Francia del Seicento," in *Il libertinismo in Europa,* ed. Sergio Bertelli, pp. 25–80 (Milan: R. Ricciardi, 1980). Earlier studies include F. E. Sutcliffe, *Guez de Balzac et son temps: Littérature et politique* (Paris: A. G. Nizet, 1959); John Stephenson Spink, *French Free-Thought from Gassendi to Voltaire* (London: University of London, Athlone Press, 1960). Among more recent texts, see Rosario Villari, *Elogio della dissimulazione: La lotta politica nel Seicento* (Bari: Laterza, 1987).

4. Leonis Allatii, *Apes urbanae sive de viris illustribus qui ab anno MDCXXX per totum MDCXXXII Romae adfuerunt ac typis aliquid avulgarunt* (Rome: L. Grignanus, 1633), pp. 114–18.

5. Naudé, *Political Considerations,* p. 25.

6. Ibid., pp. 27–28.　　　　　　　7. Ibid., p. 27.

8. Ibid., pp. 1–2.　　　　　　　9. Ibid., pp. 3–4.

10. René Descartes, *Discourse on the Method of Rightly Conducting One's Reason and Seeking the Truth in the Sciences* (1637), in *The Philosophical Writings of Descartes,* trans. John Cottingham, Robert Stoothoff, and Dugald Murdoch, vol. 1 (Cambridge: Cambridge University Press, 1985), pt. 1, p. 112.

11. Cf. Antoine Compagnon, *La seconde main; ou, Le travail de la citation* (Paris: Seuil, 1979).

12. Cf. Krzystof Pomian, *Collectionneurs, amateurs, curieux: Paris, Venise, XVIe–XVIIIIe siècle* (Paris: Gallimard, 1987), pp. 61–80; id., "Collezione," in *Enciclopedia Einaudi* (Turin: G. Einaudi, 1978), 3: 330–64, repr. as "Entre le visible et l'invisible, la collection," *Libre* 3 (1978): 3–56.

13. Philippe Hamon, *Introduction à l'analyse du descriptif* (Paris: Hachette, 1981).

14. Cf. Patricia Giudicelli-Falguières, "Invention et mémoire: Aux origines de l'institution muséographique. Les collections encyclopédiques et les cabinets de merveilles dans l'Italie du XVIe siécle" (doctoral thesis, Paris: Université Paris-I, 1988); Walter J. Ong, *Ramus: Method, and the Decay of Dialogue: From the Art of Discourse to the Art of Reason* (Cambridge, Mass.: Harvard University Press, 1958); Cesare Vasoli, *La dialettica e la retorica dell'unanesimo: Invenzione e metodo della cultura del XV e XVI secolo* (Milan: Feltrinelli, 1968); Nelly Bruyère, *Mé-*

thode et dialectique dans l'oeuvre de La Ramée: Renaissance et âge classique (Paris: J. Vrin, 1984).

15. Louis Marin, "Les combles et les marges de la représentation," *Rivista di estetica* 25 (1984): 11–33; more recently, id., *Opacité de la peinture: Essai sur la représentation au Quattrocento* (Paris: Usher, 1989).

16. On Montaigne's use of quotations, see Hugo Friedrich, *Montaigne*, ed. Philippe Desan, trans. Dawn Eng (Berkeley and Los Angeles: University of California Press, 1991), pp. 378–79; Jean-Yves Pouilloux, *Lire les* Essais *de Montaigne* (Paris: Maspero, 1970); Michael Metschies, *Zitat und Zitierkunst in Montaignes* Essais (Geneva: Droz; Paris: Minard, 1966); Compagnon, *Seconde main*, pp. 278 ff.

17. Compagnon, *Seconde main*, p. 281.

18. Ong, *Ramus*, pp. 74 ff., 96 ff., 196–214, 307–14; Henri Jean Martin, *Print, Power, and People in Seventeenth-Century France*, trans. David Gerard (Metuchen, N.J.: Scarecrow Press, 1993); Roger Chartier, *Histoire de l'édition française* (Paris: Promodis, 1982), pp. 462–603 (see pt. 3, "Le livre: Formes et usages [1530–1660]," and the bibliography).

19. Compagnon, *Seconde main*, p. 283.

20. Michel de Montaigne, *Essays*, bk. 1, xxvi, in *Complete Works: Essays, Travel Journal, Letters*, trans. Donald M. Frame (Stanford: Stanford University Press, 1957), p. 107. Montaigne would reach the point—later, to be sure—of calling a quotation an "extra ornament" (*emblème surnuméraire*). The expression is significant. "My book is always one. Except that at each new edition, so that the buyer may not come off completely empty-handed, I allow myself to add, since it is only an ill-fitted patchwork, some extra ornaments. These are only overweights, which do not condemn the original form, but give some special value to each of the subsequent ones, by a bit of ambitious subtlety" (bk. 3, ix, p. 736).

21. Ibid., bk. 1, xxv, p. 100. The third paragraph cited precedes the first two in Montaigne's original text.

22. Ibid.

23. Ibid., xxvi, p. 127.

24. Ibid., bk. 3, xii, p. 808.

25. Ibid., bk. 1, xxvi, p. 107.

26. Compagnon, *Seconde main*, pp. 296–97.

27. Ong, *Ramus*, pp. 175–86.

28. Montaigne, *Essays*, bk. 3, ix, in *Complete Works*, p. 736. Cf. Compagnon, *Seconde main*, p. 297.

29. *Essays*, "Introduction," in *Complete Works*, pp. ix–x. The final sentence is not included in the Frame translation.

30. Montaigne, *Essays*, bk. 1, xxix, p. 145.

31. Ibid., bk. 1, xxviii, p. 135.

32. Cf. Louis Marin, "'C'est moi que je peins': Topiques et figures de l'énonciation," *La part de l'oeil* (Brussels) 5 (1989): 141–53; id., "'C'est moi que je peins . . .': De la figuration du langage à la figurabilité du moi chez Montaigne,"

in *Recherches sur la philosophie et le langage*, special issue, *Hommage à Henry Joly*, 12 (1990): 373–84.

33. Montaigne, to his father on the death of La Boétie (1563?), *Letters*, in *Complete Works*, p. 1055.

34. Cf. Chapter 15, "Mimesis and Description," below.

35. Letter dated Dec. 21, 1632, cited by Jacques Guillerme in his preface to Nicolas Claude Fabri de Peiresc, *Lettres à Cassiano dal Pozzo (1626–1637)*, ed. Jean-François Lhôte and Danielle Joyal (Clermont-Ferrand: Adosa, 1989), p. 6.

36. Letter of Mar. 30, 1635, cited by Guillerme, ibid.

37. "Foundations of the Abundant Style," ed. and trans. Betty I. Knott, in *Collected Works of Erasmus* (Toronto: University of Toronto Press, 1978), 24: 577.

38. Terence Cave, *The Cornucopian Text: Problems of Writing in the French Renaissance* (Oxford: Clarendon Press, 1979), p. 28.

39. "Foundations of the Abundant Style," p. 577.

40. Cave, *Cornucopian Text*, p. 29.

41. Louis Marin, *La critique du discours* (Paris: Minuit, 1975), pp. 58–77, 351–60.

42. See Robert Lenoble, *Mersenne, ou la naissance du mécanisme* (Paris: J. Vrin, 1943); Pierre Boutroux, *L'imagination et les mathématiques selon Descartes* (Paris: Alcan, 1900); Michel Henry, "Descartes et la question de la technique," in *Le discours et sa méthode*, ed. Nicolas Grimaldi and Jean-Luc Marion, Acts of the Colloquium for the 350th Anniversary of the *Discours de la méthode* (Paris: Presses universitaires de France, 1987), pp. 285–301; Paolo Rossi, *Philosophy, Technology, and the Arts in the Early Modern Era* (New York: Harper & Row, 1970); Geneviève Rodis-Lewis, "Machineries et perspectives curieuses dans leurs rapports au cartésianisme," *XVIIe siècle* 32 (1956): 461–74. See also Jean-Pierre Cavaillé, *Descartes: La fable du monde* (Paris: Éditions de l'EHESS and J. Vrin, 1991).

43. Ibid., pp. 142–80.

44. René Descartes, *The Search for Truth by Means of the Natural Light*, in *Philosophical Writings of Descartes*, 2: 400. "This light alone, without any help from religion or philosophy, determines what opinions a good man should hold on any matter that may occupy his thoughts, and penetrates into the secrets of the most recondite sciences" (ibid.).

45. Ibid., pp. 400–401.

46. Cf. Jurgis Baltrusaitis, *Anamorphoses, ou Perspectives curieuses* (Paris: O. Perrin, 1955).

47. René Descartes, *The World*, trans. Michael Sean Mahoney (New York: Abaris Books, 1979), esp. ch. 6, "Description of a New World, and on the Qualities of the Matter of Which It Is Composed": "For a short time, then, allow your thought to wander from this world to view another, wholly new one, which I shall cause to unfold before it in imaginary spaces," Descartes writes at the be-

ginning of this chapter (p. 49); and, further on: "Now, since we are taking the liberty of imagining this matter to our fancy, let us attribute to it, if you will, a nature . . . " (p. 51).

48. Ibid., p. 199.

49. Descartes, *The World*, ch. 6, pp. 49–59.

50. Ibid., pp. 49–51.

51. Ibid., pp. 75–77.

52. Cf. Marin, *La critique du discours*, pp. 86 ff., pp. 100–105.

53. Descartes, *Discourse on the Method*, p. 132.

54. Ibid.; emphasis added.

55. Ibid., p. 133.

56. *Optics*, in *Philosophical Writings of Descartes*, p. 165.

57. See Florent Schuyl's copperplate engravings for the first edition of *L'homme* (René Descartes, *De homine figuris et latinitate donatus a Florentio Schuyl* [Leyden: Franciscum Moyardum et Petrum Leffen, 1662]). See also the illustrations by Louis de La Forge and also Girard von Gutscheven, who each worked separately on the French edition at the editor's request (*Les traitez De l'homme et De la formation du foetus*, ed. Clerselier [Amsterdam: Guillaume le Jeune, 1680]).

58. Descartes, *Rules for the Direction of the Mind*, in *Philosophical Writings of Descartes*, p. 138, rule XII, sec. 413, pp. 40–41.

59. *Oeuvres de Descartes*, ed. Charles Adam and Paul Tannery (Paris: J. Vrin, 1967), 11: 113: unpaginated figures 21, 22, and 59.

60. Cf. ibid., fig. 30; also p. 59.

61. Descartes, *Oeuvres philosophiques*, vol. 1 (1618–37), ed. F. Alquié (Paris: Garnier frères, 1963), p. 453. This passage is omitted in *Treatise on Man*, a translation of excerpts from *L'homme* in *Philosophical Writings of Descartes*.

62. Montaigne, *Travel Journal*, in *Complete Works* (Florence, Nov. 1580): "I forgot to say that in the palace of this prince, in one of the big rooms, is seen the figure of a four-footed animal in bronze relief on a pillar, represented to the life, of a strange shape, the front all scaly, and on the backbone something that looked like horns. They say that it was found in a mountain cavern and brought here alive a few years ago" (p. 932). And with reference to his second stay in Florence (June 1581), Montaigne wrote: "At this palace we saw the chimaera, which has between the shoulders a nascent head with horns and ears, and a body in the form of a little lion" (p. 1006).

63. Pietro Redondi, *Galileo Heretic = Galileo eretica*, trans. Raymond Rosenthal (Princeton, N.J.: Princeton University Press, 1987), p. 69.

64. Giuliano Fabrici, "Dell'ambizione del letterato," Agostino Mascardi, in *Saggi accademici dati in Roma nell'Accademia del Serenissimo Principe cardinale di Savoia da diversi nobilissimi ingegni* (Venice, 1630), p. 77, cited by Redondi, *Galileo Heretic*, p. 75.

Chapter 6

Originally published in conjunction with Gilbert Dagron's "Une lecture de Cassiodore-Jordanès," under the common title "Discours utopique et récit des origines," in *Annales: Economies, sociétés, civilisations* 26, 2 (Mar. 1971): 306–27. Page references to Dagron's essay are given in the text.

1. Claude Lévi-Strauss, *Structural Anthropology*, vol. 1, trans. Claire Jacobson and Brooke Grundfest Schoepf (New York: Basic Books, 1963), p. 281.

2. I am using the terms "ideology" or "ideological" in the sense in which Lévi-Strauss uses them in *Anthropologie structurale* (Paris: Plon, 1958): "Rien ne ressemble plus à la pensée mythique que l'idéologie politique . . . séquence d'événements passés, mais aussi schème doué d'une efficacité permanente, permettant d'interpréter la structure sociale de la France actuelle, les antagonismes qui s'y manifestent et d'entrevoir les linéaments de l'évolution future" (p. 231). The English translation does not use the word "ideology": "This can be made clear through a comparison between myth and what appears to have largely replaced it in modern society, namely, politics . . . a sequence belonging to the past . . . and a timeless pattern which can be detected in the contemporary French social structure and which provides a clue for its interpretation, a lead from which to infer future developments" (*Structural Anthropology*, 1: 209). Lévi-Strauss stresses the ambiguity of this definition, but it is not that of the historical and the ahistorical that concerns us: the ambiguity I am seeking to study is that of an *effective schema*, that is, of a *force*, that makes it possible to *interpret*. Such a schema is thus at the same time a *meaning* or a *grid of meanings*; this is the same ambiguity Freud encounters in the energies of instincts and the meanings they offer to *reading*.

3. The "metaphysical" indications that follow must not be allowed to conceal the methodological opposition between comparatism and structural analysis. Comparatism aims at superimposing "sameness," establishing resemblances between phenomena, facts, or texts belonging to different objects, fields, or domains. Structural analysis is, in a sense, a second-degree comparatism that takes differences into account—differences, that is, relations, instead of terms—and that studies the relations among differences, in other words, the way differences differ, or the "signifying gaps" of which a concept such as "utopia" designates the systematic articulation.

4. We know in fact that the description of the island of Utopia appears only in book 2 of *Utopia*. Book 1, in which the island is mentioned just a few times, by Raphael, is entirely devoted to discussions of the political, economic, and social situation of contemporary England and France, with some references to imaginary countries that function in More's discourse as ad hoc models constructed especially to study a particular problem. The protagonists of these dialogues are More himself and his friends in Anvers, Raphael, Cardinal Morton, and so on.

5. More composed a Latin poem that he attributes in his fiction to Anemo-lius, a utopian poet, Raphael Hytholoday's nephew. The punch line of this poem bears on the word play I have evoked: "Vtopia priscis dicta, ob infrequentiam / Nunc ciuitatis aemula Platonicae, / Fortasse uictrix, (nam quod illa literis / Di-liniauit, hoc ego una praestiti, / Viris & opibus, optimisque legibus) / Eutopia merito sum uocanda nomine." A translation is provided in the Surtz-Hexter edi-tion: "The ancients called me Utopia or Nowhere because of my isolation. At present, however, I am a rival of Plato's republic, perhaps even a victor over it. The reason is that what he has delineated in words I alone have exhibited in men and resources and laws of surpassing excellence. Deservedly ought I to be called by the name of Eutopia or Happy Land" (*The Complete Works of St. Thomas More*, vol. 4, ed. Edward Surtz, S.J., and J. H. Hexter [New Haven, Conn.: Yale University Press, 1965], pp. 20–21).

6. Letter of Peter Giles to Jerome Busleyden: "Nam quod de insulae situ lab-orat MORVS, ne id quidem omnino tacuit Raphaël, quanquam paucis admodum, ac uelut obiter attigit, uelut hoc alii seruans loco. Atque id sane nescio quo modo casus quidam malus utrique nostrum inuidit. si quidem cum ea loqueretur Ra-phaël, adierat MORVM e famulis quispiam, qui illi nescio quid diceret in aurem, ac mihi quidem tanto attentius auscultanti, comitum quispiam, clarius, ob tri-gus opinor, nauigatione collectum, tussiens, dicentis uoces aliquot intercepit." Translation: "As to More's difficulty about the geographical position of the is-land, Raphael did not fail to mention even that, but in very few words and as it were in passing, as if reserving the topic for another place. But, somehow or other, an unlucky accident caused both of us to fail to catch what he said. While Raphael was speaking on the topic, one of More's servants had come up to him to whisper something or other in his ear. I was therefore listening all the more in-tently when one of our company who had, I suppose, caught cold on shipboard, coughed so loudly that I lost some phrases of what Raphael said" (Thomas More, *Complete Works*, 4: 22–23).

7. On this subject, see Emile Benveniste's text on temporal relations in the French verb system ("The Correlations of Tense in the French Verb," in id., *Prob-lems in General Linguistics*, trans. Mary Elizabeth Meek [Coral Gables, Fla.: Uni-versity of Miami Press, 1971], pp. 205–15). As an example of one of the two dis-tinct and complementary systems between which the tenses of French verbs are distributed, Benveniste uses a text drawn from Gustave Glotz's *Histoire grecque*: historical narration is defined as "the mode of utterance that excludes every 'au-tobiographical' linguistic form" (*Problems*, p. 206).

8. Cassiodorus-Jordanes, *Getica*, 266, in *The Gothic History of Jordanes in Eng-lish Version*, ed. Charles Christopher Mierow (Princeton, N.J.: Princeton Univer-sity Press, 1915), pp. 52–53, 127; emphasis added. See also Mierow's discussion, p. 36.

9. More, *Utopia*, bk. 2, in *Complete Works*, p. 112.

10. Cassiodorus-Jordanes, *Getica*, 7 (*Gothic History*, p. 53).

11. The sentence in question is the following: "Cujus cornua fretum interfluens, millibus passuum plus minus undecim dirimit, ac per ingens inane diffusum, circumiectu undique terrae prohibitis uentis, uasti in morem lacus stagnans magis quam saeuiens, omnem prope eius terrae aluum pro portu facit." Translation: "The horns of [the island] are divided by straits about eleven miles across. The straits then unfold into a wide expanse. As the winds are kept off by the land which everywhere surrounds it, the bay is like a huge lake, smooth rather than rough, and thus converts almost the whole center of the country into a harbor . . . " (More, *Utopia*, bk. 2, in *Complete Works*, 4: 110–11). Gaffiot's dictionary gives the following for *alvus*: "1) Belly, intestine; 2) Belly flow, evacuations; 3) Womb; 4) Stomach; 5) Hive; 6) Shell of a boat." Let us note in passing the interest of the fifth meaning, given that Jordanes equates the Goths' departure from Scandza with that of a swarm of bees.

12. Plato, *Critias*, in *Timaeus; Critias; Cleitophon; Menexenus; Epistles*, trans. R. G. Bury (Loeb Classical Library), 113 d–e.

13. On this point I am departing from Jean Servier's general interpretation in his *Histoire de l'utopie* (Paris: Nouvelle revue française, 1967), and from certain comments by Arthur Leslie Morton, *The English Utopia* (London: Lawrence & Wishart, 1952)—and even from the analytic themes of Edmond Bergler and Geza Róheim, "La psychologie de la perception du temps," *L'homme et la société* 11 (Jan.–Mar. 1969): 69–80.

14. Cassiodorus-Jordanes, *Getica*, 148–51 (*Gothic History*, pp. 92–93).

15. In the Goths' entrance into Romanity and in their integration to the Empire, there is a kind of "failure," which Cassiodorus-Jordanes relates in an episode that might warrant in-depth structural analysis. The accession of Maximin, the self-styled Goth, to the supreme office of emperor, is a failure, since Maximin is killed by soldiers after a three-year reign. But it is noteworthy that his climb toward the throne (which is an entirely personal, individual ascension, and not at all a collective and national one—and that is one of the reasons, it seems, for its failure, according to Jordanes's ideological schema) can be analyzed as an initiatory narrative. In this narrative, times and individuals are measured by the significant numbers 3 and 7, and the well-marked-out phases of the itinerary could be related, without stretching things too far, to certain well-known heroic trials. Two battles occur *three days* apart, opposing Maximin to adversaries of increasing valor, but in decreasing number—sixteen camp servants, then seven soldiers. Maximin triumphs over his enemies in succession, one by one, and without catching his breath between "assaults"; similarly, the two battles are separated by a sort of test of mastery, conducted by the emperor, of the barbarous Goth's martial fury. Maximin then spends three years without fighting in the service of the emperor, for the latter, Macrinus, has conquered the empire by criminal means.

Maximin is then elected emperor by the soldiers and reigns for *three years*, but he dies at an assassin's hand because he persecutes Christians as a result of an impious vow. A hero dedicated to triplicity (of days and years), Maximin seems to be obliged, through "victory in single-handed combat . . . inspired by the great master of the martial function and on behalf of that great master" (the emperor), to accede to that function and thus to his own end (on the opposition between *furor* and *disciplina*, see "Note liminaire," *Cahiers pour l'analyse* 7 [Mar.–Apr. 1967]: 7–8, and Georges Dumézil, "Lecture de Tite-Live," ibid.: 9–42, esp. p. 36, from which the above citation is drawn). In a first phase, he serves in the cavalry; then, three days later, he is bodyguard to the emperor. But this victory entails a blemish that he will have to expiate, through the concentric circles that Septimus Severus will put him through to wear him out (mastery of *furor*), then by a rest period of three years. But *martial impiety* finally wins out, since, once he is emperor, he is led to his ruin by a criminal vow pronounced against Christians: the somewhat muddled and obliterated schema of a barbarian Horace, [that] of a Gothic Tullus [Hostilius, traditionally the third king of Rome and destroyer of Alba Longa, said to have been killed by lightning], which I invoke here as a mere suggestion. Cf. Georges Dumézil, *Mythe et épopée* (Paris: Gallimard, 1968), 1: 280: "As for Tullus, he is in Rome; an impious king, he is a living scandal, and the end of his story is only the terrible revenge that Jupiter, master of great magic, exacts against that too purely warlike king, who has so long ignored him . . . (see Livy, 1.31.6–8). Such are the fatalities of the martial function."

16. Thomas More, *Utopia*, bk. 2, in *Complete Works*, p. 146: "*Always exposed to the eyes of all [omnium praesentes oculi]*, each is obliged to practice his trade or to engage in an irreproachable leisure activity" (emphasis added).

17. The evil but marvelous birth of the Huns may bring to mind the obscure biblical episode of the birth of the Giants (Gen. 6: 1–4). The Nephilim are considered to be Titans born of the union between mortals and celestial beings. Their descendants are connected with the Hebrew people heading toward the Promised Land, for they occupy territories that the Hebrews have to cross or conquer (in this connection, see Num. 13:25–33, and, esp., 13:32–33). Their presence blocks Israel's voyage *in search of a land*, for it leads Caleb, sent ahead to explore with some companions, to make a very unfavorable report on the Promised Land. The Giants or their descendants thus constitute evil twins for the Hebrew people: they are marvelously powerful, but in a negative or malevolent sense, during the Hebrews' voyage—hence the latter's prolonged wanderings in the desert. On this episode of the explorers and what they report, see the admirable Talmudic reading by Emmanuel Levinas ("Promised Land or Permitted Land," in *Nine Talmudic Readings*, trans. Annette Aronowicz [Bloomington: Indiana University Press, 1990], pp. 51–69). An enlightening anthropological analysis of the birth of the Giants in Genesis is offered by E. R. Leach in "Genesis as Myth," *Discovery* 23 (May

1962): 30–35; repr. in *Genesis as Myth and Other Essays* (London: Jonathan Cape, 1969), pp. 7–23. The homology presupposed by our text involving the Huns is that of a negative function of the doublet, at once horrible and sacred, which, by provoking a trial, allows the "positive" people to achieve self-realization. It is remarkable that Cassiodorus-Jordanes gives the historically existing Huns an authentic structural interpretation that their fabulous character must not be allowed to conceal; Dagron saw this with particular clarity.

18. Concerning Zalmoxes, or Zalmoxis, see a quite remarkable passage in Plato's *Charmides* (in *Charmides; Alcibiades I and II; Hipparchus; The Lovers; Theages; Minos; Epiminos*, trans. W. R. M. Lamb [Loeb Classical Library]) which connects the royal function and the religious function: "Xalmoxis, our king who is a god . . . ," a Thracian doctor says to Socrates (156d). The entire passage warrants careful study.

19. Cassiodorus-Jordanes, *Getica*, 73 (*Gothic History*, p. 71). Here is the beginning of a dimension of reading that I have not pursued but that is worth mentioning briefly. Cassiodorus-Jordanes characterizes Dicineus as a sort of double for the king, a double who also stood in for Burebista's successor Comosicus. This almost-king taught the Goths all the sciences, but he was especially noteworthy for instituting a college of priests, to which "[h]e gave the name of Pilleati . . . , I suppose because they offered sacrifice having their heads covered with tiaras, which we otherwise call *pillei*." Dicineus's wisdom and the "marvelous repute" he gained among the Goths meant that "he ruled not only the common men but their kings" (*Getica*, 71 [*Gothic History*, p. 71]). These remarks, although second- or third-hand, since they are drawn from Cassiodorus and from the authors he used as sources, are nevertheless invaluable, for they point to a "moment"—historical or ideological—when Gothic royalty acquired its second function, as it were, at least in Cassiodorus-Jordanes's memory—unless the latter drew on the Roman ideological schema and the succession between Romulus and Numa Pompilius to tell their semi-fabulous story.

In the perspective opened up by this hypothesis, it would be interesting to consider the text by Dio Cassius (68.8–9) that Georges Dumézil cites and discusses in his study of the social organization of the Ossetes and the Scythians (*Mythe et épopée*, 1: 444–45). Let us note that Dio Cassius is one of the authors upon whom Jordanes-Cassiodorus relied (see "Cassiodori senatoris chronica," in *Chronica minora saec. IV, V, VI, VII*, ed. Theodor Mommsen [Berlin: Weidmann, 1892–98], 2: 109–61; *Gothic History*, pp. 26 ff.). Scythians, Ossetes, and Alans all seem to have had a form of organization with two distinct classes: on the one hand, nobles or princes (a class that may have been organized hierarchically in turn), and, on the other hand, common men, free but not noble—there are indications to this effect both in ancient authors such as Lucian and Herodotus and in more recent ethnographic studies ([e.g., of the] Circassians). Dio Cassius's text alludes to πιλοφόροι

Dacians, in opposition to common χομῆται Dacians, *capillati*, hairy ones. Similarly, one of Lucian's texts contrasts the πιλοφοριχοί Scythians to the common δημοτιχοί Scythians. "What were the πιλοφοριχοί, those *wearers of felt head-dresses?*" Dumézil writes. "Most plausibly a military aristocracy, as Rostovzeff thought. While we have no direct information about them, about the πῖλος which is their distinctive sign, we may suppose that they were analogous to the πιλοφόροι of the Dacians, who were incontestably in the martial society of the nobility."

If I understand Dumézil's point correctly, the information offered by Jordanes concerning the *Pilleati*, the college of priests, does not correlate with the information supplied by Lucian or Dio Cassius. But Dumézil goes on: ". . . these feudal societies are not functional, do not continue the Indo-European type. In particular, there does not seem to have been a 'priestly class' among the Scythians. Herodotus points out as specialists only the sorcerer-soothsayers (*The Histories*, trans. A. D. Godley [Loeb Classical Library], 4.67), and, apart from divination, religious acts were accomplished by the leaders, from kings to heads of families." What are we to conclude? Might Jordanes-Cassiodorus's text retain the trace of interference between two organizational schemas, one of the Roman, Indo-European type, the other of the feudal-Scythian type? Dicineus's appearance would then correspond to the point, the precise "moment," of this interference. The warrior nobles would then become a priestly class, and the king would be doubled by a religious king up to the "later" moment (but might that posteriority just as well be anteriority?) when the king acquires a religious function. If this hypothesis were to be confirmed or supported by specialists, the Dicineus episode would take on the full historico-ideological value that my own very rapid structural analysis has allowed me to give it.

20. In a note to her translation of More's *Utopia* (Brussels: La Renaissance du livre, n.d.), Marie Delcourt writes: "The works More cites were printed in the twenty-year period between 1495 and 1515, with the exception of Galen's *Technē Iatrikē (Art of Physick)*, which was printed by Aldes only in 1525. A companion on Vespucci's fourth voyage could not have taken Hesychius's *Lexicon*, which was published by Musurus in Venice only in 1514" (p. 105).

21. Thomas More, *Complete Works*, 4: 181.

22. Ibid., p. 183.

23. Cassiodorus-Jordanes, *Getica*, 67 (*Gothic History*, pp. 69–70).

24. Ibid., 68 (*Gothic History*, p. 70; emphasis added).

Chapter 7

Originally published in *Esprit* 423 (Apr. 1973): 913–28. Epigraphs respectively from G. W. F. Hegel, *Lectures on the Philosophy of History*, trans. J. Sibree (London: George Bell & Sons, 1902), p. 409; Claude Lévi-Strauss, *Structural Anthro-*

pology, trans. Claire Jacobson and Brooke Grundfest Schoepf (New York: Basic Books, 1963), p. 95; and id., *Introduction to the Work of Marcel Mauss*, trans. Felicity Baker (London: Routledge & Kegan Paul, 1987), pp. 55–56.

1. Xavier Léon-Dufour, *Resurrection and the Message of Easter*, trans. R. N. Wilson (London: Geoffrey Chapman, 1974; New York: Holt, Rinehart & Winston, 1975). Originally published as *Résurrection de Jésus et message pascal* (Paris: Seuil, 1971). Page references to the English edition of this work are given in the text.

2. "*La pensée sauvage* et le structuralisme," *Esprit* 322 (1963): 545–653; see esp. Paul Ricoeur, "Structure et hermeneutique," pp. 596–627, and Claude Lévi-Strauss, "Réponses à quelques questions," pp. 628–53.

3. Vladimir Propp, *Morphology of the Folktale*, trans. Laurence Scott, 2d ed. (Austin: University of Texas Press, 1968).

4. On this definition of the notion of genre, see Gilles Gaston Granger, *Essai d'une philosophie du style* (Paris: Armand Colin, 1968).

5. See Louis Marin, "Les femmes au tombeau: Essai d'analyse structurale d'un texte évangélique," *Langages* 22, special issue, *Sémiotique narrative: Récits bibliques* (June 1971): 39–74.

6. Emile Benveniste, "The Nature of the Linguistic Sign," in id., *Problems in General Linguistics*, trans. Mary Elizabeth Meek (Coral Gables, Fla.: University of Miami Press, 1971), p. 46.

7. Ibid.

8. Gérard Genette, *Figures III* (Paris: Seuil, 1972), p. 73.

9. Benveniste, "Saussure After Half a Century," in id., *Problems in General Linguistics*, p. 38.

10. E.g., Wayne C. Booth, *The Rhetoric of Fiction* (Chicago: University of Chicago Press, 1961).

11. Michel de Certeau, "Histoire et mystique," *Revue d'histoire de la spiritualité* 48 (1972): 71.

12. Lévi-Strauss, *Structural Anthropology*, 1: 62.

13. Ibid.

14. Lévi-Strauss, *Introduction to the Work of Marcel Mauss*, pp. 58–59.

15. I could make similar remarks about the proper names of the witnesses. In his hermeneutic part 4, Léon-Dufour stresses quite correctly that "two basic literary categories are concerned with the Easter event: witness and narrative" (p. 201). Now the witness is first of all a list of witnesses, a list of names of individuals each of whom "certifies to others the reality of a fact or of an experience" (ibid.). In the text, the witness is a name that designates an attestation in speech, a discursive authority, a discourse on reality; that is, a discourse grasped in its production.

16. Claude Lévi-Strauss, *The Savage Mind* (Chicago: University of Chicago Press, 1966), pp. 214–15.

Chapter 8

Originally published in *Modern Language Notes* (Johns Hopkins University Press) 91, 5 (Oct. 1976): 939–51. A version of this article was presented in December 1975 at a seminar entitled "Sign/Percept/Trace," at the annual meeting of the Modern Language Association.

1. Emile Benveniste, "L'appareil formel de l'énonciation," in id., *Problèmes de linguistique générale*, 2: 79–88 (Paris: Gallimard, 1974); emphasis added.
2. Emile Benveniste, "Le langage et l'expérience humaine," in id., *Problèmes de linguistique générale*, 2: 67; emphasis added.
3. Ibid., p. 74; emphasis added. 4. Ibid.
5. Ibid. 6. Ibid.
7. Pierre Aubenque, *Le problème de l'être chez Aristote* (Paris: Presses universitaires de France, 1962), p. 422.
8. Aristotle, *The Physics*, vol. 1, trans. Philip H. Wicksteed and Francis M. Cornford (Loeb Classical Library), 4.13.222a14–16.
9. Ibid., 14.223a8.
10. *The Confessions of St. Augustine*, trans. F. J. Sheed (London: Sheed & Ward, 1945), 11.14, p. 217.
11. "L'appareil formel de l'énonciation," p. 82.
12. *The Standard Edition of the Complete Psychological Works of Sigmund Freud*, ed. James Strachey (London: Hogarth Press, 1953–74), 19: 235–39.
13. Ibid., p. 236; emphasis added. 14. Ibid.
15. Ibid., p. 237. 16. Ibid.
17. Diogenes Laertius, *Lives of Eminent Philosophers*, trans. R. D. Hicks (Cambridge, Mass.: Harvard University Press, 1972 [Loeb Classical Library]), vol. 1, bk. 2, pp. 245–47.
18. G. W. F. Hegel, *Phenomenology of Mind*, trans. J. B. Baillie, 2d ed., rev. and corr. (London: George Allen & Unwin; New York: Humanities Press, 1977), p. 159.

Chapter 9

Preface to Bernard Sarrazin, *La Bible en éclats: L'imagination scripturaire de Léon Bloy* (Paris: Desclée de Brouwer, 1977), pp. 5–21. Page references to Sarrazin's book are given in the text.

1. *The Thoughts, Letters and Opuscules of Blaise Pascal*, trans. O. W. Wright (Cambridge: Riverside Press, 1887), pp. 473–75.
2. Ibid., letter to Mademoiselle de Roannez (Oct. 1656), p. 443.
3. Blaise Pascal, *Pensées*, trans. A. J. Krailsheimer (Harmondsworth, Eng.:

Penguin Books, 1966), 47 (172), p. 43. The first *pensée* number is from the Lafuma edition; the second, in parentheses, is from the earlier Brunschwig edition.

4. Léon Bloy, *Le salut par les Juifs* (1892), rev. ed. (Paris: J. Victorion, 1906).

Chapter 10

Originally published in *Furor* (1991): 5–24. The text consists of a number of excerpts from a seminar given in English at the University of Cambridge (King's College) in November 1990. Aristotle's texts are cited in the Loeb Classical Library editions.

1. "The Power of Fables," in *The Complete Fables of Jean de la Fontaine*, trans. Norman B. Spector (Evanston, Ill.: Northwestern University Press, 1988), bk. 8, ll. 66–70, p. 363.

2. Cf. my study of that fable in *Le récit est un piège* (Paris: Minuit, 1978), pp. 17–34, and "La voix du conte entre La Fontaine et Perrault," *Critique* 394, special issue, *Littératures populaires: Du dit à l'écrit* (Mar. 1980): 333–42.

3. Book 8 belongs to the second collection published by La Fontaine in 1678; the first six books were published in 1668. "Peau d'âne," on the other hand, was published in 1694 by Charles Perrault.

4. "At this reproof the cohort there, / By the apologue thus made aware, / Turned as one to the Orator's story. / The twist of a fable earned all the Glory" (La Fontaine, "The Power of Fables," ll. 61–64, p. 363).

5. On the notions of bifurcation and branching connections, cf. the logic of heterogeneous entities presented by Gilles Deleuze in *Le rhizome: Introduction* (Paris: Minuit, 1976).

6. Stendhal, *De l'amour*, ed. H. Martineau (Paris: Hazan, 1948), p. 83, n. 1.

7. The term *signe mémoratif* ("memorative sign") is Rousseau's. Cf. Stendhal: "Does music appeal to me as a *sign*, as recalling the happiness of youth, or *in itself*?" (*The Life of Henry Brulard*, trans. John Sturrock [New York: Penguin Books, 1995], p. 397).

8. Supplement, *suppléance*: it is the paradox of the supplement-*suppléant* that is developed by this metamorphosis of the position of discourse from a "making known" into a "giving (oneself) pleasure," a paradox that Aristotle exposes implicitly in *Nicomachean Ethics* (10.4.1174b). "The pleasure perfects the activity, not as the fixed disposition does, by being already present in the agent, but as a supervening perfection, like the bloom of health in the young and vigorous" (ibid., 8). But pleasure as supplement or ornament becomes, at the end of the chapter, the crowning of life and the accomplishment of every activity, its *suppléant* when it realizes its end. "The question whether we desire life for the sake

of pleasure or pleasure for the sake of life, need not be raised for the present. In any case they appear to be inseparably united: for there is no pleasure without activity, and also no perfect activity without its pleasure" (ibid., 11). See also my discussion of the excerpts from *Rhetoric* and *Poetics*, below.

9. The point of departure and the foundation for these remarks on the double narrative denegation and its effects of pleasure is obviously Benveniste's seminal study of the enunciative modality of "history" as opposed to that of "discourse," in "The Correlations of Tense in the French Verb," in id., *Problems in General Linguistics*, trans. Mary Elizabeth Meek (Coral Gables, Fla.: University of Miami Press, 1971), pp. 205–15.

10. Charles Perrault, *Contes*, ed. G. Rouger (Paris: Garnier-Flammarion, 1967), p. 57.

11. It would be of some interest to compare the enunciatory structure of the power play of the writer-narrator of the oral tale to the structure of the coup d'état of a prince, producing the decisive act in which state power is revealed. Cf. my study of Gabriel Naudé's *Considérations politiques sur les coups d'Etat* (2d ed., Paris, 1662; repr. Paris: Editions de Paris, 1988), in Chapter 6, "Utopian Discourse and Narrative of Origins," above.

12. Perrault, *Contes*, p. 57.

13. Ibid.; emphasis added.

14. Ibid.

15. The movement is indeed the inverse of the one Descartes analyzes in the *Discourse on the Method of Rightly Conducting One's Reason and Seeking the Truth in the Sciences* (*The Philosophical Writings of Descartes*, trans. John Cottingham, Robert Stoothoff, and Dugald Murdoch, vol. 1 [Cambridge: Cambridge University Press, 1985]) and elsewhere, in which childhood (because "we were all children before being men" [*Discourse*, pt. 2, p. 117]) is in some sense the "natural" original sin of the reasonable man: a position that in no way excludes Descartes's methodical and epistemological recourse to fable and fiction. See also Antoine Arnauld, *Logic or the Art of Thinking*, ed. and trans. Jill Vance Buroker (New York: Cambridge University Press, 1996), pp. 52–53, and my commentary in *La critique du discours* (Paris: Minuit, 1975), pp. 205–8.

16. Charles Perrault, "Preface to the Tales in Verse," in *Charles Perrault: Memoirs of My Life*, ed. and trans. Jeanne Morgan Zarvechi (Columbia: University of Missouri Press, 1989), Appendix D, p. 120.

17. Perrault, "Preface to the Tales in Verse," p. 120. This text—to continue the "dialogue" between Perrault and La Fontaine—seems to echo the verses of the fabulist that open the sixth book of the *Fables*: "Fables have more than what they seem to feature. / In them the simplest beast will serve as a teacher. / A bare moral does little but bore; / It's in stories we'll swallow precepts galore. / But fictions like this must edify, not merely beguile. / Tales for the telling don't seem to

me worthwhile" (La Fontaine, *Complete Fables*, bk. 6, 1 and 2, "The Shepherd and the Lion" and "The Lion and the Hunter," ll. 1–6, p. 243).

18. Ibid., p. 122.

19. In *Pensées and Other Writings*, trans. Honor Levi (New York: Oxford University Press, 1995), pp. 193–204.

20. Ibid., p. 193.

21. Ibid., p. 194.

22. Ibid., p. 195.

23. Ibid.

24. Ibid., p. 196.

25. Augustine; see in particular *On Christian Doctrine*, trans. D. W. Robertson, Jr. (Indianapolis: Bobbs-Merrill, 1958), bk. 4, pp. 117–69.

26. Ibid., bk. 1, ch. 4, §4, pp. 9–10. For other references in Augustine's work, see also an important note by F. Cayré in Augustine, *De doctrina christiana*, in *Oeuvres complètes* (Paris: Desclée, 1949), 11: 558–61, n. 18.

27. Pascal, *Pensées*, trans. A. J. Krailsheimer (Harmondsworth, Eng.: Penguin Books, 1966), 148 [428], p. 74. In citation of the *Pensées*, the first number is from the Lafuma edition, the second, in parentheses, is from the earlier Brunschwig edition.

28. Ibid.

29. Ibid., p. 75.

30. Pascal, *Art of Persuasion*, p. 204. Actually, the interruption (which the editor emphasizes with ellipsis dots) is less of the syntactic order than of the semantic and logical order. It seems in fact that the argument is lost in silence, a silence that seems to mark the excess of what there may be to say. In fact the "delicate" things that Pascal evokes are the principles of the spirit of finesse, which are there for all to see, but "so delicate and so numerous" that it is almost impossible not to miss some (*Pensées*, 512 [1], pp. 210–11).

31. Perrault, *Contes*, p. 57.

32. Benveniste, "Correlations of Tense in the French Verb," p. 208.

33. Cf. Michel de Certeau, "L'opération historique," in *Faire de l'histoire*, ed. Jacques Le Goff and Pierre Nora, 1: 3–41 (Paris: Gallimard, 1974). See also de Certeau, "Making History," in *The Writing of History*, trans. Tom Conley, pp. 20–55 (New York: Columbia University Press, 1988).

34. Benveniste, "Correlations of Tense," p. 206.

35. Cf. Louis Marin, "A propos d'un carton de Le Brun: Le tableau d'histoire ou la dénégation de l'énonciation," *Revue des sciences humaines* 157 (1975): 41–64.

36. Aristotle, *The Art of Rhetoric*, trans. J. H. Freese (Loeb Classical Library), 1.11.10.

37. Ibid., 11.

38. Aristotle, *Nicomachean Ethics*, trans. H. Rackham (Loeb Classical Library), 9.5.3.

39. Ibid.

40. Aristotle, *Rhetoric* 1.11.1370b11–12.

41. Homer, *The Odyssey*, trans. A. T. Murray, rev. George E. Dimock (Loeb Classical Library), 4.183.

42. Ibid., 174–80.

43. On the passage that follows, see Roselyne Dupont-Roc and Alain Le Boulluec, "Le charme du récit (*Odyssée*, IV, 219–289)," in *Ecriture et théorie poétiques: Lectures d'Homère, Eschyle, Platon, Aristote* (Paris: Presses de l'École normale supérieure, 1976), pp. 35–39, and also Jean-Pierre Vernant, *Figures, idoles, masques* (Paris: Julliard, 1990), pp. 41 ff. The use of the drug (*pharmakon*) that Helen mixes with the wine at the banquet where Telemachus is welcomed and Ulysses evoked by Menelaus's narrative would warrant lengthy analysis: Helen "cast into the wine of which they were drinking a drug to quiet all pain and strife, and bring forgetfulness of every ill. Whoever should drink this down, when it is mingled in the bowl, would not in the course of that day let a tear fall down over his cheeks, no, not though his mother and father should lie there dead . . . " (*Odyssey* 4.219–21). The "charm" of the drug and the pleasure effect of the narrative (of the hero's suffering) have been linked since antiquity (Plutarch, *Table-Talk*, in *Moralia*, vol. 8, trans. Paul A. Clement [Loeb Classical Library], 614b–c; Macrobius, *The Saturnalia*, trans. Percival Vaughan Davies [New York: Columbia University Press, 1969], 7.1.1–19). See also Ann L. T. Bergren, "Helen's 'Good Drug': *Odyssey* IV, i–305," in *Contemporary Literary Hermeneutics and Interpretation of Classical Texts / Herméneutique littéraire contemporaine et interprétation des textes classiques*, ed. Stephanus Kresic (Ottowa: Editions de l'Université d'Ottowa / Ottowa University Press, 1981), pp. 201–14; and Simon Goldhill, "Reading Differences: The *Odyssey* and Juxtaposition," *Ramus: Critical Studies in Greek and Roman Literature* 17, 1 (1988): 1–30.

44. Aristotle, *Rhetoric* 1.11.1371a21.

45. We note in Descartes the same articulation between the desire to know—admiration, the most primitive of the passions, which like every desire is accompanied by a certain pleasure—and its fulfillment in knowledge, which is complete pleasure. Cf. René Descartes, *The Passions of the Soul*, in *Philosophical Writings of Descartes*, article 53, p. 350; articles 70–72, pp. 354, and esp. article 75, "How wonder, in particular, is useful," p. 354, and article 76, "In what ways it can be harmful, and how we can make good its deficiency and correct its excess," p. 385.

46. Aristotle, *Rhetoric* 1.11.1371b23–24.

47. Aristotle, *Poetics* 1450b ff.; 1451a30–35 ff.; 1454a33; 1460a26–32.

48. Ibid., trans. Stephen Halliwell, 1448b17–19. Cf. also 1450b1–4; but here Aristotle stresses the lesser charm of randomly applied colors compared to the charm of the image drawn in black and white that allows recognition. We note in this passage that for "colors" Aristotle uses the term *pharmaka*, which empha-

sizes materiality, the colored "substance" in *Poetics*. This usage can be compared with the narrative *pharmakon* in *The Odyssey*, bk. 4; cf. n. 43 above.

49. We can also note that these pleasure effects evoked by Aristotle in the name of the opacities of mimesis in the poetic, the pictorial, or the sculptural, have a remarkable affinity with the characteristic features of the third genre of discourse studied by Aristotle in *Rhetoric*, the epideictic, or demonstrative. Positing with complete clarity the three poles of the enunciative agency, the person who speaks, the subject about which he speaks, and the person to whom he speaks, Aristotle notes that in the epideictic—and unlike the deliberative (political) or the judicial—the hearer is not judge (*kritēs*) but spectator (*theōros*), that as such he does not pronounce judgment on the past (as in the judicial) or on the future (as in the deliberative) but in the present, on the talent (*dunamis*), the power of the enunciating orator, the goals of the discourse no longer being the useful (deliberative) or the just (judicial) but the beautiful.

50. Aristotle, *Poetics* 1460a5–11. Cf. Jean Lallot's fine study of this passage in *Écriture et théorie poétiques: Lectures d'Homère, Eschyle, Platon, Aristote* (Paris: Presses de l'École normale supérieure, 1976). See also Aristotle, *La poétique*, trans. Roselyne Dupont-Roc and Jean Lallot (Paris: Seuil, 1980), p. 380, n. 8.

51. *Odyssey* 1.1–10.

52. Aristotle, *Rhetoric* 3.14.1415a8–22.

53. Hence the discussion in *Poetics* 1460b23–26 of the implausibilities allowed to produce the effect of surprise (*thaumaston*) proper to tragedy: "Say a poem contains impossibilities: this is a fault. But it is acceptable if the poetry achieves its goal (which has been stated), that is, if it makes this or some other part of the work more thrilling [*ekplēktikōteron*]." As Roselyne Dupont-Roc and Jean Lallot say in their edition of Aristotle, *La poétique*, p. 391, "the reader's pleasure, procured by astonishment . . . echoes the *thaumaston*, the pleasant surprise" (1460a17).

54. Thus in poems, in tragic poems in particular, Aeschylus's formula "One must suffer in order to learn" would take the form of a complementary reversal: "One must know in order to forget suffering [and to enjoy representation]."

Chapter 11

Lecture given at a colloquium in Cerisy, France, in July 1980, published in *Les fins de l'homme: A partir du travail de Jacques Derrida* (Paris: Galilée, 1981), pp. 317–44.

1. Ovid, *Metamorphoses*, trans. A. D. Melville (New York: Oxford University Press, 1986), 4.770–86, pp. 97–98.

2. Ibid., "Narcissus and Echo," 3.407–20, p. 63.

3. Yves Bonnefoy, *L'arrière-pays* (Geneva: Skira, 1972), pp. 10–14.

4. Pascal, *Pensées*, trans. A. J. Krailsheimer (Harmondsworth, Eng.: Penguin

Books, 1966), 31 (149), p. 37. In citation of the *Pensées*, the first number is from the Lafuma edition; the second, in parentheses, is from the earlier Brunschwig edition.

5. Edgar Wind, *Giorgione's "Tempesta," with Comments on Giorgione's Poetic Allegories* (Oxford: Clarendon Press, 1969), p. 2; emphasis added.

6. Ibid.

7. Ibid., p. 3.

8. Ibid.

9. Jacques Derrida, *The Truth in Painting*, trans. Geoff Bennington and Ian McLeod (Chicago: University of Chicago Press, 1987), pp. 119–22.

10. Immanuel Kant, *The Critique of Judgment*, trans. Werner S. Pluhar (Indianapolis: Hackett, 1987), §23, pp. 99–100.

11. Ibid., §28, pp. 119–20; second emphasis added.

12. Pierre Fontanier, *Les figures du discours* (Paris: Flammarion, 1968), p. 183.

13. *Life of Henry Brulard*, trans. John Sturrock (New York: Penguin Books, 1995), pp. 5–6.

14. Jean Laplanche and Jean-Baptiste Pontalis, *The Language of Psychoanalysis*, trans. Donald Nicholson-Smith (New York: Norton, 1973), p. 203.

15. Ibid., p. 204.

16. Ibid., p. 263.

17. Hubert Damisch, "L'alphabet des masques," *Nouvelle revue de psychanalyse*, special issue, *La passion*, 21 (1980): 131.

Chapter 12

Originally published in *Cahiers de l'École normale supérieure de Fontenay* 30–31 (1983): 11–26. The text originated in an oral presentation at a colloquium on urban development held by the Agence d'urbanisme pour l'agglomération strasbourgeoise.

Chapter 13

Originally published in *Caesar triumphans*, exhibition catalogue, ed. Daniel Arasse, pp. 33–45 (Florence: Institut français de Florence, 1984).

1. See Giuseppe Lugli, *Fontes ad topographiam veteris urbis Romae pertinentes* (Rome: Università di Roma, Istituto di topografia antica, 1965), and an overview by Raymond Chevallier, "Découverte d'une iconographie: la colonne Trajane, 8e–19e siècle," in *Influence de la Grèce et de Rome sur l'Occident moderne*, ed. id., pp. 329–48 (Paris: Les Belles Lettres, 1977).

2. Filippo Coarelli, *Guida archeologica di Roma* (Milan: Mondadori, 1974), p. 116.

3. See Louis Marin, "On Reading Pictures: Poussin's Letter on *Manna*," *Comparative Criticism* 4 (1982): 3–18. Raymond Chevallier evokes (although perhaps too succinctly) the problem of the visibility and readability of the column's bas-reliefs in his valuable article, "Le forum de Trajan," *Dossiers de l'archéologie* 17 (July–Aug. 1976): 12–19. See also a note by Alain Malissard, "Où peut-on voir la colonne Trajane?" ibid., p. 126.

4. In "Forum de Trajan," Raymond Chevallier discusses the *volumen* of the column's stone (p. 16).

5. The inscription over the entry porch is on a panel supported by two Victories. Over the course of history, it has been the object of an increasingly accurate reconstruction. The text is the following: Senatus populusque romanus / Imp(eratori) Caesari divi Nervae f(ilio) Nervae / Traiano Aug(usto) Germ(anico) Dacico Pontif(ici) / Maximo trib(unicia) pot(estate) XVII, Imp(erator) VI, co(n)s(ul) VI, p(ater) p(atriae) ad declarandum quantae altitudinis / Mons et locus tant(is oper)ibus sit egestus. Cf. Coarelli, *Guida archeologica*, p. 116. Let us not fail to note the topographical function of the column, as indicated at the end of the inscription, which signals the scope of the work undertaken for the opening of the forum.

6. The frieze is two hundred meters long.

7. Chevallier, "Forum de Trajan," p. 19.

8. Illustrations 1, 2, and 3 of Coarelli's graphic account, *Guida archeologica*, p. 118.

9. Ibid., illustrations 113, 114, p. 126.

10. Ibid., illustrations 3, 11, 14, 25, 36, and so on, pp. 118–20.

11. Ibid., illustration 43, p. 120.

12. Ibid., illustration 51, p. 121.

13. Ibid., illustration 103, p. 126.

14. We have to reject the objection arising from the fact that the frieze is 0.89 meters wide in the lower part of the column and 1.25 meters wide in its upper part. This difference is designed to compensate for the effects of perspective (the height of a figure situated in the lower part is 0.60 meters as opposed to 0.80 in the upper part). The elimination of these effects is aimed at producing the "visual" regularity of the spiral rolled around the shaft of the column, and not the "narrative" readability of the frieze.

15. Cf. Chevallier, "Forum de Trajan," pp. 16, 19; Paul Zanker, "Das Trajansforum in Rom," *Archaeologischer Anzeiger* (1970): 499–544; Christoph F. Leon, *Die Bauornamentik des Trajansforums und ihre Stellung in der früh- und mittelkaiserzeitlichen Architekturdekoration Roms* (Vienna: Böhlau, 1971). See also the overview by Alain Malissard, "Découverte d'une iconographie: La colonne Trajane, 1850–1976," in *Influence de la Grèce et de Rome*, ed. Chevallier, pp. 351–55; and a short work by the same author, *La colonne Trajane: Images, récit, bibliographie* (Tours: Edition du Centre de recherches A. Piganiol, 1975).

16. It requires, in short, the very readability of Trajan's *Commentari*, which were kept, we are told, in one of the two libraries that were adjacent to the column in the forum, whose terraces made it possible to *see* the upper parts of the monument.

17. Cf. Catherine Monbeig Goguel, "Du marbre au papier: De la spirale verticale à la bande horizontale," in the catalogue of the exhibition (*Caesar triumphans*, ed. Daniel Arasse, pp. 13–33). The total height of the sculptured column is 29.62 meters, with 23 spirals and 18 drums.

18. In this connection, see Michel de Certeau's fine book, *The Writing of History*, trans. Tom Conley (New York: Columbia University Press, 1988).

19. Cited by Chevallier, "Découverte d'une iconographie," p. 339.

20. Elizabeth Gilmore Holt, ed., *A Documentary History of Art* (Garden City, N.Y.: Doubleday, Anchor Books, 1958), 2: 147.

21. Alfonso Chacón, *Historia utriusque belli Dacici a Traiano Caesare gesti: ex simulachris quae in columna eiusdem Romae visuntur collecta* (Rome: Apud Franciscum Zanettum & Bartholomaeum Tosium socios, 1576). One hundred and thirty plates engraved by F. Villamena, accompanied by a *Brevis explicatiuncula* by Chacón [F. Alfonso Ciacono, 1540–1599].

22. Wilhelm Froehner, *La colonne Trajane, d'après le surmoulage exécuté à Rome en 1861–1862* (Paris: Rothschild, 1872–74).

23. For more on this topic, see Louis Marin, *Portrait of the King*, trans. Martha M. Houle (Minneapolis: University of Minnesota Press, 1988).

24. On the problem of continuous narrative, see, among others, Christopher M. Dawson, *Romano-Campanian Mythological Painting* (New Haven, Conn.: Yale University Press; London: H. Milford / Oxford University Press, 1944); Kurt Weitzmann, *Illustrations in Roll and Codex: A Study of the Origin and Method of Text Illustration* (Princeton, N.J.: Princeton University Press, 1947), ch. 1; Karl Schefold, *Pompeianische Malerei: Sinn und Ideengeschichte* (Basel: B. Schwabe, 1952); Jocelyn M. C. Toynbee, in *Proceedings of the British Academy*, 1953, p. 93, n. 2. On the continuous narrative of the frieze on the Trajan column, in particular, see Peter H. von Blanckenhagen, "Narration in Hellenistic and Roman Arts," *American Journal of Archaeology*, special issue, *Narration in Ancient Art: A Symposium* (1957): 80–83; and the very interesting thesis by Alain Malissard, *Étude filmique de la colonne Trajane: L'écriture de l'histoire et de l'épopée latines dans ses rapports avec le langage filmique* (Tours: Éditions du Centre de recherche A. Piganiol, 1974).

25. This is the mechanism for presenting the drawings of the frieze in the Louvre.

26. Here and in what follows I am relying on the now-classic narratological distinction between narration (productive agency), narrative, and history (the narrative's "referent").

27. Blanckenhagen, "Narration in Hellenistic and Roman Arts," pp. 80–81.

28. This is manifestly the weak point of Blanckenhagen's study.

29. Raymond Chevallier takes up the same hypothesis in "Forum de Trajan," p. 16: "In addition, we may suppose that the sketches of paintings that must have figured on the occasion of the triumph were exhibited under the porticos." For the ancient literary sources, see Blanckenhagen, "Narration in Hellenistic and Roman Arts": Livy 24.16.16 ff.; 41.28.8; Pliny 35.23; Cicero *Pro Sestio* 93.

30. On the victory and its trophies, see the insert in Raymond Chevallier, "Aspects de la civilisation romaine: Sur la Colonne Trajane," *Dossiers de l'archéologie* 17 (July–Aug. 1976): 86, and the reference to Gilbert Charles-Picard, *Les trophées romains: Contribution à l'histoire de la religion et de l'art triomphal de Rome* (Paris: E. de Boccard, 1957).

31. For further discussion, see Marin, *Portrait of the King.*

32. In *The Drawings of Poussin* (New Haven, Conn.: Yale University Press, 1979), ch. 5, Anthony Blunt links Poussin's decision to model his drawings on existing depictions of the column, rather than on the original, with his "archaeological enthusiasm."

33. As for example no. 303, plate 245, in *The Drawings of Nicolas Poussin: Catalogue raisonné*, ed. Walter Friedländer and Anthony Blunt (London: Kraus Reprint, 1974), 5: 29, corresponding to part of illustration no. 15 (Coarelli), to plates 15 and 16 (Bartoli) and 19 (Chiacconio): the cavalry and the infantry are about to set forth. Or, in another example, the lower part of no. 328, plate 257 (ibid., p. 37), corresponding respectively to Coarelli and Bartoli (78) and Chiacconio (91) on the one hand, to Coarelli and Bartoli (25) and Chiacconio (31) on the other.

34. In this connection, see Louis Marin, *To Destroy Painting*, trans. Mette Hjort (Chicago: University of Chicago Press, 1995).

35. See Emile Benveniste, "The Correlations of Tense in the French Verb," in id., *Problems in General Linguistics*, trans. Mary Elizabeth Meek (Coral Gables, Fla.: University of Miami Press, 1971), p. 208.

Chapter 14

Originally published as "In Praise of Appearance," *October* 37 (1986): 99–112. The 1994 French version, newly translated here, was revised in certain points of detail, taking into account the corrections the author made to the English-language version, on the one hand, and the French translation of Svetlana Alpers's *The Art of Describing* on the other.

1. Svetlana Alpers, *The Art of Describing: Dutch Art in the Seventeenth Century* (Chicago: University of Chicago Press, 1983).

2. Ibid., pp. xix–xx.

3. Ibid., p. xix.

4. Ibid.

5. Svetlana Alpers, "Style Is What You Make It: The Visual Arts Once Again," in *The Concept of Style*, ed. Berel Lang (Philadelphia: University of Pennsylvania Press, 1979), p. 98.

6. Ibid.

7. Alpers, *Art of Describing*, p. xxiv.

8. Ibid., p. xxi.

9. Ibid., p. 12.

10. Ibid.

11. Johannes Kepler, "De Modo Visionis," in Alistair C. Crombie, "Kepler: De Modo Visionis: A Translation from the Latin of *Ad Vitellionem Paralipomena*, V, 2, and Related Passages on the Formation of the Retinal Image," in *Mélanges Alexander Koyré*, ed. I. Bernard Cohen and René Taton, vol. 1 (Paris: Hermann, 1964), p. 150; cited in Alpers, *Art of Describing*, p. 34.

12. Alpers, *Art of Describing*, p. 36.

13. "De Modo Visionis," p. 151; cited in Alpers, *Art of Describing*, p. 36.

14. Alpers, *Art of Describing*, p. 36.

15. "De Modo Visionis," p. 186; cited in Alpers, *Art of Describing*, p. 36.

16. Svetlana Alpers, "Interpretation Without Representation, or, The Viewing of *Las Meninas*," *Representations* 1, 1 (Feb. 1983): 37.

17. Alpers, *Art of Describing*, pp. 43–44.

18. Ibid., p. 12.

19. Ibid.

20. Alpers, "Interpretation Without Representation," p. 35.

21. Alpers, *Art of Describing*, p. xxi.

22. Erwin Panofsky, *Early Netherlandish Painting* (Cambridge, Mass.: Harvard University Press, 1953), 1: 182; cited in Alpers, *Art of Describing*, p. xxi.

23. Blaise Pascal, *Pensées*, trans. A. J. Krailsheimer (Harmondsworth, Eng.: Penguin Books, 1966), 65 (115), p. 48. In citation of the *Pensées*, the first number is from the Lafuma edition; the second, in parentheses, is from the earlier Brunschwig edition.

24. Ibid., 541 (150), p. 218.

25. Panofsky, *Early Netherlandish Painting*, 1: 182; emphasis added.

26. Pascal, *Pensées*, 782 (266), p. 264.

27. Laurence Gowing, *Vermeer* (London: Faber & Faber, 1952), p. 19; cited in Alpers, *Art of Describing*, p. 37.

28. Alpers, *Art of Describing*, p. 37.

29. Ibid.

30. Louis Marin, "Toward a Theory of Reading in the Visual Arts: Poussin's *The Arcadian Shepherds*," in *The Reader in the Text: Essays on Audience and Interpretation*, ed. Susan Sullivan and Inge Crossman (Princeton, N.J.: Princeton University Press, 1980), pp. 293–324.

31. Emile Benveniste, "L'appareil formel de l'énonciation," in id., *Problèmes de linguistique générale*, vol. 2 (Paris: Gallimard, 1974), pp. 79–88.

32. Ann Banfield, *Unspeakable Sentences: Narration and Representation in the Language of Fiction* (London: Routledge & Kegan Paul, 1982).

Chapter 15

Lecture given in Amsterdam at a colloquium in April 1987 and published in *Word & Image: A Journal of Verbal/Visual Enquiry*, special issue, *Proceedings of the First International Conference on Word & Image / Actes du Premier congrès international de Texte & Image*, 4, 1 (1988): 25–36.

1. André Félibien, "Le songe de Philomathe," in *Entretiens sur les vies et sur les ouvrages des plus excellens peintres anciens et modernes; avec la vie des architectes*, vol. 4 (Trévoux: Imprimerie de S. A. S., 1725; repr. Farnborough, Eng.: Gregg Press, 1967), pp. 454–56.

2. Cf. Jacques Derrida, *Dissemination*, trans. Barbara Johnson (Chicago: University of Chicago Press, 1981), pp. 186–87.

3. Blaise Pascal, *Pensées*, trans. A. J. Krailsheimer (Harmondsworth, Eng.: Penguin Books, 1966), 40. In citation of the *Pensées*, the first number is from the Lafuma edition; the second, in parentheses, is from the earlier Brunschwig edition.

4. Philostratus the Elder, *Life and Times of Apollonius of Tyana*, trans. Charles P. Eels (Stanford University: The University, 1923), 6.19.

5. Cf. Louis Marin, "Imitation et trompe-l'oeil dans la théorie classique de la peinture au XVIIe siècle," *Rencontres de l'École du Louvre* (Paris: La Documentation française, 1984), pp. 181–96.

6. Antoine Furetière, *Dictionnaire universel* (The Hague: Arnout & Reiniers Lerrs, 1690), s.v. "Représenter."

7. François Recanati, *La transparence et l'énonciation* (Paris: Seuil, 1979), pp. 31 ff.

8. Nicolas Poussin, letter to Chantelou, Nov. 24, 1647, in *A Documentary History of Art*, ed. Elizabeth Gilmore Holt (Garden City, N.Y.: Doubleday, Anchor Books, 1958), 2: 154–56.

9. Erwin Panofsky, "Contribution au problème de la description d'oeuvres appartenant aux arts plastiques et à celui de l'interprétation de leur contenu," in id., *La Perspective comme forme symbolique*, trans. G. Ballangé (Paris: Minuit, 1975), pp. 235–55; originally published as "Zum Problem der Beschreibung und Inhaltsdeutung von Werken der bildenden Kunst," *Logos* 21 (1932): 103–19.

10. Pierre Bourdieu, *Distinction*, trans. Richard Nice (Cambridge, Mass.: Harvard University Press, 1984), p. 68.

11. Aristotle, *Categories*, in *Organon*, vol. 1, trans. Harold P. Cooke (Loeb Classical Library), 1.1.

12. Antoine Arnauld, *Logic, or, The Art of Thinking*, ed. and trans. Jill Vance Buroker (New York: Cambridge University Press, 1966), p. 120.

13. Panofsky, "Contribution," p. 236.

14. Ibid., p. 252.

15. See Oskar Bätschmann, *The Artist in the Modern World: The Conflict between Market and Self-Expression* (New Haven, Conn: Yale University Press, 1997).

16. Meyer Schapiro, "On Some Problems in the Semiotics of Visual Art: Field and Vehicle in Image-Signs," *Semiotics* 1, 3 (1969): 223–42.

17. Philippe Hamon, *Introduction à l'analyse du descriptif* (Paris: Hachette, 1981).

18. Pascal, *Pensées*, 65 (115), p. 48.

19. Emile Benveniste, "The Notion of 'Rhythm' in Its Linguistic Expression," in id., *Problems in General Linguistics*, trans. Mary Elizabeth Meeks (Coral Gables, Fla.: University of Miami Press, 1971), pp. 281–88.

20. Michel de Montaigne, *The Complete Essays of Montaigne*, trans. Donald M. Frame (Stanford: Stanford University Press, 1958), "To the Reader," p. 2; 3.2, p. 611.

21. Svetlana Alpers, *The Art of Describing: Dutch Art in the Seventeenth Century* (Chicago: Chicago University Press, 1983), esp. pp. 119–68 ("The Mapping Impulse in Dutch Art"). Cf. also Chapter 14, "In Praise of Appearance," above.

22. Pliny the Elder, *Natural History*, vol. 9, trans. H. Rackham (Loeb Classical Library), 35.68. Cf. Jackie Pigeaud, "La rêverie de la limite dans la peinture antique," in *Pline l'Ancien, témoin de son temps*, ed. id., pp. 413–30, Conventus Pliniani internationalis, Nantes, Oct. 22–26, 1985 (Salamanca: Universidad Pontifica, 1987).

23. Edmond de Goncourt and Jules de Goncourt, *French Eighteenth-Century Painters: Watteau, Boucher, Chardin, La Tour, Greuze, Fragonard* (1875), trans. Robin Ironside (Ithaca, N.Y.: Cornell University Press, 1981), pp. 116–17; emphasis added; the sentence in square brackets is not included in the published translation.

24. Frenhofer is the painter of the "unknown masterpiece" in Balzac's short story "Le chef-d'oeuvre inconnu."

25. Henri Maldiney, *Art et existence* (Paris: Klincksieck, 1985), p. 32.

26. Leonardo da Vinci, *Leonardo da Vinci Nature Studies from the Royal Library at Windsor Castle*, catalogue by Carlo Pedretti, intr. Kenneth Clark (New York: Harcourt Brace Jovanovich, 1981).

27. Ernst Gombrich, "The Form of Movement in Water and Air," in id., *The Heritage of Apelles* (Ithaca, N.Y.: Cornell University Press, 1976), pp. 39–56.

Chapter 16

Lecture given at the colloquium "Images de la mort, mort de l'image" organized by Eidos (Etude de l'Image dans une Orientation Sémantique) in Tours, Uni-

versité François-Rabelais, June 1986; published in *La mort en ses miroirs*, ed. Michel Constantini (Paris: Méridiens / Klincksieck, 1990), pp. 135–48.

1. *The Maxims of La Rochefoucauld*, trans. Louis Kronenberger (New York: Random House, 1959), maxim 26, p. 38.

2. Antoine Furetière, *Dictionnaire universel* (The Hague: Arnout & Reiniers Lerrs, 1690).

3. Blaise Pascal, *Pensées*, trans. A. J. Krailsheimer (Harmondsworth, Eng.: Penguin Books, 1966), 597 (455), p. 229. In citation of the *Pensées*, the first number is from the Lafuma edition; the second, in parentheses, is from the earlier Brunschwig edition.

4. Furetière, *Dictionnaire universel*, s.v. *tombeau*.

5. Ibid.

6. Ibid., s.v. *représentation*.

7. Ibid.

8. Ibid., s.v., *représenter*.

9. Ibid., s.v. *représentation*.

10. Pascal, *Pensées*, 199 (72), p. 91.

11. Ibid., s.v., *sujet*.

12. Pascal, *Pensées*, 257 (684), p. 106.

13. Ibid., 65 (115), p. 48.

14. André Félibien, *Entretiens sur les vies et sur les ouvrages des plus excellens peintres anciens et modernes; avec la vie des architectes* (Trévoux: Imprimerie de S. A. S., 1725; repr. Farnborough, Eng.: Gregg Press, 1967), vol. 3, 6th *entretien*, p. 194.

15. Ibid., vol. 4, 8th *entretien*, p. 88.

16. Giulio Mancini, "Regole per comprare, collocare et conservare la pittura," in *Considerazioni sulla pittura* (c. 1620), ed. Adriana Marucchi (Rome: Accademia nazionale dei Lincei, 1956), 1: 108–9.

17. Nicolas Poussin, letter to M. de Chambray, Mar. 1, 1665, reproduced in *A Documentary History of Art*, ed. Elizabeth Gilmore Holt (Garden City, N.Y.: Doubleday, Anchor Books, 1958), 2: 158.

Chapter 17

Originally published in the *Nouvelle revue de psychanalyse*, special issue, *L'épreuve du temps*, 41 (1990): 55–68.

1. "And so the saint was beheaded . . . about the year of the Lord 283" (Jacobus de Voragine, "Saint Blaise," in *The Golden Legend: Readings on the Saints*, trans. William Granger Ryan [Princeton, N.J.: Princeton University Press, 1993], p. 153).

2. Pierre Jean Georges Cabanis, *Notes sur le supplice de la guillotine*, in *Oeuvres complètes* (Paris: Bossange frères, 1823–25), 2: 171, 180.

3. Nicolas Poussin, letter to Jacques Stella, 1651, reproduced in André Félibien, *Entretiens sur les vies et ouvrages des plus excellens peintres anciens et modernes; avec la vie des architectes* (Trévoux: Imprimerie de S. A. S., 1725; repr. Farnborough, Eng.: Gregg Press, 1967), vol. 4, 8th *entretien*, p. 127.

4. André Félibien, *Entretiens*, vol. 3, 5th *entretien*, pp. 1–2.
5. Ibid., p. 2. 6. Ibid., p. 49.
7. Ibid., p. 27. 8. Ibid., p. 55.

Chapter 18

Originally published in *Critique*, nos. 373–74 (June–July 1978): 534–44.

1. Pierre Charpentrat, "Le trompe-l'oeil," *Nouvelle revue de psychanalyse* 4 (1971): 161–68. Page references to this article are given in the text.
2. Maurice Merleau-Ponty, *Phenomenology of Perception*, trans. Colin Smith (New York: Routledge & Kegan Paul, 1962), p. 255.
3. Ibid.
4. Ibid., pp. 255–56.
5. Francesco Scannelli, *Il microcosmo della pittura* (1657), ed. Guido Giubbini (Milan: Edizioni Labor, 1966), p. 51.
6. Emphasis added.
7. Emphasis added.

Chapter 19

Originally published as "Figure della ricezione nella rappresentazione pittorica moderna," in *Carte semiotiche*, special issue, *Semiotica della ricezione*, 2 (1986): 23–35. The text is based on a talk given at a meeting of the Associazione italiana di studi semiotici, "Semiotica della ricezione," Mantua, 1985.

1. Nicolas Poussin, letter to Chantelou, Apr. 28, 1639, in *A Documentary History of Art*, ed. Elizabeth Gilmore Holt (Garden City, N.Y.: Doubleday, Anchor Books, 1958), 2: 146.
2. Nicolas Poussin, letter to Chantelou, Apr. 28, 1639, in *Lettres et propos sur l'art*, ed. Anthony Blunt (Paris: Hermann, 1964), p. 36 (this part of the letter is not included in *A Documentary History of Art*).
3. Wolfgang Iser, *The Act of Reading: A Theory of Aesthetic Response* (Baltimore: Johns Hopkins University Press, 1978), p. 65.
4. Ibid.
5. Letter to Sublet de Noyers, n.d. (1642), in Nicolas Poussin, *Lettres et propos sur l'art*, ed. Anthony Blunt (Paris: Hermann, 1964), p. 62.
6. Ibid., p. 63; emphasis added.
7. Leon Battista Alberti, *De pictura*, ed. and trans. J. Spencer (New Haven, Conn.: Yale University Press, 1966), p. 77.
8. Ibid., p. 78.
9. Ibid.

10. Louis Marin, "Royal Money and Princely Portrait," *Portrait of the King*, trans. Martha M. Houle (Minneapolis: University of Minnesota Press, 1988), pp. 138–65.

11. Letter to Chantelou, Apr. 28, 1639, in *A Documentary History of Art* (Garden City, N.Y.: Doubleday, Anchor Books, 1958), 2: 146–47; emphasis added.

12. Letter to Jacques Stella, 1637, in Nicolas Poussin, *Correspondance*, ed. Charles Jouanny (Paris: F. de Nobele, 1968), p. 27; emphasis added.

Chapter 20

Originally published in *L'écrit du temps*, special issue, *Voir, dire*, 17 (Winter 1988): 61–72. Epigraph: Pierre Fontanier, *Les figures du discours* (1830; Paris: Flammarion, 1968), p. 390.

1. Nicolas Boileau-Despréaux, "Le lutrin," in *Oeuvres complètes*, ed. Françoise Escal (Paris: Gallimard, La Pléiade, 1966), p. 200.

2. Jean Racine, *Andromaque*, in *Théâtre complet*, ed. André Stegmann (Paris: Garnier-Flammarion, 1964), 1: 205. In English as *Andromaque*, trans. Richard Wilbur (New York: Harcourt Brace Jovanovich, 1982), p. 68.

3. Nicolas Poussin, letter to Chantelou, Nov. 24, 1647, in *A Documentary History of Art*, ed. Elizabeth Gilmore Holt (Garden City, N.Y.: Doubleday, Anchor Books, 1958), 2: 154.

4. Ibid., p. 156.

5. See ibid., pp. 155–56.

6. Gilles Deleuze, *Logique de la sensation: Francis Bacon* (Paris: La Différence, 1982), p. 39.

7. Will Grohmann, *Paul Klee* (New York: Harry N. Abrams, 1960), p. 311.

8. Antoine Furetière, "Voice," in *Dictionnaire universel* (The Hague: Arnout & Reiniers Lerrs, 1690).

9. Ibid.

Chapter 21

Lecture given at the Centre Georges-Pompidou on Dec. 19, 1987, and published in *Les cahiers du Musée national d'art moderne*, special issue, *Art de voir; art de décrire II* (1988): 62–81.

1. Antoine Furetière, *Dictionnaire universel* (The Hague: Arnout & Reiniers Lerrs, 1690), s.v. *représentation*: "noun, fem. Image that brings absent objects to our mind and memory, and that depicts them as they are. . . . When we go to see dead Princes on their display beds, we see only their *representation*, their effigy."

2. Ibid.: "Representation: is said at Court of the exhibition of something. . . .

When an accused man is put on trial, he is shown the *representation* of the arms that were taken from him, even of the body of the victim." "To represent also signifies to appear in person, and to exhibit the objects."

3. The valorization and legitimization in question can be seen in the essentially juridical use of the term in this sense.

4. See François Recanati, *La transparence et l'énonciation* (Paris: Seuil, 1979).

5. Antoine Arnauld, *La logique, ou l'art de penser* (Paris: Desprez, 1683), 5th rev. ed. In English as *Logic, or the Art of Thinking*, ed. and trans. Jill Vance Buroker (New York: Cambridge University Press, 1966).

6. Ibid., pp. 35–36, 119–20.

7. It is this pleasure in mimetic substitution that the Port-Royal logicians denounce on the ethical level in favor of an instrumentation of the representational sign in its *use*, in the name of rational communication.

8. Yves Michaud, "L'art auquel on ne fait pas attention (à propos de Gombrich)," *Critique* 416 (Jan. 1982): 22–41.

9. Figures are presented both by being circumscribed *on* the surface and by the support the background provides.

10. Through its inscription on the background surface, the mechanism of perspective has the effect of canceling out the very surface that allows it to operate, a particularly successful effect in landscape painting.

11. It is particularly fruitful to analyze rigorously what has been called atmospheric perspective in its relation to a concept as historically and epistemologically determined as that of infinity.

12. On the theoretical, plastic, and poetic variations of the notion of horizon, see Michel Callot, *L'horizon fabuleux* (Paris: Corti, 1988).

13. On the relation between descriptive discourse and naming, see Chapter 15, "Mimesis and Description," above.

14. For a study of Champaigne's 1662 *Ex-voto*, see Louis Marin, "Ecriture/peinture: L'*Ex-voto* de Champaigne," in *Vers une esthétique sans entrave: Mélanges offerts à Mikel Dufrenne* (Paris: Union générale d'édition, coll. 10/18, 1975), pp. 409–29.

15. Michael Fried, *Absorption and Theatricality: Painting and Beholder in the Age of Diderot* (Berkeley and Los Angeles: University of California Press, 1980).

16. On flies in trompe-l'oeil, see Giorgio Vasari, *Vies des meilleurs peintres*, ed. and trans. A. Chastel et al. (Paris: Berger-Levrault, 1984), 2: 120.

17. See Louis Marin, "Imitation et trompe-l'oeil dans la théorie classique de la peinture au XVIIe siècle," in *L'imitation: Rencontres de l'École du Louvre* (Paris: La documentation française, 1984), pp. 181–96. The cucumber mentioned here is a "squash" (*courgette*) in the article by Pierre Charpentrat discussed in Chapter 18, "Representation and Simulacrum," above.

18. See Anne-Marie Lecoq, "Cadre et rebord," *Revue de l'art* 26 (1974): 15–20;

and, on the frame and its semiotic and deictic functions as limit, Louis Marin, "Du cadre au décor, ou la question de l'ornement dans la peinture," *Rivista di estetica*, special issue, *L'ornamento*, 22, 12 (1982): 16–35.

19. Mme de Sévigné, *Correspondance* (Paris: Gallimard, 1974), vol. 2: *1675–1680*, p. 1039; Jean-Jacques Rousseau, *Emile; or, On Education*, trans. Alan Bloom (New York: Basic Books, 1979), p. 145. These two passages (cited in the Littré dictionary under *cadre*) point up, particularly in Rousseau's case, one of the ideological values of the frame. On this topic, see also the interesting documents contributed by Bruno Pons in *De Paris à Versailles, 1699–1736: Les sculpteurs ornemanistes parisiens et l'art décoratif des Bâtiments du roi* (Strasbourg: Association des publications près les universités de Strasbourg, 1986).

20. See *Revue de l'art* 76 (1987), an issue devoted to the problem of frames; in particular, P. J. J. Van Thiel, "Eloge du cadre: La pratique hollandaise," pp. 32–36, and Marilena Mosco, "Les cadres de Léopold de Médicis," pp. 37–40.

21. On the relation between the frame as border and as stretcher, cf. Meyer Schapiro, "On Some Problems in the Semiotics of Visual Art: Field and Vehicle in Image-Signs," *Semiotica* 1, 3 (1969): 223–42.

22. Nicolas Poussin, letter to Chantelou, Apr. 28, 1639, in *A Documentary History of Art*, ed. Elizabeth Gilmore Holt (Garden City, N.Y.: Doubleday, Anchor Books, 1958), 2: 146; emphasis added.

23. Jacques Derrida, *Truth in Painting*, trans. Geoff Bennington and Ian McLeod (Chicago: University of Chicago Press, 1987), pp. 37 ff. and in particular pp. 71–78.

24. For example, see Giulio Mancini, "Regole per comprare, collocare et conservare la pittura," in Mancini, *Considerazioni sulla pittura* (ca. 1620), ed. A. Marucchi (Rome: Accademia nazionale dei Lincei, 1956–1957), pp. 141–46; or Florent Le Comte, *Cabinet des singularitez d'architecture* (Paris: E. Picart & N. Le Clerc, 1699–1700), 3: 241–73.

25. Or, in semiotic terms, we can speak of the transformation of an opposition of contraries, A vs. B, into an opposition of contradictories, A vs. non-A.

26. The operation of framing or positioning is thus only the empirical moment of an ideal or essential operation of constituting a perceived object as a theoretical object.

27. Poussin, letter to Sublet de Noyer, 1642, in *Lettres et propos sur l'art*, pp. 62–63.

28. It would probably be appropriate to identify in some detail the investments, modalizations, and identifications that stem neither from the same level of description nor from the same mechanisms of inscription.

29. This is the perspective according to which, in more general terms, the frame stems from the apparatus of enunciation and is open to analysis based on the same methodological and technical procedures as those applied to discourse.

30. See Ernst Hans Gombrich, _The Sense of Order_ (Ithaca, N.Y.: Cornell University Press, 1979), pp. 95 ff.

31. On the transformation of _deixis_ into _epideixis_, see Louis Marin, _Portrait of the King_, trans. Martha M. Houle (Minneapolis: University of Minneapolis Press, 1988), pp. 35–117.

32. Daniel Meyer, _L'histoire du roy_ (Paris: Réunion des Musées nationaux, 1980).

33. In paintings we can also find figurative elements that do not stem from the frame, elements that integrate the space represented in the work with the "real" space in which the work is "presented." Thus, in Piero della Francesca's _Annunciation_ in San Francesco d'Arezzo, there is the painted shadow of a wooden bar, which is also painted, but fictitiously produced by the natural light of the large window at the rear of the chapel.

34. See Marin, _Portrait of the King_, pp. 35 ff.

35. Leon Battista Alberti, _De pictura_, bk. 2 (1435), ed. and trans. J. Spencer (New Haven, Conn.: Yale University Press, 1956), p. 78.

36. We need to recognize that it is the position—the scenic place—of the figure on the inner edge of the representation that predisposes that figure to playing the role of frame figure, though this does not mean it cannot also play a specific role in the narrative.

37. Cf. Charles Le Brun, "Conférence sur l'expression générale et particulière," a talk given in 1668 and published by Testelin in 1696, ed. Hubert Damisch, _Nouvelle revue de psychanalyse_ 21 (1980): 93–121; in English as _A Method to Learn to Design the Passions_ (Los Angeles: Williams Andrews Clark Memorial Library, University of California at Los Angeles, 1980).

38. Cf. Charles Le Brun, "Conférence . . . sur _La Manne_" (1667), in André Félibien, _Conférences de l'Académie royale de peinture et de sculpture_ (London: D. Mortier, 1705), pp. 69–71.

39. On this subject in particular, see Schapiro, "On Some Problems in the Semiotics of Visual Art."

40. See the reproduction of this map in _Cartes et figures de la terre: Exposition présentée au Centre Georges Pompidou du 24 mai au 17 novembre 1980_, exhibition catalogue (Paris: Centre Georges Pompidou, Centre de Création industrielle, 1980), pp. 48–49.

41. For a study of this map, see Louis Marin, _Utopics: Spatial Play_, trans. Robert A. Vollrath (Atlantic Highlands, N.J.: Humanities Press; London: Macmillan, 1984).

42. Gomboust himself indicates this clearly in his presentation of the map to the king. We should note that the map was drawn with the help of J. Petit, a military engineer, who also helped Pascal with his experiments with the vacuum. The map was engraved by Abraham Bosse.

43. See Marin, _Portrait of the King_, pp. 169 ff.

44. See Louis Marin, "Les voies de la carte," in *Cartes et figures de la terre* (cited n. 40 above), pp. 47–54, esp. pp. 50–52.

45. See *The Complete Works of St. Thomas More*, ed. E. Surtz, S.J., and J. H. Hexter (New Haven, Conn.: Yale University Press, 1965), 4: 16–17.

46. See Marin, *Utopics*, chs. 5 and 6.

47. On the texts that "framed" More's *Utopia* when it was published in 1516, texts that ironically sustain the uncertainty of More's correspondents as to the geographic location of the island of Utopia, see Louis Marin, "Voyages en Utopie," *L'ésprit créateur* (University of Louisiana) 25, 3 (1985): 42–51. Reprinted as "Journeys to Utopia," in Louis Marin, *Cross-Readings*, trans. Jane Marie Todd (Atlantic Highlands, N.J.: Humanities Press, 1998), pp. 25–32.

48. This soldier has been the object of numerous commentaries. Does he signify, in the name of the "framing" of the work, the projected conquest of the New World?

49. See Marin, *Utopics*, and the notion of the practice of fiction as opposed to utopic "representation."

50. Cf. C. S. Peirce: "On the map of an island laid down upon the soil of that island there must, under all ordinary circumstances, be some position, some point, marked or not, that represents *qua* place, on the map, the very same point *qua* place on the island" (*Collected Papers of Charles Sanders Peirce*, ed. Charles Hartshorne and Paul Weiss [Cambridge, Mass.: Harvard University Press, 1932], vol. 2: *Elements of Logic*, bk. 2, 2.230, p. 136).

51. It is by this very token that the plane of representation, despite its "transparency," is presented.

52. "Surrounded Islands. Project for Biscayne Bay, Greater Miami, Florida, 1982–83," in W. Spies, *Christo*, catalogue of the Cologne-Hamburg exhibition (Cologne and Hamburg: Dumont, 1985).

53. See Sir John Wyndham Pope-Hennessy, *The Portrait in the Renaissance* (New York: Pantheon Books, 1966), ch. 1, "The Cult of Personality," and ch. 4, "The Court Portrait."

54. On Poussin's self-portraits, see Louis Marin, "Variations on an Absent Portrait: Poussin's Self-Portraits, 1649–1650," in *Sublime Poussin*, trans. Catherine Porter (Stanford: Stanford University Press, 1999), pp. 183–208.

55. A diamond, put on display here by the painter, is defined as a prism by Furetière, *Dictionnaire universel*, s.v. *diamant*: "It has a particular feature: when the sun shines on it, it throws off as many rays as it has facets, and all of different colors, red, green, yellow, and blue."

56. Giovanni Pietro Bellori, *Le vite de' pittori, scultori et architecti moderni* (Rome, 1672), ed. E. Borea (Turin: Einaudi, 1976), "Nicolo Pussino," p. 455.

57. Donald Posner, "The Picture of Painting in Poussin's *Self Portrait*," in *Essays Presented to R. Wittkower* (London: Phaidon Press, 1967), 1: 200–203.

58. Leonardo Cremonini and Marc Le Bot, *Les parenthèses du regard* (Paris: Fayard, 1979), pp. 71, 77.

59. Ibid., p. 61.

60. Ibid., p. 79.

61. Svetlana Alpers, *The Art of Describing: Dutch Art in the Seventeenth Century* (Chicago: University of Chicago Press, 1983), pp. 119 ff.

62. Michel Foucault, *The Order of Things: An Archaeology of the Human Sciences* (New York: Pantheon Books, 1971).

63. Paul Klee, *Ad marginem*, 1930 (Basel Museum). Cf. Chapter 20, "On the Margins of Painting: Seeing Voices," above.

64. Paul Klee, lecture in Jena, 1924, in *Théorie de l'art moderne* (Geneva: Gonthier, 1968), pp. 15–35.

65. Will Grohmann, *Paul Klee* (New York: Harry N. Abrams, 1960), p. 311.

66. On Paul Klee's relation to sound and music, see *Klee et la musique*, exhibition catalogue (Paris: Editions du Centre Pompidou–Adagp; Geneva: Cosmopress, 1985).

67. Frank Stella, *Gran Cairo*, 1962 (Whitney Museum). This work belongs to the series called "Concentric Squares" from 1962–63, of which the prototypes were *Sharpeville* and *Cato Manor*. In 1974, Frank Stella returned to this formula, but using a much larger format, in a series known as the "Diderot Pictures," since almost all the works in the series are named after works by Diderot, in a reference to Michael Fried's work on Diderot as art critic.

68. Cf. William Stanley Rubin, *Frank Stella* (New York: Museum of Modern Art, 1970), pp. 75 ff.

69. On the diagonal or angular centrifugal forces of the frame, see Georg Simmel, "Der Bildrahmen: Ein ästhetischer Versuch," *Der Tag* (Berlin) 541 (1902), and, more recently, Claus Grimm, "Histoire du cadre: Un panorama," *Revue de l'art* 76 (1987): 19.

70. On this subject, see Rubin's remarks in *Frank Stella*, pp. 43–52.

71. In this context, we need to reread Michael Fried's fundamental studies of Stella's art of the period to which *Gran Cairo* belongs: first, *Three American Painters: Kenneth Noland, Jules Olitski, Frank Stella*, catalogue of the exhibition at the Fogg Art Museum, Harvard University (Meriden, Conn.: Meriden Gravure Co., 1965); then "Shape as Form: Frank Stella's New Paintings," *Art Forum* (Nov. 1966): 18–27; and "Art and Objecthood," *Art Forum* (June 1967): 116–17.

72. See Frank Stella's remarks on the power of Caravaggio's pictorial space in *Working Space* (Cambridge, Mass.: Harvard University Press, 1986), pp. 11 ff.

73. On this topic, see my remarks on accident and chance in Pollock, in Louis Marin, "L'espace Pollock," *Cahiers du Musée national d'art moderne* 10 (1983): 327.

74. On the reference in *Gran Cairo* and *Cipango* to the Spanish conquest of Mexico, see Richard H. Axson, *The Prints of Frank Stella: A Catalogue raisonné, 1967–1982* (New York: Hudson Hills Press, 1983), pp. 97–116.

Chapter 22

Originally published in *Ellipses, blancs, silences,* proceedings of a CICADA (Centre inter-critique des arts du domaine anglophone) colloquium (Pau: Université de Pau et des Pays de l'Adour, Département d'études anglaises et nord-américaines, 1992), pp. 77–86.

1. Pierre Fontanier, *Les figures du discours* (1830; Paris: Flammarion, 1968), pp 372–73; emphasis omitted.

2. Nicolas Poussin, *Lettres et propos sur l'art,* ed. Anthony Blunt (Paris: Hermann, 1964), p. 164.

3. In *A Documentary History of Art,* ed. Elizabeth Gilmore Holt (Garden City, N.Y.: Doubleday, Anchor Books, 1958), 2: 158.

4. *The Maxims of La Rochefoucauld,* trans. Louis Kronenberger (New York: Random House, 1959), maxim 26, p. 38.

5. Poussin, *Lettres et propos sur l'art,* p. 164.

6. Aristotle, *On the Soul.* In *On the Soul; Parva naturalia; On Breath,* trans. W. S. Hett, Loeb Classical Library (Cambridge, Mass.: Harvard University Press, 1936–64), 2.7.418b4–7.

7. In *Documentary History of Art,* ed. Holt, 2: 158.

8. In *Lettres et propos sur l'art,* p. 164: "Nothing is visible without boundaries."

9. Ibid.

10. Erwin Panofsky, *Perspective as Symbolic Form,* trans. Christopher S. Wood (New York: Zone Books, 1991), p. 66.

11. Emile Benveniste, "The Correlations of Tense in the French Verb," in id., *Problems in General Linguistics,* trans. Mary Elizabeth Meek (Coral Gables, Fla.: University of Miami Press, 1971), pp. 208, 206.

Works Cited

Alberti, Leon Battista. *De pictura.* 1435. Edited and translated by J. Spencer. New Haven, Conn.: Yale University Press, 1966.

Allacio, Leone (Leonis Allatii). *Apes urbanae sive de viris illustribus qui ab anno MDCXXX per totum MDCXXXII Romae adsuerunt, ac typis aliquid evulgarunt.* Rome: L. Grignanus, 1633.

Alpers, Svetlana. *The Art of Describing: Dutch Art in the Seventeenth Century.* Chicago: University of Chicago Press, 1983.

————. "Style Is What You Make It: The Visual Arts Once Again." In *The Concept of Style*, ed. Berel Lang. Philadelphia: University of Pennsylvania Press, 1979.

————. "Interpretation Without Representation, or, The Viewing of *Las Meninas.*" *Representations* 1 (Feb. 1983): 31–42.

Arasse, Daniel, ed. *Caesar triumphans.* Exhibition catalogue. Florence: Institut français de Florence, 1984.

————. *Le détail: Pour une histoire rapprochée de la peinture.* Paris: Flammarion, 1992.

Aristotle. *The "Art" of Rhetoric.* Translated by J. H. Freese. Loeb Classical Library. New York: G. P. Putnam's Sons, 1926. Reprint, 1959.

————. *Categories.* Translated by Harold P. Cooke. In *The Organon.* 2 vols. Loeb Classical Library. Cambridge, Mass.: Harvard University Press, 1938–60.

————. *Nicomachean Ethics.* Translated by H. Rackham. Loeb Classical Library. Cambridge, Mass.: Harvard University Press, 1926–62.

————. *On the Soul.* In *On the Soul; Parva naturalia; On Breath.* Translated by W. S. Hett. Loeb Classical Library. Cambridge, Mass.: Harvard University Press, 1936–64.

————. *The Physics.* Translated by Philip H. Wicksteed and Francis M. Cornford. Loeb Classical Library. Cambridge, Mass.: Harvard University Press, 1929–63.

————. *Poetics.* Translated by Stephen Halliwell. In *Poetics; On the Sublime; Longinus; On Style; Demetrius.* Cambridge, Mass.: Harvard University Press, 1995. In French as *La poétique.* Translated and edited by Roselyne Dupont-Roc and Jean Lallot. Paris: Seuil, 1980.

Arnauld, Antoine, and Pierre Nicole. *Logic, or, The Art of Thinking: Containing, besides common rules, several new observations appropriate for forming judgment.* Translated and edited by Jill Vance Buroker. 5th rev. ed. New York: Cambridge University Press, 1996.

Aubenque, Pierre. *Le problème de l'être chez Aristote.* Paris: Presses universitaires de France, 1962.

Aubignac, François-Hédelin, abbé d'. *La pratique du théâtre.* 3 vols. Amsterdam: J. F. Bernard, 1715.

Augustine, Saint. *The Confessions of St. Augustine.* Translated by F. J. Sheen. London: Sheed & Ward, 1945.

————. *On Christian Doctrine.* Translated by D. W. Robertson, Jr. Indianapolis: Bobbs-Merrill Educational Publishing, 1958. In French as *De doctrina christiana.* In *Oeuvres complètes,* vol. 11. Paris: Desclée, 1949.

Axson, Richard H. *The Prints of Frank Stella: A Catalogue raisonné, 1967–1982.* New York: Hudson Hills Press, 1983.

Baltrusaitis, Jurgis. *Anamorphoses, ou Perspectives curieuses.* Paris: O. Perrin, 1955.

Banfield, Ann. *Unspeakable Sentences: Narration and Representation in the Language of Fiction.* London: Routledge & Kegan Paul, 1982.

Bateson, Gregory. *Naven: A Survey of the Problems Suggested by the Composite Picture of the Culture of a New Guinea Tribe Drawn from Three Points of View.* Stanford: Stanford University Press, 1958.

Bätschmann, Oskar. *The Artist in the Modern World: The Conflict between Market and Self-Expression.* New Haven, Conn: Yale University Press, 1997.

Battista, A. M. "Come giudicano la 'politica' libertini et moralisti nella Francia del Seicento. In *Il libertinismo in Europa,* ed. S. Bertelli, pp. 25–80. Milan: R. Ricciardi, 1980.

Baudrillard, Jean, Michel de Certeau, Albert Lascault, Marc Le Bot, Louis Marin, and Paul Virilio, eds. *Traverses,* special issue, *La cérémonie,* 21–22 (1981).

Bellori, Giovanni Pietro. *Le vite de' pittori, scultori et architecti moderni.* 1672. Edited by E. Borea. Turin: Einaudi, 1976.

Benveniste, Emile. "The Correlations of Tense in the French Verb." In id., *Problems in General Linguistics,* pp. 205–15.

————. "L'appareil formel de l'énonciation." In id., *Problèmes de linguistique générale,* 2: 79–88.

————. "Le langage et l'expérience humaine." In id., *Problèmes de linguistique générale,* 2: 67–78.

————. "The Levels of Linguistic Analysis." In id., *Problems in General Linguistics,* pp. 101–11.

———. "A Look at the Development of Linguistics." In id., *Problems in General Linguistics*, pp. 17–27.

———. "The Nature of the Linguistic Sign." In id., *Problems in General Linguistics*, pp. 43–48.

———. "The Notion of 'Rhythm' in Its Linguistic Expression." In id., *Problems in General Linguistics*, pp. 281–88.

———. *Problèmes de linguistique générale.* 2 vols. Paris: Gallimard, 1966, 1974.

———. *Problems in General Linguistics.* Translated by Mary Elizabeth Meek. Coral Gables, Fla.: University of Miami Press, 1971.

———. "Saussure after Half a Century." In id., *Problems in General Linguistics*, pp. 29–40.

Bergler, Edmund, and Géza Róheim. "La psychologie de la perception du temps." *L'homme et la société* 11 (Jan.–Mar. 1969): 69–80.

Bergren, Ann L. T. "Helen's 'Good Drug': *Odyssey* IV, 1–305." In *Contemporary Literary Hermeneutics and Interpretation of Classical Texts / Herméneutique littéraire contemporaine et interprétation des textes classiques*, edited by Stephanus Kresic, pp. 201–14. Ottowa: Editions de l'Université d'Ottowa / Ottowa University Press, 1991.

Blanchot, Maurice. *Le ressassement éternel.* Paris: Minuit, 1952. Translated by Paul Auster under the title *Vicious Circles: Two Fictions & "After the Fact"* (Barrytown, N.Y.: Station Hill Press, 1985).

Blanckenhagen, Peter. "Narration in Hellenistic and Roman Arts." *American Journal of Archaeology*, special issue, *Narration in Ancient Art: A Symposium* (1957): 80–83.

Bloch, Ernst. *Spuren.* 1969. Frankfurt am Main: Suhrkamp, 1983.

Bloy, Léon. *Le salut par les Juifs.* 1892. Rev. ed., Paris: J. Victorion, 1906.

Blunt, Anthony. *The Drawings of Poussin.* New Haven, Conn.: Yale University Press, 1979.

Boileau-Despréaux, Nicolas. "Le lutrin." In *Oeuvres complètes.* Edited by Françoise Escal. Paris: Gallimard / La Pléiade, 1966.

Bonnefoy, Yves. *L'arrière-pays.* Geneva: Skira, 1972.

Booth, Wayne C. *The Rhetoric of Fiction.* Chicago: University of Chicago Press, 1961.

Bouissac, Paul. "Semiotics and Spectacles: The Circus Institution and Representations." In *A Perfusion of Signs*, ed. Thomas Sebeok, pp. 143–52. Bloomington: Indiana University Press, 1977.

Bourdieu, Pierre. *Distinction: A Social Critique of the Judgment of Taste.* Translated by Richard Nice. Cambridge, Mass.: Harvard University Press, 1984.

———. *Esquisse d'une théorie de la pratique. Précédé de trois études d'ethnologie kabyle.* Geneva: Droz, 1972. In English in part as *Outline of a Theory of Practice.* Translated by Richard Nice. New York: Cambridge University Press, 1977.

Boutroux, Pierre. *L'imagination et les mathématiques selon Descartes*. Paris: Alcan, 1900.

Bruyère, Nelly. *Méthode et dialectique dans l'oeuvre de La Ramée: Renaissance et âge classique*. Paris: J. Vrin, 1984.

Buyssens, Eric. "Origine de la linguistique synchronique de Saussure." *Cahiers Ferdinand de Saussure* 18 (1961): 29–30.

Cabanis, Pierre Jean Georges. "Note sur le supplice de la guillotine." In *Oeuvres complètes*, vol. 2. Paris: Bossange frères, 1823–25.

Cartes et figures de la terre: Exposition présentée au Centre Georges Pompidou du 24 mai au 17 novembre 1980. Exhibition catalogue. Paris: Centre Georges Pompidou, Centre de Création industrielle, 1980.

Cassiodorus-Jordanes. *The Gothic History of Jordanes in English version, with an introduction and commentary by Charles Christopher Mierow*. Edited by Charles Christopher Mierow. Princeton, N.J.: Princeton University Press, 1915.

Cavaillé, Jean-Pierre. *Descartes: La fable du monde*. Paris: EHESS / J. Vrin, 1991.

Cave, Terence. *The Cornucopian Text: Problems of Writing in the French Renaissance*. Oxford: Clarendon Press, 1979.

Certeau, Michel de. "Histoire et mystique." *Revue d'histoire de la spiritualité* 48 (1972): 69–82.

———. "L'opération historique." In *Faire de l'histoire*, ed. Jacques Le Goff and Pierre Nora, 1: 3–41. Paris: Gallimard, 1974.

———. *The Practice of Everyday Life*. Translated by Steven F. Rendall. Berkeley and Los Angeles: University of California Press, 1984.

———. *The Writing of History*. Translated by Tom Conley. New York: Columbia University Press, 1988.

Charles-Picard, Gilbert. *Les trophées romaines: Contribution à l'histoire de la religion et de l'art triomphal de Rome*. Paris: E. de Boccard, 1957.

Charpentrat, Pierre. "Le trompe-l'oeil." *Nouvelle revue de psychanalyse* 4 (1971): 160–68.

Chartier, Roger. *Histoire de l'édition française*. Paris: Promodis, 1982.

Chastel, André. "Le lieu de la fête." In *Les fêtes de la Renaissance*, ed. Jean Jacquot, 1: 419–23. Paris: CNRS, 1956.

Chevallier, Raymond. "Aspects de la civilisation romaine: Sur la Colonne Trajane." *Dossiers de l'Archéologie* 17 (July–Aug. 1976): 78–87.

———. "Découverte d'une iconographie: La colonne Trajane, 8e–19e siècle." In *Influence de la Grèce et de Rome sur l'Occident moderne*, ed. id., pp. 329–48. Paris: Les Belles Lettres, 1977.

———. "Le forum de Trajan." *Dossiers de l'archéologie* 17 (July–Aug. 1976): 12–19.

———, ed. *Influence de la Grèce et de Rome sur l'Occident moderne*. Paris: Les Belles Lettres, 1977.

Christo. "Surrounded Islands. Project for Biscayne Bay, Greater Miami, Florida." In W. Spies, *Christo*. Catalog of the Cologne-Hamburg exhibition. Cologne and Hamburg: Dumont, 1985.

Clarke, Jack Alden. *Gabriel Naudé, 1600–1653*. Hamden, Conn.: Archon Books, 1970.

Coarelli, Filippo. *Guida archeologica di Roma*. Milan: Mondadori, 1974.

Collot, Michel. *L'horizon fabuleux*. Paris: Corti, 1988.

Compagnon, Antoine. *La seconde main; ou, Le travail de la citation*. Paris: Seuil, 1979.

Comparato, Vittor Ivo. "Il pensiero politico dei libertini." In *Storia delle idee politiche, economiche e sociale*, ed. Luigi Firpo, pp. 95–164. Turin: UTET, 1980.

Courtney, Joseph William. *Gabriel Naudé, M.D., preeminent savant, bibliophile, philanthropist*. New York: P. B. Hoeber, 1924.

Cremonini, Leonardo, and Marc Le Bot. *Les parenthèses du regard*. Paris: Fayard, 1979.

Crocker, J. Christopher. "My Brother the Parrot." In *The Social Use of Metaphor: Essays on the Anthropology of Rhetoric*. ed. J. David Sapir and J. Christopher Crocker, 164–92. Philadelphia: University of Pennsylvania Press, 1977.

Dagron, Gilbert. "Discours utopique et récit des origines: Une lecture de Cassiodore-Jordanès." *Annales: Economies, sociétés, civilisations* 26, 2 (Mar.–Apr. 1971): 290–305.

Damisch, Hubert. "L'alphabet des masques." *Nouvelle revue de psychanalyse*, special issue, *La passion*, 21 (1980).

———. *Théorie du nuage: Pour une histoire de la peinture*. Paris: Seuil, 1972.

Dawson, Christopher M. *Romano-Campanian Mythological Landscape Painting*. New Haven, Conn.: Yale University Press; London: H. Mitford / Oxford University Press, 1944.

Deleuze, Gilles. *Logique de la sensation: Francis Bacon*. Paris: La Différence, 1982.

———. *Le rhizome: Introduction*. Paris: Minuit, 1976.

Derrida, Jacques. *Dissemination*. Translated by Barbara Johnson. Chicago: University of Chicago Press, 1981.

———. *The Truth in Painting*. Translated by Geoff Bennington and Ian McLeod. Chicago: University of Chicago Press, 1987.

Descartes, René. *The Discourse on the Method of Rightly Conducting One's Reason and Seeking the Truth in the Sciences*. 1637. In *Philosophical Writings*, 1: 111–51.

———. *De homine: Figuris et latinitate donatus a Florentio Schuyl*. Leyden: Franciscum Moyardum and Petrum Leffen, 1662. In French as *L'homme*, in *Oeuvres philosophiques*, edited by Ferdinand Alquié, 1: 379–480. Paris: Gallimard, 1963. Excerpted in English as *Treatise on Man*, in *Philosophical Writings*, 1: 99–108.

———. *The World*. 1664. Translated by Michael Sean Mahoney. New York: Abaris Books, 1979.

———. *Oeuvres de Descartes.* Edited by Charles Adam and Paul Tannery. Paris: J. Vrin, 1967.

———. *Optics* 1637. In *Philosophical Writings*, 1: 152–75.

———. *The Philosophical Writings of Descartes.* Translated by John Cottingham, Robert Stoothoff, and Dugald Murdoch. 3 vols. Cambridge: Cambridge University Press, 1985.

———. *The Passions of the Soul.* 1649. In *Philosophical Writings*, 1: 325–404.

———. *Rules for the Direction of the Mind.* 1701. In *Philosophical Writings*, 1: 9–76.

———. *The Search for Truth by Means of the Natural Light.* 1701. In *Philosophical Writings*, 2: 400–420.

Diogenes Laertius. *Lives of Eminent Philosophers.* Translated by R. D. Hicks. 2 vols. Loeb Classical Library. London: Heinemann, 1925–58.

Dumézil, Georges. "Lecture de Tite-Live." *Cahiers pour l'analyse* 7 (Mar.–Apr. 1967): 9–42.

———. *Mythe et épopée.* Paris: Gallimard, 1968.

Dupont-Roc, Roselyne, and Alain Le Bolluec. "Le charme du récit (*Odysée* IV, 219–289)." In *Ecriture et théorie poétiques: Lectures d'Homère, Eschyle, Platon, Aristote*, pp. 35–39. Paris: Presses de l'Ecole normale supérieure, 1976.

Eco, Umberto. *La struttura assente.* Milan: V. Bompiano, 1968.

Eliade, Mircea. *Zalmoxis: The Vanishing God. Comparative Studies in the Religions and Folklore of Dacia and Eastern Europe.* Translated by Willard R. Trask. Chicago: University of Chicago Press, 1972.

Erasmus, Desiderius. "Foundations of the Abundant Style" (*De duplici copia verborum ac rerum commentarii duo*). Edited and translated by Betty I. Knott. In *Collected Works of Erasmus*, vol. 24: *Literary and Educational Writings*, pt. 2, pp. 279–659. Toronto: University of Toronto Press, 1978–86.

Faglioli dell'Arco, Maurizio, and S. Carandini, eds. *L'effimero barocco: Strutture della teste nella Roma del '600.* 2 vols. Rome: Bulzoni, 1978.

Félibien, André. *Conférences de l'Académie royale de peinture et de sculpture.* London: D. Mortier, 1705.

———. *Entretien sur les vies et sur les ouvrages des plus excellens peintres anciens et modernes.* Vols. 3, 4. Trévoux: Imprimerie de S. A. S., 1725.

Firth, Raymond William. *The Work of the Gods in Tikopia.* London: Athlone Press; New York: Humanities Press, 1967.

Fontanier, Pierre. *Les figures du discours.* 1830. Paris: Flammarion, 1968.

Fortes, Meyer. "Totem and Taboo." In *Proceedings of the Royal Anthropological Institute of Great Britain and Ireland for 1966*, pp. 5–22. London: Royal Anthropological Institute, 1967.

Foucault, Michel. *The Order of Things: An Archaeology of the Human Sciences.* New York: Pantheon Books, 1971.

Freud, Sigmund. *The Interpretation of Dreams*. Vol. 4 of *The Standard Edition of the Complete Psychological Works of Sigmund Freud*, ed. James Strachey. 24 vols. London: Hogarth Press, 1953–74.

———. "Negation." In *The Standard Edition of the Complete Psychological Works of Sigmund Freud*, ed. James Strachey, 19: 235–39. 24 vols. London: Hogarth Press, 1953–74.

Fried, Michael. *Absorption and Theatricality: Painting and Beholder in the Age of Diderot*. Berkeley and Los Angeles: University of California Press, 1980.

———. "Art and Objecthood." *Art Forum* (June 1967): 116–17.

———. "Shape as Form: Frank Stella's New Paintings." *Art Forum* (Nov. 1966): 18–27.

———. *Three American Painters: Kenneth Noland, Jules Olitski, Frank Stella*. Catalog of the exhibition at the Fogg Art Museum, Harvard University, April–May 1965. Meriden, Conn.: Meriden Gravure Co., 1965.

Friedländer, Walter, and Anthony Blunt, eds. *The Drawings of Nicolas Poussin: Catalogue raisonné*. Vol. 5. London: Kraus Reprint, 1974.

Friedrich, Hugo. *Montaigne*. Edited by Philippe Desan. Translated by Dawn Eng. Berkeley and Los Angeles: University of California Press, 1991.

Froehner, Wilhelm. *La colonne Trajane d'après le surmoulage exécuté à Rome en 1861–1862*. 5 vols. in 2. Paris: Rothschild, 1872–74.

Furetière, Antoine. *Dictionnaire universel*. The Hague: Arnout & Reiniers Lerrs, 1690.

Gauvin, Claude. "La Fête-Dieu et le théâtre en Angleterre au XVe siècle." In *Les fêtes de la Renaissance*, ed. Jean Jacquot and Elie Konigson, 3: 439–49. Paris: CNRS, 1975.

Gell, Alfred. *Metamorphosis of the Cassowaries: Umeda Society, Language and Ritual*. London: Athlone Press; Atlantic Highlands, N.J.: Humanities Press, 1975.

Genette, Gérard. *Figures III*. Paris: Seuil, 1972.

Giudicelli-Falguières, Patricia. "Invention et mémoire: Aux origines de l'institution muséographique. Les collections encyclopédiques et les cabinets de merveilles dans l'Italie du XVIe siècle." Doctoral thesis, Université-Paris-I, 1988.

Godel, Robert. *Les sources manuscrites du "Cours de linguistique générale" de Ferdinand de Saussure*. Geneva: Droz, 1957.

Goldhill, Simon. "Reading Differences: The *Odyssey* and Juxtaposition." *Ramus: Critical Studies in Greek and Roman Literature* 17, 1 (1988): 1–30.

Gombrich, Ernst Hans. "The Form of Movement in Water and Air." In id., *Norm and Form: Studies in the Art of the Renaissance*, pp. 39–56. London: Phaidon Press, 1966.

———. *The Sense of Order*. Ithaca, N.Y.: Cornell University Press, 1979.

Goncourt, Edmond, and Jules de Goncourt. *L'art du XVIIIe siècle et autres textes sur l'art*. 1873. Paris: Hermann, 1967.

Granger, Gilles Gaston. *Essai d'une philosophie du style.* Paris: Colin, 1968.

Gregory, Tullio. "Introduction: Erudizione e ateismo nel Seicento." In *Theophrastus redivivus.* Naples: Morano, 1979.

Greimas, Algirdas Julien. *Du sens.* Paris: Seuil, 1970. In English in part as *On Meaning: Selected Writings in Semiotic Theory.* Translated by Paul J. Perron and Frank H. Collins. Minneapolis: University of Minnesota Press, 1987.

——. *The Social Sciences: A Semiotic View.* Translated by Paul Perron and Frank H. Collins. Minneapolis: University of Minnesota Press, 1990.

Grimm, Claus. "Histoire du cadre: Un panorama." *Revue de l'art* 76 (1987): 15–20.

Grohmann, Will. *Paul Klee.* New York: Harry N. Abrams, 1960.

Guenée, Bernard, and Françoise Lehoux. *Les entrées royales françaises de 1328 à 1515.* Paris: CNRS, 1968.

Hamon, Philippe. *Introduction à l'analyse du descriptif.* Paris: Hachette, 1981.

Hegel, G. W. F. *Lectures on the Philosophy of History.* Translated by J. Sibree. London: George Bell & Sons, 1902.

——. *The Phenomenology of Mind.* Translated by J. B. Baillie. London: Allen & Unwin: New York: Humanities Press, 1977.

Henry, Michel. "Descartes et la question de la technique." In *Le discours et sa méthode,* edited by Nicolas Grimaldi and Jean-Luc Marion, pp. 285–301. Proceedings of the colloquium for the 350th anniversary of the *Discours de la méthode.* Paris: Presses universitaires de France, 1987.

Herodotus. *The Histories.* Translated by A. D. Godley. 4 vols. Loeb Classical Library. Cambridge, Mass.: Harvard University Press, 1921–63.

Hild, Jean. "Fêtes." In *Dictionnaire de spiritualité ascétique et mystique, doctrine et histoire,* ed. Marcel Villiers, S.J., Ferdinand Cavallera, et al., vol. 5, cols. 221–47. Paris: G. Beauchesne et ses fils, 1964.

Holt, Elizabeth Gilmore, ed. *A Documentary History of Art.* Garden City, N.Y.: Doubleday, Anchor Books, 1958. Vol. 2.

Homer. *The Odyssey.* Translated by A. T. Murray and George E. Dimock. 2 vols. Loeb Classical Library. Cambridge, Mass.: Harvard University Press, 1995.

Husserl, Edmund. *The Phenomenology of Internal Time Consciousness.* Translated by James S. Churchill. Bloomington: Indiana University Press, 1964.

Iser, Wolfgang. *The Act of Reading: A Theory of Aesthetic Response.* Baltimore: Johns Hopkins University Press, 1978.

Jacquot, Jean, ed. *Les fêtes de la Renaissance.* Vol. 1. Paris: CNRS, 1956.

——. "Joyeuse et triomphante entrée." In *Les fêtes de la Renaissance,* ed. id., 1: 9–19.

Jacquot, Jean, and Elie Konigson, eds. *Les fêtes de la Renaissance.* Paris: CNRS, 1975. Vol. 3.

Jameson, Frederic. *The Prison-House of Language: A Critical Account of Struc-*

turalism and Russian Formalism. Princeton, N.J.: Princeton University Press, 1972.

Kant, Immanuel. *The Critique of Judgment.* Translated by Werner S. Pluhar. Indianapolis: Hackett Publishing Co., 1987.

Kepler, Johannes. "De Modo Visionis." In Alistair C. Crombie, "Kepler: De Modo Visionis: A Translation from the Latin of *Ad Vitellionem paralipomena,* V, 2, and related passages on the formation of the retinal image," in *Mélanges Alexander Koyré,* ed. I. Bernard Cohen and René Taton, vol. 1. Paris: Hermann, 1964.

Kernodle, George Riley. "Déroulement de la procession dans le temps ou espace théâtral dans les fêtes de la Renaissance." In *Les fêtes de la Renaissance,* ed. Jean Jacquot, pp. 443–49. Paris: CNRS, 1956.

———. *From Art to Theater: Form and Convention in the Renaissance.* Chicago: University of Chicago Press, 1949.

Klee et la musique. Exhibition catalogue. Paris: Éditions du Centre Pompidou–Adagp; Geneva: Cosmopress, 1985.

Klee, Paul. Lecture given at Jena, 1924. In *Théorie de l'art moderne,* pp. 15–33. Geneva: Gonthier, 1968.

La Fontaine, Jean de. *Fables.* Edited by Georges Couton. Paris: Garnier, 1962.

———. "The Power of Fables." In *The Complete Fables of Jean de la Fontaine.* Translated by Norman B. Spector. Evanston, Ill.: Northwestern University Press, 1988.

Lallot, Jean. *Ecriture et théorie poétiques: Lectures d'Homère, Eschyle, Platon, Aristote.* Paris: Presses de l'École normale supérieure, 1976.

Laplanche, Jean, and Jean-Baptiste Pontalis. *The Language of Psychoanalysis.* Translated by Donald Nicholson-Smith. New York: Norton, 1973.

La Rochefoucauld, François de, duc. *The Maxims of La Rochefoucauld.* Translated by Louis Kronenberger. New York: Random House, 1959.

Leach, Edmund Ronald. "Genesis as Myth." *Discovery* 23 (May 1962): 30–35. Reprinted in id., *Genesis as Myth and Other Essays,* pp. 7–23. London: Jonathan Cape, 1969.

———. *Rethinking Anthropology.* London: Athlone Press, 1961.

Le Brun, Charles. "Conférence sur *La Manne.*" 1667. In André Félibien, *Conférences de l'Académie royale de peinture et sculpture,* pp. 69–71. London: D. Mortier, 1705.

———. "Conférence sur l'expression générale et particulière." 1668. Edited by Hubert Damisch. *Nouvelle revue de psychanalyse* 21 (1980): 93–121. In English in *A Method to Learn to Design the Passions.* Los Angeles: William Andrews Clark Memorial Library, University of California at Los Angeles, 1980.

Leclercq, Henri. "Procession." In *Dictionnaire d'archéologie chrétienne et de liturgie,* ed. Fernand Cabrol and Henri Leclerq, vol. 14, pt. 2, cols. 1895–96. Paris: Le Touzey & Ané, 1948.

Le Comte, Florent. *Cabinet des singularitez d'architecture.* Vol. 3. Paris: E. Picart & N. Le Clerc, 1699–1700.

Lecoq, Anne-Marie. "Cadre et rebord." *Revue de l'art* 26 (1974): 15–20.

Lenoble, Robert. *Mersenne, ou la Naissance du mécanisme.* Paris: J. Vrin, 1943.

Leon, Christoph F. *Die Bauornamentik des Trajansforums und ihre Stellung in der früh- und mittelkaiserzeitlichen Architekturdekoration Roms.* Vienna: Böhlen, 1971.

Léon-Dufour, Xavier. *Resurrection and the Message of Easter.* Translated by R. N. Wilson. London: George Chapman, 1974; New York: Holt, Rinehart & Winston, 1975. Originally published as *Résurrection de Jésus et message pascal* (Paris: Seuil, 1971).

Leonardo da Vinci. *Leonardo da Vinci Nature Studies from the Royal Library at Windsor Castle.* Catalogue by Carlo Pedretti. Introduction by Kenneth Clark. New York: Harcourt Brace Jovanovich, 1981.

Lévinas, Emmanuel. *Nine Talmudic Readings.* Translated by Annette Aronowicz. Bloomington: Indiana University Press, 1990.

Lévi-Strauss, Claude. *The Elementary Structures of Kinship.* Translated by James Harle Bell, John Richard von Sturmer, and Rodney Needham. Edited by Rodney Needham. Boston: Beacon Press, 1969.

———. *Introduction to the Work of Marcel Mauss.* Translated by Felicity Baker. London: Routledge & Kegan Paul, 1987.

———. *The Naked Man.* Translated by John Weightman and Doreen Weightman. New York: Harper & Row, 1981.

———. *The Savage Mind.* Chicago: University of Chicago Press; London: Weidenfeld & Nicolson, 1962.

———. *Structural Anthropology.* Translated by Claire Jacobson and Brooke Grundfest Schoepf. New York: Basic Books, 1963.

———. *Totemism.* Translated by Rodney Needham. Boston: Beacon Press, 1963.

Linde, Charlotte, and William Labov. "Spatial Networks as a Site for the Study of Language and Thought." *Language* 51 (1975): 924–39.

Livy. *History of Rome.* Translated by B. O. Foster et al. 14 vols. Loeb Classical Library. Cambridge, Mass.: Harvard University Press, 1922–60.

Loraux, Nicole. *The Invention of Athens: The Funeral Oration in the Classical City.* Translated by Alan Sheridan. Cambridge, Mass.: Harvard University Press, 1986.

Lugli, Giuseppi. *Fontes ad topographiam veteris urbis Romae pertinentes.* Rome: Università di Roma, Istituto di topografia antica, 1965.

Macrobius, Ambrosius Aurelius Theodosius. *The Saturnalia.* Translated by Percival Vaughan Davies. New York: Columbia University Press, 1969.

Maldiney, Henri. *Art et existence.* Paris: Klincksieck, 1985.

Malissard, Alain. *La colonne Trajane: Images, récit, bibliographie.* Tours: Éditions du Centre de recherches A. Piganiol, 1975.

————. "Découverte d'une iconographie: La colonne Trajane, 1850–1976." In *Influence de la Grèce et de Rome sur l'Occident moderne*, ed. Raymond Chevallier, pp. 351–55.

————. *Étude filmique de la colonne Trajane: L'écriture de l'histoire et de l'épopée latines dans ses rapports avec le langage filmique.* Tours: Éditions du Centre de recherches A. Piganiol, 1974.

————. "Où peut-on voir la colonne Trajane." *Dossiers de l'archéologie* 17 (July–Aug. 1976): 126.

Mancini, Giulio. "Regole per comprare, collocare et conservare la pittura." In id., *Considerazioni sulla pittura* (c. 1620), 1: 141–46. Edited by A. Marucchi. 2 vols. Rome: Accademia nazionale dei Lincei, 1956–57.

Marin, Louis. "A propos d'un carton de Le Brun: Le tableau d'histoire ou la dénégation de l'énonciation." *Revue des sciences humaines* 157 (1975): 41–64.

————. "Aux marges de la peinture: Voir la voix." *L'écrit du temps*, special issue, *Voir dire*, 17 (Winter 1988): 61–72.

————. "Le cadre de la représentation et quelques-unes de ses figures." *Les cahiers du Musée national d'art moderne*, special issue, *Art de voir; art de décrire* II (1988): 62–81.

————. "'C'est moi que je peins . . . ' De la figuration du langage à la figurabilité du moi chez Montaigne." *Recherches sur la philosophie et le langage*, special issue, *Hommage à Henry Joly*, 12 (1990): 373–84.

————. "'C'est moi que je peins . . . ': Topiques et figures de l'énonciation." *La part de l'oeil* 5 (1989): 141–53.

————. "Champ théorique et pratique symbolique." *Critique* 321 (1974): 121–45.

————. "Les combles et les marges de la représentation." *Rivista di estetica* 25 (1984): 11–33.

————. "Le concept de figurabilité, ou la rencontre entre l'histoire de l'art et la psychanalyse." *Nervure* 3, 1 (Feb. 1990): 52–58.

————. *La critique du discours.* Paris: Minuit, 1975.

————. *Cross-Readings.* Translated by Jane Marie Todd. Atlantic Highlands, N.J.: Humanities Press, 1998.

————. "Déposition du temps dans la représentation peinte." *Nouvelle revue de psychanalyse*, special issue, *L'épreuve du temps*, 61 (1990): 55–68.

————. *To Destroy Painting.* Translated by Mette Hjort. Chicago: University of Chicago Press, 1995.

————. "Discours utopique et récit des origines: De l'Utopia de More à la Scandza de Cassiodore-Jordanès." *Annales: Economies, sociétés, civilisations* 26, 2 (Mar.–Apr. 1971): 306–27.

————. "La dissolution de l'homme dans les sciences humaines: Modèle linguistique et sujet signifiant." *Concilium* 86 (June 1973): 27–37.

————. "Du cadre au décor ou la question de l'ornement dans la peinture." *Rivista di estetica*, special issue, *L'ornamento*, 22, 12 (1982): 16–35.

———. "Du corps au texte." *Esprit* 423 (Apr. 1973): 913–28.

———. "Ecriture / peinture: L'*Ex-voto* de Champaigne." In *Vers une esthétique sans entrave: Mélanges offerts à Mikel Dufrenne*, pp. 409–29. Paris: Union générale d'édition (10/18): 1975.

———. "L'espace Pollock." *Cahiers du Musée national d'art moderne* 10 (1983): 316–27.

———. "Les femmes au tombeau: Essai d'une analyse structurale d'un texte évangélique." *Langages*, special issue, *Sémiotique narrative: Récits bibliques*, 22 (June 1971): 39–74.

———. "Figures de la réception dans la représentation moderne de la peinture." Published as "Figure delle ricenzioni nella rappresentazione pittorica moderna," *Carte semiotiche*, special issue, *Semiotica della ricezione*, 2 (1986): 23–35.

———. "Les fins de l'interprétation ou les traversées du regard dans le sublime d'une tempête." In *Les fins de l'homme: A partir du travail de Jacques Derrida*, pp. 317–44. Paris: Galilée, 1981.

———. "The Frontiers of Utopia." In *Utopias and the Millennium*, pp. 7–16. Edited by Krishan Kumar and Stephen Baum. London: Reaktion Books, 1993.

———. "Imitation et trompe-l'oeil dans la théorie classique de la peinture au XVIIe siècle." In *L'imitation: Rencontres de l'École du Louvre*. Paris: La documentation française, 1984.

———. "In Praise of Appearance." *October* 37 (1986): 99–112.

———. "L'inscription de la mémoire du roi." *Prépublications de l'Université d'Urbino* 90 (1980): 1–24. Reprinted in id., *Portrait of the King*, pp. 169–206. Translated by Martha M. Houle. Minneapolis: University of Minnesota Press, 1988.

———. "Journeys to Utopia." In id., *Cross-Readings*, pp. 25–32. Translated by Jane Marie Todd. Atlantic Highlands, N.J.: Humanities Press, 1998.

———. "Mimesis et description." *Word & Image. A Journal of Verbal / Visual Inquiry*, special issue, *Proceedings of the First International Conference on Word & Image / Actes du premier congrès international de Texte & Image*, 4, 1 (1988): 25–36.

———. "Mimesis et description, ou de la curiosité à la méthode de l'âge de Montaigne à celui de Descartes." In *Documentary Culture: Florence and Rome from Grand-Duke Ferdinand to Pope Alexander VII*, ed. Elizabeth Cropper, Giovanna Perinie, and Francesco Solinas, pp. 23–47. Florence: Nuova Alfa; Baltimore: Johns Hopkins University Press, 1992.

———. "Une mise en signification de l'espace social: manifestation, cortège, défilé, procession. (Notes sémiotiques.)" *Sociologie du Sud-Est*, special issue, *Sémiotique et mass media*, 37–38 (1983): 13–28.

———. "On a Tower of Babel in a Painting by Poussin." In id., *Of the Sublime: Presence in Question*, pp. 177–91. Translated by Jeffrey S. Librett. Albany, N.Y.: State University of New York Press, 1993.

———. "On Reading Pictures: Poussin's Letter on *Manna*." *Comparative Criticism* 4 (1982): 3–18.

———. *Opacité de la peinture: Essais sur la représentation au Quattrocento.* Paris: Usher, 1989.

———. "Les plaisirs de la narration." *Furor* (1991): 5–24.

———. *Portrait of the King.* Translated by Martha M. Houle. Minneapolis: University of Minnesota Press, 1988.

———. "Pour une théorie baroque de l'action." In Gabriel Naudé, *Considérations politiques sur les coups d'état.* 1639. Paris: Éditions de Paris, 1988.

———. Preface to Bernard Sarrazin, *La Bible en éclats: L'imagination scripturaire de Léon Bloy*, pp. 5–21. Paris: Desclée de Brouwer, 1977.

———. *Le récit est un piège.* Paris: Minuit, 1978.

———. "Remarques critiques sur l'énonciation: la question du présent dans le discours." *Modern Language Notes* 91, 5 (Oct. 1976): 939–51.

———. "Représentation et simulacre." *Critique* 373–374 (June–July 1978): 534–44.

———. "Ruptures, interruptions, syncopes dans la représentation de peinture." In *Ellipses, blancs, silences*, pp. 77–86. Proceedings of a CICADA (Centre intercritique des arts du domaine anglophone) colloquium. Pau: Université de Pau et des Pays de l'Adour, Département d'études anglaises et nord-américaines, 1992.

———. *Sémiotique de la passion.* Paris: Aubier-Montaigne, 1971.

———. *Sublime Poussin.* Translated by Catherine Porter. Stanford: Stanford University Press, 1999.

———. "Le tombeau du sujet en peinture." In *La mort en ses miroirs*, ed. Michel Constantini, pp. 135–48. Paris: Méridiens / Klincksieck, 1990.

———. "Toward a Theory of Reading in the Visual Arts: Poussin's *The Arcadian Shepherds.*" In *The Reader in the Text: Essays on Audience and Representation*, ed. Susan Sullivan and Inge Crossman, pp. 293–324. Princeton, N.J.: Princeton University Press, 1980.

———. *Utopics: Spatial Play.* Translated by Robert A. Vollrath. Atlantic Highlands, N.J.: Humanities Press; London: Macmillan, 1984.

———. "Variations sur un portrait absent: Les autoportraits de Poussin, 1649–1650." *Corps écrit* 5 (1983): 87–102. Translated by Catherine Porter as "Variations on an Absent Portrait: Poussin's Self-Portraits, 1649–1650," in *Sublime Poussin* (Stanford: Stanford University Press, 1999), pp. 183–208.

———. "La ville dans sa carte et son portrait: Propositions de recherche." *Cahiers de l'Ecole normale supérieure de Fontenay* 30–31 (1983): 11–26.

———. "Visibilité et lisibilité de l'histoire: à propos des dessins de la colonne Trajane." In *Caesar triumphans*, ed. Daniel Arasse, pp. 33–45. Exhibition catalogue. Florence: Institut français de Florence, 1984.

―――. "Les voies de la carte." In *Cartes et figures de la terre: Exposition présentée au Centre Georges Pompidou du 24 mai au 17 novembre 1980*, pp. 47–54. Paris: Centre Georges Pompidou, Centre de Création industrielle, 1980.

―――. "La voix du conte entre La Fontaine et Perrault." *Critique*, special issue, *Littératures populaires: Du dit à l'écrit*, 394 (Mar. 1980): 333–42.

―――. "Voyages en Utopie." *L'ésprit créateur* (University of Louisiana) 25, 3 (1985): 42–51. Translated by Jane Marie Todd as "Journeys to Utopia," in Louis Marin, *Cross-Readings* (Atlantic Highlands, N.J.: Humanities Press, 1998), pp. 25–32.

Martin, Henri Jean. *Print, Power, and People in Seventeenth-Century France*. Translated by David Gerard. Metuchen, N.J.: Scarecrow Press, 1993.

Marx, Karl. "Theses on Feuerbach." Appendix to Frederick Engels, *Ludwig Feuerbach*, ed. C. P. Dutt, pp. 73–75. New York: International Publishers, 1935.

Maupassant, Guy de. *Le Horla*. Paris: P. Ollendorf, 1894. Reprinted in *Le Horla et autres contes cruels et fantastiques*. Edited by M.-C. Banquart. Paris: Garnier frères, 1976.

Mauss, Marcel. *Oeuvres*. Paris: Minuit, 1968.

―――. *Sociologie et anthropologie*. Paris: Presses universitaires de France, 1966. Parts 3–4 in English as *Sociology and Anthropology: Essays*. Translated by Ben Brewster. London: Routledge & Kegan Paul, 1979.

Mersenne, Marin. *Harmonie universelle: The Books on Instruments*. 1636. Translated by Roger E. Chapman. The Hague: M. Nijhoff, 1957.

Mesnil, Marianne. "A propos du bestiaire archaïque d'Europe et de sa folklorisation dans la fête masquée." *Prépublications de l'Université d'Urbino*, special issue, *La fête: Approches sémiotiques*, ed. Pierre Smith et al., 92–93 (1980): 26–30.

Metschies, Michael. *Zitat und Zitierkunst in Montaignes Essais*. Geneva: Droz; Paris: Minard, 1966. In French as *La citation et l'art de citer dans les Essais de Montaigne*. Translated by Jules Brody. Paris: H. Champion, 1997.

Meyer, Daniel. *L'histoire du roy*. Paris: Réunion des musées nationaux, 1980.

Michaud, Yves. "L'art auquel on ne fait pas attention (à propos de Gombrich)." *Critique* 416 (Jan. 1982): 22–41.

Mierow, Charles Christopher, ed. *The Gothic History of Jordanes in English Version*. Princeton, N.J.: Princeton University Press, 1915.

Mikus, Francis. "Edward Sapir et la syntagmatique." *Cahiers Ferdinand de Saussure* 11 (1953): 11–30.

Mommsen, Theodor, ed. *Chronica minora saec. IV, V, VI, VII*. Vol. 2. Berlin: Weidmann, 1892–98.

Monbeig Goguel, Catherine. "Du marbre au papier: De la spirale verticale à la bande horizontale." In *Caesar triumphans*, ed. Daniel Arasse, pp. 13–33. Exhibition catalogue. Florence: Institut français de Florence, 1984.

Montaigne, Michel de. *Complete Works: Essays, Travel Journal, Letters.* Translated by Donald M. Frame. Stanford: Stanford University Press, 1957.

———. *Essais.* 1580–95. Edited by P. Villey. Paris: Presses universitaires de France, 1988.

More, Thomas. *The Complete Works of St. Thomas More.* Edited by Edward Surtz, S.J., and J. H. Hexter. New Haven, Conn.: Yale University Press, 1965.

———. *Utopie.* Translated by Marie Delcourt. Brussels: La Renaissance du livre, n.d.

Morton, Arthur Leslie. *The English Utopia.* London: Lawrence & Wishart, 1952.

Mosca, Marilena. "Les cadres de Léopold de Médicis." *Revue de l'art* 76 (1987): 37–40.

Naudé, Gabriel. *Considérations politiques sur les coups d'état.* Rome, 1639. Paris: Éditions de Paris, 1988. In English as *Political Considerations upon Refin'd Politicks, and the Master-Strokes of State, as Practis'd by the Ancients and Moderns.* Translated by William King. London: H. Clements, 1711.

"Note liminaire." *Cahiers pour l'analyse* 7 (Mar.–Apr. 1967): 7–8.

Ogden, C. K., and I. A. Richards. *The Meaning of Meaning: A Study of the Influence of Language upon Thought and of the Science of Symbolism.* 1945. London: Routledge & Kegan Paul, 1960. Reprinted New York: Harcourt Brace & World, 1964.

Ong, Walter J. *Ramus: Method and the Decay of Dialogue. From the Art of Discourse to the Art of Reason.* Cambridge, Mass.: Harvard University Press, 1958.

Ovid. *Metamorphoses.* Translated by A. D. Melville. New York: Oxford University Press, 1986.

Ozouf, Mona. *Festivals and the French Revolution.* Translated by Alan Sheridan. Cambridge, Mass.: Harvard University Press, 1988.

Panofsky, Erwin. *Early Netherlandish Painting.* 2 vols. Cambridge, Mass.: Harvard University Press, 1953.

———. *Perspective as Symbolic Form.* Translated by Christopher S. Wood. New York: Zone Books, 1991.

———. "Zum Problem der Beschreibung und Inhaltsdeutung von Werken der bildenden Kunst." *Logos* 21 (1932): 103–19.

Pascal, Blaise. *The Art of Persuasion.* In *Pensées and Other Writings.* Translated by Honor Levi. New York: Oxford University Press, 1995.

———. *Pensées.* Translated by A. J. Krailsheimer. Harmondsworth, Eng.: Penguin Books, 1966.

———. *The Thoughts, Letters and Opuscules of Blaise Pascal.* Translated by O. W. Wright. Cambridge: Riverside Press, 1887.

Peirce, Charles Sanders. *Elements of Logic.* Vol. ii of *Collected Papers.* Edited by Charles Hartshorne and Paul Weiss. Cambridge, Mass.: Harvard University Press, Belknap Press, 1960–66.

Peiresc, Nicolas Claude Fabri de. Letter to Gassendi, December 21, 1832. In Jacques Guillerme, preface to N. C. Fabri de Peiresc, *Lettres à Cassiano dal Pozzo, 1626–1637.* Edited by Jean-François Lhôte and Danielle Joyal. Clermont-Ferrand: Adosa, 1989.

Perrault, Charles. *Contes.* Edited by Gilbert Rouger. Paris: Garnier-Flammarion, 1967.

———. "Preface to the Tales in Verse." In *Charles Perrault: Memoirs of My Life,* pp. 120–23. Edited and translated by Jeanne Morgan Zarucchi. Columbia, Mo.: University of Missouri Press, 1989.

Philostratus the Elder. *Life and Times of Apollonius of Tyana.* Translated by Charles P. Eels. Stanford University: The University, 1923.

Pingeaud, Jackie. "La rêverie de la limite dans la peinture antique." In *Pliny l'Ancien témoin de son temps,* ed. id., pp. 413–30. Conventus Pliniani internationalis, Nantes, October 22–26, 1985. Salamanca: Universidad pontifica, 1987.

Pintard, René. *Le libertinage érudit pendant la première moitié du XVIIe siècle.* Paris: Boivin, 1943.

Plato. *Charmides.* In *Charmides; Alcibiades I and II; Hipparchus; The Lovers; Theages; Minos; Epiminos.* Translated by W. R. M. Lamb. Loeb Classical Library. Cambridge, Mass.: Harvard University Press, 1927–79.

———. *Critias.* In *Timaeus; Critias; Cleitophon; Menexenus; Epistles.* Translated by R. G. Bury. Loeb Classical Library. Cambridge, Mass.: Harvard University Press, 1929–75.

Pliny the Elder. *Natural History.* Loeb Classical Library. Cambridge, Mass.: Harvard University Press, 1938–79.

Plutarch. "Table-Talk." In *Plutarch's Moralia.* Vol. 8. Translated by Paul A. Clement and Herbert B. Hoffleit. Loeb Classical Library. London: Heinemann, 1969.

Pomian, Krzystof. *Collectionneurs, amateurs, curieux: Paris, Venise, XVIe–XVIIIe siècle.* Paris: Gallimard, 1987.

———. "Collezione." In *Enciclopedia Einadi,* 3: 330–64. Turin: G. Einaudi, 1978. Reprinted as "Entre le visible et l'invisible, la collection." *Libre* 3 (1978): 3–56.

Pons, Bruno. *De Paris à Versailles, 1699–1736: Les sculpteurs ornemanistes parisiens et l'art décoratif des Bâtiments du roi.* Strasbourg: Association des publications près les universités de Strasbourg, 1986.

Pope-Hennessy, Sir John Wyndham. *The Portrait in the Renaissance.* New York: Pantheon Books, 1966.

Posner, Donald. "The Picture of Painting in Poussin's *Self Portrait.*" In *Essays Presented to R. Wittkower,* 1: 200–203. London: Phaidon Press, 1969.

Pouilloux, Jean-Yves. *Lire les essais de Montaigne.* Paris: Maspero, 1970.

Poussin, Nicolas. *Correspondance de Nicolas Poussin.* Edited by Charles Jouanny. Paris: F. de Nobele, 1968.

————. *Lettres et propos sur l'art.* Edited by Anthony Blunt. Paris: Hermann, 1904.

Propp, Vladimir. *Morphology of the Folktale.* Translated by Laurence Scott. 2d ed. Austin: University of Texas Press, 1968.

Racine, Jean. *Andromaque.* In *Théâtre complet.* Edited by André Stegmann. Vol. 1. Paris: Garnier-Flammarion, 1964. In English as *Andromaque.* Translated by Richard Wilbur. New York: Harcourt Brace Jovanovich, 1982.

Recanati, François. *La transparence et l'énonciation.* Paris: Seuil, 1979.

Redondi, Pietro. *Galileo Heretic = Galileo eretico.* Translated by Raymond Rosenthal. Princeton, N.J.: Princeton University Press, 1987.

Rice, James Van Nostran. *Gabriel Naudé, 1600–1653.* Baltimore: Johns Hopkins University Press; Paris: Les Belles Lettres, 1939. Reprinted New York: Johnson Reprint Corp., 1973.

Ricoeur, Paul, and Claude Lévi-Strauss. "Débat sur *La pensée sauvage* et le structuralisme." *Esprit* 322 (1963): 545–653.

Rodis-Lewis, Geneviève. "Machineries et perspectives curieuses dans leur rapport au cartésianisme." *XVIIe siècle* 32 (1956): 461–74.

Rossi, Paolo. *Philosophy, Technology, and the Arts in the Early Modern Era.* Edited by Benjamin Nelson. New York: Harper & Row, 1970.

Rousseau, Jean-Jacques. *Emile; or, On Education.* Translated by Alan Bloom. New York: Basic Books, 1979.

Roux, Lucette Elyane. "Les fêtes du Saint-Sacrement à Séville en 1594: Essai de définition d'une lecture des formes." In *Les fêtes de la Renaissance,* ed. Jean Jacquot and Elie Konigson, 3: 461–84. Paris: CNRS, 1975.

Rubin, William Stanley. *Frank Stella.* New York: Museum of Modern Art, 1970.

Sainte-Beuve, Charles Augustin. *Portraits littéraires.* Vol. 2. Paris: Garnier frères, 1862.

Sarrazin, Bernard. *La Bible en éclats: L'imagination scripturaire de Léon Bloy.* Paris: Desclée de Brouwer, 1977.

Saussure, Ferdinand de. *Course in General Linguistics.* Edited by Charles Bally and Albert Sechehaye. Translated by Roy Harris. London: Duckworth, 1983.

————. *Mémoire sur le système primitif des voyelles dans les langues indo-européennes.* Hildesheim: G. Olms, 1987.

Scannelli, Francesco. *Il microcosmo della pittura.* 1637. Edited by Guido Giubbini. Milan: Edizioni Labor, 1966.

Schapiro, Meyer. "Muscipula diaboli: The Symbolism of the Mérode Altarpiece." *Art Bulletin* 27, 3 (Sept. 1945): 182–87. Reprinted in id., *Late Antique, Early Christian and Medieval Art: Selected Papers,* 1–19. New York: George Braziller, 1979.

————. "On Some Problems in the Semiotics of Visual Art: Field and Vehicle in Image-Signs." *Semiotica* 1, 3 (1969): 223–42.

Scheflen, Albert E., and Norman Ashcraft. *Human Territories: How We Behave in Space-Time.* Englewood Cliffs, N.J.: Prentice-Hall, 1976.

Schefold, Karl. *Pompejanische Malerei: Sinn und Ideengeschichte.* Basel: B. Schwabe, 1952.

Schwimmer, Eric G. *Exchange in the Social Structure of the Orokaiva: Traditional and Emergent Ideologies in the Northern District of Papua.* London: C. Hurst, 1973.

———. "Feasting and Tourism." *Prépublications de l'Université d'Urbino,* special issue, *La fête: Approches sémiotiques,* ed. Pierre Smith et al., 92–93 (1980).

Servier, Jean. *Histoire de l'Utopie.* Paris: Nouvelle revue française, 1967.

Sévigné, Marie de Rabutin Chantal, marquise de. *Correspondance.* Vol. 2. Paris: Gallimard, 1974.

Simmel, Georg. "Der Bilderrahmen: Ein ästhetischer Versuch." *Der Tag* (Berlin) 541 (1902).

Slusareva, N. "Quelques considérations des linguistes soviétiques à propos des idées de F. de Saussure." *Cahiers Ferdinand de Saussure* 20 (1963): 23–46.

Smith, Pierre, et al., eds. *La fête: Approches sémiotiques. Prépublications de l'Université d'Urbino,* special issue, 92–93 (1980).

Spink, John Stephenson. *French Free-Thought from Gassendi to Voltaire.* London: University of London, Athlone Press, 1960.

Stella, Frank. *Working Space.* Cambridge, Mass.: Harvard University Press, 1986.

Stendhal [Henri Beyle]. *De l'amour.* Edited by H. Martineau. Paris: Hazan, 1948. In English as *On Love.* Translated by H. B. V. under the direction of C. K. Scott Moncrieff. Garden City, N.Y.: Doubleday, 1957.

———. *Life of Henry Brulard.* Translated by John Sturrock. New York: Penguin Books, 1995.

Sutcliffe, F. E. *Guez de Balzac et son temps: Littérature et politique.* Paris: A. G. Nizet, 1959.

Toynbee, Jocelyn M. C. D. "The Ara Pacis Reconsidered and Historical Art in Roman Italy." In *Proceedings of the British Academy* 39 (1953): 67–95.

Turner, Victor Witter. *The Drums of Affliction: A Study of Religious Processes Among the Ndembu of Zambia.* Oxford: Clarendon Press; London: International African Institute, 1968.

———. *Process, Performance and Pilgrimage: A Study in Comparative Symbology.* New Delhi: Concept, 1979.

———. *The Ritual Process: Structure and Anti-Structure.* Chicago: Aldine, 1969. Reprint, Ithaca, N.Y.: Cornell University Press, 1977.

Turner, Victor Witter, and Edith Turner. *Image and Pilgrimage in Christian Culture: Anthropological Perspectives.* Oxford: B. Blackwell, 1978.

Van Thiel, P. J. J. "Eloge du cadre: La pratique hollandaise." *Revue de l'art* 76 (1987): 32–36.

Vasali, Cesare. *La dialettica e la retorica dell'umanesimo: Invenzione e metodo della cultura del XV e XVI secolo.* Milan: Feltrinelli, 1968.

Vasari, Giorgio. *Lives of the Most Eminent Painters, Sculptors and Architects.* Translated by Gaston du C. de Vere. London: Macmillan, 1912–15.

Vernant, Jean-Pierre. *Figures, idoles, masques.* Paris: Julliard, 1990.

Villari, Rosario. *Elogio della dissimulazione: La lotta politica nel Seicento.* Bari: Laterza, 1987.

Voragine, Jacobus. "Saint Blaise." In id., *The Golden Legend: Readings on the Saints,* 1: 151–53. Translated by William Granger Ryan. Princeton, N.J.: Princeton University Press, 1993.

Vovelle, Michel. *Les métamorphoses de la fête en Provence de 1750 à 1820.* Paris: Aubier-Flammarion, 1976.

Weitzmann, Kurt. *Illustrations in Roll and Codex: A Study of the Origin and Method of Text Illustration.* Princeton, N.J.: Princeton University Press, 1947.

Wind, Edgar. *Art and Anarchy.* London: Faber & Faber, 1963.

———. *Giorgione's "Tempesta," with Comments on Giorgione's Poetic Allegories.* Oxford: Clarendon Press, 1969.

Yates, Frances A. *The Art of Memory.* London: Routledge & Kegan Paul; Chicago: University of Chicago Press, 1966.

Zanker, Paul. "Das Trajansforum in Rom." *Archaeologischer Anzeiger* (1970): 499–544.

MERIDIAN

Crossing Aesthetics